For the Surrey Institute of Art and Design,

a gift from the author,

April 1996

Anna M. Muthesius,

14.1

STUDIES IN BYZANTINE AND ISLAMIC SILK WEAVING

STUDIES IN BYZANTINE AND ISLAMIC SILK WEAVING

ANNA MUTHESIUS

The Pindar Press

London 1995

Published by The Pindar Press
66 Lyncroft Gardens
London NW6 1JY

British Library Cataloguing in Publication Data

A catalogue record for this book is available from the British Library

ISBN 0 907132 93 6

Typeset by
Rex Gooch, Welhandy, Welwyn, Hertfordshire

Printed by Galliard (Printers) Ltd
Great Yarmouth, Norfolk NR31 0LL

DEDICATION

To Bianca

Contents

List of Figures ... i

Preface .. iii

I De zijden stoffen in de Schatkamer van de Sint Servaaskerk
te Maastricht ... 1

II The Silk over the Spine of the Mondsee Gospel Lectionary 21

III The Silks from the Tomb of Archbishop Walter 45

IV Practical Approach to History of Byzantine Silk Weaving 55

V Silks and Saints: The Rider and Peacock Silks
from the Relics of St. Cuthbert .. 77

VI Byzantine and Islamic Silks in the Rhine-Maaslands before 1200 105

VII From Seed to Samite: Aspects of Byzantine Silk Production 119

VIII The Impact of the Mediterranean Silk Trade on Western Europe
before 1200 AD ... 135

IX The Griffin Silk from St. Trond ... 147

X Silken Diplomacy .. 165

XI Crossing traditional boundaries: Grub to Glamour
in Byzantine silk weaving ... 173

XII The Role of Byzantine Silks in the Ottonian Empire 201

XIII Politics, piety and the silken cult of relics:
Aachen Münster treasury silks in historical context 217

XIV Silk, Power and Diplomacy in Byzantium ... 231

XV The hidden Jewish element in Byzantium's Silk Industry: Catalyst
for the Impact of Byzantine silks on the Latin Church before 1200 AD? 245

XVI The Byzantine silk industry: Lopez and beyond 255

XVII Constantinople and its Hinterland: Issues of Raw Silk Supply 315

XVIII A Silk Reliquary Pouch from Coppergate ... 337

XIX The Silk Fragment from 5 Coppergate, York ... 341

XX Review: Silks at Lyon ... 349

Index .. 355

Acknowledgements ... 373

List of Plates .. 375

Plates ... 381

List of Figures

FIGURE 1 DETAIL VAN DIE ZIJDE MET HET GEVLEUGELD PAARD. MUSEO SACRO, VATICAAN 8

FIGURE 2 RECHTERHELFT VAN HET MEDAILLON MET DUBBELKOPPIGE ADELAAR.
 ABEGG-STIFTUNG, RIGGISBERG 9

FIGURE 3 DETAIL VAN EEN ZIJDEN TAPISSERIEWEEFSEL MET EEN ACHTERGROND
 VAN SCHOPPENAASFIGUREN DIOCESAN MUSEUM, BAMBERG 11

FIGURE 4 DETAIL VAN EEN ZIJDEN STOF NO. 3872 KESTNER MUSEUM, HANNOVER.
 VERWANT IN WEEFTECHNIEK MET DE GEGRAVEERDE ZIJDEN STOFFEN 11

FIGURE 5 DETAIL VAN EEN ZIJDEN STOF ST.-SERVATIUS, MAASTRICHT 15

FIGURE 6 DETAIL VAN EEN ZIJDEN STOF ST.-SERVATIUS, MAASTRICHT 15

FIGURE 7 DIAGRAM OF DESIGN IN THE WEAVE OF THE SILK
 OF THE MONDSEE GOSPEL LECTIONARY 25

FIGURE 8 DIAGRAM OF FOUR INCISED TWILL DESIGNS 27

FIGURE 9 DESIGN MOTIFS OF 10TH TO 11TH CENTURY SILK CHASUBLES 31

FIGURE 10 CONSTRUCTION OF THE MONDSEE GOSPEL LECTIONARY 43

FIGURE 11A RECONSTRUCTED DESIGN OF THE RIDER SILK 81

FIGURE 11B DURHAM RIDER SILK: SKETCH OF THE MAIN PART OF THE DESIGN 82

FIGURE 12 BICEPHAL PEACOCK SILKS WITH "PEACOCK EYE" TAIL FEATHERS 90

FIGURE 13A ST. TROND GRIFFIN SILK 148

FIGURE 13B SITTEN GRIFFIN SILK 149

FIGURE 14A LONDON V&A GRIFFIN SILK 150

FIGURE 14B SITTEN GRIFFIN SILK 151

FIGURE 14C SENS CATHEDRAL TREASURY FRAGMENT 151

FIGURE 15A SENS ST. SIVIARD SILK .. 152

FIGURE 15B ST. TROND GRIFFIN SILK .. 152

FIGURE 15C COLOGNE DIOCESAN MUSEUM GRIFFIN SILK 152

FIGURE 15D ABEGG STIFTUNG RIGGISBERG GRIFFIN SILK 152

FIGURE 15E SITTEN GRIFFIN SILK .. 152

FIGURE 16 LE MONASTIER, ST. CHAFFRE, GRIFFIN SILK 154

FIGURE 17A SITTEN REARING LION SILK .. 155

FIGURE 17B BERCHTESGADEN, STIFTSKIRCHE GRIFFIN SILK 156

FIGURE 18 BAMBERG DIOCESAN MUSEUM, POPE CLEMENT SILK, BUSKINS 157

FIGURE 19 MUNICH, NATIONAL MUSEUM, GRIFFIN SILK 157

FIGURE 20 SPEYER HISTORISCHES MUSEUM, GRIFFIN SILK 158

FIGURE 21 FRAMEWORK FOR THE STUDY OF BYZANTINE SILKS 175

FIGURE 22 DRAWLOOM: FIGURE HARNESS WITH 40 MAILS AND 4 PATTERN REPEATS 184

FIGURE 23 THE THREE STAGES OF SILK MANUFACTURE 268

FIGURE 24 PROVINCES ON SEALS OF KOMMERKIARIOI (629-72) (AFTER OIKONOMIDES) 316

FIGURE 25 PROVINCES NAMED ON SEALS OF KOMMERKIARIOI (673-74 TO 728-9) 317

FIGURE 26 PROVINCES NAMED ON SEALS OF IMPERIAL KOMMERKIARIOI
(730-31 TO 755-56) ... 318

FIGURE 27 THEMES NAMED ON SEALS OF IMPERIAL KOMMERKIARIOI 730-31 TO
755-56 (1-4) AND UP TO THE EARLY NINTH CENTURY (5-6) 319

FIGURE 28 THE COPPERGATE SILK RELIQUARY POUCH 337

FIGURE 29 WEFT-FACED PAIRED MAIN WARP TWILL 338

FIGURE 30A SILK FRAGMENT FROM 5 COPPERGATE (651) 342

FIGURE 30B SILK FRAGMENT FROM SALTERGATE, LINCOLN 343

FIGURE 31 LINCOLN SILK FRAGMENT WORN AS A HEADSCARF 345

Preface

OVER the last twenty years, academic Textile Studies have developed rapidly, but relevant literature has tended to appear in specialised and sometimes not readily accessible publications. Through the collection of the bulk of my papers into a single volume, it has been possible to centralise disparate articles into a cohesive whole to reach a wider audience.

By their very nature, textiles are subjects of interdisciplinary study. They are at once archaeological; anthropological; historical and art historical; theological; palæographical; scientific and technical documents. Mediæval Byzantine and Islamic silks are no exception. Inevitably, over such a wide range of disciplines, much exciting work remains to be carried out. The purpose of the present volume (together with the author's 'History of Byzantine Silk Weaving', ed. J. Koder, E. Kislinger, Byzantine Institute, University of Vienna), is to stimulate further discussion in a fascinating field of study.

The present studies are reproduced very much as they originally appeared, with the addition of only a little essential updating. Φιλοχρίστων has been translated as either 'devout' or the literal 'Christ-loving' depending on the date of the article. Where appropriate, later relevant archæological discoveries and subsequent important publications appear as additional bibliographical references at the end of individual papers. Typesetting has been standardised to meet the requirements of the series, but references have not been recast.

I offer my warmest thanks to the many treasury and museum keepers throughout Europe and North America who have provided access to the silks published in this book. To Donald King (formerly Keeper of Textiles in the Victoria and Albert Museum) I owe special thanks for his most generous and invaluable teaching and advice over many years. My family, friends (especially Ephthalia and Costa Constantinides) and colleagues (at Lucy Cavendish College, Cambridge and WSCAD, Farnham) have

supported my work in numerous ways: to them I extend my deep gratitude. Finally, but not least, my very sincere thanks are due to Rex Gooch for expert technical editing, and to Liam Gallagher for making this publication possible.

ANNA MUTHESIUS
CAMBRIDGE, 1994

I
De zijden stoffen
in de Schatkamer van de
Sint Servaaskerk te Maastricht

IN DE schatkamer van de St.-Servaaskerk te Maastricht bevinden zich meer dan 250 stukken zijde van verschillend formaat. De meesten daarvan dateren uit de periode tussen de achtste en veertiende eeuw. Een bepaald aantal is van vóór de 8e eeuw en enige zijn van aanzienlijk latere datum dan de 14e eeuw. De juiste herkomst van de zijden stoffen valt moeilijk vast te stellen, maar het is een feit dat tot nu toe nog geen enkel document aan het licht is gekomen, waaruit zou moeten blijken dat de kunst van het zijdeweven vroeger dan het jaar 1147 naar het Westen is gekomen. De zijden stoffen van de daar vóór liggende periode zijn vanuit het Oosten ingevoerd. De geïmporteerde zijde kwam ofwel uit Byzantijnse of Islamitische centra. Onder de Maastrichtse zijden weefsels bevindt zich een exemplaar met een ingeweven inscriptie in Koefische lettertekens. Er zijn er echter geen met ingeweven Griekse teksten. Helaas kennen wij maar van heel weinig zijden stoffen de herkomst. Alleen in het geval van een handvol zijden weefsels is bekend, dat zij in het begin van deze eeuw uit het schrijn van Sint Servaas zijn genomen. De 12e eeuw — het tijdstip van het ontstaan van het schrijn — levert een terminus ante quem op voor de desbetreffende zijden stoffen. Paul Schulze, de conservator van de 'Königliche Gewebesammlung' te Krefeld droeg er in 1887 zorg voor, dat het grootste gedeelte van de fragmenten op kartonnen bladen werd bevestigd b.g.v. een tentoonstelling aldaar. Zijn Berlijnse collega, Lessing, was hem behulpzaam bij de beschrijving er van. In het archief van de Sint Servaaskerk bevindt zich in handschrift een anonyme en ongedateerde duitstalige cataloog van ongeveer 60 fragmenten. Naar alle waarschijnlijkheid is dit de bovenbedoelde beschrijving. De stoffen werden

volgens een op de lijsten gevonden inscriptie in 1895 onder glas gemonteerd. Overigens is er nog nooit een gedetailleerde studie over een enkele van deze stoffen gepubliceerd, die oorspronkelijk wel gediend zullen hebben als omhulsel voor de relieken in verschillende reliekhouders.[1] In dit artikel wil de schrijfster een dwarsdoorsnede geven van de zijden stoffen, terwijl ze ook bezig is met de voorbereiding van een gedetailleerde catalogus met een technische analyse van elke zijden stof.

In de vroegere literatuur over zijden weefsels baseerde men de datering op een stilistische analyse, terwijl men de weeftechniek helemaal buiten beschouwing liet.[2] Er bestaan twee redenen, waarom een stilistische analyse niet geschikt is om zijden stoffen te dateren. Ten eerste: men is geneigd de motieven op conservatieve manier te gebruiken en dat zelfs gedurende verschillende eeuwen en ten tweede: de weeftechniek is van invloed op het patroon van de zijden stoffen. Voorwerpen die louter en alleen beschreven zijn op stilistische gronden zijn voorbeelden van persoonlijke interpretatie van de weeftechniek. Door de weeftechniek er bij te betrekken krijgt men een vast uitgangspunt bij de datering van zijden stoffen, dat op zijn beurt dan weer ondersteund kan worden door gegevens uit inventarissen en archieven.

Bij het vanuit technisch oogpunt bestuderen van zijden stoffen, die zich in de schatkamers en musea van West-Europa bevinden, is het mogelijk zich een denkbeeld te vormen, welke van de verschillende weefsels vanuit het Oosten vóór 1200 werden geïmporteerd. Zo'n onderzoek wijst uit, dat er tenminste vijf onderscheiden soorten weefsels het Westen hebben bereikt. Gedetailleerde technische beschrijvingen van deze weefsels zijn voorhanden.[3] Omdat deze beschrijvingen tamelijk ingewikkeld zijn, zal er van ieder type een vereenvoudigde uitleg worden gegeven, voordat er een keuze wordt gemaakt uit de specimen van verschillende weefsels uit de St.-Servaas, die verderop besproken worden.

De namen, die deze vijf soorten weefsels gekregen hebben, zijn: TABIJN, DAMAST, KEPER, LAMPAS en TAPISSERIE. Er zijn twee soorten damast en lampasweefsels en er bestaan verschillen tussen specimen van tabijn- en gekeperde weefsels. Tabijn, damast en keper van een bepaald type werden vervaardigd vóór de 8e eeuw. Men neemt aan, dat rond het midden van de 8e eeuw gekeperde stoffen met lichte struktuurverschillen hun intrede deden en dat deze de vroegere vorm van keper op uitgebreide schaal hebben vervangen. Rond het jaar 1000 gaan in het Westen de effen gekeperde stoffen overheersen. De patronen lijken in het oppervlak van de zijde ingegraveerd te zijn. Deze werden vervaardigd vanaf het laatste van de 10e eeuw. Uit dezelfde periode stammen twee soorten lampasweefsel. Tapisserieweefsel was in het Oosten zeker al bekend vóór de 8e eeuw. In de schatkamers van het Westen zijn slechts enkele tapisserieweefsels bewaard gebleven.[4] Of de import was te moeilijk of vele zijn in de loop der

eeuwen verloren gegaan. De weinige tapisserieweefsels die er nog zijn, hebben het Westen waarschijnlijk in de 11e en 12e eeuw bereikt. Dit dateringsoverzicht van de verschillende weefseltypes is gebaseerd op het bewijsmateriaal van aanwezige zijden stoffen in westerse schatkamers en museums. Het is natuurlijk maar een breed opgezette schets, die beperkt is door het feit dat veel zijden stoffen verloren zijn gegaan. Er moet ook wel aan herinnerd worden, dat als een zijden stof eenmaal was geïntroduceerd er verschillende types gelijktijdig in productie waren. Men heeft nu een globale leiddraad bij de bepaling van de data, waarop een aantal weefsels is geïntroduceerd.

Onder de zijden stoffen van de Sint Servaas zijn deze vijf weefsels op één na te vinden. Alleen het tapisserieweefsel is er niet bij. De keperweefsels zijn bijzonder goed vertegenwoordigd, wat niet zo verwonderlijk is, omdat keper het meest algemeen geïmporteerd type zijde blijkt geweest te zijn. Een karakteristiek van het keperweefsel is dat de groeven diagonaal over het weefseloppervlak lopen, of van links naar rechts of van rechts naar links. Dit komt door de schikking van de horizontale draden over de verticale draden. Dit weefsel is afgebeeld in PL. 1.

Men kan zien, dat iedere derde verticale draad een horizontale draad bindt. Iedere rij van horizontale weefdraden schuift één verticale draad op, zodat de binddraden gezien worden als een diagonale lijn door de zijde. Het diagram laat de draden zien, die liggen tussen de twee kanten van het weefsel. Deze komen noch aan de voorkant noch aan de achterkant van het weefsel te voorschijn, maar ze liggen er tussen in en zijn daar aangebracht om zo het patroon te vormen. Door deze draden op te tillen of neer te drukken kan men bepalen of de horizontale draden aan de achter- of de voorzijde van het textiel door zullen lopen. In het diagram lopen deze 'verborgen draden' paarsgewijs. Soms lopen ze enkelvoudig en in andere gevallen drie- of vierdubbel. Het zijn juist de keperstoffen met de enkelvoudige draden die over het algemeen gedateerd worden van vóór het midden van de 8e eeuw. Van de zijden stoffen, waar deze draden met drie of vier te zamen gebundeld zijn, wordt aangenomen dat ze van latere datum zijn dan het midden van de 8e eeuw. De zijden stoffen, waarvan de draden drie- of vierdubbel zijn, heeft men kunnen dateren op de 7/8e eeuw op basis van een inscriptie, die op één er van gevonden is.[5] Een gekeperde stof van deze aard in de Sint Servaas moet uit deze periode stammen, maar een ander met dezelfde structuur moet van veel latere datum zijn en dit op grond van de aard van het dessin. Dit betekent dat zulke gekeperde stoffen ook later dan de 7/8e eeuw vervaardigd werden. De effen gekeperde stoffen die rond het jaar 1000 in het Westen ingevoerd werden hebben paarsgewijze 'verborgen draden'.[6]

Tabijn en damastweefsels zijn tamelijk goed vertegenwoordigd in de collectie zijden stoffen van de Sint Servaaskerk. Gebloemde zijden stoffen

zijn er minder. De tabijn zijden stoffen verschillen in weefsel. Sommige stukken zijn dun en over het algemeen zonder patroon, andere zijn dikker en gewoonlijk met een patroon. De dikkere stukken hebben 'verborgen draden' zoals de gekeperde stof; de dunnere stukken niet. De tabijnstoffen zonder patroon zijn bijzonder moeilijk te dateren. Tabijnweefsel kan herkend worden aan het regelmatig oppervlaktepatroon, dat gevormd wordt door de kruising van horizontale en vertikale draden. De horizontale draden gaan boven en onder een vertikale draad door de rij weefdraden heen. Deze werkwijze herhaalt zich maar dan omgekeerd. Dit weefsel is afgebeeld in PL. 1.

In de schatkamer zijn ook voorbeelden van damastweefsel aanwezig, die te vergelijken zijn met damast zijden weefsels in verschillende Zwitserse schatkamers. De Zwitserse specimen worden op technische en stylistische gronden over het algemeen niet later gedateerd dan de 8e eeuw.[7] Er zijn twee vormen van damastweefsels die in het Westen vóór 1200 geïmporteerd werden. Deze twee types worden TABIJN-DAMAST en GEKEPERDE-DAMAST genoemd. De gekeperde damast is een weefsel, waarin de beide kanten van een keperbinding worden benut. Tabijndamast is een tabijnweefsel, waarin sommige horizontale draden over meer dan één vertikale draad springen om het patroon te vormen. De horizontale draden lijken als opgelegd. Deze opgelegde draden lopen in rechte lijnen over het weefsel of in keperverband. De gekeperde-damast is afgebeeld in PL. 1.

De twee types van lampasweefsels (PL. 1) worden genoemd: TABIJN-TABIJN LAMPAS en TABIJN-KEPER LAMPAS. Voor het eerste type wordt een tabijnbinding gebruikt voor het patroon op een fond van hetzelfde weefsel. Het tweede type is een combinatie van tabijn en keperbindingen. Het patroon is ofwel een keper - en het fond een tabijnbinding of omgekeerd. De 'verborgen draden' van de lampasweefsels zijn gewoonlijk paarsgewijs.

De datering van de gekeperde stoffen in de schatkamer van Sint Servaas ligt tussen de 7e en 8e eeuw tot na de 13e eeuw. Een specimen van een vroegere gekeperde stof met enkelvoudig gerangschikte 'verborgen draden' heeft een groot medaillonpatroon. Binnen in het medaillon bevindt zich een symetrisch bladmotief met bloesems in de vorm van druppels omzoomd door een rand parels. De medaillons hebben een rand met golvende bladmotieven. Het dessin is groen tot lichtbruin-geel op een donkerder bruinachtige olijfgroene kleur. PL. 2 geeft een afbeelding van het zijden weefsel.

Het dessin op de zijde is vergelijkbaar met de bladpatronen van zijden stoffen, die in Egypte zijn opgegraven en het is waarschijnlijk dat het specimen uit de Sint Servaas in een Egyptisch centrum werd geweven.[8]

Er is geen aanwijzing, waar het stuk zijde met het bladermotief uit is genomen. In het geval van een ander stuk gekeperde zijde met enkelvoudig

gerangschikte 'verborgen draden' zijn de gegevens overvloediger. De zijden stof heeft een eigenaardige medaillontekening, waarvan de betekenis nog op bevredigende wijze moet verklaard worden. Ze wordt betiteld als de 'dioscurenstof' en toont ons twee figuren op een altaar met het offer van twee stieren beneden aan iedere kant. Twee gevleugelde genii verschijnen boven het tafereel. De zijde werd in 1863 uit het schrijn van de H. Servatius genomen. Bij die gelegenheid vond men een aangehechte inscriptie: 'Vestimenti Sci Servatij'. Een klein stukje van deze zijde bevond zich in het kruis van Sint Servaas. Heden zijn de gerestaureerde stukken van de zijde er aan toegevoegd en onder glas gemonteerd. Ze hangen tegen een muur van de schatkamer. Er is geen zijden stof met een vergelijkbaar patroon dat ons kan helpen bij de datering, maar zowel de weeftechniek en het type van de medaillonranden met golvende bladmotieven als de kleur van de zijde wijzen op een datum uit het vroege begin van de 8e eeuw. Het dessin is in wit, lichtgroen en donkerblauw op rood.

Men denkt dat verschillende zijden stoffen met medaillondessins op een rood fond van eenzelfde tijdstip zijn.[9] Het schrijn van de heilige is van veel latere datum dan de zijde. De begrafenis van Sint Servaas, bisschop der Tongeren + 384, valt op een veel vroeger tijdstip dan de zijde. Er zijn maar weinig bijzonderheden bekend over het wel en wee van de relieken tussen de 4e en de 12e eeuw, maar waarschijnlijk heeft er een translatie plaatsgevonden in 726. Bij die gelegenheid werd de zijde misschien geplaatst in een vroeger schrijn. Men heeft voor de zijde een. Byzantijnse productiecentrum verondersteld.

Een aantal stukken van de 'Dioscurenstof' bevindt zich in verschillende verzamelingen. Of deze stukken uit Maastricht afkomstig zijn is niet bekend. Drie stukken bevinden zich in particuliere verzamelingen. Een stuk in het textielmuseum te Lyon kwam uit de collectie Bock ca. 1875 en het is best mogelijk dat Bock het in Maastricht verworven heeft. In 1907 kocht het 'Kunstgewerbe Museum' in Berlijn een stuk Dioskurenstof in Parijs. Twee fragmenten zijden stof met hetzelfde patroon zijn in het 'Metropolitan Museum' te New-York en in het 'Textile Museum' te Washington.[10] Van de Maastrichtse zijde werden in de 19e eeuw copieën geweven. Een ervan hangt in de schatkamer van de Sint Servaas, een ander bevindt zich in het Metropolitan Museum' te New-York. De foto's tonen ons de Maastrichtse zijde en de copie uit New-York met de inscriptie dat Eugen Vogelsang ze in 1895 te Krefeld geweven heeft onder leiding van Paul Schulze, conservator van de 'Königliche Gewebesammlung' (PLS. 3 EN 4).

Een zijden stof met een medaillon op rood fond met enkelvoudig gerangschikte 'verborgen draden' in Maastricht heeft een dessin met een gedeelte van een leeuwenjacht. Alleen de rechterkant van het medaillon

is bewaard gebleven. Dit toont ons een te paard gezeten amazone die haar pijl richt.

Beneden bevindt zich een leeuw en een gedeelte van een bladmotief. Het medaillon heeft een bladerrand. De zwikken boven en beneden van de medaillonboog hebben dezelfde bladmotieven. Het dessin is in groen, geel, wit en donkerblauw op rood. In verschillende schatkamers bevinden zich verscheidene amazonestoffen. Een dergelijk groot stuk, dat in de 19e eeuw verknipt werd om er gewaden van te maken, bevindt zich in Säckingen.[11] Enkele amazonestoffen hebben Koefische inscripties die op een Islamitische herkomst duiden. Voor de amazonestoffen zonder inscriptie wordt een Egyptische, Syrische of Byzantijnse afkomst verondersteld, maar of dat juist is, kan niet gezegd worden. Een datering die ligt in de 8e eeuw is aannemelijk op technische gronden. (PLS. 5 EN 6.)

Van een aantal gekeperde stoffen met enkelvoudig gerangschikte 'verborgen draden' zijn de dessins eerder in de lengte dan in de breedte van het getouw geweven.[12] De patronen zijn nooit erg groot, zodat het een raadsel blijft waarom ze niet over de breedte van het weefgetouw geweven zijn. Een specimen van dit type zijde uit de schatkamer heeft een dessin van sterren met kleine vogeltjes er in, afgewisseld met rijen kleine bladmotieven bestaande uit vier hartvormige bloemblaadjes. De zijden stoffen van dit type zijn dikwijls uitgevoerd in bruine tinten. Bij de Maastrichtse zijden stof is het dessin in bruin op een roze-wit fond. Een aantal van dit soort zijden stoffen hebben Griekse inscripties. Bijzonderheden in het Grieks suggereren eerder een Egyptische dan een Byzantijnse herkomst van deze zijden weefsels. Een Egyptische herkomst van deze Maastrichtse zijden stof en een datering van vóór de 8e eeuw is wel mogelijk. (PL. 7.)

Een gekeperde stof in de schatkamer stamt uit de 8e - 9e eeuw. Ze heeft een dessin dat bestaat uit een paar naar elkaar toegewende leeuwen, staande op een platvorm van bladeren omgeven door een cirkelvormige rand. De rand wordt bezet door bladmotieven, die gescheiden worden door in groepen van drie naast elkaar geplaatste punten. In de zwikken liggen honden aan weerszijden van een boom. Het dessin is purper-bruin, groen en beige op een variant van beige. Deze stof is te vergelijken met de zijden weefsels van 2 groepen, waarvan bekend is dat ze geweven zijn in Centraal-Azië in de 7e en de 8e - 9e eeuw. Het leeuwenpatroon wordt aangetroffen op verschillende zijden stoffen van de groepen en hun kleur is in alle gevallen hetzelfde. Sommige van deze specimen zijn bewaard gebleven in de vorm van lange lopers, die vaak voorzien zijn van een franje langs de boven- en onderkant.[13] De foto's tonen ons de zijde uit de Sint Servaas en zijde uit de schatkamer van de kathedraal te Sens. (PLS. 8 EN 9.)

De getrapte contouren van het patroon zijn bij beide opmerkenswaard. Deze getrapte contouren zijn karakteristiek voor de Centraalaziatische groepen. Vanuit technisch oogpunt beschouwd betekende dit, dat er minder gebonden behoefde te worden op het getouw dan het geval zou zijn geweest, wanneer de contouren gladder zouden zijn. Hoe minder hoekig de contouren van een patroon waren des te ingewikkelder was het klaarmaken van het weefgetouw. De getrapte contouren op een ander stuk zijde uit de Sint Servaas met driedubbel 'verborgen draden' zijn eveneens opmerkelijk. De aard van de patronen op deze gekeperde stoffen laat echter geen vroegere datering toe dan de 7e-8e eeuw. Het stuk zijde toont ons naar rechts gaande leeuwen met aanziende koppen. Ze houden hun staart rechtop en achter hun lijven zijn hoekige boomvormen zichtbaar. Voor de manen zijn 'S'-vormige curven gebruikt en een decoratieve rij van omgekeerde driehoekige figuren loopt langs het onderlijf van de dieren. Over de borst en over de rug van elke leeuw lopen punten. Het patroon is uitgevoerd in een purper-rode tint op een zwart-purper fond en is onder en niet dwars door het weefgetouw heen geweven. De leeuwen zijn ongeveer 22,5 cm lang.

Het patroon van de Maastrichtse zijde kan vergeleken worden met dat van een zijden stof in het 'Diocesaan Museum' te Keulen,[14] dat afkomstig is uit het Heribertschrijn in de kerk van de H. Heribert te Keulen-Deutz. Deze zijde draagt een Griekse inscriptie, waarop staat dat ze geweven werd in Constantinopel onder de regering van Basileios en Konstantinos. Dit moet verstaan worden als Basileios II en Konstantinos VIII (976-1025) welke data overeenkomen met de stijl van het dessin op de zijde. Een andere gelijksoortige zijden stoff met Griekse inscripties stammt uit de regeringsperiode van Romanos en Christophoros (921-923). De Keulse zijde heeft een patroon van paarsgewijze elkaar toegewende leeuwen. Hun houding is gelijk aan die van de leeuwen op de Maastrichtse zijde en achter elke leeuw is een boom te zien juist zoals op de Maastrichtse zijde. Bovendien is het patroon over de breedte van het getouw geweven en niet over de lengte. De Keulse zijde is fijner van contouren en fijner van detail dan de Maastrichtse en men zou geneigd zijn een andere afkomst te veronderstellen dan de laatstgenoemde. Een meer provinciaal centrum schijnt wel aannemelijk voor de Maastrichtse zijde. Een datering in de 10e eeuw is wel mogelijk (PLS. 10 EN 11).

Er bevinden zich, behalve de hierboven op de foto weergegevene, nog andere stukken van de leeuwenstof in de schatkamer van de Sint Servaas. Deze stukken waren bevestigd aan een ander rood-purperen zijden weefsel met een bladerpatroon gevat in medaillons. Ze zijn onlangs van elkaar losgemaakt en afzonderlijk in de schatkamer geëxposéerd. Deze zijden stoffen waren afkomstig uit het schrijn van St.-Servaas. Wanneer de zijden stoffen aan elkaar genaaid werden is niet bekend, maar het is

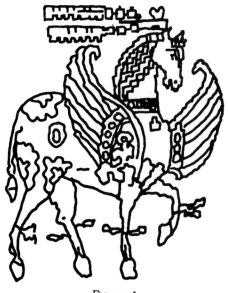

FIGURE 1
DETAIL VAN DIE ZIJDE MET HET GEVLEUGELD
PAARD. MUSEO SACRO, VATICAAN

twijfelachtig dat ze oorspron-
kelijk aan elkaar hebben ge-
zeten. Een franje, die onder aan
een van de stukken was be-
vestigd, schijnt van tamelijke
recente datum te zijn. In zijn
publicatie van 1913 vermeldt
Falke een zijden stof in het
'Schloßmuseum' te Berlijn (no.
88.196) die gelijk is aan die van
Maastricht. De auteur heeft niet
kunnen vaststellen of deze zich
nog in Berlijn bevindt. In de
jaren 1930 bevond zich een ge-
lijksoortig fragment in het
'Musée des Arts Décoratifs' te
Parijs (D. 16345).

In de schatkamer zijn veel
gekeperde stoffen met paarsge-
wijze 'verborgen draden'. Er
werden er vier uitgekozen
vanwege hun levendig patroon.
Ze zijn niet allemaal van dezelfde oorsprong of ouderdom. Een er van
kwam uit het schrijn van Sint Servaas.

Deze zijde heeft een ongebruikelijk patroon, dat bestaat uit een
ruitvormig rasterwerk met bladmotieven. Het rasterwerk wordt omzoomd
door abstracte plantenvormen en op de snijpunten van de ruiten bevinden
zich kleine cirkels met bladvormen. Het patroon is bruin op roze. De roze
kleur kan oorspronkelijk iets roder geweest zijn. Er zijn geen vergelijkbare
zijden stoffen bekend, zodat het moeilijk is datum en herkomst aan te
geven. De weeftechniek wijst op een datum van na het midden van de 8e
eeuw (PL. 12.) De andere drie fragmenten van gekeperde stof met
paarsgewijze 'verborgen draden' hebben diermotieven. De ene toont
onderdelen van twee medaillons met het achterste gedeelte van zittende
leeuwen. De behandeling van deze dieren is zeer decoratief. Op de dijen
van de dieren zijn bladermotieven te zien en de staarteinden, de ruggen
en de buiken hebben bloemachtige versieringen evenals het schouder-
gewricht boven de voorpoten. Kleine rozetten markeren de andere
gewrichten. Een rand met hartvormige ornamenten omgeeft de medaillons.
In de zwikken zijn grote bladpatroons (PL. 13).

Het gebruik van bladmotieven is vergelijkbaar met de toepassing
ervan op een zijden stof met gevleugelde paarden met linten in het 'Museo
Sacro' van het Vaticaan.[15] Deze laatstgenoemde zijde heeft geen medaillons

maar het dessin is aangebracht op een rood fond in geel, rood en groen. De Maastrichtse leeuwen-stof is ook uitgevoerd in geel, rood en groen op een rood fond. De Vaticaanse zijde was afkomstig uit het 'Sancto Sanctorum' en diende als kussen, waarop het email kruis van paus Paschalius (817-824) werd gelegd. De Maastrichtse zijde kan tot de 8e à 9e eeuw behoren, maar ook hier is het weer moeilijk de herkomst er van vast te stellen. De Vaticaanse zijde wordt dikwijls als Byzantijns aangemerkt maar er is een volkomen gebrek aan vergelijkbaar materiaal, waarvan de Byzantijnse herkomst vast-staat. Het is mogelijk dat de Maas-trichtse zijde geweven werd in een Byzantijns centrum maar een bewijs is niet voorhanden (Fig 1).

Een andere zijden stof in deze weeftechniek heeft een rood fond en diermotieven maar ze heeft geen medaillons. Aan de linkerkant van het fragment staat een vogel met opgeheven kop boven een leeuw met een wapperend lint. Aan de tegenovergestelde kant van het stuk kan men gedeelten van een

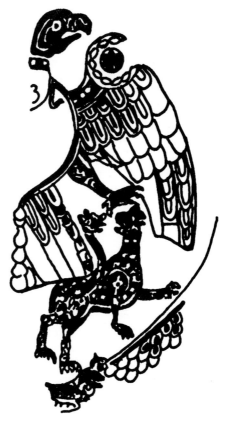

FIGURE 2
RECHTERHELFT VAN HET MEDAILLON MET
DUBBELKOPPIGE ADELAAR
ABEGG-STIFTUNG, RIGGISBERG

boom onderscheiden. Aan de kant van deze boom verschijnt de slangenkop van een dier. Het patroon is wederom uitgevoerd in geel, groen en rood op een rood fond. In het dessin zijn forse, krachtige elementen gebruikt. In zijn geheel valt het moeilijk het ergens mee te vergelijken maar in de 'Abegg Stiftung' te Bern bevindt zich een stuk zijde met slangachtige wezens op dezelfde manier met dierenkoppen getooid als de Maastrichtse zijde[16] (PL. 14).

De wapperende linten van de Maastrichtse leeuw en die van het Vaticaanse gevleugelde paard kunnen teruggevoerd worden tot Sassanidische patronen. Het motief vond in later eeuwen een wijde verspreiding en werd waarschijnlijk zowel in Islamitische als Byzantijnse centra gebruikt. Het dubbelkoppig adelaarsmotief van de Bernse zijde

was geliefd in Spanje, waar deze dieren vaak werden afgebeeld als klauwende dieren. De Maastrichtse zijde zou een product kunnen zijn uit de 10e eeuw (FIG. 2).

De laatste van de vier gekeperde stoffen van dit type heeft een dessin gevat in gelobde lijsten van elkaar afwisselend rechts en links toegewende buffels.[17] De lijsten zijn aangebracht op een ruitvormig fond, waarin zich schoppenaasachtige figuren bevinden. De tekening is uitgevoerd in een helder krachtig rood en blauw op geel. In het begin van de eeuw bevond zich een klein fragment van dezelfde stof in het 'Kunstgewerbe Museum' te Berlijn. Een ander fragment is in het textielmuseum van Lyon. Dit dessin wordt op geen enkele andere zijden stof aangetroffen maar een geruit schoppenaasfond treft men ook aan op een zijden weefsel in het 'Diocesaan Museum' te Bamberg.[18] Deze zijde diende als lijkwade voor bisschop Gunther († 1065) . Hij stierf op zijn terugreis van een bezoek aan Constantinopel. Het is hoogstwaarschijnlijk dat de Bambergse zijde — een tapisserieweefsel — een product is uit Constantinopel. De buffelstof uit Maastricht is mogelijk een Byzantijns zijdeweefsel van rond de 10e eeuw. (PL. 15 EN FIG. 3).

Verschillende specimen van gekeperde stoffen met gepaarde 'verborgen draden' in de Sint Servaas zijn van het effen type. Zoals reeds eerder vermeld, werd deze soort zijde vervaardigd in het laatst van de 10e eeuw en in het Westen geïmporteerd rond het jaar 1000. Het is hoogst waarschijnlijk, dat zowel Byzantijnse als Islamitische centra zulke zijden stoffen hebben vervaardigd, hoewel tot dusver alleen maar Koefische inscripties op sommige van de gekeperde stoffen zijn aangetroffen. Een voorbeeld uit Maastricht vormt een goede illustratie van de manier waarop de tekening als het ware ingegrift schijnt te zijn op het oppervlak van deze zijden stoffen. De zijde is donkerblauw van kleur en heeft een gedeelte van twee geometrische randen met bladornamenten. De meeste ingegrifte zijden stoffen hebben dessins met gecombineerde geometrische en bladermotieven. Een zijden stof in het 'Kestner Museum' te Hannover is verwant aan de ingegrifte zijde stoffen.[19] Ze heeft een donkerblauwe ondergrond met een tekening niet alleen in donkerblauw maar ook in purper. Dit dessin bestaat uit zeshoeken met twee soorten van bladornament die elkaar afwisselen in horizontale banden. Het dessinontwerp en het gebruik van hartvormige bloembladeren doet in zijn algemeenheid denken aan de Maastrichtse zijde. Het is onmogelijk te zeggen of het Maastrichtse fragment vervaardigd werd in een Islamitisch of Byzantijns centrum maar naar alle waarschijnlijkheid stamt het uit de 10e tot de 11e eeuw (PL. 16 EN FIG. 4).

Nog een andere gekeperde stof met gepaarde 'verborgen draden' in de Sint Servaas moet vermeld worden als vertegenwoordiger van een aparte groep zijden stoffen. Deze groep wordt gekenmerkt door het feit dat de

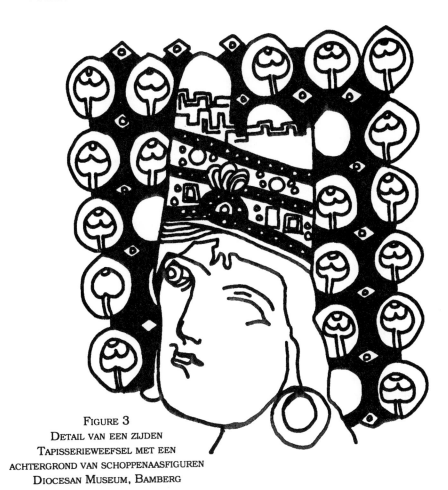

FIGURE 3
DETAIL VAN EEN ZIJDEN
TAPISSERIEWEEFSEL MET EEN
ACHTERGROND VAN SCHOPPENAASFIGUREN
DIOCESAN MUSEUM, BAMBERG

FIGURE 4
DETAIL VAN EEN ZIJDEN STOF
NO. 3872
KESTNER MUSEUM, HANNOVER.
VERWANT IN WEEFTECHNIEK MET
DE GEGRAVEERDE ZIJDEN STOFFEN

'verborgen draden' van linnen zijn en niet van zijde. Van zulke weefsels werd vroeger aangenomen, dat ze uit Regensburg kwamen, maar de laatste tijd beschouwt men ze meer als een Venetiaans product.[20] Er moet een onderscheid gemaakt worden tussen de specimen die er uitzien als smalle stroken en zijden weefsels van dit type, geweven op brede getouwen. De smalle stroken kunnen vervaardigd zijn in een Duits centrum. De brede stoffen daarentegen zijn waarschijnlijk van Venetiaanse oorsprong. Het voorbeeld op de foto (PL. 17) schijnt uit een groter stuk geknipt te zijn. Zulke textielen kunnen vervaardigd zijn in een periode vanaf de 13e eeuw en later. De Maastrichtse zijde bestaat uit twee stukken en heeft horizontale geornamenteerde banen, die bestaan uit smalle banen van halve cirkels, rechthoeken en gelijksoortige vormen. De dessins zijn uitgevoerd in groen en in lichtblauwe en witachtige tint. De blauwe zijde is met goud omwikkeld. Het weefsel is tamelijk dik, wat veroorzaakt wordt door de stevige aard van de gepaarde linnen draden. Andere stukken van dit type zijde in Maastricht hebben ook geornamenteerde horizontale banen, waarin temidden van hun motieven vogels en bloemen te vinden zijn (PL. 17).

De damastzijden weefsels zijn in geringer aantal aanwezig in de schatkamer. Van een specimen van een gekeperde damast dat van veel vroegere datum is dan de hierboven besproken zij den stoffen is slechts een fragmentarisch deel van de tekening over. De snijding van twee medaillons en het bovenste gedeelte van de rand van een van beide kan men nog zien. Deze bevatten een bladornament met druppel- en hartvormige motieven. Binnen in de medaillons bevond zich een afbeelding van een menselijke figuur. De kruin van zijn hoofd en de linkerhand van deze figuur zijn nog te zien. De hand omklemt een stok, de horens en een oor van een dier kan men aan de kant van de figuur nog onderscheiden. Het dessin is uitgevoerd in een lichter roze op een donkerroze kleur. Het druppel- en hartvormig ornament gelijkt op de stukken zijde die opgegraven zijn in Egypte. De weeftechniek suggereert een datering in de 7e tot 8e eeuw (PL. 18).

De techniek van het damastweven herleefde in de 13e eeuw in Spanje. In Maastricht bevindt zich een voorbeeld van tabijndamast, waarschijnlijk Spaanse zijde uit de 13e eeuw. Het kan niet beschouwd worden als een vroege damast, vanwege het dessin dat er in verwerkt is en omdat de z.g. opgelegde draden die over het fond lopen op chevron-keper manier zijn uitgevoerd. Bij vroege damast worden de draden van gekeperde stoffen over een tabijn fond geleid; maar de draden op de manier van chevron-keper laten verlopen is niet algemeen. De Maastrichtse zijde heeft de vorm van een reliekenbeurs met afmetingen van 10 x 12 cm. De op chevron-gekeperde manier geleide draden zijn gebruikt om kleine groene blaadjes te vormen op een roze ondergrond. De tekening loopt eerder dwars over

de beurs dan vertikaal. De kanten zijn omboord met zilverdraad en bovenaan bevindt zich een koordje van zilverdraad, roze en geelbruin. In de schatkamer bevinden zich verschillende stukken zijde, die in dezelfde techniek zijn uitgevoerd. De dessins bevatten vogels en verschillende types van geometrische ornamenten (PL. 19).

Bij de hierboven genoemde zijden stoffen kon het dessin ons helpen bij de oplossing van het dateringsprobleem van de textielen. Geheel anders is het gesteld met een tamelijk groot aantal zijden weefsels, dat een dessin ontbeert dat ons daarbij behulpzaam kon zijn. Bovendien zijn ze uitgevoerd in tabijn-weeftechniek en dit is een weefsel dat gedurende vele eeuwen geen verandering onderging. De fragmenten effen tabijnweefsels zonder patroon in de St.-Servaaskerk kunnen niet nauwkeurig gedateerd worden evenmin als de plaats van herkomst nauwkeurig kan vastgesteld worden. Globaal genomen liggen ze tussen de 8e en de 13e eeuw. Een aantal stukken in rood, verschillende tinten bruin of blauw zijn fijne stoffen zonder 'verborgen draden'. Grote stukken schijnt men tot kleinere verknipt te hebben. Sommige zijn tot cirkels verknipt, andere tot rechthoekige stukken. Misschien heeft men er kleine metalen reliekhouders mee bekleed. Dit type fijne effen tabijn kan men vaak tot in de 13e eeuw aantreffen als beschutting van miniaturen in manuscripten. Sommige van de fragmenten in Maastricht zitten vastgeplakt op karton, maar er is geen aanwijzing waar ze gevonden zijn. Het andere type weefsel van vóór 1200, dat zich in de schatkamer bevindt, is het lampasweefsel, dat zijn ontstaan vindt in het laatst van de 10e eeuw en dat rond het jaar 1000 het Westen bereikte.[21] Enige minder ver ontwikkelde vormen van dit soort weefsel worden aangeduid als 'proto-lampas'. Het klaarmaken van de weefgetouwen voor echte lampasweefsels moet wel een meer ingewikkelde zaak geweest zijn. Proto-lampas en echte lampas weefsels zijn in de schatkamer aanwezig. Drie fragmenten van proto-lampas weefsels die bij elkaar horen, werden in 1906 gevonden in het reliekenkruis van St.-Servaas. Op het ene zijn staande leeuwen afgebeeld en op het andere een paar vogels die in een boomachtige figuur zitten. Aan iedere kant van het fragment met de vogels en aan de linkerkant van het leeuwenfragment loopt een Koefische inscriptie. Deze moet nog ontcijferd worden, maar de aanwezigheid er van duidt op een Islamitische afkomst De inscriptie schijnt niet louter en alleen van decoratieve aard te zijn. De zijde is blauw, bruin en geel van kleur. De ondergrond is een tabijnweefsel en het dessin is uitgevoerd in golvende draden die bij iedere achtste vertikale draad zijn gebonden. De zijde kan waarschijnlijk gedateerd worden rond de 10e tot de 11e eeuw (PL. 20).

Op een specimen van een ontwikkeld lampasweefsel in de schatkamer staat ook een Koefische inscriptie. Het lezen van de inscriptie wordt bemoeilijkt door het feit dat er slechts een gedeelte van over is. De zijde

bestaat uit twee stukken. Met het bovenste gedeelte was in de 19e eeuw de onderkant van een draagaltaar bekleed.[22] Op de zijde is een afbeelding van een zittende leeuw te zien. Het dier wordt omgeven door decoratieve krullende ranken en bladmotieven. Dwars over de schouder is een Koefische inscriptie zichtbaar. De behandeling van de leeuw is vrij decoratief. Een rand van kleine cirkeltjes geeft de manen aan, die de vorm aannemen van een grillig gevormd ruitvormig patroon. Het dessin is uitgevoerd in krachtig olijfgroen op helder kersenrood en de zijden stof in tabijn-tabijn lampas techniek. Aan de linkerzijde is een zelfkant van een halve cm van tabijnweefsel in rood en groen. Een datering uit de 11e eeuw en een Islamitische herkomst schijnen voor deze zijde aannemelijk. (PL. 21).

Verschillende gekeperde stoffen in de schatkamer hebben meer gekunstelde dessins met ingewikkelde bloempatronen en draakachtige wezens. Ze dateren uit de 13e tot 14e eeuw en zijn van Italiaanse herkomst. Een groen zijden stof van deze soort heeft grote gevleugelde wezens die in iets wat op gras lijkt, pikken. Ze gaan vergezeld van op leeuwen lijkende dieren die tegen golvende boommotieven klauwen. Tussen de horizontale herhalingen van het dessin, bevinden zich banen met bladornamenten, die een scheiding vormen tussen kleine rennende hoefdieren (PL. 22).

De met zorg bewerkte fluwelen brokaatstoffen in de schatkamer zijn ook van Italiaanse makelij. Ze zijn even oud als de hierboven beschreven gekeperde stof. Voor een aantal reliekbeurzen is fluweel gebruikt. Sommige van de reliekbeurzen hebben brokaatwerk van zijden draden met goud en zilver omwikkeld. Een groot aantal fragmenten van ongelijke vorm, die waarschijnlijk gebruikt werden om afzonderlijke relieken in te wikkelen, geven ofwel brokaatwerk van dit type te zien of hebben kleine deeltjes van de reeds beschreven en meer gekunstelde Islamitische dessins. Deze fragmenten doen vermoeden dat vanaf de 13e eeuw nieuw verworven relieken of vroegere relieken in Italiaanse zijde zijn gewikkeld. Ongelukkig genoeg werden er geen aantekeningen van gemaakt, waar de zijden stoffen vandaan kwamen, voordat zij in hun tegenwoordige lijsten geplaatst werden. Misschien zaten er sommige in de reliekbeurzen. De beurzen stammen voornamelijk van na het jaar 1300. Eén beurs zou van rond 1200 kunnen zijn. Deze heeft een met zorg afgewerkte voorstelling van de kruisiging, uitgevoerd in gekleurde zijde. De decoratieve zig-zagrand met kleine vierbladige motieven doet denken aan de Rijn- en Maaslandse emails uit de late 12e tot de 13e eeuw. De personificatie van de treurende zon en maan verschijnen veel vroeger en speciaal op de ivoorsnijwerken van de 9e eeuw, maar op borduursels zijn ze gevleugeld. Het borduursel is duidelijk van westerse oorsprong.

Tenslotte moet nog melding gemaakt worden van een handvol zijden stoffen die zich onderscheiden door het feit dat hun dessin gedrukt is en niet geweven. Een voorbeeld van deze soort zijde heeft purperen driehoeken en rode ruiten, waarin kleine witte ruiten met een klein cirkeltje in het midden. Dit zou een latere zijden stof kunnen zijn, waarbij in China en Centraal-Azië gebruikte technieken uit de 8e eeuw werden nagebootst.

Figure 5
Detail van een zijden stof
St.-Servatius, Maastricht

Twee zijden stoffen ook van latere datum, hebben bijzonder vreemde dessins in oranje op geel en in geel op oranje. De eerste vertoont een zon met menselijke trekken. Het gelaat is omgeven door een parelrand en de stralen worden aangegeven door bloembladachtige uitsteeksels vanuit deze rand (Fig. 5). De tweede zijden stof toont ons een naakte menselijke figuur met een boosaardig gezicht en een vreemde schotelachtige hoed met een knop. Aan de linkerzijde van de figuur komen grote knokige figuren te voorschijn. De auteur kent geen enkel ander vergelijkbaar stuk zijde (Fig. 6).

Figure 6
Detail van een zijden stof
St.-Servatius, Maastricht

Conclusie

De zijden stoffen in de schatkamer van de Sint Servaas zijn symptomatisch voor één vorm van contact dat vóór 1200 tussen Oost en West bestond. Vóór dit tijdstip werd de kunst van het zijdeweven alleen beoefend in Byzantijnse en Islamitische centra en het Westen moest zijden stoffen importeren. Vier van de vijf types van zijden weefsels die het Westen vóór 1200 moest importeren, namelijk: *tabijn, damast, keper* en *lampas* weefsels kwamen in de schatkamer terecht. Het vijfde type, namelijk het *tapisserie* weefsel is niet vertegenwoordigd in de collectie. Deze soort wordt trouwens maar in enkele schatkamers in het Westen aangetroffen. De zijden stoffen van de Sint Servaas liggen in de tijdsorde van vóór de 8e eeuw tot na de 14e eeuw en ze geven grond aan de veronderstelling, dat er gedurende verschillende eeuwen een voortdurende belangstelling heeft

bestaan om zijden stoffen te bemachtigen. Toen vanaf de 13e eeuw Italiaanse zijde beschikbaar kwam, deed deze haar intrede in de schatkamer en ze werd gebruikt voor de vervaardiging van reliekbeurzen. De beschikbare Italiaanse zijde bestond uit grotere stukken dan die van vóór 1200. Over de manier, waarop de Italiaanse zijden stoffen in de schatkamer terecht kwamen, bestaat geen enkel document. Of ze door rijke personen van handelaars gekocht en daarna aan de schatkamer geschonken werden, is niet met zekerheid te zeggen. Het is wel zeker, dat de schatkamer van de Sint Servaas zeer lange tijd zeer aanzienlijk en rijk is geweest met een indrukwekkend aantal relieken om zo'n schitterende rijkdom aan zijden stoffen te hebben kunnen verwerven. Dat de zijden stoffen de tijd overleven is op zichzelf al merkwaardig. Als een van de belangrijkste schatkamers voor zijden stoffen in Europa verdient de Sint Servaas een grotere belangstelling en bekendheid dan tot nu toe het geval is geweest.[23]

Conclusion The silks in the treasury of St. Servatius Maastricht are symptomatic of one form of contact that existed between the East and the West before 1147. Prior to this date silk weaving was carried out only in Byzantine and Islamic centres and the west had to import silks. Four of five types silk weaves imported into the West before 1200, namely *tabby, damask, twill* and *lampas* weaves, reached the treasury. The fifth type, namely *tapestry* weave is not represented in the treasury, but is found in very few Western treasuries at all. The silks at St. Servatius range in date from pre-8th century to post-14th century and suggest that there was a continuing interest in obtaining silks over several centuries. When Italian silks became available from the 13th century onwards, they appeared in the treasury and a number were sewn into reliquary pouches. The Italian silks available were greater in size than the pre-1200 silks. How the silks reached the treasury is not documented. Whether or not they were bought from traders by wealthy individuals and then donated to the treasury one cannot say for certain. What is certain is that the treasury of St. Servatius must have long been an important and rich one with an impressive number of relics, for such a magnificent wealth of silks to have reached it. That these silks survive is remarkable in itself. As one of the most important treasuries for silks in Europe, St. Servatius merits greater attention and publicity than it has so far received.

BIJLAGE

Dank zij de vriendelijke bemiddeling van Mevr. R. Kroos uit München is het mogelijk enige archivalische gegevens over dit onderwerp mede te delen. Ze zijn alle getrokken uit de protocollen van het Kapittel van Sint Servaas. (Rijksarchief in Limburg, Maastricht, Archief Kapittel van Sint Servaas no.'s 1 t/m 7).

no. 1	fo	45r	1512	'De cappis'.
		169v	1585	Reparatie van de oude groenzijden misgewaden.
		207v	1588	Handelt over misgewaden.
no. 3		128r	1597	Handelt over de 'cappis aurotextis'.
		160v	1597	Vervaardiging van een groenzijden puviale.
		223r	1602	Nieuwe witte pluvialen van damast.
		301r	1603	Aanschaf van rode zijde voor twee koorkappen.
		464r	1607	Twee nieuwe witte pluvialen van damast.
		489r	1608	Zijde met franje ter versiering van het borstbeeld van Sint Servaas.
		492r	1608	Nieuw zijden lijkkleed.
no. 4		121r	1614	Vervaardiging van zilveren doosjes voor de relieken, die in oude beurzen en doeken opgeborgen zijn.
		167v	1618	Franje van gouddraad voor een koorkap.
		208v	1623	Twee nieuwe witte koorkappen geschonken.
		267r	1629	Aanschaf van nieuwe paramenten.
no. 5			1639	mei Melding gemaakt van de 'cappa et cyphus Sancti Servatii'.
no. 7			1741, 1 sept.	Nieuwe uitgouden paramenten.
			1743, 30 aug.	Witte koorkap aangeschaft.
			1749, 7 dec.	Zwart kazuifel en dalmatieken aangeschaft.
			1759, 24 mrt.	Zwarte paramenten.
			1762, 18 juni	Vijf witte koorkappen.
			1744, 23 sept.	Rode paramenten.

De relieken en in het bijzonder die van het H. Kruis des Heren zowel als het kruis zelf, genoten een bijzonder eerbetoon door ze op kostbare kussens te leggen, zoals uit verschillende plaatsen in het 'Ordinarius Custodum' van de St.-Servaas blijkt. (Rijksarchief in Limburg, Maastricht, Archief Kapittel van Sint Servaas no. 166.)

fo 6v Item in crastino Sanctae Barbarae celebratur anniversarium omnium Ducum Brabantiae ponendo in medio chori duos baldekinos auritextos supra trecam ibidem etiam ponendam cum cruce ponenda supra cussinum...

fo 11r Item circa festum Gregorij celebratur anniversarium Domini Arnoldi de Hoern, Episcopi Leodiensis cum solo baldakino ponenda supra trecum desuper cussinus cum cruce. . .

fo 12r Item in festo Palmarum... Et portabit Decanus ad processionem jocale quondam Domini Robini de Sisalmen, Dyaconus et Subdyaconus duo jocalia cum cussinis in quibus est de ligno Domini.

fo 14r Item in die Paraschevae... Item ante inceptionem officij tegitur altare cum duabus mappis antiquis... et tria jocalia cum cussinis in quibus habetur de ligno crucis. Item duo scolares habeant cathedram cum cussino uno desuper baldekinum deauratum et in medio crucem argenteam coopertam cum dicto baldekino.

fo 17v Item in festo Lancee etClavorum... Item ponantur ad ambas vesperas et missam reliquiae de sancte Cruce cum suis cussinis qui portari solent tempore rogationum.

fo 18v Item in festo Sancti Marci Evangelistae... Item exponatur maior crux cum vexilo viridi una cum reliquijs cum cussinis tunc consuetis portari.

HERKOMST VAN DE DIAGRAMMEN, FOTO'S EN SCHETSEN

FIGS. 1-6	Anna Muthesius
PLS. 1-8	Anna Muthesius
PL. 9	Schatkamer van de kathedraal van Sens
PL. 10	Anna Muthesius
PL. 11	Rheinisches Bildarchiv, Keulen
PLS. 12-22	Anna Muthesius

SPECIAL NOTE

The author is preparing an electronic catalogue of the St. Servatius, Maastricht collection, to include a colour image of each of more than 400 silks in the treasury. This work is an extension of an unpublished non-

electronic catalogue prepared in 1975. The silks were conserved at the Abegg Foundation in Riggisberg in 1991. At that time, the collection was briefly recorded by A. M. Stauffer, *Die Mittelalterlichen Textilien von St. Servatius in Maastricht.* Riggisberg 1991. Dating and provenance suggested for certain silks within this publication differs from that in the unpublished catalogue of the present author. This point will be discussed further in the electronic catalogue.

NOTES

1. Stadsarchief Maastricht, archief St.-Servaas no. 2 B 11 (551), p. 153 d.d. 2.10.1887; p. 161 d.d. 15.4.1888 en p. 238 d.d. 14.1.1894. De cataloog bevindt zich in hetzelfde archief onder no. 553. Enkele van de grotere fragmenten zijn in catalogusvorm gepubliceerd in de *Monumenten van geschiedenis en kunst in de provincie Limburg, Eerste stuk, De monumenten in de gemeente Maastricht,* derde afl., 's-Gravenhage 1935, 439-445. Zie ook F. Bock et M. Willemsen *Antiquités sacrées dans les anciennes collégiales de Saint Servais et de Notre-Dame à Maestricht,* Maestricht 1873, 90-95; 99-100.

2. Zie bijv. Otto Von Falke *Kunstgeschichte der Seidenweberei,* Berlin 1913.

3. Dit centrum genaamd: 'Centre International d'Étude des Textiles Anciens' heeft in oktober 1964 een *'Vocabulary of Technical Terms'* gepubliceerd. Deze woordenlijst is verschenen in het Engels, Frans, Italiaans en Spaans. In dit werk is een gedetailleerde verklaring van elk weefsel te vinden.

4. Een van de weinige nog bestaande tapisseriefragmenten is een nog niet gepubliceerd stuk in Susteren met dooreengevlochten bladmotieven onder bogen. Dit kan identiek zijn aan een tapisseriefragment in Barcelona gepubliceerd door F. L. May *Silk Textiles of Spain,* New York 1957, 23.

5. D. C. Shepherd en W. B. Henning *Zandaniji identified ?,* in Festschrift für Ernst Kühnel, 1959. D. G. Shepherd *Zandaniji Revisited,* in Festschrift für S. Müller-Christensen, Munich 1980, 105-122.

6. De auteur is bezig aan een publicatie in de 'Journal of the Walters Art Gallery', Baltimore U.S.A. getiteld *'The silk over the spine of the Mondsee Gospel Lectionary'.* Hierin is een lijst opgenomen van alle bestaande grotere gegraveerde effen gekeperde stoffen.

7. De Zwitserse zijde stoffen zijn gepubliceerd door E. Vogt in twee artikelen. Het zijn: *'Frühmittelalterliche Stoffe aus der Abtei St. Maurice',* in Zeitschrift für Schweizerische Archäologie und Kunstgeschichte, deel 18, 1958, afl. 3 en *Frühmittelalterliche Seidenstoffe aus dem Hochaltar der Kathedrale Chur,* in hetzelfde tijdschrift, deel 13, 1952, afl. 1.

8. Over de Koptische weefsels zie J. BECKWITH *Koptische Textilien*, Ciba Rundschau 145, 1959.

9. Twee van deze zijden stoffen bevinden zich in het Vaticaan te Rome. Er staan afbeeldingen op van de Annunciatie en de Geboorte. Er wordt veelvuldig naar verwezen in samenhang met een passage uit het *'Liber Pontificalis'* (uitgever Duchesne, deel 2, 32) *'rotas siricas, habentes storias Adnuntiatione seu Natale Domini Nostri Iesu Christi'*. In deze passage wordt een zijden stof beschreven die door paus Leo III (795-816) aan de St.-Pieterskerk in Rome werd geschonken. De groep rode zijden stoffen werd besproken door D. KING *Patterned silks in the Carolingian Empire*, in Bulletin de liaison du Centre International d'Étude des Textiles Anciens, vol 23, Jan. 1966, 47ff.

10. D. SHEPHERD *Technical aspects of Buyid silks*, 4th Congress of the International Association for Iranian Art and Archaeology, April 24 - May 3, 1960, New York and Washington, pls. 1506-1517.

11. Tentoonstellingscatalogus, *Suevia Sacra, Frühe Kunst in Schwaben*, Augsburg 1973, no's 201, 202.

12 J. G. BECKWITH *Byzantine Tissues*, in XIV Congrès International des Études Byzantines, Bucarest, 6-12 Septembre 1971, Rapports p. 35.

13. Zie noot 5.

14. Tentoonstellingscatalogus, *Rijn en Maas, Kunst en Cultuur 880-1400*, deel 1, Keulen 1972, 171, no. B2.

15. W. F. VOLBACH *Catalogo del Museo Sacro della Bibliotheca apostolica Vaticana*, vol. 3, Fasc. l, Tessuti, Vatican 1942.

16. M. LEMBERG en B. SCHMEDDING *Abegg-Stiftung Bern in Riggisberg*, II Textilien, Schweizer Heimatbücher 173/174, Bern 1973, Tafel 12.

17. Tentoonstellingscatalogus, *Edinburgh International Festival 1958, Masterpieces of Byzantine Art*, London: October 1 to November 9, 1958, no. 71, 35-6.

18. A. GRABAR in Münchener Jahrbuch, 3 Folge VII, 1956, 7-25. Ook S. MÜLLER-CHRISTENSEN Münchener Jahrbuch, Band XVII, 1966, 9ff.

19. R. GRÖNWOLDT *Webereien und Stickereien des Mittelalters*, Bildkataloge des Kestner-Museums Hannover VII, Textilien I, Hannover 1964, no. 234, Abb. 24.

20. D. KING, *Some unrecognised Venetian woven Fabrics*, Victoria and Albert Museum Year Book, 1969, 53ff.

21. F. GUICHERD suggereert dat de vroegste lampas weefsels van Buyid oorsprong zijn. Zie F. GUICHERD, *Lampas Bouyides*, in Bulletin de liaison du Centre International d'Étude des Textiles Anciens, Juillet 1963.

22. F. BOCK et M. WILLEMSEN *Antiquités sacrées conservées dans les anciennes collégiales de St. Servais et de Notre-Dame à Maestricht*. Maestricht 1873, fig. 11.

23. Ik wens van deze gelegenheid gebruik te maken om zowel de heer J. Brouwers als Br. S. Tagage te danken voor hun vriendelijke hulp, die zij mij geboden hebben tijdens mijn verblijf in de schatkamer van St.-Servaas om daar de zijden stoffen te bestuderen. Een bijzonder woord van dank aan Br. S. Tagage, die zorg droeg voor de vertaling.

II
The Silk over the Spine of the Mondsee Gospel Lectionary

THE Mondsee Gospel Lectionary in the Walters Art Gallery has long been renowned for its beautiful binding. A feature of this binding is the silk sheathing the spine, which in itself has a fascinating history. I first studied the binding and the silk with the late Dorothy Miner; together we worked out how the binder had tackled the various stages of his task. More recently, with the help of another colleague, rare bindings conservator Guy Petherbridge, I have examined over sixty mediæval silk bindings but none of them has a silk-sheathed spine comparable to that of the Lectionary. The feature which distinguishes the Lectionary spine form the others sheathed with silk is the alum-tawed spine liner. This acts to prevent the silk form rubbing against the double thongs underneath, to which the gatherings are sewn. A description of the binding is supplied in Appendix B by Christopher Clarkson, Conservator of Rare Books and Manuscripts at the Walters Art Gallery. My task will be to examine the origin, weave and design of the silk itself.

As far as I am aware, silks on bindings are mentioned only rarely in Byzantine and Western sources in the ninth century. I know of only two references to silk bindings and these seem to be the earliest mention of the silks by book binders. In 838 AD a silk-sheathed binding, described by Florus of Lyon, was presented to the king by Bishop Amalarius. And the *Vita S. Ignati* of Nicetas Paphlago, written in the first half of the tenth century, reports that in 867 AD Photius was in possession of a manuscript in two volumes with a binding of gold, silver, and silken cloth.[1]

Western bindings, with silks placed over the boards, lining them, or sheathing the spine, are extant in many museums, libraries and church treasuries, and some similar silk bindings are in Mount Athos and other Greek monasteries and libraries. A comprehensive survey of silk bindings

does not exist at this stage, and for this reason it is particularly important to record individual bindings, such as that of the Mondsee Gospel Lectionary (PL. 23). The silk of the spine is a significant addition to the group of monochrome compound twill silks mentioned in the work of Falke and Kendrick early in this century, but only dealt with in technical detail in the last twenty years by Sigrid Müller-Christensen.[2] Appendix A offers a list of the most important silks of the group, a considerable number of which are considered Byzantine by these authors. Some of these silks will be compared to the silk of the Walters sample.

The Mondsee Gospel Lectionary contains the Gospel lessons arranged in order for use during the entire year. Enriched with five large initials in gold and silver, it was described by Dorothy Miner in the exhibition catalogue *Two Thousand Years of Calligraphy*[3] as a "sumptuous service book". The manuscript and its binding are of interest from many points of view: the fact that the text and the greater part of the binding, including the silk spine, are contemporary is perhaps one of the chief points of interest. The codex has traditionally been associated with the Benedictine abbey of Ss. Peter and Michael at Mondsee in Austria, although there is no documentary evidence to support this. In the nineteenth century the codex was in a German archducal collection. It was acquired by Henry Walters from Jacques Rosenthal of Munich around 1926.

On the thick upper oak board of the Lectionary is a cover with silver plaques enriched with filigree and with four ivory plaques representing the Evangelists and their symbols (PL. 24), of which St. Luke is a nineteenth century replacement. The four silver plaques between the ivories are gilded and form the arms of a cross, at the centre of which is a large cabochon rock crystal covering a painting of the crucifixion in gold leaf. Around this is the inscription MORS XPI MORS MORTIS ERAT TUUS INFERE MORSUS. The corners of the board are covered with four nielloed roundels. Gems that once decorated the border are now missing. On the lower board (PL. 25) is an engraved plaque depicting St. Michael and the dragon, which must originally have had a metalwork border, judging by the nail holes visible around it on the wood.

The manuscript is thought to be a product of the Regensburg school, dating to the second third of the eleventh century. Bernard Bischoff has tentatively identified the chief hand in the Lectionary with Othlon, who was in the scriptorium of St. Emmeram at Regensburg between 1032 and about 1055, and who lists two Gospel Lectionaries amongst the manuscripts which he copied.[4] The manuscript and the silk used over the spine are close in date. The silk is comparable to a considerable number of examples that reached the West by the mid-eleventh century and which appear to have been produced in Byzantine and in Islamic centres in the tenth to eleventh centuries. Such silks were in use largely on the Upper

Rhine, in Franconia, and in Bavaria, and there is evidence to suggest that several of them were presented as gifts by the Emperor Henry II (1002-1024).

Only two examples of spines sheathed with the same type of silk as that on the Mondsee Gospel Lectionary are known to the author. These belong to a life of St. Stephen from Weihenstephan near Freising (Munich, Bayerische Staatsbibliotek Clm. 21585 Cim. 1 56), and to the Codex Aureus of Echternach (Nürnberg, Germanisches Nationalmuseum ms. K.G. 1138). While both have been published, their methods of binding have not been closely studied.

The Weihenstephan manuscript is of the twelfth to thirteenth centuries. The metalwork cover of the upper board belongs to around 1200, whilst the *repoussé* figures date into the fourteenth century (PLS. 26, 27).[5] The central ivory is of the eleventh century. Both boards are covered with a single piece of red silk. This extends over the spine and can be seen beneath a damaged section of the metalwork upper cover. While the boards of the Mondsee Gospel Lectionary are of equal thickness, the upper board on the Weihenstephan binding is much thicker, at 5 cm, than the lower board. It has been hollowed out on the inside beneath the *repoussé* figures of the cover to produce a series of cavities for relics. On a Western binding, it is possible to replace the boards without re-sewing, although they do have a structural connection with the sewing, so that it is difficult to determine whether this thicker board is original or, in fact, a fourteenth century replacement. The channels are carved in the boards at an angle rather than horizontally. Possibly the binder thought in this way to secure the stout bands more firmly.

In the case of the Nürnberg Gospels, the binding itself can be considered contemporary with the text-block, apart from the earlier reused metalwork cover of the upper board (PL. 28). Metz has dated the manuscript between 1053 and 1056.[6] A variety of silks are used on the binding, some early and others clearly part of a late restoration; the mediæval silk spine, for example, was backed with a modern silk at an unknown date. The areas of wear across the original silk spine indicate that it has worn from rubbing against the raised bands. Evidently there was no sheepskin pad to protect the silk, which is a yellow olive-green in colour (PL. 29). A red silk is beneath the metalwork covering the edges of the lower board, and this red silk also seems to be of a later date. As on the Mondsee Lectionary, leather was stretched over the boards and horizontal channels were carved into the boards to accommodate the stout bands. Traces of red silk with some threads of black and gold may be seen beneath the leather over the spine, which can be examined because both boards are detached. It is not clear, however, from what part of the binding these silk remains came.

Neither the Weihenstephan nor the Nürnberg binding has semicircular tongues comparable to the extant tongue of the Mondsee binding. Leather tongues, some silk-lined, do survive on leather bindings of the Romanesque period, and several from Bury St. Edmunds have been published by the late Graham Pollard.[7] In the case of the Bury manuscripts it is probable that the tongues were used for lifting the bindings out of a storage closet, but the Mondsee Gospels, with their precious metalwork and ivory covers, are hardly likely to have been stored in this manner. The Mondsee Gospels originally had tongues at either end of the spine and they seem to have served a decorative rather than a utilitarian purpose.[8]

The Mondsee, Weihenstephan, and Nürnberg silks used on the spines of the bindings belong to a group of monochrome silks. These silks are weft-faced compound twills with their designs produced by a change in weave rather by colour contrasts. The structure of a compound twill is illustrated in PLATE 1.[9] The main warps are paired, but they appear neither on the obverse nor on the reverse of the weave. On the Mondsee silk the main warps are undyed and twisted to the right, probably to give them extra strength. The binding warps, which as their name suggests bind down the weft, are undyed, single, and twisted to the right. The weft is untwisted and is a deep blue-green in colour. The main warps are undyed, indicating that the textile was not dyed after weaving.

The silk was woven on a drawloom operated by two people. One sat at the loom and controlled the binding warp and the weft, and the other operated a pattern-producing device called the "figure-harness", which controlled the main warps. The latter mechanism raises or lowers the main warps so that the weft, when passed across, appears either on the obverse or the reverse of the textile according to the requirements of the pattern. In twill weave, the weft is bound down after every second or third set of warps, and a characteristic "furrow" results from beginning each successive row one set of warps further in to the right. The diagonal furrow on the Mondsee silk runs from left to right; it is less common for such a furrow to run in the opposite direction.

A good description of how patterns are produced on monochrome compound twills is given by Sigrid Müller-Christensen, who describes them as "incised twills".[10] Essentially, what happens is that the positions of the two sets of weft threads employed for the weave are altered, the first weft passing to the back of the weave, and the second weft being brought to the surface, so that a "furrow" results where the two wefts have exchanged positions. The furrows form the lines of the design: if the process is carried out between the same warps in successive rows, a straight line appears; but if a curved line is required, it is produced by repeating the process between varying warps in successive rows.

The details of the designs on all incised silks are rather difficult to distinguish immediately. Different parts of the design are highlighted according to the way in which the light falls on the silk. Birds, griffins, lions and foliate motifs are usual on incised silks, and there is one example of a bust in a medallion. Paired birds are found in the Weihenstephan silk, and the Nürnberg silk has a foliate design which is difficult to distinguish. It is possible to reconstruct at least in part the design on the Mondsee silk. Along the length of the spine (29 cm) are two complete repeats with parts of another two on either side (PL. 30). The width of the spine is 8.5 cm, approximately the same as the height of the repeat.

The width of the Mondsee silk is employed along the length of the spine, and the design appears the correct way up when the manuscript is viewed from the side resting flat. Two diamond shapes with linking medallions on either side are visible along the length of the spine (FIG. 7). The medallions, with a pearl border between paired outlines, constitute the clearest part of the design. In the centre of each medallion is a rosette with four sets of heart-shaped petals, which are separated by narrow projections resembling a St. Andrew's cross. Similar medallions appear in part below. They act as primary motifs within the next row of diamonds. The wefts in the area of the diamond motifs are worn, and it is difficult to distinguish the design, but these diamonds appear to have wide borders enclosing some kind of

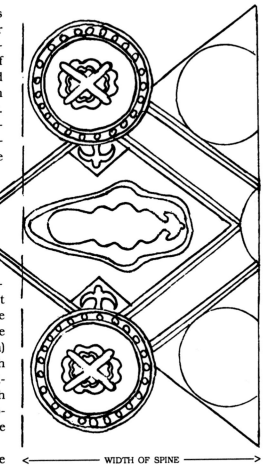

<----------- WIDTH OF SPINE ----------->

FIGURE 7

DIAGRAM OF DESIGN IN THE WEAVE OF THE SILK
OF THE MONDSEE GOSPEL LECTIONARY

running tendril ornament. Inside, set within a fluid form that has a double outline, are irregular foliate motifs, with left and right an arrow-like projection enclosing a tendril motif, the stems of which rest upon linking medallions.

It is unusual for incised silks to have linking motifs as large as the Mondsee rosettes. It is unusual, too, to have the design of the linking medallion repeated within the diamond pattern. A more detailed recon-struction of the design is desirable, but this is impossible with the naked eye. Despite this, there are four incised twill silks that can be compared to the Mondsee silk, and a sketch of each is given (FIG. 8).

 a Fragments from a chasuble found in the grave of a certain Adalbero, in the lower crypt of Basle Cathedral, and now in the Historisches Museum, Basle.[11]

 b A chasuble from St. Peter's, Salzburg, in the Museum of Fine Arts, Boston.[12]

 c Fragments of a silk divided in 1913 between the Kunstgewerbe Museum, Berlin, and the Kunstmuseum, Düsseldorf.[13]

 d A fragment of silk from the collection of Canon Bock, now in the Victoria and Albert Museum, London (1242-1864).[14]

"Running" tendrils in the borders of diamond shapes are found on the Basle, Boston and London silks. The infilling motifs of the Basle and Düsseldorf silks with rosette and St. Andrew's cross are very close to the linking medallions of the Mondsee silk. All four comparative silks incor-porate some kind of arrow-like projection motif with tendril infilling, but the Basle motif is closest to that on the Mondsee silk. Two different motifs are enclosed in alternate rows in the diamonds of the four silks, and this is true also of the Mondsee silk; although here one of two motifs, namely the rosette, is used as a linking motif as well as part of the primary design.

The incised twill in Basle is in several fragments, which, if fitted together, would form part of a chasuble. One of the fragments has survived in particularly good condition (1907/1845). It measures about 19 x 21 cm and is brownish-yellow in colour, although other conserved fragments of the same silk indicate that the original colour was a strong golden yellow. Both warps and wefts are dyed (unlike those on the Mondsee silk) so that the Basle textile may have been dyed after weaving. A band of a plain twill weave can be seen on one of the larger fragments (52 x 16 cm). The silk could have come from any one of three graves that were accidentally disturbed in Basle Cathedral during course of work on the building. The three graves belong to an unspecified Bishop Adalbero, to Lutold I of Arburg (d. 1213), and to Henry II of Thun (d. 1238). Of these the most likely owner of the silk is Adalbero II (d. 1026), who dedicated Basle Cathedral in the presence of its founder Henry II, in 1019.[15]

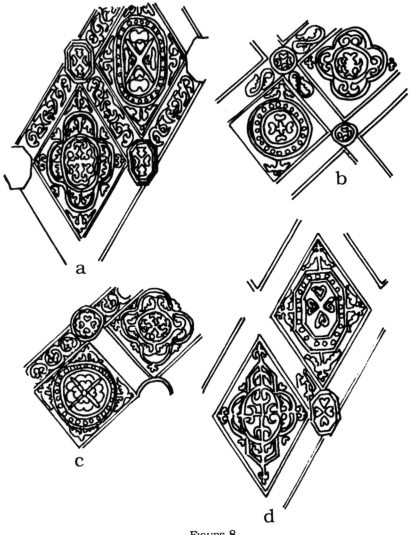

FIGURE 8
DIAGRAM OF FOUR INCISED TWILL DESIGNS

The incised silk chasuble in Boston is blue-black in colour and the main warps are undyed, suggesting that the wefts were dyed before weaving. There is a woven purple inscription in Kufic script, which is partly hidden by the gold orphrey. This has not been fully deciphered, in part because of the silk's fragile condition. Beckwith has suggested that the inscription reads "Great is Allah". It has also been tentatively sug-

gested that the words "Nasr al-Daula", which mean "Succour of the State", can be read.[16] "Succour of the State" was one of the titles of the Marwanid dynasty, who held office between 1010/11 and 1061, and whose name appears in the woven inscription of an incised twill at St. Ambrogio, Milan. The Boston silk and that in Milan, which has a design of small interlocking forms, offer evidence that incised silks were woven in Islamic centres in the eleventh century. The Boston chasuble belonged to a certain Heinrich, judging by the golden embroidered inscription in Latin along the hem. This reads: *Hanc vestem claram Petri patravit ad aram Heinrich peccator eius sit ut auxiliator* (Heinrich the sinner has prepared this noble garment for St. Peter's altar, that it may be his helper). It has been proposed that the inscription refers to the abbot of that name at St. Peter's, Salzburg, between 1167 and 1188: if this is correct, the silk was already between 100 and 150 years old at the time the Latin inscription was added.

The incised twill fragment in the Kunstmuseum, Düsseldorf (13444) was donated in 1888 by Professor Kothoff of Paderborn. It is said to have served as the lining around the neck of a vestment that belonged to Bishop Meinwerk of Paderborn (d. 1036) which has since disappeared.[17] The fragment measures 31.5 x 13 cm, and has deep blue-violet wefts.

The London silk is in several fragments, which were acquired in 1864 after the death of Canon Bock, but there is no information as to where he obtained them. The weft is yellow to olive-green in colour, while the main warps are either completely undyed or a little greenish in tone. The silk is closest in colour to that on the spine of the Nürnberg Codex Aureus. None of the silks so far mentioned is the deep blue-green colour of the Mondsee silk. Taken as a whole, though, the silks illustrate the wide range of colours found on incised twills: red to blue-black and blue-violet, and golden yellow to yellowish olive-green.

Within the group of incised twill silks, several have some connection with Emperor Henry II, although the connection should not be over-stressed since incised twills were found in the graves of several emperors and their consorts in Speyer Cathedral. Like other emperors, Henry was in a position to donate silks to favoured foundations (particularly to the Bamberg and Basle Cathedrals), and to ecclesiastics, whom he appointed. Envoys, usually bearing gifts, passed frequently between Byzantium and the West in this period; for example, Henry received Byzantine envoys in 1002. In 1083 silk diplomatic gifts are specifically mentioned in the care of Byzantine envoys.[18] It seems quite probable that a considerable number of the Byzantine silks in mediæval European treasuries reached the West as diplomatic gifts to different emperors, who subsequently donated them to various foundations. Henry's gifts to a number of centres are recorded in contemporary chronicles. At the dedication of Basle Cathedral under Bishop Adalbero in 1019, they included a chasuble of "samite inwoven

with golden eagles".[19] Four years earlier in 1015, on a visit to Cluny, he presented gifts including a "golden Imperial garment".[20] To Monte Cassino in 1022 he offered precious textiles including "a chasuble with inwoven patterns and golden borders, a stole, a maniple, and a belt, all with gold ornament. A cope with inwoven ornaments and golden borders and also a tunic of the same fabric with golden ornaments as well as a handkerchief with inwoven ornaments and gold ornaments". The "gold ornaments" are probably embroideries in golden thread.

In Bamberg Cathedral treasury are a number of incised twill silks with golden embroidery. One mantle has embroidered panels with seated rulers in Eastern costume (PL. 31), and embroidered alongside the panels is the name Henry. The mantle probably belonged to Henry II (1002-1024), who founded Bamberg Cathedral, although until quite recently it was thought to have belonged to Cunigunde, his wife. The association with Cunigunde stems from the fact that her portrait appears on a hood added to the mantle by Jorg Spiess in 1448. The embroidered name of Henry was not revealed until the late 1950s, when the mantle was conserved. At this time it was also discovered that the original silk ground of the embroidery is an incised twill with a design related to that of the Mondsee silk and its sister silks described above. Pearl borders, foliate motifs, and interlocking geometrical forms are found in the designs of all these silks. It is unfortunate that not much of the original silk ground remains: the embroidery was remounted in the sixteenth century. Also remounted are the embroideries of Old and New Testament scenes on another mantle at Bamberg, but enough remains beneath the embroideries to determine that the ground was originally an incised twill silk. A third embroidered mantle in Bamberg shows mounted falconers, and this has an interesting twill silk lining with a Kufic inscription that reads "The Kingdom is of God". The oldest inventory of Bamberg Cathedral treasury dates from 1127 and includes forty chasubles, of which fifteen were decorated with golden thread.

The incised twill silk ground of the mantle at Bamberg, with the embroidered name of Henry, is similar in design to the Mondsee silk with its foliate ornament in geometric compartments, and it is indeed almost identical to two silks in Mainz and in Munich. The silks were used to form chasubles, and these are by tradition said to have belonged to Archbishop Willigis of Mainz (975-1011). The possibility that Willigis actually wore the chasubles cannot be dismissed; one chasuble is still in the treasury of St. Stephen, Mainz (FIG. 9A), and dates to the tenth to eleventh centuries. The second chasuble reached the Bayerisches Nationalmuseum, Munich, from Aschaffenburg (FIG. 9B) in the 1790s by way of Bishop Kolborn, "provicar" of Mainz.[21] Willigis consecrated Henry II in 1002, and the silks may have been gifts from the emperor. Alternatively, they could have been

presented to Willigis by Otto II, who had appointed the Archbishop: in this case it is tempting to think the silks may have come from Byzantium via the Empress Theophanou.

There is some evidence to suggest that Henry II presented certain incised twill silk chasubles to bishops whom he appointed. The chasuble at Niederaltaich, which has an ogee design similar to that of the Mainz, Munich and Bamberg silks, may have been a gift from Henry. The vestment appears to have belonged to Abbot Godehard: an inscription, apparently added posthumously, invokes eternal life for the abbot: *Salus capiti sit ut abbatis Godehardi atque deus vitam ducat in æternum.* Godehard was abbot of Niederaltaich before being elevated to the see of Hildesheim in 1022 by Henry II. It is possible that the emperor presented the chasuble to Godehard on his appointment, and that the latter left it to his former abbey on his death in 1038.

As mentioned above, the Düsseldorf silk is said to have come from a vestment of Bishop Meinwerk of Paderborn. This bishop, appointed by Henry II, could have received gifts from the emperor on the occasion of his investiture in 1000 or at the time of the consecration of the Cathedral of Paderborn in 1015. Similarly, the Basle silk discussed earlier may have been a gift from Henry II to Adalbero II on the occasion of the dedication of Basle Cathedral in 1019.

Another incised twill chasuble, today in the National Museum of Budapest, may have been presented by Henry II. According to an embroidered inscription, the chasuble was offered to the church of the Virgin at Székesfehérvár by King Stephen of Hungary and by Queen Gisela in 1031. Gisela was the sister of Henry II. Eva Kovács has drawn attention to the similarity between the embroidered figures of the chasuble and the metalwork standing Christ on the Basle antependium, presented to Basle Cathedral by Henry II.[22]

From the examples discussed so far there is evidence to show that incised twill silks were arriving in the West in numbers by the eleventh century; the fact that several of these silks were used to clothe the body of Pope Clement II (d. 1047) underlines the point. The Pope had been Bishop of Bamberg, and when he died his body was taken to Bamberg Cathedral for burial.[23] Incised silks were used for Clement's chasuble and pluvial, for the bands at the top of the buskins, and for a number of unattached ribbons. The golden-yellow chasuble employs an ogee design and foliate infilling motifs like those on the Willigis silks (PL. 32). On Clement's red pluvial, medallions with paired griffins and panthers are enclosed in alternating rows with paired birds used as linking motifs in the spandrels. The same design is seen on a chasuble from St. Peter's, Salzburg, now in the Abegg Stiftung, Riggisberg. The design is found again, in a different weaving technique, on the buskins of Pope Clement

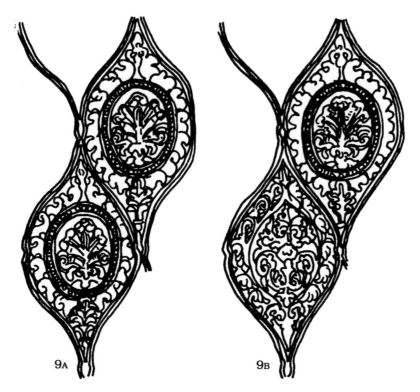

FIGURE 9

DESIGN MOTIFS OF 10TH TO 11TH CENTURY SILK CHASUBLES

II.[24] The incised silk band at the top of the buskins is blue-black with a rosette motif surrounded by a border of pearls.

Ascribing provenance to any silk is problematic, because there is not enough information about the types of silks woven in different weaving centres. The Milan and the Boston silks, with their intelligible Kufic inscriptions, nevertheless indicate that incised twills were woven in Islamic centres. Evidence that such silks were also woven in Byzantine centres is offered by the incised twill of Bamberg, embroidered with seated Byzantine Emperors. Müller-Christensen asks the question: does the mantle represent a Byzantine work of art intended as a gift for the emperor, or is it a Byzantine silk embroidered in the West?[25] Conservation work has shown that both silk and embroidery are Byzantine, as they use the same thread. The subject matter of the embroidery is anyway most unusual in the West and differs from that of the other embroidered silks at Bamberg. It is known that silks did arrive in the West as diplomatic gifts and, as mentioned earlier, Henry II did receive Byzantine envoys during

his reign. From the *Book of the Prefect*, a tenth century document dealing with the non-Imperial guilds in Constantinople, it is clear that large scale monochrome silks were reserved for Imperial manufacture.[26] This not only proves that monochrome silks were woven in Constantinople at that date, but it also serves to show that such silks were unlikely to have reached the West in any manner other than as diplomatic gifts.

In light of the fact that incised twills seem to have been woven in both Byzantine and Islamic centres in the tenth to eleventh centuries, it is unwise to state categorically that the silk sheathing the spine of the Mondsee Gospel Lectionary is definitely Byzantine or Islamic: it could be either. It serves as an example of one of the types of silks that came to the West, and its use on a binding reflects the practice that had become widespread by this date.[27] It is fortunate that the binding has been well preserved and that its eleventh century character can still be appreciated today.

NOTES

1. E. Sabbe, "L'importation des tissus orientaux en europe occidental", *Revue Belge de Philologie et d'Histoire*, 14:3, 1935, p. 817, note 3; Nicetas Paphlago, *Vita S. Ignati*, 1, col. 450ff. quoted by C. Mango in "The Art of the Byzantine Empire 312-1435", *Sources and Documents in the History of Art Series*, Jansons ed., New Jersey, 1972, p. 191.

2. O. von Falke, *Kunstgeschichte der Seidenweberei*, Berlin, 1913, vol. 2; W. F. Kendrick, *Catalogue of Early Medieval Fabrics*, London, 1925; S Müller-Christensen, *Das Grab des Papstes Clemens II im Dom zu Bamberg*, Munich, 1960.

3. Dorothy Miner, Victor Carlson, P. W. Filby, *Two Thousand Years of Calligraphy*, Baltimore, 1965, p. 32, no. 16. The covers are described and dated by Frauke Steenbock, *Der Kirchliche Prachteinband im frühen Mittelalter*, Berlin, 1965, No. 87, pp. 181-83, pls. 119,120.

4. D. Miner, *Calligraphy*, op. cit., loc cit.

5. I am indebted to S. Müller-Christensen of the Bayerisches Nationalmuseum, Munich, for drawing my attention to the Weihenstephan manuscript. The manuscript is published in the *Catalogus Codicum Manuscriptorum Bibliothecae Regiae Monacensis*, Wiesbaden, 1969, vol. 4, part 4. Here a twelfth to thirteenth century date is given for the manuscript. Müller-Christensen has pointed out that the silk covering the spine of the Weihenstephan manuscript is the same as that over the inside seams of the shoulders of the chasuble of St. Ulrich (d.

973). It is mentioned in her publication *Liturgische Gewänder mit dem Namen des hl. Ulrich*, in *Augusta 955-1955*, 1955, p. 58. See also by the same author: *Sakrale Gewänder des Mittelalters*, Munich, 1955, p. 15, no. 10. The chasuble is in the Maximilian museum, Augsburg. (see *Suevia Sacra, Frühe Kunst in Schwaben*, Augsburg, 1973, no. 211). I wish to thank Peter Lasko for his help in dating different parts of the cover.

6. The Codex Aureus of Echternach is published by Peter Metz in *Das Goldene Evangelienbuch von Echternach im Germanischen Nationalmuseum in Nürnberg*, Munich, 1956. The spine is only mentioned very briefly on p. 111 in note 100.

7. G. Pollard, "The Construction of English 12th century Bindings", in *The Library, Transactions of the Bibliographical Society*, London, 5th series 17:1, 1962, pp. 1-22. Pollard mentions 15 Bury St. Edmunds' manuscripts which have silk-lined tongues, but does not give their locations. The present author examined seven such Bury manuscripts with their bindings at the Bodleian Library, Oxford.

1-3.	Jesus College	D66	Purple silk
		62	worn silk with blue and white stitching around edge.
		65	scrap of blue and yellow silk lining upper tongue. Yellow and pink stitching around the edges.
4-5.	Laud. lat.	19	tongues cut off, but traces of green and red silk lining.
		567	upper tongue has scrap of red silk lining.
6-7.	Bod.	582	both tongues with traces of red and blue silk lining.
		737	both tongues lined with silk depicting inverted heart motifs; green and red, and blue and red on yellow.

An eighth Bury binding was examined at the British Library (Egerton 3776). The upper tongue is lined with a purple silk, which is worn and seamed. The lower tongue has spindly, curving, yellow tendrils on a brilliant sky-blue ground. Purple-red inverted petals appear in pairs to the right. The layers of the tongue are secured together in a similar way to those of the Mondsee Gospel Lectionary with a complex buttonhole stitch. Dorothy Miner brought to my attention a number of twelfth century manuscripts with tongues at each end of the spine, many of which are English. Some bindings are reproduced in a sales catalogue, *The Chester Beatty Western Manuscripts*, part 1, Sotheby's London, December 3, 1968, lots 6 and 7, pl. 8. Lot 6 was acquired by the Henry E Huntington Library, San Marino, California. See also "Some Anglo-Saxon Bookbindings" by Graham Pollard, published in *The Book Collector*, vol. 24, 1, 1975, pp. 130-59.

8. See also Berthe van Regemorter's article in *Scriptorium* 15, 1961, pp. 327ff. She notes the use of silver thread to embroider the edges of the small leather tongues of mss. 6 and 13 at Albi, and in addition the general use of silks on bindings.

9. N. Reath and E. Sachs, *Persian Textiles and Their Technique from the Sixth to the Eighteenth Centuries*, New Haven, 1937, fig. 10 of part 4.

10. S. Müller-Christensen. *Das Grab*, op. cit., pp. 57ff.

11. E. A. Stückelberg, "Die Bischofsgräber der hintern Krypta des Basler Munsters", in *Basler Zeitschrift für Geschichte und Altertumskunde*, 8, 1909, pp. 287ff.

12. G. Townsend, *Boston Museum of Fine Arts Bulletin*, 33, Feb 1935, p. 10.

13. O. von Falke, *Kunstgeschichte*, op. cit., 1921 edition, pl. 204.

14. The London silk is not published in detail. All four silks were examined by the author in 1972-73. The Basle and Boston silks are in a very delicate condition.

15. There were three bishops named Adalbero at Basle. The first bishop died several centuries earlier than the 10th-11th century date of the silk, and the third Bishop Adalbero is unlikely to have been buried in it: he died at Arezzo in 1132.

16. This interpretation was offered by Dr. Bivar of the School of Oriental and African Studies, London University. Dr. Bivar expressed reservations because the weave of the silk is liable to distort the script of any Kufic inscription.

17. I wish to extend my thanks to Dr. Ricke of the museum, who provided this information.

18. W. Ohnsorge, *Abendland und Byzanz*, Darmstadt, 1958. "Die Legation des Kaisers Basileios II an Heinrich II", pp. 300-316. The Greek envoys in the West in 1083 were intent in gaining help against the Normans on behalf of their Emperor Alexius.

 O. Lehmann-Brockhaus, *Schriftquellen zur Kunstgeschichte des 11. und 12. Jahrhunderts*, 1938, reprinted in New York, 1971, no. 2723, "*Eodem tempore legati Grecorum venerunt, munera multa et magna in auro et argento vasisque ac sericis afferentes*". Envoys from Byzantium came to the West frequently in connection with planned marriages; see F. Dölger, *Regesten der Kaiserurkunden des Oströmischen Reiches von 565-1453*, Munich and Berlin, 1924, 1925, 1932, nos. 325, 339, 443, 480, 536, 642, 784, 830, 989, 1003 for example, which date between 765 and 1074.

19. *Sources and Documents in the History of Art Series*, p. 118 of the volume entitled *Early Medieval Art*, 300-1150, by Caecilia Davis-Weyer, New Jersey, 1971. Here the dates of Bishop Adalbero are given as 999-1021.

20. *Ibid.*, pp. 11, 120. Note also that in 1023 rich parting gifts were presented by Henry to the church of St. Andrew. Gerhard of Cambrai (1012-1051) was a close contact of the emperor. The chronicle of St. Andrew's, Cambrai records under the year 1023 the acquisition of a relic of St. Andrew with a reliquary from Constantinople, together with two *pallia* for the Virgin and one purple-red *pallium*. The chronicle of 1133 is based on earlier records. Again, one wonders if Henry distributed gifts that he had earlier received from Constantinople.

21. In the seventeenth century, at least one silk chasuble was still at Mainz. It is reported together with an alb and a stole at St. Stephen, Mainz. *Kirchenschmuck*, vol. 26, 1896, p. 11, note 7. The name of Willigis is not mentioned by the Jesuit, but there are no later chasubles of the saint at Mainz: it can be inferred that he was talking of one of the incised silk chasubles.

22. Eva Kovács, "Casula Sancti Stephani Regis", in *Acta Historiae Artium*, Budapest, vol. V. fasc. 3-4, 1958, pp. 191ff.

23. See note 2.

24. M. Lemberg, B. Schmedding, "Abegg Stiftung Bern in Riggisberg 11, Textilien", in *Schweizer Heimatbücher* 17, 3/4, Bern, 1973, pl. 13.

25. S. Müller-Christensen, *Sakrale Gewänder*, op. cit. no. 18, p. 17. M. Schuette and S. Müller-Christensen, *The Art of Embroidery*, London, 1964 (translation by D. King), Historical introduction p. XVI, cat. no. 29/30, p. 299.

26. J. Nicole, *Le livre du Prefet*, Geneva and Basle, 1894 (Variorum reprint, Switzerland, 1970), Chapter VIII, i, see pp. 162, 245 for the translation of the relevant passage by Freshfield (Cambridge, 1938).

 Cf. A. Boak, "Notes and Documents. The Book of the Prefect", *Journal of Economic and Business History*, 1, 1929, pp. 597-618, esp. p. 609, "The silk weavers are forbidden to manufacture the prohibited cloaks, namely, large-sized outer cloaks of a single colour."

 For the dating of the *Book of the Prefect*, see A. Stöckle. "In welche Zeit fällt die Redaktion unseres Edikts?", *Klio*, 9, 1911, 142-3; and G. Ostrogorsky in a review of G. Zoras "Le Corporazione bizantine", *Byzantinische Zeitschrift*, 33, 1933, pp. 389-95, esp. 391ff.

27. I am indebted to those who made it possible for me to examine bindings with silks. In particular I would like to thank Dr. Bahns and Dr. Leonie von Wilckens at the Germanisches Nationalmuseum, Nürnberg, and Dr. Klaus Maurice, Keeper of Manuscripts in the Bayerisches Nationalmuseum, Munich. Dr. Maurice provided the negatives for the photos of the Weihenstephan binding.

SPECIAL NOTE

The Book of the Prefect has been republished by J. Koder, *Das Eparchenerbuch Leons des Weisen* CFHB 33, Wien, 1991.

A HANDLIST OF THE MOST IMPORTANT EXTANT INCISED TWILL SILKS, ALSO KNOWN AS MONOCHROME COMPOUND TWILLS

1. Augsburg, Maximilian Museum and Church of St. Ulrich and Afra

Chasubles of St. Ulrich (d. 973). The shoulder piece of the chasuble in the Maximilian Museum is a red incised twill silk. S. Müller-Christensen, *Sakrale Gewänder*, Munich, 1955, no. 9; *idem, Das Grab des Papstes Clemens II im Dom zu Bamberg*, 1960, p. 69; *idem, Liturgische Gewänder mit den Namen des Heilige Ulrich, Augusta 955-1955*, Munich, 1955.

2. Baltimore, Walters Art Gallery

Silk over the spine of Ms. W. 8, a Gospel Lectionary, written by scribes of Regensburg around the second third of the eleventh century.

3. Bamberg Cathedral Treasury (housed in the Diocesan Museum adjoining the Cathedral)

3.1 Choir mantle with embroidered emperor panels, and with the name "Henry" embroidered alongside a panel. Originally on an incised twill silk ground and long called the Cunigunde cope on account of a later hood with an embroidered portrait of St. Cunigunde added by Jorg Spiess in 1448.

3.2 Mantle with embroidered Old and New Testament scenes, originally mounted on an incised twill silk ground.

3.3 Mantle with embroidered falconers. Incised twill silk lining, with Kufic inscription. The inscription reads "The Kingdom is of God". The inscription is in mirror image along the silk as well as the correct way round.

3.4 Chasuble, pluvial, bands on top of the buskins, and various ribbons from the grave of Pope Clement II (d. 1047) in Bamberg Cathedral. S Müller-Christensen, *Sakrale Gewänder*, nos. 18, 25, 24; *idem, Das Grab*, op. cit., pp. 37-43, 57ff.

4. Basle, Historisches Museum

Fragments of incised twill silk from the grave of a certain Adalbero in the lower crypt of Basle Cathedral. Perhaps the grave of Bishop Adalbero II (d. 1026). Inventory number on one of the fragments, 1907, 1845. E. A

Stückelberg, "Die Bischofsgräber der hintern Krypta des Basler Münsters", *Basler Zeitschrift für Geschichte und Altertumskunde*, 8, 1909, pp. 287ff.

5. Budapest, Church of the Virgin at Székesfehérvár, later in the Hofburg at Vienna, today in the National Museum, Budapest.

Chasuble with an embroidered Latin inscription bearing the names of Stephen of Hungary (crowned in 1031) and Gisela, his queen, who was sister of the Emperor Henry II (d. 1024). The chasuble had an incised twill silk ground, examined by S. Müller-Christensen during the 1939-45 war. The embroidered inscription states that the chasuble was presented to the Church of the Virgin at Székesfehérvár, which was consecrated in 1031. The silk was used as a coronation mantle in the nineteenth century, and is called a mantle, rather than a chasuble in the literature. E. Kovács, *Casula Sancti Stephani Regis: Acta Historiae Artium*, V Budapest, 1958, p. 181.

6. Berne, Riggisberg, Abegg Stiftung
Chasuble from St. Peter's, Salzburg. Legendary association with St. Vitalis (c. 700). S. Müller-Christensen, *Das Grab*, op. cit., fig. 88.

7. Boston, Museum of Fine Arts
Chasuble from St. Peter's, Salzburg, with woven Kufic inscription. J. Beckwith has suggested that the inscription reads: "Great is Allah". See Byzantine Tissues in *XIV Congrès International des Études Byzantines*, Bucarest, 6-12 Sept. 1971, p. 42. Members of the School of Oriental and African Studies of the University of London have suggested part of the inscription may have been taken to read: "For Nasr al-Daula". The reading is tentative, because of wear over part of the script. There is also the possibility of a number of spelling mistakes. "Nasr al-Daula" means "Succour of the State". The script is plainer than that of the Milan silk, and probably earlier. Other titles of the ruler were: "al-Amir al Ajall" (the most noble arur) and "izz al-Islam" (glory of Islam). His patronymic or Kunya was "Abu Nasr" (Father of victory). An added embroidered inscription in Latin names a certain Henry; this may refer to Abbot Henry (1167-1188), G. Townsend, *Boston Museum of Fine Arts Bulletin*, vol. 33, Feb. 1935, p. 10.

8. Düsseldorf, Kunstmuseum
This fragment (13 444) is close in design to the silk sheathing the spine of the Mondsee Gospel Lectionary. It is also comparable to a silk in the Museum für Angewandte Kunst, Vienna (T.757-4014). O. von Falke, *Kunstgeschichte der Seidenweberei*, 1913, vol. 2, fig. 230. There was once a piece of the same textile in the Gewebesammlung, Berlin, but it has not

been possible to ascertain whether it is still there. A fragment, possibly from a lost chasuble of Meinwerk of Paderborn, has to be considered as well. See 1966 Corvey catalogue, vol. 2, no. 118, *Kunst und Kultur im Weserraum*, Münster, 1967. The chasuble is said to have been discovered at the time of a recognition of the saint in 1367.

9. Halberstadt, Cathedral Treasury
Incised twill silk chasuble. The author has not seen this vestment. *Generalverwaltung der Museen Berlin, Ausstellung von Kirchengewändern*, 1911, no. 1. S. Müller-Christensen, *Das Grab*, op. cit., p. 59, note 15

10. Hannover, Kestner Museum
There are a number of silk fragments which are incised twill silks. From Lüneburg there is an incised reliquary pouch (WM XXIa, 50m). Some fragments are incised in two shades of one colour (3872, 3856). Ruth Gröwoldt, *Bildcataloge des Kestner-Museums, VII, Textilien I, Weberein und Stickereien des Mittelalters*, Hannover, 1964, nos. 7, 23, 24, 25, p. 23, pp. 31-32.

11. Herrieden, Bavaria. Monastic Church
A chasuble now destroyed. W. M. Schmid, "Eine Kasel des späten II Jahrhunderts", in *Festschrift des Münchner Altertumsvereins*, 1914, p. 147. Article unfortunately unavailable to the author.

12. Krefeld Gewebesammlung
Inv. no. 00139 with an incised design of the ogee compartment type. Inv. no. 00050 identical to no. 11357 in the Kunstmuseum, Düsseldorf, and to a fragment at one time in Merseburg Cathedral. Ogees and medallions enclosing foliate motifs. The fragments can be compared to the chasuble in Xanten Cathedral Treasury. *Alte Gewebe in Krefeld*, Krefeld, 1949, p. 25, no. 86, and p. 26, no 87, with bibliography.

13. London, Victoria and Albert Museum
The numbers are taken from W. F. Kendrick, *Catalogue of Early Medieval Woven Fabrics*, London, 1925. He catalogues three incised twill silks: nos. 1016, 1023 and 1024. The inventory numbers are: 8564-1863, 8235-1863 and 8556-1863.
The first fragment, 1016, is traditionally said to have formed part of the tunic of Henry II (d.1024), but this tunic no longer exists. The tunic is thought to have been bordered by embroidered griffins, which are re-mounted on a tunic in the Diocesan Museum, Bamberg.
1023 is said to have formed part of a chasuble of Arnold of Trier (d. 1183); but it does not correspond to fragments at the Archiepiscopal Museum,

Trier, which are also said to belong to a chasuble of Arnold of Trier. The graves at Trier were examined between 1846-1852, but no publication of the silks have been made in detail.

1024 is an incised twill silk stole with no indication of where it came from. The ogees with foliate motifs are comparable to those on the chasubles of Willigis of Mainz.

No. 1020 is similar to all three above.

Inv. no. 1242-1864 is an incised twill silk with a diamond trellis design like that on the silk sheathing the spine of the Mondsee Gospel Lectionary.

No. 1021 is from Halberstadt Cathedral. It can be compared to a fragment in Merseburg Cathedral, to Krefeld Gewebesammlung 00050, and to Vienna T.728. F. Kendrick, *op. cit.* pp. 42, 52; S. Müller-Christensen, *Das Grab, op. cit.*, pl. 76 and 77, p. 80, note 14.

14. Mainz, St. Stephen; Munich, Bayerisches Nationalmuseum

Two chasubles of Willigis of Mainz (d. 1011), with ogee designs. The two are not quite identical. Otto von Falke, *op. cit.*, vol. 2, p. 9. W. F. Volbach, *Early Decorative Textiles*, 1969 translation, pl. 70

15. Merseburg Cathedral treasury

A fragment traditionally held to have come from the cloak of Otto I (d. 973). It has not been possible for the author to see the fragment. The design is like that of the Krefeld Gewebesammlung 00050. There was once a fragment at the Kunstgewerbe Museum, Berlin. The author has not been able to establish whether this still exists. W. F. Kendrick, *op. cit.*, p. 41, note 2; S. Müller-Christensen, *Das Grab, op. cit.*, p. 80, note 4; J. Lessing, *Die Gewebesammlung Königlichen Kunstgewerbe Museum*, Berlin, 1900-1913, vol. 4, fragment 78 458.

16. Milan, St. Ambrogio

So-called "dalmatic of St. Ambrogio". There is a fragment in the Victoria and Albert Museum, London (8560-1863), from the Bock collection, which came from this dalmatic. There is a Kufic inscription on both dalmatic and fragment, allowing the silk to be dated between 1010/11-1061, in the reign of Nasr al-Daula Abu Nasr Ahmad, third of the Marwanid rulers. A. de Capitani d'Arzago, *Antichi Tessuti della Basilica Ambrosiana*, Milan, 1951. A. R. Guest, *Journal of the Asiatic Society*, April 1906, p. 394; U. Monneret de Villard, "Una inscrizione mawanide ... " in *Orient Moderno*, 20, no. 10.

17. Munich, Bayerisches Nationalmuseum

A fragment said to have belonged to a tunic of Henry II (d. 1024). The embroidered griffin borders from the alleged tunic are re-mounted on a

tunic in the Diocesan Museum, Bamberg. Comparable to the Victoria and Albert fragment 8564-1863. S. Müller-Christensen, *Sakrale Gewänder*, op. cit., nos. 22, 23. See no. 21 also.

18. Munich, Bayerisches Staatsbibliothek

Manuscript Clm. 21585 cim. 156 from the abbey of Weihenstephan near Freising. The manuscript is a life of St. Stephen of the twelfth to thirteenth centuries. Both boards and the spine of the manuscript are covered with a red incised silk twill. The silk is the same as that used to line the shoulders of a chasuble of St. Ulrich in Augsburg. S. Müller-Christensen, *Sakrale Gewänder*, op. cit., no. 10, p. 15. *Buchkunst in Bayerischen Handschriften des Mittelalters. Ausstellung der Bayersichen Staatsbibliothek*, Munich, 1930, no. 151.

19. New York, Pierpont Morgan Library

There are incised monochrome rosettes on a silk otherwise multi-coloured. The birds on the silk are in contrasting colours. The silk lines the upper board of the Lindau Gospels. It is stuck over a marbled endpaper, indicating it was not necessarily part of the original binding. H. A Elsberg, *Two Medieval Woven Silk Fabrics in the Binding of the Ninth Century Manuscript the "Four Gospels" in the Pierpont Library*, New York. See pls. 1 and 2 of this article in *The Bulletin of the Needle and Bobbin Club*, 17:1, 1933, pp. 3ff.

20. Niederaltaich, Bavaria, Abbey Church

Incised twill silk chasuble of St. Gotthard (d. 1038). Gotthard was Abbot at Niederaltaich from 996-1022. He then became Bishop of Hildesheim. S. Müller-Christensen, *Sakrale Gewänder*, no. 12.

21. Nürnberg, Germanisches Nationalmuseum

Silk sheathing the spine of the Codex Aureus (K.G. 1138). F. Steenbock, *Der kirchliche Prachteinband im frühen Mittelalter*, Berlin, 1965, no. 42.

22. Regensburg, St. Emmeram

Incised silk used to line part of the chasuble of St. Wolfgang (d. 994). S. Müller-Christensen, *Sakrale Gewänder*, no. 16. W. F. Volbach, *Early Decorative Textiles*, p. 145.

23. Reims, St. Rémi

Pillow and shroud of St. Rémi. The pillow has an embroidered inscription, showing that it was made by the sister of Charles the Bald for a translation of the relics of St. Rémi under Hincmar of Reims in 852. The date attached to this incised twill silk is so much earlier than the dates given to the

remaining silks of the weave, that the possibility remains of the inscription being purely commemorative. W. F. Volbach, *Early Decorative Textiles*, no. 68; *Bulletin de Liaison du Centre International d'Étude des Textiles Anciens*, Lyon, 1955, p. 15, and Jan 1962, pp. 38ff.

24. Sens Cathedral Treasury

The design on the chasuble of St. Ebbo (d. 750) is only partially incised. The pairs of birds, and the inner drawing of a tree form between them, are incised. There was a translation of the saint in 976, and although the silk is generally considered to have belonged to the saint in the eighth century, it is not impossible that it was placed about the relics of St. Ebbo in the tenth century. It is by no means certain that it dates to the eighth century, and not to the tenth. *Revue de l'art chrétien*, vol. 61, 1911, p. 380.

25. Speyer, Historisches Museum der Pfalz

Several incised twill silks are found in the graves of a number of the emperors and bishops in the Cathedral of Speyer. Fragments of the hose of Henty III (d. 1056) are incised. The grave of a bishop, perhaps Reginbald (d. 1039), yielded fragments of an incised twill silk chasuble. In 1900, Lessing made a sketch of a silk from the grave; probably of the chasuble. The silk is being restored in the Bayerisches Nationalmuseum, Munich. A woven pseudo-Kufic inscription on a band was incorporated in a reconstruction of the fragments made around 1900. The fragments were made up into the form of a chasuble. In one grave were fragments of a mitre that is thought to have been incised. The end of a maniple from the same grave is incised. H. E. Kubach and W. Haas, eds., *Der Dom zu Speyer, Die Kunstdenkmäler von Rheinland-Pfalz*, 5, Munich, 1973. Two volumes. The silks are treated by S. Müller-Christensen in the section "Die Gräber im Königschor, Textilien I, pp. 923ff., which also includes an extensive bibliography. For the sketch by Lessing see vol. 1 p. 974. Photographs of the silk are in vol. 2.

26. Vienna, Hofburg

The coronation mantle of Roger of Sicily was embroidered in Palermo in 1134, as a Kufic inscription embroidered upon it states. The ground is an incised twill silk. H. Fillitz, *Die Schatzkammer in Wien*, 1964, pl. 55. Kendrick mentions that the silk cuffs and lower border of an imperial tunic in this collection are of a reddish-purple silk with an incised ogee design: W. F Kendrick, *Early Medieval Woven Fabrics*, 1925, p. 41.

27. Xanten, St. Victor

Incised twill silk chasuble. It may have come from Brauweiler. The association with St. Bernhard of Clairvaux is probably purely legendary.

There was a fragment in the Kunstgewerbe Museum, Berlin, 85, 965. Otto von Falke, *op. cit.*, vol. 2 of 1913 edition, p. 9.
(Kendrick wrongly classifies two further silks as incised or monochrome twills. The silk of the chasuble of St. Bernward (d. 1022) at Hildesheim Cathedral Treasury is a tabby, twill lampas; and there is no incised twill silk from the Heribert shrine at Cologne-Deutz. The bird silk from the shrine at Deutz is a polychrome, paired main warp, compound twill.)

A NOTE ON THE CONSTRUCTION OF THE MONDSEE

GOSPEL LECTIONARY

by Christopher Clarkson, Conservator of Rare Books and Manuscripts at the Walters Art Gallery

Silks were certainly widely used for decorative purposes in the binding construction of this period. In the case of the Mondsee Gospel Lectionary it is possible to see a great part of how the binding was constructed because the thongs attaching the upper boards have all broken at this joint, thus allowing the board to be slightly turned back, exposing the text-block spine treatment as shown in figure 10.

The gatherings were sewn with heavy thread to double thongs (alum-tawed slit straps) in one of the herringbone stitch forms. The oak boards next appear to have been laced on in typical late eleventh century fashion, the double thongs passing through tunnels, which start on the spine edge of the board and emerge onto the exterior face. These tunnels fork apart in channels and then pass through the thickness of the board. The thongs are then twisted together to anchor them and then laid within a linking channel to cut into the inner face of the board (this has been confirmed by X-rays taken of the lower board). A soft alum-tawed spine liner, the thickness of the text-block plus boards and longer than the spine, was nailed to the board edges; this is typical of twelfth century work, whatever the covering material. Blue-grey silk, added at either end of the spine between the text-block and the liner, formed the decorative 'facing' of the extending tabs (sometimes called tongues). The endbands were worked around cores of double thongs similar in weight to the main sewing

supports, which were also laced into the boards in a similar manner. There is no preliminary thread sewing of endbands but they were surprisingly enough worked directly in red twisted floss, which holds the cores, text-block gatherings, silk tab-facing, and liner firmly together. The volume was then covered with a soft alum-tawed skin. Unusually, the portion of the cover which extends into the head-tab is a separate piece which is neatly joined by sewing before covering (the tail-tab has been cut off by later librarians). Perhaps the part of turn-in usually left intact to form the tab was accidentally cut off when the spine corners were being shaped. The silk sheathing the spine was cut wider to allow the edges to be pasted down to the board sides; these in turn would be covered by the silver plates. The tabs were then trimmed to form a curve extending a maximum of two centimetres from the text-block.

It remained to secure together the four layers of the tabs consisting of silk facing, spine liner, alum-tawed cover, and silk sheathing and to anil the metalwork covers in place. The layers of the tab were secured by a 'perimeter' sewing around the edge in a complex type of buttonhole stitch with silver wire.

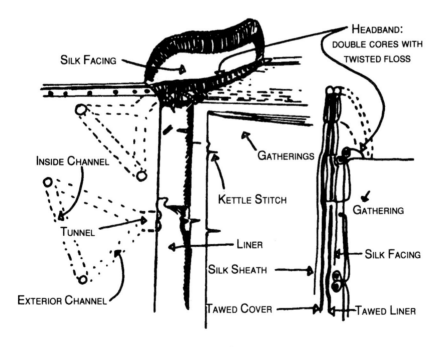

FIGURE 10
CONSTRUCTION OF THE MONDSEE GOSPEL LECTIONARY

III
The Silks from the Tomb
of Archbishop Hubert Walter

A LMOST eight centuries have elapsed since Archbishop Hubert
Walter was interred, and yet, despite the ravages of time and the
processes of natural deterioration, over forty silk fragments from
his tomb survive. These give us an idea of the vestments in which he was
buried. The Canterbury fragments are among the thousands of extant
and documented silks that were in ecclesiastical treasuries of Europe
before 1200. Up to the thirteenth century, the Church was certainly the
greatest user of silks. These served for ecclesiastical hangings and
furnishings, as linings in reliquary caskets, to embellish manuscript
bindings, for wrapping relics, for shrouding bodies and, not least, for
making vestments. The silks were mainly imported from Byzantine and
Islamic centres, while a few came from Latin Sicily in the late twelfth
century.[1]

The graves of many archbishops and bishops at Bremen, Trier,
Speyer and Bamberg, amongst other places, have been opened this
century and have yielded a wealth of splendid mediæval silk vestments.[2]
The silks, recovered from the grave of Pope Clement II (d. 1047) in
Bamberg include particularly impressive vestments like the pluvial and
buskins with paired griffin and panther design on medallions.[3]

In 1893, W. H. St. John Hope published a brief description of the silks
from the Canterbury tomb that he believed belonged to Archbishop
Hubert Walter (1193-1205). He described the following silks:

- a tunicle fragment
- panels from a lost linen alb
- a dalmatic fragment
- a chasuble fragment
- an embroidered panel from an amice
- a mitre

- a stole
- buskins and shoes.[4]

Only the mitre, stole, buskins and shoes survive in good condition and can be easily identified. The chasuble can be recognised because of attached bands that formed part of an orphrey, but the remaining silk fragments cannot be positively distinguished as part of specific vestments. Indeed, it seems possible that the fragment that St. John Hope called a piece of tunicle, is in fact part of the chasuble. Technically and stylistically, it is identical to the silk of the chasuble (PLS. 33A, B AND 34A).[5] On his seal, Archbishop Hubert Walter wears a narrow-sleeved undergarment (probably an alb), with a wide-sleeved dalmatic, and, uppermost, a lengthy chasuble. An amice is shown about his neck, and his mitre has a central peak.[6]

The three silk fragments (two of 7 x 28.5 cm and one of 19 x 44.5 cm) which St. John Hope suggested served as apparel on a lost linen alb, are neatly hemmed and lined: it is reasonable to suppose that they were sewn to a linen undergarment that perished next to the body (PLS. 34B, C). The largest piece is a fragment of silk identical to that used for the chasuble, while the two smaller pieces have the same design as the silk fragment St. John Hope thought came from a dalmatic (PLS. 35A, B). These panels would have been attached across the cuffs of the sleeves, and along the lower hem at the front of the skirt of the alb. Amongst surviving mediæval albs is an Imperial coronation vestment in Vienna. It has panels embroidered in Palermo in 1181.[7] The unpatterned Canterbury pieces are bordered with *plain tabby weave* strips, red and green in colour. These are fine silks with only one system of warps and wefts. The weft passes alternately over and under one warp in the first pass, under and over one warp in the next pass, and so on.[8] This type of silk is particularly difficult to date precisely, for it was woven all over the Eastern Mediterranean from at least the sixth to the thirteenth centuries. Generally this fine kind of silk was reserved in Western Europe for use as curtains over gilded miniatures, or it was used for wrapping very small relics, or, as at Canterbury, for some seal pouches.[9]

The fragment of the chasuble that survives measures 59.5 x 58 cm (h x w). It represents the upper part of the back of the vestment, and has a forked orphrey. The orphrey is made from a wide band of *tablet woven* fabric, and a narrower *tablet woven* band is sewn along the area of the shoulders.[10] The latter kind of band must have appeared quite extensively on the chasuble, judging by the surviving roll, which is c. 122 cm long. Some irregular, small silk fragments, today under glass, and numbered 15 and 9, may have also come from the chasuble.

Splendid silk chasubles were found extensively in Western Europe by the thirteenth century, and more than thirty early fragments are extant.[11]

These vestments are semicircular in shape, and are generally c. 1.5 cm long, and about 2 m wide around the lower hem: they are called 'bell chasubles'. Two tenth to eleventh century examples are the chasuble of St. Willigis (d. 1011) at St. Stephan, Mainz; and the so-called Vitalis chasuble at Riggisberg from St. Peter's, Salzburg.[12] By the late twelfth century, chasubles were becoming slightly narrower and more pointed in shape. It seems Hubert Walter is wearing the narrower kind of vestment on his seal. An astonishing number of silk chasubles are listed in mediæval inventories. They appear in the twelfth and thirteenth centuries at Ely, Glastonbury, Arborfield, Mere, Chiswick, Peterborough, and Canterbury amongst other places.[13]

As mentioned above, the same design is found on the largest chasuble fragment with attached orphrey, on the fragments in frames 5 and 19 perhaps from the chasuble, on the so-called 'tunicle' piece, and on the largest of the hemmed panels. The latter could have acted as apparel on a lost linen alb. This design is enclosed in bordered medallions (17.5 cm diameter). The medallions are set in horizontal rows across the silk. Each encloses a pair of facing birds (8 cm high) and a simple representation of a tree behind. The medallion borders have undulating tendril motifs. The spandrel areas between the medallions house uncomplicated palmettes and a few tendrils. Between the two rows of medallions on the chasuble fragment with orphrey, is a narrow horizontal band. A similar band is found on the largest hemmed panel, but here it passes indiscriminately straight through the centre of a row of medallions, cutting into the bird design. These band have curious repeating geometrical and foliate motifs. They look at first sight like part of a Kufic inscription (PL. 36A). Nevertheless, the shape cannot be identified with Kufic script, and they do not read as part of an inscription. It has to be assumed that they are purely decorative: some form of pseudo-Kufic ornament.[14] These bands, as well as the heads and feet of the birds, parts of the medallion borders, and the centre of the spandrel motifs, are all woven with a gilded leather strip wound on a silk core. The rest of the silk is monochrome yellow. The creation of the pattern relies on changes in the weave, rather than on colour contrasts. A *tabby, tabby lampas weave* is used. The design is rendered visible through the contrasting amounts of light reflected by the pattern and the background areas, so that birds, medallion borders and spandrel motifs all appear lighter and brighter in tone than the spaces in between. This is achieved by contrasting the two faces of a *tabby weave*, one reflecting more light than the other.[15] The upside down design on the chasuble fragment with orphrey is unusual. The makers of similar chasubles were generally careful to place the silk in such a way as to ensure that the design was seen upright on the back of the vestment.[16]

The silk of the so-called 'dalmatic' fragment is also a *tabby, tabby lampas weave* fabric (65 x 62.4 cm). There are no seams on the piece, and St. John Hope has simply assumed that it came from a dalmatic. For the sake of convenience here it will be called the dalmatic fragment, although it could have come from a pluvial.[17] The silk is a monochrome yellow. Silver appears to have been painted on in certain areas. Like the chasuble, it has a design in medallions (of diameter 48 cm) in horizontal rows. Each medallion encloses a pair of birds. These birds are larger (25 cm high) than those on the chasuble silk, and they are more elaborate. Their bodies are highly ornamented, with palmettes above a band of pearls at the tops of the wings. Pearl shapes also appear across the tops of the tails, and across the necks, whilst the bodies and legs are drawn with a double outline that periodically terminates in a flourish of scrolled leaves. The bodies of the birds face each other, but their faces are turned away. The representation of a tree behind these birds has carefully structured, pointed leaves. The medallion borders and the spandrels also have more complicated designs than those in similar areas of the chasuble silk. The borders house a series of 'running' quadrupeds. The spandrels contain a square shape with lobed sides, which in turn encloses a central circle of pearls: this circle supports four palmette motifs. Top and bottom, and to either side of the medallion borders, linking roundels are edged with pearl shapes. The roundels contain foliate patterns and interlace.

Technically and stylistically, the two Canterbury silks are closely enough related to have come from the same workshop; although the dalmatic clearly has a more ambitious design than the chasuble silk. In both cases the *tabby, tabby lampas weave* is characterised by a haphazard distribution of the *main warps*. Nevertheless, this should not be seen merely as a sign of poor workmanship.[18] A regimented distribution of the main warps occurs on twelfth century Spanish *tabby, tabby lampas weave* silks, and has been described by Dorothy Shepherd. Perhaps the Canterbury silks can be seen as 'provincial cousins' of the Spanish pieces. Both iconographically and stylistically, the Hubert Walter chasuble and dalmatic silks can be compared to the Spanish group: in particular, to the 'Lion-strangler' silk from Vich; the silk with addorsed lions at Quinatanaortuno; an Eagle and a Griffin silk from Siguenza; a lost double-headed Eagle silk once at Quedlinburg; a Bird silk in Salamanca; and another bird silk used for a chasuble at St. Quiriace, Provins. The St. Quiriace silk, significantly, is called the chasuble of St. Edmund, Archbishop of Canterbury (d. 1240). The Antelope silk in Berlin, another member of the Spanish group, will also be described in comparison to the Canterbury Hubert Walter pieces.[19]

The common use of decorative Kufic script links the Canterbury dalmatic and chasuble silks to the Spanish group. The Siguenza Eagle silk

has a band of pseudo Kufic script across the upper part of the wing. Among the shapes present, there is one resembling a cross. This, too, occurs on the Canterbury chasuble silk. It is interesting to note that, elsewhere on the Siguenza silk, legible Kufic inscriptions do occur: beneath the talons of the eagles, and in the area around the medallions.[20] This suggests that, in the field of weaving, pseudo Kufic inscriptions were not the 'prerogative' of non-Islamic workshops. The presence of this kind of ornament on the Canterbury chasuble silk cannot be regarded as proof that it was not woven in an Islamic centre. Indeed, several further links, between the Canterbury chasuble silk and dalmatic fragment on the one hand, and the Spanish *tabby, tabby lampas weave* pieces on the other, argue very strongly in favour of an Islamic centre of production for them.

The strange decorative double-outline with scrolls on the lower part of the birds on the dalmatic fragment at Canterbury, finds a parallel on the design of the Berlin Antelope silk, as well as in the Lion silk from the grave of Maria Almenar.[21] The well rounded type of bird with small head seen on the Canterbury silks is like that on the Spanish silks at Salamanca and Provins.[22] In addition, the running quadrupeds in the medallion border of the Canterbury dalmatic silk are comparable to those on the Lion silk at Quinatanaortuno; to those on the Eagle silk from Siguenza; to those on the lost piece once at Quedlinburg; and to those on the Lion-strangler silk from the coffin of Bishop Bernard Calvo of Vich (1233-43).[23] There seems to be sufficient evidence to suggest that the Canterbury chasuble and dalmatic fragments were made in a Spanish workshop influenced by the weavers of the silks grouped together by Shepherd. The Canterbury pieces are perhaps less accomplished than the best of Shepherd's group, and they may be the work of provincial craftsmen. Two more *tabby, tabby lampas weave* silks, with paired birds in medallions, are unpublished fragments in Sens. They seem to be related to the Canterbury pieces. One of the silks came from the grave of Peter of Corbeuil (d. 1222); the other was taken from the grave of Gilon II (d. 1292).[24]

Archbishop Hubert Walter wore a pair of green silks buskins and shoes: both were lined with an amber silk. The buskins (PLs. 36B,C) are 69 cm high, 26 cm wide at the top, and 17 cm wide at the ankle. The feet measure 29 cm across. The green silk is woven in a twill weave, and there seem to be single main warps.[25] The fabric is unpatterned. Technically it is comparable to the silk of the mantle of Philip of Swabia (d. 1204). Suggesting a provenance for any unpatterned silk is problematic, but it should not be forgotten that Philip of Swabia was married to the Greek princess Irene.[26] Embroidered on the leg of the buskins is a lace pattern. It encloses eagles and foliate crosses in silver gilt thread in underside couching.[27] The buskins were tied at the top by means of silk tapes. Some

tablet woven tape survives on one of the buskins. The shoes or sandals,[28] as they are often called, are also embroidered in silver gilt and silk threads, using both underside and surface couching and stem stitch. They have patterns of dragons, lions, eagles, and foliate scrolls with large 'tear' shaped motifs that terminate in fleur-de-lys patterns. Small carbuncles are sewn on. The shoes are beneath a perspex cover. The silk cannot be examined closely, but it appears to be a twill weave fabric. It has discoloured from green to amber. The length of the shoes is approximately 29 cm, which, incidentally, corresponds approximately to an English size 7. The embroidery is English work datable to 1170-1200 (PLS. 37A, B).[29]

The embroidery on the apparel of the amice from the tomb of Archbishop Walter is English work of the same period (PL. 38A). There are seven circles embroidered across the silk, which measures 9 x 56.5 cm. The central medallion encloses a seated Christ with sun, moon, and the letters alpha and omega. The four medallions to the sides have the symbols of the Evangelists; on the right of Christ first Matthew and then Luke, on the left John followed by Mark. It appears that the symbols of Luke and Mark have been inadvertently interchanged, and these are not correctly inscribed. The two outermost medallions (far left and far right) enclose the named Archangels Michael and Gabriel. Between medallions are foliate scrolls. The embroidery is carried out in silver gilt thread, as well as in silk, in underside couching and stem stitch. Between medallions, some type of metalwork or gem seems to have been placed, judging by the indentations that can be seen there today. The ground silk for the embroidery is a yellow colour (perhaps faded). The weave of the fabric is *tabby, tabby lampas*. It is not possible to reconstruct the design on the silk from what can be seen.

Eight pieces of the stole of Hubert Walter remain. They are 5.2 cm wide. Their length varies, the largest piece measuring 46 cm. The stole is embroidered in plait stitch, with coloured silks now faded to shades of brown and green. There are cruciform, swastika and labyrinth designs set in square shapes (PL. 38B). The embroidery ground has decayed, but was probably linen. In 1963, this piece was called English work of 1170-1200.[30] An alternative provenance for the piece was suggested during the course of the conference at Canterbury.[31]

The mitre of the Archbishop (PL. 38C) uses an unpatterned, silk, twill weave fabric. It is 29.5 cm wide and 24.5 cm at its tallest point. The mitre has a central horn, and is like that worn by Hubert Walter on the Canterbury seal mentioned earlier. On the seal of Hubert Walter, dating from the time of his period of office as Bishop of Salisbury (1189-93), he wears a mitre with two horns on the sides. The mitre with central horn seems to have come into use in England late in the twelfth century. Among surviving mitres with this shape are a number embroidered with the

martyrdom of St. Thomas: these date after 1170.[32] It is difficult to say where the silk of the Canterbury mitre was woven, as it is unpatterned. Twills were woven widely all over the Eastern Mediterranean before the thirteenth century. The lappets of the Canterbury mitre are 39 cm long.

Finally, mention must be made of a few miscellaneous silk fragments from the tomb of Hubert Walter. They include a *single main warp, twill weave* fragment (in frame 26) with a rosette in red and green, that on stylistic grounds is datable to around the eighth century.[33] Frames 7, 8, and 12 contain a number of unpatterned, *plain tabby weave* silks. Frame 12 has the remains of what seems to be a pallium made of wool.

One may conclude that St. John Hope correctly identified the tomb. Most of the silks belong to the twelfth century, as does the shape of the mitre. The two most impressive silks, the dalmatic and chasuble fragments, seem to be late twelfth century Spanish pieces. The English embroidery of the buskins and shoes was carried out no earlier than the last quarter of the twelfth century. An amusing, if secondary, point on which to end, is that the unpatterned *plain tabby weave* silks that border the hemmed panels from the tomb are very much like the silk that protects the seal of Hubert Walter, Bishop of Salisbury (1189-93) on the British Library charter Add. 19611. Could the Venerable Hubert Walter have travelled around with his own stock of silks, I wonder?

ACKNOWLEDGEMENT

I wish to thank Miss Ann Oakley and her colleagues for their kind assistance in showing me the silks. They also made it possible for me to take the slides for my talk and the photographs which appear in this paper.

NOTES

The following abbreviated titles are used in the Notes that follow:

Brockhaus: Otto Lehman-Brockhaus, *Lateinische Schriftquellen zur Kunst in England, Wales und Schottland vom Jahr 901 bis zum Jahre 1307* (München 1955).

Lemberg and Schmedding: M. Lemberg and B. Schmedding, *Abegg-Stiftung Bern in Riggisberg Textilien (Schweizer Heimatbücher)*, 173/174 (Berne 1973).

May (1957): F. L. May, *Silk Textiles of Spain* (New York 1957).

Opus Anglicanum: D. King, *Opus Anglicanum* (Arts Council Exhibition, London, 1963).

Sakrale Gewänder: S. Müller-Christensen, *Sakrale Gewänder* (Munich 1955).

Schuette and Müller-Christensen: M. Schuette and S. Müller-Christensen, *The Art of Embroidery*, transl. D. King (London 1964).

1. The earliest documented Latin silk weaving centre was that established in Palermo under Roger II of Sicily (1130-54). Otto of Freising described how, in 1147, Roger captured silk weavers from Thebes, Athens and Corinth to work in his centre. Recently it was suggested that there was silk weaving earlier in Sicily; and that there was silk weaving in Southern Italy. For a discussion of these problems, with references to the appropriate sources, see A. Muthesius, *Eastern silks in Western shrines and treasuries before 1200*, PhD thesis, Courtauld Institute of Art, London University (submitted 1980), 10, 12, 254ff.

2. Very detailed reports were written on the Speyer and Bamberg silks. The Trier silks require an up-to-date study. The Bremen silks appear to have been only summarily published. See Müller-Christensen, Kubach and Stein, 'Die Gräber in Königschor' in Der Dom zu Speyer, ed. Kubach and Haas (Deutscher Kunstverlag 1972); *Sakrale Gewänder*, no. 37, 46, 47; J. von Wilmowsky, *Die historisch denkwurdigen Grabstätten der Erzbischöfe im Dom zu Trier* (Trier 1876). For Bremen silks, 'Das Geheimnis in Bremer Dom', *Die Zeit Magazin*, 28 March, 1975, 24-36. The silks from the bishops' graves at Basel are in a poor state of conservation. See E. A. Stückelberg 'Die Bischofsgräber der hintern Krypta des Basler Münsters', *Basler Zeitscrift für Geschichte und Altertumskunde*, 7-8 (Basel 1908-9), 287ff.

3. S. Müller-Christensen, *Das Grab des Papstes Clemens II in Dom zu Bamberg* (München 1960).

4. St. John Hope (1893).

5. There are no seams on the fragment to indicate which part of a vestment it may have come from. The piece measures 36 x 30.5 cm (w x h). The medallions with borders on the silk are 17.5 cm in diameter: the paired birds enclosed in them are 8 cm high. These measurements are the same as those of the medallions and the birds on the silk with orphrey from the chasuble.

6. The seal is on British Library, Harley charter 83c27. I am indebted to T. A. Heslop of the University of East Anglia for providing a slide of the seal.

7. Albs listed in inventories tend to be of linen rather than of silk before 1200. The alb embroidered in Palermo in 1181 was made for William II (1165-89). See F. Bock, *Die Kleinodien Des Heiligen Römischen Reichs Deutsche Nation...* (Wien 1864). Schuette and S. Müller-Christensen, nos 67, 69, 71.

8. All the technical terms used in this paper can be checked in the Vocabulary of Technical Terms (English, French, Spanish, Italian), Centre International d'Étude des Textiles Anciens (Lyons 1964).

9. Silk miniature protectors are documented in the *Life of St. Margaret of Scotland* (d. 1093), ed. H. Hinde, *Surtees Society*, 51 (Durham 1868), Appendix III, XI, p. 250.

10. Tablet weaving was carried out in north-west Europe before the thirteenth century. For this technique consult *Ciba Rundschau*, 117 (November 1956), 2-29; M. Schuette, 'The rediscovery of tablet weaving'; 'Implements of the technique'; 'Medieval tablet weaving'.

11. Chasubles, as well as other vestments, were discussed by J. Braun, *Die Liturgishce Gewandung im Occident und Orient* (Darmstadt 1964) (reprint of original published in Freiburg in 1907); 149=239 are concerned specifically with chasubles.

12. *Sakrale Gewänder*, no. 11 refers to a second chasuble of St. Willigis in Munich. The Riggisberg chasuble is illustrated in Lemberg and Schmedding, Taf. 14.

13. Brockhaus, nos. 1571, 1636, 1655, 1868, 109, 3136, 1053, 1055, 3503, 930.

14. 'Kufic ornament' certainly appears in the West. See K. Erdman, 'Arabische Schriftzeichen als Ornamente in der abendländischen Kunst des Mittelalters' (*Academie der Wissenschaften und der Literatur, Abhandlungen der Geistes und Sozialwissenschaftlichen Klass*), 9 (Jahrgang 1953), 467-513.

15. The two faces of a tabby weave are contrasted. The *weft faced*, tabby binding used for the pattern areas reflects more light than the *warp faced*, tabby binding background areas. This is because the *weft faced* areas use silk that is untwisted and reflects the maximum of light: whereas the *warp faced* areas present twisted silk threads that have a smaller surface and reflect less light.

16. The traditional manner of celebration of the Mass perhaps made it necessary for the back of the vestment to appear with the design upright. The celebrant faced the altar, with his back to the faithful.

17. Silk dalmatics were recorded in Carolingian ecclesiastical inventories, but appeared more frequently in later lists, particularly in twelfth to thirteenth century inventories. For dalmatics in sources, see thesis cited above, pp. 268-70 and pp. 273-80.

18. See *The Relics of St. Cuthbert*, ed. C. Battiscombe (Oxford 1956), 485, where Flanagan considered that the irregular distribution of *main warps*, together with the appearance of weaving faults, to be signs of a poor workshop. The design on the dalmatic fragment in particular must have been relatively difficult to weave.

19. D. Shepherd, 'The Hispano-Islamic textiles in the Cooper Union Collection', *Chronicle of the Museum for the arts of decoration of the Cooper Union*, 1, no. 10 (December 1943), 355-401, esp. 365-377. Also 'A Twelfth century Hispano-Islamic silk', *The Bulletin of the Cleveland Museum of Art*, 38 (1951), 59-62, cf. 74-75. In addition, 'Two Hispano-Islamic silks in diasper weave', *The Bulletin of*

the *Cleveland Museum of Art*, 42 (1955), 6-10. Cf. 'A dated Hispano-Islamic silk', *Ars Orientalis*, 2 (1957), 373-82, esp 376ff. and figs. 3 and 4, for the weave and method of brocading. The *brocading* on the Spanish examples uses a special 'honeycomb' binding, whereas the leather strips on the Canterbury chasuble silk are bound in tabby. For photos of the silks see May (1957), 43, fig. 29; 34, fig. 22; 40, fig. 25; 40, fig. 26; 28, fig. 17; 31, fig. 19 and 29, fig. 18.

20. Shepherd in *Ars Orientalis*, 2 (1957), 380. Cf. *Bulletin of the Cleveland Museum of Art*, 42 (1955), 9.
21. May (1957), 29, fig. 18; 80, fig. 53.
22. May (1957), 31, fig 19; 28, fig. 17.
23. Shepherd, *Ars Orientalis*, 2 (1957), Pl. 3, Pl. 10A, Pl. 9A, Pl. 8A.
24. See Muthesius, *Eastern Silks in Western Shrines*, above, no. 1, 201-02.
25. *Main warps* are the vertical threads that sit between the two faces of a *compound weave*. They do not appear on the face or the reverse of the fabric. When they are raised or lowered in the correct sequence, according to the requirements of the pattern, they determine on which face of the weave the *weft* passes. The *main warps* of *twill weave* silks, dating from the eighth to ninth up to the thirteenth centuries, were paired, with only a few exceptions, The pairing probably gave greater strength.
26. The vestment of Philip of Swabia has two embroidered roundels which may be Byzantine, although it has been suggested that they were Western copies. See S. Müller-Christensen, 'Die Tunika König Philipps von Schwaben', *900 Jahre Speyerer Dom* (Speyer 1961), 219. Also Schuette and Müller-Christensen, no. 73.
27. For embroidery terms, see Schuette and Müller-Christensen, VIII-XII and figs. 1-19. Fig. 19 shows *underside couching*.
28. I have preferred to speak of 'shoes'. 'Sandal' suggests a cutaway foot covering, whereas the Canterbury footwear encloses the whole foot up to the ankle.
29. *Opus Anglicanum*, nos. 6, 7.
30. *Opus Anglicanum*, no. 8, cf. no. 9 for amice.
31. A paper by Dr. Majul, read out by Dr. Alan Borg, suggested that the embroidery represented Islamic inscriptions.
32. For example, *Opus Anglicanum*, no. 134.
33. It was not unusual for silks to be stored in Western ecclesiastical treasuries for centuries. See Muthesius, *Eastern Silks in Western Shrines*, above, no. 1, 349 and n. 27.

IV

Practical Approach to History of Byzantine Silk Weaving

THE expression 'Byzantine silks' conjures up a picture of sumptuous, exotic fabrics; but how were they woven in the period up to 1204? What is known of the organisation and the running of the silk weaving workshops? How far did the degree of sophistication of the looms or the complexity of the weaves govern the style of the patterns that appeared on the silks? To what extent did the cost factors relating to raw materials affect the kind of silks that individual workshops were able to produce?

Up to now mainly traditional historical and art historical approaches have been used to study Byzantine silk weaving. A broader basis of enquiry is desirable so that the results of scientific and technical enquiries may be taken into account. The study of dyes promises to yield important information and the analysis of weaving types provides a sound basis for grouping the silks. Using stylistic, iconographic, circumstantial and other evidence it has been possible to provide a broad chronology of weaving types.[1] A first hand study of several thousand fragments of early mediæval silk has shown that they fall into five main weaving categories before the thirteenth century. The names given to these categories are *tabby*, *damask*, *twill*, *lampas and tapestry* weave.[2] Up to the eleventh century twill weave seems to have predominated. Thereafter lampas weaves were developed and woven side by side with the twills (PL. 1).

Concerning the silk weaving workshops themselves, little is known.[3] All that can be said at present is that there were at least three kinds of workshops in the Byzantine and the Islamic world before 1200:

1. Imperial or royal workshops under the patronage of individual rulers.[4]
2. Public workshops within the framework of guilds.[5]

3. Private workshops in the homes of wealthy Byzantine citizens
 and in the homes of modest Islamic craftsmen.[6] Possibly too,
 simpler silks were woven in some monasteries.[7]

In the course of this paper a small but extremely important group of
inscribed Imperial Byzantine, twill weave silks will be examined.

1. THE IMPERIAL LION SILKS

FIVE silks patterned with lions are known to have been woven
under Imperial patronage. Of these, three survive in a fragmentary state and the other two are known only from documents. The key
silk of the group is the Lion silk from the shrine of St. Anno (d. 1075) at
St. Servatius, Siegburg.[8] It is the only precisely dated Byzantine silk that
has come down to us, yet every author writing about it in the last thirty
years falsely reported the Siegburg Lion silk to have been destroyed in the
last war.[9] I discovered two fragments of the silk, together measuring c. 230
x 65 cm, at Schloß Köpenick in Berlin. On the larger of the two fragments
of silk there is a pair of facing lions with an inscription between them, and
on the extreme left hand side there is a vertical row of pearl shapes. On
the smaller fragment of silk is a single lion facing to the right[10] (PL. 38). The
inscription on the silk reads:

✝ ΕΠΙ ΡѠΜΑΝȢ ΚΑΙ ΧΡΙϹΤΟΦѠΡȢ
ΤѠΝ ΦΙΛΟΧΡΙϹΤΟΝ ΔΕϹΠΟΤѠΝ

† Ἐπὶ Ῥωμανοῦ καὶ Χριστοφ<ό>ρου
τῶν φιλοχρίστ<ω>ν δεσποτῶν

which can be translated:

'During the reign of Romanos and Christophoros the devout rulers'.
The latter must refer to Christophoros the son of Romanos I Lecapenos,
who became co-emperor in 921 and who died in 931.[11] He was sole co-
emperor only from 921-923, so that the dating could be further narrowed
down to 921-923.

On what sort of a loom could the Siegburg Lion silk have been woven?
Certainly not on any of the primitive looms depicted in some Byzantine
manuscripts.[12] The silk must have been woven on a hand drawloom that

had a form of pattern producing device.[13] This loom would have been operated by two people, one of them seated at the front of the loom guiding the passage of the weft threads, the other probably seated high up on a platform above the loom operating the pattern making mechanism.[14] No early depictions of this kind of loom exist. However, certain seventeenth century Chinese looms were of this type, and they are shown in contemporary drawings.[15]

Authors writing about the Siegburg Lion silk generally used photographs that showed only part of the fabric. Only Migneon writing in 1908 published a photograph of the whole silk[16] (PL. 39A) and it is most fortunate that he did so. The two surviving fragments of the Siegburg Lion silk do not reveal the serious error that was made in the weaving of the fabric, but from Migneon's photograph it is clear that on the extreme right hand side of the piece a vertical row of pearl shapes intersected the Imperial inscription that should have appeared there in full. As early as 1868 Ernst aus 'm Weerth had mentioned a vertical row of pearls down the right hand side of the silk. These are visible on an unpublished watercolour of the Siegburg Lion silk, dated 1881, now at the Kunstgewerbe Museum of Schloß Charlottenburg in West Berlin[17] (PL. 39B). Migneon's photograph shows three lions across the Siegburg silk, one pair of animals with an inscription between them and a further single lion facing to the right accompanied by the inscription that was cut in half by mistake. There can be little doubt that the weavers originally intended two pairs of lions and two full inscriptions across the silk. What could have gone wrong in the weaving of the silk? The most likely answer is that the weavers miscalculated the size of their repeat, leaving insufficient room for the second pair of lions that should have appeared on the right side of the silk. It is possible to see how they made their mistake. The surviving fragments of Siegburg Lion silk yield two important pieces of information: they indicate that the length of the lions is c. 62 cm and that the design is woven down rather than across the loom. The length of warp available to the weavers can be calculated as some 230 cm allowing space for the inscriptions on the silk. To be able to weave two pairs of lions with accompanying inscriptions down a warp of this length, each animal should have measured no more than around 50 cm in length. The space allowed for the paired lion repeat with its extensive inscription was simply too great for the length of warp available to the weavers. It could be argued that the weavers of the Siegburg Lion silk miscalculated the size of their repeat because they were unused to weaving their designs down the loom, but if this was true why did they not weave the pattern across their loom in the normal way? Could it be true to say that in tenth century Byzantium, looms as wide as 230 cm had not yet been built?[18] Of this one cannot be absolutely certain, but it is true to say that there are several advantages in weaving complex,

asymmetrical designs down rather than across hand drawlooms with pattern producing devices. By working down the loom the weavers were able to save themselves considerable trouble in preparing the loom for weaving; and the pattern making device, the so-called *figure-harness* became less complex to operate than if the design had been woven across the loom. This was because each horizontal step in the outline of the Siegburg Lion silk repeat had to be tied up on the figure-harness, and represented one manipulation of the pattern producing device. Naturally, there were fewer of these steps to cope with using the repeat sideways on. It was far narrower than if used horizontally.

At an unknown date prior to 1892, another inscribed Imperial Byzantine Lion silk was taken from an unnamed Lower Rhenish church. This silk was subsequently divided and sent to three museums. It is unfortunate that those fragments sent to the Kunstgewerbe Museum in Krefeld were accidentally burnt during the course of the last war. A reconstruction of their design painted by P. Schulze in 1893 was once at the Victoria and Albert Museum, London (PL. 43). In 1897 P. Schulze painted a reconstruction of the design of two fragments of the silk sent to Schloß Charlottenburg in West Berlin. The two fragments were actually glued to his reconstruction (PL. 40). Similarly, in 1898, P. Schulze painted a reconstruction incorporating the six fragments of this silk that were sent to the Kunstmuseum in Düsseldorf (PL. 41). For reasons of convenience this second Lion silk will be called the Krefeld-Berlin-Düsseldorf fabric in this paper.[19]

A third Imperial Byzantine Lion silk was removed from a shrine built to hold the relics of St. Heribert, Archbishop of Cologne (d. 1021), who was canonised in 1147. This shrine has been variously dated as early as 1150 and as late as 1170 and it is at St. Heribert, Cologne Deutz.[20] The silk is no longer in the shrine; it is on display at the Diocesan Museum in Cologne (PL. 42).

The Siegburg Lion silk, the Krefeld-Berlin-Düsseldorf Lion silk and the Cologne Lion silk have several features in common. These are explained under a series of separate headings.

a) Technical structure
The three Lion silks have the same technical structure, that is they are all twill weave silks, with paired main warps. The latter appear to be undyed and they are twisted to the right (Z). The wefts show no appreciable twist. PLATE 1 illustrates one kind of twill with paired main warps.[21]

b) Composition
A single composition serves for the three Lion silks. This incorporates confronted pairs of lions posed to the sides, their faces turned towards the

spectator. At the level of the upper legs on the lions, between each pair of them, there is an inscription. A small tree form can be seen behind each lion and this feature finds a precedent on Roman pavements.[22] Decorative markings occur in similar positions on the faces and on the bodies of the lions on the three silks. At most, there are differences in the facial features of the animals on the three silks. The outlines of the actual design are extremely smooth and in every case the composition was woven down and not across the loom.[23]

c) Colour scheme

The three Lion silks exhibit a uniform colour scheme. The background areas are purple and the design is mainly golden yellow in every case. Near the ankles of the lions, there is a small foliate spray marked out in a lemon yellow colour. The eyes of the animals are enlivened with a small circle of blue-green colour.

d) Inscription

Each of the three Imperial Byzantine Lion silks incorporates, in its repeat, a woven Greek inscription. This has a standard formula of the type 'During the reign of x, the devout rulers'. This formula would appear to reflect a pre-Iconoclastic form of address that was adopted as part of an Imperial titular after Iconoclasm.[24]

The inscription on the Krefeld-Berlin-Düsseldorf Lion silk can be transcribed:

+ ΕΠΙ ΚѠΝCΤΑΝႽ ΚΑΙ ΒΑCΙΛΕΙΟΥ
ΤѠΝ ΦΙΛΟΧΡΙCΤѠΝ ΔΕCΠΟΤѠΝ

† Ἐπὶ Κωνσταν(τίν)ου καὶ Βασιλείου
 τῶν φιλοχρίστων δεσποτῶν
and translated:
'During the reign of Constantine and Basil the devout rulers'.
The inscription on the Cologne silk may be transcribed:

+ ΕΠΙ ΒΑᶜΙλᴱΙႽ Ϟ ΚѠΝCΤΑΝΤΙΝႽ
ѮΝ ΦΙλ°ΧΡႻΤѠΝ ΔΕCΠοΤѠΝ

† Ἐπὶ Βασιλείου χ(αὶ) Κωνσταντίνου
 τῶν φιλοχρίστων δεσποτῶν
which translated reads:
'During the reign of Basil and Constantine the devout rulers'.

The names Basil and Constantine that occur in both inscriptions could refer either to Basil I and to his son Constantine, who ruled jointly from 868-69 or to Basil II and his brother Constantine VIII, who reigned together between 976 and 1025. On the Cologne silk it is the name of Basil that occurs first, but on the Krefeld-Berlin-Düsseldorf silk the name of Constantine precedes that of Basil. Much has been written about the significance of the order of the names on the two Lion silks, but the arguments put forward are invalidated by the simple fact that the Krefeld-Berlin-Düsseldorf inscription is no more than a painted reconstruction.[25] No one so far has pointed out that the inscription does not survive on any fragment of the silk itself. It was a man named Halenz who, in 1892, painted the earliest reconstruction of the inscription on the Krefeld-Berlin-Düsseldorf silk. He did this by using the evidence from several fragments of silk. Halenz could easily have confused the order of the names in the inscription.[26] When in 1893 Schulze came to paint the Krefeld reconstruction, he may simply have relied on the reconstruction of the previous year by Halenz.

On the Cologne Lion silk, as it is the name of Basil that comes first, it is possible that either of the two sets of Emperors was intended. Had the name of Constantine occurred first in the inscription on the silk, it could be argued that the second set of Emperors was intended; the name of Constantine was hardly likely to be placed before that of his father Basil I.[27]

At present, the best way of dating the Krefeld-Berlin-Düsseldorf Lion silk and the Cologne Lion silk is through a close technical and stylistic comparison with the firmly dated Siegburg Lion silk. The close similarities between the Siegburg silk and the other two Lion silks argue in favour of a dating between 976 and 1025, rather than suggesting the earlier dating of 868-69 for them. It seems then, that paired main warp, twill weave Lion silks were in production in the Imperial workshop for at least fifty to one hundred years. Further evidence indicates that the same type of inscribed Imperial Byzantine Lion silk was being woven prior to 921-31.

A fourth Imperial Byzantine Lion silk once at Crépy St. Arnoul, today lost, is known only from an eighteenth century account by a man named Carlier. He described a silk patterned with lions posed to the side, their front paws slightly raised.[28] His copy of the woven inscription on the silk was inaccurate but this may be corrected to read as follows:

Ἐπὶ Βασιλείου κ(αὶ) Κωνσταντίνου τῶν φιλοχρίστων δεσποτῶν
'During the reign of Basil and Constantine the devout rulers'

Carlier gave neither stylistic details nor technical information about the silk, apart from noting that the bodies of the lions were decorated with red and green ornament. Nevertheless, this detail alone is sufficient to set apart the Crépy silk from the Lion silks so far described. Perhaps the

closest parallel for the use of ornamental motifs on the bodies of animals patterning silks, is found on the so-called 'Pegasus' silk in the Vatican Museum, Rome.[29] Foliate patches in red, green and yellow, ornament these horses. The Vatican silk was originally sewn into a cushion, which supported an enamel cross in an oblong silver cross reliquary. The cross inside the reliquary has the following inscription:

"ACCIPE QUAESO A DOMINA MEA REGINA MUNDI HOC VEXILLUM CRUCIS QUOD TIBI PASCHALIS EPISCOPUS OPTULIT".

'Accept I beseech you from my Lady the Queen of the world this standard of the cross, which the Bishop Paschal presents to you.'

'Bishop Paschal' could refer either to Pope Paschal I (817-24) or to Pope Paschal II (1099-1118). Stylistically speaking, the cruciform reliquary and the enamel cross belong to the ninth and not to the eleventh century, and it is generally agreed that the earlier Paschal is the Pope in question.[30] The Pegasus silk itself belongs to a group of twill weave silks that have single rather than paired main warps, and these are datable no later than the early ninth century. Around the late eighth to the early ninth century a change seems to have occurred in the internal structure of twill weave silks. The looms were threaded up with pairs of main warps instead of with single main warp threads. This was probably because wider looms were being developed to weave heavier silks. The main warps threaded in these looms simply had to withstand a greater strain, and the most obvious way of strengthening them would have been to use them in pairs rather than singly.[31] Although one cannot say that the Crépy silk was a single main warp, twill weave silk on the available evidence, the decorative markings on the bodies of the lions as well as the inscription allow for the possibility that it was woven during the reign of Basil I and his son Constantine (867-79). Certainly, Lion silks were documented in churches in Rome in the ninth century, amongst them a gift to St. Martins from Pope Gregory IV (827-44).[32] Also, it is worth noting that several Byzantine silks reached the churches of Rome in this period via the Papacy.

A fifth inscribed Imperial Byzantine Lion silk is known only from the written description of an anonymous author. This writer reported that Bishop Gaudry of Auxerre (918-33) gave to St. Eusèbe, Auxerre, a Lion silk with the following inscription:

Ἐπὶ Λέοντος τοῦ φιλοχρίστου δεσπότου

'During the reign of Leo, the devout ruler'.

The Auxerre Lion silk is said to have resembled another silk already in the treasury of the church. Is it possible that a sixth inscribed Lion silk existed?[33] Concerning the silk presented by Bishop Gaudry, it is fascinating to speculate about whether an Imperial Byzantine Lion silk could have been purchased on the open market. Where did the Bishop get his Lion silk from?

Grabar and Frolow concluded independently that the name of Leo on the Auxerre Lion silk referred to the Emperor Leo VI (886-912).[34] I can see no reason why the inscription could not equally indicate the Emperor Leo III (717-41), the Emperor Leo IV (775-80) or the Emperor Leo V (813-20).

To summarise this section on the inscribed, Imperial Byzantine, Lion silks one may conclude that the Siegburg Lion silk is the only precisely datable piece and that it belongs 921-23. The Krefeld-Berlin-Düsseldorf Lion silk and the Cologne Lion silk most likely date between 976 and 1025. The lost Crépy Lion silk could date between 868 and 869. It is far from certain whether the lost Auxerre Lion silk was woven in the eighth or the ninth centuries. If it is true that the same kind of Lion silk was in production in the Imperial workshop for something like a century and a half, this would point to a remarkable conservatism. The three surviving Lion silks certainly reveal a tendency to adhere to traditional workshop practices.

2. THE LION SILK AT ST. SERVATIUS, MAASTRICHT

A FEW Lion silks without Greek inscriptions, for example, the impressive Lion silk in the Museo Nazionale in Ravenna, may well have been woven in an Imperial Byzantine workshop, but superficial iconographical similarities should not be taken as proof that every silk with some form of comparable lion motif was woven under Imperial patronage.[35] To illustrate this point it is instructive to examine closely the Lion silk at St. Servatius, Maastricht (PL. 44), which was taken from the twelfth century shrine of St. Servatius (d. 384). The Maastricht Lion silk survives in five fragments and outwardly in its subject matter and composition it closely resembles an Imperial Lion silk. Stylistically and technically, however, the Maastricht Lion silk is nothing like its Imperial counterparts.[36] Once more, for the sake of clarity, the main differences between this silk and the Imperial Lion fabrics will be treated under a series of separate headings.

a) Composition and style
The Maastricht lions are posed to the sides and they face the spectator like the Imperial lions, but they are shown singly and not in pairs and they measure only 22.5 to 23 cm across. The usual tree motif and the regular

decorative markings on the lions can be seen on the Maastricht silk, but the style of the design is very different from that on the Imperial Byzantine Lion silks. Whereas the Imperial Lions have smooth, sinuous outlines and markings, the Maastricht animals display rough, jagged edges. Features such as the tree on the Maastricht silk, are over-enlarged and distorted. A rigid, two dimensional style characterises the Maastricht design. The roots of this style lie in the technique of the piece.

b) Technical structure

The twill weave used for the Maastricht Lion silk has a different internal structure from that observed in the Imperial Lion silks. The main warps in the Maastricht weave are grouped in threes and fours instead of being paired. At the same time the actual yarn used for the Maastricht main warps is a coarse, thick, black silk instead of a fine, undyed yarn like that of the Imperial Lion silks. The effect of using a greater number of thicker main warps, and of employing less fine stepping of the outlines of the design on the Maastricht silk, is obvious in stylistic terms; and yet so many authors have classed the Maastricht Lion silk alongside the Imperial Byzantine Lion fabrics.[37] The loom that wove the Maastricht Lion silk was nowhere so difficult to thread, and the figure-harness nowhere so difficult to manipulate, as the looms that produced the Imperial Lion silks. A completely different workshop is indicated for the Maastricht Lion silk.

c) Colour scheme

Only one of the Imperial Byzantine Lion silks has been tested for its purple dye: this is the Berlin fragment of the Krefeld-Berlin-Düsseldorf Lion silk. The dye here appears to be a mixture of indogen and madder. This does not seem to be what the Maastricht craftsmen had to hand when their silk yarn was dyed, for an analysis of the dye content of the purple on their Lion silk indicated the presence of a mixture of indogen and a lichen.[38]

d) Inscription

There is no inscription on the Maastricht Lion silk.

The use of a very similar Lion motif to those that appear on the Imperial Lion silks, taken in conjunction with the fact that the Maastricht design was woven down rather than across the loom, like the designs of the Imperial Lion silks, suggests that the weavers of the Maastricht textile may have been imitating the products of the Imperial Byzantine work-shop. It is hardly possible to think that they had not seen an Imperial Byzantine Lion silk of the inscribed type. At the same time the technique of the Maastricht piece points towards an Islamic rather than a Byzantine workshop. Central Asian silk weaving workshops are known to have been

using twill binding with three to four main warps in the ninth to tenth centuries.[39] Perhaps Islamic craftsmen had an Imperial Byzantine silk to copy. Silks were sent as diplomatic gifts both to Islamic rulers and to Western Emperors from Byzantium. The surviving inscribed, Imperial Byzantine Lion silks must have reached the West as diplomatic gifts and not as merchandise.[40] No less than sixteen marriages were either negotiated or arranged between Byzantium and the German Emperors from the eighth to the twelfth centuries.[41] Byzantine envoys definitely carried silks as gifts,[42] and these may well have been old rather than contemporary silks, for some Byzantine Emperors stored, renovated and even reused old silks.[43] In the same way silks were stored and cherished in the Islamic world and in the West.[44]

3. THE IMPERIAL ELEPHANT SILK (Pls. 45, 46)

A LARGE silk (162 x 137 cm), at Aachen Münster treasury, with a design of elephants in medallions, was taken from the shrine of Charlemagne (d. 814) in 1843.[45] On the silk today there is only one complete repeat and part of another, but originally across the silk there were at least three medallions, each with a single elephant motif.[46] The design was woven across the loom in the normal way, using a twill weave with paired main warps. Each medallion of the design measures some 78 to 80 cm in diameter, and the loom that was used to weave the Aachen Elephant silk must therefore have been 240 cm or more wide. If there was an even rather than an odd number of medallion repeats across the silk, that is four instead of three repeats, the width of the loom would have been quite staggering at 320 cm.

Along the lower edge of the Aachen Elephant silk are two rows of pearl shapes like those on the Siegburg Lion silk, and the following inscription is twice repeated; in one case it is only partially visible because of wear (Pls. 47A, B):

† ἘΠ' ΜΪ ΠΡ'ΜΪ ΚΟΪ} ΕΙΔΙΚȢ

† ΠΕΤΡȢ ΑΡΧΟΝͭ ΤȢ ξΗΠȢ ΙΝ̂

† Ἐπὶ Μιχ(αὴλ) πριμι(κηρίου ἐπὶ τοῦ) κοιτ(ῶνος) (καὶ) εἰδικοῦ
† Πέτρου ἄρχοντ(ος) τοῦ Ζευξήπου ἰνδ(ικτιῶνος) [...]

The inscription may be translated:
>In the time of Michael, πριμικήριος ἐπὶ τοῦ κοιτῶνος and εἰδικός
>When Peter was the archon of Zeuxippos, indiction ...[47]

Ten authors have variously dated the silk from as early as 784 to as late as 1199, using an indiction number that they believed existed at the end of the inscription. Two main points seem to have been overlooked so far. Firstly, the silk cannot be dated with the help of the indiction number, because this does not exist on the silk. The areas in the two repeats of the inscription where this should have appeared have completely worn away. At best, on the more well preserved repeat of the inscription, the seventh indiction could have been mistaken for the last letter of the word denoting indiction.[48]

The second point is that the titles in the inscription are found in sources dating no earlier than 843 and apparently no later than 1088.[49] This rules out the possibility that the silk was buried with Charlemagne in 814. Most often it is suggested that the silk was donated by Otto III in the year 1000. However, it could have been given later, either by Frederick Barbarossa in 1165 when Charlemagne was canonised, or in 1215 by Frederick II, upon the completion of the shrine of Charlemagne.[50]

A further point to consider is whether the name 'Zeuxippos' actually refers to an Imperial weaving establishment. So far no archaeological evidence has come to light to show that the bath at Zeuxippos built in c. 196, and which seems to have fallen out of use for this purpose after 713, was at any later time used for a silk weaving establishment.[51]

At least twelve silks have been compared to the Aachen Elephant silk but it is quite obvious that none of them are the technical equal of the Imperial silk.[52] No less than 1440 manipulations of the figure-harness were required to weave one repeat of the Aachen Elephant silk.[53] This silk with its large scale, asymmetrical design using extremely finely gradated outlines, demanded of its weavers a miraculous technical dexterity. It represents the high point of Byzantine silk weaving as it has survived; the silk must have been a unique commission upon which no expenses were spared. Both technically, and stylistically from the point of view of the delicacy of outline and the fine detailing of the designs, the Lion silks with Imperial inscriptions come closest to the Aachen Elephant silk. At the same time the advanced technical complexities involved in weaving a single repeat of the Aachen design tend to suggest it belongs a stage further ahead of even the latest of the Lion silks, that is post 976-1025. My own feeling leads me to think that the Aachen Elephant silk was woven well into the eleventh century. Further evidence may even point to a somewhat later date for this magnificent silk.

SPECIAL NOTE

The text of this contribution is, in essence, identical to a lecture given at the Institut für Byzantinistik und Neogräzistik at the University of Vienna in June 1983. I am very grateful to Prof. Hunger for the invitation to speak as well as for the publication of the text. Thanks are due also to his assistants, especially to Dr. Hörandner and Dr. Seibt, for a number of useful additional suggestions.

NOTES

1. Beckwith pointed out the benefits of technical analysis of Byzantine silks. See J. BECKWITH, Byzantine Tissues, in: Actes du XIVᵉ Congrès International des Études byzantines (Bucarest 1971). I. Bucarest 1974, 343-53. Historians and art historians generally have no knowledge of weaving technique, and their articles and books dealing with Byzantine silks consequently fail to provide a technical analysis of the fabrics. A number of valuable and highly technical examinations of Byzantine silks have been made by individuals at the International Centre for the study of Historical Textiles in Lyons. The terms used by this Centre have been defined in several Vocabularies. I have used the *C.I.E.T.A. Vocabulary of Technical Terms* (English, French, Italian, Spanish), Lyons 1964, for the purposes of this paper.

2. Definitions of these five weaving types are given in the Vocabulary cited above. First hand examination of the silks was necessary as their technical structure had not previously been recorded in most cases. The silks are largely unpublished, although a handlist of many is given as an Appendix in my thesis 'Eastern silks in Western shrines and treasuries before 1200 AD', Courtauld Institute of Art, London University PhD 1980, and a large number of the pieces are discussed in the text of the thesis. The contents of this thesis are under preparation for publication.

3. So far I have not come across any Byzantine source that describes the workings of a silk weaving factory in Byzantium. The *Book of the Prefect* includes regulations governing the non-Imperial silk guilds of Constantinople in the tenth century. See J. NICOLE, Le Livre du Préfet. Geneva and Basel 1894 (reprinted by Variorum in 1970).

4. The existence of Imperial and of royal workshops is based on the evidence of the surviving inscribed silks as well as on the evidence of historical sources.

5. A valuable article about the Byzantine non-Imperial silk guilds was published by D. SIMON, Die byzantinischen Seidenzünfte. *BZ* 68 (1975) 23-46. The precise meaning of the regulations contained in the *Book of the Prefect* have yet to be fully understood. See also S. VRYONIS, Byzantine ΔHMOKPATIA and the guilds in the eleventh century. *DOP* 17 (1963) 289-314 (=IDEM, Byzantium: its internal history and relations with the Muslim world. London, Variorum 1971, III), esp. 300 n. 46. Here Vryonis is critical of some of the ideas proposed earlier by R. S. LOPEZ, Silk industry in the Byzantine Empire. *Speculum* 20 no. 1 (1945) 1-42.

6. In the *Book of the Prefect* there are references to members of the ruling classes, 'ἀρχοντικὸν πρόσωπον', who are said to have sold valuable silk garments to the silk merchants, but who were forbidden to weave large pieces of silk dyed with purples of the kind restricted to Imperial use. See NICOLE, Livre du Préfet, 8 ii and 4 ii. Numerous descriptions of Islamic workshops in the homes of modest craftsmen were included in the study of the Cairo Geniza documents published by S. D. GOITEIN, A Mediterranean Society, I, II, III. New York 1967, 1971, 1978. Relative costs of weaving and of dyeing are given for example, in I, ii, 90 and in I, iv, 107.

7. So far no documentary evidence has been found to show positively that silks were woven in monasteries.

8. The relics of St. Anno were translated in 1183 at the time of his canonisation. All the available documentary evidence was gathered together and presented in the catalogue Monumenta Annonis, Köln und Siegburg. Weltbild und Kunst im hohen Mittelalter, Schnütgen Museum 30 April - 27 Juli, 1975, ed. A. VON EUW, A. LEGNER, M. PLÖTZEK. Köln 1975. See especially 65-66 and 185 onwards. The shrine of St. Anno is examined also in the catalogue Rhein und Maas, Kunst und Kultur 800-1400, I. Köln 1972, 321-22.

9. H. PETERS, Der Siegburger Servatius-Schatz. Honnef 1952, 29, for instance. Also an entry in the recent catalogue, Splendeur de Byzance. Bruxelles 1982, 216, in the section on the Lion silk of the Diocesan Museum, Cologne. The Siegburg Lion silk, it is claimed, was destroyed in 1945.

10. The silk was in an extremely delicate condition.

11. A precise date for the Siegburg Lion silk was first established by E. AUS 'M WEERTH, Byzantinisches Purpurgewebe des 10. Jahrhunderts. *Jahrbuch des Vereins für Kunstwissenschaft* 1 (1868) 162-165. He noted the two misspellings Χριστοφώρου and Φιλοχρίστον, which should read Χριστοφ<ό>ρου and Φιλοχρίστ<ω>ν

12. Primitive looms depicted in a number of Greek manuscripts have no mechanism for the automatic repeat of the design across the fabric. Looms of the type shown would not be suitable for weaving silks with any but the least simple form of geometric or small scale, foliate designs. Some examples were illustrated by F. M. HEICHELHEIM, Byzanz. *CIBA Rundschau* 84 (1949) 3131, 3136, 3138. A systematic search for illuminations showing looms has not been carried out and would be desirable.

13. The pattern producing device is known as *the figure-harness* (See C.I.E.T.A. Vocabulary of Technical Terms, 18, for a definition of this term). *The figure-harness* controls the *main warps* (see Vocabulary, 31), and the latter are raised or lowered according to the requirements of the design, so that the weft passes either to the front or the back of the silk as necessary. The *main warps* are not

visible either on the obverse or on the reverse of the silk. It is the *binding warps* that bind down the silk *wefts* (see Vocabulary, 3 and 57 for definitions of these terms).

14. The second person seated on a platform above the loom is given the name *draw-boy* (see Vocabulary, 15). It is the task of this person to operate *the figure-harness,* which controls the *main warps* and acts as the pattern producing device.

15. Chinese hand draw-looms of that period were shown with a draw-boy seated high above the loom. Illustrations can be seen in a number of articles. For instance, J. F. FLANAGAN, Figured fabrics, in: History of Technology, III. Oxford 1957, 191, pl. 126. See also an early article by J. F. FLANAGAN, The Origin of the Drawloom used in the making of early Byzantine silks. *Burlington Magazine* 35 nos. 196-201 (1919) 167-172. In addition, G. SCHAEFER, The Handloom of the Middle Ages and the following centuries. *CIBA Rundschau* 16 (1938) 554-557. The looms illustrated here have no figure-harness attachment. Further, mediæval looms are discussed by R. PATTERSON in: C. SINGER, E. HOLMYARD, A. HALL, History of Technology, II. Oxford 1956, 210 onwards. Volume one of the same publication includes an article by G. CROWFOOT, with information on mediæval looms (I, Oxford 1955, 425-447). One of the few books on the history of looms to deal more fully with the very early period is by C. RODON Y FONT, L'historique du métier pour la fabrication des étoffes façonnées. Paris and Liège 1934. Figure 3 on page 16 shows a hand drawloom with a draw boy and a third person appears to be assisting. The detailed history of the hand drawloom before 1200 is virtually unknown. To understand the possible workings of the hand draw-looms that produced the elaborate silks of the middle ages, it is necessary to look at the surviving silks and to envisage how they could be rewoven. At present with the assistance of a very experienced hand drawloom weaver (Miss Amelia Uden), and with the aid of a Leverhulme Research Fellowship, work is underway to complete a hand drawloom that will be capable of weaving some of the complex mediæval techniques found on Byzantine silks dating before the thirteenth century. It is hoped that a full record of this work will be published in conjunction with a 'History of Byzantine silk weaving'.

 Nineteenth century Chinese prints with hand draw-looms of the type under discussion are not always extremely accurate in terms of the structure of the looms. One example is shown by D. BURNHAM, Warp and Weft, A textile Terminology. Royal Ontario Museum, Canada, 1980, 50.

16. *Gazette des Beaux-Arts* 40, part two (1908), 471.

17. I discovered the watercolour in a cupboard of the museum depot in 1979. For the article, see note 11 above.

18. The exact width of any loom can be judged if a piece of cloth woven on it retains its *selvedges* on either side (See C.I.E.T.A. Vocabulary, 42). A few loom widths can be gauged from the surviving Byzantine silks. A large silk tapestry in the Diocesan Museum, Bamberg was buried with Bishop Gunther (d. 1065) in Bamberg Cathedral. This was woven on a tapestry loom some 210 cm across. The silk used for the chasuble of St. Vitalis in the Abegg Stiftung, Riggisberg, which is datable late 10th or early 11th centuries and could be Byzantine, is 262 cm wide. The silk for the chasuble of Pope Clement II (d. 1047), datable to the

same period and also possibly Byzantine, was woven on a loom at least 255 cm wide. A series of Central Asian silks at Huy, Sens and elsewhere were woven around the ninth century on looms some 120 cm wide. A catalogue of these and of other surviving mediæval silks, datable before 1200, will be included in the planned publication on the History of Byzantine silk weaving.

19. Dalton published a picture of the Krefeld reconstruction of 1893 by Schulze, but mistakenly called it a copy of the Düsseldorf silk. See O. DALTON, Early Christian and Byzantine Art. Oxford 1911, 594, fig. 374. For the Berlin fragments see J. LESSING, Die Gewebesammlung des Königlichen Kunstgewerbemuseums zu Berlin. Berlin 1900-1913, I, pl. 65. The Düsseldorf fragments of Lion silk were purchased from Peter Schmitz in Cologne in 1891. They measure 90.5 x 14.5cm; 58.5 x 32.5cm; 39 x 10cm; 38 x 21cm; 38.5 x 14cm and 5 x 14 cm (w x h). These fragments were published by H. FRAUBERGER, Der Byzantinische Purpurstoff im Gewerbemuseum zu Düsseldorf. *Jahrbücher des Vereins von Altertumsfreunden im Rheinland* 92 (1892) 224-232, pl. X.

20. The *Vita* of St. Heribert by Laurent of Liege, c. 1050, makes no reference to a Lion silk used at the time of burial. Neither the shrine nor the silk is mentioned in the account of the elevation of the relics in 1147. The *Codex Tiodorici*, written by a sacristan of Deutz in 1164-7, briefly recorded the date of the translation of the relics of St. Heribert. See *MGH Script*.XIV, 565. For the dating of the shrine consult J. BRAUN, Der Heribertusschrein zu Deutz, seine Datierung und seine Herkunft. *Münchner Jb.*, N. F. 6 (1929) 109-123. KÖTZSCHE dated the shrine 1160-70 (Rhein und Maas I, 277, no. H. 17). It seems a shrine must have been ready for the important translation in 1147. P. LASKO, Ars Sacra. London 1972, 194-196, dated the shrine 1150-1160.

21. For definitions of the terms *twill, main warps* and *wefts* see C.I.E.T.A. Vocabulary, 52-53, 31, 57. The lion silks are 1.2 twills.

22. For example, on the pavement at Horkstow in Lincolnshire. Illustrated in F. KLINGENDER, Animals in Art and Thought to the end of the Middle Ages. London 1971, pl. 74.

23. The smallest gradation of the outline of the design is termed the découpure. See C.I.E.T.A. Vocabulary, 12. It is difficult to examine closely those silks kept under glass but the stepping appears to be across one pair of main warps and down two weft passes.

24. The epithet φιλόχριστος does occur in conjunction with the name of an Emperor before Iconoclasm. Consult I. I. REISKE, Constantini Porphyrogeniti Imperatoris, De Caerimoniis aulae Byzantinae. Bonn 1829-1840, II. 493-4. Compare G. RÖSCH, ONOMA ΒΑΣΙΛΕΙΑΣ *(B V* 10). Vienna 1978, Index s. v; O. KRESTEN, Iustinianos I, der "christusliebende" Kaiser. Zum Epitheton φιλόχριστος in den Intitulationes byzantinischer Kaiserurkunden. *Röm. Hist. Mitt.*21 (1979) 83-109.

Immediately after Iconoclasm the epithet is found in the heading of the *Taktikon Uspenskij*, a document compiled under Michael III (842-67) and his mother Theodora (842-55) and dated 842-43 by N. OIKONOMIDES, Les listes de préséance byzantines des IX⁰ et X⁰ siècles. Paris 1972, 44-47. The epithet is used to refer to the ruling Emperor Leo VI in the *Treatise of Philotheos*, dated 899 and in the *Taktikon Beneševič*, datable 934-44. OIKONOMIDES deals with these works in his book on 65-235, and on 237-53: note especially 81 and 240-3. In

seventeen out of twenty five cases in the *De Administrando Imperio* the epithet is applied either to the Emperor Basil I (867-86) or to the Emperor Leo VI (886-912). For this source refer to GY. MORAVCSIK, R. JENKINS, Constantine Porphyrogenitus, De Administrando Imperio *(CFHB* 1). Washington, 1967, 26, 29, 45, 48, 50-51. Constantine VII used the same epithet in the *Book of Ceremonies*, see A. VOGT, Constantin VII Porphyrogénète, Le livre des Cérémonies I-II, commentary 1-2, Paris 1935, I, 112 line 13, II, 124 lines 15-16, 30 line 53 onwards. The epithet also occurs on seals; on one seal it is applied to a theme (G. ZACOS-A. VEGLERY, Byzantine Lead Seals I/1. Basel 1972, no. 222). The epithet does not appear to have been usual on coins before 1200.

25. For the Krefeld-Berlin-Düsseldorf Lion silk and the Cologne Lion silk, in addition to the works cited in note 19 above, the following publications may be referred to: J. LESSING, Die Gewebesammlung des Königlichen Kunstgewerbemuseums zu Berlin. Berlin 1900-13, plates 65, 66, 68, 69; O. VON FALKE, Kunstgeschichte der Seidenweberei. Berlin 1913, II, 12 and in the same publication printed in Berlin in 1936, 26, pl. 183; J. EBERSOLT, Les arts somptuaires de Byzance. Paris 1923, 80 onwards, pl. 39; A. F. KENDRICK, Catalogue of Early Medieval Woven Fabrics. London 1925, no. 1008, pl. 5; Die Kunstdenkmäler der Rheinprovinz, VII/3. Düsseldorf 1934, 2/3, 968ff.; F. M. HEICHELHEIM, Byzantinische Seiden. *C.I.B.A. Rundschau* 84 (1949) 3146; A. GRABAR, Les succès des arts orientaux à la cour byzantine sous les Macedoniens. *Münchner Jb. der Bildenden Kunst*, 3. F., 2 (1951) 33-34; E. FLEMMING, Les Tissus. Paris 1957, pl. 28; H. SCHMIDT, Alte Seidenstoffe. Brunswick 1958, 73ff. and plate 53; S. MÜLLER-CHRISTENSEN, Das Grab des Papstes Clemens II im Dom zu Bamberg. München 1960, pl. 80; BECKWITH cited in note one above, page 41; Rhein und Maas, 1972, I, 171-2, no. B1.

 At St. Barbara in Cappadocia there is an inscription where the names of these Emperors appear to have been reversed by mistake. The inscription was recorded by A. WHARTON EPSTEIN in her thesis for London University, The date and context of some Cappadocian rock cut churches, Courtauld Institute of Art, PhD thesis, 1975, Appendix of inscriptions.

26. FRAUBERGER in his article cited above (note 19), named Halenz — the very unusual abbreviation ΚΩΝΣΤΑΝΟϒ could be due to the reproduction as well.

27. After all, on the Siegburg Lion silk, the name of Christophoros follows on from that of his father. On coins the name of Basil II generally seems to come before that of Constantine VIII. Similarly, on coins the name of Basil I precedes that of his son.

28. C. CARLIER, Histoire du duché de Valois, I-III. Paris 1764, I, 268-9. The term Carlier used was 'leopards passans' a description found in heraldry that indicates an animal walking with the front paw raised. The silk came from the relics of St. Arnoul, Bishop of Tours, a disciple of St. Rémi, who was buried at Gruyères, where his remains were kept until the ninth century. Between the ninth and the tenth centuries the relics of the saint were translated on several occasions. On 27th September 949, the relics reached Crépy in the care of Count Raoul I. One of the sons of this count rebuilt the church of St. Arnoul at Crépy and in the early eleventh century the relics were translated into a shrine. The priest Stephen translated the relics once again after 1080 into a painted wooden

shrine. It was the painted shrine that Carlier saw in the eighteenth century. Carlier said that the silk must have been the gift of the son of Count Raoul I, but there is no documentary evidence to support this idea. See CARLIER, I, 132-8, also 259-63 of volume two and 444 of volume 3 of his history.

29. W. VOLBACH, Catalogo del Museo Sacro della Biblioteca Apostolica Vaticana, III, Fasc. 1, Tessuti. Vatican City 1942, 44. A colour plate appears in W. VOLBACH, Early Decorative Textiles. Feltham 1969, pl. 60.

30. H. GRISAR, Die Römische Kapelle Sancta Sanctorum und ihr Schatz. Freiburg 1908, 80 onwards and 62 onwards. Compare LASKO, Ars Sacra, 55.

31. The surviving silks datable to this period were fully analysed in my doctoral thesis. A chapter on these silks will be included in the planned publication on Byzantine silk weaving.

32. Liber Pontificalis, ed. L. DUCHESNE, I, II. Paris 1892, II, 83 line 4, 75 lines 18-19, 18 line 23 (from Alexandria?) 77, line 28 (from Tyre?) 9, lines 6-7, 194 lines 31-2, from Byzantium? For the gift of Pope Gregory IV, see II, 76 line 29.

33. The gift of a Lion silk to Auxerre by Bishop Gaudry (918-33) was recorded in the Gesta Pontificium Autiossodorensium, which has been edited by a number of different scholars. A. FROLOW, Quelques inscriptions sur des oeuvres d'art du moyen âge. Cah. Arch.6 (1952) 163-64, used an edition of 1890 by M. QUANTIN, where the Greek inscription was transcribed into Latin. Other editions of the Gesta are by L. DURU, Bibliothèque historique de l'Yonne, I. Paris 1850, 375; by P. LABBE, Nova bibliotheca manuscriptorum librorum. Paris 1675, 443 and by J. LEBŒUF, Mémoires concernant l'histoire ecclésiastique et civile d'Auxerre, I. Paris 1743, 214. The name of Leo occurs in the inscription on the Lion silk as edited by Quantin and Lebœuf, but not as edited by Labbe.

34. See A. GRABAR, Les succès des arts orientaux à la cour byzantine sous les Macédoniens. Münchner Jb. f. Bildende Kunst,3. Folge, 2 (1951) 33-36, particularly 33. Compare FROLOW, Cah. Arch. 6 (1952) 163-64.

35. The Ravenna Lion silk was taken from the tomb of St. Julian in Rimini in 1911. It came from the upper of two wooden coffins, both of which were enclosed in a marble sarcophagus. The Bollandists have shown that the saint celebrated in Rimini is St. Julian of Cilicia (m. early fifth century) and not St. Julian the Istrian, son of Asclepiodora (m. c. 249). St. Julian the Istrian seems to be an invention of the thirteenth century and the Actsof his Life date to the fourteenth century. The earliest surviving passion of St. Julian the Cilician is in the Menologion of Basil II (976-1025), see J. VAN DEN GHEYN, Un fragment des actes de S. Julien d'Anazarbe.AnBoll15 (1896) 73-76. For the discussion about which saint Julian is celebrated in Rimini consult H. DELEHAYE, Santi dell' Istria e Dalmazia. Atti e Memorie della Società Istriana di Archeologia16 (Parenzo 1900) 3-4. The most comprehensive article so far concerning the contents of the wooden sarcophagus is by G. GEROLA, La ricognizione della tomba di S. Giuliano in Rimini. Bollettino d'Arte 5 (1911) 106-20; especially 115 note 2, 117-18 and note 4, for the discussion about St. Julian's identity. There was no official Papal sanctification but St. Julian was recognised in a bull of Pope Boniface IX dated 1389. The Lion silk has variously been dated as early as the ninth and as late as the eleventh century. On technical, stylistic and iconographical grounds I would date this silk late ninth to early tenth centuries. The

weave is paired main warp, twill, like that of the surviving inscribed Lion silks. The Ravenna lions measure only 32 cm in length and the design was woven across and not down the loom.

36. The relics of St. Servatius were translated following his canonisation in 1164. It seems reasonable to think that the shrine was either completed or nearing completion by this date, but it is most often given a date of 1160-70 (Rhein und Maas, I, 245-46, no. G 8). Compare F. BOCK, M. WILLEMSEN, Die mittelalterlichen Kunst- und Reliquienschätze zu Maastricht. Köln-Neuss 1872, 29A. One fragment of Maastricht Lion silk measuring 28.1 x 19.5 cm with a single lion facing right, was purchased in 1888 by J. Lessing, Director of the Kunstgewerbemuseum, Berlin (inv. 88.196). The Lion silk was exhibited in Edinburgh, J. BECKWITH, Masterpieces of Byzantine Art. Edinburgh 1958, 43 no. 103. It was exhibited also in Athens, Council of Europe exhibition of Byzantine Art, Athens 1964, no. 579. A catalogue of some 400 pieces of silk in the treasury of St. Servatius, Maastricht is under preparation.

37. Technical factors can have a profound effect on the style of the design of individual silks. Cost factors too, may play a part in the quality of outline. The coarser the steps in the outline of any design, the less the manipulation of the figure-harness that was required to produce it, the easier the setting up of the loom, and the cheaper the production of the textile, excluding the use of expensive dyes.

38. The study of mediæval textile dyes is in its infancy. I am indebted to those who donated samples for analysis, particularly to the Keepers of the Berlin Lion silk and the Maastricht Lion silk. Twelve samples of silk dyed with purple were analysed by John Harvey working under Professor Whiting of Bristol University. Tentatively two dyeing traditions were distinguished, one using indogen and madder, the other mixing indogen with a lichen. Further work is desirable to substantiate this thesis. I wish to thank John Harvey and Professor Whiting for their generous assistance.

39. For the Central Asian silks the key articles are D. G. SHEPHERD, W. B. HENNING, Zandaniji identified? in: Festschrift für Ernst Kühnel. Berlin 1959, 15-40 and D. G. SHEPHERD, Zandaniji revisited, in: Dokumenta Textilia, Festschrift für S. Müller-Christensen. München 1981.

40. Byzantine silks sent as gifts to Islamic rulers were discussed by M. HAMIDULLA, Nouveaux documents sur les rapports de l'Europe avec l'Orient du Moyen Âge. *Arabica* 7 (1960) 281-300. For the idea of Byzantine silks sent as dowry gifts consider H. WENTZEL, Das byzantinische Erbe der ottonischen Kaiser. Hypothesen über den Brautschatz der Theophanou. *Aachener Kunstblätter* 143 (1972) 11-96. However, the silks discussed by Wentzel, on technical grounds, are not all datable to the tenth century. These silks appear to range in date from as early as the eighth to as late as the eleventh centuries, and they seem to represent both Byzantine and Islamic silk weaving workshops.

41. Constantine Porphyrogenitus (913-59) certainly made it clear that marriage alliances between Byzantium and the Franks were desirable. See GY. MORAVCSIK, R. J. H. JENKINS ed., Constantine Prophyrogenitus, De Administrando Imperio (*CFHB* 1). Washington 1967, 70-73. In 945 Constantine VII sent precious gifts to Otto I. It is interesting to speculate whether the

Siegburg Lion silk could have been amongst them. Romanos himself does not appear to have had diplomatic contact with his Western contemporary Henry I (919-36). F. DÖLGER, Regesten der Kaiserurkunden des Oströmischen Reiches von 565-1453, I. München 1924, no. 651. Between the years 1000-1002 there were negotiations for the marriage of Zoe, daughter of Constantine VIII and Otto III. Perhaps the Cologne Lion silk was sent in connection with these discussions. DÖLGER, Regesten, I, nos. 784, 787. If the Auxerre Lion silk was indeed woven under Leo VI and not earlier, could it have reached the West in connection with marriage negotiations between 898-901 involving Anna, daughter of Leo VI, and the future Louis III? DÖLGER, Regesten, I, no. 536.

42. The Chronicle of Ekkehard for the year 1083 recorded that Greek legates appeared in the West bringing many great gold, silver and silk gifts. O. LEHMANN-BROCKHAUS, Schriftquellen zur Kunstgeschichte des 11. und 12. Jahrhunderts für Deutschland, Lothringen und Italien, I-II. New York 1971, I, no. 2723.

43. Theophilus (829-42) is said to have renovated Imperial garments and to have adorned them with gold embroidery. Constantine VII (913-59) restored garments according to Theophanes. C. MANGO, The Art of the Byzantine Empire 312-1453. Englewood Cliffs, N. J. 1972, 160 and 207 with sources.

44. For example Masudi reported that patterned silks of the Umayyad Sulaiman (715-717) were kept in the court of the Abbasids and nearly a hundred years later were worn by Harun al Raschid. F. E. DAY, Ars Orientalis 1 (1954) 240.

45. The shrine of Charlemagne at Aachen Münster is datable c. 1165-1215. E. GRIMME, Aachener Kunstblätter 42 (1972) 66-69, no. 44 and no. 30.

46. P. CAHIER and P. MARTIN, Mélanges d'archéologie 2 (1851) 234. For bibliography on the Elephant silk consult E. GRIMME, Aachener Kunstblätter 42 (1972) 46.

47. As I have interpreted them, Michael's titles indicate that he was head of a bureau occupied in the running of the state factories, that he was a member of the Emperor's personal guard, and perhaps that he was a eunuch. Peter was head of the state weaving factory. His office is one of four described in the bureau of the εἰδικόν as described by Philotheos in 899 and by Constantine VII in his Book of Ceremonies. See further note 49 below. Many authors have transcribed the inscription on the Aachen Elephant silk: CAHIER and MARTIN, Mélanges d'archéologie 2 (1851) 234; F. BOCK, Byzantinische Purpurstoffe mit eingewebten neugriechischen Inschriften. Zeitschrift des Bayerischen Kunstgewerbevereins 2 (1894) 65 onwards; J. LESSING, Die Gewebesammlung des Königlichen Kunstgewerbe-Museums zu Berlin. Berlin 1900-13, pl. 67 with caption; CH. DIEHL, L'étoffe byzantine du reliquaire de Charlemagne, in: Bulicev Zbornik. Zagreb, Split 1924, 441-47. MARTIN and DIEHL read the name 'Michael' in the first line of the inscription on the Aachen Elephant silk but LESSING suggested that the name should be read 'Epimachos'. The letters on the silk leave no doubt that Michael was intended. Many authors published transcriptions and translations in line with the work of both Martin and Diehl: O. VON FALKE, Kunstgeschichte der Seidenweberei. Berlin 1913, II, 13; H. J. SCHMIDT, Alte Seidenstoffe. Braunschweig 1958, 70 onwards; J. EBERSOLT, Les Arts somptuaires de Byzance. Paris 1923, 78; K. FAYMONVILLE,

Kunstdenkmäler der Rheinprovinz, X no. 1, 216; A. F. KENDRICK, Catalogue of Early Medieval Woven Fabrics. London 1925, 35; A. GRABAR, cited in note 34 above, 33-36; H. SCHNITZLER, Rheinische Schatzkammer. Düsseldorf 1957, no. 30; W. F. VOLBACH and J. LAFONTAINE-DOSOGNE, Propyläen Kunstgeschichte III. Berlin 1968, no. 68, 194; J. BECKWITH, as cited in note 1 above, 41; E. GRIMME, *Aachener Kunstblätter* 42 (1972), no. 30; H. WENTZEL, *Aachener Kunstblätter* 40 (1971) 18; PLÖTZEK in Rhein und Maas, I, 173 no. B3. Recently V. LAURENT (Le corpus des sceaux de l'Empire byzantin. Tome II: L'administration centrale. Paris 1981, 312, n° 613) published a seal belonging to a Michael πριμικήριος ἐπὶ κοιτῶνος, βασιλικὸς νοτάριος καὶ εἰδικός. Laurent dates the seal to the eleventh century (first half) and identifies its owner with the person mentioned in the inscription on the Aachen Elephant silk — a very plausible identification which would fit very well to my dating of the silk.

48. The indiction number was not visible in 1913, judging by the photograph of the silk published by O. VON FALKE in his 'Kunstgeschichte der Seidenweberei'. Different authors suggested that the second, the twelfth or the seventh indiction number could be seen. Amongst those that favoured the seventh indiction were BOCK, LESSING, FALKE, EBERSOLT and GRABAR cited in the previous note, as well as BECKWITH. BOCK dated the silk twelfth century, whilst the others apart from LESSING favoured a tenth century dating. LESSING thought the silk had been buried with Charlemagne in 814.

49. The title εἰδικός is found in the *Taktikon Uspenskij* of 842-43. See DIEHL, Bulicev Zbornik, 443. Also J. BURY, The Imperial Administrative system in the ninth century with a revised text of the Kletorologion of Philotheos. London 1911, 98. The title is found in 899 in the *Treatise of Philotheos*. The bureau of the εἰδικόν is not documented in the early ninth century, see DIEHL, as above, 446. There is no mention of the εἰδικός in the early ninth century Chronicle of Theophanes. In Theophanes Continuatus ed. I. BEKKER, Bonn 1838, part 4, 173 line 13 the following passage occurs:

 τὰς μὲν ὁλοχρύσους τὰς δέ χρυσοϋφάντους οὔσας ἐν τῷ εἰδικῷ...
 'some (fabrics) were all gold, others were interwoven with gold being in the εἰδικόν*.

The earliest named identifiable official with the title under discussion is Nicetas, who served under Basil I (867-86). See Genesius, ed. A. LESMÜLLER-WERNER and I. THURN (*CFHB* 14) Berlin 1978, 50, 94-95 (= p. 71 Bonn):

 παραπλησίως οὖν καὶ Νικήτα υἱῷ τοῦ αὐτοῦ ἐπὶ τοῦ εἰδικοῦ σεκρέτου καηηγουμένῳ. . .
 'being next to Nicetas, his son, head of the bureau of the εἰδικόν'

From the tenth century onwards the spelling εἰδικόν rather than ἰδικόν is usual both in documents and on seals. The detailed evidence for this will be discussed in the forthcoming publication on Byzantine silk weaving. The bureau of the εἰδικόν does not seem to have functioned beyond 1088, see N. OIKONOMIDES, L'évolution de l'organisation administrative de l'empire byzantin au XIᵉ siècle. *TM* 6 (1976) 125-152, esp. ch. 6: Les finances, pp. 135-41. It seems that the bureau of the εἰδικόν served several different functions in the mid-ninth and the tenth centuries. For the Cretan expedition of 949 it supplied equipment and stores. During the reign of Michael III (842-67) it acted as a place for storing the

gold melted down from works of art. In the tenth century it was used to house brocaded garments. See F. DÖLGER, Beiträge zur Geschichte der byz. Finanzverwaltung. Leipzig 1927, 35-39. Compare BURY, Imperial Administrative System 98 onwards, and 80-82 for the Emperor's private treasury. In 899 Philotheos described four categories of office in the εἰδικόν: OIKONOMIDES, Les listes de préséance byzantines, 123 lines 6-10. The same four categories are found again in the *Book of Ceremonies*, see REISKE, De Caerimoniis, II, 720 lines 1-4. Peter as ἄρχων served in the second category of office in the bureau of the εἰδικόν as described by Philotheos and in the *Book of Ceremonies*. The four categories of office were the notaries, ἄρχοντες of the factories, ἑβδομάριοι of the factories and μειζότεροι of the factories. Note OIKONOMIDES, Les listes de préséance byzantines, 317.

The title πριμικήριος is a general one that occurs in many types of office: ecclesiastical, military, judicial, administrative and domestic. See R. GUILLAND, Recherches sur les institutions byzantines, I-II. Berlin 1967, I, 300ff. One problem that arises concerning this title is whether Michael should be seen as πριμικηρίου ἐπὶ τοῦ κοιτῶνος or πριμικηρίου (καὶ) κοιτωνίτου, that is, whether one or two separate titles were intended. DIEHL and EBERSOLT thought two titles were involved, whereas BOCK, DREGER, SCHNITZLER, SCHMIDT, VOLBACH and PLÖTZEK translated the words in the inscription as a single title; see the works cited in note 47 above. DIEHL, Bulicev Sbornik, 442 note 2, pointed out that on seals the chief of the κοιτωνῖται was termed the ἐπὶ τοῦ κοιτῶνος. The κοιτών or sleeping quarters of the Emperor were served by the κοιτωνῖται or private Imperial guards, and they normally were eunuchs. Πριμικήριος is the title used to denote the fifth rank of eunuch as found in the *Treatise of Philotheos* (899), in the *Taktikon Beneševič* (934-44) and in the *Taktikon of the Escorial* (971-5), see OIKONOMIDES, Les listes de préséance byzantines 126, no. 5, 248 line 6, 268 line 24. It seems plausible that Michael was πριμικήριος and that he served as one of the personal guards in the κοιτών of the Emperor. Note R. GUILLAND, Recherches sur les institutions byzantines, I, 178, 202, 269, 351.

50. The exact location of Charlemagne's burial in the Palace Chapel in 814 remains unknown. For a discussion of the problems involved consult E. TEICHMANN, Zur Lage und Geschichte des Grabes Karls des Großen. *Zeitschrift des Aachener Geschichtsvereins* 37 (1915) 141-202; J. BUCHKREMER, Das Grab Karls des Großen. *Ibid.* 29 (1907) 35 onwards; H. BEUMANN, Grab und Thron Karls des Großen zu Aachen, in: Karl der Große, Lebenswerk und Nachleben, IV. Düsseldorf 1967, 9-38; L. THORPE, Two Lives of Charlemagne. Harmondsworth 1969, 84, chapter 31. In the year 1000 the body of Charlemagne was in a burial chamber at Aachen Münster, and Otto III accompanied by Count Lomello clothed the remains in white vestments. See C. CIPOLLA, *Chronicon Novaliciense*, Monumenta Novaliciensia Vetustiora, 2 *(Fonti per la storia d'Italia)*. Rome 1901, III, 32, 197ff. There was no mention of any fabric resembling the Elephant silk.

51. Falke, Ebersolt and Lessing thought that the name Zeuxippos in the inscription should be identified with a weaving factory. O. VON FALKE, Kunstgeschichte der Seidenweberei. Berlin 1921, 24; EBERSOLT, Les arts somptuaires, 78; LESSING, Die Gewebesammlung, caption to plate 67. Lessing read χεηξίππου, but this spelling is not justified on the basis of the letters visible in the

inscription. DIEHL, Bulicev Sbornik, 442 suggested the spelling Ζευξήπου but he thought it might have been possible to read Ζευξίππου instead.

For a discussion of documentary evidence relating to the baths see C. MANGO, The Brazen House. Copenhagen 1959, 40-41; R. JANIN, Constantinople byzantine. 2nd edn. Paris 1964, 222-224. More recently Middle Byzantine occupation of the area around the baths was indicated by R. NAUMANN and H. BELTING, Die Euphemia-Kirche am Hippodrom zu Istanbul (*Istanbuler Forschungen* 25). Berlin 1966.

52. The Elephant silk most often compared to the Aachen Münster Elephant fabric is in the Louvre in Paris and this has an inscription indicating that is was woven before 962. See G. MIGNEON, Un tissu de soie persan du Xe siècle au musée du Louvre. *Syria* 3 (1922) 41-43. The textile is fully analysed in *C.I.E.T.A. Bulletin* 33 (1971) 22-57. The elephants on the Louvre silk, which came from St. Josse sur Mer, are only half the width of the Aachen animals, and the stepping of the outlines is far more marked on the former than on the latter silk. The technical difficulties of producing the St. Josse Elephant silk were nowhere so great as those facing the weavers of the Aachen Elephant silk.

53. Details concerning the weaving of the Aachen Elephant silk are in *C.I.E.T.A. Bulletin* 6 (1961) 29ff.

SPECIAL NOTE

See Koder reference on page 35.

V
Silks and Saints:
The Rider and Peacock Silks
from the Relics of St. Cuthbert

ORE than 2000 fragments of mediæval silk survive in ecclesiastical treasuries and many of them have some connection with the cult of relics. Most of these fragments were taken from reliquaries in the nineteenth century, but unfortunately records were rarely kept. Today it is often no longer possible to associate particular silks with the reliquaries, which are more easily and more precisely datable. Also, much was lost in troubled times such as at the Dissolution of the Monasteries in Britain and the Revolution in France, as well as by the natural deterioration over the centuries of the delicate fabrics themselves. In this country Durham Cathedral alongside Canterbury Cathedral has one of the finest collections of mediæval silks to survive. On the Continent the greatest number of splendid mediæval silks is to be found in the treasuries of Aachen Cathedral, of St. Servatius, Maastricht, and of Sens Cathedral.[1]

From the fourth century, silks were considered appropriate for wrapping the bones of saints, and the sarcophagus of St. Paulinus of Trier (d. 358) has yielded two examples. Naturally the possession of major relics enhanced the prestige of ecclesiastical centres and encouraged the beneficial growth of pilgrimage.[2] Before 1200 it was rare to have a special room set aside as a treasury for housing the numerous precious reliquaries and shrines in which the relics of the saints were preserved. Instead, they were normally associated with particular altars and housed in special chapels in churches, monasteries and cathedrals. For example, at Chur Cathedral,[3] and at the chapel of St. Michael at Le Puy, before the twelfth century, the area beneath the main altar served as a treasury for

reliquaries.[4] At Chur and at Le Puy there was an altar slab, which was placed above a sizeable hollow structure that held reliquaries, relics and silks. The Sancta Sanctorum in the Lateran Palace in Rome had a wooden cupboard with a grille front, through which a variety of wooden and metalwork reliquaries enclosing relics and silks could be seen. This wooden structure was inscribed with the name of Pope Leo III (795-816).[5] At the Abbey of St. Pierre, Sens there was a silver shrine into which relics, including those of St. Peter donated by the Emperor Charlemagne (d. 814), were placed by Archbishop Magnus in 809.[6] Many of the small silk fragments at Sens, datable eighth to ninth centuries, may originally have served as wrappings for relics in this silver shrine.[7] In 1106 the shrine is documented as being behind the main altar at St. Pierre, Sens, but today it and numerous other shrines once at Sens are lost.[8] The relics of St. Victor came to St. Pierre, Sens, from St. Maurice d'Agaune in 769 with Archbishop Willicaire of Sens. Subsequently they were wrapped in an eighth to ninth century Byzantine silk and enclosed in a shrine no longer extant. The relics of St. Siviard, which are said to have reached St. Pierre in the ninth century, were translated into a shrine in 1029. At this time it is likely that the tenth to eleventh century Byzantine griffin silk, which is still at Sens, was added. The relics of the Holy Innocents were wrapped in an eighth to ninth century Central Asian silk at St. Pierre and a later Islamic silk was used to shroud the relics of St. Potentien there. At St. Columbe, Sens, important relics were also enveloped in silk and placed into shrines long since lost. The relics of St. Columbe and of St. Loup were shrouded in two pieces of a Central Asian lion silk datable to the seventh or eighth centuries. This silk must have been cut into two at the time of the simultaneous translation of the relics of the saints under Archbishop Wenilon in 853.[9]

Magnificent golden shrines, studded with precious gems and enamels, were built in the twelfth century to receive the relics of newly-canonized saints. At St. Servatius, Maastricht, for instance, the Servatius shrine held many silks alongside the relics of the patron saint. An eighth to ninth century Byzantine silk with 'Dioscurides' design, an Islamic silk with lion pattern datable tenth to eleventh centuries, and other silks (including a Central Asian piece of the eighth to ninth centuries) were found in the shrine in the late nineteenth century. The twelfth century shrine of St. Heribert, Archbishop of Cologne (d. 1021) at St. Heribert, Cologne-Deutz, held an imperial Byzantine lion silk. This has an inscription yielding the date 976-1025 for the fabric. Another Byzantine silk of the same period with birds and trees was also found in the shrine in the late nineteenth century. From a third twelfth century shrine [that of Anno, Archbishop of Cologne (d. 1075), at St. Servatius, Siegburg] came an imperial Byzantine lion silk. This is precisely datable to 921-23 by its

inscription. The shrine of the Emperor Charlemagne himself (d. 814), which was finished early in the thirteenth century, held a variety of impressive silks including two magnificent imperial Byzantine pieces, an eighth to ninth century example with charioteer design, and a silk of around 1000 AD with medallions enclosing large elephant motifs.[10]

For lesser relics it appears to have been usual to cut small patterned squares of silk. Examples survive at Sens, in a number of Swiss treasuries including Chur and St. Maurice, and at St. Servatius in Maastricht.[11] For reliquary pouches, pieces of patterned silks and plain silks were used, some of the latter being embroidered. Sens Cathedral has one pouch made from a small piece of a purple and olive-green lion silk, which is probably tenth century Byzantine. The Museo Sacro in Rome has a silk reliquary pouch with the design of a figure, perhaps Samson, in combat with a lion; this belongs to an extensive group of Samson silks, most probably Byzantine in origin, which reached the West in the eighth to ninth centuries.[12] St. Servatius, Maastricht, has twenty silk reliquary pouches, most of fourteenth to fifteenth century Italian velvet.[13] Beromünster in Switzerland has a pouch with embroidered foliate design that may be eleventh century Byzantine work[14] and a lion silk pouch, perhaps a ninth to tenth century Byzantine textile sewn in the West.[15] Smaller silk purses at Canterbury Cathedral treasury were probably used for seals.[16] A very small purse from the Viking dig at Coppergate in York was made from a purple silk, perhaps Byzantine, and this suggests that relics may have been carried on the persons of their owners in England in the tenth century.[17]

Thirteenth century ecclesiastical inventories indicate the existence of quite a few reliquary pouches in churches and cathedrals in England at that time. These were termed *theca, bursa and marsupium* in different inventories. Amongst the churches with such pouches were Adbury and Brent Pelham. At Clopton a small silk *bursa* was used as a cover for the host.[18] A splendid silk reliquary pouch in the Germanisches National Museum, Nürnberg, is thought to be eleventh century Byzantine work.[19] Probably some Byzantine pouches, together with relics, did reach the West from Byzantium. However, the careless stitching that is evident on most of the surviving reliquary pouches suggests that they were 'home-sewn' using imported silks.

Sometimes relics wrapped in silks were placed in smaller reliquaries instead of in larger shrines. For instance, an early thirteenth century head reliquary of St. Eustace from Basle Cathedral, now in the British Museum, enclosed several relics wrapped in silk. The head itself consists of a wooden carving with a silver gilt casing. Also, a small enamel cross at St. Servatius, Maastricht, of the late tenth to mid-eleventh centuries, contained a relic wrapped in a scrap of the Dioscurides silk, a larger piece of

which came from the shrine of St. Servatius at Maastricht.[20] No doubt
many unopened metalwork shrines and reliquaries still house both silks
and relics, and of course those reliquaries which are empty today did
originally contain relics, probably wrapped in silks. At Durham it is
fortunate that the coffin-reliquary of St. Cuthbert exists alongside silks
from the relics of the saint.

The use of silks for the relics of St. Cuthbert can be fully understood
only in the context of the widespread use of silks for the relics of saints on
the continent in the mediæval period. Close parallels between Durham
and the continent can be drawn in three respects:

 i. At Durham and abroad silks were considered appropriate for
enveloping the relics of distinguished saints.

 ii. At Durham just as on the continent, a splendid twelfth century
translation of the relics of the patron saint was seen as an
occasion for the addition of further magnificent silks to the
relics.

 iii. At Durham, in the same way as at Chur, at Sens, in the
Rhineland, and in Rome, reliquaries and shrines housing
precious relics wrapped in magnificent silks were set near
high altars, where they formed a focal point for the attention
of visiting pilgrims.

It is beyond the scope of this introductory discussion to describe in
detail the many and varied ecclesiastical uses of silk in the mediæval
church, but it should be mentioned that the main impetus for the
widespread appearance of silks in the Latin church undoubtedly came
from the mediæval papacy.[21] The popes donated thousands of patterned
silks to the churches of Rome for use as hangings, furnishings, vest-
ments, and for decorating manuscript bindings. There can be little doubt
that the 'silken churches of Rome' in the eighth and ninth centuries
especially set an enviable example to major ecclesiastical centres in the
rest of Europe.

Of the silks removed from the relics of St. Cuthbert in 1827 and briefly
described by Raine, I wish to concentrate upon two particular examples.[22]
These are the Rider silk and the Peacock silk, which are examined
separately below.

1. THE RIDER SILK (PLS. 48, 49)

IN 1956 Gerard Brett published the silk with falconer design at Durham under the title of 'the Rider silk' *(Relics,* pp. 470-83). Relying on stylistic, iconographic, and technical evidence, he assigned it to a workshop in Persia and dated it to the late tenth or early eleventh centuries. While it is possible to agree with his dating of the silk, an entirely different centre for its weaving will be proposed.

The main problem in reconstructing the design on the silk lies in the fact that much of the pattern has worn away as it was printed on to the surface of the fabric and not woven in. Brett relied on a painted photograph of 1888 (Victoria and Albert Museum no. 1626-1888) for reconstructing the design on the silk but this has misleadingly hard outlines, and may have led him to draw unsatisfactory stylistic parallels with other works of art, as will be discussed below. My reconstruction of the design (FIGS. 11A AND 11B) has been drawn using a particularly clear photograph of the silk at the Victoria and Albert Museum (M2157), in conjunction with what I have observed from the remaining sections of pattern on the silk itself in the Monks' Dormitory at Durham Cathedral.

On the pastiche of six fragments which make up the Rider silk, two lobed octagonal shapes enclosing a mounted falconer appear. The octagons have pearl edging and are set side by side across the silk. They are separated by a tear-shaped, foliate, decorative motif that also occurs on

FIGURE 11A RECONSTRUCTED DESIGN OF THE RIDER SILK

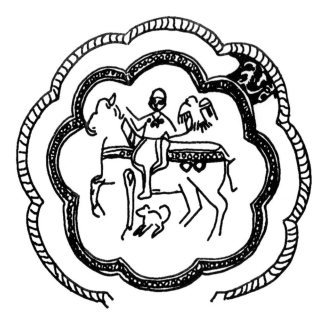

FIGURE 11B DURHAM RIDER SILK: SKETCH OF THE MAIN PART OF THE DESIGN

its side at intervals in the area below the two octagons. Beneath are two
horizontal bands of ornament. The upper band with guilloche edging
encloses a series of linear ornaments. The lower band shows small hares
facing to the left in a repeated series. The falconer within the lobed octagon
faces to the left and carries the bird of prey on his raised left arm. He wears
a short tunic that reaches just below the knee. His horse has a compli-
cated bridle and decorative trappings that are hung with jewels and
studded with pearls. The joints of the limbs of the animal are marked by
small circular designs.

The origin of the falconer motif is probably Near Eastern, although the
sport itself was known from the fifth century onwards in Byzantium as
well as in the Arab and the Latin worlds. The widespread popularity of the
sport perhaps explains why falconer scenes were represented in the art
of many cultures from an early date.[23] At Argos in the Peloponnese for
example, there is a falconer mosaic on the floor of a villa, and this has been
dated to c. 500 on stylistic grounds. In this mosaic, it is a small standing
figure who carries the falcon. At Klinte Oland, on a carved stone, the
hunter is mounted. Further mounted falconers appear on Viking sculp-
tures situated in the north of England.[24] Brett draws particular attention
to the iconography of the falconer as it appears on works of art that he
considers to be Persian, but the parallels he draws are not always wholly
convincing.

Brett described a series of eight metal plates thought to be Persian, one from Outemilski, one from an unknown site and today lost, the rest from the Perm region. Brett freely admits that there is no firm evidence for dating any of these.[25] He relies on the fact that two were excavated in Central Asian sites to suggest Persian provenance for all eight dishes, but this seems a poor argument, as they may have been imported works rather than dishes produced locally. No details of the excavations at Outemilski or in the Perm region are discussed to allow the reader to reach a firm conclusion on this question, but quite apart from the lack of circumstantial evidence, the iconographic and stylistic parallels that can be drawn between the Durham falconer motif and the falconer designs on the dishes are of little real value. This is because the falconer motif as it appears on the dishes presents a rendering a great deal cruder than that of the motif on the Durham silk. The dishes from the Perm area (figs. 3 and 4 on pl. XLIX in Brett) show very disproportionate and distorted riders on horses rendered as no more than flat 'wooden' creatures. The horses show none of the bridle or decorative trappings found on the Durham falconer design. The falcons held by the hunters on the dishes are portrayed in a scanty manner with none of the detail found on the Durham silk, where individual feathers are indicated. The falconer in figure 5 of Brett's plate XLIX is shown with more detail but the piece is labelled 'provenance and present owner unknown', so there is no information that can help either with date or provenance for the Durham silk. The Outemilski silver dish, now in the Hermitage in Leningrad (Brett's pl. XLVIII), is the finest of the dishes, but even here the proportions of the mounted falconer are different from those on the Durham silk, the rider being much larger than on the silk. Also, his falcon appears in profile whereas the bird is shown in three-quarter view on the silk. The decorative trappings on the horse of this silver dish do not specifically show jewels including pearls, and they are like those on the Durham silk.

The most significant difference between the Durham and the Outemilski iconography, a point overlooked by Brett, is the fact that only the latter shows a rider with stirrups. There are no stirrups on the design of the silk at Durham. Stirrups were used from the sixth century onwards, but it is curious that artists very rarely depicted them on works of art before the thirteenth century. The large group of Byzantine and Islamic hunter silks of the eighth to ninth centuries, with one exception only, show mounted hunters without stirrups.[26] Stirrups occur only on an imperial Byzantine hunter silk of the eighth century from Mozac, now in the Textile Museum at Lyons.[27] Perhaps the artists thought it would have been inappropriate to show their emperor mounted on a horse without this vital piece of fighting equipment.

Returning to the silver dishes described by Brett, it has to be said that a firmer chronology for the series is required before useful parallels with the Durham silk can be made. Perhaps Brett was misled into comparing some of the cruder dishes with the silk because he worked from the painted photograph of 1888: here the Durham Rider does have a some-what crude outline. A falconer silk in the Detroit Institute of Fine Arts is also cited by Brett as a parallel for the Durham Rider silk.[28] (Another piece of the Detroit falconer silk is at Columbia Textile museum and a third is housed at the Abegg Stiftung in Bern.) This silk does show a stirrup. Stylistically as well as technically it belongs no earlier than the late twelfth to early thirteenth centuries. Before discussing the design on this silk some explanation of its weave is necessary. The Detroit/Columbia/Abegg Falconer silk is woven in what has been termed a *triple weave*.[29] The weave of the Rider silk is *twill* with paired main warps.[30] The triple weave divides the warp into three parts so that three textiles, one above another, are produced simultaneously. The three textiles change position as required by the pattern. The twill weave of the Durham Rider silk is typical of Eastern Mediterranean silks of the eighth or ninth to twelfth centuries. A twill is a weave based on three or more ends (warp or vertical threads) and three or more adjacent picks (weft or horizontal threads). Each end passes over two or more adjacent picks and under the next one or more, or under two or more adjacent picks and over the next one or more. The twill is termed weft-faced if the ends predominate on the surface of the weave and warp faced if the picks take precedence. The Durham silk is a weft-faced twill. Twills of the Durham type are 'one layer' fabrics, but between the two sides of the textile there are paired vertical threads which do not appear either on the obverse or on the reverse of the fabric. These are called *main warps*. They are indicated in a diagram of twill weave (PL. 1). The main warps were raised or lowered to allow the correct passage of the weft to the front or the back of the textile according to the requirements of the design. A special pattern-producing device attached to the loom was operated by one or more weaving assistants, and this controlled the main warps.

Double and triple cloths were the speciality of Persian weavers in the Middle Ages, judging by the extant material.[31] Double cloths are related to triple cloths previously described. Just as triple cloths have three layers above one another, double cloths have two textiles one above the other. An example of a double cloth said to have come from a grave in Teheran is now in the Abegg Stiftung in Bern and this shows a falconer.[32] The latter silk, like the Detroit/Columbia/Abegg Falconer silk discussed above, shows a mounted falconer with bird depicted in profile. Neither shows the type of three-quarter falcon with outspread wings noted on the Durham Rider silk. The falconers on the Persian examples are unlike the Durham Falconer, in that they wear more elaborate costumes with patterned boots

and they are larger in proportion to their horses than is the rider on the Durham silk. The stirrup appears on both Persian Falconer silks but, as was noted earlier, it does not appear on the Durham silk. The saddle cloths on the Persian silks are heavily patterned; and they are large saddles in comparison to the small, unpatterned saddle of the Durham Rider silk. The treatment of individual features of the Persian horses differs from that found on the Durham Rider silk. For example, the tail of the horse on the Durham silk is tied but left to hang, whereas on the Persian piece the horses' tails are tied up high. The entire setting of the falconer scene is different on the Persian silks from the setting of the Durham Rider silk. The lobed octagons filled with the falconer motif on the Durham silk contrast with the paired falconers that mirror image one another about a central tree motif on the Persian silks. The Persian triple cloth has an octagonal border but it is not of the lobed type found at Durham. The Persian double cloth places the whole scene in an irregular, angular geometric border, quite unlike what is found on the Durham silk. The elaborate foliage that accompanies the scenes on the Persian silks finds no counterpart on the Durham silk.

The iconography and style of the Persian Falconer silks described above is not close enough to conclude that either has a direct bearing on the date or provenance of the Durham silk. Indeed, a not inconsiderable number of so-called Persian silks at the Abegg Foundation have been tested and it is believed that traces of nineteenth century aniline dye have been found on them, so that some authorities have declared them to be forgeries.[33]

Parallels for the falconer iconography outside Persia are not hard to find. For example, there is a splendid vestment with embroidered falconer motifs at Bamberg Cathedral treasury, which is thought to be Byzantine work of the eleventh century.[34] Here the crowned Byzantine emperor holds a falcon shown in three-quarter view with its wings outspread. The bird on the Durham silk is in the same pose. The pearled and jewelled trappings of the imperial horse bring to mind those on the Durham silk, and the small dog shown on the Bamberg embroidery in the area in front of the forelegs of the horse finds a parallel on the Durham silk. Although the dog is a feature hard to see with the naked eye on the silk itself in its present state of conservation, it has been painted on the photograph at the Victoria and Albert Museum (1626-1888). It must have been more visible in 1888 when the photograph was taken. On the Durham silk, the hunting dog appears in the area between the fore and the hind legs of the horse. On a Spanish embroidery in Fermo the falconer with his hunting dog appears in a number of slightly differing versions, each in some way comparable to the falconer motif of the Durham silk. Indeed the art of

Spain furnishes many close parallels for the Durham falconer iconography.[35]

The elaborately embroidered chasuble at Fermo has an inscription that says it was made in Almeira in 1116. The significance of Almeira as a silk-weaving centre of Spain will be discussed more fully below as a conclusion to this article. At present it is sufficient to point out the close iconographic and stylistic similarities between this Spanish piece and the Durham Rider silk. Both the printed silk and the embroidered piece have designs that give the impression of being almost 'cut out' of a precious gold metal. The riders on the embroidery as on the silk are in proportion to their horses, and these are sturdy creatures like the Durham Rider silk's horse. The falconers in all cases wear short tunics and show no sign of having stirrups. They carry their birds of prey in their left hands. The Fermo falcons are, nevertheless, shown in profile and not in three-quarter pose as on the Durham silk. The lobed octagonal setting of the Durham silk cannot be paralleled on the Fermo chasuble either. The embroidery is set with interlinking medallions. Another Spanish embroidery less refined in style, with the falconer set in lobed octagons, came from St. Lazare in Autun, and on stylistic grounds it has been dated to the eleventh century.[36] This embroidery shows a mounted falconer wearing a short tunic and a pointed hat. His falcon appears in profile and he holds a stick in one hand. His horse has a distorted and over-elongated, thickly set body and head, and it wears jewelled, decorative trappings like those of the Durham Rider silk.

The most convincing parallels for the 'falconer in lobed octagonal setting' iconography that I have discovered so far are on a series of tenth to eleventh century Spanish ivory caskets. These are particularly valuable works of art to use for comparative purposes because they are precisely datable through their various inscriptions. The inscriptions also suggest where some were made. One of these caskets is in Pamplona Cathedral treasury and its inscription proves that it was made for Abd al-Malik, son of al-Mansur, in 1104-5.[37] Another of these caskets, today in the Victoria and Albert Museum, London (368-1880), was made for Ziyad ibn Aflah, the prefect of police at Cordoba in 969-70.[38] A third casket with the falconer iconography was made for the Prince al-Mughira, son of the caliph Abd al Rahman III, in 968, and this today is in the Louvre Museum in Paris.[39] All three caskets portray a mounted falconer carrying a bird of prey on his raised left arm. The bird appears in strict profile on the Ziyad ibn Aflah casket; but it is turned towards the spectator on the other two caskets and the wings are extended instead of at rest, particularly on the casket made for Prince al-Mughira in 968. There were probably two iconographical traditions for the pose of the falcon; one that showed the bird in profile with wings at rest, and the other that showed a threequarter

view with wings outspread. These two types of bird are found on Byzantine examples of the falconer iconography. The falcon with outspread wings is seen on the embroidered chasuble at Bamberg Cathedral, which has already been described. A falcon in profile with lowered wings occurs on a Byzantine enamel plaque, stylistically datable to the early eleventh century. This plaque is from the Pala d'Oro at St. Mark's in Venice.[40]

The actual placing of the falconer motif in the lobed octagons is very similar on the Durham Rider silk and on the Spanish ivory caskets under discussion. In both cases the rider fills up the entire octagon, the bird's head touching one of the edges of the lobed structure itself. On the caskets, as on the silk, the rider is rendered in proportion to his mount. The horses of the caskets and of the Durham Rider silk are close in type, with sturdy bodies and thickset necks; they are similarly decorated with ornamental jewelled trappings. The extensive mane combed down over the neck of the horse on the Louvre casket and its looped, hanging tail are features that may be compared particularly closely with the Durham Rider silk. On the Durham silk and the caskets alike the riders themselves wear short tunics and do not have stirrups.

The Spanish ivory caskets are intimately connected with the caliphs of the Umayyad house of southern Spain. The Louvre casket was made for the son of the Umayyad Caliph Abd al Rahman III (929-61) in 968 in a palace workshop of Cordoba, according to its inscription. The casket of the prefect of police in the Victoria and Albert Museum has an inscription that yields a date of 969-70 for its manufacture, but Beckwith assigns this piece not to a court workshop, but to a commercial workshop of Cordoba, basing his view on the fact that the style of the carvings is coarser than that of the royal caskets.[41] He also noted that the scene on the casket that shows the sovereign enthroned on a divan and surrounded by attendants, was an adaptation of a Persian scene familiar on Sassanian metalwork. The concept of Persian influence in Spain is interesting in the light of Brett's attribution of the Durham Rider silk to Persia. Might it not be argued that the Persian elements detected by Brett represent no more than Persian influence in Spain? Indeed several authors have pointed to specific Persian influences in Spain, not least in silk weaving workshops themselves. Certainly Spanish weavers were not above falsely attributing to Baghdad the silks that they wove locally. No doubt Persia had its tradition of falconer iconography, as demonstrated by the appearance of this motif (albeit in somewhat crude form), on the tenth century pottery dishes of Nishapur; but neither Persian plates nor Persian silks provide as convincing a parallel for the Durham Rider motif as do the designs of the Spanish ivory caskets under discussion.[42] The Victoria and Albert Museum casket and the Louvre caskets were made in Corboda. The

possibility of the Durham silk being made in a workshop of that city will be discussed more fully below.[43]

The technique of the Durham Rider silk cannot be closely examined whilst the silk remains under glass, but Brett thought that the gold was printed onto a resinous base. Accepting that this is so, it must be said that few gold printed silks of any kind survive, although the technique was known in ancient times in China and later in Persia, Egypt and elsewhere. In China a splendid silk garment decorated in 'gold and silver dust' came from a Han tomb datable between 193 and 141 BC at Changsha. The funerary ornaments from the tomb recorded the family name Tai, and three generations of this family are recorded between the dates 193-141 BC. Unfortunately, the silk is only scantily published.[44] At Astana, seventh to eighth century block printed silks were excavated.[45] There is a literary reference to printed stuffs from Tabaristan dated 1025, as Brett remarked, and there are printed silks from the Cave of the Thousand Buddhas at Tun-huang, walled up in the early eleventh century.[46] In Coptic Egypt resist-dye techniques incorporated printing on occasion.[47] There is one enigmatic printed mediæval fabric from Halberstadt Cathedral with a peculiar iconography showing a figure being carried aloft by an eagle. Lessing identified the subject with a scene from the legend of Ganymede and assigned the piece to sixth to seventh century Sassanian Persia. Herzfeld and Migeon also drew parallels with Persian subject matter, and Migeon agreed with Lessing that the fabric was a Sassanian textile. However, it may be profitable to compare the printed Halberstadt piece with a silk of the Cluny Museum (21.872), showing a prince carried aloft by an eagle, as Ackermann has done more recently. In style and technique the latter silk cannot be seen as a Sassanian piece: it and the Halberstadt fabric probably belong to the eleventh to twelfth centuries rather than earlier. Persian provenance has been suggested by Ackermann for the Cluny silk on technical and stylistic grounds, but whether the Halberstadt piece was printed in Persia, or in a centre under Persian influence, remains to be seen.[48]

The actual weave of the Durham Rider silk, a paired main warp twill, is not useful for fine dating of the piece; for as discussed earlier, twills of this nature were widely woven from the ninth to the twelfth centuries. Nevertheless, the pairing of the main warp, as opposed to the use of single main warp, should be noted as a development of the eighth to ninth centuries; and it may be linked to a desire for weaving more complex patterns on wider looms when additional strengthening of these warps would be required.[49]

A final point on technique is that Brett noted uncertainties in the printing on the Durham Rider silk. He concluded that the silk was a pre-Seljuk piece, bearing 'all the marks of an experiment by a provincial

craftsman in an unaccustomed technique'.[50] Such a conclusion would accord equally well with the hypothesis that the silk was produced in Spain in the tenth to eleventh centuries at a time when in all probability the technique of silk printing was a new introduction. It was most probably added to the relics of St. Cuthbert at the time of the translation in 1104.

2. THE PEACOCK SILK (PLS. 50,51)

THE design on the Peacock silk is woven rather than printed: for this reason it has survived more clearly than that of the Rider silk. Even so, it is helpful to refer to a nineteenth century drawing of the Department of Textiles in the Victoria and Albert Museum, London.[51] The colours of the Peacock silk, now all but faded to brownish tones, were originally blue, red, and yellow, so that the overall effect must have been quite brilliant. The silk has a frontal view of double-headed peacocks as its motif. These nimbed birds are set in oval shapes with pairs of seated griffins in the interspaces. Flanagan, who published an account of the silk in 1956, freely admitted that there was little evidence for assigning a date or provenance to it. On grounds of its stylistic affinities with Byzantine silks, especially those of the eleventh century, he was inclined to regard it as a Byzantine silk woven at that period, The occurrence of a pseudo-Kufic inscription on the breasts of the peacocks seemed to corroborate this insofar as it seemed to him to make an Islamic provenance unlikely.[52] In fact both pseudo-Kufic and legible Kufic inscriptions occur on Byzantine as well as Islamic works of art, as several authors have demonstrated.[53] Also, I have found pseudo-Kufic inscriptions on silk from the tomb of Archbishop Hubert Walter (d. 1205) at Canterbury Cathedral Chapter Library, and this, stylistically and technically, belongs with an extensive group of twelfth to thirteenth century Spanish silks.[54]

Iconographically speaking, there are only two silks that can be compared with the Durham Peacock silk: both can be shown to be Spanish (FIG. 12). Only on these two silks are double-headed peacocks depicted. They are:

 i. a Peacock silk from the grave of Alfonso VII, king of Castile (1126-57), at Toledo;[55]

 ii. a Peacock silk fragment in the Museum of Historical Textiles
 in Lyons, probably from the larger Peacock silk in the parish
 church of Thuir in the French Pyrenees.[56]
On both silks the double-headed birds clasp captive gazelles in their
talons, and distinctive ogee foliate motifs occur between rows of the
design. It is a characteristic 'peacock eye' tail feather which marks out the
double-headed birds on the two silks as peacocks. This feather occurs
above the heads of the birds on the Toledo silk as if the tail is held up. On
the Lyons/Thuir silk the distinctive 'peacock eye' tail feathers appear on
the extensive tail which is extended down below the body of the bird. These

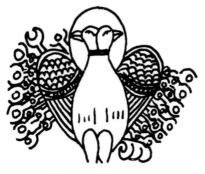

DURHAM CATHEDRAL

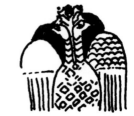

SILK FROM THE TOMB OF ALFONSO VII,
TOLEDO CATHEDRAL: TAIL HELD ABOVE

LYONS, MUSÉE HISTORIQUE DES TISSUS,
AND THUIR PARISH CHURCH

FIGURE 12 BICEPHAL PEACOCK SILKS WITH "PEACOCK EYE" TAIL FEATHERS

feathers have small circular eye markings. On the Durham Peacock silk, the peacock tail is fanned out and forms a semicircular shape encompassing the bird. The 'peacock eye' tail feathers are very prominent, and the small circular eyes of the feathers are joined together by narrow shafts representing the spines of the feathers. The 'peacock eye' tail feathers on the Toledo and the Lyons/Thuir silks have been quite overlooked by textile historians so that these birds have incorrectly been identified as eagles.

The fact that the Toledo and the Lyons/Thuir silks were found on Spanish soil suggests they may well be locally woven pieces. This idea is supported by the fact that they belong to an extensive group of silks, found chiefly on Spanish soil, which display a peculiarly Spanish iconography. The group of silks to which they belong has as the design motif double-headed eagles (the tail feathers are oblong without the 'peacock eye' marking), and these birds of prey clasp captive gazelles in their talons. Amongst silks of the group are the following pieces:

 i. A silk from the reliquary of the early Christian martyr St. Librada at Siguenza;[57]

 ii. a silk from the shrine of St. Anno (d. 1075), whose relics were translated into a splendid twelfth century shrine at St. Servatius, Siegburg;

 iii. a silk of the Kunstgewerbemuseum, Berlin (1881-474a and b),[58] closely related to ii;

 iv. a silk today lost, once at Quedlinburg Cathedral, formerly Berlin (1882-1170).[59]

All these silks are woven in what is called a lampas weave with 'tabby, tabby' binding. This weave has been defined by C.I.E.T.A. as one 'used exclusively for figured textiles in which a pattern, composed of weft floats bound by a binding warp, is added to a ground fabric formed by a main warp and a main weft.' On the silks under discussion the ground is tabby weave and the wefts forming the pattern are bound by the ends of the binding warp in a tabby binding that is supplementary to the ground weave. Shepherd has brought together about fifty-five silks of this weave, of which she has published some fourteen examples: she calls them Spanish lampas weave silks on the basis of circumstantial, technical, stylistic, and iconographic evidence.[60]

The Spanish lampas weave silks that Shepherd described do not have bird and gazelle motifs exclusively. A great variety of designs including paired quadrupeds and foliate ornament are amongst the designs on the silks. Detailed publication of the 'double-headed eagle clasping gazelle' motif silks themselves has still to be made. Certainly Shepherd would assign these to Spain. Grönwoldt considers that the silk from the tomb of Peter Lombard (d. 1160 or 1164) from St. Marcel, Paris, now Cluny

Museum (no. 13 286) — a 'tabby, tabby' lampas weave silk with freestanding bird and freestanding gazelle motifs as well as foliate ogees — belongs with the group, but she is unwilling to commit herself to definite provenance for the silk.[61] Without drawing specific stylistic or iconographic parallels, Plötzek suggests that the Siegburg 'double-headed eagle clasping gazelle' silk is a Sicilian piece. Perhaps this view was influenced by the presence of a bird and gazelle 'tabby, tabby' lampas weave silk in the tomb of Henry VI at Palermo (now British Museum, Department of Medieval and Later Antiquities 78, 9-7, 4).[62] However, the latter silk, like the Peter Lombard silk described by Grönwoldt, shows only freestanding birds and freestanding gazelles. It does not directly belong to the 'double-headed eagle grasping gazelle group'. The birds are not only freestanding on those silks but they have only one head. The evidence for Sicilian silk weaving is in any event problematic, through there being a distinct lack of silks that can definitely or even reasonably be proved to have come from Sicily.

Only one silk, a brocaded twill fabric in the Kestner Museum, Hanover (inv. 3875), can be reasonably proved to come from twelfth century Sicily.[63] This fragmentary silk shows part of a medallion design with paired quadrupeds, perhaps lions. It has a Latin inscription that reads 'made in a workshop of the realm'. This has been identified as the workshop of Roger II, established in Palermo in 1147 using Greek weavers captured in Thebes and Corinth, and probably also employing native Islamic silk weavers. The Hannover silk is quite distinct from other twelfth century twills in using pale pastel shades, mainly light blue and purple. In no way does it bring to mind either the Durham Peacock silk or the Peacock silks of the lampas group studied by Shepherd. Serjeant has brought together the documentary evidence for silk weaving in Sicily, indicating there was certainly much silk weaving in Palermo. There was an Islamic state weaving factory in Palermo in 978, and the first Latin silk weaving workshop was established by Roger II in the same city after his capture of the city in 1147. The city is further documented as having an Islamic *tiraz* factory in 1184.[64] The problem is that none of the silks woven there or elsewhere on the island were described in sufficient detail for surviving silks to be called Sicilian on the basis of their designs. On the available evidence there is no reason to assign the 'tabby, tabby' lampas weave silks to Sicily rather than to Spain, especially as the 'eagle grasping gazelle' motif is found on dated Spanish works of art. For instance the motif occurs on a marble basin in the Museo Arqueologico Nacional in Madrid. The basin came from Medina az Zahira, and has an inscription that indicates it was made for Almanzor, the minister of Caliph Hisham II of Cordoba in 987-88.[65]

Single-headed peacocks are of course a common motif in all media from an early date. Examples are preserved at San Vitale in Ravenna; on different pieces of Sassanian metalwork; on a seventh to eighth century Eastern Mediterranean silk at Aachen Cathedral; on a twelfth century silk (perhaps Islamic) at Canterbury Cathedral; and on a tenth to eleventh century silk (perhaps Byzantine) at the Abegg Stiftung in Bern. The latter silk has been compared to the magnificent Byzantine Eagle silks at Auxerre and Brixen, which can be dated around 1000 AD on stylistic grounds.[66] In Spain a good example of the frontal peacock, albeit without nimbus, occurs on one of the caskets discussed earlier in connection with the Durham Rider silk. This is the Louvre casket, which was made for the Prince al-Mughira, son of the Caliph Abd al-Rahman III in 968. This peacock is situated in an upper spandrel between lobed octagons of the casket. It is particularly close to the Durham Peacock silk motif in that it has a fanned-out tail that makes a large semicircle enclosing the entire bird. Also the manner of depicting the 'peacock eye' feathers on the silk and on the ivory is very close. Circular patterns are joined by narrow shafts that represent the spine of the feathers, both on the ivory and on the silk.[67] Apart from the lack of nimbus and second head, the peacock on the Spanish casket is a perfect parallel for the Durham Peacock silk. I should like to propose that the weaver or weavers of the Durham Peacock silk followed an iconography that was an amalgamation of the frontal peacock with the double-headed eagle type, and that the development of the double-headed peacock motif was an essentially Spanish phenomenon. There is no sign from surviving works of art that the double-headed peacock was a type known in antiquity which had been transmitted down the ages.

The dating of the Durham Peacock silk must in part rely on the terminus ante quem of 1104, set by the fact that the coffin-reliquary does not seem to have been reopened after the translation of the relics at that date. A late eleventh century date for the Durham silk is not unacceptable, if one sees it as a silk added to the relics for the translation in 1104, but the presence of a thirteenth century ring amongst the relics must open up the possibility that there was an undocumented thirteenth century 'recognition' at Durham.[68] If further evidence should come to light in support of this idea, it would be possible to consider that the Durham Peacock silk might have been made later in the twelfth century. The question of where exactly it could have been woven forms the subject of my conclusion below.

3. CONCLUSION

ASSIGNING any textile provenance without the evidence of a woven inscription is difficult. In the case of the Durham Rider silk, the close stylistic and iconographic parallels found with ivories from Cordoba makes it tempting to say that the Rider silk was made in a workshop of that city in the tenth to eleventh centuries. The Peacock silk, an eleventh to twelfth century fabric, may have been woven elsewhere. Serjeant has brought together the main references to silk weaving in Spain, which may be briefly considered here.[69] Serjeant saw as Persian the origin of the state weaving factory or *tiraz* that produced inscribed silks, largely for distribution to distinguished civil servants. Reference to *tiraz* workshops in Spain under the Umayyad occur first in Ibn Dhaldun (1332-1406), but the earliest such workshop was probably established in Cordoba under Abd al Rahman I in 821. It certainly flourished there under Abd al-Rahman III (912-61) and May has found fine *tiraz* of Cordoba listed in a Portuguese document of 1090.[70] Sometimes *tiraz* robes of honour were presented to Christian princes who were guests in Cordoba during the time of the Umayyads. May cites the example of Ordono IV, King of Leon, Asturias and Galicia, at the court of al-Hakam II in 962, who received a tunic of 'gold tissue'. It is particularly interesting to note that, in 970, the embassy of the count of Barcelona, Borrell I, to the Caliph of Cordoba, saw the exchange of silk gifts. Borrell presented beautiful silk clothes to the caliph and the latter gave sumptuous Cordoba silks to the Spanish ambassador on his return home in 971.[71] Evidently there was plenty of scope for the transmission of Cordoban artistic influence in Spain.

By the eleventh century Cordoba was no longer the leading silk weaving city of Spain. Almeira in particular had risen in prominence and silks were exported from Almeira to Christian countries. The Fermo chasuble mentioned above was a product of Almeira in 1116 and may well have reached Italy by way of trade: otherwise it might have been captured as booty and later transported abroad when Almeira fell to the Christians in 1147. Shepherd has postulated that the 'tabby, tabby' lampas weave silks described above may have been woven in Almeira in the eleventh to twelfth centuries. This seems a possible centre also for the weaving of the Durham Peacock silk. There were *tiraz* factories at Basta, Finyana, Seville and Malaga; and Toledo had silk weavers, although there are not many references to the types of silk woven there.

In conjunction with the other silks discovered in the coffin-reliquary of St. Cuthbert, the Rider and the Peacock silks demonstrate the acqui-

sition of impressive textiles, both Byzantine and Islamic, over a period spanning six centuries or more. The presence of an imperial Byzantine example, the Nature Goddess silk, which could have arrived only as a diplomatic gift (for the export of such silks was forbidden), emphasizes the royal and other aristocratic patronage that the relics of St. Cuthbert attracted. This silk at least must have been donated by a royal patron, who had received it as a gift from Byzantium.[72] The silks at Durham pay homage to the reverence in which the relics of St. Cuthbert were held, and as magnificent works of art in their own right they deserve far greater attention than they have thus far received. The silks at Durham are truly amongst the most impressive mediæval textiles to survive in Europe.

WEAVE AND SIZE OF REPEAT

ON THE DURHAM RIDER AND PEACOCK SILKS

Both silks are under glass. The lighting in the Monk's Dormitory, where the silks are housed, does not allow for a thorough technical analysis of the fabrics. Only details that can be fairly accurately gauged appear here. It is hoped a full technical analysis as recommended by C.I.E.T.A. may be made at a later stage if the silks are remounted.

RIDER SILK

Six fragments stuck down together measuring 87 x 62 cm (w. x l.)

Weave: Paired main warp twill 1.2, (Direction S)
Warps: 1 binding, Z, silk, yellow.
 2 main, Z, silk, yellow.
Wefts: Little twist, single yellow silk.
Selvedge: 3 cord, linen.
Width of pattern repeat including lobes: 39 cm (31.5 + 7.5 cm)
Length of repeat of hares: 6 cm.
Width of border strip with guilloche edging: 7.5 cm.
Length of geometric repeat within this border: c. 11.5 cm.

PEACOCK SILK
 Total size 61 x 64 cm (w. x l.)
Weave: Paired main warp twill 1.2, (Direction S).
Warps: 1 binding, firm Z, silk, yellow-brown.
 2 main, firm Z, silk, yellow-brown. (c. 14 pairs of main warps
 per cm.)
Wefts: Little twist, single, red, greenish-blue, and perhaps originally
 golden yellow, silk.
Width of pattern repeat (half roundel): 13 cm and 14.5 cm (size varies)
Length of pattern repeat: c. 39 cm.
(Stepping over either 1 or 2 warps and across 4 wefts in most cases)

NOTES

1. More than 1000 of the surviving silks are studied in A. Muthesius, 'Eastern Silks
 in Western Shrines and Treasuries before 1200 AD' (unpublished PhD thesis,
 University of London [Courtauld Institute], 1982), hereafter referred to as
 Muthesius, 'Eastern Silks'. My introductory discussion on silks used for
 wrapping relics is taken from the thesis, pp. 264-8. Further liturgical uses of
 silk are discussed on pp. 268-305 of this thesis. For the silks in the treasuries
 of Aachen Cathedral, of St. Servatius, Maastricht, and of Sens Cathedral
 treasury respectively, the reader is referred to the following publications:
 *Aachen Cathedral treasury:*An incomplete catalogue of the silks appears in
 E. Grimme, 'Der Aachener Domschatz', *Aachener Kunstblätter*42 (1972), pp. 1-
 400. Silks not described here appear in Muthesius, 'Eastern Silks', pp. 4, 69,
 394, 405, 435, 470-1, 495, 509-10. There are thirty one early mediæval silks in
 the treasury at Aachen and several hundred later silks including vestments.
 St. Servatius, Maastricht: More than 450 silks survive in this treasury. A
 preliminary catalogue with photographs was prepared by the author in 1980.
 Some of the early mediæval examples are in Muthesius, 'Eastern Silks', pp.
 51ff., 93ff., 217ff., 236ff., 392-3, 396, 411, 423, 426, 433, 435, 437, 454, 482-
 3, 500, 553, 564, 577. Reference to earlier literature on a few individual silks
 of the collection which have been published is included amongst the pages cited
 above. A brief catalogue of the collection has since been assembled by A.
 Stauffer, *Die Mittelalterliche Textilien von St. Servatius in Maastricht* (Riggisberg
 1991). The collection is also discussed in A. Muthesius, A History of Byzantine
 Silk Weaving (forthcoming).
 Sens Cathedral treasury: More than 500 silks, most datable before 1200,
 survive in this major mediæval treasury. The silks in part were listed and

described (without technical detail) by E. Chartraire, 'Les tissus anciens du trésor de la cathédrale de Sens', *Revue de l'Art Chrétien* 61 (Paris, 1911), pp. 261-80, 370-86. A fuller preliminary catalogue of the entire collection at Sens Cathedral has been made by the author.

The Durham Cathedral silks from the relics of St. Cuthbert were briefly described by Raine, *St. Cuthbert*, pp. 194-7. Flanagan and Brett discussed the silks in greater detail in *Relics*, pp. 484-525, 470-83. The mediæval silks at Canterbury Cathedral were published by G. Robinson and H. Urquhart with weaving notes by A. Hindson, 'Seal Bags in the Treasury of the Cathedral Church of Canterbury', *Archaeologia* 84 (1934), pp. 163-211.

2. On the cult of relics in general there are interesting points in J. Sumption, *Pilgrimage: An Image of Medieval Religion* (London, 1975), pp. 22-53. A short essay on mediæval treasuries by F. J. Rönig, 'Die Schatz und Heiltumskammern', is in the exhibition catalogue *Rhein und Maas* (2 vols., Köln, 1972), 11, 134-41. The St. Paulinus silks are in W. Reusch, *Frühchristliche Zeugnisse im Einzugsgebiet von Rhein und Mosel* (Trier, 1965), p. 179, pls. 3a, b.

3. The altar at Chur was studied by C. Caminada, 'Der Hochalter der Kathedrale von Chur', *Zeitschrift für Schweizerische Archaologie und Kunstgeschichte* 7 (1945), p. 23ff.

4. The altar at Le Puy was detailed by F. Enaud, 'Découverte d'objets et de reliquaires à Saint Michel d'Aiguille (Haute-Loire)', *Les Monuments Historiques de la France* n. s. 7 (1961).

5. The wooden reliquary structure at the Sancta Sanctorum was examined by H. Grisar in *Die Römische Kapelle Sancta Sanctorum und ihr Schatz* (Freiburg, 1908), pp. 1ff., pl. 1, 15, 55ff., pl. 29.

6. See Chartraire, op. cit., p. 268. The report was made by Archbishop Guy of Nogers in 1192.

7. For example, ibid., nos. 1 and 2 on p. 270. Chartraire does not list the majority of the tiny patterned silk scraps at Sens Cathedral treasury. Cf. Muthesius, "Eastern Silks', pp. 445-7, 458-9, 464, 490-1, 516, 532, 540-1, 555, 566-7, 569-71, 575 for fuller discussion of some of the Sens silks. Others are briefly listed on pp. 390-92, 393, 397-400, 413-14, 423-4, 436, 438.

8. The thirteenth century account of the relics at St. Pierre, Sens, by Geoffrey de Courlon was published as *Libellus supa reliquiis monasteri Sancti Gaufridi de Gellone*, in *Documents publiés par la Société Archéologique de Sens, no. 1* (Sens, 1876).

9. At the time of the French Revolution, relics and silks of St. Columbe were deposited in Sens Cathedral. In 1844 a casket containing anonymous relics was taken from the abbey of St. Pierre, Sens, to Sens Cathedral treasury. It was from this casket that in 1896 many silks were taken. They had been used to envelop the individual relics. The vast collection of mediæval silks at Sens Cathedral today therefore represents pieces originally in the abbey of St. Pierre, a few silks from St. Columbe, Sens, and pieces belonging to the cathedral itself.

10. The canonization of saints in the twelfth century led to a spurt in the growth of some major continental treasuries, at which time elaborate and costly shrines were built to receive their relics. Impressive, inscribed imperial Byzantine lion silks were used for the relics of important saints, such as Heribert, archbishop

of Cologne (d. 1021) and Anno, archbishop of Cologne (d. 1075). The silks were added to the relics at the time of the translation of the respective relics into magnificent twelfth century shrines. These and related lion silks are described in A. Muthesius, 'A Practical Approach to the History of Byzantine Silk Weaving', *Jahrbuch der Österreichischen Byzantinistik Gesellschaft* 34 (1984), pp. 135-54.

11. At Sens Cathedral there is a mass of unpublished relics wrapped in silks. Each silk originally bore an identifying vellum label. Today the labels survive, but they have become detached from the silks and the relics. In Swiss church treasuries, relics still wrapped in small scraps of silk have also been discovered, for example at Beromünster. See B. Schmedding, *Mittelalterliche Textilien im Kirchen und Klostern der Schweiz* (Bern, 1978), nos. 42, 43, on pp. 52-3. At an unknown date in the nineteenth century small 'silk-enveloped' relics were stored in a large glass jar at St. Servatius, Maastricht. Today a photograph of the jar, but not the container itself, can be seen at the treasury.

12. For the reliquary pouch see M. F. Volbach, *Catalogo del Museo Sacro della Biblioteca apostolica Vaticana*, 3, Fasc. I Tessuti (Vatican City, 1942), T103. The largest fragment of silk to survive with the pattern of 'Samson and the lion' is at Ottobeuren. It is published in the exhibition catalogue, *Suevia Sacra, Frühe Kunst in Schwaben* (Augsburg, 1973), no. 200, pp. 192-3, pls. 188, 189.

13. The reliquary pouches at Maastricht are unpublished. They are briefly described in Muthesius, 'Eastern Silks', p. 100. One unpatterned example, on technical grounds, may be dated to the eleventh to twelfth centuries. The more elaborately patterned fifteenth and sixteenth century Italian silk pouches may have replaced earlier unpatterned ones.

14. Schmedding, op. cit., no. 14, pp. 29-30. On technical and stylistic grounds, it would be possible to argue for an earlier date for this piece. The twill weave described by Schmedding is characteristic of pieces dating up to the ninth century; only extremely rarely is it found in the twelfth century. The twill has only one main warp as opposed to two, characteristic of twills dating from the eighth to ninth centuries onwards; see further note 49 below.

15. Ibid., no. 11, pp. 25-6.

16. Robinson and Urquhart, op. cit., no. 32, p. 32.

17. The archaeological context of the find suggests a tenth century date for the silk. It is discussed by the author and by P. Walton in conjunction, in *Interim: Bulletin of the York Archaeological Trust* 6, no. 2 (York, 1979), pp. 5-6, as 'A Silk Reliquary Pouch from Coppergate'.

18. Otto Lehmann-Brockhaus, *Lateinische Schriftquellen zur Kunst in England, Wales und Schottland vom Jahre 901 bis zum Jahre 1307* (5 vols., München, 1955), 1, no. 1064.

19. A. Schönberger, *Germanisches Nationalmuseum, Ausgewählte Werke* (Nürnberg, 1971), pl. 14 (not mentioned in the short text preceding the plates). See also S. Müller-Christensen, *Sakrale Gewänder* (Munich, 1955), no. 43, p. 27. Pilgrims do appear to have transported relics. For example, Richard, abbot of St. Vanne, in 1026-7 travelled to Jerusalem and Constantinople and he returned with two relics of the True Cross and with a precious purple fabric. This is discussed by E. Lesne, *Histoire de la propriété ecclésiastique en France, vol. III* (Paris, 1036), p. 249, n. 1 and p. 249, n. 2 with source references.

20. In the early 1960s under the direction of Peter Lasko, the metal casing was removed from the wooden core. Eleven relics wrapped in a variety of silks and linen fabrics were discovered in the head. These were opened out and flattened down. They are now in the Department of Medieval and Later Antiquities at the British Museum. Vellum labels attached to the relics named each in turn, and a complete description of all eleven is given in Muthesius, 'Eastern Silks', p. 309. For the Servatius cross see *Rhein und Mass*, 1, 179.

21. For the shrine of St. Cuthbert behind the main altar see *Rites of Durham*, ed. J. T. Gowler (SS 107; Durham, 1903), p. 73, and *Relics*, p. 58. For full discussion of silks donated by the papacy and source references see Muthesius, 'Eastern Silks', pp. 280-7.

22. Raine, *St. Cuthbert*, pp. 194-7, listed five silks that he said were found with the relics of St. Cuthbert in 1827. A purple silk listed as no. 4 by Raine, seems lost today. The Rider silk and the Peacock silk at Durham appear as nos. 1 and 5 respectively in Raine's list.

23. For a full survey of the early history of the falconer the reader is referred to H. Epstein, 'The Origins and Earliest History of Falconry', *Isis* 34 (1943), pp. 497-509. Also see J. E. Harting, *Essays on Sport and Natural History* (London, 1883), and F. M. Allen, *Falconry in Arabia* (London, 1980). There is a valuable discussion in C. Hicks, 'The Bird on the Sutton Hoo Purse', *ASE* 15 (1986), pp. 153-65, esp. 162-5. The latter author distinguishes between falcons with long wings and hawks with short wings, but for the purpose of this paper I have not tried to determine which was represented on the works of art cited.

24. Hicks, op. cit., p. 164, notes 54 and 56. She also draws attention to an early example on a Lombardic panel at Santa Saba in Rome. For the Argos mosaics mentioned see G. Akerstrom-Hougen, 'The Calendar and Hunting Mosaics of the Villa of the Falconer in Argos', *Skrifter utgivna av Svenska institutet i Athen* 23 (1974).

25. Brett in *Relics*, pp. 47-8, pl. 49, figs. 1, 3-6 and pl. 48, figs. 1-3 with pp. 472-3.

26. The date of the introduction of the stirrup is discussed in detail in L. White, *Medieval Technology and Social Change* (Oxford, 1971), pp. 20ff., p. 144 and n. 5. There are silks patterned with hunter motifs at St. Ambrogio, Milan; at Prague Cathedral Library; at St. Calais, Sarthe; at St. Cunibert, Cologne; at Nürnberg, Germanisches Museum; at St. Ursula, Cologne; at St. Fridolin, Säkkingen; and at St. Servatius, Maastricht. These silks are described and dated in Muthesius, 'Eastern Silks', pp. 131-2, 136-45. Five of them have been catalogued on pp. 468 and 474-9, as nos. 27, and 31-4, in a catalogue of 120 silks that appears as an appendix to the thesis.

27. The Lyons silk came from the church of St. Austremoine, Mozac, in 1904. The silk shows a Byzantine emperor as a mounted hunter wearing stirrups. He plunges a spear into the throat of a lion rearing up from below. In 764 the relics of St. Austremoine were carefully taken from her burial place at Issoire (Puy de Dôme) to the church of St. Calais at Mozac. They were wrapped in a silk donated by Pepin and which originally bore the royal seal. Bishop Robert of Clermont saw the silk with its seal in the shrine of St. Austremoine on 10 April 1197 at the time of a later 'recognition' of the relics. In 1904 the silk was taken from a

seventeenth century shrine of the saint and sold to the museum at Lyons. There was no sign of the seal at that time, but there is no evidence to show that the silk presented by Pepin was ever subsequently replaced. Stylistically and technically the silk does belong to the eighth century. It acts as a pivot for dating the other hunter silks that survive. The silk and the source material are discussed more fully in Muthesius, 'Eastern Silks', pp. 132-5. The silk has more recently appeared in brief catalogue form in M. Martiniani-Reber, Lyon, *Musée Historique des Tissus, soieries sassanides, coptes et byzantines V-XI siècles* (Paris, 1986), in the series Inventaire des collections publiques françaises, as no. 30. See pp. 109-11, no. 96. A review of this publication by the author is to be published by the Byzantine Institute of the University of Vienna in the forthcoming *Jahrbuch der Österreichischen Byzantinistik Gesellschaft.*

28. M. Lemberg and B. Schmedding, *Abegg Stiftung Bern in Riggisberg Textilien,* Schweizer Heimatbücher 173/4 (Bern, 1973), page unnumbered and colour plate 10, opposite this.

29. All definitions used conform to the standard International C.I.E.T.A. format published by the international centre for the study of mediæval textiles at Lyon. See *Vocabulary of Technical Terms, Fabrics, English, French, Italian, Spanish* (Lyon, 1964), pp. 14, 52.

30. Ibid., pp. 52-3.

31. The Persian material as a whole has been studied by P. Ackermann, *Survey of Persian Art I* (London and New York, 1938), section 10, chapter 52 ('Textiles of the Islamic Periods'), pp. 2033ff., for example nos. 20, 21, 29, 30, 31 for double and triple cloths.

32. M. Lemberg and B. Schmedding, op. cit., page unnumbered and coloured plate 9 opposite this.

33. M. Fleury-Lemberg has argued that the silks are forgeries but D. Shepherd has replied that she remains unconvinced in spite of the scientific findings. See a variety of discussions in *C.I.E.T.A. Bulletin* 37 (1973). pp. 28-54, 70-117, 120-33 and 143-5.

34. In 1127 fifteen embroidered silk chasubles were extant in the treasury at Bamberg Cathedral. Today several examples survive in the Diocesan Museum, Bamburg. See S. Müller-Christensen, *Sakrale Gewänder* (Munich, 1955), nos. 18-25. The Emperor Henry 11 (d. 1024) and Queen Cunigunde were the principal patrons at Bamberg. See Muthesius, 'Eastern Silks', pp. 329-32 on this point.

35. See D. Storm Rice, 'The Fermo Chasuble of St. Thomas à Becket (d. 1170) revealed as the Earliest Fully Dated and Localised Major Islamic Embroidery Known', *Illustrated London News* 225 (3 October 1959), pp. 356-8.

36. E. Baer, 'The Suaire de St. Lazare: An Early Datable Hispano-Islamic Embroidery', *Oriental Art* n. s. 13 (1967), pp. 36-49.

37. J. Beckwith, *Caskets from Corboda* (London, 1960), p. 61, pl. 23.

38. Ibid., pls. 20-21 on pp. 58-9.

39. Ibid., pp. 54-5, pls. 16 and 17.

40. K. Wessel, *Byzantine Enamels* (Shannon, Ireland, 1969), pp. 149-50 and fig. 46 v-x, on p. 151.

41. Beckwith, op. cit., pp. 20-1.

42. Considerable Persian iconographic influence is noticeable on a number of Spanish silks. Moreover, an elephant silk from Leon, inscribed 'Made in Baghdad', has been shown to belong to Spain itself. The inscription was probably intended to add false value to the piece. See A. F. Kendrick and A. Guest, 'A Silk Fabric Woven at Baghdad', *Burlington Magazine* 49 (1926), pp. 261-7. Cf. May, op. cit., p. 24, and fig. 14. Also C. D. Shepherd, 'A Dated Hispano-Islamic Silk', *Ars Orientalis* 2 (1957), p. 380. She makes relevant notes also in 'The Hispano-Islamic Textiles in the Cooper Union Collection, *Chronicle of the Museum for the Arts of the Cooper Union* 1, no. 10 (Dec. 1943), pp. 357-401, especially p. 365. See F. Day, 'The Inscription of the Boston Baghdad Silk', *Ars Orientalis* 1 (1954). pp. 190-4, especially pp. 190-1. A pottery bowl from Nishapur is shown in D. Talbot-Rice, *Islamic Art* (Norwich, 1975), pp. 51-2, pl. 43.

43. May, op. cit., pp. 5, 11. The first *tiraz* silk weaving factory in Spain, weaving fabrics with official inscriptions, was established in Cordoba. The founder of the first factory may have been Abd al-Rahman II (821-52), although this is not documented. Certainly, the factory is documented at the time of Abd al-Rahman III (912-61). The page Khalaf the elder, a court official, was in charge of it. May gives the source for this information on p. 250 in note 11. Fine *tiraz* silks of Cordoba are documented in the tenth century and described also in the 1090s. See May, op. cit., p. 9, note 7.

44. The Chinese finds have been published only very summarily in a booklet with unnumbered pages and without named editor called, *New Archaeological finds in China* (Peking, 1974). Here a section of coloured plates of finds from the tomb of Magwangtui Changsha is included. The garment in question is a long-sleeved gown with a crossover front. The body of the gown, which seems to reach well below the knees, is a deep-pink silk. On the cuff, neck and lower hem areas is a golden yellow silk. Both the pink and the golden yellow silks appear to be decorated in gold and silver with a small repeating geometric motif. A detail of the design on the pink silk shows small swirling circular motifs representing clouds. The silver looks dark due to oxidation. The author speaks of 'painted' cloud design.

45. For printed and other silks found in Central Asia, see in particular the work of Sir Aurel Stein, including *Serindia* (Oxford, 1921) and *Innermost Asia* (Oxford, 1928). Brett, op. cit., p. 480, refers to printed silks described in *Innermost Asia*, on pp. 672ff., pls. 82, 86, 88, cf. p. 618, pl. 82. For trading and other links between China and Central Asia, see Needham's foreword to *Silk Roads, China Ships: An Exhibition of East-West Trade*, Royal Ontario Museum (Toronto, 1984), esp. pp. 26-44. On the silk road from ancient times there is interesting information in H. Uhlig, *Die Seidenstrasse. Antike Weltkultur zwischen China und Rom* (Bergisch Gladbach, 1986), pp. 72-101. Also I. Franck and D. Brownstone, *The Silk Road* (New York, 1986), pp. 59ff.

46. Brett, op. cit., p. 480. The silks from the caves were published by Stein, *Serindia*, pp. 901ff. and 986ff.

47. Coptic textiles in the wax-resist technique were sometimes hand-painted, sometimes printed. For explanation of the technique and further information see V. Illgen, 'Zweifarbige reservetechnisch eingefärbte Leinenstoffe mit

grossfigurigen biblischen Darstellungen aus Ägypten' (Inaugural Dissertation, J. Gutenberg, Universität, Mainz, 1968), pp. 59-62 ('Die Technik und Formgebung des Reservauftrages') with bibliography on pp. 80-2.

48. The Halberstadt fabric was described by J. Lessing, 'Mittelalterliche Zeugdrucke im Kunstgewerbemuseum zu Berlin', *Jahrbuch der königlich preussischen Kunstsammlungen* I (1880), pp. 119-24. Cf. E. Herzfeld, 'Der Thron der Khosro', in the same periodical, 41 (1920), pp. 132-3, fig. 28. Also G. Migneon, *Les arts du tissu* (Paris, 1929), p. 20. See Ackermann, op. cit., 2014, fig. 649 for Cluny Museum (21.872).

49. There were five main weaving types before 1200. These were tabby (also with extra pattern floats), damask, twill, lampas and tapestry weaves. These are defined and illustrated in Muthesius, 'Eastern Silks', Appendix A ('Weaving types'), pp. 357-62. The significance of the different groupings of the main warps in twills, whether singly, in pairs (gummed or degummed), or in threes to fours, is explained fully there.

50. Brett, op. cit., p. 482.

51. Victoria and Albert Museum 425-1887. I wish to thank L. Wooley for kindly making this and other photos available to me.

52. *Relics*, pp. 513-25, especially pp. 514 and 516. I am indebted to Dr Bivar of the School of Oriental and African Studies, University of London, for his advice concerning the inscription on the Durham Peacock silk. He considers that this is a pseudo Kufic inscription and that it cannot be read.

53. See, for example, S. D. T. Spittle, 'Cufic Lettering in Christian Art', *Archaeological Journal* 111 (1955), pp. 138-52.

54. A. Muthesius, 'The Silks from the Tomb', in *Medieval Art and Architecture at Canterbury before 1220* (British Archaeological Association; London, 1982), ed. N. Coldstream and P. Draper, pp. 81-7, pls. 18-23.

55. M. Gomez-Moreno, *Ars Hispaniae: Historia universal del arts Hispánico* (Madrid, 1951), pp. 350-1, fig. 408b.

56. May, op. cit., pp. 41-2, 45, pl. 27.

57. Ibid., p. 39 and pl. 25 on p. 40.

58. For the Siegburg piece see *Monumenta Annonis*, Köln und Siegburg, Weltbild und Kunst im hohen Mittelalter, Schnütgen Museum, Köln 30 April - 27 July 1975 (Köln, 1975), pp. 180-1 and fig. 22d (J. M. Plötzek, 'Textilfragmente aus Siegburger Schreinen'). Here an Islamic inscription on the Siegburg silk is translated 'Praise to the birth of Allah'. Also, P. Schmölz, *Der Siegburger Servatius Schatz*, (Köln, 1952), p. 28, pl. Both the Siegburg and the Berlin silks are in O. von Falke, *Kunstgeschichte der Seidenweberei* (Berlin, 1921 edition), figs. 155-6. In *Monumenta* the Siegburg silk is called 'perhaps Sicilian', but Schmölz prefers Spanish provenance for the piece. Neither Plötzek nor Schmölz cite iconographic parallels to support their views. Plötzek talks of 'Fatimid influence in Sicily'.

59. May, op. cit., pp. 39-40, pl. 26.

60. For 'Lampas' see *Vocabulary of Technical Terms*, p. 28; for 'tabby', see p. 48. Consult Shepherd, *Ars Orientalis* 2, pp. 373ff. for the Spanish lampas weave silks.

61. R. Grönwoldt, 'Kaisergewänder und Paramente', in *Die Zeit der Staufer* (2 vols., Stuttgart, 1977), I, no. 791 on pp. 627-8, and II, pl. 576.

62. Plötzek, op. cit., p. 180. For the Palermo silk, see Grönwoldt, op. cit, in *Die Zeit der Staufer*, I, no. 776 on pp. 617-18, and II, pl. 567.

63. For the Hannover textile (inv. 3875) see ibid., I, no. 780 on pp. 621-2, and pl. 571. Textile historians have put forward the view that Sicily specifically imported Spanish silks. See for example, F. Torrelia Niuho, 'Problèmes posés par l'étude des tissus hispano-arabes', *C. I. E. T. A. Bulletin* 30 (1969), pp. 20-2. The author has read information from unpublished Spanish sources, but these are not specifically cited. Inventories and royal accounts of the houses of Catalonia and Aragon are said to yield much information about Hispano-Arab textiles. His prime concern is to show problems in using the term Hispano-Arab. Should this refer only to silks of Moslem Southern Spain; or should silks related in style and technique thought to have been woven in the Christian north of Spain (whether by 'imported' Islamic or by Mozarab craftsmen), be given a different name? See also F. Volbach, 'Etoffes espagnoles du Moyen-Âge et leur rapport avec Palerme et Byzance', *C.I.E.T.A. Bulletin* 30 (1969), pp. 23-5. Volbach also states that Spain imported Sicilian silks but cites no source references.

64. The most systematic examination of Islamic sources was undertaken by R. B. Serjeant, 'Material for a History of Islamic Textiles up to the Mongol Conquest' which appeared as a series of chapters in different volumes of *Ars Islamica* 9 (1942), pp. 54-92, 10 (1943), pp. 71-104, 11-12 (1944-6), pp. 98-145, 15-16 (1951), pp. 29-85. Of this material, specific references to Sicily with full references to source material are in chapter 19, pp. 55-6, under the heading 'Sicily'. Serjeant writes that, according to Ibn Djubair, writing in the 1180s, Sicily traded with Spain. See Ibn Djubair, *Voyage en Sicile*, text and translation by Mamari in *Journal Asiatique*, 19 (1845), pp. 35ff.

65. May, op. cit., p. 41, fig. 28 and p. 45.

66. For San Vitale see coloured plate in S. Bettini, 'Les mosaïques de Ravenne à Saint-Vital', *Chefs d'Oeuvre de l'Art*, no. 10 (Paris, 1969), p. 23. For Sassanian metalwork see the exhibition catalogue, *Sassanian Silver* (University of Michigan Museum of Art, 1967 foreword by H. Sawyer; 'Historical Survey by M. Carter on pp. 11-17; 'An Introduction to the Art of Sassanian Silver' by O. Grabar on pp. 19-84; see also no. 42, pp. 126-7). Sassanian metalwork is difficult to date because museums tend to have no records of where the pieces were excavated or from where they came. Stylistic and iconographic evidence is used to date most pieces. The sculptures of Tak-i-Bustan showing Sassanian emperors prove useful for parallels. The sculptures were published by E. Herzfeld, *Am Tor von Asien* (Berlin, 1920), esp. figs. 32-43. Grabar admits that the Sassanian silver with peacock is unusual, op. cit., p. 70. He assigns it to Sassanian Iran and suggests it may post date the fall of the Sassanian Empire in 651 (Sassanian traditions were preserved in areas in the north of Iran for a considerable time before the coming of Islam, according to Carter, op. cit., pp. 16-17). See also Grimme, op. cit., no. 14 on pp. 20-21. Grimme has followed Falke's 'Antinoë silks' as in his *Kunstgeschichte*, (2 vols., 1913 edition), I, 35-6. Falke dated silks found in graves excavated at Antinoë to the sixth century. The Antinoë theory has fallen out of favour. Silks excavated there could anyway have been imported.

For further discussion see A. Muthesius, 'Eastern Silks', pp. 174-5. This type of silk was probably produced in several centres of the Eastern Mediterranean simultaneously in the seventh to eighth centuries. For the Canterbury piece see Robinson and Urquhart, op. cit., pp. 182-4, pl. 55, fig. 2. The Abegg silk comes from Beromünster. See Schmedding, op. cit., no. 13, pp. 27-8 with colour plates. For the Byzantine eagle silks at Auxerre and Brixen see Muthesius, 'Eastern Silks', pp. 63-7. These date around 1000 AD on stylistic and technical grounds.

67. Beckwith, op. cit., p. 55, pl. 17 and pp. 16-20.
68. The ring with further references is discussed in *Relics*, pp. 85-6.
69. Serjeant, *Ars islamica* 15-16, pp. 29-40 ('Textiles and the Tiraz in Spain'), esp. pp. 34, 35, 37, 4.
70. May, op. cit., p. 9 and n. 15 for source reference.
71. Ibid., p. 9 and n. 17 for source reference.
72. Imperial Byzantine silks were frequently sent as diplomatic gifts. See Muthesius, 'Eastern Silks', pp. 23-4.

ADDITIONAL NOTE

For the Maastricht silks see A. Stauffer, *Die Mittelalterlichen Textilien von St. Servatius in Maastricht*, Riggisberg 1991.

VI
Byzantine and Islamic Silks in the Rhine-Maaslands before 1200

IN THE period up to 1200, richly patterned Byzantine and Islamic silks were reaching Western Europe in great numbers and a large if random sample of these textiles survives to the present day.[1] Others are known from documentary sources, most particularly from accounts in ecclesiastical inventories and from detailed descriptions in the *Liber Pontificalis*, that lists many hundreds of silk gifts presented by the Papacy to important churches in Rome, principally in the 8th to 9th centuries.[2] More than 150 ecclesiastical centres in Western Europe had impressive and valuable silk treasuries, and in the Latin Church these textiles served a great variety of different purposes. Most particularly they were used for fashioning splendid ecclesiastical vestments; to create decorative hangings and furnishings; as shrouds for venerated relics or as an embellishment for manuscript bindings. The foremost silk patrons were the Emperors and the Papacy, important Archbishops and Bishops and wealthy laymen of rank, and the silks reached the West either in the form of diplomatic gifts or as items or merchandise.[3] A proliferation of silk treasuries in the Rhine-Maaslands is not surprising; for example at Xanten, Brauweiler, Köln, Siegburg, Mainz, Worms and Speyer on the Rhine; and at Maaseik, Sustern, Münsterbilsen, Tongeren, Liège and Huy along the Maas; with Aachen situated between these two great rivers. Economically, ecclesiastically and politically, the Rhine-Maas region was ideally placed for the reception of Eastern silks. In economic terms after a decline between the mid 9th to mid 10th centuries following massive Saracen, Norman Viking and Hungarian raids, recovery in the West was effected through growing trade with Italy, Byzantium and the Mediterra-

nean. By the later 10th century during the rule of the Ottonians this region
served as the major centre of economic activity of the Empire. In addition,
places such as Aachen, Liège and Köln constituted vital political and
religious centres that exerted influence over much of the Empire during
the Carolingian and the Ottonian periods. Contacts with Byzantium that
had been established under the Carolingians were strengthened under
their successors. As a climax to these increasingly close East-West
relationships, in 972 Otto II married the Byzantine Theophanou.[4] Bautier
has suggested that by the 10th to 11th centuries there was an interna-
tional economic community and a common civilisation throughout both
the Mediterranean world and the Western areas under its influence, but
the question is: how were cross-cultural influences transmitted?[5] The
exchange of silks between Byzantium and her Islamic neighbours, and
the export of both Byzantine and Islamic silks to the West, furnish one
clear example; after all, silks were light and easily transportable items.[6]
In order to fully appreciate the significance of these silks in the Rhine-
Maaslands before 1200, they have to be viewed not only in the context of
the general and widespread use of Eastern silks in the West, but also in
the light of remarkably similar uses of silks both in Byzantium and in the
Islamic world.[7] Indeed silk was a powerful instrument of cross-cultural
exchange. The purpose of this short paper is to describe which types of
Eastern silks were reaching the Rhine-Maaslands before 1200, and to
highlight some aspects of their profound economic, political, ecclesiasti-
cal and cultural significance to the region.

 An analysis of more than 1000 extant silks that reached the West
before 1200 AD indicates that they fall into five main technical categories
in the following percentages:

Weave	Percentage
Tabby	20.0
Damask	5.0
Twill	54.5
Lampas	20.0
Tapestry	0.5

A broad chronology for the different weaving types can be established
using technical, scientific, historical, art historical and circumstantial
evidence, as shown in the table on the next page.

 The fact that examples of all these different types of silks were
reaching the Rhein-Maaslands suggests that the region may have played
an important part in their distribution in the West.[8] Allowing that many
more silks perished than survived during the course of the centuries, the
presence of such a wide ranging sample in the Rhein-Maaslands also
implies that the different kinds of silks may have been arriving in
considerable numbers.

Weave	Structure	Century	Provenance
Tabby	One or two systems of warp/weft.	6th-12th	Byz/Islamic
Tabby	With extra pattern wefts.	6th-9th	East Med.
Damask	1.2 and 1.3 twill.	4th-9th	East Med.
Twill	Single main warp, twisted, degummed	6th-9th	East Med.
	(Rare later examples	11th-12th	Latin, Sicily?)
Twill	Paired main warp, twisted, degummed	9th-12th	Byz/Islamic
Twill	Paired main warp, grège	9th-12th	Central Asian
Twill	3/4 main warps, grège	7th-9th	Central Asian
	(Rare later examples	10th-11th	Central Asian)
Twill	Chevron. Rare.	10th-11th	Islamic/Spain
Lampas	Pseudo/true. Tabby, tabby	10th-11th	Byz/Islamic
	Tabby, twill.		
Tapestry	Slit. Rare.	11th-12th	Byz/Islamic

The most impressive fabrics to enter the region were a series of Byzantine inscribed Lion silks and an Elephant silk that must have arrived in the West as diplomatic gifts.[9] The silks span a period of Imperial Byzantine production from 867-1025, which corresponds to the heyday of the great Macedonian dynasty, and which represents a time when there was a tremendous flowering of the arts in Byzantium.[10] The importance of the silks is twofold: firstly they indicate what sorts of silks the Imperial Byzantine workshops were capable of producing, and secondly they demonstrate the close political links that were forged between Byzantium and the West at this period.[11]

Of the five Lion silks that are known to have been woven in Imperial Byzantine workshops, three survive in a fragmentary state and two are known from documentary descriptions. Each of the five silks had lions, accompanied by Greek inscriptions giving the names of the rulers under whom the pieces were woven. The inscriptions yield dates for the fabrics. The three extant silks are as follows:

1. Lion silk from Saint-Servatius, Siegburg now at Schloß Köpenick, Berlin, inscribed 'During the reign of Romanos and Christophoros, the devout rulers', and precisely datable to 921-923.[12]

2. Lion silk taken from an unnamed lower Rhenish church before 1892, and divided between the Kunstgewerbe Museums of Krefeld, Berlin and Düsseldorf, datable to 976-1025 on technical and stylistic grounds. Silk with painted inscription by Schulze that reads 'During the reign of Constantine and Basil,

the devout rulers', a misinterpretation of 'During the reign of Basil and Constantine, the devout rulers'.[13]

3. Lion silk from the shrine of St. Heribert at St. Heribert, Köln-Deutz, now in the Diocesan Museum, Köln, inscribed 'During the reign of Basil and Constantine, the devout rulers', a reference to Basil II and his brother Constantine VIII, joint rulers 976-1025.[14]

All these silks show paired lions from the side, with heads turned towards the spectator, and with the inscriptions set between pairs of animals. The designs are in yellow on a purple ground and the weave is a paired main warp twill in all cases.[15] The gradation of the contours of the design are very fine, and the lions are woven down rather than across the loom. The lions vary in length on the three silks; the Siegburg lions measure 62 cm, those of the Krefeld-Berlin-Düsseldorf silk 73 cm, and the Köln lions 78-80 cm. The weavers of the Siegburg piece misjudged the length of their warp, and a second pair of lions originally intended for the silk were cut midway through their dividing inscription.[16] A photograph published by Migeon in 1908 reveals the original appearance of the design with three lions and one and a half inscriptions. No doubt the work was carried out down rather than across the loom for reasons of technical ease, but in the case of the Siegburg silk it may be reasonable to think that a loom wider than the 230 cm length of the warp may not have been available in the Imperial Byzantine workshop in 921-23.[17]

There seems no reason to suppose that the Krefeld-Berlin-Düsseldorf silk was woven under the earlier pair of Byzantine rulers Constantine and his son Basil (868-869), and that the silk predated the Köln silk by a century, merely on the basis of the entirely reconstructed, painted inscription of Schulze.[18] He could easily have reversed the names of Basil and Constantine by mistake if he was working from scattered fragments. Documentary evidence does show that inscribed Lion silks were woven in Byzantium before the late 10th century but they appear to have been more decorative.

A fourth inscribed Lion silk, no longer extant today, was at Crépy St. Arnoul in the 18th century. It was described at that date by Carlier as a silk decorated with lions, whose bodies were ornamented with red and green motifs.[19] Carlier transcribed the inscriptions on the silk as 'During the reign of Basil and Constantine'. This is likely to refer to the earlier pair of Byzantine rulers, Constantine and Basil (868-869).[20] A fifth inscribed Imperial Byzantine Lion silk bore a different inscription. This read 'During the reign of Leo, the devout ruler', which could refer to a number of Emperors with this name whose dates span different years between 717 and 820.[21] The silk was at the Cathedral of Auxerre but its lion design was not described in detail.[22]

Two previously unpublished fragments at the Schloß Charlottenburg, in Berlin (inv. 78.634, inv. 78.645) could represent parts of Imperial Lion silks. These show decorated lion motifs that suggest they belong before the 10th-11th century inscribed examples.[23] Another unpublished scrap of purple ground silk with what may be the foot of an imperial Lion was used for a tiny reliquary pouch at Sens cathedral treasury (inv. 69).[24] To the same group of purple ground Imperial Byzantine Lion silks belongs the magnificent uninscribed Lion silk at Ravenna.[25]

How did the Lion silks reach the West, and why were they sent from Byzantium? The most likely answer is that they came as diplomatic gifts in connection with marriage negotiations between Byzantium and the German Emperors. From the 8th-12th centuries, 16 marriages were either negotiated or arranged between these two Empires.[26] The Siegburg silk woven 921-923 coincided in date with the reign of Henry I, but he exchanged no envoys with Byzantium. Constantine VII, son-in-law of Romanos, did send gifts to Otto I, son of Henry I, in 945. Could the Siegburg Lion silk have been amongst them?[27] Was it then stored in the Imperial treasury until the reign of Henry III (1028-1056), and presented to Anno, Archbishop of Cologne, by this Emperor? Henry III did elevate Anno to the Archbishopric and he presented him with a ceremonial sword.[28] In turn, did Anno give the silk to his foundation at Siegburg in 1064, and was it subsequently used for a shroud when the relics of St. Anno were translated into a splendid shrine after the canonisation of the saint in 1183?[29] Similarly, could the Köln and the Krefeld-Berlin-Düsseldorf silks datable to 976-1025 have arrived in the West in connection with the negotiations of 1000-1002 for the marriage of Otto III to the daughter of Constantine VIII?[30] Again, if the Leo named on the Auxerre silk was Leo VI then could this silk have been sent as a diplomatic gift in 898-901, to herald the impending marriage of the daughter of the Byzantine Emperor Leo VI to the future Western Emperor Leo III?[31] In spite of a lack of firm documentary evidence, it does seem at least plausible to suggest that this might have been so. How else might the presence of Imperial Byzantine silks in the West be explained? Their export from Byzantium was certainly prohibited, and officially they could have arrived only as diplomatic gifts.[32]

It is interesting to consider the relationship of these Imperial Byzantine purple Lion silks to the purple Lion silk at St. Servatius, Maastricht, which has also been called a Byzantine piece.[33] Five fragments of the silk were taken from the shrine of the saint on 9th November 1863. One of the fragments was sold to the Kunstgewerbemuseum, Schloß Charlottenburg, Berlin in 1888.[34] The silk shows a striding lion with its face turned towards the spectator and its tail raised, resembling the Lions of the Imperial silks. The style of the design is very different from that on the Imperial silks and there is no inscription. In addition, the Maastricht lion is only 23 cm wide,

but still the design is woven down and not across the loom. The silk has a design in black on a purple ground, and it is woven in twill. The main warps are not paired and not Z twisted as is the case on the Imperial silks; instead they are grège; and grouped in threes to fours.[35] An analysis of the dye of the Berlin Imperial Lion silk shows a mixture of madder and indogen was used for the purple, whereas the purple of the Maastricht Lion silk employs a mixture of indogen and a lichen.[36] In every way the Maastricht silk reflects totally different workshop practices to those of the Imperial Lion silks, from the contrast in the fineness of the découpure and the difference in the internal structure of the twill, to the type of dye used and the degree of sensitivity shown towards the subtleties of the complex design.[37] The exaggerations and distortions apparent on the tree of the Maastricht Lion silk and the hardening of style, not least by the addition of a rigid row of dots along the stomachs of the lions on the Maastricht silk, are unthinkable in an Imperial Byzantine workshop.[38] Neither does it seem likely that a provincial Byzantine workshop would receive an Imperial Byzantine piece to copy.[39] What does seem possible is that there were Imperial Lion silks in Central Asia that were copied. The use of grège silk and main warps grouped in 3/4s is a characteristic that Shepherd has noted on the Lion silk twills of her Central Asian 'Zandaniji' group one.[40] Jerussalimskaja, in addition, has pointed to the important trade links established between Byzantium and Central Asia during the 8th-11th centuries.[41] Furthermore, a great number of Central Asian silks were reaching the Maasland treasuries including the key silk of Shepherd's 'Zandaniji' 1st group, the Ram silk at Huy. There are important interrelationships between these Imperial Lion silks; the Maastricht Lion silk; and Lion silks from Central Asia (Zandaniji 1 examples one from Münsterbilsen, now in Brussels 372; another at Liège Al nr. 81; and the later grège, paired main warp twill, Zandaniji group 2 example, Maastricht inv. 7.i). They mirror the economic and political situation not only in the Rhine-Maaslands but in Byzantium and the Near East, over a period spanning the 7th to the 11th centuries.[42] Apart from being interesting objects of art, the silks reflect trade between the Maas region and Central Asia from the 7th to the 10th or 11th centuries. The Rhadanite Jewish merchants are known to have travelled to Central Asia before the 9th century, and also to have resided in the Maaslands, which offers an explanation for the arrival of the earlier pieces.[43] For the 10th century and later, the Central Asian silks may have arrived via Italian intermediaries.[44] How strange, yet how significant, to contemplate that the Lion silk at Maastricht may be a Central Asian piece under Byzantine influence that served to shroud the relics of a great Latin saint. It is a silk that indeed brings together three worlds: Latin, Byzantine and Near Eastern. Undoubtedly, there was ample Byzantine influence in Central Asia, as red

ground hunter silks such as the piece in the British Museum demon-
strate. Here the Central Asian weavers were clearly struggling to interpret
unfamiliar, traditionally Eastern Mediterranean motifs (PLS. 52 and 8).[45]

The Aachen Elephant silk, a very fine Imperial Byzantine paired main
warp twill, originally with at least three c. 90 cm medallions across the
width of the loom, required 1440 manipulations of the pattern making
device for the creation of one repeat of its design and must represent the
high point of Imperial Byzantine production.[46] Its inscription naming
Michael, a Chamberlain in Imperial service, and Peter, head of the silk
weaving workshop at Zeuxippos, unfortunately bears an indication date
that cannot be read.[47] The titles of the inscription show that the silk was
woven not earlier than 843 and not later than 1088. This means that the
silk cannot have entered the shrine of Charlemagne in 814, but that it
might have been donated by Otto III in the year 1000.[48] Alternatively, it
could have been presented by Frederick II in 1215 on the occasion of the
completion of the shrine of Charlemagne.[49] With the inscribed Lion silks,
it demonstrates the highest degree of political intercourse between
Byzantium and the West. Its use to shroud the relics of Charlemagne
reflects the esteem in which Byzantine silks must have been held by the
Latins. Technically and stylistically it belongs with the inscribed Lion silks
and a dating in the 11th century seems most appropriate for it.

Whilst Imperial Byzantine silks are not evident in the Maaslands in
the 10th to 11th centuries as they are in the Rhinelands, important
Byzantine pieces existed in both the Rhine and the Maaslands earlier. At
Aachen there is the Charioteer silk, a single main warp twill of the 8th to
9th centuries, and at Maastricht is the Dioscurides silk with its peculiar
mixture of classical and Sassanian motifs.[50] From Münsterbilsen came
the Charioteer silk with peculiar sun and moon motifs. Like the Dioscurides
silk, it is a single main warp twill of the 8th to 9th centuries.[51] The Samson
silk at Liège with its purely classical iconography is another example, and
there was a Samson silk at Maastricht, which today is lost. These pieces
of course belong to a vast group of silks with related Samson designs that
reached many different Western European treasuries; and which in
varying forms may have been woven in different centres of the Byzantine
Empire.[52] To the same period and ambience belong the Amazon silk at
Maastricht and the Hunter silk at Aachen.[53] The 'Heraclius' silk at Liège
is a paired main warp twill, perhaps dating just after the single main warp
twill silk group just described. The monogram has often been used to date
the piece to the reign of the Emperor Heraclius, but it does not appear to
correspond to any of the silver stamp monograms of Heraclius that are
known. At Maastricht, the 8th to 9th century paired main warp twill weave
stage of development is represented by a silk showing the rear quarters
of a seated lion (PL. 13).[54]

The monochrome or 'incised' paired main warp twills that were woven in both Byzantine and Islamic centres from the 10th to 11th centuries onwards are also well represented in the Rhine-Maasland treasuries.[55] Two Liège pieces (Al 50 and Al 56) are patterned with geometric and foliate motifs. Magnificent, similarly patterned silks exist in the form of great chasubles at St. Victor, Xanten and at Mainz Cathedral.[56] Monochrome lampas weave silks, either tabby, tabby lampas or tabby, twill lampas include Liège Al 30 with eagles and antelopes (perhaps from Moslem Spain), a Lion silk with cut Kufic inscription at Maastricht (inv. 114), a lion and bird silk at St. Servatius, Siegburg and a bird silk at Utrecht from Dokkum. These great 11th and 12th century pieces represent both Byzantine and Islamic weaving centres (PL. 21).[57]

Of the scarcer weaving types — chevron twill and tapestry — there are isolated Rhein-Maasland examples. A chevron twill with griffins is at St. Ursula, Köln, and a tapestry weave silk fragment with arch and tendril motif is at Sustern.[58] The latter seems to be almost identical to tapestry alb ornaments from the 11th century tomb of Arnoldo Ramon de Biure, now in Montreal and Barcelona.[59]

The surviving silks suggest that the most prolific time for the acquisition of these wonderful fabrics in the Rhein-Maaslands was the 8th to 12th centuries. This is not surprising, as it coincides with great periods of Imperial patronage under the Carolingian, the Ottonian and the Salian Emperors, as well as with an age of increasing economic activity. It seems to have been principally Byzantium and the Central Asian region that were supplying the silks, either in the form of diplomatic treasures, or as items of merchandise. The presence of Imperial Byzantine pieces in centres such as Aachen and Köln reflects the close political links that existed between East and West, whilst the Central Asian silks found principally in Maasland centres illustrate how widely the nets of commerce were cast from an early date. In an age when Pope Clement II (d. 1047) could be buried with a silk about his head invoking 'Blessings to Allah', one might begin to postulate that silk could transcend even the boundaries of religion.[60] Certainly, the imported silks as a whole suggest that cultural, political and economic divisions between East and West were only a superficial barrier to cross-cultural exchange before 1200.

NOTES

1. Over 1000 pieces are listed and discussed in A. MUTHESIUS, *Eastern silks in Western shrines and treasuries before 1200*, PhD thesis, Courtauld Institute of Art, University of London, 1982. An expanded publication on the History of Byzantine Silk Weaving 400-1200 AD, incorporating the thesis material is under press with the Byzantine Institute at the University of Vienna, and will appear in two volumes with 150 plates. Thesis hereafter, MUTHESIUS, *Eastern Silks*.

2. *Le Liber Pontificalis*, ed. E. DUCHESNE, 2 vols., Paris 1884-92. Third volume of corrections and additions C. Vogel, Paris 1957.

3. See references to Liber Pontificalis in MUTHESIUS, *Eastern Silks*, pp. 264-328 in section on *Uses of silks in the West.* See also pp. 329-339 on *Silk patronage,* and points in *Summary of conclusions* on pp. 340, 346-8.

4. On the subject of the presence of Theophanou in the West, see for instance W. OHNSORGE, *Konstantinopel und der Okzident*, Darmstadt 1966, pp. 59-61, 176, 181, 203-205, 224, 228ff., 231, 237, 243, 246, 297. Also K. CIGGAAR, *The Empress Theophanou (972-991). Political and cultural implications of her presence in Western Europe for the Low Countries, in particular for the county of Holland, in Byzantium and the Low Countries*, ed. K. Ciggaar and others, Holland, 1985.

5. R. H. BAUTIER, *The Economic development of Medieval Europe*, London 1971, pp. 49-57. See also A. VERHULST, *The origins of towns in the low countries and the Pirenne Thesis. Past and Present*, 122 (1989), 3-35.

6. On trade routes as they are reflected in the Cairo Geniza Documentation, see S. D. GOITEIN, A *Mediterranean Society*, I, *Economic Foundations*, Berkeley, Los Angeles, London 1967, pp. 211-214 on trade routes and volume of commerce, pp. 222-224 on prices of silk.

7. For uses of Eastern silks in the West consult note 2 above. For their use in the Moslem World see S. D. GOITEIN, *A Mediterranean Society*, IV, *Daily Life,* Berkeley, Los Angeles, London 1983, pp. 18, 120, 121, 159, 165, 167-170, 183, 184, 187, 193.

8. The detailed evidence for dating each weaving category is too extensive to enter here. It is discussed fully in MUTHESIUS, *Eastern Silks*, pp. 1-251.

9. For extensive discussion of the Lion and the Elephant silks consult A. MUTHESIUS, *A Practical Approach to the History of Byzantine Silk Weaving*, in *Jahrbuch der Österreichischen Byzantinistik*, 34, 1984, pp. 235-54.

10. There was an element of classical revival in the arts of the Macedonian period 867-1056. See for example, K. WEITZMANN, A *tenth century Lectionary. A lost Masterpiece of the Macedonian Renaissance,* in *Byzantine Liturgical Psalters and Gospels,* Variorum Reprint, London 1980, section 10, pp. 617-640. There were oriental and Islamic influences on Byzantine culture also. See for instance, C. MANGO, *Discontinuity with the Classical Past in Byzantium,* in *Byzantium and its Image*, Variorum Reprint, London 1984, III. In addition, A. GRABAR, *Les succès des arts orientaux à la cour byzantine sous les Macedoniens,* in *Münchner*

Jahrbuch der Bildende Kunst, dritte Folge, 2, 1951, where pp. 33-36, the Lion and the Elephant silks are included.

11. On the subject of Byzantium and the West in general, see, for instance, W. ZALOZIECKY, *Byzanz und Abendland,*Salzburg 1936; W.OHNSORGE, *Konstantinopel und der Okzident,*Darmstadt 1966; O. MAZAL, *Byzanz und das Abendland,*Wien 1981.

12. See MUTHESIUS, *Eastern Silks,* pp. 16-25 and pp. 31-38 and MUTHESIUS, *Practical Approach,*pp. 237-241.

13. Discussed in Muthesius, *Practical Approach,* pp. 243-244.

14. Ibid., 243.

15. Ibid., 242. For a definition of the technical term 'paired main warp twill' see *C.I.E.T.A. Vocabulary of Technical Terms (English, French, Italian, Spanish),* Lyons, 1964, pp. 31 and 52.

16. Shown as figure 2a in MUTHESIUS, *Practical Approach.* Taken from MIGEON in *Gazette des Beaux Arts,* 40 part 2, (1908) p. 471.

17. Relevant comments are inMUTHESIUS, *PracticalApproach,*pp. 240-241. To be able to judge the width of a loom that produced any given fabric, the textile must retain its two 'selvedges' (*C.I.E.T.A. Vocabulary,* p. 42) on either side. Some mediæval silks do have both selvedges, for example the tapestry from the grave of Bishop Gunther (d. 1065) at Bamberg (silk 210 cm wide); the so-called Vitalis chasuble at the Abegg Stiftung, Riggisberg, Bern of the late 10th to 11th centuries (silk 262 cm wide). The chasuble of Pope Clement II (d. 1047) at Bamberg used a silk at least 255 cm wide. Central Asian silks of the 7th-9th centuries are generally c. 120 cm wide. These silks are discussed in more detail inMUTHESIUS, *Eastern Silks,*on pp. 93-95, 97-99, 525, 522, 217-235 respectively, and with bibliographical references.

18. Fuller arguments are presented in MUTHESIUS, *Practical Approach* pp. 241ff. Dating can be further narrowed down, however. Basil I and his son Constantine ruled jointly only between 868-869. Constantine was crowned in 868, but in 870 he was joined by Leo. A fourth son of Basil I (867-886), Alexander was also crowned c. 879. On this point I have to thank Dr. Kislinger of the Byzantine Institute in Vienna and to refer to his article, *Eudokia Ingerina, Basileios I und Michael III,* in *Jahrbuch der Österreichischen Byzantinistik,* 33 (1983), pp. 119-137.

19. Refer to MUTHESIUS, *Practical Approach,* p. 245. The silk is documented in C. CARLIER, *Histoire du duché de Valois,* I-III, Paris, 1764, I, pp. 268-9.

20. The decorative markings are not usual on the 10th to 11th century Lion silks, and their use points to an earlier date for the lost silk. The best parallel for the occurrence of such markings is found on a Pegasus silk in the Vatican, Rome. This silk comes from a metal reliquary cross inscribed with the name of Paschal, that plausibly can be taken to refer to Pope Paschal I (817-824). For a fuller description of the silk and reliquary seeMUTHESIUS, *Practical Approach,* pp. 245-246.

21. On the same point see MUTHESIUS, *Practical Approach,* pp. 246-247. Grabar and Frolow independently argued that the name of Leo VI was intended on the silk but they did not state their reasons for dismissing the possibility that the silk was woven under an earlier Emperor with the name of Leo. See A. GRABAR, *Les*

succès des arts orientaux à la cour byzantine sous les Macédoniens, in *Münchner Jahrbuch für Bildende Kunst,* dritte Folge, 2 (1951) pp. 33-36 and A. FROLOW, *Quelques inscriptions sur des oeuvres d'art du moyen âge,* in *Cahiers Archéologiques,* 6 (1952), pp. 163-164. It should be remarked that for the silk to have been woven under Leo VI it is necessary to suppose that the name of his brother Alexander was left out of the inscription, for the latter was co-emperor with Leo VI from the beginning of his reign. G. OSTROGORSKY, *History of the Byzantine State,* Oxford, 1968, pp. 241-242 and note 1 on p. 242, also stresses that there is no evidence to show that Leo VI ever deprived Alexander of his position as co-emperor, although the two brothers were not close. In the case of the other possible Leos: Leo III (717-741) took his son Constantine as co-emperor from 720; Leo IV (775-780) shared the throne with his son Constantine from 776; Leo V (813-820) raised his son Constantine to the dignity of co-emperor in 813. A preliminary survey of this question suggests that only Leo III from 717-719 and Leo IV in 775 ruled alone. More detailed work on this question may lead to a further refinement of dating.

22. There are a number of different editions of the *Gesta Pontificium Autiossodorensium* that record the gift of a Lion silk to Auxerre by Bishop Gaudry (918-933). The source references are given in MUTHESIUS, *Practical Approach,* p. 246 note 33.

23. See MUTHESIUS, *Eastern Silks,* pp. 507, 508. A research catalogue of the Berlin silks dating before 1200 was compiled by the author in Berlin in 1980 and is unpublished. More recently see L. VON WILCKENS, *Mittelalterliche Seidenstoffe,* Landshut, 1992.

24. The author compiled a catalogue of some 500 pieces of silk at Sens in 1979 and this material, including photographs of each silk, is being edited for publication at the present time. The work was carried out with the kind assistance of Madame Saulnier at Sens.

25. Further discussion and bibliography in MUTHESIUS, *Eastern Silks,* pp. 55-60 and on 506.

26. MUTHESIUS, *Eastern Silks,* pp. 348-349 list the individual marriage negotiations.

27. F. DÖLGER, *Regesten der Kaiserurkunden des Oströmischen Reiches von 565-1453,* I-III, München and Berlin, 1924, 1925, 1932, I n° 651. Hereafter, DÖLGER, *Regesten.*

28. P. SCHRAMM and F. MÜTERICH, *Denkmale der deutschen Könige und Kaiser,* Munich 1962, p. 172, n° 152.

29. For the translation of the relics of St. Anno see *Monumenta Annonis, Köln und Siegburg. Weltbild und Kunst im hohen Mittelalter.* Schnütgen Museum, Köln, 1975, pp. 65-66 in *Translatio und Miracula* section. Cf. 172 n° E2 for the Anno sword. For the large Romanesque shrines as a whole refer to *Rhein und Maas. Kunst und Kultur 800-1400,* I-II, Köln, Schnütgen Museum, 1972, II, pp. 65-94, A. LEGNER, *Zur Präsenz der grossen Reliquienschreine in der Ausstellung Rhein und Maas.* For the Anno shrine in particular consult H. PETERS, *Der Siegburger Servatiusschatz,* Honnef, 1952, pp. 18-21, pls. 25-38.

30. DÖLGER, *Regesten,* I, n° 784, 787.

31. Ibid. I, n° 536. But cf. note 21 above. Unfortunately, it is not documented whether or not all co-emperors had to be named on Imperial silks. There is also the possibility that the inscription was not recorded properly. In any event any

silk sent as a diplomatic gift in connection with the proposed marriage of Gisela, daughter of Pipin and Leo son of Constantine V, would surely have borne the name of Constantine.

32. Export of silks from Byzantium was strictly regulated. In this connection see, for instance , J. NICOLE, *The Book of the Prefect*, Geneva, 1894, Variorum reprint London 1970, chapter 4 section 1, given in Greek, Latin, French and English in various parts of the volume. The message of the regulations governing the non-Imperial silk guilds of Constantinople in the 10th century includes provision to prevent strangers receiving silks reserved for Imperial use. Even silks that could be sold had to be stamped by the City Prefect (see chapter 4, section 4). Tailoring of silks had to be carried out in Constantinople itself, and the buyers could purchase silks only for their own wear (chapter 4, section 8). Chapter 8 section 1 lists a whole range of silks, including several categories of purple dyed ones that stringently were forbidden for manufacture. There has been considerable discussion about the meaning of the names of the silk guilds without sufficient reference to the practicalities of the silk industry as a whole. Several functions are assigned to single silk workers without regard to the fact that each stage of production was and still remains the speciality of a single body of workers. The *SIRIKARIER* cannot be silk dressers, dyers, weavers and tailors as Simon implies; rather they must be some type of factory owner under whom all these different craftsmen work. Silk dressing is the work of the *KATARTARIER* in the *Book of the Prefect*, and as cocoons cannot be stored it might be assumed that they are not unravellers but only degummers of silk, the unravelling being carried out either by the cocoon rearers or by workers in the countryside close to rearing centres. It is difficult to think that the Syrians carried cocoons to Constantinople rather than silk yarn or woven silks. Almost 90% of the weight of the cocoon is lost in the unravelling and degumming process and so it would be more profitable to deal in finished yarns and silks. Domestic silk may have been handled in the form of cocoons as well as yarns but here again there is the pressure of unravelling and reeling the silk from the cocoon before the moths emerge. Further detailed discussion of these and other points are in A. MUTHESIUS, *The Byzantine Silk Industry: Lopez and Beyond, Journal of Medieval History*, 19 (1993) 1-67. The literature on the *Book of the Prefect* is too long to list here but see D. SIMON, *Die Byzantinische Seidenzünfte*, in *Byzantinische Zeitschrift*, 68 (1975), pp. 23-46, with extensive bibliography in the footnotes. *The Book of the Prefect* as a whole is to be republished by Professor Koder of the Byzantine Institute at the University of Vienna. The story of the confiscation of Imperial Byzantine silks from the baggage of the envoy Luitprand of Cremona is well known. It is mentioned in F. A. WRIGHT, *The Works of Luitprand of Cremona*, London, 1930, chapter LIV, pp. 267ff.

33. Noted in MUTHESIUS, *Practical Approach*, pp. 247-250.

34. Information from Museum notes in Berlin. I have to thank Frau Mundt and Frau Berner of the Museum for extensive help during my studies there.

35. Grège is the term given to silk still with its coating of gum. Mediæval silk yarns were usually degummed. For wefts the degummed silk served best to reflect most light, and for warp threads the degummed silk was given a sharp twist, which acted to strengthen it. In Central Asia, instead of using degummed and

twisted silk yarn for warps, silk with its gum and without twist was employed. It would be interesting to test the relative strengths of grège silk, untwisted warp, and degummed, twisted silk warp yarns. It is also of interest to find out why the degree of twist on some degummed warp yarns needed to be so high.

36. The dyes were tested by Professor Whiting and his colleagues at Bristol University. I owe a debt of gratitude for this valuable work. See MUTHESIUS, *Eastern Silks*, p. 53 for the results of several dye tests.

37. The découpure is the name given to the smallest gradation of the outline of a design.

38. The découpure on Imperial Byzantine silks is so fine as to be almost imperceptible by the 10th to 11th centuries. This is not the case with Central Asian silks. The marked stepping on the latter silks dating up to the 10th century is sometimes in part due to the fact that the internal warps are of a thick yarn and they are grouped in threes to fours, creating a wide area to be spanned.

39. Nothing is known about provincial Byzantine silk weaving apart from the fact that it did exist in the 12th century in Thebes and Corinth. Whether this also existed in Athens, as Otto of Freising claimed, is open to speculation, as Byzantine sources (including Nicetas Choniates), do not mention it. On this point see E. WEIGAND, *Die Helladisch-Byzantinische Seidenweberei, Mneme S. Lampros*, Athens, 1935, pp 503-514, esp. 505.

40 The relevant articles are D. G. SHEPHERD and W. B. HENNING, *Zandaniji Identified?* in *Festschrift für Ernst Kühnel*, Berlin, 1959, 15-40. D. G. SHEPHERD, *Zandaniji Revisited. Documenta Textilia. Festschrift für S. Müller-Christensen*, Munich, 1980, pp. 105-122.

41. Jerussalimskaja has published several articles but only some with English or French summary. Amongst her printed works are the following: *Le Cafetan aux simourghs du tombeau de Mochtchevaja Balka (Caucase Septentrional)* in *Studia Iranica*, 7 (1978), pp. 183-211; *Silk fabrics from Moschevaya Balka*, in *Soobscheniya Gosudarstvennogo Ermitazha*, 24 (1963), pp. 35-39; *Silk era of the northern Caucasus in the Early Middle Ages*, in *Sovietskaia Archeologiia*, 2 (1967), pp. 55-78; *On a unique piece of fabric from the northern Caucasus burial mound of Moschevaya Balka*, in *Narodov Asii Afriki*, 3 (1967), pp. 119-126. Finally, see *On the formation of the Sogdian School of artistic weaving*, in *Srednia la Aziia i Iran Gosudarstvennogo Ermitazha*, (1972), pp. 5-46. Also of interest is H. W. HAUSSIG, *Die Beziehungen des Oströmischen Reiches zu Zentralasien und ihre Rezonanz*, in *Oriens Extremus*, 19 (1972), pp. 236ff.

42 For the Münsterbilsen silk in Brussels see I. ERRERA, *Catalogue d'étoffes anciennes et modernes*, Bruxelles, 1927, n° 4 on pp. 20-21. The author has compiled a catalogue of the Maastricht collection of over 250 silks, which is under preparation for publication. Some Liège silks were included in the exhibition *Splendeur de Byzance*, Bruxelles 1982, *Les Tissus de Sole*, pp. 205-218. The publication of the whole of this important collection is to be warmly welcomed.

43. R. A. BINOWITZ, *Jewish Merchant Adventurers. The study of the Radanites*, London, 1948.

44. The Italians acted as an important intermediary in trade between Byzantium and the West; see for example, W. HEYD, *Histoire du Commerce du Levant*,

Leipzig, 1936, pp. 93-125. Also M. BALARD, *Amalfi et Byzance Xe-XIIe siècles*, in *Travaux et Mémoires*, 6 (1976), pp. 89-90.

45. A photograph of the British Museum silk is in E. KITZINGER, *Early Medieval Art*, British Museum guide, 1963, pl. 14.

46 See MUTHESIUS, *Eastern Silks*, pp. 25-30, 38-50, 509-510. Also MUTHESIUS *Practical Approach*, pp. 251-254 with bibliography in footnotes. A detailed technical analysis of the silk was published in *C.I.E.T.A. Bulletin*, 6 (1961), pp. 29ff.

47. The surface wefts are worn away completely in the area of the indiction number. The silk was closely examined and photographed in the 1980s by the author. Today it is back in the shrine of Charlemagne.

48. The detailed evidence is given by MUTHESIUS, *Eastern Silks*, 25-27, notes 36-46 on pp. 40-48.

49. For the shrine of Charlemagne see P. LASKO, *Ars Sacra 800-1200*, London, 1972, pl. 295 and pp. 253-4. Also *Aachener Kunstblätter*, 42 (1972), pls. 52-56b and Cat. n° 44 on pp. 66-69.

50. Discussed in MUTHESIUS, *Eastern silks*, p. 120 and listed as item f.

51. *Splendeur de Byzance*, Bruxelles 1982, Tx.3 on p. 209. Hereafter, *Splendeur de Byzance*. Also MUTHESIUS, *Eastern Silks*, p. 120 item e.

52. The largest surviving piece belongs to Ottobeuren. It is published in the catalogue *Suevia Sacra, Frühe Kunst in Schwaben*, Augsburg, 1973. See S. MÜLLER-CHRISTENSEN, *Textilien in Schwaben*, pls. 188-189, cat. n° 200 on pp. 192-193. An extensive literature on the group is given there.

53. The Aachen Hunter silk is in E. GRIMME, *Der Aachener Domschatz*, in *Aachener Kunstblätter*, 42 (1972), Cat. n° 13 on pp. 19-20.

54. See *Splendeur de Byzance*, Tx 1 on p. 207.

55. Discussed in MUTHESIUS, *Eastern Silks*, pp. 188-216.

56. *Ibid.* 192, and p. 523 (Xanten), p. 521 (Mainz).

57. Inv. 114 silk amongst other Maastricht pieces is in MUTHESIUS, *De zijden stoffen in de Schatkamer van de Sint Servaaskerk te Maastricht*, overdruk uit *Publications*, 1974, see pl. 20.

58. The Sustern piece is unpublished.

59. Consult F. MAY, *Silk Textiles of Spain 8th-13th century*, New York, 1957, fig. 12.

60. The Bamberg silks were conserved and first published by S.MÜLLER-CHRISTENSEN, *Das Grab des Papstes Clemen II im Dom zu Bamberg*, München, 1960

VII
From Seed to Samite: Aspects of Byzantine Silk Production

SILK is a marvel of nature that transcends the boundaries of science and technology. In spite of the creation of numerous artificial yarns, it is widely regarded as the 'Queen of Fibres'.[1] The production of high-quality silk yarn, essential to the running of the silk industry in the Byzantine Empire from the fourth to the twelfth centuries, was directly dependent on the correct application of skilled moricultural and sericultural practices. An appreciation of the intricacies of these practices is vital for the proper understanding of surviving historical documentation on the Byzantine silk industry, but remarkably little interest in this aspect of Byzantine silk production has been shown by historians and philologists.[2] Also, it has been insufficiently recognized that, by virtue of a certain logic of situation, silk weaving in mediæval Byzantium cannot have been so far removed from non-industrialized silk weaving of our own times. Many contemporary silk worm rearing and silk working practices in parts of India and China may be seen as time capsules mirroring ancient practices, and as such they are capable of casting valuable light on Byzantine silk production.[3] It was Donald King who first introduced me to the fascinating topic of mediæval silk weaving. In gratitude to him as a distinguished textile historian, an excellent teacher, and a dear friend, I offer some thoughts on the relationship between empirical analysis and interdisciplinary theoretical research in the field of Byzantine textile history.

THE THREE STAGES FROM SEED TO *SAMITE*
In the progress from seed (silkworm egg) to *samite* (woven silk) three distinct stages can be discerned:[4]

1. The production of the raw material.
2. The processing of the yarn into woven cloth.
3. The marketing of the finished products (PLS. 53-56).

Stage one, the production of the raw material, may be further divided into three parts: a) moriculture, b) sericulture and c) cocoon processing. Stage two, the manufacture of the silk cloths, includes a study of guilds and workshops, and an analysis of the legislation governing their organization and operation. Stage three, marketing, encompasses research into both domestic and foreign markets and an analysis of trade routes. It is not possible to enter into each aspect of the three stages fully in the course of this short paper. The first stage is covered in some depth, but only a selection of problems associated with stage two will be discussed. Amongst these is the question of the function of the private silk guilds as they are described in the tenth century *Book of the Prefect*, a document containing regulations governing the non-imperial silk guilds in Constantinople. A flow chart (PL. 57) presents a synopsis of my analysis of the information contained in the *Book of the Prefect*.[5] This chart illustrates the flow of raw material and of finished silk goods in the Byzantine silk industry around the tenth century. It is designed to indicate the complex relationships that existed between agriculturalist, craftsman, merchant, and consumer, both in private and in imperial silk manufacture. Space does not allow for any discussion of the Byzantine silk trade, another important aspect of Byzantine silk production.

When was Sericulture introduced into Byzantium? Before dealing with individual aspects of the three stages outlined above, it is necessary to ask at what date sericulture was introduced into Byzantium and from which precise region it came. The most commonly held view is that sericulture came to Byzantium from China in the sixth century and that earlier than this date there was no production of raw silk in the Empire.[6] The evidence in support of this view relies upon information in two sixth century documentary accounts, which nevertheless differ in their interpretations of the evidence. According to Procopius of Caesarea (500-65), the introduction of sericulture into Byzantium was accomplished by Indian monks smuggling silkworm seed from a sericultural land called 'Serindia'. On the other hand Theophanes of Byzantium, writing towards the end of the sixth century, claimed that a Persian had smuggled out the necessary silkworm seed to Byzantium from the silk-producing 'land of the Seres'.[7] Whilst in principle it may not matter a great deal whether an Indian or a Persian transported the silkworm seed, it does seem crucial to establish where the seed came from. Dr Wada has established that the 'land of the Seres' to a sixth century Byzantine probably meant no more than 'the land from which the silk came'.[8] Neither

is Serindia definitely to be pinpointed, for the name occurs in no other source. In spite of this, Wada does go on to identify the location from which sericulture was transposed to Byzantium as the most southerly region of the east Caspian sea coast.[9] As there is no firm documentary evidence that this region practised sericulture in the sixth century, however, this suggestion is inconclusive. Others using the same evidence have suggested as widely differing regions as Ceylon and Khorasan.[10] The truth is that we do not know precisely from where silkworm seed may have been introduced into Byzantium in the sixth century, if indeed it was. Certainly there was sericulture in China from the third millennium BC, and some carbon-dated prehistoric cocoons have been excavated by archaeologists in China.[11] The lack of similar finds and documentary records in other lands has tended to entrench the idea that all sericulture stems originally from China, but this can be refuted. According to Professor Jolly of the Sericultural Institute in Mysore, the Indian Nistari moth, for example, genetically cannot be derived from the domesticated Chinese silk moth: the Nistari moth is native to India not China.[12] Perhaps future research will reveal how and when this moth first came to flourish in India. Professor D. Kuhn has concluded that the earliest Chinese domesticated silk moth originated from a wild moth, and if this is true why then could not other wild silk moths outside China have been domesticated in the same way?[13] From Aristotle's 'Natural History' we hear of silk fibre on the island of Cos in the fourth century BC, and there are many references to an expensive, translucent fabric 'Amorgian' in classical Greek literature, that could be identified with silk textiles.[14]

Dr J. P. Wild and Hero Granger-Taylor have demonstrated the use of imported Chinese silk for weaving in antiquity.[15] During the classical period it has been assumed that there was no domestic silk production, and much the same has been assumed for the early Byzantine period between the fourth and the sixth centuries. Nevertheless, if sericulture was not introduced into the Byzantine Empire until the sixth century, as Procopius and Theophanes suggest, I am inclined to ask: 'How did the silk industry manage over many centuries without a domestic supply of raw silk?'. Need the reports of Procopius and Theophanes be accepted at face value? An investigation of some Imperial Chinese annals provides a possible answer. In particular the *Wei Shu* written before 572 AD and embracing the period 386-556 AD describes a country called *Da Qin* also called *Li Gan*, which 'produces all kinds of grain, the mulberry tree and hemp', where 'the inhabitants busy themselves with silkworms and fields'.[16] F. Hirth has identified *Da Qin* with Roman Syria, using internal evidence from reports in several different dated Chinese annals: his ideas deserve greater study.[17] If his identification is correct, Syria, as part of the Byzantine Empire, would have had sericulture before the sixth century

AD. Procopius does report that there was a flourishing domestic silk industry in Tyre and Beirut up to the time of Justinian in the sixth century and the question is, did Syria grow its own silk as well as importing silk from China via Persia and other intermediaries? Early seals of *kommerkiarioi* or imperial silk officials have been seen as quality stamps for imported raw silk, but how does one know that they were not used to quality stamp domestic silk?[18] The earliest extant seal belonged to Magnos the Syrian, minister of Justin II (565-78) and administrator of Imperial estates at Antioch.[19] He is thought to have imported raw silk into one of the official trading posts on the eastern frontier of the Byzantine Empire and to have stored it in Antioch. Could he not at the same time have been storing domestic silk supplies yielded by the Imperial estates under his charge? According to Procopius, Justinian ruined the silk industries of Tyre and Beirut but it is unclear how.[20] Did he levy a ceiling price of eight gold coins on a pound of imported raw silk as Lopez believes or did he, as N. Oikonomides thinks, levy sumptuary laws setting this as a ceiling price for luxury silk garments sold in the Byzantine Empire?[21] Whatever the correct answer, either the costs of the imported or the domestic raw silk, or alternatively the costs of manufacture of the finished silks, rendered unacceptable the profit margin realized by their sale. The mystery of the origin of Byzantine sericulture is far from solved, but an appreciation of the essential processes of mediæval sericulture does reveal that its establishment in Byzantium cannot have been the spontaneous occurrence that Procopius or Theophanes or, for that matter, later authors quoting these sixth century authors, would have us believe. The two accounts at best may be seen as acknowledging the general truth, that sericulture penetrated further into the Byzantine Empire at some point during the sixth century.

From Seed to Samite, Stage One: Moriculture

It is necessary merely to glance at the vast range of processes essential to the running of the silk industry to understand that the skills required for rearing the delicate silkworms could be acquired only over a lengthy period of time. Even if mulberry trees had been cultivated in Byzantium prior to the introduction of foreign silkworms, there was still no guarantee that the native species of mulberry would be suitable for foreign silkworms. If Byzantium had only unsuitable wild mulberry species, then foreign mulberry trees as well as foreign silkworms would be required; moricultural as well as sericultural skills would need to be learnt. If there were unsuitable native mulberry species in Byzantium, the other possibility is that foreign species were grafted on to domestic varieties. In any event, mulberry cultivation involved a working practical knowledge in five basic areas: propagation, planting, cultivation, cropping, and pruning.

Propagation in turn involved four interrelated activities: seeding, grafting, cutting, and layering, all different means of increasing mulberry stock. Seeding was accomplished by squeezing the ripe fruit, while grafting entailed inserting a scion (small branch) into the stock (a rooted plant). Grafting was one means of introducing a foreign species into native stock or of strengthening domestic varieties. As well as branches, shoots, roots or buds could be grafted. Mulberry trees could be grown from cuttings, (either twigs or branches), by rooting and by replanting. Layering involved depressing mulberry shoots or branches into the ground whilst the sapling or tree stood upright. Each buried shoot or branch developed into a new tree. All these are mediæval methods documented in Chinese sources.

Either mulberry bushes or fully grown trees (from fifteen years upwards) could be cultivated. Tilling, weeding, and manuring were necessary in the case of either bush or tree mulberry, but the cropping and gathering of leaves and the trimming of shoots varied according to the size required and depended also on the number of silkworm crops to be reared. Certainly, a delicate balance was necessary between production and demand. In mediæval China there were two methods of cropping: one involved cutting down whole branches, whilst the other entailed stripping only leaves from the branches. A variety of special axes, knives, stools, and ladders was necessary for these activities as well as for pruning, which entailed the trimming of drooping or diseased branches. The mulberry tree was subject to disease (fungal and bacterial), and if silkworms ingested infected leaves, whole silk crops could be eliminated at a single stroke.

Silkworm rearing, Cocoon processing and Yarn production

Silkworm rearing necessitated the presence of a rearing house and the acquisition of proper feeding instruments. Three principle areas of activity can be recognized: feeding of the silkworms, processing of cocoons, and production of yarn. Feeding was a labour intensive, skilled occupation, which involved chopping the mulberry leaf to the correct size according to the stage of development of the silkworm from the time of hatching up to the time of maturity. Feeding continued at regular intervals day and night. As the worms grew in size, their beds or trays had to be enlarged to avoid the spread of disease through overcrowding. It was necessary too, to keep a constant watch for waste products after feeding, and to clear litter, which again could give rise to infection amongst the silkworm crop.

Cocoon production fell under the heading of five main tasks, from the setting up of spinning boards and the mounting of silkworms ready to spin, to the laying of seed by female moths allowed to emerge from their

cocoons and to mate. The three intervening tasks were: control of humidity, noise levels, and temperature; the dismantling of spinning boards at the proper time; finally the gathering and grading of the cocoons, some of which might be stored for a short period (in mediæval China in large salted pots).

Yarn production demanded the attention of yet more specialists. Vat tenders and reelers had the task of boiling the cocoons and unwinding the silk threads from the cocoons. Waste or floss silk had to be collected, and required spinning as opposed to reeling. The yarn that was to be degummed had to be boiled in a special solution and hung to dry. After this it could be dyed and/or twist could be added. Probably there were silk weighers and silk graders, to attach a mark of quality and a market value to the yarn before it was ready to be woven. There were also those who were skilled in the making of gold threads with silk cores (see further Pl. 54).

Stage Two: Manufacture of the silks — Workshop skills At this stage the yarn was ready for use either by Imperial or by private silk guild weavers, in workshops where a variety of categories of craftsmen would be working. Some yarn would also be used in the homes of wealthy Byzantines for domestic production, and further silk yarns may have been woven up in monasteries, although documentary evidence for this suggestion is lacking.

The presence of at least eight skilled craftsmen in the workshops can be envisaged thinking of workshops in India today: carpenters for the looms; pattern makers to design motifs for weaving; weavers to tie up the looms to weave the cloths; drawboys to operate the figure-producing device attached to the hand draw looms; dyers; embroiderers; and printers and tailors of silk garments. Two further categories of workers may well have been employed: craftsmen for making a design prototype to assist in the tying up of the loom (in India today called *Naksha* makers), and craftsmen who specialized in preparing the warp for tying up of the loom. From the Cairo Geniza documents (tenth to eleventh centuries, Eastern Mediterranean), it is evident that warp threads could be purchased, presumably silks with sufficient twist to act as warp. In the case of warps that required a particularly high twist, perhaps this was added under the special direction of the weavers themselves, by another category of craftsman either working in the weaving workshops, or privately in their own homes (Pl. 54). As will be discussed below, the tenth century *Book of the Prefect* describes a guild of the *serikarioi*, under whom a series of different craftsmen operated. It is not necessary to think all these craftsmen, with their widely differing jobs, were engaged in a single workshop. There may well have been a series of related workshops under

the control of the *serikarioi*, who may be seen as factory owners rather than as craftsmen personally involved in different stages of manufacture.

There are indications that Byzantium faced severe sericultural problems **Essential** as late as the tenth century. Indeed, why else should Syrian silk **Processes** merchants have enjoyed such very special privileges of residence in **described in** Constantinople in the tenth century in return for the supply of raw or **more detail in a** woven Syrian silk?[22] Unfortunately, there are no mediæval Byzantine **Mediæval** sericultural manuals, but the *Geng Zhi Tu*, datable c. 1145, is a Chinese **Chinese source** sericultural treatise covering every stage of silkworm rearing, with seventeenth century woodcuts believed to be directly based on twelfth century illustrations.[23] The treatise describes in some length the process of bathing the silkworm seed in water to promote hatching and the immediate gathering of mulberry leaves chopped into tiny pieces for the feeding of the pinhead sized, newly hatched larvae. It goes on to describe in great detail the four stages of the life cycle from seed to larva and from pupa to moth. The treatise reveals that feeding of increasingly more coarsely chopped mulberry leaves occupied all hours of the day and the night, except for short periods of respite when the silk worms fell asleep and moulted. Moulting occurred either three or four times during the course of the thirty or so days between hatching and maturity. At all times the strictest watch had to be kept on hygiene, ventilation, and humidity to prevent stress and disease amongst the silkworms. *Geng Zhi Tu* also shows how special spinning frames of wicker or bamboo were prepared for the silkworms at the time of maturity. In principle, these differ little from the wooden wicker trays still used for the same purpose in present day India. The spinning process occupied two or three days when special precautions were necessary to prevent the silkworms from ceasing to spin before their cocoons were completed.[24] At this time, the silkworms were particularly sensitive to excess light and noise, and they did not respond well to any smoke that escaped from fires lit under spinning trays to keep them warm.[25]

Following the spinning of the cocoons, pupation occurred. This lasted about two days, after which time it was imperative to decide whether the moths were to be stifled over heated pans of water, or whether they were to be allowed to emerge so that mating could occur, eggs could be laid and seed gathered for storage. The female moths were larger than their male counterparts, and it was necessary to recognize male from female even in the cocoon so that the correct numbers of moths of each sex might be allowed to emerge. As mentioned, in mediæval China it was customary to store some cocoons in large salted jars rather than immediately following stifling by reeling as described above. In some ways this was preferable

because water vapour could harm the silk fibre. For those cocoons required immediately, reeling was effected with a simple apparatus — a heated basin attached to a silk winder. Kuhn has discovered an illustration of a thirteenth century Chinese example; this differs but little from the country *charka* still in use in India today.[26] Sericulture was a labour intensive and specialized seasonal industry in mediæval China, where there must also have been considerable liaison between the mulberry leaf growers and the silkworm rearers, to ensure that fresh food supplies were always available for the voracious grubs. Naturally, the greater the number of silkworm crops a year, the more varieties of mulberry coming into leaf at different times of the year that would have been required to keep the silkworms adequately nourished throughout spring, summer, and winter. Similarly, the greater the number of silkworm crops raised, the more pressing became the need to breed species of moths that laid fast-hatching seed rather than seed which required a long incubation period. Finally, the more high-powered the production, the greater the necessity for special breeding houses taking the industry out of the hands of the agriculturalist and into the hands of the professional sericulturalist; where indeed it belonged if it were to support a national industry, as opposed to a small cottage venture. The same considerations will have applied to the Byzantine silk industry.

Mulberry Cultivation and the Organisation of the Silk Industry in the Byzantine Empire So far only one document has come to light to indicate where mulberry plantations were actually situated in the Byzantine Empire. This document deals with the taxation of mulberry trees in mid eleventh century Byzantine southern Italy. It has been suggested that the trees were grown to yield leaf for the rearing of silkworms and for the production of raw silk. The mulberry plantation belonged to a Byzantine monastery under the jurisdiction of the metropolis of Reggio. The document, a parchment scroll found in the private archives of the counts of Calabria, was published by Professor Guillou, who calculated that the 6,425 fully grown mulberry trees recorded in it yielded sufficient leaf to nourish silkworms capable of producing raw silk to the value of 1,250,000 dinars.[27] He took the average price of raw silk as revealed in contemporary documents to be 2.5 dinars a kg.[28] The Cairo Geniza documents reveal that an average family in eleventh century Egypt needed about 2.5 dinars a month to live, so that in real terms, Guillou's estimated income from the raw silk yield would have been sufficient for the upkeep for a year of an enormous number of families.[29] However, these figures must be treated with care, for an investigation of the ratios used by Guillou to establish the size of raw silk production reveals inconsistencies.[30] Guillou estimates that one mature mulberry tree yields 300 kg of leaves. This corresponds with figures that

were recorded for nineteenth century Calabria as well as present-day figures available in parts of India.[31] However, Guillou's ratio for the weight of mulberry leaf to the weight of silk worm seed that could be nourished is inaccurate. Guillou states that one tree produces enough leaf for one kg of seed, but the correct ratio is one tree to 10 g of seed — a figure not only available in nineteenth century Calabrian sericultural records, but verifiable in present day India. Guillou's prediction of raw silk yield seems one hundred times too great. Not only this, but the ratio he uses for the weight of cocoon to the weight of raw silk, at 4:1, represents a standard of production twice as high as that for modern-day India, where vast sericultural research stations have succeeded in reducing this ratio at best to 8:1 Other stages in Guillou's argument may be similarly modified and are discussed in greater detail elsewhere.[32] As the analysis of the document stands, the scale of production and the tax yield are erroneously forecast: moreover a false impression has been given of southern Italy as an important supplier of raw silk to Byzantium. Not only was the yield quite low but we know nothing of the quality of the silk. How do we know that it was good enough for the workshops of Constantinople? It might have been used locally for embroidery thread or for provincial, small-scale silk weaving. The Cairo Geniza documents reveal that no less than twelve different qualities of silk were available on the open market in the Eastern Mediterranean.[33] We have no indication of the actual quality or type of silk that may have been produced in Calabria.

In the manufacture of the silk yarns and textiles, perhaps the most pressing task is to identify the role of the different guilds that are recorded in the tenth century *Book of the Prefect*.[34] This source gives details of regulations governing the functioning of five non-imperial silk guilds in tenth century Constantinople. So far the document has been analysed without reference to the essential processes governing the preparation of silk yarn, and there has been a tendency to lump together many functions, which in fact were specialized occupations that could not possibly have been carried out in one location or by a single set of people. An instance of this is the suggestion by D. Simon that the *serikarioi* of the *Book of the Prefect* were silk weavers also responsible for the reeling, the degumming, the twisting, the dyeing, and the tailoring of silk in a single workshop location.[35] The degumming process alone occupies one man and perhaps an assistant. It is a dirty business whereby the gum is boiled off, nowadays in India in a large charcoal heated burner, in a special place well away from the meticulously clean workshop of the weavers. In Byzantium in any event, there was the guild of the *katartarioi* whose very name implies that its members cleaned the silk in some way, and there were *melathrarioi*, who were poorer cousins of the silk dressers, not organized into an official guild, but available to dress silk.[36] The weavers

would have had their hands full with tying up the loom and with the weaving. Apart from the silk merchants, the silk dressers, and the weavers, two guilds dealt with domestic and with imported silk (mainly Syrian silk garments). The latter were the *vestiopratai* and the *prandiopratai*.[37] Thus, the mediæval Byzantine silk guilds spanned the gaps between silk merchants, silk workers, and fabric brokers, and encompassed both production and marketing. Unfortunately, the statutes of the guilds are not described; rather there is a somewhat hasty list of regulations of uneven length for each guild, in general designed to protect the quality of production and to ensure the integrity of the guild members as well as to ensure compliance with specific Imperial regulations. Not least, the guilds had to observe a ban on the manufacture of murex-dyed silks, a prerogative of the Emperor and a vital symbol of his political authority.[38]

The Byzantine silk industry had an imperial and a non-imperial sector apparently served both by domestic and by foreign raw silk suppliers. There were five non-imperial silk guilds by the tenth century: *metaxopratai* or raw silk merchants; *katartarioi* and *melatharioi* (I translate these respectively as degummers of silk, and as spinners of waste or broken silk fibre); *serikarioi* (I suggest these were factory owners under whom there was a degree of silk dressing, silk weaving, dyeing, and tailoring; not necessarily in one location); *vestiopratai,* who sold domestic silk garments, and *prandiopratai* who marketed foreign silks. Imperial silks were used for the Imperial household and as gifts to ecclesiastics, military and civil leaders, and foreign diplomats and rulers. Privately manufactured silks of specially regulated types were sold locally or exported abroad in restricted numbers (PL. 56).[39] Oikonomides has studied the seals of raw silk officials and has shown how, with the loss of Byzantine territories in Asia Minor by the tenth century, sericulture was centred in Macedonia. However, it should be added that if the regulation in chapter 7.1 of the *Book of the Prefect* does indeed apply to silk grown in the neighbourhood of the capital, some domestic raw silk may also have been brought into Constantinople from outlying local regions. What percentage of raw silk was purchased outside the Empire it is difficult to say, but it is certain that the export of woven silks from the Empire was strictly regulated and that Byzantine silks were much coveted.[40] In fact, it was only because Byzantine silks were so highly prized that the survival of many hundreds of fragments abroad was assured. Sadly, Byzantium suffered too many vicissitudes for silks to survive *in situ:* between 1204-61 the capital was under Latin occupation, and in 1453 she suffered disastrous defeat at the hands of the Turks. Only those Byzantine silks that had found their way to the west before the thirteenth century, either as items of merchandise or as gifts, survived. Many of the most splendid

were diplomatic gifts sent from Byzantium to Western rulers, who subsequently passed them on to their favourite ecclesiastical foundations. A series of inscribed Imperial Lion silks in Rhenish treasuries are good examples. They are variously datable between 867 and 1025, a period when numerous marriage alliances were either arranged or negotiated between Byzantium and the West. Indeed, in 972 the Byzantine princess Theophanou was married to the Ottonian Emperor Otto II. But even earlier, under the Carolingians, silks were appearing in great numbers in the West. Many survive at Aachen and at Sens in particular. Charlemagne himself donated many relics to Sens, and it is likely that the smaller scraps of silk in the treasury today were originally wrappings of these relics.[41]

The splendid Elephant silk at Aachen was, amongst others, used to shroud the relics of Charlemagne (Pls. 45, 46). These silks not only show the esteem in which Byzantine silks were held, but they also indicate that such silks were stored and used over centuries in the West.[42] The inscription on the Aachen Elephant silk indicates that it was woven at Zeuxippos, a district near the Grand Palace in Constantinople, under Michael, a prominent chamberlain of the Emperor, and Peter, the head of the Imperial weaving factory.[43] Technically the silk required an extremely complex pattern-producing device for the creation of the design, and this was probably thought out by the weavers themselves, as in China and in India today. This perhaps gives some idea of why the weavers did not have time to concern themselves with degumming of threads in tenth to eleventh century Byzantium, and it is this type of consideration which renders it impossible to accept Simon's interpretation of the serikarioi as processors of yarn as well as dyers, weavers, and tailors of silk.[44] It is difficult to envisage the type of loom used for weaving the kind of extremely complex, large-scale, pattern of the Elephant silk. Byzantine miniatures show simple looms without figure-harnesses. There are mediæval Chinese representations of more complex Chinese drawlooms, but the relationship between these and Byzantine drawlooms has still to be established. Did Byzantium adopt the Chinese drawloom or did it develop its own loom in Syria? Is it possible that there were Eastern Mediterranean influences on Chinese drawlooms as well as Chinese influences on Byzantine and Islamic drawlooms? There does survive a valuable Chinese technical manual of 1263 describing the building of a drawloom, but its text breaks off at the section dealing with the construction of the figure-harness. Neither is anything known in detail of the development of the Persian drawloom. There is much work to be done in this field of study.[45] So far no one has considered the possibility of a multi-tier drawloom. In the confined space of Zeuxippos, where the Elephant silk was woven, could there have been multi-tier drawlooms that did not occupy so much

space? Such a loom was observed in operation in India recently, and on it a series of never-repeating geometrical patterns involving 1440 harness cords were being woven.[46] Of course there is nothing to link such a loom to the Elephant silk, but this illustrates the point that little is known about the overall capabilities of hand drawloom weaving. Sound empirical research in this field was begun by the late John Becker and, after many years of work, valuable insight was shed on some techniques.[47] However, the apparatus on which the re-weaving was carried out was not necessarily that used by mediæval silk weavers, and similar work needs to be done on drawlooms with figure-harnesses. As W. Endrei and D. De Jonghe have pointed out, there was never a single type of loom in operation in one region at any given time. No doubt some regions were very much more advanced than others in using sophisticated looms with figure-harness devices.[48] In the Imperial Byzantine workshop of the eleventh century which produced the magnificent Aachen Elephant silk, cost was no obstacle, and the loom used there was likely to have been a unique piece of apparatus, one that stood out from simpler looms in less imposing Byzantine workshops. To operate this magnificent loom there must have been very skilled weavers both capable of setting up and of working in combination with drawboys, the intricate, vast pattern-producing device of the loom. Now that so much has been done on the historical and on the weave-analysis side in textile history, perhaps it is an appropriate time to turn in earnest to the history of weaving technology. I have no doubt that the innermost secrets of Byzantine silk weaving will not be revealed until the silks have been rewoven, and not as bland modern copies but as fabrics embodying the texture, spirit and beauty of the marvellous originals. When this has been achieved a full picture of the path from seed to *samite* will emerge.[49]

ACKNOWLEDGEMENT

I wish to thank Mr. R. Gooch of IBM UK Academic Systems for his expertise in producing the flow charts using IBM Personal Publishing equipment, and for other help.

NOTES

1. On artificial fibres see R. Hünlich's, *Textile Rohstoffkunde*(Berlin, 1968), pp. 89-133.

2. Difficult silk terms that occur in the *Book of the Prefect* (see note 22 below) cannot be understood by a literal translation or by comparing them with similar terms used in an entirely different context. They have to make sense in the context of the silk industry.

3. On recent visits to India I have found the survival of ancient moricultural techniques and traditional sericultural practices that have much in common with processes described in mediæval Chinese sericultural manuals. I wish to thank the British Academy for two Fellowships that enabled me to carry out extensive research in India in 1986 and in 1987.

4. Seed is the technical term given to the eggs of the domesticated Bombyx Mori silk moth. *Samite* or *samit* is the old term for weft-faced compound weave. On this point see *CIETA Vocabulary of Technical Terms*, (English, French, Italian, Spanish), (Lyons 1964), p. 58. Compare D. K. Burnham, *Warp and Weft. A Textile Terminology* (Ontario, 1980), p. 180.

5. A fuller discussion of the silk guilds is contained in a two-volume *History of the Byzantine Silk Industry*, presently under publication by the author. On the chart, the term 'dress' has been used to denote the process involved in the reeling and degumming of silk fibre as well as the spinning of unreelable silk. Dyers and printers appear in the sequence of skills in the workshops for two reasons: firstly because some of the monochrome incised twill weave silks of the tenth to eleventh centuries may have been dyed in the piece, and secondly because there may have been continuation of resist dyeing traditions in some workshops. In present day Northern Greece there survives a tradition of monochrome hand-weaving, using gummed silk, where the fabrics are washed in a special solution and then dyed in the piece.

6. Since Lopez accepted a sixth century date for the introduction of sericulture into the Byzantine Empire, others have followed his lead without further question. See R. S. Lopez, 'Silk Industry in the Byzantine Empire', *Speculum*, XX (1945), pp. 1-42, esp. p. 12. The names of the authors that have quoted Lopez are too numerous to list.

7. Both accounts are discussed in H. Wada, *Prokops Rätselwort Serinda und die Verpflanzung des Seidenbaus von China nach dem oströmischen Reich*, PhD thesis (Cologne University, 1972), pp. 63-70, with source bibliography.

8. Wada, *Serinda*, p. 64

9. Wada, *Serinda*, pp. 71-85.

10. Wada, *Serinda*, pp. 64-67.

11. D. Kuhn, *Textile Technology: spinning and reeling*, in J. Needham ed., *Science and Civilisation in China*, volume v part 9 (Cambridge, 1988), pp. 272ff., 311-12.

12. Personal communication, Mysore, 1987

13. Kuhn, *Spinning*, p. 307.

14. See H. Granger-Taylor, 'Two silk textiles from Rome and some thoughts on the Roman silk-weaving industry', *CIETA Bulletin*, LXV (1987), pp. 13-31 with further references in the footnotes.
15. H. Granger-Taylor, 'Two silk textiles', p. 25. J. P. Wild, 'Some early silk finds in Northwest Europe', *The Textile Museum Journal* (1984), pp. 17-23.
16. This source amongst others was quoted by Hirth in F. Hirth, *China and the Roman Orient: Researches into their Ancient and Mediaeval Relations as represented in old Chinese records* (Shanghai, 1885).
17. Hirth's thesis was expounded in an article entitled 'The Mystery of Fulin', *Journal of the American Oriental Society,*XXX (1910), pp. 1-31; XXXIII (1913), pp. 193-208.
18. On the seals see N. Oikonomides, 'Silk trade and production in Byzantium from the sixth to the ninth century: the seals of kommerkiarioi', *Dumbarton Oaks Papers*, XL (1986), pp. 33-53.
19. Oikonomides, *Seals*, p. 37.
20. Procopius, *Secret History*, ed. H. B. Dewing (London, 1969), pp. 290ff.
21. Oikonomides, *Seals*, p. 34 note 1.
22. On the *Book of the Prefect* and important Syrian silks, see J. Nicole, *The Book of the Eparch*(London, Variorum Reprint, 1970). A new edition is in preparation by Professor Koder of the Byzantine Institute in Vienna. See J. Koder, *Das Eparchenbuch Leons des Weisen*, CFHB 33 (Wien, 1991). A bibliography on the *Book of the Prefect* is contained in S. Vryonis,*Byzantium: its internal history and relations with the Muslim World*(Variorium Reprints, London, 1971), III, pp. 293-94, note 13.
23. O. Franke, *Keng tschi tu, Ackerbau und Seidengewinnung in China* (Hamburg, 1913). Abhandlung des Hamburgischen Kolonialinstituts, II, Reihe B, Völkerkunde, Kulturgeschichte und Sprache, 8.
24. See *FAO Agricultural Services Bulletin*, 15/1-3 (Rome, 1972-76). On spinning consult 15/3, 5.
25. The silkworms produce a protein called fibroin with a gumlike sericin coating, which we know as silk fibre. On protein fibres see for instance, E. Truter, *Introduction to Natural Protein Fibres. Basic Chemistry* (London, 1973), pp. 50-59.
26. Kuhn, *Spinning*, p. 356, Fig. 222. The Indian country *charka* was seen in operation by the author in S. India in 1987.
27. A. Guillou, *Le brebion de la métropole byzantine de Region* (Corpus des actes Grecs d'Italie, IV) (Vatican City, 1974).
28. Guillou, *Brebion*, p. 95.
29. On living costs, see E. Ashtor, Histoire des prix et des salaires dans l'orient médiéval (Paris, 1969).
30. Preliminary remarks were made by the author in her PhD thesis '*Eastern silks in Western Shrines and Treasuries before 1200*', Courtauld Institute of Art, University of London (1982), pp. 254-55, 259-62.
31. For Calabria, see L. Grimaldi,*Studi statistici sulla industria agricola e manifatturiera dells Calabria*, (Naples, 1845), chapter 7, p. 57.
32. Further discussed in forthcoming *History* cited in note 5 above.

33. S. D. Goiten, *A Mediterranean Society*, II (New York, 1971), section iii E, pp. 222-24 and note 53.

34. Detailed work on these problems is contained in the *History* cited in note 5 above.

35. D. Simon, 'Die Byzantinische Seidenzünften', *Byzantinische Zeitschrift*, LXVIII (1975), pp. 23-46, 34.

36. Nicole, *Eparch*, chapter 7, chapter 6, p. 15.

37. Nicole, *Eparch*, chapters 4 and 5.

38. Nicole, *Eparch*, chapter 4, p. 1, 4, p. 3, 8, p. 1, 8, p. 4.

39. For the use of silk clothing and home silk furnishings, see S. Goiten, *A Mediterranean Society*, IV (New York, 1983), passim.

40. Silk was a powerful prestige symbol for Byzantium, who distributed silks to the Latin and to the Islamic courts as a political gesture.

41. The earliest reference to this shrine is a twelfth century account, but many silk fragments at Sens clearly belong to the time of Charlemagne and earlier. See E. Chartraire, 'Les tissus anciens du trésor de la cathédrale de Sens', *Revue de l'Art Chrétien*, LXI (1911), 268. Muthesius, PhD thesis, 'Eastern silks in Western Shrines and Treasuries before 1200' (Courtauld Institute, London, 1982) catalogue numbers 4, 5, 6a, 6b, 17, 18, 23, 43, 44, 63, 78, 85, 96, 104, 106, 107, 108, 112, handlist pp. 382-84, 386, 388-89, 390, 393, 397-400, 413, 414, 423, 433, 436, 438 with discussion of individual silks in the text, particularly on pp. 101-19, 177-81, 217-35. A catalogue of all the Sens silks (500 pieces) was compiled by the author in 1979, and further work on the Sens silks in under preparation for publication.

42. The Charioteer silk from the shrine of Charlemagne is an Imperial Byzantine silk of the eighth to ninth centuries. It must have been stored for centuries before being placed in the shrine, which was completed in 1215. On the subject of silks stored and reused by the Byzantine Empire, in the Islamic world and in the West, see Muthesius, PhD thesis, pp. 48-49, note 47, p. 288. The Aachen Elephant silk may not have been presented in the year 1000 by Otto III. It could have been a gift from Frederick Barbarossa, or a gift from Frederick II, under whom the shrine was completed. See further note 43.

43. The Aachen Elephant silk alongside the Imperial Lion silks was discussed by the author in 'A practical approach to the history of Byzantine Silk Weaving', *Jahrbuch der Österreichischen Byzantinistik*, XXXIV (1984), 235-54. For the inscription, see pp. 251-54.

44. A detailed technical analysis of the silk was published in *CIETA Bulletin*, VI (1961), pp. 29ff.

45. D. Kuhn, Die Webstühle des Tzu-jen i-chih aus der Yüan-Zeit (Wiesbaden, 1977).

46. Details of the loom will appear in the forthcoming publication cited in note 5 above. The loom was worked by four men.

47. Becker does show that simpler apparatus is capable of complex weaving, but the use of such looms would prove to be slow, and to raise labour costs. See J. Becker, *Pattern and Loom* (Copenhagen, 1987).

48. The warp weighted loom was in use in the West at least up to the twelfth century.

49. Re-weaving research is being carried out in Cambridge by the author and by Amelia Uden with a reconstructed hand drawloom and hand-reeled silk. The work was begun in 1982.

ADDITIONAL NOTE

The Koder edition of the Book of the Prefect was published in Vienna in 1991.

VIII

The Impact of the Mediterranean Silk Trade on Western Europe before 1200 AD

S ILK, trade and politics were common spokes in an intricate wheel, propelling Mediterranean influence towards the West. At a time when Western Europe lacked the ability to manufacture silk cloth, Eastern silken stuffs were eagerly sought for secular and ecclesiastical purposes. Byzantium in particular, in return for silks, demanded Western military and naval aid, and her silk trade concessions bore the hallmark of powerful political bargaining counters. The survival of more than one thousand silks in church treasuries of Western Europe, provides unspoken insights into the complex impact of Mediterranean silk trade on the West before 1200 A.D. The purpose of this paper is to explore the broader ramifications of these remarkable influences.

The Mediterranean silk trade spanned economic, political, cultural and religious divides between East and West:

- Its economic impact was reflected by the breadth, scale and regularity of distribution of the silks on the Western market.
- Its political impact was demonstrated by the existence of a 'diplomatic silk trade' allied to a policy of special silk trade concessions in exchange for military or naval aid.
- Its cultural impact was evident in the uses of silks in Western society.
- Its religious impact was crystallised in the widespread and parallel uses of the silks in the Byzantine and the Latin Church.

The economic and political influences were inextricably linked, and these together with the ensuing social and religious influences were spurred along by Western courts eager to rival their Eastern counterparts.

It was not surprising that before the establishment of Latin silk weaving centres under Roger of Sicily at Palermo in 1147, the West should seek large numbers of patterned silks through silk trade with the Mediterranean (Weigand, 1935). Only the survival of large numbers of silks illustrates just how widespread was their distribution across Western Europe (Muthesius 1982 and forthcoming) (PL. 57). Over a hundred centres were receiving silks from the Mediterranean region at varying times between the fourth and the twelfth centuries.

Grouping the surviving silks according to weave The surviving silks as a whole may best be grouped according to technique and they fall into five main weaving categories:

TABBY, DAMASK, TWILL, LAMPAS and TAPESTRY.

A vocabulary of technical terms explains the particular names used for the weaves (C.I.E.T.A. Vocabulary 1964). Of these types the twills predominate and the tapestry pieces are rare.

A broad chronology for the different weaving groups is established through a combination of art historical, historical, technological and circumstantial data (Muthesius 1982 and forthcoming). The chronology of weaving types can be expressed in the form of a bar chart (Pl. 58).

The earliest surviving silks are damasks or tabbies with a pattern weft and these are found between the fourth and the sixth centuries. From the sixth century onwards different types of twill weaves appeared, initially with single internal threads or 'main warps'. From the eighth to ninth centuries these were paired for extra strength.

In Central Asian twills the 'main warps' were of gummed untwisted silk, used first in groups of three to four and later in pairs. The change occurred in the eighth to ninth centuries. The large groups of 'main warps' were composed of sturdy threads and caused the designs on the silks to be particularly stepped in outline, as can be seen on a characteristic eighth to ninth century Central Asian Lion silk at St. Servatius, Maastricht. The Central Asian silks are included in this paper because it is likely that some reached the West via Byzantium (Jerussalimskaja 1963, 1967, 1972; Pigulevskaja 1946).

By way of contrast, fine 'Monochrome twills' with designs that appeared incised were popular from the tenth to eleventh centuries in both Islamic and Byzantine workshops. Delicate 'Monochrome Lampas weave' silks adhered to the same stage of development. Tapestry weave

was an ancient technique but the surviving silk examples all belong late in date; eleventh to twelfth centuries (Muthesius 1982).

A clear pattern of distribution for these different types of silks emerges **Pattern of** from a study of the extant pieces. The first silks, tabby weaves and **distribution of** damasks ranging in date from the fourth to the seventh centuries, found **the silks in the** their way to centres in what today are Italy, Switzerland, France, Holland **West** and Germany. Of these, the earliest are two fourth century pieces from the grave of the St. Paulinus at Trier. At Sens Cathedral treasury a two-toned tabby weave silk, woven down not across the loom, has scenes of the story of Joseph accompanied by Greek inscriptions. Peculiarities in these Greek inscriptions suggest the silk was woven in sixth to seventh century Egypt prior to the Islamic conquest of 640.

The early twills, ranging in date between the sixth and the eighth centuries, follow a similar pattern of distribution to the tabbies and damasks described above. Sixth to seventh century twills with both figurative and foliate, and small scale animal and bird designs, are found in Italy, Switzerland and France. Central Asian silks were reaching those areas too, but they survive in concentration in the Lowlands in particular. The early twills with single 'main warps' datable to the eighth to ninth centuries were widely scattered in Italy, Switzerland, France, Germany and the Lowlands. It is noticeable that the same holds true of the later silks, the twills with paired 'main warps', and the monochrome twills and lampases.

How does the pattern of distribution of the silks tie in with what we know **Mediterranean** of Eastern Mediterranean and of Near Eastern trade routes in general? **trade** Documentation for Mediterranean trade between the eighth to tenth centuries is lacking. In comparison there is a wealth of evidence for the earlier and for the later periods with the Periplus of the Erythraen Sea and the Cairo Geniza sources (Schoff 1912; Goitein 1967, 1971, 1983). Heyd (1936) considered that the late antique fairs of Alexandria, Tyre, Beirut, and Trebizond continued into the mediæval period; it was only the Greek and Roman traders who were replaced by other intermediaries: Italian, French and Spanish merchants initially. In Merovingian Gaul the Syrians traded Mediterranean goods, and Italians at Pavia held silk fairs in the Carolingian period.

Lewis (1978) divided economic supremacy in the Mediterranean into different Byzantine and Islamic phases. Up to 641 he saw Byzantium holding the important industrial and commercial centres such as Syria, Egypt, Asia Minor and the Crimean coast in the east; in the west North

Africa, Southern Spain, and the seaport cities of Italy and Dalmatia. Alexandria and Constantinople dominated as trading cities. Marseilles acted as a Merovingian port connected to the interior by way of the Rhone valley, providing a route for import of Eastern silks in the hands of Syrians, Greeks and Jews living in Gaul. With the Arab conquests of the seventh century some of these centres passed under Moslem control but freedom of trade in the Mediterranean continued. Certainly, the West does not seem to have had a break in silk supply at least from the sixth to the twelfth centuries, in spite of all obstacles to trade. Pirenne's thesis about the devastating economic effects of the Arab conquests in the seventh century have been challenged on several grounds and the extant silks provide more fuel against his ideas (Havighurst 1958).

Following the Islamic victories, Lewis suggested some return of economic power to the Byzantines by the eighth to ninth centuries. This was achieved at first through a Byzantine blockade of Arab goods such that Arab trade with Byzantium was permitted only through Trebizond (Lewis 1978, 93). Byzantium tried to channel international commerce via Cherson, Constantinople, and Thessalonika as well as Trebizond, restricting activity in Mediterranean centres under Islamic control. There is no evidence of Byzantine trade with Egypt in the ninth century. From this time on Byzantine trade was placed increasingly into the hands of Italian merchants, who carried Byzantine goods to the West. Byzantium did not take part in the raw silk trade of the Islamic Mediterranean in so far as her raw silk could not be exported. Her interest in the Mediterranean trade was principally for spices and culinary herbs and these she could import via Trebizond.

By the tenth century trade was concentrated in Fustat and at Constantinople and Trebizond. Prior to the Fatimid conquest in 969 AD, a Greek market at Fustat was mentioned, but how far Byzantine merchants traded in Egypt is difficult to say. The book of the Prefect (Nicole 1970) suggested it was usual for foreign merchants to travel to Constantinople to buy silks. The Italians had special quarters in the Capital by the tenth to twelfth centuries as did the Syrians, who supplied Byzantium with silks in return for fabrics and other goods. Other Moslem traders were apparently still restricted to Byzantine markets of Trebizond, although it is interesting to note that Egyptian silks could be bought on the open market in Constantinople in the tenth century (Haldon 1989).

Goitein has concluded from more than 1200 letters of Jewish traders, that between the eleventh and twelfth centuries in general, most cloth was traded across two principle areas. These were Spain, Sicily and Egypt; and Egypt, North Africa, Syria and India. The cloths were largely Islamic, although fine Byzantine brocades also reached the markets of Fustat and were much sought after. His research concluded that ninety per cent of

Mediterranean trade was between the Moslem East and the Moslem West (Goitein 1973).

Mediterranean trade was directed to Western Europe through the increasingly crucial Italian merchants, who in their intermediary role carried silks both from the Muslim Mediterranean and from Byzantium directly to the West.

It has been suggested from sixth century coin finds, that the early **Specific trade** mediæval trade routes carrying Mediterranean goods passed through **arteries in the** Italy across the Alps to Switzerland and up river northwards into France, **West** Holland and Germany (Adelson 1958, cf. Wescher 1947). This pattern fits well with that of the surviving silks. Italy certainly seems to have played a leading role from an early date. Procopius in the sixth century already reported Italian merchants travelling between Constantinople and the Italian shores, in the same way as they carried goods to Italy from Alexandria. More exotic travels were undertaken by the Rhandanite Jews, who crossed deep into Central Asia on their way to China. Central Asian silks penetrating the Lowlands in the seventh to ninth centuries were most probably amongst the wares that these particular merchants carried (Rabinowitz 1948). Some Central Asian silks may have arrived in the West at second hand. These silks could have been acquired by Byzantine merchants in the Northern Caucasus, and subsequently have been traded on the open Mediterranean market.

The Ottonian Emperors in particular encouraged trade along the Rhine Maas artery and the ample supply of silks in churches along those rivers attests to the success of the waterways in dispersing silks carried to the West by Italian merchants in the tenth century (Baker 1938; Pounds 1973).

The overall pattern of distribution that emerges from at least the sixth to seventh centuries onwards, is one of widespread dispersal through Western Europe, thanks largely to Italian intermediaries. In exchange for silks the West supplied principally metals, slaves and, where necessary, military muscle to her trading partners.

About two thirds of the silks can be assigned Byzantine provenance on art **The provenance** historical grounds. The early pieces were probably woven in Egypt before **of the silks** the Islamic conquest in 640. Later pieces were largely the work of Constantinopolitan workshops where silk weaving was concentrated by the tenth century. It is difficult to say what types of silks were woven in provincial workshops such as Thebes and Corinth in the twelfth century.

Islamic silk weaving appears to have blossomed after the conquests of the seventh century and it is reasonable to assume that silk production continued in Egypt and Syria under Moslem rule. There was also silk weaving in Islamic centres in Spain, and numerous centres of the Near East (Serjeant, 1942-46).

Only very rarely did a Chinese silk appear in the West before the thirteenth century. One remarkable exception is a small silk from a reliquary at St. Servatius, Maastricht.

Inscribed silks provide useful pointers to the provenance of some silks. Coptic, Byzantine, and Kufic inscriptions survive on a number of fabrics. Most of the Greek inscriptions decorate Imperial pieces sent to the West between the tenth and the eleventh centuries as diplomatic gifts (Loughis 1980). The Kufic inscriptions belong to a variety of silks only some of which can be linked to specific individuals, such as Abu Mansur of Khurasan (executed in 961). The Elephant silk from St. Josse (PL. 59), on which his name occurs, may have been carried back to the West by Stephen of Blois, one of the commanders of the first Crusade. A silk at St. Ambrogio, Milan has the name of Nasr ad Daulah, Marwanid ruler of Upper Mesopotamia from 1010-1025. This piece would have been woven in a royal workshop and cannot have arrived in the West by way of trade. Islamic silks available on the open market were uninscribed and altogether less distinguished: for instance, some unpatterned and other simply striped pieces at Sens Cathedral treasury.

Byzantine silks often harked back to classical precedents. Examples are the eighth to ninth century Aachen Charioteer and Maastricht Hunter silks (PL. 60). This is not to say that Islamic centres did not copy classical motifs; for instance, there were Amazons wearing scarves with Kufic inscriptions. Byzantine workshops also adopted and adapted foreign motifs into their own repertoire as in the case of certain Sassanian elements in Byzantine hunter scenes. It is remarkable that by the eleventh century there was an 'International style' of silk weaving in the Mediterranean, so that Islamic and Byzantine workshops were producing very similar silks. At that point one might expect the West to have acquired an equal number of Byzantine and Islamic silks from markets centred in Constantinople, Fustat and Trebizond; but this does not appear to have been the case. Byzantium required political allies in the West far too strongly to allow Islamic rather than Byzantine silks to reach the West. Jonathan Shepard has underlined the way in which Byzantium turned to the West especially, for support against the Normans (Shepard, 1984). No less than sixteen diplomatic marriages were negotiated between Byzantium and the West from the eighth to the twelfth centuries and marriage negotiations appear to have been sealed with Imperial Byzantine silks (Muthesius 1990).

Byzantium made no secret of using her silks for political ends. She **The political** concluded silk trade treaties with the Russ and the Bulgars involving **impact of the** military and naval assistance, just as she did with the West (Lopez 1948, **Mediterranean** Muthesius 1991). She even courted Islamic favour by trading her silks **silk trade** with the Syrians on special terms in Constantinople, although other Moslems had to buy Byzantine silks at Trebizond. With Syrians she shared the trade taxes levied at Aleppo in the tenth century; her main intent was to retain Aleppo as a buffer state between Byzantium and hostile Islamic neighbours (Farag 1979, 1990).

As early as 812 Byzantium began to approach the West with the promise of trade concessions, although her early promises came to nothing. Venice from 742 was an autonomous state and she carried slaves and timber to Syria and Egypt against the orders of Leo V. By the late tenth century, she had become one of the staunchest of Byzantium's allies. Trading concessions granted to Venice by Byzantium spanned the period 992-1198, endorsed within eight major treaties. Pisa drew up three similar treaties in 1111, 1170 and 1192; Genoa also concluded trade treaties between the 1140s and 1192.

Venice at one stage received 4,320 gold pieces per annum from Byzantium and silk trade concessions in exchange for being on call to defend the Byzantine Empire at all times. Venice was on duty whenever Byzantium needed help; in particular against Robert Guiscard, Bohemond, or Roger of Sicily, but Pisa and Genoa were obliged to provide naval support only if they were in the immediate vicinity at times of unrest. Venice received direct trade concessions in 1082 and in 1147/48 in the face of Norman threats. On the other hand, concessions of 1126 were to prevent Venice turning against Byzantium. The privileges granted to Pisa in 1111 and renewed in 1136 were designed to gain support for a Byzantine offensive against Crusader kingdoms in Syria and Palestine, whilst the Byzantine trade agreement with Genoa in 1155 was an attempt to raise support against Norman Sicily. The Byzantine trade alliances with Genoa and Pisa of 1168/70 were blatant acts designed to raise support against the German Emperor. These treaties were turned on their head when Byzantium changed course in 1170 and instead sought a German alliance. Later trade treaties with the Italians were designed to stop piracy in Byzantine waters. An alliance with Venice in 1189 had the more serious intention of counteracting dangers inherent in the launch of the third Crusade (Lilie 1984).

In these various treaties Byzantium manipulated the West: her constant aim was for political support in return for the promise of silk trade concessions. Between 1157-1172, her Italian allies kept her safe in particular from the Norman threat, and perhaps it was the paucity of Byzantine naval power that was to a large extent responsible for the

transport of Byzantine silks to the West. Political necessity more than economic desire thrust Byzantine silks on to the West.

The uses of The manifold social and religious influences that the silks imparted on the
Mediterranean West can be described only briefly here (Muthesius 1982 and forthcom-
silks in the ing). The primary uses of the silks were for court dress, especially under
West the Ottonians, and for ecclesiastical use. The Papacy in the eighth to ninth centuries imparted a strong taste for silks in the hangings, furnishings and vestments of the churches of Rome. From Rome the fashion for the use of silks spread to the churches further north. The Liber Pontificalis and church inventories (Duchesne 1892; Muthesius 1982) attest to vast numbers of silks over doors, on altars, around ciboria, between nave arcades, across triumphal arches and in every conceivable corner of the churches. Gospels had silk bindings and sat on silk cushions above silk altar cloths. Pulpits had silk covers as did even the host on the altar. Mass was celebrated in splendid silk vestments and the court attended clad in silk, followed by an equally silk-clad nobility.

All the individual uses of silk, whether for court or civil dress or for religious observance, can be paralleled in Byzantium from the fourth century, so that not only the silks but their uses exerted Byzantine influence (Muthesius, forthcoming). The Islamic silks, fewer in number, were used for burial shrouds of Popes on occasion even though they had inscriptions reading 'Blessings to Allah'. The relics of saints in the West, just as in Byzantium, had to be wrapped in silks and they were held in silk-lined reliquaries and exposed to the faithful on special days. The rise of the cult of relics was accompanied by the fanatical collection of silks for holy purposes, some treasuries having as many as 500 pieces dating between the sixth and the twelfth centuries.

Conclusion The Mediterranean silk trade undoubtedly played a major role in the transmission in particular of Byzantine influence to the West. Not only were the silks economic and political pawns on the Mediterranean stage, but they provided perpetual scope for direct cultural and religious intercourse between Byzantium and her Western allies. Byzantium required concrete assistance from the West, whilst the West seemed hungry for the cultural refinement inherent in the silks of the East. That Western Europe should have been held in this silken web for six hundred years or more bears testimony to the all-powerful impact of the Mediterranean silk trade on the West before 1200 AD.

BIBLIOGRAPHY

Adelson 1958: H. L. Adelson, Early medieval trade routes. *American Historical Association paper*. Washington, December 29, 1958,

cf. Adelson 1957: *Light weight Solidi and Byzantine trade during the sixth and seventh century*. New York, 1957.

Baker 1938: J. N. L. Baker, Medieval trade routes. *Historical Association pamphlet*. London, 1938,

cf. Grierson 1958: P. Grierson, Commerce in the Dark Ages. *Transactions of the Royal Historical Society*, 195 (1958) 133-40.

C.I.E.T.A. Vocabulary 1964: *Centre for the study of Ancient Textiles Vocabulary of Technical Terms*. Lyons, 1964.

Duchesne 1892: *Liber Pontificalis*. Paris, 1892,

cf. Michel 1852, 1854: F. Michel, *Recherches sur le commerce, le fabrication et l'usage des etoffes de soie etc*. Paris 1852, 1854.

cf. Sabbe 1935: E. Sabbe, L'importation des tissus orientaux. *Revue Belge de Philologie et d'Histoire*, 14 (1935) 811-848, 1261-1288.

Farag 1979: W. A. Farag, *Byzantium and its Muslim neighbours during the reign of Basil II (976-1025)*. Ph.D. thesis. University of Birmingham, 1979

cf. Farag 1990: The Aleppo question. *Byzantine and Modern Greek Studies* 14 (1990) 44-60.

Goitein 1967, 1971, 1983: S. D. Goitein, *A Mediterranean Society* I, II, IV. London 1967, 1971, 1983.

Goitein 1973: *Letters of Medieval Jewish traders*. Princeton, New Jersey, 1973.

Haldon 1989: J. F. Haldon, Three treatise on Imperial military expeditions, *CFHB* 28 (1989).

Havighurst 1958: A. F. Havighurst, *The Pirenne Thesis*: analysis, criticism and revision. Boston Mass. 1958.

Heyd 1936: W. Heyd, *Histoire du commerce du Levant au moyen-âge*. Leipzig 1936.

Jerussalimskaja 1963: A. Jerussalimskaja, Silk fabrics from Moschchevaya Balka. *Soobscheniya gosudarstvennogo Ermitazha* 24 (1963) 35-39.

Jerussalimskaja 1967: Silk era of the N. Caucasus in the early Middle Ages. *Sovietskaia archeologiia* 2 (1967) 55-78.

Jerussalimskaja 1972: On the formation of the Sogdian school of weaving. *Srednia ia Aziia, Iran gosudarstvennogo Ermitazha*, 5-46, Leningrad 1972.

Lehmann-Brockhaus 1955: O. Lehmann-Brockhaus, *Lateinische Schriftquellen*. München, 1955

cf. Lehmann-Brockhaus 1971: *Schriftquellen zur Kunstgeschichte des 11 und 12 Jahrhunderts*. New York, 1971.

Lewis 1951: A. Lewis, *Naval power and trade in the Mediterranean A.D. 500-1000*. Princeton, 1951.

Lilie 1984: R. J. Lilie, *Handel und Politik zwischen dem byzantinischen Reich und den Italienischen Kommonen Venedig, Pisa und Genua in der Epoche der Komnenen und der Angeloi (1081-1204).* Amsterdam, 1984.

Lopez 1945: R. S. Lopez, Silk trade in the Byzantine Empire. *Speculum* 29 (1945) 1-42,

cf. Lopez 1955: *Medieval trade in the Mediterranean world.* New York, 1955.

cf. Lopez 1959: The role of trade in the economic readjustment of Byzantium in the seventh century. *Dumbarton Oaks Papers* 13 (1959) 67-85.

Loughis 1980: T. C. Loughis, *Les ambassades byzantines en Occident.* Athens 1980.

Muthesius 1982: A. M. Muthesius, *Eastern silks in Western shrines and treasuries before 1200 AD,* PhD thesis, Courtauld Institute of Art. University of London, 1982,

cf. Muthesius 1984: A practical approach to Byzantine silk weaving. *Jahrbuch der Oesterreichischen Byzantinistik* 34 (1984) 235-254.

cf. Muthesius 1989: Mediterranean silks in the Rhine Maas region. *Paper, Euregio Congress on Textiles,* particularly in the Meuse-Rhine area. Alden Biesen, 1989.

Muthesius 1990: *Byzantine Diplomacy* (J. Shepard, S. Franklin ed.) Twenty-fourth Spring Symposium of Byzantine Studies, Cambridge March 1990. London 1992, 237-248.

Muthesius 1991: Lopez and beyond. *Mediaeval History* 19 (1993) 1-67.

Muthesius forthcoming: *A history of the Byzantine silk industry.* Byzantine Institute, University of Vienna, forthcoming.

Nicole 1970: J. Nicole, *The Book of the Prefect.* Variorum reprint, London, 1970.

Pigulevskaja 1946: M. V. Pigulevskaja, *Byzantium and Iran at the end of the sixth century and the beginning of the seventh century.* Moscow, Leningrad 1946,

cf. Frye 1972: R. H. Frye, Byzantine and Sassanian trade relations with N. E. Russia. *Dumbarton Oaks Papers* 26 (1972) 263ff.

Pounds 1973: N. J. G. Pounds, *An historical geography of Europe.* Cambridge, 1973.

Rabinowitz 1948: L. I. Rabinowitz, *Jewish Merchant Adventurers.* London, 1948,

cf. Ashtor 1981: E. Ashtor, Gli Ebrei nel commercio Mediterraneo Nell' alto Medioevo sec. X-XI. *Settimane di studio del centro Italiano di studi Alto Medioevo,* XXVI. Spoleto 1981.

Schoff 1912: W. H. Schoff, *The Periplus of the Erythraean Sea.* London 1912.

Serjeant 1942-46: R. B. Serjeant, Material for a history of Islamic textiles up to the Mogul conquest. *Ars Islamica* 9-16 (1942-1946),

cf. Shepherd 1959: D. J. Shepherd and W. B. Henning, Zandaniji Identified? *Festschrift Ernst Kuehnel.* Berlin, 1959, 15-40.

cf. Shepherd 1980: D. G. Shepherd, Zandaniji Revisited. *Festschrift S. Mueller-Christensen.* Munich 1980, 105-122.

Shepard 1984: J. Shepard, Byzantium and the West c. 850-1200. *Proceedings of the 18th Spring Symposium of Byzantine Studies, Oxford 1984.* Amsterdam 1988.

Weigand 1955: E. Weigand, *Die helladisch-byzantinische Seidenweberei.* Athens, 1935.

Wescher 1947: H. Wescher, The opening up of the Alpine passes. *Ciba Review* 62 (1947) 2246-2249.

ADDITIONAL NOTE

see further J. Shephard, *Byzantine Diplomacy, AD 800-1204: means and ends* in Byzantine Diplomacy, Papers from the Twenty-Fourth Spring Symposium of Byzantine Studies, Cambridge March 1990, London 1992, 41-71.

Acknowledgement
The author wishes to thank Rex Gooch of IBM UK Academic Systems, for the preparation of the text and the illustrations in this paper.

IX
The Griffin Silk from St. Trond

A WEALTH of Eastern Mediterranean and Near Eastern silks reached
Rhine-Maasland ecclesiastical treasuries in the period before
1200 AD and their use in the West in a liturgical context was
greatly influenced by Byzantine religious practices. Most particularly the
Latin Church imitated the Byzantine use of silks as reliquary shrouds,
and many hundreds of silks, ranging in size from tiny scraps to large scale
fabrics, were considered appropriate wrappings for the relics of Western
saints. In the West already in the fourth century, silks were found in the
sarcophagus of St. Paulinus at Trier; just as in Byzantium in the fourth
century, the relics of St. Athanasius were carefully enveloped in silk.[1] The
major difference between the appearance of these fabrics in the East and
in the West is that the Latins had to import their silks, and the question
is where exactly did they get them from and how did they arrive? In some
cases it is evident that splendid Byzantine diplomatic gifts were involved,
such as the Lion silks in Rhenish treasuries or the sumptuous Aachen
Elephant silk.[2] In other cases Central Asian pieces appeared, most
probably carried by the Rhadanite Jewish traders, who in the eighth to
ninth centuries travelled from West to East and back again across lands
described in their 'Book of the Routes and the Kingdoms'. Indeed, it is
astonishing to find these merchants in lands as distant as China and it is
instructive to observe how remarkably well their activities linked markets
of the Far and the Near East with those of the Mediterranean and the Latin
West.[3] In an age of high speed travel it is difficult to comprehend how
international mediæval merchants survived the drawbacks of lengthy
and tedious journeys by land and sea in the service of their wares, but
survive they did and Rhine-Maasland silks throw much light on trade
activities of the period. The purpose of this talk is to examine a particularly
interesting Griffin silk from St. Trond, now in Liège, of which there was

once also a fragment in Berlin.[4] How does the silk fit into its St. Trond context and how far is it possible to establish exactly where it was woven?

Why St. Trond? Before examining the silk itself it is important to appreciate the significance of St. Trond as a religious centre, where relics and silks played a central part in the life of the Church.[5] From the humble beginnings of the eighth century with its Abbey Church protecting the relics of the founder saint, the eleventh century saw appreciable expansion under Bishop Adalbero I. Pilgrimage grew and the faithful came from all over Namur, Nivelles, Huy, Anvers and further afield. To cater for the increased religious fervour new churches were built and Papal recognition followed by 1107, with the first documented confirmation of the privileges and possessions of the Abbey.[6] By the end of the eleventh century St. Trudo held parish status and there was a secular as well as a religious expansion in the area of the Abbey.

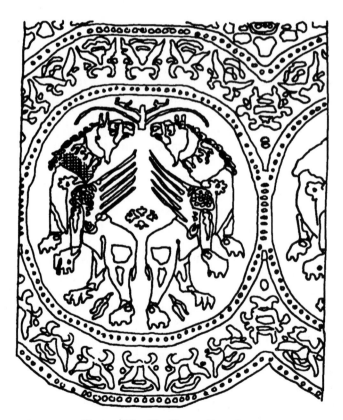

FIGURE 13A ST. TROND GRIFFIN SILK

Out of the small local market established in the close vicinity of the Abbey in the eleventh century there grew in the following four centuries, developed, specialised markets, and by 1366-67 a purpose built trade hall, which lay on the boundary line dividing the jurisdictions of the Abbey and the Bishopric. The primitive markets inside the Abbey enclosure in the eleventh century were gradually transformed into fairs set at times of religious festivals such as Pentecost, when pilgrims were plentiful. Little is known of the precise nature of commercial activity set within the Abbey boundary before the thirteenth century but the abbey certainly bought horses, cloth, wine and wood at these fairs in the mid thirteenth century.[7]

St. Trond was well placed for international trade connected as it was to the old Roman route, with Maastricht to the east and Huy to the south. By the beginning of the twelfth century the Abbey also held houses in Cologne and the route from Cologne to Bruges via St. Trond was established by the mid thirteenth century. The thirteenth to fourteenth centuries saw St. Trond at the heart of an International trade complex, which extended to Lorraine and Champagne in the south, to Germany in the East and to England in the West.[8]

The establishment of guilds proper appears to have taken place in the later eleventh to the twelfth centuries. In the mid eleventh century one hears only of the confraternity of St. Euchère founded by the Abbot Gontran (1034-1055), which offered its members in exchange for a set fee, burial rights in the Abbey cemetery.[9] Part of the rents for the Abbey market was made over to the Friary of Notre Dame in 1171, but earlier there were disputes between tradesmen and the Abbot over market rents. In 1112 Abbot Rodulphe required payment of nine deniers from guildsmen wishing to sell their wares on the Abbey market, but some insisted on payment of only three deniers. Finally a quota of eighteen sous was set to cover many traders and it was presented to the Abbot on the day of St. Amour.[10] The money was used to feed and clothe the poor.

In all this, the guild of weavers, mentioned in 1135, seems to have stood somewhat aloof from the other guilds. In

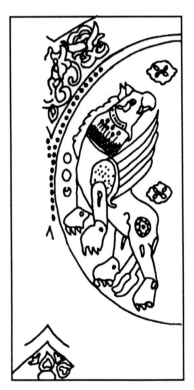

FIGURE 13B SITTEN GRIFFIN SILK

FIGURE 14A LONDON V&A GRIFFIN SILK

the thirteenth century certain textile guildsmen formed themselves into a Charity, whose role it was to carry out good works and to make donations for the poor to the Abbey on the feast day of St. Trudo.[11] Thus, religion, society and regional and international economics were closely bound up one with another. St. Trond provided the perfect mediæval setting in which to find fine silks embellishing the relics of the local saint. It was an active pilgrimage centre, nourished by all manner of exotic imports by virtue of its key economic situation.[12]

The Griffin silk
(PL. 61)

The Griffin silk at the Diocesan Museum, Liège came from St. Trond. The silk measures 33.3 x 74.5 cm and it has a pattern repeat of 28.2 x 34.5

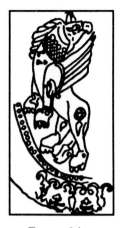

FIGURE 14B
SITTEN GRIFFIN SILK

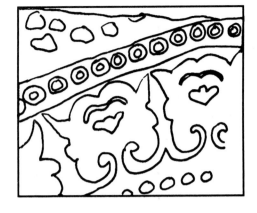

FIGURE 14C
SENS CATHEDRAL TREASURY FRAGMENT

cm in ivory on a rose coloured ground. The design consists of paired, addorsed rearing griffins 21.5 cm high, in a pearl-edged, medallions 28 cm wide, with a foliate border. The medallion borders are inter-linked and they contain a continuous frieze of palmette motifs. In the spandrel areas outside the medallions are symmetrical foliate designs. The griffins themselves are highly ornate with decorative geometric markings around the collar, at the tops of the wings, and in the areas of the joints, as well as across the breast. The remnants of a tree setting appear above the heads of the griffins. Over the adjoining haunches of the creatures, there is an oval motif.[13]

The fabric is a 2.1 silk twill with grège, undyed, paired main warps. The stepping of the contours of the design are down one warp and across one weft thread. The two unusual features about the silk are the fact that a cotton rather than a linen selvedge is used on the right hand side of the piece, and that the twill weave changes direction in a random type of way across the silk. The change of direction occurs sometimes after only 2, 3, or 4 weft passes but also elsewhere after a great many more passes constituting several centimetres of weaving. There seems no technical reason for this to occur, rather that a workshop tradition is reflected in the practice. Similarly with the selvedge, which consists of seven bundles, each containing four single cotton threads, the presence of cotton rather than linen may be purely a matter of tradition. It is true that later Italian silks were sold by weight and that cotton selvedges rather than linen ones were used to cut down on bulk, but there is no evidence that this was generally true for earlier Eastern Mediterranean pieces, with which the Griffin silk belongs (FIGS. 13A, 15B).[14]

FIGURE 15A SENS ST. SIVIARD SILK
FIGURE 15B ST. TROND GRIFFIN SILK
FIGURE 15C COLOGNE DIOCESAN MUSEUM GRIFFIN SILK
FIGURE 15D ABEGG STIFTUNG RIGGISBERG GRIFFIN SILK
FIGURE 15E SITTEN GRIFFIN SILK

The single parallel for a silk with cotton selvedge that I have so far **Comparable** encountered is a fragment at Sens cathedral treasury (Chartraire Inv.19 **silks** DH), (Fɪɢ. 14c). This silk was briefly mentioned by Chartraire in 1911, but remains unpublished in detail.[15] Sens Cathedral treasury Inv. 19 DH measures 30 x 18 cm. It is a fragment with part of a pearl-edge medallion border enclosing palmette motifs. Insufficient remains of it to suggest what design the medallion enclosed but part of the spandrel motif between medallions is visible and this shows adjoining heart shapes in which geometric ornament appears. A number of small heart shapes are scattered in the area between spandrel hearts and the pearl edge of the medallion border. The latter border is 12 cm high and the palmette motifs in it measure 6 x 8 cm. The design is in a pale yellow and brown on a purple ground. The silk is a 1\2 twill with paired main warps, grège and untwisted. The selvedge of cotton uses five sets of paired S threads. There are also paired cotton threads that act as a border across one width of the fragment. These appear to be a finishing border, which would indicate that it is the right selvedge which survives. After a starting border it would seem an odd thing to begin the design proper in the middle of a spandrel motif. The fragment was examined under glass at Sens Cathedral treasury in 1979 and it was difficult to make a precise analysis. For instance, the paired S cotton threads of both finishing border and selvedge could not be 'unspun' to examine their make up further. Preliminary analysis at the time suggested that there were c. 30 paired main warps per cm and c. 15 binding warps and that the different wefts numbered c. 30 per cm. The gradation of the design was uneven, smooth in places such as around the curves of the palmette and extremely jagged in other areas including the medallion border edge. The découpure could be as fine as that of the St. Trond silk. No doubt the detailed examination of all the silks, which is presently in progress at Sens, will yield more technical data in time.[16]

The use of the irregular twill on the St. Trond silk is also very difficult to parallel on surviving mediæval silks. The single important example that springs to mind is another largely unknown piece, which unfortunately, was also under glass when I examined it recently at St. Gereon, Cologne. This is the Griffin silk taken from a sarcophagus in the confessio of St. Gereon, Cologne in 1869 (Fɪɢ. 15c).[17] The silk measures c. 91 cm square. It has medallions 31 cm in diameter set in horizontal rows bordered by running tendrils and including linking roundels with similar foliate ornament. Within the medallions are paired, seated, facing griffins with one paw raised. A tree motif separates the creatures. The spandrels hold running tendril ornament in a diamond format. Across the top of the silk is a chequer-board design in green and red on white. The main design is in blue on a red ground in the first and the third horizontal row. The

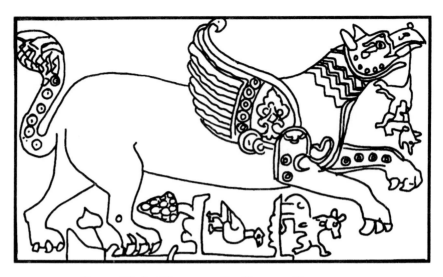

FIGURE 16 LE MONASTIER, ST. CHAFFRE, GRIFFIN SILK

central, second row is in green with lighter blue and yellow. This mixture of clear, vibrant colours is unusual.

The St. Gereon silk is basically a chevron twill, 1\2 and 1/2, but as on the St. Trond piece there are irregularities so that the twill alters direction almost haphazardly in places. There would seem to be no sound technical reason for this to occur. There is certainly a technical link with the St. Trond Grifffin silk, but stylistically other Griffin silks lie much closer to the St. Trond piece. In 1985, Leonie von Wilckens put forward stylistic grounds to suggest that the St. Gereon silk might be twelfth century Spanish.

The closest comparison for the griffins on the St. Trond silk can be drawn with the griffins on a silk from Sitten cathedral, which Brigitte Schmedding conserved at the Abegg Foundation and published in 1978 (PL. 81, FIGS. 13B, 14B, 15D).[18] The Sitten silk, 51.3 cm x 107.5 cm, perhaps formed part of a dalmatic. The repeat on the silk measures c. 51.5 cm x 30 cm and shows rearing, addorsed griffins in practically identical poses to the St. Trond griffins. Also, as on the St. Trond silk, there are pearl and other distinctive markings on the creatures and a foliate motif sits above their haunches. The pearl-edged medallion border and foliate palmette ornament in the border on the Sitten and the St. Trond silks are closely related. In addition, the manner in which the medallions curve one into the other is very similar on the two silks. The Sitten silk is in a black, green-yellow and white on a violet ground. It is a high quality, 1/2 paired main warp twill that has been dyed with murex purple. The implication

FIGURE 17A SITTEN REARING LION SILK

is that an Imperial workshop was involved, although Schmedding suggests the piece was woven in eleventh century Syria, in the light of a parallel she made with Fatimid crystals. This point will be discussed further below. Byzantine provenance seems more likely. Schmedding terms another comparable Sitten silk piece with rearing lions (Cat. No. 237) eleventh century Byzantine (FIG. 17A).

The use of the palmette motif on the St. Trond and on the Sitten griffin silk ties in with its appearance on the very fine Aachen Elephant silk, a paired main warp twill, which I have argued elsewhere belongs eleventh century in date.[19] The inscription of this silk does not yield a precise date because its indiction number has worn off, but it does reveal that the silk was woven in an Imperial Byzantine workshop in Constantinople. Equally comparable foliate palmettes to those found on the St. Trond silk can be cited on the shroud of St. Siviard at Sens Cathedral (FIG. 15A). This is a monochrome lampas weave silk, which I have also suggested elsewhere is a Byzantine weave of the 10/ 11th centuries.[20] Here the Griffins are placed singly in the medallions, whose diameter with border is 65 cm. The Sens griffins are much larger in size than those of the St. Trond silk but the characteristic markings are on both: tear shapes for joints; a rosette on the haunches; pearls across the neck and a zigzag motif mane as well as the 'old man's beard' of the

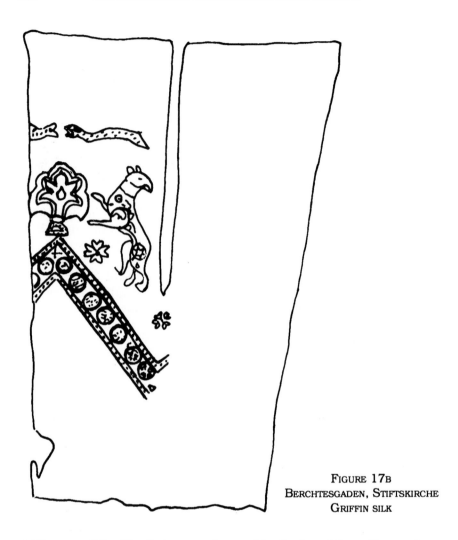

FIGURE 17B
BERCHTESGADEN, STIFTSKIRCHE
GRIFFIN SILK

griffins are all familiar features and except for the beard they all occur too, on the Sitten griffins.

Date and Clearly there was a basic decorative scheme for the griffin motif and there
provenance for were several characteristic poses too. The addorsed, rearing griffin type
the St. Trond occurs not only on the St. Trond and the Sitten silks but also on a host of
Griffin silk paired main warp twill and lampas weave silks, all of which belong 10th-
11th centuries in date. These silks can be grouped around two pieces from
the grave of Pope Clement II at Bamberg (d. 1047).[21] One of them is a
monochrome, paired main warp twill and was used for a pluvial, the other
is a lampas weave silk, which was cut for the buskins of the Pope (FIG. 18).

The silks must have been woven before 1047 when the Pope was buried as there are no signs of additional silks having subsequently been placed in the grave. The pluvial silk is red and in design it is very similar to the green silk at the Abegg Stiftung used for the so-called chasuble of St. Vitalis (FIG. 15E).[22] All three griffin silks use a variation on the St. Trond and Sitten griffin type with decoratively marked creatures raised on their hind legs, but this time with front paws raised instead of hanging down. The foliate palmette motif, however, does not appear on the Bamberg Pope Clement or on the Riggisberg Vitalis silks. Similarly, it is absent from the medallion borders of three further griffin silks very like the Clement and the Vitalis griffin silks in design. These pieces are a fragment at Speyer, Historisches Museum, a fragment in the National Museum, Munich, (FIGS. 20, 19), and a fragment at the Victoria and Albert Museum, London (FIG. 14A).[23] The Munich piece allied to the London fragment, is traditionally associated with the Emperor Henry II (d.1024). In Byzantine art the palmette appears frequently in manuscript illumination of the tenth to the eleventh centuries and it is found on metalwork. It occurs too, on textiles of various sorts. Prominent and elaborate foliate palmette motifs occur for example, on the Gunther tapestry at Bamberg Cathedral. This silk may have been woven under Basil II to celebrate his victory over the Bulgars in 1017.[24]

Further silks with griffin motifs that do incorporate palmette motifs, albeit not in pearled medallion borders, do exist and they are relevant for trying to assign a provenance to the St. Trond silk. Important examples are the Griffin silk of St. Chaffre, Le Monastier (PL. 62 AND FIG. 16) and the Griffin silk of the Stiftskirche, Berchtesgaden (FIG. 17B), first published by Sigrid Müller-Christensen in 1973. The St. Chaffre silk, measuring 52.5 cm

FIGURE 18
BAMBERG DIOCESAN
MUSEUM, POPE CLEMENT
SILK, BUSKINS

FIGURE 19
MUNICH, NATIONAL MUSEUM,
GRIFFIN SILK

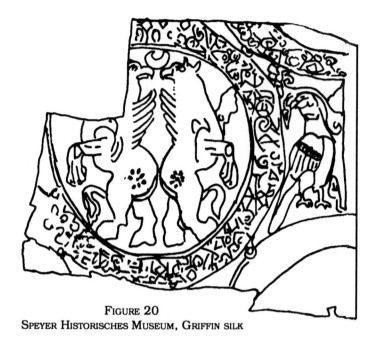

FIGURE 20
SPEYER HISTORISCHES MUSEUM, GRIFFIN SILK

x 64.5 cm, shows striding griffins 30 cm long. A small quadruped is suspended in the beak of the griffin on the silk. A fine, ornamental palmette motif appears on the wing of the creature. The silk has been called both a Byzantine and an Islamic fabric and it has been dated either tenth or eleventh century.[25] The Berchtesgaden silk was highlighted in an article by Sigrid Müller-Christensen entitled, 'Two silks as witness to Byzantine-Islamic cross influences' and this point lies at the crux of trying to assign provenance to any silks of the tenth to the eleventh centuries. It should be further noted that Müller-Christensen favoured a Syrian provenance for several of the tenth to eleventh century monochrome silk pieces that she published.

By the year 1000 AD an International style of silk weaving existed in the Eastern Mediterranean. Silks were light and easily transportable articles. Documents, such as the Cairo Geniza records of the tenth to the twelfth centuries, indicate how all manner of silks were traded by Greeks and Arabs in the Mediterranean. Monochrome twills and lampas weave silks of the tenth to the eleventh centuries in particular have been variously assigned to both Byzantine and to Islamic workshops. Whilst it is not difficult to assign an eleventh century date to the St. Trond silk on stylistic grounds it is difficult to decide a provenance for any silk solely on stylistic criteria, for motifs travelled easily. Technically speaking, the St.

Trond silk is so unusual in its use of cotton selvedge and its application of an 'irregular twill' weave that it cannot be placed within a large stabilised group. It is just as difficult to assign provenance to the Sens Inv. 19 silk, compared in this paper to the Belgian silk, as it is to do so for the St. Trond piece itself. What does need to be explored further is the use of cotton as such, in a silk fabric. Where and in which way was cotton widely used in the eleventh century?

Watson writing on the theme of 'Old World cotton' draws attention to the fact that cotton was known in the Mediterranean well before the Islamic invasions but that its cultivation spread rapidly through Arab territory by the tenth to eleventh centuries.[26] The lack of cotton in surviving Byzantine silks, and the absence of any mention of a cotton guild in Constantinople in the tenth century Book of the Prefect, would suggest that this fibre was not used as a yarn. Linen and silk guilds alone are mentioned in the document.[27] Cotton described in other Byzantine sources appears to have been imported.

The cotton selvedge on the St. Trond silk would seem to point to an Islamic rather than a Byzantine centre, but on the other hand surviving Islamic pieces do not have cotton selvedges. Rather, cotton was either used in mixed fabrics (perhaps as a cheaper substitute for pure silk cloths), or cotton was used alone.[28] Was the cotton selvedge of the St. Trond piece a substitute for a linen one and did this indicate a lack of available linen? If this were the case one could argue that Egypt was unlikely to be the place of origin of the silk, because this was the cradle of the linen industry.

There was linen but not cotton production in Byzantium. But what of the Byzantine stylistic features on the St. Trond piece? The foliate palmette is clearly related to that of the Imperial Elephant silk at Aachen, and the murex Griffin silk at Sitten seems far more Byzantine than Syrian in style. The attribution to Syria lies in a comparison Schmedding made between motifs on Fatimid crystals and the design on the silk. However, as early as 1951 Canard wrote a lengthy article pointing out the tremendous influence of Byzantine court ceremonial at the Fatimid court. Could there not also have been some Byzantine artistic influence at the Fatimid court?[29]

The 'Byzantine versus Islamic' problem

The close stylistic and technical similarity between the Imperial Byzantine Lion silks of Siegburg, Cologne, Düsseldorf and Berlin and the Sitten Griffin silk, which I have described elsewhere, in conjunction with the use of a murex purple on the Sitten silk, persuade me to see it as an Imperial Byzantine piece. Murex is rare on surviving silks and even the

purple diplomatic gifts sent from Constantinople to the West seem to use indigo and madder instead of murex.[30] Murex was reserved for the Emperor in the tenth to twelfth centuries in Byzantium, just as it had been from the fourth century onwards.[31] On the other hand, certain Islamic silks, even those greatly influenced in design by the Imperial Byzantine pieces, like the Maastricht Lion silk for example, used a mixture of indigo and a lichen for their purple dye.[32]

There is indisputable documentary evidence to indicate that Byzantine silks did reach Islamic courts. The Emperor Romanos I, for instance, under whom the Siegburg Lion silk was woven in 921-923, in 938 presented to the Caliph Al-Radi Billah many gifts including crystals and silks. The silks had different patterns: bi-coloured eagles; foliate motifs in three colours; both coloured and monochrome tree motifs; seated lions; and portraits of a mounted Emperor carrying a standard. A number were purple silks and some were gold brocaded pieces. The Arabs also wished to impress the Byzantines with their fine textiles. When the Emperor Basil II (d.1025) sent envoys to the Fatimid caliph of Egypt, they were taken to a special hall expressly lavishly furnished with valuable cloths to impress them.[33] Both Arabs and Byzantines presented silks as diplomatic gifts.

Close Byzantine-Islamic contact over silks was established in connection with Syria in particular. The tenth century Book of the Prefect related how the Byzantines gave very special trading privileges to the Syrian silk merchants resident in the Capital of the Empire. Silk was a booming industry in Syria and it probably had been even earlier than the tenth century. The Liber Pontificalis in the eighth to ninth century is full of references to what seem to be Syrian silks decorated with Christian themes at a time when Iconoclasm reigned in Byzantium. It is even possible that non-Christian weavers were making religious silks for sale to the West. It is possible too, that some Christian silk weavers survived the Islamic invasion of Syria and continued working under their Moslem overlords, as happened in Egypt.[34]

In any event, Byzantine interests went right into the heart of Syria with Basil II's conquests in Northern Syria in 999. In 1001 the treaty with the Fatimid Caliph of Egypt ensured the recognition of Byzantine Antioch and Byzantium held onto suzerainty of Aleppo. Trade taxes levied at Aleppo were to be divided, the Byzantines retaining those on silk.[35] Sigrid Müller Christensen suggested a possible Syrian origin for a number of the tenth to eleventh century monochrome silks and perhaps it is not too implausible to think that Syrian silks that reached Byzantium could then further have made their way to the Latin West, either as diplomatic gifts or as merchandise. The big question is, in the light of the strong Byzantine features on the St. Trond piece, is it reasonable to say the silk could have been woven in a centre like Syria in the eleventh century? If so, were the

weavers Christian or Moslem? Positive answers to these questions can only be provided if further evidence comes to light, but a highly unusual silk must have been woven somewhere slightly outside the main areas of production already examined by textile historians, and Syria certainly appears to be one possibility that might be explored further. Syrian merchants were active in southern Italy and the silk may have been carried to St. Trond via Italian merchants in contact with them.

An argument for Spanish provenance for the St. Trond silk, alongside the St. Gereon silk, to me seems difficult to substantiate from comparison with surviving Spanish material. The St. Trond silk, with its uneven finish and its use of a distinctive 'softer' type of silk yarn, seems almost work of a workshop that has once woven complex designs, but which may have suffered a decline. The craftsmen attempt a complex design and they are capable of operating a figure-harness device for such patterns, but they make constant errors in their interpretation of the design. They work in as few colours as possible, perhaps for ease of weaving as well as to save costs. These are not the characteristics of weavers in flourishing Byzantine workshops. Also, the use of cotton rather than linen for the selvedge argues against Byzantine provenance in general, although one must admit that we know nothing of provincial Byzantine silk weaving at a date appropriate to the St. Trond piece; documentary references to provincial Byzantine silk weaving belong to the twelfth century.

In the context of the rest of the silks from St. Trond (mainly Spanish and Italian pieces of the thirteenth and the fourteenth to fifteenth centuries, and later West European pieces), the Griffin silk is an extremely important fabric. It illustrates just what splendid textiles could be acquired in the early mediæval period well before the full economic flowering at St. Trond.[36]

Acknowledgement

The author has pleasure in thanking Wingate Scholarships for support in her research and for the electronic equipment used to produce this article.

NOTES

1. For the Trier silks see T. K. KEMPF, W. REUSCH, Frühchristliche Zeugnisse im
 Einzugsgebiet von Rhein und Mosel, Trier 1965, 178. For Byzantine silks
 consult, A. M. MUTHESIUS, Eastern silks in Western shrines and treasuries
 before 1200 AD, Doctoral Thesis, Courtauld Institute of Art, University of
 London, 1982 and forthcoming volume, History of Byzantine Silk Weaving, (J.
 KODER, E. KISLINGER eds.) Byzantine Institute, University of Vienna.
2. The Rhineland Lion silks and the Aachen Elephant silks are discussed in A.
 MUTHESIUS, 'A practical approach to Byzantine silk weaving' in Jahrbuch der
 Österreichischen Byzantinistik 34, 1984, pp. 235-254. Hereafter, MUTHESIUS,
 Practical approach. See also A. MUTHESIUS, Silken Diplomacy, in: Byzantine
 Diplomacy (J. Shepard, S. Franklin ed.) Twenty-fourth Spring Symposium of
 Byzantine Studies. Cambridge March 1990. London 1992, 237-248.
3. L. I. RABINOWITZ, Jewish Merchant Adventurers, London 1948.
4. STOF UIT DE KIST, De middeleevwse textielschat uit de abdij van St.-Truiden,
 St.-Truiden 1991, pp. 390-392. Hereafter, STOF UIT DE KIST. I have not traced
 the Berlin fragment of the St. Trond Griffin silk either at Schloss Charlottenburg
 or at Schloss Köpenick in Berlin.
5. J. L. CHARLES, La ville de Saint-Trond au Moyen Âge, (Bibliothèque de la
 Faculté de Philosophie et Lettres de l' Université de Liège, 173), Paris 1965, pp.
 75-99. Hereafter, CHARLES, Saint Trond.
6. CHARLES, Saint-Trond, pp. 194-196.
7. Ibid., p. 213.
8. Ibid., pp. 241-257.
9. Ibid., p. 222.
10. Ibid., pp. 223-224.
11. Ibid., pp. 224-225.
12. Ibid., pp. 213-264.
13. STOF UIT DE KIST, p. 391 has the Helbig plate of the Liège Diocesan Museum
 St. Trond Griffin silk fragment, inv. nr. 69.
14. I thank Lisa Monnas for her advice on the subject. See L. MONNAS, 'Develop-
 ments in Figured Velvet Weaving in Italy during the 14th century' in C.I.E.T.A.
 Bulletin, 63-64, 1986, pp. 63ff. See also the valuable article by D. and M. KING,
 'Silk weaves of Lucca in 1376' , Opera Textilia , Statens Historiska Museum.
 Studies 8, Stockholm 1988, I. ESTHAM and M. NOCKERT eds., pp. 67-76.
15. E. CHARTRAIRE, 'Les Tissus Anciens du Trésor de la Cathédral de Sens', Revue
 de l'Art Chrétien, 61, 1911, pp. 261-80 and 370-86, under Inv. no. 19DH.
16. In 1979 the author completed a preliminary catalogue of the Sens collection.
 Lack of funds prevented the French authorities from further work or publication
 at that time. At present a new concentrated study has been initiated by the
 French Historical Monuments Commission involving scientific analysis of the
 fabrics. It is to be hoped that this major collection will be comprehensively
 published as a result.

17. MUTHESIUS, Eastern Silks, p. 573. L. von WILCKENS, Ornamenta Ecclesiae, Köln, 1985, vol. 2, silk E31 on pp. 236-237, with bibliography. Detailed reasons for the stylistic link made with Spain are not given.

18. MUTHESIUS, Eastern Silks, p. 497. B. SCHMEDDING, Mittelalterliche Textilien etc., Berne, 1978, no. 236. Hereafter, SCHMEDDING, Textilien.

19. MUTHESIUS, Practical Approach, pp. 251-254.

20. MUTHESIUS, Eastern Silks, pp. 201, 216, 540-541 with bibliography.

21. Ibid., pp. 190, 524, 545-546 with bibliography.

22. Ibid., p. 525 with bibliography.

23. Ibid., pp. 190, 206. The Speyer Historisches Museum silk, inv. D52 is traditionally said to have come from a vestment of Elizabeth of Andechs. Twelve fragments of comparable silk are at Andechs, see R. RUCKERT, Kloster Andechs, 1967, no. 4, p. 15. The Munich, Bayerisches Nationalmuseum fragment has a traditional association with a tunic of Henry II (d.1024). See MÜLLER-CHRISTENSEN, Das Grab des Papstes Clemens II, Bamberg 1960, pl. 90. The London Victoria and Albert Museum silk (inv. 8233-1863) is similar to a fragment at the Museum für Angewandte Kunst in Vienna. A lampas weave silk with related design was used to line the upper and lower covers of the boards of Würzburg Universitätsbibliothek ms. th. fol. 68. The type was evidently widespread from the tenth to eleventh centuries.

24. MUTHESIUS, Eastern Silks, pp. 93-96, pp. 548-549 with bibliography.

25. Ibid., pp. 68-77, p. 519 with bibliography.

26. A. M. WATSON, Agricultural innovation in the early Islamic World. Cambridge 1983, ch. 6, 'Old World cotton', pp. 31-41.

27. The latest edition of the Book of the Prefect is J. KODER, Das Eparchenbuch Leons des Weisen, Wien 1991. On textile terms in the Book of the Prefect see A. MUTHESIUS, 'Lopez and Beyond', Medieval History, 19 (1993)1-67. Also, J. KODER, Problemwörter im Eparchikon Biblion, in Lexicographica Byzantina, Wien 1.-4.3.1989, Wien 1991, pp. 185-197.

28. Mixed fibre fabrics were an Islamic speciality. I am grateful to Dr. Gillian Eastlake (Vögelsang) and to A. Wardell for discussion on this subject. G. EASTLAKE discussed such fabrics in her Doctoral thesis on Islamic Textiles for Manchester University, 1991.
Numerous references to mixed fabrics occur in Islamic sources on textiles gathered together by R. B. SERJEANT, 'Material for a history of Islamic Textiles up to the Mogul Conquests', Ars Islamica, 9-16, 1942-1946 as follows: 9 (1942) pp. 54-92; 10 (1943) pp. 71-104; 11-12 (1944-6) pp. 98-145; 15-16 (1951) pp. 29-85.
On mediæval and later mixture fabrics see a series of articles in Ciba Review 141, vol. 12, Dec. 1960, pp. 9-28.
On mixed fabrics in Europe there is also M. F. MAZZAOUI, 'The cotton industry of N. Italy in the Late Middle Ages 1150-1450', Journal of Economic History, 32.1. 2., 1972, see especially pp. 264, 269.

29. P. CANARD, 'Le Cérémonial Fatimite et le Cérémonial Byzantin', Byzantion, 21, 1951, pp. 355-420.

30. The Sitten Griffin silk was dyed with murex, see SCHMEDDING, Textilien, 251. For imitation purple on Imperial Byzantine Lion silks see MUTHESIUS, Practical Approach, p. 249 and note 38.

31. MUTHESIUS, Eastern Silks, pp. 345-346 and p. 353 note 15; also p. 36 note 23; p. 78-79 note 7 and chart on p. 253.

32. MUTHESIUS, Practical Approach, pp. 247-250.

33. M. HAMIDULLAH, 'Nouveaux documents sur les rapports de l'Europe avec l'Orient Musulman au Moyen Âge', Arabica, 7, 1960, pp. 281-300, esp. p. 297.

34. For silks in the Liber Pontificalis see MUTHESIUS, Eastern Silks, pp. 280-287, pp. 320-324.

35. See W. FARAG, 'The Aleppo Question: a Byzantine-Fatimid conflict of interests in N. Syria in the late 10th century A.D.', Journal of Byzantine and Modern Greek Studies, 14, 1990, pp. 44-60.

36. For the Spanish and Italian pieces see the catalogue STOF UIT DE KIST, pp. 155-246.

X
Silken Diplomacy

BYZANTINE silks were the diplomatic gift 'par excellence'; precious, light and easily transportable items that embodied the prestige and power of the Empire. Not surprisingly, they were much sought after in foreign courts, most particularly in Western Europe before 1200 AD prior to the establishment of Latin silk weaving centres. Byzantium ranked silk alongside gold and silver in her hierarchy of diplomatic gifts and Ekkehard of Mainz in 1083 could write with justifiable pride that Greek legates appeared in the West, 'bringing many great gifts in gold and silver and vases and silks'.[1]

The survival of a vast body of Byzantine silks in ecclesiastical treasuries of Western Europe illustrates just how widespread the fashion for Byzantine and other Eastern Mediterranean silks had become by the twelfth century (PL. 57).[2] The more splendid of the extant Byzantine silks bear Imperial inscriptions, a few with the names of specific rulers, and it is primarily these which provide clues to the nature of Byzantine 'Silken diplomacy' before 1200 AD (PLS. 42, 45, 47A, B).

Whilst undoubtedly the majority of Byzantine silks reaching Western Europe came by way of trade and not as diplomatic gifts, the 'Silken Diplomacy' evident in Byzantine politics before 1200 AD indicates how far Byzantium was able to exploit what was essentially an economic asset, for purely political ends. The purpose of this short paper is to highlight the special role of silks in diplomatic exchanges between Byzantium and the West before 1200 AD.

Perhaps the most obvious sign of Imperial pedigree on a Byzantine silk is the appearance of an Imperial inscription. A select if small group of inscribed, Imperial Byzantine silks survive. These fabrics are:

- the so-called 'Nature Goddess' silk at Durham Cathedral (PL. 77);

- the Lion silks from a variety of Rhenish treasuries (PLS. 38-43) and
- the Elephant silk at Aachen, housed in the shrine of Charlemagne (d. 814) (PLS. 45-47B).[3]

Nevertheless, not all diplomatic silks necessarily bore Imperial inscriptions. It will be argued that some Byzantine silks were diplomatic gifts, on the grounds of their very high technical quality, their Imperial subject matter or their use of precious dye stuffs officially reserved for the Imperial house.

Silks in this category include:

- a piece with an Imperial hunter motif from Mozac, now at Lyons (PL. 64);
- a tapestry showing a triumphal Byzantine Emperor in the Diocesan museum at Bamberg (PL. 78), and
- a Griffin silk dyed with murex purple, in Sion Cathedral treasury (FIG. 13B).[4]

The earliest extant silk of the inscribed group is the so-called 'Nature-Goddess' textile at Durham.[5] This fabric not only exemplifies concrete diplomatic links between England and Byzantium that are little documented elsewhere, but it also indicates the type of silk which was considered suitable for diplomatic purposes. It has been suggested, plausibly enough, that the Durham 'Nature-Goddess' silk was one of two 'pallia Graeca' presented to the shrine of St. Cuthbert by King Edmund in 944.[6] Stylistically and technically the silk belongs eighth to ninth centuries in date and the question is, 'Was it sent to the English court at the time of its manufacture or was it a piece carried to the West in the tenth century two hundred years after its manufacture?' It is known from documentary sources that silks were stored for centuries and re-used not only in Byzantium, but also in the Islamic courts and indeed in the West; and of course St. Cuthbert's relics were wrapped in the most costly pall that could be found in the treasury at Durham on the occasion of his canonisation in 1104.[7] To prove that the Durham silk was first stored in Byzantium and later conveyed as a diplomatic gift to the West, further evidence is required, but this seems not unlikely in the light of what we know of other diplomatic silks.

The large silk tapestry used as a shroud for Archbishop Gunther of Bamberg (d. 1065) for example, appears to have been a diplomatic gift from the Emperor Constantine X (1059-67) to Henry IV, King of the Romans (1054-1084), carried by the envoy Archbishop Gunther, who unfortunately died on the return journey to Bamberg. It is reasonable to suggest that both through necessity and as a sign of respect, the body of the Archbishop was enveloped in the large tapestry to facilitate its transport home for burial.[8] The Bamberg Gunther shroud was removed

from the Archbishop's grave early this century and meticulously con-
served.[9] Beckwith identified the subject matter of the silk as the triumphal
entry of the Emperor Basil II into Athens and Constantinople, following his
defeat of the Bulgars in 1017.[10] If the subject has been correctly identified,
then it might be suggested that the piece was commissioned by the
Emperor himself, following his great victory. If this was the case, the
tapestry would date between 1017, the year of victory, and 1025, the time
of Basil's death. Certainly, close parallels that can be made with drapery
styles on the early eleventh century mosaics at Hosios Lukas near Delphi
support a dating to this period.[11] In addition, two of the inscribed Lion silks
bear the names of Basil II and Constantine VIII, which underlines the fact
that Imperial silks definitely were produced under these Emperors.[12]

The curious thing about using the Gunther tapestry as a diplomatic
gift in 1065 is that by then it would have been almost fifty years old. Was
it the usual Byzantine practice to store splendid silks, pieces that indeed
might have originally decorated the Imperial palace, until a valuable
diplomatic gift was called for, by which time the initial purpose of the silk
would have been long forgotten? After all, to the Latins one victorious
Byzantine entry would have looked much the same as another, and in any
event, would not the general theme of Byzantine prowess have been clear
for all to see? What did it matter whether Basil II or another Byzantine
Emperor appeared on the silk? A precious large scale Imperial silk wall-
hanging almost 220 cm square could not have been lightly disposed of; it
certainly would not have been suitable for sale on the open market. What
better way to have 'killed two birds with one stone', than to have sent
precious out-dated Imperial silks to the West in the guise of costly Imperial
gifts. The impression that Byzantium did so, is heightened by the fact that
at least one of the inscribed Lion silks also may not have been contempo-
rary when sent to the West.[13]

The victorious and glorious Emperor theme appeared frequently on
eighth to ninth century Byzantine silks and it served as the subject of the
Mozac Imperial Hunter silk, presently housed in the Textile Museum at
Lyons.[14] This silk has been identified with a piece that bore the seal of
Pepin and which was presented to the relics of St. Austremoine at Mozac
in 764. It seems reasonable to accept that the silk was a diplomatic gift
sent to Pepin in connection with a planned marriage alliance between
Byzantium and the West. Negotiations for a nuptial alliance between the
daughter of Pepin and Leo son of Constantine V were first documented in
765, a year after the translation of saint Austremoine; but still, the silk
may well have been amongst diplomatic gifts, sent with envoys from
Byzantium in 756/7.[15]

The Mozac silk illustrates two important points. It indicates the type
of political circumstances that prompted Byzantium to entrust valuable

diplomatic silks to the West from an early date and it provides a nascent example of 'Silken nuptial Diplomacy' in the service of East-West relations. It is not difficult to appreciate the delicate political position of Pepin in the 750s, subject as he was to both Papal and Byzantine petitions in the face of Lombard attacks in Italy. In 754, by allying with the Papacy, itself isolated from Byzantium through the Iconoclast activities of Constantine V, Pepin pre-empted the Byzantine annexation of Sicily, Calabria and Ilyricum. The arrival of Byzantine envoys bearing gifts in 756-7 and the subsequent marriage proposals of 765 have to be seen against this background.

It is important to note the special relationship built up between Byzantium and the West from the mid ninth to the eleventh centuries, in which both proposed and actual marriage alliances played an important part.[16] One may ask, 'Does the Mozac silk imply the existence of similar diplomatic tactics a century earlier?' How far can documented tenth century Byzantine attitudes towards the West, and particularly the sentiments expressed in the De Administrando Imperio, be thought a natural consequence of ties established through numerous earlier 'Silken diplomatic' contacts?[17] Indeed, a constant diplomatic exchange was maintained between Byzantium and the West from the mid eighth to the thirteenth centuries. Particularly close relationships pertained from the mid tenth century up to 1204, during which period only Henry I (919-36) did not appear to have exchanged envoys with Byzantium.

It is remarkable, but not surprising, to find that no less than sixteen marriages were either negotiated or arranged between Byzantium and the West at different times between the eighth and the twelfth centuries.[18] The surviving, inscribed Imperial Lion silks from a variety of Rhenish treasuries I have earlier suggested were diplomatic gifts sent to seal some of these nuptial contracts.[19] The series of Lion silks, both extant and documented, were a vehicle for the expression of Byzantine Imperial authority. The Lion motif itself, with small background tree form, found a classical precedent on ancient Greek vases and on Roman pavements, including one at Horkstow in Lincolnshire. The use of a purple ground for the lion motifs in conjunction with the names of Byzantine rulers underlined Imperial authority. Murex purple was the dye traditionally reserved for Imperial use.[20] However, it is important to recognise that murex was not necessarily employed on all Imperial silks. The Lion silk in the Textile collection of Schloß Charlottenburg, West Berlin, for example, bears the inscription of Basil II and Constantine VIII but it is dyed with a mixture of madder and indogen and not with murex purple.[21] The question is, was this sent as a murex purple to an unsuspecting Latin court or were imitation purples usual on Imperial silks destined to serve as diplomatic gifts?

The tenth century Book of the Prefect included strict provisions against the application of different categories of purples reserved for Imperial use, and this in conjunction with the fact that the Basilics reinforced earlier prohibitions against illicit murex dyeing, suggests murex still in the tenth and the eleventh centuries was an Imperially restricted category of dye.[22] In fact the unfortunate experiences of the Italian envoy Liudprand, who unsuccessfully attempted to export prohibited murex purple dyed silks from Byzantium, underlines the point that in the tenth century the Imperial monopoly over such dyes still held strong.[23] In the case of the diplomatic silks one might enquire, 'Were the Byzantine Emperors economising by using imitation purples but at the same time were they taking advantage of the connotations implicit in the use of purple dye on an Imperial silk?' How far was it reasonable to think that the West would be fooled into believing a genuine murex purple, immensely rare and valuable, had been sent as a gift? This enquiry in turn leads on to a final question, which is, 'Where were the Imperial diplomatic silks actually produced?'

The use of imitation purples on Imperial Lion silks is as puzzling as the use of murex purple on an uninscribed Griffin silk that somehow reached Sion cathedral treasury in the mediaeval period.[24] Were both categories of distinguished Imperial silks made in a single workshop? The Book of the Prefect reveals that Imperial silks were woven both in Imperial workshops of the Capital and under commission in the private workshops of the Serikarioi. It seems that the Eparch stamped all silk garments made in the City and that the Serikarioi had an obligation to deliver certain silk garments to the Imperial store. Some members of the guild of Serikarioi must have been in the habit of delivering inferior silks to this Imperial store however; that is silks purchased outside the city rather than those made in their own workshops, for a special provision against this practice was included in the tenth century regulations of the Book of the Prefect.[25] The Book of the Prefect also indicates that the Serikarioi were dyeing various categories of purple cloths, albeit not true purples, and it is possible that they were commissioned to weave pieces like the inscribed Lion silks dyed with madder and indigo. These silks would have been sent to the Imperial store mentioned in the Book of the Prefect (probably identical with the Eidikon known from Theophanes Continuatus and the Book of Ceremonies), before being sent out to foreign courts.[26] The murex-dyed purple Griffin silk at Sion, on the other hand, was most likely an Imperial workshop production. This silk has a distinctive medallion border motif of open palmettes characteristic of the Aachen Elephant silk, known from its inscription to be the work of Imperial Byzantine weavers at Zeuxippos.[27] The high quality of the Sion piece technically, the use of a griffin motif favoured in Byzantium and the appearance of murex dye all

argue strongly for an Imperial Byzantine centre of manufacture. There is no evidence that such silks were produced in Syria, although griffin motifs do appear on some Islamic mountain crystals.[28]

In the case of the Aachen Elephant silk, which was produced under the auspices of the Eidikos Michael, there can be little doubt that it was destined for storage in the Eidikon.[29] Perhaps it was specially woven as a diplomatic gift, although there is no precise evidence to suggest exactly when it reached the West. It has been suggested that it was placed about the relics of Charlemagne in 1000 AD by Otto III.[30] Of course, particularly from the time of the marriage of Theophanou to Otto II in 972, there would have been many opportunities for Byzantine silks to arrive in the West, although not all silks at Aachen are tenth century Byzantine pieces from Theophanou's dowry, as some have suggested.[31]

It is not surprising to find diplomatic silks firmly entrenched in the Imperial Palace of the Capital in the tenth century. The Byzantine court itself was resplendent with magnificent silk furnishings and robes. 'Silken diplomacy' was embedded at the heart of Byzantine politics; silks were a powerful political tool not only in the sphere of Byzantine diplomacy with the West, but also in her economic dealings with Italians, Rus' and Bulgars alike.[32] Silk, trade and politics went hand in hand, as long as Byzantium required an ally to defend her far flung territorial boundaries. The silks described in this paper serve only to underline how deeply entrenched was the practice of 'Silken Diplomacy' before the eleventh century, and to indicate what a powerful tool this luxury fabric was to become in skilled political hands.

Acknowledgement

The author is pleased to thank Wingate Scholarships for electronic equipment used to produce this paper.

NOTES

1. Ekkehard of Mainz, Ekkehardi chronicon, anno 1083, in: Otto Lehmann-Brockhaus, *Schriftquellen zur Kunstgeschichte des 11. und 12. Jahrunderts für Deutschland, Lothringen und Italien*, 1-2 (New York, 1971) 1, 644, no. 2723.
2. See A. Muthesius, *Eastern silks in Western shrines and treasuries before 1200 AD*, PhD Thesis, Courtauld Institute of Art, University of London, 1982; A. Muthesius, 'Byzantine, Islamic and Near Eastern silks in the Lowlands before 1200 AD' in: *Euregio Congress on Textiles, particularly in the Meuse-Rhine area* (Alden Biesen, 1989) 143-161; A. Muthesius, 'The impact of the Mediterranean silk trade on the West before 1200 AD' in: *Textiles in Trade, Textile Society of America, Biennial Symposium* (Washington, 1990) 126-135.
3. Consult, H. Maguire, *Earth and Ocean. The terrestrial world in early Byzantine art* (London, 1987) 75-76. See also, C. Higgins, 'Some new thoughts on the Nature Goddess silk', and H. Granger-Taylor, 'The inscription on the Nature Goddess silk', in: *St. Cuthbert, his cult and his community*, ed. G. Bonner, D. Rollason, C. Stancliffe (Woodbridge, 1989) 329-337 and 339-341.
 In addition, see Muthesius, *Eastern silks in Western shrines*, 16-62, 104-108, and A. Muthesius, 'A practical approach to Byzantine silk weaving' *JOB* 34 (1984) 235-254.
4. The silks are discussed in A. Grabar, 'La soie byzantine de l' éveque Gunther a la cathédrale de Bamberg', *Münchener Jahrbuch* 3, f. 7. (1956) 7-25; F. Guicherd, R de Micheaux, 'The Mozac hunter silk', *Bulletin, International Centre for the Study of Ancient Textiles* (C.I.E.T.A) 17 (1963) 14-16; S. Müller-Christensen, *The Bamberg Gunther shroud*. Diocesan Museum pamphlet (Bamberg, 1966) 1ff.; B. Schmedding, *Mittelalterliche Textilien in Kirchen und Klöstern der Schweiz* (Bern, 1978) 252-254; A. Geijer, *A history of Textile Art* (Pasold, 1979) 134; M. Martiniani-Reber, *Lyon, musée historique des tissus. Soieries sassanides, coptes et byzantines V-XI siècles* (Paris, 1986) 109-111.
5. For this silk see A. Muthesius, *Eastern silks*, 104-108; A. Muthesius, *A history of Byzantine Silk Weaving* ed. Byzantine Institute (Vienna, forthcoming); Higgins and Granger-Taylor as in note 3 above; H. Granger-Taylor, 'The earth and the ocean silk from the tomb of St. Cuthbert at Durham; further details', in: *Ancient and medieval textiles. Studies in honour of Donald King*, ed. H. Granger-Taylor, L. Monnas (Pasold, 1989) 151-166.
6. Granger-Taylor, *The Inscription*, 341.
7. Muthesius, *Practical approach*, 250, notes 43, 44.
8. Muthesius, *Eastern silks*, 93-100.
9. S. Müller-Christensen, *Das Grab des Papstes Clemens II im Dom zu Bamberg* (München, 1960).
10. J. Beckwith, *The Art of Constantinople* (London, 1968) 98.
11. Muthesius, *Eastern silks*, 95ff.
12. Muthesius, *Practical approach*, 242ff.
13. Muthesius, *Eastern silks*, 24.
14. Muthesius, *Eastern silks*, 101-173.

15. F. Dölger, *Regesten der Kaiserurkunden des Oströmischen Reiches von 356-1453*, I (München, Berlin, 1924) 339.

16. J. Shepard, 'Byzantium and the West c. 850-1200' in: *Proceedings of the XVIII Spring Symposium of Byzantine Studies, Oxford, 1984* (Amsterdam, 1988) 67-118.

17. Muthesius, *Eastern silks*, 346ff. ; W.Ohnsorge, *Konstantinopel und der Okzident* (Darmstadt, 1966) 49-92, 208-226; Shepard, *Byzantium and the West*, 77.

18. Muthesius, *Eastern silks*, 347ff. ; T. C. Lounghis, *Les ambassades byzantines en Occident depuis la fondation des états barbares jusqu'aux Croisades (407-1096)* (Athens, 1980).

19. Muthesius, *Practical approach*, 250 note 41.

20. The relevant legislation is recorded in C. Pharr ed., *The Theodosian Code. The Corpus of Roman Law I* (Princeton, 1952) 10.21.3, and in P. Krüger ed., *Corpus Iuris Civilis, 2, Codex Iustinianus* (Berlin, 1915) 4.40.1.

21. Muthesius, *Practical approach*, 243ff., pl. 3.

22. For the Book of the Prefect see, J. Nicole, *The Book of the Prefect*. Variorum Reprint (London, 1970) 35-38. For the legislation in the Basilics see, G. E. and C. G. E. Heimbach, *Basilicorum Libri, LX* (Leipzig, 1833-1870) 19.1.80.

23. With regard to Liudprand see, F. A. Wright, *The works of Liudprand of Cremona* (London, 1930).

24. Schmedding, *Mittelalterliche Textilien*, no. 236.

25. Nicole, *Book of the Prefect*, 8. 1-2; 8. 11.

26. For Theophanes see, I. Bekker ed., *Theophanes Continuatus* (Bonn, 1838) 4, 173; 13. For the Eidikon in the Book of Ceremonies see, F. Dölger, *Beitrage zur Geschichte der byz. Finanzverwaltung* (Leipzig, 1927) 35-39.

27. Muthesius, *Practical approach*, 251ff.

28. Schmedding, *Mittelalterliche Textilien*, 250-252.

29. Muthesius, *Practical approach*, 251.

30. Muthesius, *Practical approach*, 252ff.

31. On the subject of Theophanou's dowry see, H. Wentzel, 'Das byzantinische Erbe der ottonischen Kaiser. Hypothesen über den Brautschatz der Theophanou' *Aachener Kunstblätter* 43 (1972) 11-96. In addition see, Muthesius, *Eastern silks*, 355 note 23.

32. Discussed in A. Muthesius, *Mediterranean silk trade*, 126-135.

XI
Crossing traditional boundaries: Grub to Glamour in Byzantine silk weaving

BYZANTINE silk research evokes images of glamour but it is prudent to consider grass roots as well as exotic aspects of this enticing subject: without the grub there would be no glamour. In its fullest sense a study of Byzantine silk weaving entails research on many and varied levels, across a broad range of disciplines. An immense variety of topics require consideration: the production of the silk yarn; the various workshop practices involved in weaving the yarn into silk cloth; the relationship between technique and design; the marketing and the numerous uses of the silks both at home and abroad; and the implications of the distribution of Byzantine silks purely through diplomatic channels.

The purpose of this paper is to describe an inter-disciplinary research method for the analysis of Byzantine silks. The methodology outlined illustrates how a variety of traditional, theoretical research approaches may be combined with more individual, empirical investigative techniques to yield fresh results.

A second paper by Rex Gooch describes modern opportunities for handling and presenting research information, in the field of academic Byzantine textile studies. PLATE 63 shows a sample computer screen from my pictorial retrieval system for Byzantine silks.[1] The text and diagrams for both papers were prepared using the techniques described in the second contribution.

The key to the fascination of the history of the Byzantine silk industry lies in the way that the silks coloured so many aspects of Byzantine life;

artistic and social, economic and political, as well as religious. A broad appreciation of all these aspects is necessary and affects the formulation of a working methodology. To accommodate all the different aspects of the study under a single research umbrella, it is necessary to integrate appropriate working methods across a broad spectrum of disciplines. Then questions that cannot be handled satisfactorily using established research methods, themselves will demand application of novel approaches still to be fully tested. A sensitive relationship between enquiry and research approach encourages the flexibility of mind helpful to the fullest study of Byzantine silks. This allows room for refinement in the light of new discoveries without disturbing a basic framework around which to organise research. Such a framework (FIG. 21) will be explained in detail later in the article.

Only Beckwith (1971) in a paper entitled 'Byzantine Tissues', so far, has outlined his views on the nature of Byzantine textile studies. He observed, 'The study of mediæval woven textiles is highly complex and is, perhaps, the most difficult discipline in the entire field of art history'. He spoke of 'years of correspondence between a handful of experts lengthening into a lifetime' and he regretted that 'only very few people were equipped or trained for the work.' Amongst the initial obstacles to a wider study of mediæval textiles including Byzantine silks, he pointed out the difficulties of inspecting at first hand the mass of surviving fabrics in scattered and inaccessible locations all over Europe and America. Hot on the heels of this impediment followed the arduous task of mastering 'the highly complex research techniques necessary for the fullest appreciation of the fabrics'. These techniques involved:

- wide art historical learning and sensitivity,
- historical appraisal of political and cultural developments throughout the Mediterranean area over a wide range of time, and
- scientific and technical understanding of weaving processes.

Translated into broader terms the student of Byzantine silks (amongst other mediæval textiles), required art historical, historical, scientific and technical training. Insofar as scientific examination of textiles and increasingly their sociological and anthropological significance belong also to the realms of archaeological study, this discipline too, is relevant for the student of mediæval textiles.

The particular technical analysis of fabrics developed under the auspices of C.I.E.T.A. (Centre International d'Études des Textiles Anciens) over the period of the last twenty years represents a major contribution for the grouping of the surviving material, and forms part of an integrated approach used by textile historians in mediæval textile studies.[2] A broad dating of the weaving categories is achieved through

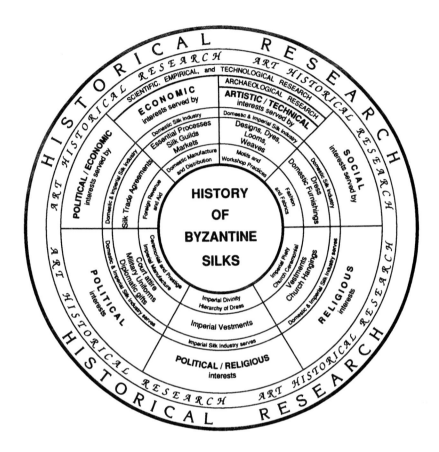

FIGURE 21
FRAMEWORK FOR THE STUDY OF BYZANTINE SILKS

interpretation of art historical, historical and circumstantial evidence: Muthesius (1982, 16-252 and forthcoming). The results can be illustrated in a bar chart, (PL. 58).

Earlier literature

What then has been the contribution of earlier literature to the study of mediæval textiles, in particular to the study of Byzantine silks? Beckwith, perhaps referring only to art historical publications, thought earlier literature 'often worthless' (1971, 33). Several hundred books and articles are relevant to the study of the History of Byzantine Silks: Muthesius (1982, 584-94, 613-23 and forthcoming). Naturally, not all of them can be discussed here but examination of a representative selection of them does

reveal the breadth of the field of study and emphasises its inter-disciplinary character.

Historical A key source for the study of economic aspects of the Byzantine silk
publications industry is the Book of the Prefect which contains regulations governing the non-Imperial silk guilds of Constantinople. Since Nicole's publication of 1894 (Variorum reprint 1970), a vast literature on the subject has grown up, as indicated in the bibliography outlined by Vryonis (1963, Variorum Reprint 1971, III, 293-94 note 13). Close critical scrutiny of the silk guild regulations was made by Simon (1975) in a thorough and intricate article. His individual observations in the context of literal translation of the text are coherent and persuasive. Some of his conclusions in the light of the actual workings of a non-industrialised silk industry nevertheless, appear to be impractical if not entirely untenable: (see PL. 56); Muthesius (1989, 144-46); Koder (1989, 1991).

A critical approach is also necessary in dealing with the rare economic documents on Byzantine sericulture that have survived the ravages of time. Guillou's admirable discovery and publication of the Reggio Brebion detailing taxation of mulberry trees in Calabria, provides insight both into raw silk supply and taxation systems in Byzantium. However, an interpretation of the importance of Calabria as a supplier of raw silk depends on an accurate estimate of the raw silk yield for a given number of mulberry trees. In this respect there appear to be marked discrepancies between the figures suggested by Guillou and those available for nineteenth century Calabria and for present day non-industrialised sericultural production in India: Muthesius (1982, 254-58; 1989, 143-4; and forthcoming). As Guillou recognised, it is instructive in attempting to judge the size and importance of raw silk cultivation in Calabria, to consider silk yarn supplies of the Mediterranean as a whole and the prices of the twelve varieties of silk thread that were on the market: Goitein (1967, 222-24, 454-55 note 63; 1971; 1983) and Ashtor (1969) respectively.

In a similar vein in the interests of practical considerations it is necessary to subject to scrutiny traditional interpretation of historical documentation. The age old myth that sericulture was transposed on to Byzantine soil by ingenious 'undercover' means in the sixth century, needs finally to be laid to rest: Muthesius (1989, 136-7). Even when authors admit that the region from which sericulture was supposedly transposed on to Byzantine soil cannot be identified from the names 'Serindia' and the 'Land of the Seres' used in the sixth century sources describing the event, attempts are made to pinpoint exact geographical regions: Wada (1972, 71-85). Until the entire history of sericulture in the Far and the Near East has been established through the evidence of

historical documentation as well as archaeological remains, answers to questions like these cannot be provided. The search for fresh documentation need not be confined to Byzantine sources. Chinese sources of the mediæval period provide a wealth of geographical and sericultural information that throws light on the possible origin and running of the Byzantine silk industry: Muthesius (1989, 136-7 and forthcoming). The report of sericulture in Byzantine Syria as identified by Hirth (1855, 13-14) and Needham (1979, 185-86, 201, 205) requires careful consideration, particularly in the light of the important role played by Syria in raw silk supply to Byzantium in subsequent centuries. If sericulture did not begin in Byzantium in the sixth century when was it introduced? The question of where sericultural techniques were learnt also remains: Muthesius (forthcoming).

An overall study of the history of the Byzantine silk industry was published long ago by Lopez (1945) but received regrettably little detail in review: Kazhdan (1950). Perhaps it has been the lack of a corpus of the surviving material that has deterred further work in the field.[3] The contribution of Lopez has been to suggest the wide variety of levels on which Byzantine silk operated: social and political alongside economic. Questions that he raised about the organisation and the administration of the industry lie at the heart of an understanding of Byzantine silk weaving. These include:

- What was the relationship of the private to the Imperial silk industry?
- How far was there Imperial control of the private silk industry and was it justified?
- Was the Imperial silk industry a drain on the economy?
- As a political weapon what role did Byzantine silks play abroad?

These and related questions are the subject of further enquiry in a forthcoming paper: Muthesius (1991).

Detailed articles on different aspects of the Byzantine silk industry have appeared sporadically since the nineteenth century: Michel (1852-54), Zachariae von Lingenthal (1865), Stöckle (1911), Persson (1923), Hennig (1933), Andreades (1934), Sabbe (1935), Canard (1951), Vryonis (1963), Charbonnel (1964), Oikonomides (1972, 1986), Kislinger (1990) amongst others. Some like Michel and Sabbe have been useful for gauging the extent of silk trade, although these authors touched only the tip of the iceberg in the light of more than a thousand extant and documented Eastern Mediterranean silks that are known: Muthesius (1982, 264-339 and forthcoming), (PL. 57). Others raised problems that still have to be solved, such as the date of the novella 'Peri Metaxes' first discussed by Lingenthal. The interpretation of other silk legislation too, has differed

between authors; for example, whether ceiling prices on silks applied to yarn or garments: Lopez (1945, 11), Oikonomides (1986, 34 note 4), Muthesius (1989, 137 and 1991 forthcoming). Similarly the interpretation of difficult textile terms in the Book of Ceremonies and in the Book of the Prefect has prompted a variety of interpretations: Haldon (1989), Koder (1989, 1991), Muthesius (forthcoming). In some cases terms remain obscure; a specialised technical language has been characteristic of most textile industries through the ages. In other cases explanations can be tested with recourse to practical knowledge of silk weaving and with reference to information in later silk guild regulations containing specifications for the manufacture of controlled silks.[4] The status of the artisans, the political role of the guilds, the quality of the fabrics produced, the relationship between raw silk supply, demand for Byzantine silks, and the size of trade revenue are aspects that have been considered in passing by these and other authors. Most recently, Hendy attempted to gauge the extent of the silk trade with Italy and its impact on the Imperial budget. He concluded that silk trade revenue from this source was small: Hendy (1985, 590-602). There still is no answer to the question, "What percentage of silk trade revenue as a whole did this represent?" Elsewhere Hendy (1989, I, 1-4), initiated a call towards an ordered methodology for the study of Byzantine economic history.

The survival of a vast body of Byzantine silks in Western Europe alone may alter the economic light in which the Byzantine silk industry traditionally has been viewed. If so many Byzantine silks were reaching the West, how many were in fact being produced over all? How widespread was moriculture in the Byzantine Empire and what taxes were incumbent on sericulturalists? To what extent was moriculture and sericulture practised on the estates of the landed nobility and how far were 'noble faces' embroiled in the manufacture of silks under cover of servants, in whose name landowners and civil servants could penetrate the silk guilds?[5] General histories do not deal with questions like these: Harvey (1990).

Art historical Art historical approaches came to the fore in nineteenth century general **publications** textile histories: Blanchet (1847), Fischbach (1883), followed by Dreger (1904), Mignern (1909), Falke (1913), Schulze (1917), Flemming (1927); more recently amongst others Schmidt (1957) and Geijer (1979). Of all these publications Falke's Kunstgeschichte der Seidenweberei, stands as a pioneering landmark. It incorporated a survey of the elaborately patterned silks of the Byzantine and the Islamic Mediterranean, and of the Near and the Far East. Quite remarkably, without recourse to technical analysis, Falke was able through art historical, stylistic and iconographi-

cal analysis, to divide the material into broadly correct chronological and geographical categories. Only recently has it been possible to refine his divisions substantially, with the hindsight of more scientific techniques and after the appearance of further definitive material.

Textiles as decorative objects naturally have been studied for their ornament. In certain publications this was the sole or the main aspect that was stressed: Dupont-Auberville (1877), Cole (1899), Cox (1900), Fischbach (1902) and a modern example, Klesse (1967). The last publication succeeded in paralleling ornament on textiles with ornament in paintings, so providing dating evidence. This is less easy in the case of Byzantine textiles. For example, only occasionally do the elaborate griffins or eagles in medallions typical of tenth to eleventh century Byzantine silks appear in manuscript illumination or on wall paintings.

Other authors chose to concentrate on figurative subject matter and they found historical descriptions in sources such as the Liber Pontificalis, of great value: De Waal (1888). A natural progression has been to consider the subject matter in relation to theological and political debate of different periods: Muthesius (1990). Iconoclasm for instance, would appear to have had a direct influence on the charioteer and hunter themes that decorate Byzantine silks produced in the eighth to ninth centuries: Muthesius (1982, 131-149). One silk from this period, the hunter fabric from Mozac, probably a gift from Pepin to the relics of St. Austremoine at the time of a recognition in 764, shows an Imperial hunter (PL. 64). Constantine V is known to have favoured hunter themes and this Byzantine Emperor did exchange envoys with Pepin in 756/7: Muthesius (1982, 135). Relations between Constantine V and Pepin were sufficiently close for a proposed marriage alliance between the son of Constantine V and the daughter of Pepin, to be documented in 765. There can be little doubt that the Mozac hunter silk arrived in the West as a diplomatic gift.

Amongst Byzantinists few purely textile specialists emerged, probably largely due to the fact that many of the fabrics were inaccessible and therefore, unknown. Nevertheless, the sumptuous nature of the Byzantine silk industry was legendary and stressed, not least by Ebersolt (1923). Specific Byzantine pieces were singled out: Frauberger (1898), Justi (1898), Dalton (1911), Chartraire and Prou (1913), Lethaby (1913-14), Diehl (1925), Volbach, Salles and Duthuit (1931, 1933), Peirce and Tyler (1932), Heichelheim (1949). Kondakov (1924) and Grabar (1951) drew attention to Oriental influences on Byzantine court dress, whilst Canard (1951) found evidence that Byzantine court ceremonial was influential at the Fatimid court.

Many earlier authors were concerned to establish the extent of Sassanian influence on Byzantine silk weaving motifs. It was largely Beckwith who recognised that silks previously termed Sassanian could be

assigned Byzantine provenance. This he did during discussions before the actual silks as they were displayed in the exhibition Sakrale Gewänder in Munich: Beckwith (1955, 305-30). King (1966, 47) followed by Muthesius (1982, 120-73), discussed how, simultaneously, different centres might be producing very similar designs right across the Mediterranean region. It was no longer necessary to think of Islamic and Byzantine workshops working in isolation from one another. Indeed, by the eleventh century, an International style of silk weaving had made its mark so that some Byzantine and Islamic silks were difficult to distinguish not only in design but also in technique: Muthesius (forthcoming).

Catalogues offered a natural means of recording and guiding visitors through exhibitions of textiles and they were a useful tool for art historians concerned with assigning date and provenance to mediæval fabrics. Textile catalogues were published to record public, private and ecclesiastical collections and many of these housed Byzantine pieces.

The earliest catalogues presented only basic descriptions of textiles and their designs, without recourse to weave analysis or to scientific analysis of dyes and fibres. In cases where date and provenance were suggested, there was often a lack of firm evidence for the attributions. It is true though, that these publications recorded many fabrics that were lost or destroyed in subsequent years and for this reason they are valuable.

In the early stages textiles merely were included within general museum guides: Paris, Cluny (1883), Hannover, Kestner (1894), Nürnberg, Kunstgewerbe Museum (1896). Subsequently, large numbers of textiles, both bought and excavated fabrics, were catalogued more fully, and published by museum curators in sizeable volumes incorporating elaborate hand-drawn plates and photos: Berlin, Kunstgewerbemuseum (1900-13); London, Victoria and Albert Museum (1922, 1924, 1925), more recently Hannover, Kestner Museum (1964), Lyon Textile Museum (1987).[6]

More rarely private collections were published: C. de Linas (1865), J. Pasco (1905). A type of modern day parallel may be found in some Sotheby sale catalogues, although these are intended to serve prospective buyers rather than the owners of the textiles.

Church treasury catalogues appeared from an early date in far greater numbers, for example at: Brixen (1861), Maastricht, St. Servatius (1873), Sens, (1886, 1897, 1911), and Rome, Vatican (1908, 1942) and it was in this type of publication that many Byzantine silks were listed. Here scientific detail became increasingly evident until, in the most recent examples, intricate and lavishly illustrated encyclopaedic treasury catalogues have emerged. This is generally only after detailed conservation work on the textiles has been carried out and prior to exhibition of the pieces: Schmedding (1978) for example, (compare the much briefer earlier

descriptions of Vogt (1954, 1958). The Abegg Stiftung publications with their emphasis on conservation and recording of pieces have achieved a high standard, but only after the necessary financial backing: Fleury-Lehmberg (1989). Today in general, high production costs threaten publication of academic text books, which are so necessary to provide a corpus of surviving material and to draw together documentary sources over wide ranging aspects of a complex field of study.

Frequently exhibitions served to highlight the existence of a rich mediæval textile heritage. An early example like Kirchengewandern (1911) set a precedent for much later exhibitions on a grand scale, for instance Sakrale Gewänder (1955), already mentioned. For this exhibition all surviving mediæval vestments of importance were assembled together under a single roof.[7]

Ecclesiastical silks certainly provided scope for many important nineteenth century textile publications: Bock (1856-71), C. de Linas (1860-63), C. Rohault de Fleury (1883-89). Apart from recording the pieces for posterity with plates and basic catalogue descriptions, the authors included valuable circumstantial evidence that otherwise would have been lost. These large works foreshadowed the noteworthy publication of Braun (1907), which drew together into a comprehensive history what must have amounted to all the available empirical and historical evidence about liturgical vestments and cloths both Byzantine and Latin. It has remained a standard reference work (witness the reprint of 1964). For specifically Byzantine vestments, most of which belong to a later date, there were the publications of Millet (1939), Papas (1965) and Johnstone (1967). Walter (1982) looked at vestments in Byzantine art. Speck (1981) concentrated on documented Byzantine liturgical cloths and others described rare surviving examples: Patmos (1988, bibliography 368-369).

Summary

Thus, buried in general mediæval textile publications, evidence about a fraction of surviving Byzantine textiles was available. However, with the exception of the most up-to-date catalogues, descriptions of weave structures necessary for the basic grouping and dating of the material were not provided. Even as late as 1982 art historical descriptions of Byzantine silks, with only second-hand and sometimes inaccurate and incomplete weave analysis descriptions appeared. Art historians failed to appreciate that the grouping and dating of the silks relied on technical data, to which stylistic and iconographical data then had to be allied in historical context and with consideration of circumstantial evidence. The fact that the same motifs appeared over centuries and that motifs moved between different workshops, are just two of the reasons against the pure

stylistic and iconographic grouping of the type used by Starenseier (1982, 490ff.). Alongside incorrect and second-hand technical analysis of one piece she listed, came unjustified analogy between a smooth and well rounded Imperial Lion motif and a highly stepped and distorted far smaller scale Lion design. The former Lion silk was woven across and not down the loom like its Imperial counterpart but this point was not noticed: Starenseier (1982, cat. 46). Not only the weaving technique, but the dye analysis and even the style of the motifs, argued against the two silks being the product of a single workshop. Although exhibited as a Byzantine silk in Athens (1964), the Maastricht Lion silk, unlike its Imperial Byzantine counterparts, belonged far more to an Islamic than a Byzantine ambience: Muthesius (1984, 247-50). (PLS. 10, 39A).

First hand experience of the silks is crucial on several counts, not only for developing 'an eye' for the silks in general and for technical analysis, but indeed to verify what exactly exists. Starenseier (1982, cat. 44) in common with every author writing of the Siegburg Imperial Byzantine Lion silk since the second world war, claimed it had been burnt. The silk survives at Schloss Köpenick in East Berlin: Muthesius (1984, 237ff.). It is of paramount importance as it is the only precisely datable, inscribed Byzantine silk in existence. Only first hand examination of the fabric could reveal the nature of the technical fault on the silk, whereby the paired Lion motif with central inscription had been mistakenly cut in half on one side: Muthesius (1984, 239-41). Precise technical analysis is essential also, because silks are sometimes returned to the shrines from which they were removed in the nineteenth century and then they are no longer available for study: Aachen Elephant silk: Muthesius (1984, 251-54), C.I.E.T.A. Bulletin (1971, 22-57) (PLS. 45-47B). Today even closer first hand scrutiny of individual weaving faults reveals important clues about the nature of the looms that produced the pieces. This type of study belongs to a category of technical textile history publication.

Scientific, empirical, and technological publications The work of a few nineteenth century authors, notably Blümner (1874) and later for example Marquardt and Mommsen (1886), is unusual for highlighting technical and scientific matters. These authors gave detailed consideration to fabric terminology, and more specifically to exactly how textiles were woven, opening up embryonic discussions on fibres and dyes as well as looms. The breadth of their approach was quite remarkable.

Silk as a fibre interested Pariset from an early date (1862, 1865, 1890) and silk was the subject of a two volume work by Silbermann (1897).

Scientific analysis of fibres and dyes has been considerably refined only in recent times, but more samples are needed to raise the standard of investigation even further: Faymonville (1900), Pfister (1935), Hofenk

de Graff (1970-90), Bridgeman and others (1987), York collected papers (1981-87), and modern computer aided analysis (1989).

A Vocabulary of Technical Terms has taken many years to prepare and is the crowning achievement of the International centre for the study of Ancient Textiles at Lyons: C.I.E.T.A. (1964). The Vocabulary underlies the international system for the scientific and technical analysis of textiles mentioned above, and this approach is best illustrated in articles in the C.I.E.T.A. Bulletin. Similar systems have appeared elsewhere later: Burnham (1980).

Theory and practice were combined best by those either familiar with weaving itself, or possessing a good knowledge of the technical problems involved in weaving: Hooper (1911), Crowfoot (1936, 1937), Flanagan (1957), Wild (1971), De Jonghe and Tavernier (1977, 1978, 1980), Endrei (1989). This work progresses slowly towards a technological history of looms, beyond the outline surveys at present available: Broudy (1979). A history of the Byzantine hand drawloom is still to come but the necessarily complex type of pattern producing device of the loom can be imagined: Muthesius (forthcoming) (FIG. 22).

Catalogues have proved an important medium for archaeologists as well **Archaeological** as art historians. Many excavated sites yielded textiles that required a **publications** catalogue record: Akhmim-Panapolis (1891), Dura Europos and Palmyra (1934, 1937, 1940, 1945), Birka (1938), Halabiyeh-Zenobia (1951), and more recently London, York and Perth archaeological finds.[8] These archaeological catalogues have become increasingly technical with elaborate weave structure, dye analysis and other scientific data accompanying the usual descriptions of fabric size, design and colour. Steps have been taken to incorporate textile specialist skills into archaeological training, but often excavated pieces are sent to textile historians originally trained in art history. The lack of academic centres for mediæval textile history hinders the training of specialists to serve in the field.[9] The survival of Eastern Mediterranean silks even amongst the Viking finds at York, indicates how far they were carried in trade and the extent to which they were prized abroad well outside court circles: Muthesius (1982 Finds, 132-36).

Many technical problems cannot be solved theoretically. Looms have to be reconstructed and mediæval textiles rewoven, before even the relevant questions to be asked can be envisaged. This type of work is only just beginning in earnest, although the idea is not new: Becker (1987). The work calls for the combination of the skills of a weaver master craftsman and an academic textile historian and it truly belongs in the field of experimental archaeology: Nan King (1980-90), Uden and Muthesius

(1982-90). The problems of housing experimental, large scale hand draw-looms in academic institutions can be envisaged, and already progress in this crucial branch of textile history has been hampered through lack of much needed research accommodation.[10]

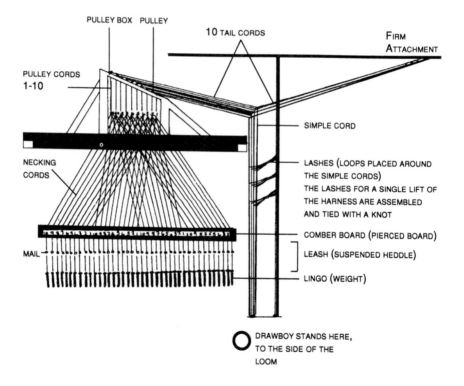

FIGURE 22

DRAWLOOM: FIGURE HARNESS WITH 40 MAILS AND 4 PATTERN REPEATS

AN INTEGRATED, INTER-DISCIPLINARY
METHODOLOGY

This extended survey of mediæval textile literature incorporating work on Byzantine silks has been included to introduce some of the approaches and a good number of the aspects of study relevant to the formulation of a coherent methodology for the study of Byzantine silks. The methodology makes no claim to completeness, but it does provide a framework around which to hang future research. This framework can be visualised in a diagram, as mentioned at the beginning of the article (FIG. 21). The structure of the diagram can be examined under a series of separate headings:

The four research approaches relevant to Byzantine silk studies are **Four research** shown in bands outermost on the circle: **approaches**

- Historical
- Art Historical
- Scientific and Technical
- Archaeological

These are supplemented by empirical investigation with reference to the evidence of contemporary, non-mechanised silk industries. I have included empirical investigation alongside scientific and technical approaches on the diagram.

The four research approaches serve five principal areas of interest: **Five principal**
- Artistic and Technical **areas of interest**
- Social
- Religious
- Political
- Economic

In two instances at least, areas of interest overlap and these have been shown as separate segments on the diagram:
- Political/Economic
- Political/Religious

The five main and two subsidiary areas of interest are marked in seven segments on an inner band of the circle. Each was serviced, either jointly or separately, by the private and by the Imperial silk industry, as shown on the diagram.

Relationship between research approaches and areas of interest Historical and art historical research approaches are relevant to answer questions on every aspect of Byzantine silk weaving, in so far as documentary evidence as well as surviving silks raise questions in all spheres of interest outlined. Some of these questions already have been considered during discussion of earlier literature. Æsthetic preoccupations such as the tremendous shift from polychrome to monochrome silk production during the eleventh century belong properly to the realm of art history, but they were accompanied by technical innovations, namely the move from twill to lampas weave production. These structural changes in turn reflect advances in hand draw-loom technology that had the effect of cutting down the time and the cost of production and of affecting the economics of the industry. In a sense one may ask, "Where are the boundaries between disciplines?". Here aesthetic, technological and economic factors are all heavily inter-related.

Indeed empirical approaches help to answer questions of economic interest in a practical down to earth way. Take, for instance, the ratio of mulberry leaf to raw silk yield, or the organisation of essential processes in the industry. Both can be observed in present day India. Certain common sense observations, such as the fact that silk moths emerge from their cocoons within days and need to be stifled not to tear the continuous silk filaments, can be used to help explain silences in the Book of the Prefect. For example, this knowledge implies that Syrian silk was unlikely to have arrived in Constantinople in the form of cocoons. Cocoons can be salted, as described in mediæval Chinese treatise, but only for a short period; in any event this practice has the effect of rendering the silk brittle. Working on common sense arguments, it can be suggested that the silk merchants of the Book of the Prefect, the Metaxopratai, could handle cocoons only if they were produced in the vicinity of the Capital. A similar line of thought can be used to fill in other gaps in the regulations in the Book of the Prefect. The conclusions are not documented but they are at least plausible in the light of the realities of the operation of the silk industry. Plausible suggestions are preferable to interpretations that give no weight to the realities of the situation.

In addition to art historical and historical research approaches, scientific and other empirical and technological approaches are pressed into operation to answer questions about the structure and appearance of the surviving silks. Fibre and dye analysis, and study of the interaction between yarn, technique and design are as important as the study of the actual designs and colours themselves.

Many topics can be discussed under the headings of the different areas **Topics of** of interest described above. Perhaps most important under the various **concern** headings are the following:

- Artistic/Technical: designs, dyes, looms, weaving techniques.
- Social: dress and domestic furnishings.
- Religious: vestments and church hangings.
- Political/Religious: Imperial vestments.
- Political: court attire, military uniforms, diplomatic gifts.
- Political/Economic: foreign trade revenue and military and political aid.
- Economic: essential processes, silk guilds and markets.

A study of these topics yields information on specific central aspects of the History of Byzantine silks, but naturally the manner in which the questions are asked will colour the answers received.

Central aspects of the History of Byzantine silk weaving that emerge from **Central aspects** a study of the topics outlined above, are indicated in appropriate segments around the middle of the circle. These are:

- Motifs and workshop practices.
- Fashions and fabrics.
- Church ceremonial.
- Hierarchy of dress.
- Imperial manufacture in the service of Imperial ceremonial and prestige.
- Foreign trade as a means of securing revenue, and military and naval aid.
- Domestic manufacture primarily for home distribution.

The acquisition of data is quite a different matter from its interpretation. **The role of silks** It is beyond the scope of this article to define the philosophical stances that **in Byzantium** could be taken within each discipline involved in the study of Byzantine silks, even if this were possible. The experience of the author has been to work outwards from the material. The methodological framework presented represents aspects of Byzantine silk weaving that can be studied with reference to surviving or documented silks. The interpretation of the information gained through a study of these aspects using an interdisciplinary approach of the kind suggested, must remain personal, according to the conscious or subconscious ideological stance of the individual researcher.[11] A potential danger lies in the temptation of applying ideology in the absence of thorough first hand experience of the

surviving material. Some theories may work on paper but do they also work in practice?

The data in general seems to point to a great emphasis on ceremonial and prestige through the use of silks. Silken ceremonial parades on secular and religious occasions and the use of special purples and silken robes underlined the prestige but also the piety of the Emperor. At a lower level silks were used to enforce a strict hierarchy of dress throughout the civil, military and ecclesiastical ranks of the Byzantine Empire. Less precious domestic silk production served the landed and noble classes primarily. They tried to ape the splendour of court dress and no doubt to furnish their homes with silks in the manner of the Eastern Mediterranean brides, whose silken dowry accounts adorn the Cairo Geniza archives: Stillmann (1972), Muthesius (forthcoming).

Again, on a political level, the promise of silk trade concessions brought foreign military and naval aid to the rescue of besieged Byzantine territories on more than one occasion and diplomatic silks helped to secure advantageous marriage alliances: (Muthesius, 1982, 1984, 1990).

The economic significance of the silk industry has received less attention in the light of the lack of sufficient statistical evidence. As mentioned earlier, the problem here is that we do not have figures for the size of the silk industry. Also we do not know where the mulberry plantations were planted or how much tax was payable to the state for moricultural lands: Muthesius (1989, 143-44). On present available information the economic significance of the Byzantine silk industry cannot be quantified. Nevertheless, essential processes and their economic significance can be described: Muthesius (1989, forthcoming).

The survival of a vast body of Eastern Mediterranean and Near Eastern silks in Western Europe does add fuel to the arguments against Pirenne's thesis about the effects of the Arab invasions: Muthesius (Trade, 1990). The survival of the silks also indicates the scope for Byzantine cultural influence on the West before the development of Latin silk weaving workshops.

In centres where Byzantine silks could be copied, the artistic influence is remarkably clear. One insufficiently recognised and understressed example is the replacement of traditional animal motifs by alien Byzantine hunter themes in Central Asian workshops of the tenth century. These asymmetrical and irregular Byzantine hunter designs were difficult to weave and as a result often were misrepresented: Muthesius (1982, forthcoming). The Byzantine hunter silks of the eighth to ninth centuries transformed taste and colour preference in Central Asian workshops. The power of the silks to influence taste at a distance is perhaps nowhere else so graphically shown. In this instance trade acted as a catalyst for cultural influence at a distance. The impetus behind the

development of Byzantine hunter theme silks may well have been Imperial (Muthesius {forthcoming}), so that political, economic, artistic and cultural elements again become interwoven in a complex web.

Byzantine silk weaving moves along a labyrinth of intricately inter-twined avenues with no short cuts between paths. The more that is understood about each aspect of the industry the greater the scope for the appreciation of the History of the Byzantine silk industry as a whole.

ACKNOWLEDGEMENT

The author is pleased to acknowledge the assistance of Wingate Scholarships in her research.

NOTES

1. I am greatly indebted to Rex Gooch (Consultant Systems Engineer, IBM) for producing all diagrams in this article, and for other much appreciated assistance to publish many aspects of my research elsewhere. Some of these diagrams belong to a forthcoming *History of the Byzantine Silk Industry*, (J. Koder, E. Kislinger ed., Byzantine Institute, Vienna).

2. C.I.E.T.A. technical analysis has been published for a number of relevant silks. For instance, see the examples in the bibliography under C.I.E.T.A analysis. Also for a silk on a manuscript cover in the Vatican, Rome, see L. de Adamo, La couverture en soie de l'évangeliare de santa Maria in Via Lata a Vatican.*C.I.E.T.A. Bulletin*, 51-52 (1980 I and II) 15-17. This silk has been termed Syrian by the author but it is possible that it was produced in a Byzantine centre of the Eastern Mediterranean. There is no evidence that bear hunter scenes were particular to Syria, and this type of twill was woven all over the Eastern Mediterranean by the 8th-9th centuries.

 The most complex type of technical discussions relate specific weaves to loom types. See D. De Jonghe and M. Tavernier, Les Damasses de Palmyre, *C.I.E.T.A. Bulletin* 54 (1981 II) 20-53.

3. A full catalogue of 120 silks and a handlist of a further 1240 pieces appear in an appendix to a forthcoming *History of the Byzantine Silk Industry* by the author. The handlist includes some Islamic silks (Eastern Mediterranean and Near Eastern) that are comparable to Byzantine pieces. Extracts from the handlist and the catalogue appear as figures 3 and 5 in: Rex Gooch, 'New Opportunities in Storing, Retrieving and Publishing Information', *Journal of Byzantine and Modern Greek Studies*, 15 (1991) 366-379.
 It is difficult to distinguish between Constantinopolitan and provincial silk manufacture, because so little is known from documents about silk weaving outside the Capital. See E. Weigand, Die helladisch-byzantinische Seidenweberei. *Eis Mnemen S. Lamprou.* (Athens 1935) 503-514.

4. The mediæval Italian silk guilds produced carefully regulated types of silks. The documented regulations for Lucca are dated 1376 with revisions of 1381 and 1382. These indicate that several factors were important including: loom width; number of main and binding warps across the piece; number of main warps in the dent of the reed; and the use of gummed and degummed silk. See D. and M. King, Silk weaves of Lucca in 1376. *Opera textilia. The Museum of National Antiquities, Stockholm.* Studies 8, L. Estham, M. Nockert ed. (Stockholm 1988) 67-76. I suggest that some regulations in the Book of the Prefect refer to technical factors as specific as these: Muthesius (forthcoming).

5. Servants could represent their masters in the guilds of the Vestiopratai, the Metaxopratai, and the Serikarioi. See *The Book of the Prefect*, (Variorum Reprint 1970), 27, 32, 38 for regulations 4.2, 6.7, and 8.13 respectively, cf. Koder (1991), 93, 99, 107.

6. The Lyon publication was reviewed by the author. See *Jahrbuch der Österreichischen Byzantinistik* 37 (1987) 399-402.

7. The exhibition Sakrale Gewänder was discussed in detail by Beckwith amongst others in, Probleme der Mittelalterliche Textilforschung. *Kunstchronik* 11, 8 (1955) 305-333.

8. London and other British archaeological finds are being catalogued for publication under E. Crowfoot, F. Pritchard and K. Staniland (Dept. of the Environment and Museum of London).
 For York publication see Muthesius (1982 Finds) in bibliography to this article. See also, A. Muthesius, P. Walton, A silk reliquary pouch from Coppergate. *Interim* 6, 2 (1979) 5-6.
 The Perth textiles are in *Excavations in the Medieval Burgh of Perth.* Society of Antiquaries of Scotland Monograph Series 5. P. Holdsworth ed. (Edinburgh 1987). See Textiles, by H. Bennett and A. Muthesius, 159-73.

9. An ancient Textile Unit has been set up under J. P. Wild at Manchester University. However, there is no University in this country or abroad, which offers academic mediæval textile studies as a substantial part of its undergraduate or post graduate degree course.
 The teaching of the decorative arts in the mediæval period is incomplete without reference to the production of textiles. Textiles in the mediæval period were also important economic, social, ecclesiastical and political assets, so that they are of great significance for an understanding of mediaeval history in general.

10. The author seeks a site for a reconstructed hand drawloom upon which some tenth to eleventh century Byzantine silks will be rewoven by the master weaver A. Uden.

11. Discussions on methodology have been prevalent in the last decade. Archaeological enquiry was spearheaded by C. Renfrew. See for example, C. Renfrew, *Approaches to Social Archaeology.* (Edinburgh 1984). In art history M. Podro, *The critical Historians of Art,* (Yale 1982) and *The New Art History* A. L. Rees and F. Borzello ed. (London 1986) can be compared. Some historical ideologies have been discussed, for example in *The Philosophy of the Social Sciences,* 16.2 (1986) 101-105, and 197-210; 16.4 (1986) 459-88. The nature of and the similarities or the differences between methodologies and ideologies in distinct disciplines forms a vast field of study, well beyond the bounds of the present discussion.

BIBLIOGRAPHY

Titles cited in the article are given below and a selected list of related literature is appended.

Akhmim-Panapolis (1891): R. Forrer, *Römische und byzantinische Seiden Textilien aus dem Gräbern von Akhmim-Panapolis.* (Strassburg 1891).

Andreades (1934): A. Andreades, Byzance paradis du monopole et du privilège. *Byzantion* 9 (1934) 177ff.

Ashtor (1969): E. Ashtor, *Histoire des prix et des salaires dans l'orient médiéval.* (Paris 1969).

Athens (1964): *Byzantine art an European art.* Ninth Council of Europe exhibition, April 1 to June 15 1964. (Athens 1964).

Becker (1987): J. Becker, *Pattern and Loom.* (Copenhagen 1987).

Beckwith (1955): J. Beckwith, E. Keuhnel, F. Volbach, Probleme der mittelalterlichen Textilforschung. *Kunstchronik* 8 Jahrgang, 11 (1955) 305-30.

Beckwith (1971): J. Beckwith, Byzantine Tissues. *XIV Congrès International des études Byzantines.* (Bucarest 1971).

Berlin (1900-13): J. Lessing, *Die Gewebesammlung des königlichen Kunstgewerbe Museums zu Berlin.* (Berlin 1900-13).

Birka (1938): A. Geijer, *Birka III. Die Textilfunde aus den Gräbern.* (Uppsala 1938).

Blanchet (1847): P. Blanchet, *Tissus antiques et du Moyen Age.* (Paris 1847).

Blümner (1874): H. Blümner, *Technologie und Terminologie der Gewerbe und Kunste bei Griechern und Römern.* (Leipzig 1874-1912).

Bock (1856-71): F. Bock, *Geschichte der liturgishen Gewänder des Mittelalters.* (Bonn 1856-71).

Braun (1907, 1964): J. Braun, *Die liturgische Gewandung im Occident und Orient nach Ursprung, Entwicklung, Verwendung und Symbolik.* (Freiburg im Breisgau 1907. Reprinted Darmstadt 1964).

Bridgeman (1987): J. Bridgeman, Purple dye in Late Antiquity and Byzantium. *The Royal Purple and the Biblical Blue.* (E. Spanier ed.) (Jerusalem 1987) 159-63.

Brixen (1861): G. Tinkhauser, Die alte und neue Domkirche zu Brixen in Tirol. *Mitteilungen der K. K. central Kommission zur Erforschung und Erhaltung der Baudenkmale* 6 Jahrgang (1861) 120-34.

Broudy (1979): E. Broudy, *The book of looms.* (London 1979).

Burnham (1980): D. Burnham, *Warp and Weft, a textile terminology.* (Ontario 1980)

C.I.E.T.A. (1964): Centre International d'étude des textiles anciens, *Vocabulary of Technical Terms.* (Lyons 1964).

C.I.E.T.A. analysis: G. Vial, Le tissu aux éléphants d'Aix-la-Chapelle. *C.I.E.T.A. Bulletin* 14 (1961) 29-34; Chasuble de Brauweiler. *C.I.E.T.A. Bulletin* 18 (1963) 28-38; R. de Micheaux, Le tissu dit de Mozac. *C.I.E.T.A. Bulletin* 17 (1963) 12-20, analysis F. Guicherd.

Canard (1951): Le cérémonial Byzantin. *Byzantion* 21 (1951) 355-420.

Charbonnel (1964): N. Charbonnel, La condition des ouvriers dans les ateliers impériaux aux 4ᵉ et 5ᵉ siècles. *Travaux et Recherches de la Faculté de droit et des sciences économiques de Paris,* séries historiques 1 (1964) 61-93.

Chartraire, Prou (1899): E. Chartraire, M. Prou, Note sur un tissu byzantin du trésor de la cathédrale de Sens in: *Mémoires de la Société nationale des Antiquaires de France* 18 (1899).

Christophilopulos (1935): A. P. Christophilopulos, *To eparchikon biblion Leontos tou sophou kai ai syntechniai en Byzantio.* (Athens 1935).

Cole (1899): A. S. Cole, *Ornament in European silks.* (London 1899).

Computer Analysis (1989): J.Wouters, De analyse van de kleurstoffen, *Tongeren Basiliek van O.-L.-Vrouw Geboorte.* Textiel (Leuven 1988), 100-106.

Cox (1900): R. Cox, *L'art de décorer les tissus.* (Lyons 1900).

Crowfoot (1936, 1937): G. Crowfoot, Of the warp-weighted loom. *Annual of the British School at Athens.* (London 1936, 1937).

Dalton (1911): O. M. Dalton, *Byzantine Art and Archeology.* (Oxford 1911).

De Fleury (1883-89): C. Rohault De Fleury, *La Messe. Etudes archéologiques sur ses monuments.* Cont. G. Rohault de Fleury I-VIII. (Paris 1883-89).

De Jonghe and Tavernier (1977, 1978, 1980): D. de Jonghe, M. Tavernier, Die spätantiken Körper 4-Damasten aus dem Sarg des Bischofs Paulinus in der Krypte der St. Paulinus-Kirche zu Trier. *Trierer Zeitschrift* 40/41 (1977/78) 145-75; De schachtentrekstoel van Fez, *Bulletin van de Koninklijke Musea voor Kunst en Geschiedenis Brussel.* 48 (Brussels 1978) 145-62; Met selectieroeden geweven Koptische weefsels. *Same periodical as previous.* 50 (Brussels 1980) 75-106.

De Linas (1860-63): C. de Linas, *Anciens vêtements sacerdotaux et anciens tissus conservés en France.* (Paris 1860-63, third edition).

De Waal (1888): E de Waal, Figürliche Darstellungen auf Teppichen und Vorhängen in römischen Kirchen bis zur Mitte des neunten Jahrhunderts nach dem Liber Pontificalis. *Römische Quartalschrift* (1888) 313ff.

Diehl (1925): C. Diehl, *Manuel d'art byzantin.* (Paris 1925).

Dreger (1904): M. Dreger, Kunstlerische Entwicklung der Weberei und Stickerei. Wien 1904.

Dupont-Auberville (1877): J. Dupont-Auberville, *L'Ornament des tissus*. (Paris 1877).

Dura Europos (1945): R. Pfister, L. Bellinger, The Textiles, in: *The excavations at Dura Europos, final report IV*, (M. I. Rostovtzoff ed.) part II. (New Haven 1945).

Ebersolt (1923): J. Ebersolt, *Les Arts Somptuaires de Byzance*. (Paris 1923).

Endrei (1989): W. Endrei, A dozen mediaeval looms. *Alden Biesen Rhine-Meuse Textile Conference*. (Alden Biesen 1989).

Falke (1913): Otto von Falke, *Kunstgeschichte der Seidenweberei*. (Berlin 1913). Reprints 1921, 1936.

Faymonville (1900): K. Faymonville, *Die Purpurfarberei*. (Heidelberg 1900).

Fischbach (1902): F. Fischbach, *Die wichtigste Webeornamente bis zum 19 Jahrhundert*. (Wiesbaden 1902).

Flanagan (1957): J. Flanagan, Figured Fabrics. *A History of Technology 3*. (C. Singer, E. J. Holmyard, A. R. Hall ed.) (Oxford 1957).

Flemming (1927): E. Flemming, *Encyclopaedia of Textiles*. (Berlin 1927).

Fleury-Lehmberg (1989): M. Fleury-Lehmberg, *Textile Conservation*. (Abegg Foundation, Berne 1989).

Frauberger (1898): H. Frauberger, Der Byzantinische Purpurstoff im Gewerbemuseum zu Düsseldorf. *Jahrbücher des Vereins von Altertumsfreunden im Rheinland* 92 (1892) 224-32.

Geijer (1979): A. Geijer, *A History of Textile Art*. (London 1979).

Goitein (1967, 1971, 1983): S. D. Goitein, *A Mediterranean Society I, II, IV*. (New York 1967, 1971, 1983).

Grabar (1951): A. Grabar, Les succès des arts orientaux à la cour byzantine sous les macédoniens, *Münchner Jahrbuch der Bildende Kunst* dritte folge, 2 (1951) 31ff.

Guillou (1974): A. Guillou, *Le Brébion de la metropole byzantine de Reggio in: Corpus des actes Grec d'Italie 4*. (Vatican City 1974).

Halabiye Zenobia (1951): R. Pfister, *Textiles de Halabiyeh*. (Paris 1951).

Haldon (1989): J. Haldon, The feudalism debate once more: the case of Byzantium. *Journal of Peasant Studies*. 17 no.1 (Oct. 1989) 5-40.

Haldon (1989): J. Haldon, Three treatise on Imperial military Expeditions. (C.F.H.B.) 28 (1989).

Hannover, Kestner (1964): R. Grönwoldt, *Webereien und Stickereien des Mittelalters. Textilien 1. Bildkataloge des Kestner Museums, Hannover VII*. (Hannover 1964).

Harvey (1990): A. Harvey, *Economic expansion in the Byzantine Empire 900-1200*. (Cambridge 1989).

Heichelheim (1949): F. M. Heichelheim, Byzantinische Seiden. *C.I.B.A. Rundschau* 84 (1949) 2742-2768.

Hendy (1985): Studies in the Byzantine monetary economy c.300-1450. (Cambridge 1985).

Hendy (1989): M. F. Hendy, *The Economy, Fiscal Administration and Coinage of Byzantium*. (Variorum 1989) 1-48, 57-80.

Hennig (1933): R. Hennig, Die Einführung der Raupenzucht im Byzantinerreich. *Byzantinische Zeitschrift* 33 (1933) 295-312.

Hirth (1855): *China and the Roman Orient*. (Shanghai, Hong Kong 1855, New York 1966).

Hofenk-De-Graf (1970-1990): J. Hofenk-de-Graf, Analyse des matières colorantes dans les textiles anciens. *C.I.E.T.A. Bulletin* 35 (1972) 12-21. Also unpublished research at the Central laboratory Amsterdam, 1970-90.

Hooper (1911): L. Hooper, The technique of Greek and Roman weaving. *Burlington Magazine* 18 (1911) 276-84.

Johnstone (1967): P. Johnstone, *The Byzantine Tradition in Church Embroidery*. (London 1967).

Justi (1898): F. Justi, (Rider silks) *Zeitschrift für Christliche Kunst* 12 (1898) 361ff.

Kazhdan (1950): A. P. Kazhdan, Review of 'Lopez Silk Industry in the Byzantine Empire'. *Vizantiiskii Vremennik* 3 (1950) 290-93.

King (1966): D. King, Patterned silks in the Carolingian Empire. *C.I.E.T.A. Bulletin* 23 (1966) 47-52.

Kislinger (1990): E. Kislinger, Jüdische Gewerbetreibende in Byzanz, in: *Die Juden in ihrer mittelalterlichen Umwelt*. (Wien 1990).

Klesse (1967): B. Klesse, *Seidenstoffe in der Italienische Malerei des vierzehnten Jahrhunderts*. (Berne 1967).

Koder (1990): J. Koder, *Delikt und Strafe im Eparchenbuch: Aspekte des mittelalterlichen Korporationswesens in Konstantinopel*. (Wien 1990).

Koder (1991): J. Koder, *Das Eparchenbuch des Weisen*, CFHB 33 (Wien 1991).

Kondakov (1924), A. Kondakov, Les costumes orientaux, à la cour byzantin. *Byzantion* 1 (1924) 7-49.

Lethaby (1913-14): J. Lethaby, Byzantine silks in London museums. *Burlington Magazine* 24 (1913-14) 145ff.

London (1922): A. F. Kendrick, *Textiles from burying grounds in Egypt I-III*. (London 1920-22).

London (1924): A. F. Kendrick, *Muhammadan textiles of the Medieval Period*. (London 1924).

London (1925): A. F. Kendrick, *Catalogue of Early Medieval Woven Fabrics*. (London 1925).

Lopez (1945): R. S. Lopez, Silk Industry in the Byzantine Empire. *Speculum* 20 (Jan. 1945) 1-42.

Lyon Textile Museum (1987): M Martiniani-Reber, *Soieries sassanides, coptes et byzantines 5e-11e siècles. Lyon, musée historique des tissus*. (Paris 1986).

Maastricht (1873): F. Bock, M. Willemsen, *Antiquités sacrées conservées dans les Anciennes Collégiales de S. Servais et de Notre Dame à Maastricht*. (Maastricht 1873). (German ed. Köln and Neuss 1873).

Marquardt and Mommsen (1886): J. Marquardt, T. Mommsen, *Handbuch der Römischen Altertümer* 7. 2 ed. (Leipzig 1886). See J. Marquardt, Das Privatleben der Römer.

Michel (1852, 1854): F. Michel, *Recherches sur le Commerce, la Fabrication et l'usage des étoffes de soie d'or et d'argent et autres tissus en Orient et en Occident, principalement en France I-II*. (Paris 1852, 1854).

Migeon (1909): G. Migeon, *Les arts du tissu*. (Paris 1909).

Millet (1939): G. Millet, *Broderies religieuses de style byzantin*. (Paris 1939, 1942).

Muthesius (1982) Finds: A. Muthesius, *Anglo-Scandinavian Finds from Lloyds Bank, Pavement, and Other sites.* (York Archaeological Trust 1982), 132-36.

Muthesius (1982): *Eastern silks in western shrines and treasuries before 1200 A.D.* PhD Thesis, Courtauld Institute of Art, University of London, 1982.

Muthesius (1989): A. Muthesius, From Seed to Samite, aspects of Byzantine Silk Weaving. Ancient and medieval textile studies in honour of Donald King, *Textile History* 20 part 2 (1989) 135-149.

Muthesius (1990) Trade: A. Muthesius, *The impact of the Mediterranean silk trade on the West before 1200 A.D.* Textiles in Trade Conference. Textile Society of America. (Washington 1990).

Muthesius (1990): A. Muthesius, *Silk and the mediæval Papacy: influences on the Latin Church outside Rome.* Lecture Cambridge University, 1990.

Muthesius (1991): A. Muthesius, The history of the Byzantine silk industry. Lopez and beyond. *Journal of Medieval History* 19 (1993) 1-67.

Muthesius forthcoming: A. Muthesius, *History of the Byzantine Silk industry.* (J. Koder ed.) (Byzantine Institute, Vienna, forthcoming).

Nan King (1980-1990): Nan King Textile Institute, China. Reconstruction of ancient weaves. See D. de Jonghe, Métiers à tisser Chinois. *Chine Ciel et Terre.* (Brussels 1989), 270-315. (Weavers demonstrating at the exhibition on the reconstructed loom were from Nan King).

Needham (1979): J. Needham, *Science and Civilisation in China I.* (Cambridge 1954, reprint 1979).

Nicole (1894): J. Nicole, *Le Livre du Préfet.* (Geneva and Basel 1894). (Variorum Reprint 1970).

Oikonomides (1972): N. Oikonomides, Quelques boutiques de Constantinople au Xe siècle: Prix, loyers, imposition (Cod. Patmiacus 171). *DOP* 26 (1972) 345-56.

Oikonomides (1986): N. Oikonomides, Silk trade and profits in Byzantium from the sixth to the ninth century. *DOP* 40 (1986) 33-53.

Palmyra (1934, 1937, 1940): R. Pfister, *Textiles de Palmyre 1-3.* (Paris 1934, 1937, 1940).

Papas (1965): T. Papas, Geschichte der Messgewänder. *Miscellanea Byzantina Monacensia* 3 (Munich 1965).

Pariset (1862, 1865, 1890): E. Pariset, *Histoire de la soie.* (Paris 1862, 1865, 1890).

Pasco (1905): J. Pasco, *Catalogue de la collection de Miguel y Badia.* (Barcelona 1905).

Patmos (1988): A. Kominis ed. *Patmos treasures of the Monastery.* (Athens 1988).

Peirce, Tyler (1932): H. Peirce, R. Tyler, *L'art byzantin.* (Paris 1932).

Persson (1923): A. W. Persson, Staat und Manufaktur im römischen Reiche. *Skriften veten skaps-societeten Lund* 3 (1923) 68-81.

Pfister (1935): R. Pfister, Teinture et alchimie dans l'Orient. *Seminarium Kondakoviqnum* (1935) 48ff.

Pirenne thesis: A. Riising, The fate of Henri Pirenne's theses on the consequences of the Islamic expansion. *Classica et mediaevalia* (Copenhagen 1952); A. F. Havinghurst, *The Pirenne thesis.* (Boston 1958).

Rome Vatican (1908): H. Grisar, *Die Römische Kapelle Sancta Sanctorum und Ihr Schatz.* (Freiburg im Breisgau 1908).

Rome Vatican (1942): W. F. Volbach, *I tessuti del museo Sacro Vaticano.* (Rome 1942).

Sabbe (1935): E. Sabbe, L'importation des tissus orientaux. *Revue Belge de Philologie et d'Histoire* 14 (1935) 811-848, 1261-88.

Sakrale Gewänder (1955): S. Müller-Christensen, *Sakrale Gewänder*. (Munich 1955).

Schmedding (1978): B. Schmedding, *Mittelalterliche Textilien in Kirchen und Klöstern der Schweiz*. (Bern 1978).

Schmidt (1957): H. Schmidt, *Alte Seidenstoffe*. (Brunswick 1957).

Schulze (1917): P. Schulze, *Alte Stoffe*. (Berlin 1917).

Sens (1886): G. Julliot, *Trésor de la Cathédrale de Sens*. (Sens 1886).

Silbermann (1897): H. Silbermann, *Die Seide 1-4*. (Dresden 1887)

Simon (1975): D. Simon, Die byzantinische Seidenzünfte. *BZ* 68 (1975) 23-46.

Speck (1981): P. Speck, Die Endyte. *Jahrbuch der Österreichischen Byzantinisten Gesellschaft* 15 (1966) 323-75.

Starensier (1982): A. de la Barre, Starensier *An art historical study of the Byzantine silk industry*. (PhD thesis, Columbia University 1982).

Stillmann (1972): Y. K. Stillmann, *Female attire in medieval Egypt according to the Trousseau Lists and Cognate material from the Cairo Geniza*. PhD thesis, University of Pennsylvania. Philadelphia 1972.

Stöckle (1911): A. Stöckle, Spätrömische und byzantinische Zünfte, *Klio* 9 (1911) 24ff.

Uden and Muthesius (1982-1990): A. Uden, A. Muthesius, Preparations for reweaving Byzantine twills and lampas weave silks of around 1000 A.D. Unpublished research.

Vogt (1952): E. Vogt, Frühmittelalterliche Seidenstoffe aus dem Hochaltar der Kathedrale Chur, *Zeitschrift für Schweizerische Archaeologie und Kunstgeschichte* 13 part 1 (1952).

Vogt (1958): E. Vogt, Frühmittelalterliche Stoffe aus der Abtei St. Maurice, *Zeitschrift für Schweizerisches Archaeologie und Kunstgeschichte* 18 (1958) 110-40.

Volbach, Salles, Duthuit (1931, 1933): W. F. Volbach, E. Salles and G. Duthuit, *Art Byzantin, Cent planches*. (Paris 1931, 1933).

Vryonis (1963, 1971): S. Vryonis, Byzantine Demokratia, in: *Byzantium its internal history and relations with the Muslim World*. (1963, Variorum reprint 1971).

Walter (1982): C. Walter, Art and Ritual of the Byzantine Church. *Birmingham Byzantine Series* (Variorum 1982).

Zachariae von Lingenthal (1865): E. Zachariae von Lingenthal, Eine verordnung Justinians über den Seidenhandels aus den Jahren 540-547. *Mémoires de l'Académie Impériale des sciences de St. Petersbourg*. 7 ser. 9, 6 (1865).

SELECTED LIST OF RELATED LITERATURE

H. Antoniades-Bibicou, *Recherches sur les Douanes à Byzance.* (Paris, 1963), esp. 157-92.

F. Bock, Byzantinische Purpurstoffe mit eingewebten neugriechischen Inschriften. *Zeitschrift des Bayerische Kunstgewerbevereins* 2 (1894) 65ff.

H. Boll ed., *L. Seligmann Sammlung.* (Köln 1930).

A. de Capitani d'Arzago, *Antichi tessuti della Basilica Ambrosiana.* (Milan 1941).

E. Chartraire, *Inventaire du Trésor de l'église primatiale et Métropolitaine de Sens.* (Paris 1897).

E. Chartraire, Les Tissus Anciens du Trésor de la Cathédral de Sens. *Revue de l'Art Chrétien* 61 (1917) 261-80, 370-86.

C. de Linas, Notice sur cinq Anciennes Étoffes tirées de la collection de M. Félix Lenard a Verdun. *Mémoires à la Sorbonne* (1865).

C. Diehl, L'étoffe byzantine du reliquaire de Charlemagne. *Bulicev Zbornik* (1924) 441-47.

E. aus m'Weerth, Byzantinisches Purpurgewebe des 10. Jahrhunderts, *Jahrbuch des Vereins für Kunstwissenschaft* 1 (1868) 162-65.

I. Fihmann, K charakteristike korporatsii vizantiiskogo Egipta. *Vizantiiskii Vremennik* 17 (1960) 17-27.

H. Fillitz, *Katalog der Weltlichen und der Geistlichen Schatzkammer.* (Vienna 1971).

J. Flanagan, The origin of the drawloom in the making of early Byzantine silks. *Burlington Magazine* 45 (1919) 167-72.

J. Flanagan, Early figured silks: the effects of the use of the scale harness on early Islamic silks. *Burlington Magazine* 68 (1936) 145-47.

J. Flanagan in: *The relics of St. Cuthbert.* (J. Battiscombe ed.), (Oxford 1956).

E. Flemming, *Les Tissus.* (Paris 1957).

E. Frances, L'état et les métiers à byzance. *Byzantinoslavica* 23 (1962) 231-49.

A. Frolow, Quelques inscriptions sur des oeuvres d'art du moyen âge. *Cahiers Arch.* 6 (1952) 163-64.

A. Geijer, *Sidenvavnaderne i Heliga Knuts helgonskrin in Aarbögen für Nordisk Old kyndighed oy Historie.* (Kopenhagen 1935).

A. Geijer, Technical viewpoints on Textile Design. *Studi alto medioevo.* (Spoleto 1971) 685-712.

V. Gervers, Medieval garments in the Mediterranean World, in: *Cloth and Clothing in Medieval Europe. Essays in memory of E. M. Carus Wilson (N. B. Harte, K. G. Ponting ed.) Pasold Studies in Textile History* 2. (London 1983) 279-31.

E. Grimme, Der Aachener Domschatz, *Aachener Kunstblätter* 42 (1972).

H. Grisar, *Die Römische Kapelle Sancta Sanctorum und ihr Schatz.* (Freiburg 1908).

F. Guicherd, G. Vial, St. Rémi, Reims silk., *C.I.E.T.A. Bulletin* 15 (1961) 38-50.

A. Guillou, La soie Sicilienne in: Miscellani G. Rossi-Taibi. (Palermo 1974).

A. Guillou, Production and profits in the Byzantine province of Italy, tenth to eleventh century, an expanding society. *DOP* 28 (1974) 91-109.

A. Guillou, La soie du Katepanat d'Italie. *TM* 6 (1976) 69-84.

Henri d'Hennezel, *Le musée historique des tissus de la Chambre de commerce de Lyon.* (Paris 1927).

Henri d'Hennezel, *Pour comprendre les tissus d'art.* (Paris 1930).

A. A. Jerussalimskaja, Trois soieries Byzantines anciennes découvertes au Caucase septentrional. *C.I.E.T.A. Bulletin* 24 (1966) 11-39.

A. P. Kazhdan, Cechi i gosudarstvennye masterskie v Konstantinople v 9.-10. v. *Vizantiiskii Vremennik* NS 6 (1953) 132-55.

E. Kislinger, Gewerbe im späten Byzanz, in:*Handwerk und Sachkultur im Spatmittelalter.* (Ost. Akad. Wiss., phil.-hist. Kl.), (Wien 1988) 103-26.

J. Koder, *Probleme des Eparchenbuches. Vortrag.* (East Berlin 1987).

J. Koder, 'Problemwörter' im Eparchikon Biblion, in: *Kolloquium zur byzantinischen Lexikographie.* (Wien 1990).

P. Koukoulès, Byzantine costume in: *Vizantinon Vios kai Politismos* 2 (1948) 5-99, 6 (1955) 267-94.

P. Lauer, Le trésor du Sancta Sanctorum. *Monuments et Mémoires* (1906) 107ff.

A. Leger, *Monumenta Annonis Köln und Siegburg. Weltbild und Kunst im hohen Mittelalter.* (Köln 1975).

E. Lesne, *Histoire de la propriété ecclésiastique en France I.* (Paris 1936).

B. Malich, Wer Handwerker ist, soll nicht Kaufmann sein — ein Grundsatz des byzantinischen Wirtschaftslebens im 8./9. Jahrhundert, in: Studien zum 8. und 9. Jahrhundert in Byzanz. *BBA* 51 (1983) 47-59.

B. Mannowsky, Ein Byzantinischer Stoff in Seligenstadt.*Beitrage für G. Swarzenski.* (Berlin, Chicago 1951) 21-25.

A. J. J. Marquandt de Vasselot, *Catalogue raisonné de la Collection Martin le Roy.* (Paris 1906, 1908).

L. von Matt, *Art Treasures of the Vatican.* (New York 1976).

F. May, *Silk Textiles of Spain.* (New York 1957).

M. Mazotti, Antiche stoffe liturgische Ravennati. *Felix Ravenna* 53 (1950) 40-6.

B. Mendl, Les corporations byzantines. *Byzantino Slavica* 22 (1961) 302-19.

H. Messerer, *Der Bamberger Domschatz.* (Munchen 1952).

H. Miyakawa, A. Kollautz, Ein Dokument zum fernhandel zwischen Byzanz und China zur Zeit Theophylakts. *Byzantinische Zeitschrift* 77 (1984) 6-19.

U. Monneret de Villard, La tessitura Palermitana sotti i Normani e i sui rapporti con l'arte Bizantina. *Studi e Testi* 123 *Miscellanea Giovanni Mercati* 3 (1946).

J. Munro, The medieval Scarlet and the economics of sartorial splendour, in: Cloth and Clothing in Medieval Europe. Essays in Memory of E. Carus Wilson, (N. Harte, K. Ponting ed.) *Pasold Studies in Textile History* 2 (London 1983) 13-70.

A. Muthesius, De zijden stoffen in de schatzkammer van de sint servaaskerk te Maastricht, *Publications*, Maastricht 1974.

A. Muthesius, The silk over the spine of the Mondsee Gospel Lectionary. *Journal of the Walters Art Gallery* 26 (1978) 50-73.

A. Muthesius, The silks from the tomb of Archbishop Hubert Walter (d. 1205), Medieval Art and Architecture at Canterbury before 1220, (N. Coldstream, P. Draper ed.), *British Archaeological Association.* (London 1982), 81-87.

A. Muthesius, in: *Anglo-Scandinavian finds from Lloyds Bank, Pavement and other sites. Archaeology of York.* (York Archaeological Trust 1980)132-36.

A. Muthesius, The Rider and the Peacock silk from the relics of St. Cuthbert, in: *St. Cuthbert, his Cult and his Community to 1200 A.D.* (Woodbridge 1989) 343-64.

A. Muthesius, *The silken relics of St. Cuthbert: Silks, saints, the medieval Latin Church and the Eastern Mediterranean.* (Durham Dean and Chapter, Public Lecture, May 1988).

S. Müller-Christensen, Beobachtungen zum Bamberger Gunthertuch *Münchener Jahrbuch* 17 (1966).

S. Müller-Christensen, *Liturgische Gewänder mit dem Namen des hl. Ulrich. Augusta 955-1955.* (Munich 1955).

S. Müller-Christensen, *Das Grab des Papstes Clemens II im Dom zu Bamberg.* (München 1960).

S. Müller-Christensen, *Suevia Sacra.* (Augsburg 1971).

S. Müller-Christensen, *Der Dom zu Speyer.* I. (München 1972).

E. Nardi, La seta nella normativa imperiale romana, in: *Atti Accad. Scienza Ist. Bologna* 77, Rendiconti 71 (1982/83) 75-105.

M. Pardessus, Le commerce de la soie chez les anciens. *Mémoires de l'Académie Royale des Inscriptions et Belles-Lettres* 15 (1842) 1-47.

H. Peirce, R. Tyler, *L'art byzantin I-II.* (Paris 1934).

H. Peirce, R. Tyler, The Prague rider silk and the Persian Byzantine problem. *Burlington Magazine* 68 (1936) 211ff.

E. Piltz, *Studies in Byzantine Imperial garments and ecclesiastical vestments.* PhD thesis. Stockholm Institute of Art, 1970.

A. Reinle, Der Schatz des Münsters zu Säkkingen, *Zeitschrift für Schweizerisches Archaeologie und Kunstgeschichte* 11 (1948/9).

W. Reusch, T. Kempf, *Frühchristliche Zeugnisse im Einzugsgebiet von Rhein und Mosel.* (Trier 1965).

R. M. Riefstahl, Early textiles in the Cooper Union Collection, *Art in America* 3 (1945).

C. Rodon y Font, *L'Historique du métier pour la fabrication des étoffes façonnees.* (Paris, Liège 1934).

M. C. Ross, *Catalogue of the Byzantine and early medieval antiquities in the Dumbarton Oaks collection.* (Washington 1965).

W. M. Schmid, Ein Kasel des späten 11 Jahrhunderts. *Festschrift des Münchener Altertumsvereins.* (München 1914).

A. Schnütgen, *Catalog einer Sammlung, von Geweben und Stickerein.* (Köln 1876).

M. Schuette, S. Müller-Christensen, *The Art of Embroidery.* (Tübingen 1963). Translated in 1969 by D. King.

P. Schulze, *Alte Stoffe.* (Berlin 1920).

R. B. Serjeant, Material for a history of Islamic textiles up to the Mogul conquests. *Ars Islamica* 9-16 (1942-46).

D. G. Shepherd, W. B. Henning, Zandaniji identified? in: *Festschrift für Ernst Kühnel.* (Berlin 1959) 15-40.

D. G. Shepherd, Technical aspects of Buyid silks. *Fourth Congress of the International Association for Iranian Art and Archaeology.* (New York, Philadelphia, Baltimore, Washington, April 24 to May 3, 1960).

D. G. Shepherd, Zandaniji Revisited in: *Festschrift für S. Müller-Christensen.* (Munich 1980) 105-122.

M. Sjuzjumov, Remeslo i torgovlja v Konstantinopole v nacale 10. vwka. *Vizantiiskii Vremennik* NS 4 (1951) 12-41.

M. Sjuzjumov, *Vizantijskaja kniga eparcha. Vtsupitelnaja statja, perevod, kommentarii.* (Moskau 1962).

W. H. St. John Hope, On the tomb of an archbishop recently opened in the Cathedral Church of Canterbury in: *Vetusta Monumenta, VII i.* (Westminster 1893).

E. A. Stückelberg, *Unveröffentliche Walliser Gewebefunde 1923.* (Basel 1924, 1925).

E. A. Stückelberg, Sittener Gewebefunde, *Blätter aus der Wallischer Geschichte* N.F. 25 (1923) 317-333. N. F. 26 (1924) 95-115.

P. Veybras, H. de Vos, *Trésor de Sens.* (Yonne 1965).

W. F. Volbach, *Spätantike und Frühmittelalterliche Stoffe.* (Mainz 1932).

W. Volbach, *Early Decorative Textiles.* (Feltham 1969).

W. F. Volbach, E. Kuehnel, *Late Antique Coptic and Islamic Textiles of Egypt.* (Berlin 1926).

A. Weibel, *Two thousand years of Textiles.* (New York 1962).

L. von Wilckens, Mittelalterliche Textilien aus Schweizerischen Kirchen und Klöstern. *Kunstchronik* 27 (1974) 9-15.

J. P. Wild, *Textile Manufacture in the N. Roman Provinces.* (Cambridge 1970).

J. P. Wild, The Roman Horizontal Loom. *American Journal of Archaeology* 91 (1987) 459-71.

N. X. Willemin, A. Potter, *Monuments Français inédits I-II.* (Paris 1839).

J. von Wilmowsky, *Die historisch denkwürdigen Grabstätten der Erzbischöfe im Dom zu Trier.* (Trier 1876).

P. Witte, *Die liturgischen Gewänder und Kirchlichen Stickereien der Sammlung Schnütgen.* (Berlin 1926).

ADDITIONAL NOTE

The topic of provincial Byzantine silk weaving has been raised recently: see further reference at end of note 11 on page 331 of this book. See also note 59 on pages 334-335.

XII
The Role of Byzantine Silks in the Ottonian Empire

THE marriage of Otto and Theophanou in 972 marked the consummation of a long-standing relationship between Byzantium and the West: Byzantine influence, felt from a distance for so long, was experienced in 'the flesh' at the heart of the Ottonian court. A lengthy history of silken Byzantine diplomacy set the stage for this event and, indeed, the repercussions of this nuptial alliance were felt on cultural and artistic as well as ecclesiastical and political levels for generations to come.[1] The splendid Byzantine silks that graced the Ottonian court and its favoured ecclesiastical foundations, many of which survive in West European treasuries to this day, offer unique insights into East-West cross-currents of the tenth to the early eleventh centuries.[2] The purpose of this paper is to illustrate the all important role played by Byzantine silks in the Ottonian period, and to indicate the deeper significance of their presence within the German Empire. When and why did these silks arrive? What did their presence symbolise and how exactly were they used in the Latin West?

1. WHEN AND WHY DID THE SILKS ARRIVE?

It is important to note that the Ottonians, in the same way as their **Background** Carolingian predecessors, eagerly vied for possession of Byzantine silks; not least because these luxury fabrics were nowhere yet manufactured in Latin workshops. Silk weaving proper in the West was first established

only in the second half of the twelfth century under Roger of Sicily in Palermo. Even then, he had to employ Byzantine and Islamic craftsmen.[3] Byzantium was well aware of the rarity value of her silks and she took the opportunity to exploit them to the full. In fact, Byzantium chose to imbue her silken fabrics, in particular those of Imperial manufacture, with an aura of the power and the prestige of her Empire. The most rare and valuable of her silks were dyed with Imperial murex purple dyes and reserved solely for the use of the Emperor. Between the fourth and the twelfth centuries the penalty for the illegal use of such silks was death. Certain murex purple silks especially embodied the quintessence of Byzantine Imperial authority, and consequently their misuse was considered tantamount to treason.[4]

Byzantium was well aware that she possessed a key economic asset, and by the tenth century she concentrated her silk industry in Constantinople, where five private silk guilds operated under the watchful eye of the City Prefect. Strict regulations were enforced in the Book of the Prefect to maintain standards, to safeguard the Imperial monopoly over manufacture and use of purple murex silks, and to ensure total surveillance over export of silk goods from the Empire.[5] Confident in the manufacture of her unsurpassed silks, and mindful of an eager Western market, Byzantium was in a position to, and indeed, did widely exploit her silks both for economic and for political ends.[6] Byzantium, always eager for a Western ally in the face of Arab and other foreign threats to her Imperial territories, developed a rarefied form of foreign policy, a strategy based upon a peculiar blend of economic and of political expediency. Byzantine rulers discovered that Byzantine silks could be employed as a kind of political standard, a flag that could be unfurled in the face of friend and foe alike; whether to entice political alliance, or to deter territorial hostilities. For centuries, Byzantium gained naval and military assistance from foreign powers as varied as the Italians, the Bulgars and the Rus' in exchange for favourable silk trade concessions.[7] Byzantine silk was a major economic asset easily transformed into a powerful political weapon. It was through Silken Diplomacy that the economic and the political aspects of the material were brought into powerful juxtaposition, and that much Byzantine foreign policy was implemented.

Silken diplomacy and marriage alliances East-West With this background in mind, one has to ask when and why did Byzantine silks reached the West? Let us first consider the question of the arrival of valuable Imperial Byzantine diplomatic silks. Here two factors are strongly pertinent. The first significant point is that there had been a constant diplomatic dialogue between Byzantium and the West from the eighth to the twelfth centuries: only under Henry I (919-36) was there no

record of diplomatic exchanges with Byzantium.[8] The second important point is that much of the diplomatic discourse between Byzantium and the West involved marriage negotiations.[9] The marriage of Otto II and of Theophanou in 972 fitted in perfectly with a policy of East-West nuptial alliances, that can be traced back to the time of Pepin and which continued into the twelfth century. No less than seventeen East-West marriage alliances were either negotiated or arranged between Byzantium and the West during the course of the eighth to the twelfth centuries. Between 764 and 972 alone, seven major East-West marriage alliances had been explored: Gisela daughter of Pepin and Leo son of Constantine V; Charlemagne himself, and Eirene; Rotrud the daughter of Charlemagne and Constantine VI; Louis, son of Lothar I and an unnamed Byzantine princess; the future Louis III and Anna, daughter of Leo VI; Conrad I and an unspecified Byzantine princess; and finally the niece of Otto I, Hadwig, and the son of Constantine VII. The marriage of Otto II and of Theophanou in 972 very much represented the crowning glory of a long-standing East-West nuptial alliance policy.[10] These marriage negotiations offered the perfect opportunity for the introduction of impressive Imperial Byzantine silks into foreign courts, and most of all into the Frankish court.

The official tenth century Byzantine stance on foreign marriage alliance was, of course, clearly voiced by the Emperor Constantine Porphyrogenitus (905-59) in his work on the Administration of the Byzantine Empire. He advised that marriage alliances between Byzantium and the 'Franks' were acceptable, but that Chazars, Turks, Russians, Pechengs and Slavs constituted manifestly unsuitable suitors. It was the traditional 'fame and nobility' of the Franks that qualified them for inter-marriage with the Byzantines according to the Emperor.[11] Naturally, Ottonian Imperial circles were regarded as potential 'fertile ground' for the 'seeding' of Byzantine princesses in the West, just as earlier Carolingian courtly nuptial alliances had been investigated. Surviving silks clearly chart the course of nuptial alliances, whilst they also indicate how closely marriage negotiations shadowed political events.

Undoubtedly, the strongest bone of contention between Byzantium and the West was the question of sovereignty of Southern Italy. An eighth century Imperial Byzantine silk illustrates well the role of precious textile gifts in political negotiations involving this sensitive issue.[12] The fabric in question came from the shrine of St. Austremoine at Mozac, and it can be identified with a silk that bore the seal of Pepin, and which was presented to the relics of the saint in 764.[13] The fabric was most likely amongst the documented Byzantine diplomatic gifts despatched to Pepin in 756/7.[14] The background to the arrival of the gifts was one of conflict over political

The Mozac Imperial Hunter silk (Pl. 64)

authority in Italy. Pepin himself was in a difficult political position as he was the subject of both Byzantine and of Papal petitions in the face of Lombard aggression in Italy. In 754 Pepin had allied himself with the Papacy, itself isolated from Byzantium owing to the Iconoclastic stance of the Emperor Constantine V. In so doing he had pre-empted the Byzantine annexation of Sicily, Calabria and Ilyricum. This set the scene for the Byzantine diplomacy of 756/7 and indeed, for the later marriage plans of 765. The Mozac silk does not seem in this case to have been a gift directly associated with the planned marriage of the daughter of Pepin to the son of the Byzantine Emperor. The silk was first documented in 765, a year after Pepin presented his silk gift for the relics of St. Austremoine. Rather the Mozac silk appears likely to have been amongst diplomatic gifts despatched from Byzantium in connection with the diplomacy of 756/7.

The inscribed Imperial Lion silks (PLS. 38-43) On the other hand, a series of both documented and surviving Imperial Lion silks indicate that a standard type of Byzantine diplomatic silk did exist; and that at least some such silks could have been used to seal marriage negotiations. Five inscribed, Imperial Byzantine Lion silks reached the West as diplomatic gifts between 867-1025.[15] Of these Lion silks, two are documented and three survive in a fragmentary condition. All five silks were decorated with paired facing Lion motifs separated by a Greek inscription naming the ruler or the rulers under whom the fabrics had been woven. The two documented examples may be placed earliest in the group of five Lion silks. One of them was presented to Auxerre Cathedral by Bishop Gaudry (918-33). This silk bore the woven inscription, 'During the reign of Leo, the Christ loving Emperor'. Leo here could refer either to Leo III, who ruled alone between 717-719, or similarly to Leo IV in 775. Leo VI has been suggested; but if this were true then Alexander, co-emperor of Leo VI, surely would have been named too. Certainly, on the three extant Lion silks, co-emperors were named. On the precisely datable Lion silk from Siegburg (now at Schloß Köpenick, Berlin), both Romanos and his son Christophoros, who ruled jointly from 921-923, were named. In the same way Constantine VIII as well as Basil II (976-1025) were cited on the two Imperial Lion silks that reached Rhenish treasuries. One of these silks is today at the Diocesan Museum in Cologne and the other is divided between the Kunstgewerbe museum, Düsseldorf and the Kunstgewerbe Museum at Schloß Charlottenburg, Berlin. Further fragments of the same silk, once at Crefeld, are today lost.

The second of the two documented, inscribed Imperial Lion fabrics at Créspy St. Arnoul, is known only from an eighteenth century inscription. It is apparent that the silk differed from the purple ground extant pieces in certain aspects. Whilst it had an inscription of the usual kind ('During

the reign of Basil and Constantine the Christ loving Emperors'), the treatment of the actual Lion motif was different. The Imperial Lions on this silk were decorated with foliate patches in red and green. The three surviving silks, from technical and stylistic evidence, and on the basis of their inscriptions, are datable to the tenth to the early eleventh centuries.[16] On the other hand, on stylistic grounds, it is possible to link the lost Créspy St. Arnoul silk with surviving Byzantine silks of the ninth century, which also favour red and green colouring and foliate patches set upon animal motifs. An example of this type of silk is in the Vatican in Rome and it shows a Pegasus motif. The silk came from a reliquary commissioned by Pope Paschal I (817-24).[17] Although there is little description of the precise nature of the Créspy silk, from what is known it is probable that it dated from the reign of Basil I and Constantine VII (867-869) rather than from the time of the later pair of Emperors of the same name.

It is important to establish a chronology for the Imperial Lion silks insofar as they chronicle East-West diplomacy over several centuries. The five Lion silks indicate that from the eighth to the eleventh centuries Byzantium produced a remarkably conservative series of diplomatic silks designed for foreign consumption. The fact that they all reached the West implies that they may even have been specially woven for the purpose. The five Imperial Byzantine Lion silks indicate that Byzantium wished to present a traditional face to the West. A Lion motif, that can be traced back to ancient Greek times and which appears on Roman pavements, was chosen to symbolise the ancient legitimacy of Imperial Byzantine authority.[18] The presence of the silks on Western soil from the ninth to the eleventh centuries demonstrates perfectly how Byzantine silken diplomatic practices of Carolingian times were merely extended into the Ottonian period. The presence of Byzantine silks in the Ottonian Empire was no chance occurrence: it was part of a carefully orientated Byzantine foreign policy, that had been evolved and cultivated over preceding centuries. The strong diplomatic role of Byzantine silks in the Ottonian Empire can be fully appreciated only in the light of this knowledge.

Did all of the Lion silks arrive as the result of marriage negotiations? It is difficult to determine a precise answer here, because one does not know how far contemporary silks were used. In the case of the precisely dated Siegburg Lion silk of 921-923, if it is seen as a contemporary gift it would have been received by Henry I (919-36); but as remarked earlier, there is no documented report of any exchange of envoys with Byzantium under this Emperor. However, one knows, for example, from the later Gunther tapestry, that sometimes out-dated silks were sent as diplomatic gifts to the West. The Byzantine silk tapestry at Bamberg Cathedral treasury, from the grave of Bishop Gunther (d.1065), most probably dates between 1017, the year of Basil II's triumphal entry into Athens and

Constantinople (after his defeat of the Bulgars, the event plausibly suggested to be shown on the silk), and 1025, the year of his death.[19] If the tapestry is dated 1017-1025, it would have been almost fifty years old when it reached the West in 1065 with Bishop Gunther. It was used as a shroud for the unfortunate Bishop, who died on the return journey from a diplomatic mission to Constantinople, but it seems that the tapestry was intended as a diplomatic gift from the Emperor Constantine X (1059-67) to Gunther's master, the German Emperor Henry IV (1056-1106).

Like the Gunther tapestry, could the Siegburg silk have been a non-contemporary diplomatic gift? Could it have been amongst the gifts sent by Constantine VII to Otto I in 945? The Byzantine Emperor Romanos under whom the Siegburg silk was woven, was the father-in-law of Constantine VII; Romanos died in 944, a year prior to the despatch of Byzantine diplomatic gifts to Otto I.[20] Constantine VII easily could have removed the silk from the Imperial store after the death of Romanos.[21] The silk would not have been ill-received in the West even if the names of Romanos and of Christophoros rather than that of Constantine VII had been legible to the Latins. Surely, the silk would have passed for an Imperial Byzantine murex purple piece, immensely valuable and quite unavailable on the open market? Western recipients would undoubtedly not have observed that certain of the Lion silks (such as the Berlin/Düsseldorf piece woven under Basil II and Constantine VIII (976-1025)), were dyed not with precious Imperial murex reserved for Imperial use, but with a common indigo and madder mix.[22]

Another Lion silk that deserves mention here is the fabric at Ravenna from the relics of St. Julian at Rimini. This piece was perhaps the gift of Otto I to the relics of the saint, and it might have been amongst diplomatic gifts sent to the Emperor by Nicephoros in 967.[23]

The Aachen Elephant silk (PLS. 45-47B) Perhaps the most famous of surviving Byzantine diplomatic silks is the magnificent Elephant fabric at Aachen Münster.[24] Here the inscription on the silk is indecisive as far as dating is concerned; the titles in the inscription yield a date between 843-1088, but the technical mastery of the piece precludes a date for it before the beginning of the eleventh century. At least three occasions presented themselves on which Byzantium might have considered the despatch of such an outstanding gift to the West: 1000-1002 in connection with the proposed marriage of Otto III and Zoe daughter of Constantine VIII; 1027 when Conrad II sought the hand of a Byzantine bride; and 1081, at which time many rich gifts, including silks, were sent to Henry IV.[25] Although it is tempting to think that the silk was a gift to Otto III, and that it was placed about the relics

of Charlemagne at the time of a recognition in the year 1000, it is more prudent on technical grounds to date the silk later.

The design required 1440 manipulations of the pattern producing device on the loom for its production, and the silk was far more complex to weave than even the inscribed Lion silks of 976-1025 discussed above. It seems not unlikely that the piece was amongst the one hundred silks sent by Alexios I (1081-1118) to Henry IV in 1081.[26]

2. WHAT DID THE SILKS SYMBOLISE

AND HOW WERE THEY USED?

ON one level the power and dignity of the Byzantine Empire was embodied in the Imperial silks. Their bestowal as diplomatic gifts by Byzantium implied some recognition of the recipients' status. Naturally, the Carolingians and the Ottonians could not help but approve of Byzantine recognition of their own Imperial status. However, on a different level, the silks signalled Western acceptance of Byzantine artistic traditions as well as several Byzantine social and ecclesiastical practices.

From an artistic point of view, the motifs found on Byzantine silks in the tenth century included not only the Lions mentioned above, but as the Book of Ceremonies testifies, also griffin, bird and foliate motifs.[27] The very marriage contract of 972 took as its design the Byzantine theme of the griffin attacking a quadruped. This ancient motif was used on Byzantine silks such as the fabric at St. Ursula in Cologne, traditionally thought to have been taken from the grave of Viventia, daughter of Pepin.[28] The Western tapestry at St. Gereon, Cologne with similar theme, also must have known a Byzantine prototype.[29] The Gospel Book of Echternach has a cover with a metalwork decoration on which Theophanou and Otto 'Rex' are depicted. It dates between 983 when Otto III was crowned and 991, the year Theophanou died. The ivory of the cover and the manuscript inside are of the mid-eleventh century and it is interesting to see that the fly leaves of the manuscript are purple pages with Lion motifs like those of the Imperial Lion silks. Could there have been silks from the time of Theophanou that inspired the later illumination?[30] No doubt the dowry of Theophanou did include many wonderful silks: Wentzel already suggested that many well known pieces at Aachen were once part of this

dowry.[31] In view of the widespread religious use of Byzantine silks in the West since the eighth century (to be discussed further below), it is unwise to attribute all the silks, at Aachen or elsewhere, to the dowry of Theophanou. Nevertheless, there are tenth century Byzantine silks in ecclesiastical treasuries that may well have an association with her. For example, there is a Bullock silk at St. Servatius, Maastricht. Bullock silks are mentioned in the Book of Ceremonies. The Eagle silks at Auxerre and at Brixen too, may be contemporary with Theophanou; again Eagle silks are known from the Book of Ceremonies.[32] Another type of silk that was developed in Byzantium in the time of Theophanou exploited mono-chrome effects; an example survives at St. Ulrich and Affra at Augsburg. This silk with Imperial portrait medallions formed part of the chasuble of St. Ulrich, Bishop of Augsburg (d.973).[33] The list of silks could be multiplied, and it could be argued that Theophanou also carried a number of prized, older silks with her, but this remains in the realms of specula-tion. What is beyond dispute is that Theophanou did exercise artistic patronage at St. Pantaleon, Cologne for instance. She was in a good position to do so in important centres including Aachen, Quedlinburg, and Nivelles; and in centres where she sometimes resided, such as Nijmwegen, Maastricht and Utrecht. In these centres she would have found an already well-established ecclesiastical tradition for the use of precious silks. Furthermore, the great variety of silks used at least from the eighth century onwards in the Latin Church (more than 500 mediæval pieces survive at Sens alone) suggests that trade as well as Imperial patronage must have played an important part in their acquisition in religious centres. Not all Byzantine silks in the West were diplomatic gifts; the Italians, above all the Venetians, enjoyed considerable silk trade concessions from Byzantium as remarked earlier, and they no doubt acted as powerful intermediaries for the transport of Byzantine silks to the West. In the tenth century Liudprand indeed reported that the Italians were carrying even fine purple silks to the West.[34] During the Ottonian period, it was the Rhine Maas trade arteries in particular that were important for the distribution of the imported silks to churches along their length.[35] Not only this, but returning to a secular note, as early as Carolingian times nobles had purchased fancy silks at special fairs in Pavia; how much more would they have been sought after in the Ottonian period? Not every Ottonian noble who wished to wear fine silks would have been fortunate enough to have received a silken diplomatic gift. In general one must conclude that it was a combination of shrewd Italian trade practices and Byzantine diplomacy that ensured a silk supply for the West.

A remarkably close parallel exists between the uses of silks in Byzantium **The uses of** and in the West. This suggests a far deeper Byzantine influence than **Byzantine silks** hitherto recognised. Even the most intricate uses of silks were adopted, **in the West** and where necessary, were adapted to Western practices. It was one thing for the West to import a foreign luxury item, but quite a different matter for both the Latin Court and the Latin Church to imitate Byzantine civil and ecclesiastical silken ceremonial, as increasingly proved to be the case. By the Ottonian period there were few Byzantine uses of luxury silks that were not reproduced in the West.

In Byzantium from the fourth century onwards silks played a special role in court life and in the life of the Church. Silk served equally for court dress, for ecclesiastical vestments, for shrouding the relics of saints, to decorate the covers of liturgical books, and as furnishings in important churches used by the Emperors and the nobility. Special purple silks clothed the Emperor, but sometimes even these were donated by the court to favoured ecclesiastical foundations. By the time of Theophanou, silks formed an integral part of Byzantine court life, in the form of attire as well as furnishings. In particular, on the occasion of great feasts there were elaborate Imperial silken processions to important churches in the Capital. Whether at home or abroad, the Emperor had silks close at hand. For instance, in the tenth century, the Imperial Baggage train carried Imperial silk sheets for his use whilst on campaign, and there were also special silk tunics with which to reward faithful generals on the battle-field.[36]

Under the Franks, silks were worn by females of the court of Charlemagne, although the Emperor himself chided against their use. Certainly, Charlemagne's Bishops had a taste for fine silks, much to his displeasure, and even monks had to be reprimanded for sewing pieces of silk on to their tunics.[37] In 790, Charlemagne presented two silk cloths to St. Goar, and others to St. Riquier. He offered many relics to Sens, and it is likely that the early silks that survive there in great number stem from the time of his patronage also. The practice of wrapping relics in fine silks was known in Byzantium from the fourth century and in the West it was general by the eighth century.[38] The fashion for use of silks in the Latin Church was given tremendous impetus under the Papacy in the eighth to ninth centuries and specific uses appear to have been transmitted from Byzantium via Italy.[39]

The Ottonian Emperors spent considerable time in Italy; and no doubt they were party to some of the silken church ceremonial there. They could have seen some of the Byzantine silks sent to the Papacy by the Byzantine Emperors in earlier days; for instance the Imperial purple silk at St. Peters despatched to Pope Benedict III (855-8) by the Byzantine Emperor Michael III (842-67).[40] Certainly, Otto III customarily appeared on Easter

Monday at St. Apollinarius in Classe, in purple silk embroidered with gold, much in the manner of a Byzantine Emperor.[41] Byzantine court dress is not unlikely to have been influential under Otto II and Theophanou. Both were depicted in 982/3 on a coronation ivory (Cluny Museum, Paris) clad in Byzantine ceremonial robes, precisely in the manner of Romanos II and Eudocia on a Byzantine ivory of 945-949, (Paris, Louvre).[42]

Church inventories of the Carolingian and the Ottonian periods illustrate just how many splendid silk cloths and vestments were housed in the West. Even the most ornate silks were in evidence as at St. Florent de Saumur between the tenth and the eleventh centuries, where vestments with elephant and lion motifs were recorded.[43] In the West, although perhaps less in Byzantium, successive translations of relics called for ever more splendid silk shrouds; and often a series of both early and later silks remain in shrines of the twelfth century. Of the surviving Imperial Lion silks described above, the Cologne piece came from the twelfth century shrine of St. Heribert, Archbishop of Cologne (d. 1021), and the Siegburg Lion silk was taken from the twelfth century shrine of St. Anno, Archbishop of Cologne (d.1075). The Aachen Elephant silk is still today in the shrine of Charlemagne, which was completed in 1215.[44]

But for the premature death of Otto III, Byzantine influence would have been strengthened even more with the arrival of another Byzantine bride at the Ottonian court.[45] Nevertheless, as events turned out, under Henry II, Otto III's successor, Byzantine silken influence continued unabated. Henry was particularly well favoured towards the Church, and a peaceful situation north of the Alps allowed him to exercise lavish ecclesiastical patronage. It is likely that he, as well as his consort Cunigunde, wore splendid silk robes and that he donated many fine silks to his ecclesiastical foundations and to Bishops consecrated at his command.[46] To the Abbey of Monte Cassino, Henry presented a patterned, woven chasuble and cope with gold borders, and a similar tunic and handkerchief and belt. In 1019, to his foundation, Basle Cathedral, Henry gave an eagle silk, which puts one in mind of the extant Auxerre and Brixen Byzantine eagle silks. Adalbero II of Basle, consecrated under Henry II (who officiated at the dedication of the Cathedral of Basle), appears to have been buried in many silks, perhaps the gift of Henry II.[47] Meinwerk of Paderborn, appointed by Henry in 1009 as Bishop; and Godehard of Niederaltaich, elevated to the see of Hildesheim in 1022; and Willigis of Mainz, who in 1002 consecrated Henry II; all appear to have been in receipt of splendid vestments made from Byzantine silks, most probably gifts from the Emperor.[48]

Henry and Cunigunde presented many magnificent embroidered silks to Bamberg Cathedral. Five surviving vestments there are thought to have belonged to the Emperor and his consort. One of these vestments

bears the name of Henry; it shows embroidered portraits of seated Byzantine Emperors.[49]

The full impact of silken splendour was felt also by relatives it seems. Gisela, sister of Henry II, was married to King Stephen of Hungary in 1031. The fine vestment presented to the Church of the Virgin at Székesfehérvár by the royal pair, is of a silk so close in type to those associated with Henry II, that it is reasonable to suggest it might have been a gift to Gisela from her brother.[50.]

In conclusion it must be remarked that several thousand Byzantine silks **Conclusion** have survived the ravages of time and exist in Western ecclesiastical treasuries, whilst many hundreds more are documented in inventories between the eighth and the twelfth centuries. The Ottonian period witnessed the heyday of their use in the West, which is not surprising given the close Byzantine alliances that were forged at the time. What is perhaps less appreciated is the fact that the seeds for the use of Byzantine silks had been sewn generations before the Ottonian period. By the time that Theophanou arrived in the West there were already many Byzantine silken practices in place, both at court and in the Latin Church. The arrival of Theophanou can have acted only to strengthen the use of Byzantine silks in the West. The joy that her silken patronage would have brought might well be imagined; in turn how rewarding it would have been to Theophanou to see Byzantine silks so much admired and appreciated in the West. The extent of her influence in the field should not be undermined although no inventory of silks under Theophanou exists. Indeed, there is reason to suggest that those in her close circle may have been directly influenced by Byzantine silks in their own artistic patronage. Consider, for example, Bernward of Hildesheim, who was tutor to Otto III under Theophanou from 987-993, and who accompanied Theophanou to Rome in 989. Is it just a remarkable coincidence that manuscripts illuminated for this Bishop incorporated so many motifs derived from Byzantine silks? Similarly, would Bernward have possessed a magnificent tenth to eleventh century Byzantine silk chasuble with bird motifs, had he not been in such close contact with the Ottonian court?[51] Surely, it was the close connections between Church and State in the Ottonian period that facilitated the heightened use of Byzantine silks in the Empire. The presence of Theophanou herself, acted as the crowning glory to their use in the West at this time.

ACKNOWLEDGEMENT

The author takes pleasure in thanking Wingate Scholarships for assistance in her research and for the electronic equipment used to produce this paper.

NOTES

1. Byzantium and the Low countries in the Tenth century. Contacts of Art and History in the Ottonian Era. K. Ciggaar ed., Netherlands 1989, 'The Empress Theophano (972-991): political and cultural implications of her presence in W. Europe for the Low countries in particular for the county of Holland'. For diplomatic contacts see T. C. Loughis, Les ambassades byzantines en Occident. Athens 1980.

2. More than one thousand surviving Eastern Mediterranean silks are discussed in A. M. Muthesius, 'Eastern silks in Western shrines and treasuries before 1200 AD', PhD thesis, Courtauld Institute of Art, University of London, 1982. Hereafter, Muthesius, Eastern Silks.
 The material in the thesis is incorporated into a History of the Byzantine Silk Industry, J. Koder, E. Kislinger ed., Byzantine Institute, University of Vienna, under publication.

3. Muthesius, Eastern Silks, 256-258. Also E. Weigand, 'Die Helladisch-Byzantinische Seidenweberei' in: Mneme S. Lamprou. Athens 1935.

4. For regulations on Imperial Byzantine purple dye and purple dyed silks see: C. Pharr, The Theodosian Code in: Corpus of Roman Law 1. Princeton 1952. 10.21.3; P. Krüger, Corpus Iuris Civilis, 2. Codex Justinianus. Berlin 1915. IV.40.1; P. Noailles and A. Dain, Les Novelles de Leon VI le Sage. Paris 1944. Pages 272-274, Novel LXXX; G. E. and C. G. E. Heimbach, Basilicorum Libri, Leipzig 1833-1870, II, books 13-23, 269, 19.1.80.
 On murex purple in general consult W. Born, 'Die Purpurschnecken'. CIBA Rundschau, 1936, 110-128, with bibliography on 134. More recently, V. Verhecken, 'Het antiek purpur' in: Second Euroregio Congress on Textiles, Rhine-Meuse area. Alden Biesen 1991, proceedings under publication.

5. J. Koder, Das Eparchenbuch Leons des Weisen. CFHB 33, Wien 1991. For silk guild regulations see 91-107, and for purples 91, 93, 103, 105.
 The terms for purples used in the Book of the Prefect are difficult to interpret. Linguists and historians have not related the terms to the evidence of surviving silks. For some discussion of purple terms see A. M. Muthesius, 'Lopez and

Beyond', *Journal of Medieval History* 19 (1993), 46-56. Terms referring to silk guilds are similarly obscure until viewed from a practical angle. See A. M. Muthesius, 'From seed to samite: aspects of Byzantine silk production'. Festschrift in honour of Donald King. Textile history 20 (2) 1989, 135-149.

6. A. M. Muthesius, 'Silken Diplomacy' in: Byzantine Diplomacy (J. Shepard, S. Franklin ed). Papers from the Twenty-fourth Spring Symposium of Byzantine Studies, Cambridge, March 1990. London 1992, 237-248: hereafter, Silken Diplomacy. Cf. A. M. Muthesius, 'The Impact of the Mediterranean Silk Trade on West Europe before 1200 AD' Textiles in Trade Conference. Textile Society of America, Washington 1990.

7. For Italian matters, see R. J. Lilie, Handel und Politik zwischen den byzantinischen Reich und den Italienischen Kommonen Venedig, Pisa und Genua in der Epoche der Komnenen und der Angeloi (1081-1204). Amsterdam 1984.
 For the Russian contacts, see S. H. Cross, O. P. Sherbowitz, The Russian Primary Chronicle. Cambridge Mass. 1953.

8. F. Dölger, Regesten der Kaiserurkunden des Oströmischen Reiches von 565-1453, I-III, München, Berlin 1924, 1925, 1932. Hereafter, Dölger Regesten.

9. A useful indication of the position is given in J. Shepard, 'Byzantium and the West c. 850-1200', in: Proceedings of the XVIII Spring Symposium of Byzantine Studies, Oxford 1984. Published Amsterdam 1988, 67-118.

10. Muthesius, Eastern Silks, 346-348.

11. G. Moravcsik, R. J. H. Jenkins ed., Constantine Porphyrogenitus, 'De Administrando Imperio'. Washington 1967, 70-73.

12. Muthesius, Eastern Silks, 131-135, 479. The silk was described in C. I. E. T. A. Bulletin 17, 1963, 14ff.

13. Muthesius, Silken Diplomacy, describes the Mozac silk in its historical context.

14. Dölger, Regesten, I, 339.

15. A. M. Muthesius, 'A practical approach to the history of Byzantine silk weaving'. Jahrbuch der Österreichischen Byzantinistik, 34, 1984, 235-254. Hereafter, Muthesius, Practical approach.

16. Muthesius, Practical approach, 247.

17. Muthesius, Practical approach, 245.

18. Muthesius, Eastern silks,16-50. Behind the lions on the silks a small tree appears. This motif goes back to classical times. It can be seen, for example, on a Roman pavement at Horkstow in Lincolnshire. See F. Klingender, Animals in art and thought to the end of the Middle Ages. London 1971, pl. 74.

19. Muthesius, Eastern Silks, 93-100.

20. Dölger, Regesten I, no. 651.

21. Precious silks were stored over centuries in Byzantium as well as in the Islamic world and in the Latin West. See Muthesius, Eastern Silks, 48-49 with note 47. Both the Emperor Theophilus (829-42) and the Emperor Constantine VII (913-59) restored and renovated precious Imperial garments. See CSHB 34 (1842) 215; CSHB 48 (1838) 447ff. section 15.
 There was a private Imperial treasury and a public treasury where valuable garments were housed. Consult J. Bury, The Imperial Administrative System in the ninth century. London 1911, 80-82, 98ff.

22. Muthesius, Practical approach, 249.

23. Muthesius, Eastern Silks, 55-58, 81-83 notes 11-18.

24. Dölger, Regesten I, no. 709, cf. I, no. 658, I, no. 664, I, no. 748 for Byzantine envoys sent to Otto I.

25. Muthesius, Eastern silks, 27. Cf. Muthesius, Practical approach, 253.

26. Dölger, Regesten, II, no. 1068.

27. Eagle, griffin, bullock and other decorative motifs appeared on textiles described in the Palace under Constantine VII (d. 959). See I. I. Reiske, De Caerimoniis aulae Byzantinae I-II, Bonn 1829-1831, I book 2, 577 lines 20-22, 578 lines 1-6. Hereafter, Reiske, De Caerimoniis.
 Several surviving Byzantine Eagle silks are known. Cf. Muthesius, Eastern silks, 84-85, note 27.

28 Muthesius, Eastern silks, 73-77, 90-92. See also the contribution of D. Matthes, 'Die Heiratsurkunde' in the present publication. In addition, there are two contributions in Kaiserin Theophanu, Gedenkschrift des Kölner Schnütgenmuseums zum 1000 Todesjahr der Kaiserin, ed. A. von Euw and P. Schreiner, volume 2, Köln 1991, section 5, W. Georgi, 'Ottanianum und Heiratsurkunde 962/972', 135-160, and A. von Euw, 'Ikonologie der Heiratsurkunde der Kaiserin Theophanu', 175-191. Catalogue hereafter, Theophanu ed. A. von Euw, P. Schreiner.

29 For the St. Gereon tapestry, Muthesius, Eastern silks, 77. This is Nürnberg Germanisches National Museum Gew. 421. It was discussed in Ars Sacra, Exhibition catalogue, Munich 1950, no. 188, pl. 46. See also, S. Müller-Christensen, Sakrale Gewänder, Munich 1955, no. 33.

30. The Echternach Gospels were published by P. Metz, Das Goldene Evangelienbuch von Echternach im Germanischen National Museum zu Nürnberg. München 1956.

31. On Theophanou's dowry consider H. Wentzel, 'Das byzantinische Erbe der ottonischen Kaiser. Hypothesen uber den Brautschatz der Theophanou', Aachener Kunstblätter, 43, 1972, 11-96. Cf. Muthesius, Eastern silks, 355 note 23. Not all silks at Aachen could have been part of such a dowry.

32. Compare note 27 above. Also for the Maastricht Bullock silk, see Muthesius, Eastern silks, 96, 500. Descriptions of such textiles are in Reiske, De Caerimoniis, I, book 2, 577 lines 20-22, 578 lines 1-6.

33. Muthesius, Eastern silks, 190, 528.

34. F. A. Wright, The works of Liudprand of Cremona. London 1930.

35. A. M. Muthesius, 'The impact of the Mediterranean silk trade on Western Europe before 1200 AD' Textiles in Trade conference. Textile society of America. Washington 1990, 126-135. In addition, A. M. Muthesius, 'Byzantine and Islamic silks in the Rhine-Maaslands before 1200 AD' in: First Euregio International Textile Conference. Alden Biesen 1989, 143-161.

36. J. Haldon, Constantine Porphyrogenitus, Three Treatises on Imperial Military Expeditions. CFHB 28, Wien 1990.

37. Many applications of silk are described in Muthesius, Eastern silks, 'The uses of silks in the West', 264-328.

38. Muthesius, Eastern silks, 'Silk patronage', 329ff.

39. For the spectacular patronage of the Papacy between 772-855 see Muthesius, Eastern silks, 281-287. The main beneficiaries were St. Peters, St. Pauls, St.

Maria Maggiore, St. Maria in Domnica, St. Lawrence, St. Cecilia and the Lateran.

40. For the gift of the Byzantine Emperor Michael III, see L. Duchesne, Liber Pontificalis, I-II, Paris 1892, 148 lines 2-3.

41. Muthesius, Eastern silks, 288, 324 note 161. MGHS IV, 849.

42. Theophanu, ed. A. von Euw, P. Schreiner, abb. 4, abb. 2, with discussion in N. Gussone, 'Trauung und Kronung. Zur Hochzeit der byzantinischen Prinzessin Theophanu mit Kaiser Otto II', 161-173.

43. Muthesius, Eastern silks, 269, 311 note 26 with source.

44. The silk was replaced into the shrine in 1989. Since the 1890s it had been housed in an upper room of the Münster at Aachen. Today it is back in the shrine of Charlemagne at Aachen Münster.

45. Otto III died before his proposed marriage to one of the daughters of Constantine VIII could take place.

46. The silken patronage of Henry II is discussed in Muthesius, Eastern silks, 329-333, 337-338 notes 5-9.

47. On the dedication of Basle Cathedral in 1019, Henry II presented gifts including a silk chasuble with woven Eagle design. See Muthesius, Eastern silks, 331 and 338 with note 8 for source. On the Adalbero silks see, Muthesius, Eastern silks, 529 with bibliography.

48. Two silk chasubles of archbishop Willigis of Maiz are at St. Stephan Mainz. These are described in Muthesius, Eastern silks, 192 and 521 with bibliography.

49. Muthesius, Eastern silks, 192 and 208-209 note 10 with further discussion and references.

50. E. Kovacs and Z. Lovag, The Hungarian Crown and other Regalia, Budapest 1980, 58-75.

51. V. Elbern, H. Reuther, Der Hildesheimer Domschatz. Hildesheim 1969. See for instance, the Gospels, 29-31, no. 18. The boards of the manuscript were also covered in silk. Silks were used extensively to cover manuscript boards and as a setting for metalwork covers. An extended discussion of this aspect of the use of silks in the West before 1200 AD occurs in Muthesius, Eastern silks, 291-305, 325-328 with notes 180-202. For the splendid silk chasuble of Bernward of Hildesheim see, Kirchenkunst des Mittelalters, M. Brandt ed., Hildesheim 1989, 125-134, and cf. earlier, Muthesius, Eastern silks, 542-543.

XIII

Politics, piety and the silken cult of relics: Aachen Münster treasury silks in historical context

THE magnificent silks in the treasury of Aachen Münster bear witness to an all-embracing mediæval piety, and they reflect the way in which precious cloths were considered particularly appropriate for wrapping the relics of venerated saints.[1] Silks for relics were known both in Byzantium and in the Latin West at least from the fourth century onwards, but in the West their use gathered particular momentum when at the beginning of the ninth century Charlemagne decreed that every newly consecrated altar should house relics of the saints. The Papacy in the eighth to ninth century began to lavish hundreds of silks on the important churches of Rome, not only for wrapping holy relics but for church hangings and for furnishings. At the same time, silks came into widespread use not only in Rome but in the whole of the Carolingian Empire. The growth of the Cult of Relics in the most notable religious centres of the Latin West, increasingly became associated with the ostentatious display of precious fabrics; silk vestments worn by the living clergy acted as a parallel for the silks that enveloped the relics of the saints. Pilgrims were drawn from far and wide: piety and the silken cult of relics became synonymous at an early date. But the acquisition of precious silks before the twelfth century was no easy matter at a period when all silks had to be imported either from the Islamic or the Byzantine Mediterranean and from the Near East. Indeed, the most outstanding silks, pieces like the Byzantine Aachen Münster Elephant silk, could not be bought at any price and were acquired solely through diplomatic

channels. In the period up to the twelfth century in particular, successive German Emperors took it upon themselves, both by virtue of their Coronation ceremonies at Aachen and by their donations of splendid diplomatic silks, to see that politics as well as piety were placed at the service of the Church.[2]

The main purpose of this paper is to understand the Aachen silks beyond purely textile criteria in order to appreciate their broader religious and political significance. The paper will be divided into two parts, the first of which will set the scene with a discussion of the silks in relation to the reliquaries, the relics and the growth of pilgrimage at Aachen.[3] The second part of the paper will summarise the salient deeper ecclesiastical and political considerations, which lay behind the acquisition of relics and silks at Aachen between the eighth and the fifteenth centuries.

PART ONE

Important periods of textile acquisition at Aachen The silk fragments at Aachen Münster most probably represent only a fraction of the wealth of mediæval silks once housed in the treasury, for after all there were over 70 relics there in the Carolingian period and each would require an appropriate textile shroud.[4] The surviving silks themselves were summarily listed by Canon Bock in a publication of 1860.[5] He briefly described the Elephant silk, and the Charioteer silk and also thirteen other unspecified, Eastern Mediterranean, early mediæval pieces. In addition, he detailed eight unspecified Islamic fabrics as well as what he described as a Sicilian piece. Of the vestments he noted a pearl embroidered bell chasuble of St. Bernard and a series of fourteenth and fifteenth century as well as many Renaissance, Rococo and nineteenth century examples.[6]

Main groups In the space of this paper it is not possible to deal individually with all the textiles mentioned by Bock, but it is perhaps useful to categorise the main kinds of silk fragments that survive, for it is these that were in all likelihood some of the Aachen relic wrappings. Here a broad date and provenance for the silk fragments can be suggested and one can distinguish five principle groups, geographically and chronologically distinct as follows:[7]

1. Eastern Mediterranean twills, seventh to ninth centuries, and also tenth to eleventh centuries, (for example, Inv. nos. 010603 hunters, single main warp; unnumbered Charioteer, single main warp; 010602 palmettes paired main warp; unnumbered Elephant, paired main warp). (Pls. 65, 60, 66, 45-47B)

2. Central Asian twills, seventh to ninth century, (for example, Inv. nos. 010608 back of a bird, three to four main warps; 010610 three small birds, 010609 ducks, paired degummed main warp). (Pls. 67, 68, 69)

3. Sicilian twill, thirteenth century, (for example Inv. no. 010620, hares, paired main warp). (Pl. 70)

4. Italian twills, semi-silks or lampas weave silks, thirteenth to fourteenth centuries, (for example, Inv. nos. 010616 double-headed lions, twill; 010613 birds, semi-silk twill; unnumbered dragon silk, lampas).[8] (Pls. 71, 72, 73)

5. Islamic twill and lampas weave silks, fourteenth and fifteenth centuries, (for example, Inv. no. 010622, lampas). (Pl. 74)

The surviving fragments illustrate that there was continuous acquisition of silks at Aachen between the eighth and the fifteenth centuries and that these silks came from most of the main silk producing lands. Byzantine and Islamic centres of the Eastern Mediterranean provided textiles between the seventh and the twelfth centuries, whilst from Central Asian came silks of the seventh to ninth centuries. From the thirteenth century Sicily is represented, and in the fourteenth to fifteenth centuries Italy became important. Contemporary Islamic pieces feature more rarely. The pattern of textile acquisition at Aachen is fairly standard for major mediæval silk church treasuries up to the fifteenth century; and at both Sens Cathedral and at St. Servatius, Maastricht, for example, the distribution is jointly comparable.[9] The uniformity of silk acquisition in mediæval treasuries well reflects the extensive foreign trade links of the period, and Aachen, set in the heart of the important Rhine-Maas trade area, was well placed to receive silks from all regions. The Central Asian silks were carried by Rhadanite Jewish merchants, and the Eastern Mediterranean silks in the main would have arrived via Italian merchant intermediaries.[10] There are no surviving Cloth of Aresta pieces at Aachen, which is surprising in relation to their proliferation in other Rhine-Maas treasuries and to their presence at Sens, but this could be just accident of survival.[11]

As mentioned above, the practice of wrapping relics in precious fabrics is documented both in Byzantium and in the Latin West from the fourth century onwards and it is not surprising to think that relics of an important centre like Aachen should be enveloped in silk. What is puzzling **Storing the silk clad relics in precious shrines and reliquaries**

is that so few early reliquaries survive at Aachen. Little remains of the splendours of the early Carolingian treasury outside the dispersed Stephan burse reliquary and the sword of Charlemagne, the talisman of the Emperor and his Palace Gospels.[12] There are no small Early Christian boxes and pyxis like those of Swiss treasuries before the ninth century and the question is: where were the relics and their precious coverings initially placed?[13] At Chur the relics were placed beneath the altar slab. Before the existence of treasuries altars served as an ideal location for relics.[14] At St. Ambrogio, Milan a special golden altar held the sacred relics and their silk envelopes in the Carolingian period.[15]

At Aachen excavations of 1861 and of 1910 revealed a fabric-lined grave situated beneath the area of the Carolingian altar to the Virgin; this arrangement Schiffers compared to the Early Christian reliquary grave of S. Apollinaire Nuovo in Ravenna. He concluded that the cruciform pit was a reliquary grave of the time of Pippin over which a Carolingian reliquary chapel was constructed. Charlemagne built a gold, silver and jewel-decorated shrine to hold the relics removed from Pippin's reliquary depository and he added many relics that he had personally acquired. This was a pioneering act whereby the relics in their shrine were made more accessible to the gaze of visiting pilgrims, as the shrine sat on the altar of the Virgin in the Carolingian reliquary chapel.[16] At Sens Cathedral too, Charlemagne is said to have donated many relics that were housed in a shrine built by the Emperor and set on the main altar.[17] Three times in the ninth century the relics, and presumably their shrine, had to be taken to safety outside Aachen in the wake of Norman invasions, and once they had to survive a fire, so that by the thirteenth century the Carolingian shrine had become very worn. In 1238/39 the shrine was replaced by a new shrine of the Virgin. This translation too, would have occasioned the addition of splendid new silks to the relics.[18]

Turning to the relics of Charlemagne, it has to be noted that the exact original burial place of Charlemagne is unknown but perhaps he was buried in the antique Prosperina sarcophagus initially. By 1165 at the time of Charlemagne's canonisation under Frederick Barbarossa, a splendid gold shrine was under construction to hold his relics.[19] By this period, the lucrative growth of pilgrimage and the attendant prestige that important relics gave to ecclesiastical centres cannot be under-estimated. Again the canonisation and the translation would have provided an excellent opportunity for the addition of silks to the relics. It has been suggested that the Sicilian Hare silk found its way into the shrine by the time of its completion in 1215, to complement the Elephant silk already resplendent there.[20]

Continuing rich Imperial patronage is evident at Aachen from the Carolingian period onwards, even if only a few of the 37 Emperors and

their consorts crowned at Aachen between the tenth and the fifteenth centuries actually resided in the Palace at Aachen. Important pieces in the treasury which reflect this Imperial patronage on a grand scale include the Lothar cross, the golden altar and the ambo of Henry II, the ivory situla, the Barbarossa candelabra and the magnificent Charlemagne shrine and arm reliquary, and the shrine of the Virgin. Furthermore, the Simeon reliquary, the plate reliquary, the bust of Charlemagne, the Charlemagne chapel reliquary and the treasures of the Hungarian chapel, demonstrate the active patronage and the increasing veneration of the relics at Aachen in the fourteenth to fifteenth centuries under Charles IV and Louis the Great. Of course, many of these reliquaries and shrines would have necessitated the addition of cloths with which to envelop or at least to partly shroud the holy relics they housed.[21]

The relics at Aachen were acquired principally through Pippin and **The relics** Charlemagne. The names of the saints gathered under Pippin are largely unknown, but those of the time of Charlemagne are mainly Roman saints rather than Frankish saints, which underlines Papal links. The relics were acquired from Rome and from Jerusalem as well as via Byzantium. Broadly speaking they represent two distinct traditions of veneration; that of the purely ecclesiastical saint and that of the Imperial saint. The relics can be divided into four main categories:

1. relics that belonged to the time and the ambience of Christ; that is the all important textile relics of the Virgin, of Christ and of St. John the Baptist, the relics of the True Cross, and of the crucifixion sponge, and relics of the apostles including Thomas and Bartholomew.
2. relics of early Christian and of later mediæval saints both those named, that is Saints Simeon, Ursula, Anastasius, Thomas, Gertrude, Lucia, Marcellinus, Victorinus, Cyriacus, Catherine and Agnelis; and further unnamed saints.
3. relics pertaining to Charlemagne.
4. relics of important individuals, specifically of Pope Leo III and Stephen of Hungary.

The relics demonstrate the move away from Frankish cults to those of Rome under Charlemagne, a move to match the adoption of the Roman liturgy at Aachen in 802 and the Papal consecration of the Palace Chapel.[22] In addition, the relics show that Charlemagne cannot have been unaware of Byzantine tradition. The two principal relics of the Virgin, her girdle and her garment, were objects of veneration in Byzantium from the sixth century onwards and were said to be housed in Constantinople. The church of the Virgin Chalcoprateia was reputed to hold not only the

Virgin's girdle but also the swaddling clothes of Christ. In the seventh century there was an active feast of the deposition of the girdle of the Virgin there. The Byzantine church of the Virgin Blachernae was traditionally held to house the garment of the Virgin taken from Palestine in 473/4. This was placed into a specially built chapel under Leo I (d. 474) and greatly venerated in Constantinople. At Haghia Sophia, the Imperial church of the Byzantine Capital, in 614, relics of the sponge of Christ were documented; and in 635 relics of the True Cross were recorded there. Also, the icon of the Virgin painted by St. Luke was reputedly housed in the Byzantine church of the Virgin Hodegetria. It was venerated there in the seventh century.[23] It seems that Charlemagne had direct reference to Constantinople in the choice of important cloth relics from the time of Christ. Not only did he acquire relics of the girdle and of the vestment of the Virgin, but he also obtained relics of the Passion sponge and relics of the True Cross; whilst the Byzantine steatite Virgin and Child (formerly in Aachen) may also have had a link to the legend of the Virgin painted by St. Luke.[24] This seems an Ottonian rather than a Carolingian acquisition at Aachen. It is possible that both in Carolingian and in Ottonian times, some relics came from Constantinople, for documents show that Byzantine envoys carried both relics and silks on occasion. Charlemagne himself was approached for his hand in marriage by the Byzantine Empress Irene in the 790s. In addition, there were plans for a diplomatic marriage involving a daughter of Charlemagne.[25]

Documented sources for the acquisition of relics at Aachen include the Patriarch of Jerusalem, various Popes and even Harun al Raschid, who also sent Charlemagne an elephant.[26] Numerous of the Aachen relics were re-distributed by Charlemagne and his successors to Prüm and to Centula amongst other monasteries. A good idea of the Carolingian relic holdings can be established by comparison of the relic inventory of Centula of 804, the relic inventory of Prüm of 1003, a Carolingian inventory of relics at Aachen and an extensive list of Aachen relics made in 1238/39. The latter stems from the time when the relics were translated into the new shrine of the Virgin, which was built through the donations of pilgrims. Schiffers has published a useful comparative table of the relics of Centula, Prüm and Aachen in the Carolingian period.[27]

Aachen as a centre of Pilgrimage Aachen under Charlemagne was established as a pilgrimage centre. Under his successors Aachen was also transformed into the seat of an Imperial cult. The real blossoming of the pilgrimage element at Aachen came with the canonisation and the translation of the relics of Charlemagne into a new shrine in 1165 This was followed by the translation of the relics of the Virgin, amongst others, into the new shrine of the Virgin

in 1238/39. The institution of the seven year pilgrimage may stem from the 1240s but it is unclear when the relics of the Virgin were first openly displayed to the faithful. The earliest record of the display of relics belongs to 1312; this was carried out inside the church. In 1322 however, there is a record that the relics were shown in the bell tower, a structure that was not completed until 1350. Another record of the display of relics on the tower belongs to 1376. Alongside the strengthening of the cult of the Virgin at Aachen came a growth of interest in the cult of Charlemagne, particularly under Charles IV. This opened up the way for the addition of fourteenth and fifteenth century Italian silks to the relics. These silks would have been acquired from Italian merchants living in the region of Maastricht amongst other places. The new Gothic choir built from 1355 further facilitated the accommodation of a growing multitude of pilgrims, and allowed for the more impressive display of shrines and reliquaries. The Aachen septennial pilgrimage, set on the day of the consecration of the church probably in mid-July, was planned to coincide with other important pilgrimages of the Rhine-Maas area so that pilgrims could tour the main pilgrimage centres in rotation.[28]

PART TWO

Aachen clearly stood as a symbol of Charlemagne's Empire. He stayed there no less that twenty seven times. Numerous privileges were received by the citizens of Aachen. Rich gifts of land and property were made to the Palace chapel foundation not only under Charlemagne but right up to the end of the eleventh century.[29] Although after the eleventh century Emperors built Residences in southern Germany and tended to patronise southern Bishoprics, Aachen remained at the heart of the German Empire in its role as symbolic coronation centre. The foundation of a clerical order in the mid ninth century initially strengthened the position of Aachen as a combined religious and political centre; this position was increasingly entrenched with every passing coronation in a long series from 936 until 1561.[30]

Overview of ecclesiastical and political considerations behind the acquisition of relics and textiles at Aachen

Overall, four important chronological phases can be recognised at Aachen:

 1. The establishment of the centre under Charlemagne.

2. A stage of revival under Frederick Barbarossa in the twelfth century.

3. A strengthening phase in the early thirteenth century with the translation of relics into the new shrine of the Virgin.

4 A strong upsurge in the fourteenth to fifteenth centuries with the building of the splendid Gothic choir and the patronage of Charles IV and Louis the Great.

Each phase raised new ecclesiastical and political questions and was intimately tied to the acquisition of relics, reliquaries and textiles.

1. Aachen under Charlemagne

a. Many important consequences, closely intertwined and intricate, underpinned the activities of Charlemagne at Aachen. He, in the wake of Pippin, set the scene at Aachen for Kingship and piety to be forged as a visible sign of the mediæval concept of Christian Kingship.

b. This in turned involved the Papacy, for Christian rulers were Defenders of the Faith as well as of their subjects and of peace and justice too. Charlemagne, it should be remembered, duly collected relics of Roman rather than Frankish saints and he also instituted the Roman rite at Aachen.

c. Any contact between the German house and the Papacy immediately alerted Byzantium, who did not wish to see her traditional links with the Papacy challenged. Perhaps, when both Pippin and Charlemagne on different occasions were called to come to the aid of the Papacy, they also began to receive diplomatic overtures from Byzantium.

d. Undoubtedly, Byzantine influence was paramount at Aachen not only in the architecture and the Palace School of illumination but most probably also in the lavish use of silks for wrapping relics. Indeed, the most splendid Charioteer silk was most likely an early Byzantine diplomatic gift. After all, Pippin had earlier received the Byzantine Imperial Hunter silk, which he gave to the relics of the patron saint at Mozac in 764.[31] The relics of the Virgin and of the Passion also echoed cults established by Byzantium in the sixth century.

To this early phase of development at Aachen can be assigned the Eastern Mediterranean silks and the early Central Asian pieces. Under the Ottonians an increasing Byzantine influence was felt, which, of course, culminated in the marriage of Otto II and Theophanou in 972.[32] Ottonian links with Aachen could but strengthen Byzantine ties and it may be through Theophanou that further Byzantine silks and metalwork

(the Elephant silk and the Anastasius reliquary, for instance), reached the
Aachen treasury.[33]

The canonisation of Charlemagne provided further opportunity for the **2. Revival under**
important addition of silks to the relics. To this phase the Sicilian Hare silk **Frederick**
may belong. The two elements that gave a spurt to the canonisation were: **Barbarossa**

1. The growing cult of Charlemagne at St. Denis, which threat-
 ened to place the cult at Aachen in the shade; and
2. The canonisation of Edward the Confessor at Westminster
 Abbey in 1163 under Henry II.[34]

Before discussing the second point further it is important to note that
Frederick Barbarossa was active in translating relics of saints elsewhere,
Lodi and Augsburg included. His predecessors had done the same
elsewhere; Charles the Bald at Soissons and Henry III at Stavelot. What
was important was not the act of helping in the translation of relics but the
act of participating in the translation of a dynastic predecessor's relics.[35]

The canonisations of Edward the Confessor and of Charlemagne, in
1163 and 1165 respectively, lent an air of sanctity to their Royal/Imperial
cults. At the same time, the Royal/Imperial saints stood as national
figures in much the same way as St. Denis served as a national saint
under Louis in the early twelfth century. The canonisation and translation
symbolised the passage of the saints to heaven, after a pious life
underlined in their God given right of Kingship. The successors of Edward
the Confessor and of Charlemagne elected them a sacred status based on
their personal piety, but the canonisations ensured sanctity as against
purely sacral standing for the two saints.

The roots of the beliefs lie in the Anglo-Saxon Royal cults that stem
back to the ninth century. These beliefs were centred on the canonisation
of Edward the Confessor, and were in turn indirectly expressed in the
canonisation of Charlemagne. Ridyard has made a thorough study of
these cults. She concludes that they formed a branch of high Politics. The
question is, how far did High Politics enter into the cult of Charlemagne?[36]

The characteristics of the Anglo Saxon Royal cults Ridyard analysed
as follows:

a. They were cults that dominated the religious communities
 entrusted with their care
b. The cults attracted the patronage of successive rulers
c. The reasons that successive rulers promulgated the cults was
 that they both saw the cult as a means of declaring adherence
 to a traditional dynasty and as a means to declare that the
 earlier dynasty was supplanted by the present ruler.

d. The cults allowed close contact between ruling houses and the Church, an important point, as stable royal power was central to the well-being of the Church.[37]

These characteristics could equally be applied to Charlemagne's cult at Aachen. The initially close links between Church and State, it could be argued, had already been forged through Pippin and Charlemagne, by way of monastic reform as well as by Papal allegiance. The use of the rite of Edward the Confessor's canonisation as a basis for the canonisation of Charlemagne was effected through the close ties of the Angevin and the Staufer houses, but it symbolised far more than a passing influence. The Anglo-Saxon Royal cults at the basis of the Angevin canonisation echoed all the elements already in place at Aachen before the canonisation of Charlemagne.

As far as precious textiles were concerned, the relics of Edward the Confessor appear to have been shrouded in a Byzantine lampas weave silk with birds, fragments of which survive at the Victoria and Albert Museum, London.[38] Thus, the royal saint like the non-royal saint, for instance St. Cuthbert at Durham, were honoured by the addition of precious fabrics.[39] By the early thirteenth century at Aachen, the shrine of Charlemagne may have contained more than just the Elephant silk and the Hare silk, for if further relics were kept in the same shrine at that time, they too would have required silk coverings.

3. A strengthening period of the early thirteenth century The Gothic shrine of the Virgin gave the opportunity for the actual relics from the time of Pippin and Charlemagne to be unwrapped so that the relics could be properly viewed: this was a concept foreign to earlier periods. With this feeling of 'nothing hidden', the stage was set for the display of relics in the fourteenth century. Meanwhile the pilgrimage to Aachen grew. This would have been the period when Spanish cloths of Aresta were flooding into the Rhine-Maas area alongside early Italian silks and semi-silks. As mentioned, the Cloth of Aresta does not seem to be represented at Aachen, but could three new fragments recently discovered at Aachen be Spanish? They have the feel of fine silk fragments at Sens Cathedral, by some called Spanish.[40]

CONCLUSION

By 1355 the Gothic choir at Aachen had been built, as had the bell tower **4. Upsurge** from which the relics were to be displayed. A new outward ostentation was **under Charles IV** heralded by the construction of fresh reliquaries like the Simeon reliquary and the plate reliquary. At the same time, the treasury acquired examples of splendid fourteenth to fifteenth century Italian silk, which no doubt protected important relics of the treasury. The largest pieces one would imagine can only have been placed in the two important shrines of the Virgin and of Charlemagne.[41]

Charles IV especially entered fully into the spirit of Charlemagne's Aachen, residing there no less than six times after his coronation. He underlined his close association with Charlemagne's memory by setting his own coronation ceremony 66 years to the day after the death of Charlemagne. If the bust of Charlemagne has been correctly identified as a gift of Charles IV, it embodies much that Aachen represented. Charles IV like Charlemagne, the pious Christian King, draws strength from his association with the founder of the Imperial dynasty. From his coronation at Aachen, Charles legitimised his Imperial position. In turn Charles IV lavishes privileges and gifts on Aachen and further promulgates the cult of the founder saint.

With the last great coronations at Aachen (including those of Charles in 1349, Maximilian in 1486, Charles V in 1520 and Ferdinand I in 1531), a great era in the history of mediæval Aachen and an important phase in the acquisition of precious textiles, drew to a close. This paper has touched upon only the silk fragments. In addition, the presence of so many impressive silk vestments at Aachen, ranging in date from the twelfth right up to the twentieth century, indicates just how well mediæval textile precedents were followed in later years. One can but conclude that Aachen was truly the home of a 'Silken Piety' whose roots penetrated deep into the heart of mediæval politics.

NOTES

1. A preliminary catalogue study of the Aachen Treasury silks was undertaken by the author in 1980 and the collection was photographed by M. Brandon-Jones for an archive at the University of East Anglia.

2. The surviving Byzantine silks in West European treasuries were studied by the author over the period 1970-1980 for a doctoral thesis, 'Eastern silks in Western shrines and Treasuries before 1200 AD Courtauld Institute of Art, University of London, 1982. This work has been enlarged for a forthcoming, ' History of the Byzantine Silk Industry' to be published under the auspices of the Byzantine Institute, University of Vienna. For the Aachen Elephant silk see A. Muthesius, A practical approach to the history of Byzantine weaving, *Jahrbuch der Österreichischen Byzantinistik* 34 (1984) 235-254. For the use of silks to shroud relics, see A. Muthesius, The Rider and the Peacock silks from the Relics of St. Cuthbert, in: St. Cuthbert, his Cult and his Community to AD 1200, ed. G. Bonner, A. Rollason, C. Stancliffe, (Woodbridge, 1989) 343-366.

3. For the metalwork at Aachen consult, P. Lasko, Ars Sacra 800-1200. (London, 1974) 14ff., 125. Also, A. Grimme, Der Aachener Domschatz, *Aachener Kunstblätter 2 (1972).* In addition, Rhine Maas Kunst und Kultur, exhibition catalogue, ed. A. Leger, (Cologne, 1972) I 161ff., II 65, 191ff..

4. For comments about the Aachen relics see Grimme cited in the note above, XIff.

5. F. Bock, Der Reliquienschatz des Liebfrauen Münsters zu Aachen. (Aachen, 1860), introduction XXIII-XXXI, and 74, 80, 88.

6. Aachen treasury includes a large number of impressive unpublished silk vestments, which await further study. Around 40 such vestments were photographed for the survey of 1980 mentioned in note 1 above.

7. A chronology of weaving types was included in the author's thesis cited in note 2. A summary was given in A. Muthesius, 'The impact of the Mediterranean silk trade on Western Europe before 1200 A. D. in, Textiles in Trade. Proceedings of the Textile Society of America. Biennial Symposium, (Washington, 1990), 126-135.

8. The technical terms are defined in a Vocabulary of Technical terms ed. G. Vial, published by C.I.E.T.A. (Lyons, 1974).

9. St. Servatius, Maastricht has over 450 silks; most are Italian 14th-15th centuries. Sens has over 500 silk fragments, mainly Eastern Mediterranean (Islamic and Byzantine) pieces dating before the thirteenth century, as well as some thirteenth century Spanish examples.

10. For the Rhadanite Jewish merchants, see L. I. Rabinowitz, Jewish Merchant Adventurers. (London, 1948). For other points about the Jewish contribution to the silk trade see A. Muthesius, 'The Hidden Jewish Element in Byzantium's Silk Industry' *Bulletin of Judaeo-Greek Studies* 10 (1992) 19-25 with references to Goitein, Starr and other authors in the footnote literature citations.

11. For cloth of 'Aresta' see S. Desrosiers, 'Cloth of Aresta' in, Ancient and medieval Textile History in Honour of Donald King, Pasold Foundation. *Textile History* 20 (2) 1989, 135-149.

12. Grimme as cited in note 3 above, 11ff..
13. For Swiss and other early reliquaries see Muthesius, Eastern Silks, 264-268.
14. For Chur consult Muthesius, 'The Rider and Peacock silks', see note 2 above, 344 and its note 3.
15. For St. Ambrogio, Milan, see Lasko, Ars Sacra, 50ff..
16. A. Schiffers, Der Reliquienschatz Karl des Grosse und die Anfänge der Aachenfahrt. (Aachen, 1951) 87-96 for Pippin's reliquary croft.
17. Unnumbered 12th century manuscript, Sens cathedral treasury.
18. For the shrine of the Virgin, see Grimme, Aachener Domschatz, 71-73. For questions concerning the original burial place of Charlemagne, refer to Muthesius, Practical approach, 253-254 and note 50.
19. For the Charlemagne shrine and its recent conservation there is the publication, H. Lepie, Die Geschichte der Sicherung und konservierung des Karlsschreins, *Die Waage*, Sonderheft Oktober 1988.
20. For pilgrimage in general see J. Sumption, Pilgrimage, an Image of Mediaeval Religion. (London, 1975). R. Grönwoldt suggested that Frederick II and not Frederick Barbarossa added the Hare silk to Charlemagne's shrine. See Zeit der Stauffer, exhibition catalogue, I (Stuttgart, 1977), 619-620. This is still open to question. The fineness of the silk and the pastel colours are reminiscent in part of another silk with inscription stating it was made in Palermo, see R. Grönwoldt, Kestner Museum, Hannover catalogue (Hannover, 1964) no. 31. For this reason the present author considers Sicilian provenance a possibility for the Hare silk. The marriage of Frederick II to a Sicilian princess naturally would strengthen Sicilian connections that were already in place earlier.
21. Grimme, Aachener Domschatz, 38ff..
22. For Papal alliances in the Carolingian period, see M. Kerner, 'Die frühen Karolinger und das Papstum', *Zeitschrift des Aachener Geschichtsvereins* 88/89 (1981-1982) 20-41. For the Carolingian reliquary holding at Aachen, see A. Schiffers, Der Reliquienschatz Karls des Grossen. (Aachen, 1951), 1-86.
23. P. Maraval, Lieux Saints et Pèlerinages d'Orient, ed. E. Dagron. (Paris, 1985), 409 note 66.
24. The steatite was not of the time of Charlemagne. It may belong to the Ottonian period. See Grimme, Aachener Domschatz, 48ff..
25. For Byzantine silken diplomacy see A. Muthesius, 'Silken Diplomacy', in Byzantine Diplomacy, ed. J. Shepard and S. Franklin (Aldershot, 1992), 237-248.
26. Schiffers, Reliquienschatz, 175ff. for relics donated.
27. Ibid., 195ff.
28. Rhein-Maas catalogue I, see pieces by J. Torsy, E. Stephany, and K. Köster, 131, 142-143 and 146.
29. P. Nolden, Besitzungen und Einkünfte des Aachener Marienstifts. *Zeitschrift des Aachener Geschichtsvereins* 6-87 (1979-1980) 117-456. Especially 379.
30. Quellentexte zur Aachener Geschichte volume 3. Die Aachener Königs Krönungen. (Aachen, 1961) ed. W. Kaemmerer.
31. For Mozac silk see Muthesius, Silken Diplomacy, 237ff..
32. For Theophanou see the Conference Papers, Kaiserin Theophanou I-II (Köln, 1992) ed. G. Sporbek.

33. For the Anastasius and the Felix reliquaries see Grimme, Aachener Domschatz, 6-48.
34. J. Petersohn, 'S. Denis-Westminster-Aachen, Die Karls-Translation von 1165 und ihre Vorbilder. *Deutsche Archiv für Erforschung des Mittelalters* 31 (1975) 420-454.
35. Ibid. 420ff.
36. S. Ridyard, Anglo Saxon Royal Saints. (Cambridge, 1989).
37. Ibid. Chapters 1, 8.
38. Discussed fully in Muthesius, History of Byzantine Silk, forthcoming.
39. For the St. Cuthbert silks see reference in note 2 above, the St. Cuthbert publication, 303-343.
40. The Sens fragments are unpublished. The three new Aachen fragments were first mentioned during the Aachen conference.
41. For the background, see Studien zur Vorgeschichte der Krönung Karls IV in Aachen, in *Zeitschrift des Aachener Geschichtsverein* 88/89 (1981-1982) 43-93.

XIV
Silk, Power and Diplomacy in Byzantium

I N BYZANTIUM between the fourth and the twelfth centuries, a hierachy of silken splendour was established across social, artistic, religious, economic and political boundaries. On one level silk was a decorative fabric socially exploited for its aesthetic qualities. On another level it was prized as a fabric fit for furnishing the House of God. Above all though, the Imperial house was intent to raise what was essentially a valuable economic asset to the heights of a powerful political weapon. Consequently silk was made to serve both as the prime Imperial ceremonial fabric and as the diplomatic cloth 'par excellence'.[1] The present paper seeks to explore two questions in this context:

How and why did silk assume such a strongly political role in Byzantium?

What were the foreign ramifications of Byzantium's silken diplomacy?

Silk was established as a power base in Byzantium between the fourth and the twelfth centuries under three umbrellas:

Silk as a power base

- It was granted an elevated status through Imperial legislation and through its association with Imperial murex purple dyes.[2]
- Concomitantly it was rendered indispensable to Imperial Ceremonial.[3]
- It was featured in domestic and in foreign policy as a tool for the implementation of Imperial policy.[4]

Imperial silk legislation Imperial silk legislation survives in two forms: Imperial decrees (embodied in the Theodosian and the Justinianic Codes, in a Novel of Leo the Wise and in the Basilics)[5] and in economic legislation (as found in the Book of the Prefect).[6] The Decrees were concerned first to establish and then to maintain an Imperial monopoly over the production of silks intended for court consumption and principal amongst these were the murex dyed purple silks.[7] From the fourth to the tenth centuries, Imperial silks and purples appear to have been manufactured only in Imperial workshops, but in the tenth century some were manufactured under strict control by non-Imperial silk guilds in Constantinople. The Book of the Prefect, which details non-Imperial silk guild regulations, indicates that seven categories of Imperial silk garments or purples were in non-Imperial production.[8] These included whole silk garments and petticoats of Imperial cut, and exclusive Imperial red or blue purples of different strengths, as well as some peach and other green tinted purple silk shades. These purple dyes were produced through labour intensive and costly processing of the light sensitive, purple yielding juices from the glands of murex sea snails. The Imperial monopoly over manufacture and use of the murex purple silks in particular, immediately rendered Imperial silk a political presence. Leo VI (d. 912) was well aware that murex purples had a high political profile and that they had long since become synonymous with Imperial authority and power. Leo VI stated (Novel 80):

> 'I do not understand why the Emperors, my predecessors, who dressed in purple, were induced to legislate to forbid any piece of purple material from figuring as an article of commerce, or prohibit the purchase and sale thereof. To prevent the trade in a whole piece of the fabric would not be a vain matter for legislation; but since scraps and clippings cannot be of practical use or advantage to buyers and sellers, what honest purpose, and exempt from jealousy of their subjects can have prompted the idea of the legislators: and how can it be prejudicial or derogatory of the Imperial rank? Since we do not approve of such an idea, we ordain that scraps and clippings, to which our subjects attach distinction and importance, and which they can use for any purpose not forbidden by law, may be bought and sold. Besides other benefits which the Emperor confers upon his subjects he must not be envious of their luxuries.'[9]

Imperial silk ceremonial Certainly, elaborate silk costume played an essential part in Imperial court ceremonial. In the Book of Ceremonies of the tenth century, the Emperor and his consort were described as being dressed in precious long mantles open on one side, accompanied by lavishly decorated, lengthy stoles.[10] Detailed descriptions of individual Emperors also survive. For example, Constantine Manasses described Emperor Nicephoros III (1078-

1081) 'mantled in garments glittering with gold and dressed in gold woven pearl bearing cloth, brilliant with purple-dyed blossoms and gold'.[11] Nicetas Choniates (1155-1215) in 1176 described how the Emperor Manuel I (1143-1180) 'removed his surcoat (yellowish) embroidered with purple and gold and presented it to Gabras, envoy of the Turkish sultan'.[12] The same author described the Emperor Andronikos (1182/3-1185) as the 'King of dandies', who wore 'a violet coloured garment of Iberian weave, open at the sides and reaching down the knees and buttocks and covering the elbows'. Choniates amusingly confided that this particular individual was titillated by 'fine long robes and especially those that fall down over the buttocks and thighs and are slit and appear to be woven on the body'.[13] A painted miniature portrait of Emperor Alexios V (Vienna Nat. Libr. Cod. Hist. gr. 53) shows the ruler around 1204 AD, wearing a long purple robe with woven griffin medallion design and broad gold borders on hems and sleeves (PL. 75).[14]

Whilst ceremonial silk and purples in particular expressed Imperial prowess, a vast array of lesser silken cloaks and tunics were required to garb Imperial court officials. Various ranks of court dignitaries were distinguished one from the other through the use of differently coloured silk uniforms, first recorded in detail by Pseudo-Codinus in the fourteenth century.[15] In addition, the tenth century Book of Ceremonies described many short court tunics called 'skaramangia'. The most elaborate of them were patterned with lions, eagles, or griffins. These designs can be paralleled on Byzantine silks, datable tenth to eleventh centuries, which reached the Latin West.[16] These silks include the Eagle silks of Auxerre and Brixen (PLS. 80, 76) and the Lion silk of Cologne (PL. 42).[17] The Griffin silk of Sitten is dyed with murex purple, which suggests that this was a piece originally destined for Imperial Byzantine use.[18] The Book of Ceremonies, in chapter 46, also listed elaborate costumes worn by high ecclesiastics and important civil dignitaries during religious ceremonies, including white, purple and gold tunics and mantles, and gold breast plates.[19]

Silk was featured equally prominently at the Byzantine court on a purely domestic and on a manifestly political front. Silk was considered appropriate for the cradle of the new born Imperial infant, just as silk bed sheets were the order of the day for the Emperor engaged on military campaign.[20] Silk cloths covered trolleys used to transport immensely heavy fruit-filled gold vessels to Imperial banquet tables in the same way as silks were used to cover a supporting raised platform and the Imperial throne itself.[21] Palatial silk curtains certainly were described by Pseudo-Codinus in the fourteenth century.[22]

Silk on the battlefield So integral was silk to Imperial living, and so closely was it bound to the idea of Imperial power, that it was inevitable it too should appear with the Imperial retinue upon the battlefield. Silk standards were designed to rally the troops, and these as well as many other silks were transported into the battle zone as part of the Imperial Baggage train, carried in special purple leather pouches secured with metal fastenings.[23] The Imperial workshop was responsible for the supply of these valuable silks, not least for special 'skaramangia', or tunics, some decorated with woven eagles, which were customarily awarded by the Emperor to his generals in honour of outstanding service rendered on the battle field.

The Baggage Train account appended to the tenth century Book of Ceremonies indicated that each category of officer had a specific type and cut of tunic and that these were more or less impressively festooned according to rank. The tunics with eagles were probably designed to be worn with the silk leggings woven with eagle motifs.[24] There were also hornet designs on second quality leggings.[25] Additionally, there were tunics and mantles with broad or with narrower stripes and others patterned with what was termed a 'sea design'.[26] Hoods and belts were dyed with three categories of superior purple dye as well as with cheaper purples, probably for the lower ranks.[27] The Byzantine army must have been a splendid sight in its silken finery, and it is interesting to note that Arab armies too, fought wearing silk.[28]

A representation of Byzantine military uniform is found on a fresco of the second half of the twelfth century at the Anargyroi church in Kastoria.[29] Here two military saints are shown side by side. The left hand side figure wears a cloak above a coat of mail and a short tunic. He has a pair of leggings with diamond lattice design and ankle boots. The right-hand figure wears a long tunic beneath the shorter tunic covering his leggings. This shorter garment is sumptuously patterned with a silk-like medallion design. Large decorative borders ornament the upper sleeves, the lower hem and the front of the skirt, which brings to mind a Byzantine saying recorded by Theophanes, 'A robe is revealed in advance by its border'.[30] The use of borders on the military uniforms described in the Baggage Train account, and the military borders shown on the fresco, suggest that such ornaments could have had special significance for distinguishing military rank.

The Baggage Train account illustrates to just what an extent Imperial silken ceremonial was entrenched upon the battlefield.

Silken diplomacy Silken Imperial ceremonial and silken diplomacy were skilfully merged into one as Palace ceremonial was extended to encompass elaborate political festivals carefully staged in Constantinople. Such occasions

provided an opportunity for the finest Imperial silks, resplendent with Imperial power, to be paraded before the citizens of Constantinople and before the eyes of visiting foreign dignitaries. Of the celebrations that followed the victory of the Emperor Manuel I over the Serbs and the Hungarians, Choniates wrote: 'the Emperor led a most splendid procession through the streets of the city (Constantinople). Decked out in magnificent garments far beyond the fortune of captives, the newly captive Hungarians and the captured Serbs enhanced the procession's grandeur. The Emperor provided these adornments so that the victory might appear most glorious and wondrous to citizens and to foreigners alike, for these conquered men were of noble birth and worthy of admiration'.[31] 'Every purple-bordered and gold speckled cloth' was hung out to mark the return of the Emperor to Constantinople.[32] Choniates also described how the same Emperor entered Constantinople with the Sultan. There he proclaimed a magnificent triumph 'resplendent with exquisite and precious robes and diverse adornment cunningly wrought'.[33]

It is relevant to note that the route taken by Emperor Basil I (867-886), from the Golden Gate to the Chalke, following his military victories in Tephrike and in Germanikeia, was decorated with silk hangings and skaramangia, and strewn with flowers by the Eparch of the City of Constantinople — the official, amongst other things, in control of non-Imperial silk guilds of the capital.[34] The Emperor entered the capital wearing a skaramangion, which he exchanged for a gold-breasted military tunic decorated with pearls. This was subsequently changed for a long ceremonial Imperial tunic with elaborate borders, worn together with a gold embroidered mantle. Thus dressed, the Emperor presided over a magnificent feast.[35]

Whilst silks were fully exploited for political ends in Byzantine as an integral element of domestic policy, in the context of foreign relations they **Silks as** **diplomatic gifts** also served as valuable, light and easily transportable diplomatic gifts. Byzantine silks were particularly sought after by Islamic courts envious of Byzantine silken magnificence, and Byzantine court ceremonial is known to have had a great influence on the Fatimid court.[36] Even more significantly, Byzantine silks were coveted by Latin rulers, who themselves were totally bereft of any native silk weaving industry before the twelfth century.

At least three different categories of silken diplomacy prompted the despatch of Byzantine textiles:
- Diplomacy designed to stave off imminent military attack
- Diplomacy intended to establish or to renew a political alliance

- Diplomacy engendered so that economic favours could be rendered in return for long term military or naval assistance

Silken diplomacy designed to stave off attack or intended as part of peace treaty negotiations is especially apparent in Byzantium's dealings with the Arabs. Examples include 200 Imperial silk costumes that Basil II sent to Abud al Daulah in 983, and the gift of fifty silk-covered chests plus one thousand silk costumes sent by Constantine IX to Caliph Al Mustensir in 1045.[37]

It was natural that in the face of Arab, Lombard (and later Turkish) threats to different parts of her Empire, including southern Italian possessions, Byzantium was ever anxious to maintain moral allies in the Latin West. Towards this end, no less than sixteen marriages between Byzantium and the West were either negotiated or arranged between the eighth and the twelfth centuries.[38] The survival up to the present day of a sizeable number of Imperial Byzantine silks in West European Church treasuries, suggests that diplomatic silks were sent by Byzantium to the West in connection with at least some of these negotiations. Imperial Byzantine silks that survive include:

a. The Mozac Hunter silk (PL. 64).[39]
b. The inscribed, so-called 'Nature Goddess' silk at Durham Cathedral (PL. 77).[40]
c. A series of inscribed Rhenish Lion silks: Berlin, Schloß Köpenick Museum; Cologne, Diocesan Museum; Crefeld, formerly Kunstgewerbe Museum (lost) — Düsseldorf, Kunstgewerbe Museum — Berlin, Schloß Charlottenburg Museum; and two documented silks once at Auxerre and Créspy St. Arnoul (PLS. 38D-43).[41]
d. The Gunther tapestry in Bamberg (PL. 78).[42]
e. The inscribed Aachen Elephant silk (PLS. 45-47B).[43]

The Mozac Hunter silk now at the textile museum of Lyons shows a mounted Imperial Byzantine Emperor dressed in elaborate ceremonial costume. The silk was taken from the relics of St. Austremoine at Mozac in the nineteenth century, from where it passed to the museum. It has been plausibly identified with a silk donated to the saint's relics by Pepin in 764. It may be suggested that the silk arrived as a diplomatic gift sometime during protracted negotiations between the Byzantine Emperor Constantine V and Pepin concerning the marriage of the son of the Byzantine ruler and Pepin's daughter. The reason behind the proposed alliance lay in Byzantium's anxiety over the Lombard threat in southern Italy. Pepin had been approached for support both by the Papacy and by Byzantium, but in spite of Byzantium's silken diplomacy he lent his favour to the Papacy.[44]

Another diplomatic silk that has survived is the so-called 'Nature Goddess' silk at Durham Cathedral treasury. This bears an illegible Greek inscription, which may originally have included the name of the Emperor under whom the silk was woven. The design on the silk is partly worn away, but it has been suggested that what was intended was a 'Nature goddess' theme of a type known in Byzantium in the eighth to ninth centuries, the period in which the silk was woven. The Durham silk served to shroud the seventh century relics of St. Cuthbert, and it could have been one of the two Greek cloths offered by King Edmund for the relics in 944.[45] The reason for a tenth century Anglo-Byzantine diplomatic alliance is unclear, but Anglo-Saxon soldiers were known to have fought in the Byzantine army as mercenaries.

Two documented and five extant Lion silks with Imperial inscriptions, appear to have served as examples of a standard form of diplomatic gift that accompanied marriage negotiations with the Latin West.[46] The Lion silks of Cologne, Düsseldorf and Berlin, together with lost fragments once in Crefeld, belong to the reign of Basil II and Constantine VIII (976-1025). The Lion silk at Schloß Köpenick from Siegburg was woven under Romanos and Christophorous his son between 921-923. Documented Lion silks once at Auxerre and at Créspy St. Arnoul, suggest that this type of diplomatic silk was also in production earlier. In the light of the many marriages negotiated and arranged between Byzantium and the West, there would have been many opportunities for these silks to reach the West. They have been preserved around the relics of important saints, and it is clear they were donated by Latin Emperors for use in this way.

Beckwith plausibly suggested that a large silk tapestry, taken from the grave of Bishop Gunther (d. 1065) in Bamberg, depicted the triumphal entry of the Emperor Basil II into Athens and Constantinople after his victory over the Bulgars in 1017. This silk was a diplomatic gift sent from the Byzantine Emperor Constantine X (1059-1067) to the German Emperor Henry IV (1056-1106). The envoy Gunther died on the return journey from a combined pilgrimage and diplomatic mission to the Holy Land and Constantinople. The silk was used to shroud his body upon burial. The silk would have been around fifty years old when it was sent as a diplomatic gift from Byzantium, but the triumphal theme would still, no doubt, have created the desired impression in the West.[47]

The Aachen Elephant silk was removed from the relics of the Emperor Charlemagne (d. 814) in the nineteenth century, but in the last years it has been returned to the relics within the mediæval shrine of Charlemagne, completed in 1215.[48] The silk bears an Imperial Greek inscription, indicating that it was woven under Michael, a eunuch and personal guard of the Emperor. Michael was also head of the palace bureau of the Eidikon, which amongst other things served to store imperial silks. The head of the

weaving factory at Zeuxippos in Constantinople under whom the piece was produced was named Peter.[49]

The Aachen Elephant fabric cannot be dated through the indiction number intended to be on the silk, because the areas where this should have twice appeared have worn off. However, Michael the Eidikos has been identified with an official Michael bearing the same titles as those on the silk. He is known from a lead seal datable to the first half of the eleventh century. Stylistically and technically the silk, a paired main warp twill, belongs into the eleventh century. It is clear that it cannot have been buried with Charlemagne; but it may have been presented by Frederick I in 1165 on the canonisation of Charlemagne, or by Frederick II on completion of the shrine of Charlemagne in 1215. An eleventh century dating would preclude its presentation by the Emperor Otto III at the recognition of the relics of Charlemagne that took place in the year 1000. When the silk arrived in the West is open to speculation, but it clearly belongs with the series of inscribed Lion silks that acted as a channel for diplomatic relationships between Byzantium and the West. Particularly after the marriage of Theophanou to Otto II in 972, Byzantine influence was at its height at the Latin court.[50]

Silk as part of Byzantine domestic and foreign policy The greater foreign demand for Byzantine silks became, the more expedient it was for Byzantium to further tighten controls on export of her silks. By controlling production and by limiting supply as demonstrated in certain regulations of the Book of the Prefect, she also achieved two further important goals:

- she held in check the silk guilds, who, in common with other guilds of the capital, by the eleventh century were to show marked signs of political activity;
- she was able to offer silk trade concessions to foreign powers in exchange for special alliances or for military and naval aid.

In the context of the first point, Hendy has demonstrated the political power of the Constantinopolitan guilds by the eleventh century, a strength which had been built up through the distribution of honours and offices to the mercantile classes by the Byzantine Emperors of the second quarter of the eleventh century. In fact, so powerful a political voice did these classes gain, that Hendy suggested they were actually responsible for the deposition of the Emperors Michael V (1041-42), Michael VI (1056-1057) and Michael VII (1071-1078), between the fourth and the seventh decades of the eleventh century.[51]

Regarding the second point, the exploitation of silk concessions for political gain, Byzantium's policy was strongly enforced on several fronts. Between 907 and 971, three special silk trade alliances were cemented

with Russia. These alliances took place against a background of political intercourse that culminated in the conversion of Russia to Byzantine Orthodoxy and, by 989, in the marriage of Vladimir of Russia to Anna the sister of the Byzantine Emperor Basil II.[52]

The Russian trade agreements meant that Russians were specially favoured above other foreigners; they alone could purchase even the most valuable of Byzantine silks costing 50 nomismata, a high price at a date when a good horse might fetch just twelve nomismata. These silks had to bear an Imperial stamp. It is interesting that the Russians also claimed two pieces of silk for any slaves lost on Byzantine territory and that the Russians in 907-911 demanded Byzantine silk sails for their ships as part of the trade agreement negotiations.[53]

Whilst enjoying these trade privileges, Russia was fighting to defend Byzantine interests. In 960-61 Russian infantry soldiers fought for Byzantium in the expedition mounted against Crete. Most crucially, in 988 Vladimir of Kiev was instrumental in quelling an uprising in Asia Minor, which threatened to depose the Byzantine Emperor Basil II himself.[54] Indeed, this was the event which procured for Vladimir a Byzantine princess 'born in the purple', that is, of true Imperial stock.

Comparable economic cum political ties were established with Italy. An initial ninth century silk trade agreement between Byzantium and Venice came to nothing, but by the tenth century Venice enjoyed privileged silk trade with Byzantium in exchange for naval aid to defend Byzantine southern Italian territory.[55] In 992, under the Byzantine Emperor Basil II (976-1025), the Venetian Doge procured tax reductions for the Venetian merchant marine in Byzantine waters in exchange for the transport of Byzantine troops to southern Italy.[56] Under the Byzantine Emperor Alexios I (1081-1118) the Venetian fleet was called out to engage the Norman fleet off Durazzo. Whilst the Venetian fleet was successful at sea, unfortunately the Byzantine army was defeated on land. Nevertheless, Venice received lavish trade concessions for her services: she was exempted from all import, export, sales and purchase taxes in trade transactions with Byzantium so gaining impressive trading advantages over her rivals, Amalfi, Pisa and Genoa.[57] By the twelfth century, in common with these states, Venice had her own trading quarters in Constantinople itself. Military as well as naval assistance appears to have been offered to Byzantium by Venice. Certainly, the envoy Liudprand in the tenth century found Venetian mercenaries in the Byzantine army.[58]

On a different note, it was Liudprand, whilst on a diplomatic mission to Constantinople, who tried unsuccessfully to export forbidden categories of Byzantine purple silks. It may well be that some foreign diplomatic expenses were covered through gifts of Imperial Byzantine silk, and it may be in this context that Liudprand felt he should not have been subject to

the usual export controls.[59] However, he was so scathing about the Byzantine court in general, that his remark concerning Venetian merchants freely carrying prohibited Byzantine silks for sale in the West, should be taken with a pinch of salt. In fact, the tightest security was imposed on the export of such silks from Constantinople in the tenth century Book of the Prefect. In the Carolingian period some imported silks definitely were available at fairs in Pavia.[60] An early eleventh century decree, probably issued under the Latin Emperor Henry II (1002-1024), limited Venice to selling precious cloths at special fairs in Pavia, and in two other as yet unrecognised centres in the West.[61]

Most notable amongst Byzantium's economic/political silk dealings with the Arabs, were the trade concessions granted to Syrian silk merchants in the tenth century in exchange for Syrian raw silk and garments. All the Syrian silk had to be purchased whatever its quality, and so short was the supply of raw silk in Constantinople that the ban had to be lifted on the sale of Byzantine silks to the Arabs outside Trebizond.[62] The major political reason for cementing Byzantine-Syrian relationships was that Byzantium was particularly interested in retaining a presence in Aleppo; a buffer state between Byzantium and hostile Islamic forces. The Byzantine occupation of parts of northern Syria in the tenth century was accompanied by a trade treaty with the Arabs. This treaty ensured that Byzantium received the silk trade taxes collected at Aleppo.[63]

Conclusion To summarise, it can be said that silk was consciously built into the fabric of the Byzantine Empire between the fourth and the twelfth centuries, and that economic silk policy came increasingly to be closely allied to political needs during this period. Silken Imperial ceremonial appears to have set the tone for a diplomacy characterised by the wide distribution of silken tribute textiles and diplomatic gifts. Only by understanding the very special association of Byzantine silk with Imperial authority, can the full significance of such textiles be appreciated. These silks represented far more than valuable diplomatic gifts; they were used as political weapons and served as the prime symbol of Imperial Byzantine power. Above all, and most significantly for Byzantium, as economics and politics became inextricably linked, Byzantine silks offered an important means of attracting allies in Byzantium's fight to maintain her territorial boundaries. Inevitably the ramifications of Byzantine silken diplomacy were felt far and wide, but nowhere was the effect more continuously documented than in the Latin West. It is no coincidence that over one thousand Byzantine silks survive to this day in the treasuries of West European churches. These silks stand both as a symbol of Byzantine silken diplomacy and as a tribute to her truly magnificent mediæval silk

industry: an industry which either directly or indirectly touched upon the lives of all her citizens.

NOTES

1. Also discussed in 'Silken Diplomacy', a paper read at the *Twenty-fourth Byzantine Spring Symposium*, Cambridge University, Cambridge 1990, in: *Byzantine Diplomacy* (J. Shepard, S. Franklin ed.). London 1992, 237-248.

2. For the historical background to the use of murex purples, consult M. Reinhold, The history of purple as a status symbol in antiquity. *Collection Latomus*. 116 (1970) 50ff. Cf. G. Steigererwald, 'Das Kaiserliche Purpurprivileg in spätrömischer und frühbyzantinischer Zeit'. *Jahrbuch für Antike und Christentum* 33 (1990).

3. Byzantine ceremonial is best exemplified in I. I. Reiske, *Constantini Porphyrogenitui imperatoris, De Caerimoniis aulae Byzantinae*. Bonn 1829-31.

4. In her dealings with Bulgaria, Russia, Venice, Pisa, Genoa, Amalfi, the mediæval German Empire and the Islamic Mediterranean in particular, Byzantium made extensive use of silken diplomacy and of silk trade concessions. See further in the present paper 'Silk as part of domestic and foreign policy' with bibliographical references.

5. For the Theodosian Code, see C. Pharr, in: *The Corpus of Roman Law*. I. Princeton 1952, 10.21.3; 10.20.17; 7.1.7; 8.1.13; 8.7.4, 8-9, 16; 12.1.70. For the Justinianic Code see P. Krüger, P. Mommsen, T. Schoell, G. Kroll, *Codex Justinianus*. Berlin 1954, IV.40.1. A relevant Novel of Leo the Wise was published in P. Noailles and H. Dain, *Les Novelles de Léon VI le sage*. Paris 1944, 272-4. The Basilics are published in H. J. Scheltema, N. Wal, P. Holwerda, *Basilika*, Gröningen 1955-1960, see especially, III, 923, BXIX, I, 82.

6. Most recently published by J. Koder, *Das Eparchenbuch Leons des Weisen*. CFHB 33. Wien 1991.

7. Amongst the publications on murex there is an interesting piece by I. Ziderman, 'Purple dyes made from shellfish in antiquity'. *Review of progress in Coloration and related topics*. 16 (1986) 46-52. Consider also, G. W. Taylor, 'Reds and purples: from the classical world to pre-conquest Britain', in: *Textiles in Northern Archaeology*, P. Walton, J. P. Wild ed., (NESAT II. Textile Symposium York 6-9 May 1987). London 1990, 37-46. Murex purples and other Byzantine dyes are discussed in 'Introduction to Byzantine dyes', chapter 3, in a *History of the Byzantine Silk Industry* by the present author, under publication with the Byzantine Institute, the University of Vienna.

8. See note 6 above. Regulations 4.1; 8.2; 8.4.

9. Noailles and Dain cited in note 5 above.

10. E. Manara, 'Gli abiti di corte dal De Cerimonniis', in:*Aspetti e problemi degli studi sci tessili antichi*, ed. G. Chesne, D. Griffo. Firenze 1981, 107-115, on pages 107-108.

11. J. Bekker, *Constantine Manesses. Brevarium Historiae.* Bonn 1837, 285.

12. J. L. van Dieten, *Niketas Choniates Historia.* CFHB, 11/1, 11/2, Berlin, New-York 1975, 189.

13. Ibid. 139.

14. A. Grabar, *Byzantium.* London 1966, 21 plate 2.

15. On the uniforms of different dignitaries, see *Pseudo Codinus*, ed. J. Verpeaux. Paris 1966, 141-66.

16. Different kinds of ceremonial tunics were discussed by J. Ebersolt, 'Les vêtements impériaux dans le cérémonial', in: *Mélanges d'histoire et d'archéologie byzantines.* Paris 1951, part 2, chapter 6, 50-69, with preface by A. Grabar.

17. A. Muthesius, *History of the Byzantine Silk Industry*, Byzantine Institute, University of Vienna (forthcoming), chapter 5, section 2 and catalogue numbers M61, M62, for the Auxerre and the Brixen Eagle silks. For the Cologne Lion silk see chapter 4 and catalogue number M54.

18. Ibid. chapter 5 section 3 and catalogue number M48. The Sion Griffin silk was earlier published in detail by B. Schmedding,*Mittelalterliche Textilien in Kirchen und Klöstern der Schweiz.* Bern 1978, 251.

19. See reference in note 10 above.

20. J. F. Haldon, 'Constantine Porphyrogenitus. Three Treatises on Imperial Military Expeditions'. *CFHB* 28, Wien 1990, 261.

21. The silk trolley covers were reported by the western envoy Liudprand of Cremona. See J. Becker, *Liudprand Antapodosis.* Hannover-Leipzig 1915, chapter 6, 5.8.

22. Verpeaux, *Pseudo Codinus*, 278, lines 14-30; 279 lines 1-9.

23. Haldon, *Expeditions*, 300-301, 247, 256.

24. Ibid. 239.

25. Ibid. 240-241.

26. Ibid. 241.

27. Ibid. 243-244.

28. M. M. Ahsan, *Social Life under the Abbasids*, London 1979, 60 and notes 274, 276.

29. S. Pelekanidis, M. Chatzidakis, *Kastoria*, Athens 1984, 22-45, plate 33 lower right.

30. C. de Boor, *Theophanis Chronographia.* Leipzig 1883, 1885; Hildesheim 1963 reprint, 492.

31. Van Dieten, *Niketas Choniates*, 93.

32. Ibid. 157.

33. Ibid. 119.

34. Haldon, *Expeditions*, 724ff.

35. Two important early works on the subject of Byzantine ceremonial are: A. Alföldi, 'Die Aufgestaltung des monarchischen Zeremoniells am römischen Kaiserhof', in: *Mitteilungen des Deutschen Archäologischen Instituts. Römische Abteilung* 49-50 (1934-35) and O. Treitinger, *Die oströmische Kaiser und Reichsidee nach ihrer Gestaltung im höfischen Zeremoniell.* Jena 1938.

36. M. Canard, Le cérémonial fatimite et le cérémonial byzantin. *Byzantion* 21/2 (1951) 355-420.

37. M. Hendy, *Studies in the Byzantine Monetary Economy*. Cambridge 1985, 269.

38. For diplomacy between Byzantium and the West, see T. C. Lounghis, *Les ambassades byzantines en occident depuis la fondation des états barbars jusqu' aux Croisades (407-1096)*. Athens 1980.

39. Muthesius, *Silk Industry*, chapter 7 section 2 and catalogue number M34.

40. Ibid. chapter 6 and catalogue number M42.

41. Ibid. chapter 4 section 1 and catalogue numbers M52, M53, M54.

42. Ibid. chapter 11 and catalogue number M90.

43. Ibid. chapter 4 section 2 and catalogue number M58.

44. See reference in note 1 above.

45. C. Higgins, 'Some new thoughts on the Nature Goddess silk' and H. Granger-Taylor, 'The inscription on the Nature Goddess silk' both in: *St. Cuthbert, His Cult and his Community to 1200*, G. Bonner, D. Rollason, C. Stancliffe ed. Woodbridge 1989, 329-338 and 339-342 respectively.
 Further, H. Granger-Taylor, ' The earth and the ocean silk from the tomb of St. Cuthbert at Durham, in: *Ancient and medieval textiles. Studies in honour of Donald King*, H. Granger-Taylor, L. Monnas ed., *Textile History* 20/2 (1989) 151-166.

46. Earlier published as a group in A. Muthesius, 'A practical approach to Byzantine silk weaving'. *Jahrbuch des Österreichischen Byzantinistik* 34 (1984) 143-161.

47. Muthesius, *Silk Industry*, chapter 4 and note 42.

48. See E. Grimme, 'Der Aachener Domschatz'. *Aachener Kunstblätter*, 42 (1972) 66-69, no. 44 for the shrine of Charlemagne.

49. For full discussion of the titles see Muthesius cited in note 46 above, 251-252 with notes 47, 48, and 49.

50. To celebrate the millenium of the death of Theophanou in 1991, two important publications appeared. These were A. von Euw, G. Sporbeck ed., *Vor dem Jahr 1000, Abendländische Buchkunst zur Zeit der Kaiserin Theophanou*. Köln 1991; and A. von Euw, P. Schreiner ed., *Kaiserin Theophanuou, Begegnung des Ostens und Westens um die Wende des ersten Jahrtausends*, I, II, Köln 1991. In addition there are under publication the Proceedings of an international conference held in Köln and in Gandersheim on the theme of *Theophanou, Byzanz und Abendland im 10. und 11. Jahrhundert*, (held under the auspices of the Greek-German Initiative centred in Würzburg and presided over by Professor E. Konstantinou). In these Proceedings, the present author's paper is entitled 'The role of Byzantine silks in the Ottonian Empire'.

51. Hendy, *Monetary economy*, 584-585.

52. D. Obolensky, ' Aux sources du Christianisme Russe' in: *Mille Ans de Christianisme Russe 988-1988. Actes du Colloque International de l'Université*. (Paris X-Nanterre, 20-23 Jan. 1988) Paris 1989, 9-15.

53. For Russian-Byzantine trade agreements consult: S.H. Cross, O. P. Sherbowitz, *The Russian Primary Chronicle*. Cambridge Mass. 1953. Silk sails are mentioned on 65 under no. 32. On Byzantine silks in trade in general, see A. Muthesius, 'The impact of the Mediterranean silk trade on western Europe before 1200 AD'

in: *Textiles in Trade, Proceedings of the Textile Society of America Biennial Symposium.* (Washington, Sept. 14-16, 1990). Washington 1991.

54. Obolensky, cited in note 52 above, 12ff.

55. See D. Nicol, *Byzantium and Venice.* Cambridge 1988 and also G. W. Day, *Genoa's response to Byzantium 1155-1204.* Illinois University 1988.

56. For Basil II's dealings with Venice see Nicol, cited in note above, 39-40, 42-48, 50-51, 55, 186, 423.

57. Byzantine-Italian trade relations were fully discussed in R. J. Lilie, *Handel und Politik zwischen dem byzantinischen Reich und den italienischen Kommonen Venedig, Pisa und Genua in der Epoche der Kommenen und der Angeloi (1081-1204).* Amsterdam 1984.

58. See note 21 above for Liudprand. Also see W. Heyd, *Histoire du Commerce du Levant au Moyen Age.* Leipzig 1936, 93-125, esp. 112 and note 2, 114-115 and 115 notes 2-3.

59. Liudprand has been translated in F. A. Wright, *The works of Liudprand of Cremona.* London 1930. For Liudprand's difficulties see chapter LIV, 267ff. especially.

60. For foreign silks imported into Carolingian Pavia, see L. Thorpe ed, *Einhard and Notker the Stammerer. Two lives of Charlemagne.* Bungay 1969, 165-167.

61. Heyd, cited in note 58 above, 116 and note 2.

62. The Syrian silks are detailed in the Book of the Prefect, see Koder cited in note 6 above, 94-97.

63. W. A. Farag, 'The Aleppo question'. *Byzantine and Modern Greek Studies* 14 (1990) 44-60.

Acknowledgements

The author wishes to thank Rex Gooch of Welhandy for the preparation of the master print on equipment kindly provided by Wingate Scholarships, and the British Academy and the Pasold Foundation for conference funding.

XV
The hidden Jewish element in Byzantium's Silk Industry: a Catalyst for the Impact of Byzantine silks on the Latin Church before 1200 AD?[1]

CAIRO Geniza documents published by Goitein illustrate that by the eleventh century there was an advanced silk processing, weaving, dyeing and retailing industry in the hands of Jewish communities over the length and breadth of the Islamic Mediterranean.[2] The question is how far did Jewish silk workers and merchants also participate in the Byzantine silk industry of the Eastern Mediterranean.[3] Not only this, but what was the broader significance of any Jewish participation in Byzantine silk manufacture? Official prejudice did not allow any really marked Jewish contribution to be directly acknowledged in Byzantine sources and it is only by carefully examining the non-Byzantine literature and by analysing the distribution and nature of the surviving mediæval silks in West European treasuries that any kind of representative picture of the situation emerges.

Silk in the Eastern Mediterranean between the eighth and the twelfth **Historical** centuries in particular, acted as a key economic asset on a par with gold, **context** and served a role equivalent to that of present day oil or steel. In matters sericultural, Byzantium stood supremely advantaged in relation to the Latin West, for silk weaving was not introduced there until the twelfth century.[3] As with any valuable economic asset even today, (witness the

Gulf oil crisis in recent times), rare commodities offered endless opportunities for manipulation. Byzantium realised that, with her silk, she had the means to bend nations to her will. So long as she could engender and engineer, as well as maintain sufficient demand for and interest in this rare and desirable commodity, her silken power would remain intact. She certainly exploited this supremacy to the full, and always fully to her sole advantage. She maintained interest in the product by limiting foreign export and by always reserving the most splendid examples for the Imperial Byzantine house. With silks of lesser quality, she supplied foreign nations as different crisis situations arose and as circumstance demanded. At different times between the eighth to the twelfth centuries she exploited silk trade concessions. She thereby gained special military and naval favours, as well as reciprocal trade from nations as varied as the Bulgars, the Russ, the Italians (Venetians, Pisans, Genoese and Amalfians alike) and the Moslem Syrians.[4] From most she demanded military or naval assistance to help guard her Imperial territories against foreign attack; but from Syria she required silk, the essential raw material that sustained her sericultural industry. This she demanded in the face of insufficient domestic raw silk production. So pressing was the shortage of raw material in Byzantium by the tenth century, that in exchange for Syrian raw silk, Moslem Syrian merchants were favoured above all others in Constantinople. Syrians were permitted to reside there on a semipermanent basis in the tenth century. All other foreign merchants were granted permits for no longer than three months. The Byzantines further agreed to purchase all Syrian merchandise that entered Constantinople, whether there was a ready market for it or not, so eager were they to maintain Syrian raw silk supplies.[5]

On the political level, Byzantium had a particular desire for a symbolic western ally in the face of Moslem, and later, Norman and Turkish threats to different parts of her Empire. Towards this end, she established with the German Imperial house, from the eighth century onward, an avid silken diplomacy.[6] No less than sixteen marriage alliances were either negotiated or arranged between Byzantium and the West during the course of the eighth to the twelfth centuries, and nuptial diplomacy was accompanied by splendid Imperial Byzantine gifts of silk.[7] In short, the power and the prestige of the Byzantine Empire were woven into the very fabric of her silks. With these fabrics she set out to project an Imperial image to the rest of the world. This image extended over religious as well as secular domains, for Byzantine Emperors saw themselves as God's representatives on Earth. It was important for them to be seen in sumptuous silks within magnificently silk festooned religious edifices; both the buildings and the Imperial persona reflected the Glory of God. For this purpose, there grew up in Byzantium between the fourth and the

twelfth centuries, an elaborate silken ecclesiastical ceremonial. This entailed lavish use of silk church furnishings, hangings and vestments, icon covers and holy manuscript covers of silk.[8] Most important, the relics of the saints were enveloped in silks before they were encased in reliquaries. This eventually led to the growth of an enormous silken cult of relics, which in turn exerted an immense influence on the Latin West.[9] So powerful was the influence of Byzantine ecclesiastic ceremonial over Western Europe, that by the eighth to ninth centuries, a handful of Popes alone had donated more than one thousand specially imported silks for use in the important churches of Rome.[10] The survival of several hundred Byzantine silks in western church treasuries to this day further under-lines the immense store set on the acquisition of such fabrics in Western Europe before 1200 AD[11]

With the knowledge that skilled Jewish silk workers and dyers were **The Jewish** available within her Empire, one might argue that Byzantium would have **contribution** been anxious to exploit the situation, It has to be remembered that, particularly from the fifth century onward, there was an ever present intolerance towards the Jews in the Empire. The Orthodox Church strove increasingly to isolate the Jewish community, and Jews were barred from holding public office. Nevertheless, one can envisage a situation whereby the Byzantine state was too astute to let the particular talents of the Jews in her midst go to waste, and she therefore devised an 'undercover' means of harnessing this potential silk producing power. In a delicate situation of this kind, it is not surprising to find only the merest hint of Jewish participation in the silk industry documented in official Byzantine sources. It is only in Jewish sources that something of the truth begins to emerge. Important amongst the relevant documents is a Cambridge University Library Cairo Geniza fragment Or 1081 J 9, which paints a bleak picture of the fate of a Jewish Imperial silk dyer, who fled from Constantinople to Egypt on a charge of spoiling an Imperial silk.[12] He was tortured almost to death and his children were held to ransom, before he escaped to seek funds from his co-religionists in Egypt. The document vividly illustrates several points: the employment of a Jewish dyer in the Imperial silk industry; the tremendous value of the dye materials entrusted to him; and the harshness of the Imperial house towards the dyer who erred in his duties. Whether the punishment meted out to him would have been less cruel had he been a Christian dyer is open to question. It should be borne in mind that the spoilt silk very probably had been treated with a priceless Imperial murex purple dye. The accepted penalty for the improper use of this dye was death, whoever it was that was at fault.[13]

At this point it is relevant to stress that Jewish craftsmen had long been renowned for their skills in dyeing and in silk weaving. In Palestine, silk working and the association of Jewish dyers with murex purple dyes reached back to antiquity. Purple in the Bible and in Talmudic literature is indicated by the words *tekhelet* and *argaman*. The Talmud, indeed, contains a passage explaining the *tekhelet* dye process for colouring the fringes on priestly vestments.[14] In this connection it is interesting to tie in a post-Talmudic source Maimonides (d. 1204), who discussed the use of linen and wool priestly vestments in some detail.[15] The ordinary priest had four white linen vestments and an embroidered girdle of wool. The High priest had, in addition, gold vestments, a robe, an ephod worn over his back and shoulders, a breastplate and a frontplate (*Book of Temple Service* 8: 1, 2). It was specially noted that *tekhelet* designated wool dyed sky blue and that *argaman* meant wool dyed red, whilst *tola at hassani* meant 'wool dyed scarlet with the dye from a worm' (8.13). The High priestly robe was sky blue and the skirt on either side was hung with sky blue, red and scarlet wool fringe and bell attachments (9.4). The gold thread of the ephod and the breastplate consisted of twined yarns; a special combination of numbered pure gold, scarlet, red, and sky blue linen threads.

Specific association of purple with silk could not have occurred in a Temple context, since by tradition it was linen and wool that were prescribed for Temple vestments. The association of murex purples with silk must have occurred elsewhere. When Cosmas Indikopleustes in the sixth century emphasised that Jewish craftsmen 'most zealously culti-vated' various arts amongst which were 'workmanship in blue and purple and scarlet thread, and fine twisted linen', the context is apparently again a temple setting.[16]

In Byzantium, from as early as the fourth century, the use of certain special murex purple dyed silk fabrics, was reserved exclu-sively to the Imperial house. At this time only female Christian weavers were employed in Imperial silk weaving establishments. One reads that some of these workers had left the Imperial factories, supposedly enticed by Jews, but they were severely reprimanded and instructed to return to the Imperial service (Theodosian Code 16.8.6). In the sixth century both male and female Christian silk workers were recorded in Imperial service. The question remains how early Jews were employed as silk workers or purple dyers? The first explicit mention of Jews in the Imperial service is in the Cairo Geniza fragment already referred to, which dates eleventh to twelfth centuries. It is likely that Jews were active in the Byzantine silk industry earlier than this, at least in the non-Imperial silk guilds of Constantinople. At any rate, the tenth century *Book of the Prefect*, a work which gives detailed regulations for

the non-Imperial guilds in Constantinople, includes a 'Jewish oath', to be taken by those who could not swear allegiance by the Christian formula.[17] These regulations stipulate that raw silk was not to be handled by Jews, lest they sell it outside the Capital. The export of raw silk from the Empire was anyway totally forbidden. Since Jews could not trade in raw silk, how else could they have been active in the industry? One way seems to have been as dyers of purple. In view of the large numbers of special purple silks that the non-Imperial guilds were obliged to supply to the Imperial court in the tenth century, this seems a likely suggestion.[18] It is known that Jewish dyers were active in parts of the Empire in the mid Byzantine period. An example is the epitaph of a young Jewish dyer, Caleb, discovered at Corinth.[19] It is known that by the twelfth century, Corinth, amongst other Byzantine centres, housed a good number of Jews occupied in the silk and in the dyeing industries.

The eleventh and twelfth century documents recovered from the Cairo Geniza and utilised by Goitein in his book *A Mediterranean Society*, give some idea of the wide range of services that Jewish craftsmen were capable of offering to the silk industry. The enormous contribution of Jews as raw silk handlers, weavers, dyers and merchants in and well beyond the Eastern Mediterranean makes it clear that Jewish craftsmen could have operated skilfully within any branch of the Byzantine silk industry whether private or Imperial. Similarly, Jewish merchants would have been capable of carrying Byzantine silks to all corners of the Mediterranean and the Near East. The question is not one of whether they were capable workers but only of how far they were actually allowed to participate in the Byzantine silk industry.

Byzantine sources give us no real clue as to how widespread such participation was, but we have explicit reference to it in the writings of Benjamin of Tudela, who travelled extensively in the Byzantine Empire in 1161-62.[20] Of Thessaloniki he wrote, 'It is a very large city with about 500 Jews... There are restrictions on the Jews and they are engaged in the manufacture of silk garments'. Visiting Constantinople itself, he found, 'about 2,000 Rabbinite Jews'; 'Amongst them are workers in silk, many merchants and many rich men'. The Jews lived in the district of Pera and were separated from the Christian population of the Capital. Nicetas Choniates, brother of the twelfth century Athenian ecclesiastic Michael Choniates, speaks of the splendid silk dress of the local Byzantines in his time.[21] One might venture to suggest, in view of Benjamin's testimony, that some of the silks worn may well have passed through Jewish hands. Similarly, it is interesting to speculate, in the absence of explicit information from Byzantine documents, about the precious Byzantine brocade bed covers that reached Fustat and were sold to decorate the homes of

Jewish brides. Were they produced in the Capital and were they transported to Egypt by Jewish merchants? Alternatively, were they woven and transported by Jews operating in the provinces? There are some rare reports of Byzantine merchants at Fustat. Byzantine silks were usually sold to Islamic nations via Trebizond, whilst from the tenth century they were carried directly to Western Europe by Italian merchants.[22] There is evidence that Jewish merchants were active in Byzantine trade at an earlier period. From the seventh to the ninth centuries they were known to have carried goods between China and Byzantium and to the Near East, as well as the eastern and the western Mediterranean and the Latin West.[23] These Rhadanite merchant adventurers were active in a diverse and remarkably widespread trade. They appear to have been displaced only by the growth of the Italian mercantile states from the tenth century onwards.[24]

An interesting offshoot of this earlier Jewish silk trading activity in the Latin West is evinced by a series of Central Asian silks that still survive in situ in a number of mediæval ecclesiastical treasuries in Belgium and France. A lion silk at St. Servatius, Maastricht is one striking example.[25] Byzantine trade connections with Central Asia are well documented. It is noteworthy that Byzantine silks totally transformed the motifs and colour ranges of Central Asian silk weaving centres in the tenth century.[28] Here Jewish merchants were responsible for carrying Byzantine influence to the 'far ends of the earth'.

Conclusion This brief glimpse of Jewish involvement in International silk production and trade in the Middle Ages, makes it is possible to place into a firmer context the scantily-documented Jewish contribution to the Byzantine silk industry. Already master craftsmen in silk production and in purple dyeing from an early date, the Jewish silk worker employed in the private or Imperial silk industry would have had much to offer. At the same time their services may have been cheap to secure, since they stood at a social disadvantage in an empire where Jews were tolerated rather than treated as equals. Nevertheless, reports of rich Jews, some of them directly involved with silk, suggests that by the twelfth century in the provinces in any case, this activity was richly rewarded despite any state imposed disadvantages. The intricate trading network and the advanced trading partnership organisation attested by the Cairo Geniza documents in respect of Jewish silk merchants plying their trade between Sicily, Spain, Egypt and the Near East, indicate the sophistication of Jewish industrial organisation and merchandising practice already in place in the eleventh century across the Islamic world. Perhaps a similarly sophisticated organisation existed, albeit on a much smaller scale, amongst Jewish silk

trading communities in provincial Byzantine centres by the twelfth century. It may be nothing more than lack of documentation for Jewish involvement in silk-working and silk-trading communities in the provinces (Thessaloniki, Corinth and Thebes included) that so far has prevented an appreciation of the true extent of the Jewish contribution to silk manufacture and trade in Byzantium as a whole. What evidence there is certainly suggests that ancient Jewish skills in the weaving and dyeing of silk, as well as involvement in International trade, were put to good use in Byzantium in both Imperial and private contexts. In conjunction with the evidence from the Cairo Geniza about Islamic lands, it is time to recognise the major impact the Jews may have exerted on the Byzantine silk industry and the international trade in Byzantine silks. Some of the silks preserved in church treasuries in the Latin West are a key testimony to this activity.

NOTES

1. This paper was originally read to the Seminar in Hebrew and Jewish Studies at Cambridge University in the Lent term of 1992 (March 11). I am indebted to Dr. Nicholas de Lange for inviting me to speak and for subsequently requesting me to publish my talk here. I also wish to thank Wingate Scholarships for supporting my research.

2. See S. D. Goitein, *A Mediterranean Society*, I (London, 1967) 101-108, and numerous other references to 'silk' in the index (p. 547). See also volume IV and the index (p. 484). Passages cited include descriptions of Byzantine brocades used for decorative purposes, e.g. page 299.

3. The first Latin silk weaving workshop was established in Palermo in 1147 by Roger of Sicily, who had forcibly transported silk workers from Thebes and Corinth to work in his establishment. The Latin report of the incident is by Otto of Freising; see *MGH Scriptores*, XX, 370. Otto mentions Athens alongside Thebes and Corinth but the Greek report by Nicetas Choniates omits Athens. For Choniates see ed. I. Van Dieten, Chronike diegesis 74. 76. 98. I am grateful to E. Kislinger for bringing this discrepancy to my notice. An inscribed silk with the name of Palermo survives in the Kestner museum, Hannover. See R. Gronwöldt, *Webereien und Stickereien des Mittelalters*, (Hannover, 1964) 37, Inv. 3875, cat. no. 31.

4. For a discussion of the silk trade concessions with further bibliography see A. Muthesius, The Impact of the Mediterranean silk trade on Western Europe

before 1200 AD, in Textiles in Trade, *Proceedings of the Textile Society of America, Biennial Symposium* September 14-16, (Washington, 1990) 126-135.

5. See J. Koder, *Das Eparchenbuch Leons des Weisen*, Wien 1991. For the main Syrian silk regulations see 5.1-5, on 95-97.

6. See A. Muthesius, ed. S. Franklin, J. Shepard, *Silken Diplomacy*, Papers from the twenty fourth Byzantine Spring Symposium, Cambridge U.K. March 1990 (London, 1992) 237-248.

7. The uses of silk in Byzantium are discussed in A. Muthesius, *A History of Byzantine Silk Weaving*, (ed. Byzantine Institute, University of Vienna), forthcoming. Its use on Byzantine bindings was treated in A. Muthesius, Eastern Silks in Western Shrines and Treasuries before 1200 A.D, PhD thesis, Courtauld Institute of Art, University of London, 1982, 291-305 and 325-328.

8. The ceremonial is most clearly expressed in the tenth century *Book of Ceremonies*. See I. I. Reiske, *ed., Constantini Porphyrogenti imperatoris, De Caerimoniis aulae Byzantinae*, I-II, (Bonn, 1829-31).

9. The influence of Byzantium is apparent in Aachen from an early date. See A. Muthesius, Politics, piety and the silken cult of relics: Aachen Munster silks in historical context, in *Proceedings of the Third Euregio Congress on Rhine Maasland textiles*, Aachen May 12-15, 1992 forthcoming. Cf. A. Muthesius, The Rider and the Peacock silks, in: *St. Cuthbert, his cult and his community to AD 1200*, (Woodbridge, 1989) 343-366.

10. See L. Duchesne, *Liber Pontificalis*, I-II, (Paris, 1892).

11. More than a thousand Eastern Mediterranean silks were listed by the author in her doctoral thesis, (see note 7 above), of which two thirds were found to be Byzantine pieces that reached Western shrines and treasuries before 1200 AD.

12. See Goitein, op. cit., I, 50, section i, 2 and note 54.

13. For regulations on Imperial purples see C. Pharr, ed., Theodosian Code 10.21.3 in *Corpus of Roman Law*, I. (Princeton, 1952) 10.21.3; Codex Justinianus IV.40.1 in P. Krüger, Codex Justinianus, (Berlin, 1954); P. Noailles and A. Dain, *Les Novelles de Léon VI le Sage*, (Paris, 1944) 272-274, Novel LXXX; H. J. Sheltema, N. Wal, P. Holwerda, *Basilika*, (Gröningen 1955-1960) 111, 923, B xix, I. 82.

14. See ed. E. Spanier, *The Royal Purple and the Biblical Blue, Argaman and Tekhelet*, (Jerusalem, 1987); I. Herzog, The dyeing of purple in ancient Israel. *Judaism Law and Ethics*, (London, 1974) 1-11; Y. Yadin, The finds from the Bar-Kokhba periods in the Cave of Letters. *Judean Desert Studies*, (Jerusalem, 1963) 171ff. (dyes and colours). In addition, A. Baginski delivered a paper on, 'Textiles in the Mishnah and the Talmud' at the early Textiles Symposium, (Manchester, 1988).

15. M. Lewittes, *Code of Maimonides*. Book 8. (London, 1957) 69-80.

16. Kosmas Indikopleustes, *Christianike topographia* III 70 (I 511 Wolska-Conus) cited also by E. Kislinger, Jüdische Gewerbetreibende in Byzanz in: *Die Juden in Ihrer Mittelalterlichen Umwelt*, (Wien, 1991) 105-111. I wish to thank the author for sending me a copy of this article, which I received after my paper was read in Cambridge. See also, Id., Gewerbe im späten Byzanz in: *Handwerk und Sachkultur im Spätmittelalter*, (Österr. Akad. Wiss., phil. hist. Kl. Sitzungsberichte 513) (Wien, 1988) 104-105.

17. See J. Starr, *The Jews in the Byzantine Empire* 641-1204. (Athens, 1939) 20, 21, 163ff., 221ff..

18. See Koder op. cit., 103-107.

19. J. Starr, The epitaph of a dyer in Corinth, *Byzantinische Neugriechische Jahrbücher*, 12 (1936) 42-49.

20. See M. Adler, *The Itinerary of Benjamin of Tudela*. (London, 1907). See also Kislinger, Jüdische Gewerbetreibende, 106 and n.15.

21. Niketas Choniates, *O City of Byzantium*, translated by H. J. Magoulias (Detroit, 1984) 317. He mentions 'luxurious garments and elegant royal veils at Constantinople'.

22. See for instance R. J. Lilie, *Handel und Politik zwischen den byzantinischen Reich und den Italienischen Kommonen Venedig, Pisa und Genua in der epoche der Komnenen und der Angeloi* (1081-1204), (Amsterdam, 1984).

23. See L. I. Rabinowitz, *Jewish Merchant Adventurers*, (London, 1948).

24. See R. J. Lilie op. cit. and also A. Lewis, *Naval power and trade in the Mediterranean AD 500-1000*. (Princeton, 1951).

25. On this silk see Muthesius, *History of Byzantine Silk Weaving*, catalogue M1175b and chapter on Byzantine influence upon Central Asian silks. See also A. M. Stauffer, *Die Mittelalterlichen Textilien von St. Servatius in Maastricht*. (Berne, 1991) Inv. no. 7.

26. See Muthesius 'Impact of the Mediæval Silk trade' (see note 4 above), p. 132, references to Pigulevskaja and Frye.

ADDITIONAL NOTE

See further note 59, page 334

XVI
The Byzantine silk industry: Lopez and beyond

ABSTRACT

The Byzantine silk industry played a major role in the history of the Byzantine Empire. Silk, a key economic asset, had strong political overtones, and the effects of its multiple influences were felt far and wide, both within Byzantium and abroad. This article highlights some of the difficulties encountered in the interpretation of important documentation surrounding the Byzantine silk industry in the period up to 1204 A.D.

1. INTRODUCTION

SURPRISINGLY, only one extensive article on the history of the silk industry in the Byzantine Empire has been published (Lopez 1945) and no full review of this seminal piece has emerged over the last forty five years. The article well deserves careful analysis, for both directly and indirectly, in it Lopez raised many important questions about the structure and the running of the Byzantine silk industry up to the twelfth century. In his introduction Lopez emphasised the dual role of silk in the

Byzantine Empire: it served not only as an economic asset but also as a political tool. Silks were desirable items of manufacture, luxuries with potential for raising considerable trade revenue. Imperial Byzantine silks in particular carried unmistakable political overtones.

The Imperial silk industry primarily manufactured garments for the court whilst the non-Imperial silk industry mainly supplied private wealthy customers with impressive fabrics. For those who could not afford to buy silks themselves, the chief benefit was that an active silk trade and silk diplomacy engendered and fostered a general economic and political stability in the Byzantine Empire. The strict Imperial administration of the whole of the silk industry, Lopez considered worthy of praise rather than criticism. Controls of standards of production as well as adequate export controls were essential to the health of the industry he argued. Three questions in particular interested Lopez: "Was the Imperial silk monopoly effectively protected; was it not too costly in economic terms and was it an effective weapon?" Lopez argued that export control regulations largely worked and that they did prevent certain silks from leaving the Empire illicitly. In the absence of essential statistics he felt unable to provide the answer to the second question, the economic cost of maintaining a luxury Imperial silk industry. His reply to the third question was positive. Byzantine silks were a symbol of power in the eyes of foreign rulers, who vied with each other to obtain the precious stuffs. This article aims to reach out beyond the conclusions drawn by Lopez in two particular ways. First through the application of a practical approach to the historical documentation it seeks to understand how the non-industrialised silk industry of the Byzantine Empire functioned at grass roots level. This approach uses empirical evidence from contemporary non-industrialised silk production and it illustrates how literal interpretation of key historical documentation can be misleading in the light of practical considerations. Second the author examines the evidence of the surviving silks in relation to conclusions reached by Lopez in the absence of reference to the extant material. Whilst agreeing with Lopez that Imperial regulation of silk manufacture in general was beneficial and effective, the survival of a large body of Byzantine silks in Western Europe prompts the author to raise new questions about the economic cost of the so-called 'Imperial monopoly' (PL. 57). Were Byzantine silks as difficult to obtain abroad as Lopez and later authors have implied? Was the non-Imperial silk industry truly as restricted in its output and export capability as suggested so far? The author concludes that the surviving material suggests a thriving export market and one which paralleled production in the Islamic Mediterranean and the Near East. In the context of silk production in the Mediterranean as a whole, it appears that Byzantium was no less anxious to export to Western Europe than Islamic producers

were keen to export to the Near East. How far an 'Imperial monopoly' was intended to maintain standards and prices as against restricting economic growth and exports, requires thought. Traditional and purely documentary-based ideas about the constrained size of the Byzantine silk industry, its lack of economic significance and its narrow cultural influence, are subject to scrutiny in the light of the evidence of the surviving silks.

2. THE MAIN POINTS RAISED BY LOPEZ

TO appreciate individual points that Lopez made, it is helpful to outline his arguments under the headings he used in his article. Where appropriate comments by later authors are added and discussed.

Lopez sought the origin of the Byzantine silk industry in late fourth century Imperial silk guilds, which supplied silks to the Emperor and to his court and wove state presents for despatch to foreigners. Three late Roman state guilds, the gynaeciarii, the bapheis or purpurarii and the barbaricarii Lopez saw as the forerunners of Imperial tenth century clothiers and tailors, purple-dyers and gold embroiderers. In a note he remarked that the Roman Empire "knew no legal distinction between the Imperial guilds, directly managed by the state and for the state, and the private guilds working as self managed enterprises but responsible to the state for the execution of specific public works." (Lopez 1945:5 note 2). Vryonis accused Lopez of confusing the Imperial silk guilds with the private silk guilds, and he also pointed out that it was incorrect to say the Basilica did not include regulations governing non-Imperial guilds (Vryonis 1971:300-301 note 46).

The Imperial guilds: an aristocracy of labour

By the first half of the seventh century, Lopez detected a complete transformation from obligatory and hereditary duty to privileged and non-hereditary service in the Imperial silk industry (Lopez 1945:4-5). In the ninth to tenth centuries he argued, the Imperial silk workers formed an 'aristocracy of labour' and participated in the finest Imperial processions. Essentially, he felt that the organisation of the Imperial silk industry if not its structure, had remained untouched between the fourth and the tenth

centuries. The late Roman provost of workers and the director of the weaving establishments, the praepositi and the procurator, he saw as the forerunners of the μειζότεροι or πραιπόσιτοι and the ἄρχων ἐργαστηριάρχης or the μελήδων (Lopez 1945:6-7). The duties of the Late Roman Count of the Sacred Largesses were assumed by the head of the Eidikon Lopez argued, and very likely the Prefect of the City like his predecessor the Praetorian Prefect retained supreme control over all industry in the Capital. The Prefect certainly was caretaker of standards and practices in the private sector of the silk industry according to the Book of the Prefect.[1]

Provincial guilds in the Late Roman period were supervised by the Count of the Sacred Largesses but by the seventh century the provincial governors had taken over control. Sometime between the seventh and the ninth to tenth centuries Lopez considered that all provincial textile factories were suppressed and weaving was concentrated in the Capital (Lopez 1945:7-8).

The decline and the renaissance of private industry

The five private or non-Imperial silk guilds, the Metaxopratai, the Katartarioi, the Serikarioi, the Vestiopratai and the Prandiopratai, Lopez respectively identified as: the merchants of raw silk; the silk spinners; the clothiers and dyers; the merchants of domestic silk garments and the merchants of imported silk fabrics. These attributions will be examined in further detail later in this article. The non-Imperial guilds produced less valuable silks than the Imperial industry and were subject to rules of the Book of the Prefect. The workers were not members of hereditary castes and they did not directly stem from any ancient guild system (Lopez 1945:8-9).

The rise of the private industry Lopez saw as a concomitant of the decline in the Imperial monopoly over silk supply and manufacture. To illustrate this Lopez gave a brief resume of the history of the regulations governing the purchase of raw silk. He saw a development from a rigid, centralised, Imperially controlled purchasing machinery under the Comes Commerciorum per Orientem in the fourth century, to a wider network of officials, the kommerciarioi, in the seventh. He noted that the latter appeared before the former had disappeared (Lopez 1945:9, 12). This point will be discussed further below. The catalyst for the broadening of silk purchasing possibilities, Lopez equated with a reaction against the unfortunate raw silk purchasing policy of Justinian in the sixth century. Based on Procopius' account of events, Lopez argued that Justinian had set the purchase price of raw silk very low at 8 nomismata a pound, with the result that foreign dealers refused to sell. Consequently, the lack of raw silk led to the ruin of the private silk industry (Lopez 1945: 11). Nevertheless, Lopez could not explain why the Imperial silk industry was

not similarly disastrously affected by the dearth of raw material. Oikonomides disagreed with Lopez about the ceiling price of 8 nomismata in so far as he thought this applied to garments and not to raw silk. He thought that garments worth more than 8 nomismata were the subject of restrictive regulation (Oikonomides 1986:33-34, note 4). At the same time Justinian raised the price of Imperial silks to 6 nomismata, the special holoveron pieces, to 24 nomismata an ounce (Lopez 1945:12).

Kommerciarioi mentioned in an undated Novella entitled 'Peri Metaxes' were ordered to purchase raw silk at 15 nomismata a pound and to retail it at the same price to metaxarioi and to other unspecified persons (Lopez 1945:12-13).[2] Lopez contended that the mention of kommerciarioi suggested a post Justinianic date for the Novella but this is unacceptable. References to kommerciarioi reach back to the fifth century as shown by Oikonomides, who considered that the Novella could not be firmly dated on present evidence. Oikonomides suggested only that the possibility the Novella post dated the 8 nomismata regulation could not be ruled out (Oikonomides 1986:34-35, 37ff.). These issues are discussed in greater detail later.

Whether or not the kommerciairoi merely dealt in raw silk is another matter to be considered. As Hendy pointed out, there is evidence to show that they handled other supplies too (Hendy 1985:630ff.). Naturally, a precise definition of the role of the kommerciarioi is helpful in examining the conclusions reached by Oikonomides and broader analysis of these issues is presented below together with the question of raw silk supply in the time of Justinian. Some fresh avenues of thought are explored and a number of serious objections are raised to Lopez's suggested date for the introduction of the silk worm in to the Byzantine Empire (553-554), (Lopez 1945:11-12).

Imperial monopoly over certain types of gold and purple silk clothing Lopez saw as a source of contention. Illicit manufacture of forbidden cloths indicated the populace did not accept the hierarchy of clothing that the Imperial house wished to impose (Lopez 1945:9-11). Justinian attempted to cope with the problem by temporarily allowing women to wear even the finest of the Imperially produced silks. Meanwhile, the number of Imperial purple dyers had become excessive and some were discharged from their duties under Justinian (Lopez 1945:5). This action would have been unthinkable in the fourth and the fifth centuries, when special legislation was issued to prevent an illegal drainage of manpower from the Imperial to the private sector.

The private guilds and the other authorized manufacturers Apart from the five private guilds detailed in the Book of the Prefect Lopez noted that the ἀρχοντικά πρόσωπα, wealthy Byzantine citizens, had author- ity to manufacture silks for private use (Lopez 1945:15). There were also poorer silk workers, probably non-guild members, called the μελαθράριοι, the μεταξάριοι and the εὐτελέστεροι Κατταρτάριοι (Lopez 1945:16, note 3).[3] The poorer silk workers could purchase raw silk from richer guild members, who were entitled to make a profit of no more than eight and a half per cent (Lopez 1945:16). This and other silk regulations of the Book of the Prefect are studied in greater detail below.

Lopez noted that the private manufacturers were restricted in the types of silks they could legally manufacture. Certainly, Imperial purples were amongst the items forbidden to them: the κεκωλυμένα detailed in the Book of the Prefect (Lopez 1945:15, cf. 10 note 2).[4] Leo VI did allow small pieces of Imperial purple to be worn (Lopez 1945:14 note 3).[5] Neverthe- less, the Basilics in force under the same Emperor, essentially adopted the prohibitions of the Theodosian and the Justinianic Codes. Capital pun- ishment had been and it remained the normal penalty for illicit manufac- ture of forbidden purples (Lopez 1945:14 note 2).

Lopez mentioned the abolition of sales tax on raw silk coming in to the Capital in the tenth century and he saw this as an indication of a shortage of raw material. He pointed to the puzzling term assigned to those bringing in the precious raw material, the ἀπὸ τῶν ἔξωθε, which meant 'those outside the city'. The latter did not specify whether or not the strangers were foreigners to the Byzantine Empire (Lopez 1945:14 note 1). However, Lopez argued justifiably, the fact that they were lodged in 'mitata' indicated they did come from abroad (Lopez 1945:25 note 2).

A powerful 'silk guild profile' had been forged by the tenth century under a 'rising oligarchy of masters' according to Lopez. Vryonis later produced an interesting article on the political role of the non-Imperial guilds (Vryonis 1971:288-314). More recently, Hendy argued that the economic and social development of the mercantile classes between c. 1080 and 1180 had been politically blocked quite deliberately (Hendy 1985:664).

Guild equality and industrial integration: a parallel with Western Europe To dispel Nicole's contention that the Byzantine Emperors were blind despots regulating all economic development within the Empire, Lopez drew attention to the work of Andreades and Mickwitz (Lopez 1945:17 note 2, cf. 3 note 1, 4 note 1). He also showed that regulations in the Book of the Prefect prefigured those later imposed on the independent textile guilds of Western Europe (Lopez 1945:17 note 3). Lopez saw the prologue to the Book of the Prefect as expressing the personal concern of the Emperor Leo VI for justice and equality amongst members of the mercan-

tile classes. The key factors behind Leo VI's legislation Lopez saw as, "stability, control and sharing of business opportunity" (Lopez 1945:18).

No doubt the regulations that obliged certain guild members to pool their resources and to function as a cartel in the purchase of raw materials did encourage equality of opportunity.[6] However, as Lopez indicated, some of the silk guilds seemed particularly powerful. The Μεταξοπρᾶται or silk merchants, and the σηρικάριοι, whom I see as factory owners, and whom Lopez termed clothiers, had power to hire in workers for example (Lopez 1945:18-19). Lopez pointed out how the σηρικάριοι could manufacture, dye and sell cloth and they could set slaves in their place to run their business. In fact, slaves could become full members of the guilds both of Metaxopratai and Serikarioi (Lopez 1945:19).[7]

The private silk industry in Constantinople ultimately was responsible to a state official, the Prefect or Eparch of the city. He policed standards and prices and ensured that forbidden silks, 'kekolymena', did not leave the Capital without his authority. These forbidden silks were destined for the personal use of the Emperor and for distribution abroad or to senior members at court and in the military and civil administration. Lesser officers received non-Imperially manufactured cloths, purchased on the open market (Lopez 1945:21).[8] Most recently Haldon has made a study of the types of military garments described in the Baggage Train account of the Book of Ceremonies and some of these terms are discussed in greater detail below (Haldon 1989:30, 5-6 and 26, 6).

Hierarchy through clothing and the regulation of internal trade

For non-citizens of the Capital in the tenth century there were no restrictions on the multiple purchase of silk garments, provided that individually their value did not exceed ten nomismata (Lopez 1945:21-22). Lopez thought that it was difficult to judge the precise value signified here. Nevertheless, there are roughly contemporary accounts of horses selling for twelve nomismata, and these provide a guide to the worth of the more valuable garments.[9] Ostrogorsky and Hendy estimated the cost of accepting certain civil offices in the Byzantine Empire and the level of pay of different military and civil bodies, and these figures are similarly useful in assessing the buying power of ten nomismata in the tenth century (Hendy 1985:182-187). It must be noted that Russian traders were specially privileged in being able to buy garments priced at 50 bezants. Presumably these were equivalent to the cost of five of the most expensive silk garments available on the open market in Constantinople in the tenth century (Cross and Sherbowitz 1953:73ff.).

Lopez considered that the regulations were concerned with ensuring adequate supplies for the Capital. This is why there were restrictions on export of garments and why raw silk was not to be sold to Jewish

merchants, who might smuggle it out of Constantinople (Lopez 1945:23). Benjamin of Tudela certainly was impressed by the fine silk clothing of the citizens of the Capital (Lopez 1945:24). Lopez indicated that provincial silk manufacture seemed to have been suppressed before the tenth century, but although there may have been no Imperial factories in the provinces, there was private industry. Nicetas Choniates spoke of the fine silks in the Capital, made in Thebes and Corinth.[10] Roger of Sicily had raided these cities and according to Otto of Freising Athens also, in search of silk weavers for his workshop in Palermo in the mid twelfth century (Lopez 1945:24 note 3). It should be said that the Greek sources do not include Athens and that no other record of silk weaving there survives, and this could indicate an inaccuracy on the part of Otto of Freising.

Lopez asked an interesting question which deserves fuller study. The question was to what extent the Jewish people played an active role in the silk industry of the Eastern Mediterranean. The silk trade was peppered with Jewish merchants from at least the seventh century onwards and Jewish purple dyers were attested in documents (Lopez 1945:24 note 4 cf. Kislinger 1990). Lopez suggested that there may have been a form of Jewish oath for those Jews unable to enter the silk guilds in Constantinople in the tenth century. This oath would have marked entry into some type of Jewish silk association (Lopez 1945:24 note 4; Starr 1939:163, 219, 221-222).[11] The regulation against selling raw silk to Jews in the Book of the Prefect does indicate their presence in the Capital and suggests an association with the silk trade. However, if the Jews did not handle the raw silk, their role in the manufacturing process can not have been that of silk merchant or of silk dresser. Neither could they have been weaving without access to raw silk. In my opinion the only way in which they could have taken part in these processes of silk manufacture would have been to find employment in the service of either a member of the guild of Metaxopratai or a member of the guild of Serikarioi.

The clearing houses and the general regulation of foreign trade Border outposts set up under the Late Roman Empire were customs centres for collection of ten per cent sales tax whilst serving too, as police stations and as venues for state-controlled fairs. Trebizond, Aleppo and Kherson where cited by Lopez as late examples of such border outposts (Lopez 26 note 4). In general after the sixth century, collection of customs dues was placed increasingly into the hands of the kommerciarioi in charge of apothekai, spread across the Empire (Lopez 1945:27). Hendy discussed their role in great detail and references to his conclusions are made later (Hendy 1985:592, 626-642, 654-62).

During the tenth century in Constantinople foreign merchants in the Capital were under close surveillance. Most were housed in a special

lodging house and could stay for three months only. They had to declare all they brought in and all they took out of the Capital. The merchandise that they purchased was declared to the Prefect by the vendors of the silk garments (Lopez 1945:28, note 1).

Lopez stressed the importance of tenth century commercial agreements between Byzantium and her Northern neighbours the Russ (Lopez 1945:34, notes 1-4, 35, notes 1-4). He noted also that Byzantium and the Moslem world, not least Syria, concluded silk treaties of paramount importance on a diplomatic as well as a commercial level (Lopez 1945:29-31). The western Moslems traded in Constantinople, others carried out their business in Trebizond (Lopez 1945:29, note 3). The Syrians enjoyed very special trade agreements with Byzantium in the tenth century. After the re-conquest of Northern Syria in the second half of the same century there was a special agreement, whereby the rulers of Aleppo extended special protection to Greek caravans. Even the ten per cent sales tax was shared between the Moslems and the Greeks (Lopez 1945:30, notes 1-3, 31, note 2). Farag discussed the treaty in detail in relation to the role of Syria as a buffer state between Byzantium and the Arabs (Farag 1979:167ff. cf. Farag 1990). **Commercial treatise with the Moslems and the Slavs**

The Bulgars trading linen and honey, were less favourably treated by Byzantium from the tenth to the early eleventh century, prior to their subjugation under Basil II (Lopez 1945:31, note 1). Undeniably, through the medium of trade treaties Byzantium was able to press her silks into duty for political ends. Military or naval support was received from the Russ, even from the Bulgars on occasion, not to mention the Venetian and other Italian states, largely in return for silk trade concessions (Lopez 1945:31-32).

Indeed, Lopez described how Byzantium traded with the West from the ninth century onwards through the intermediary of Venice rather than directly (Lopez 1945:36). After the failure of a reciprocal Byzantine Western trade agreement of 812, the way was paved for Venice steadily to become almost like a vassal state of Byzantium. She was called upon for naval and military support against the Arabs and later the Normans and the Turks threatening the Byzantine Empire (Lopez 1945:38-40). Amalfi and later Pisa and Genoa too, were political and economic allies of the Empire at one and the same time (Lopez 1945:36-38). By upholding the restrictions on the export of the most precious silks from the Empire, Byzantium was able to maintain western demand for them right up to the twelfth century. **Commercial treatise and trade relations with Western Europe**

3. SUMMARY OF THE MAIN ISSUES RAISED BY

LOPEZ'S ARTICLE

THE most important question that Lopez raised throughout the article was, 'What was the role of the silk industry in Byzantium?' In answer to this question he provided examples illustrating the joint economic and political significance of the industry, for instance in trade agreements. The relationship between silk, trade and politics is a burning issue in the article. Lopez correctly pointed to Byzantium effecting economic concessions as a matter of political necessity. One could ask to what extent was inadequate military and naval build up in the Byzantine Empire the cause and the arbitrator of Imperial silk policy?

The rise of an influential private silk industry by the tenth century as described by Lopez, begs the further question, 'What was the overall role of trade and manufacture in the Byzantine economy? 'What financial contribution did trade and in particular silk trade make to the Imperial budget? Was private silk manufacture really so restricted in size that its financial contribution to the budget was totally negligible? If this indeed was the case, is there any reason at all to see the silk industry fulfilling an economic role? Was it not merely a political tool? Was the private silk industry simply non-profitable, whilst the Imperial silk industry was a veritable drain on financial resources? Were Byzantine silks produced 'merely for show'? These are key questions to which I return later.

Another issue raised by Lopez is the cost of the silk goods that were manufactured in relation to the cost of living. How far down the social scale could silk reasonably be expected to have penetrated? In the Islamic Mediterranean by the tenth century, silk was a household word in so far as even those of modest means might hope to own some small piece of it. Goitein estimated that one pound of standard quality raw silk was equivalent to the monthly cost of living of an average working class family (Goitein 1967:97, 222-224).[12] In Byzantium silk clothing costing up to ten nomismata could be purchased at a time when twelve nomismata was the price sought for a good horse or five times the cost of entry to one of the silk guilds. The weight of a silk garment need not have exceeded one pound but of course it may have had valuable dye or embroidery of gold, increasing its cost. In any event the price of silk garments in tenth century Byzantium does not appear to have been as high as that for the fourth century under the Emperor Diocletian. The Price Edict of this Emperor issued in 301 provides an excellent opportunity for gauging the relative prices of silk commodities (Lauffer 1971).[13] The prices for silks, as

compared to the wages cited for different manual workers, indicates quite clearly that silks in the fourth century were available only to the wealthy. This was not the case in the Eastern Mediterranean by the tenth century.

In his description of the administration of the industry Lopez raised several questions but others must be added to them and initially, it is important to establish how the industry was supplied with its raw material. Was the silkworm introduced into the Byzantine Empire only in the sixth century? What was the role of the kommerciarioi in supplying the industry with raw silk? These two issues were insufficiently explored by Lopez and fresh suggestions are discussed in depth in the next section of this article.

Lopez contrasted the origins of the Imperial and the private silk industries. He saw the Imperial silk guilds as a continuation of the Late Roman guild system but the private guilds he could not trace back to the fourth century. What then was the relationship of private silk weaving in the Late Roman period to later, non-Imperial silk weaving, for instance in Syria under Justinian? This is a further question to which I will return later. Lopez was more concerned with the relationship of Imperial monopoly to private silk manufacture. He saw a direct correlation between a decline in Imperial monopoly and a rise in private enterprise. Conversely, a strengthening of Imperial monopoly in the sixth century, following Lopez's line of argument, would herald a decline in the private sector. This pattern of growth and decline assumes a totally dependent role for private silk manufacture, but it is based on only two examples: Procopius' account of the decline of the Syrian silk industry and the silk sections in the Book of the Prefect. What of later provincial manufacture? How did state production relate to provincial manufacture in Thebes and Corinth in the twelfth century, for instance? Must one assume a decline in Imperial monopoly gave rise to provincial manufacture in the twelfth century? Lopez considered that provincial manufacture had been suppressed by the tenth century.

Taking the evidence of the extant material, the survival of several hundred Byzantine silks in the West, variously datable from the sixth to the twelfth century, suggests a fairly steady silk production right across the period (Muthesius 1982 and forthcoming). If silk exports had been reliant on a private silk industry tied to a waxing and waning Imperial silk monopoly, one might reasonably expect Byzantine silks to have reached Western Europe only in sporadic bursts. The chronology and the pattern of distribution of the surviving silks, boosted by documentary accounts describing silks used in the West, disputes this idea (Muthesius forthcoming) (PLS. 58, 57).

Lopez saw the Imperial silk industry in Byzantium as factory based. On the other hand, he considered that the private silk industry was

grouped around smaller workshops. This point of view can be challenged if the role of the Serikarioi is interpreted as that of factory owners, under whom a series of different processes were carried out in adjoining work areas; essentially in small factories. The idea of the Serikarioi as an umbrella guild embracing many workers occupied in distinct workshops within a factory structure is discussed further below.

The status of the artisans was described in passing by Lopez and the move from male to male and female workers in the industry (Lopez 1945:6 note 3). Perhaps understandably, Lopez did not enquire into how the guilds were administered; who kept the account books; what were the provisions for training apprentices, or what were the social functions of the guilds? Documentary evidence to answer these queries is sadly lacking. The extant silks nevertheless, give an indication of the complexity of weaving; and parallels with contemporary non-industrialised pat-terned silk production indicate that the Byzantine silks of necessity were woven by master weavers with assistants. These apprentices, whose job it was to act as drawboys manipulating the pattern-producing device of the loom, would have required lengthy practical training in the weaving workshops.

In general, Lopez saw the Book of the Prefect as a benevolent piece of Imperial legislation, a document protective of the silk workers. How then did it compare with earlier legislation governing Imperial silk workers? The fact is that the document is a unique source and centuries ahead of its time if silk legislation in Italy at a later date is taken as any guide. There is no comparable Byzantine documentary evidence for any other period either earlier or later. The regulations of the Book of the Prefect present a picture of the non-Imperial silk industry at a frozen moment in time. How far a similar situation pertained earlier and how far it extended beyond the tenth century is not documented. The uneven length of the silk regula-tions and their selective nature suggests they may have been gathered together in haste under Leo VI prior to his death, and with the help of the guilds themselves, as Koder has emphasised (Koder 1988:89-90).

The private manufacture of silks in wealthy homes Lopez did allude to, although the fact that the nobility could sell extremely costly silk garments to the guild of Prandiopratai perhaps was not fully stressed. One wonders how far did the nobility and important civil servants manage to penetrate the silk industry, some under the guise of their servants? This point is explored in greater depth in the next section.

Directly tied up with the role of the guilds is the identification of their exact function within the silk industry. What was the job of each silk guild? Lopez had a different interpretation from Freshfield, Nicole or Boak amongst others. The question of whether or not any of these interpreta-tions are acceptable from a practical point of view, is tackled below.

Finally, Lopez did admit that he was ignorant of techniques of manufacture of Byzantine silks and so his views were uncoloured by practical considerations. So far historians have not attempted to explain the documentary evidence in the light of the surviving material; neither have they kept in mind the complexity and multiplicity of actual processes involved in the manufacturing of silks. These processes have been described in detail elsewhere and are summarised below (Muthesius 1989).

4. STAGES OF MANUFACTURE FROM SEED TO 'SAMITE'

FIGURE 23 shows the three stages from seed to 'samite', that is:
- Production of the raw material
- Manufacture of the silks
- Marketing of the finished products

These three stages are further defined in PLATE 53.

Stage I — Supply of raw material

Stage one concerns processes essential to the supply of raw material covered mulberry cultivation, silkworm rearing and the processing of cocoons into silk yarn. Briefly described, stage one can be divided into two areas of activity; moriculture and sericulture (PL. 54).

Moriculture
Mulberry cultivation entailed five main chores: propagation, planting, cultivation, leaf harvesting (cropping), and pruning.

Sericulture (silkworm rearing, cocoon production, yarn production)
Silkworm rearing leading to yarn production was more complicated. Four principle areas of activity were involved: building of rearing quarters, feeding of the silkworms, production of cocoons and finally processing of the yarn. The feeding of the silkworms was labour intensive and required correct sizing of leaf, adaptation of trays to suit growing silkworms and immaculate attention to clearance of waste products. Disease could wipe out a whole crop of silkworms overnight.

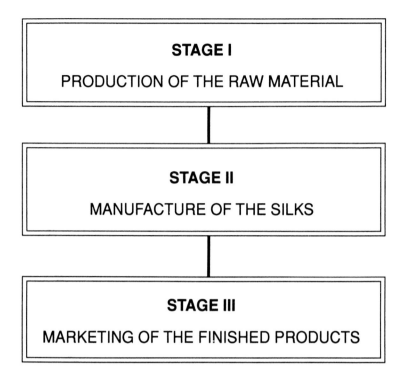

FIGURE 23 THE THREE STAGES OF SILK MANUFACTURE

Successful cocoon production entailed proper attention to five basic duties. Before anything else, special spinning boards on which the mature silkworm were mounted, had to be carefully erected. Then during spinning great attention was paid to humidity, temperature and noise control, so that the silkworms did not cease their work. Thirdly, once the cocoons were ready the silkworms had to be removed from the spinning boards, and these dismantled. Next the cocoons either were graded and stored, or unravelled. The fifth and final stage was to allow some moths to pierce a number of cocoons specially selected out of the crop. These moths, after mating, produced the seed that was stored for the coming season.

Yarn production required the skills of at least seven different types of workers. The first process, baking and reeling, demanded vat tenders and reelers and perhaps also collectors of the waste floss silk that was left behind in the vat. Degumming, the second stage of yarn production, was probably carried out over charcoal heated basins by one man and an assistant. Separate craftsmen were responsible for adding twist to the silk yarn to increase its tensile strength, or for spinning waste, broken silk

filament. Others carried out the dyeing of the hanks of degummed silks. There must have been those who weighed and graded the silk prior to sale also. To make valuable silk-core, gold yarns that were used in brocading work, special craftsmen were required.

Stage two encompassed the organisation and running of the silk industry (PL. 55). The organisation was divided into two parts. On the one hand there were Imperial and non-Imperial guilds. On the other hand there were private workshops in the homes of wealthy Byzantine citizens. It is possible too, that some weaving was carried out in monasteries, although there is no firm proof of this. Both the Imperial and the private sectors of the silk industry were subject to Imperial legislation. At all times before 1200 A.D. there were strict rules about the types of silks which could or could not be manufactured. **Stage II — Manufacture of the silks**

Stage three, the marketing of the silks, involved sales both at home and abroad (PL. 56). The domestic and the foreign markets essentially catered for the same three categories of customers. These were Emperors and foreign rulers; wealthy and middle class, Byzantine and foreign secular patrons, and lastly high ecclesiastics in Byzantium and in the West. **Stage III — Marketing**

Sequence of skills in the workshops
The sequence of skills necessary in the silk workshops come under at least ten headings. First the silk workshops required the skills of carpenters for complex hand drawlooms on which the fabrics were woven. There must have been artists to draw out the patterns of the silks too. Perhaps, as in India today, there were craftsmen, who made a special design prototype, which subsequently assisted the weaver in tying up the loom for weaving. It is likely that the warp for the loom was prepared by particular workers. The weavers, probably several to a loom, threaded the apparatus for weaving, and wove different types of silks, assisted by draw-boys. The latter operated the 'figure harness' mechanism, which allowed for the automatic repeat of complex patterns on the loom. The silks could be woven and then passed on to dyers for colouring or they could be woven with differently dyed threads. In any event, dyers and weavers appear to have been distinct from one another. Three further categories of crafts-men: embroiderers in silk or gold; silk printers, and tailors of silk garments, have to be considered. These craftsmen probably worked in specialised workshops.

5. A PRACTICAL APPROACH TO THE HISTORICAL

DOCUMENTATION

The Lopez regarded either 553 or 554 as the probable date for the introduction
introduction of of the silkworm into the Byzantine Empire and in so doing he relied on the
raw silk into the evidence of Procopius of Caesarea. Lopez was not the first to do this and
Byzantine neither has he proved to be the last historian to accept the theory that
Empire sericulture was introduced into Byzantium in the sixth century. Every
subsequent author writing on any aspect of the Byzantine silk industry
has automatically done the same (Oikonomides 1986:34 note 5). This idea
is totally unacceptable on practical grounds.

First it should be pointed out that Procopius and later in the sixth
century Theophanes differed considerably in their accounts concerning
the introduction of the silk worm into Byzantium. To be clear in exactly
which manner the accounts differ, it is worth quoting translations of the
relevant passages here: (Yule 1866:clix, clx; Wada 1972:63-70)

> "About the same time certain monks arrived from the (country of the)
> Indians, and learning that the Emperor Justinian had it much at heart
> that the Romans should no longer buy silk from the Persians, they came
> to the king and promised that the Romans should not have to purchase
> the article either from the Persians or from any other nation; for they had
> lived, they said, a long time in the country where there were many nations
> of the Indians, and which goes by the name SERINDA. When there they
> had made themselves thoroughly acquainted with the way in which silk
> might be produced in the Roman territory. When the Emperor questioned
> them very closely and asked how they could guarantee success in the
> business, the monks told him that the agents in the production of silk
> were certain caterpillars, working under nature's teaching, which con-
> tinually urged them to their task. To bring live caterpillars from that
> country would be impracticable indeed, but arrangements might be made
> for hatching them easily and expeditiously. For the eggs produced at birth
> by one of those worms were innumerable and it was possible to hatch
> these eggs long after they had been laid by covering them with dung,
> which produced sufficient heat for the purpose. When they had given
> these explanations, the emperor made them large promises of reward if
> they could verify their assertions by carrying the thing into execution. So
> they went back again to India and brought a supply of the eggs to
> Byzantium. Having treated them just as they had said, they succeeded
> in developing the caterpillars, which they fed upon the mulberry leaves.

From this beginning originated the establishment of silk-culture in the Roman territory."

Procopius of Caesarea (500-65)

"Now in the reign of Justinian a certain Persian exhibited in Byzantium the mode in which (silk) worms are hatched, a thing which the Romans had never known before. The Persians on coming away from the country of the Seres had taken with him the eggs of these worms (concealed) in a walking stick, and succeeded in bringing them safely to Byzantium. In the beginning of spring he put out the eggs upon the mulberry leaves which form their food and the worms feeding upon those leaves developed into winged insects and performed their other operations. Afterwards when the Emperor Justinian showed the Turks the manner in which the worms were hatched, and the silk which they produced, he astonished them greatly. For at that time the Turks were in possession of the marts and ports frequented by the Seres, which had been formerly in the possession of the Persians. For when Epthalanus King of the Ephthalites (from which indeed the race derived that name) conquered Perozes and the Persians, these latter were deprived of those places, and the Epthalites became possessed of them. But somewhat later the Turks again conquered the Ephthalites and took the places from them in turn."

Theophanes of Byzantium (end of the sixth century)

There are two serious discrepancies between the accounts. Firstly Procopius and Theophanes disagreed over the name of the country from which the silkworm eggs came. Secondly they differed about the nationality of the silkworm egg carriers. Procopius thought Indian monks had performed the task, bringing the eggs from a land called 'Serindia'. Theophanes attributed the deed to Persians transporting the eggs from 'the land of the Seres'. While it may not matter a great deal whether Indians or Persians carried the silkworm seed, it does seem significant to establish whether or not 'Serindia' or 'the land of the Seres' can be pinpointed geographically. The most thorough examination of this problem so far, has been by Wada (Wada 1972). In his doctoral thesis on the puzzling word 'Serindia' in Procopius, Wada came to the significant conclusion that this place cannot be identified. Neither was Wada able definitely to locate the 'land of the Seres' (Wada 1972:63-64, 66-70). Indeed, Wada concluded that the 'land of the Seres' to the sixth century Byzantine, signified no more and no less than 'the land from which the silk came' (Wada 1972:43-46, 64 and note 3).

Wada whilst acknowledging that the name 'Serindia' had no real significance in geographical terms, like others before him, nevertheless tried to assign a positive location to it. Regions as geographically disparate

as Khorasan and Ceylon had been previously suggested for 'Serindia'
(Hennig 1933:295-312, esp. 296-299, 306). Wada put forward the idea
that 'Serindia' in fact was located in the Gurgan region (Arabic Djurdjan).
Even more precisely, he pinpointed the area as the southernmost part of
the east coast of the Caspian sea (Wada 1972:71-85). Although Wada
argued for the existence of sericulture in the regions of Central Asia from
the third century onwards, he did not offer positive documentary proof
that the Gurgan region to the south west of Khorasan cultivated silk-
worms in the sixth century. His argument seems based merely on
possibility. It would have been possible for the silkworm seed to have been
transported across the Caspian and from its west coast to have been taken
overland from Tiflis to Phasis or Trebizond. From there, Wada argued, it
could have been transported across the Black Sea to Constantinople.
Politically and geographically this may have been a possibility as Wada
said, but then equally easily the silkworm seed could have come from
elsewhere and have been transported via Wada's suggested route (Wada
1972: 84-85). Wada's argument that the climate of the Gurgan region was
suitable for moriculture is not significant if one pauses to think that the
same reasoning is applicable to a host of other regions too. Neither is it
convincing of Wada to argue that the Gurgan region grew wild mulberries
of a type available in Byzantium. There is no documentary evidence to
indicate what type of mulberry was fed to the silkworm crops in Byzan-
tium anyway. Wada's observation that the silk producing region would
need to have been on a trade route leads only to similarly general
conclusions.

Perhaps the most positive of Wada's observations in favour of his
Gurgan theory, is the documented presence of a Turco-Sogdian embassy
in Constantinople in 568, offering silk for sale (Wada 1972:76-77, note 3).
However, the silk that the ambassadors offered for sale, first to Persia and
then to Byzantium is not specifically termed Sogdian. As Wada admitted,
it could have been imported into the Sogdian region and then have been
re-offered for sale at a profit. There is no firm proof that sericulture
flourished in the Sogdian region in the sixth century. The Central Asian
silks identified and published by Shepherd and by Jerussalimskaja are
datable from the seventh to eighth century onwards (Shepherd and
Henning 1959; Shepherd 1980; Jerussalimskaja 1972).

Wada noted that, 'every dynasty in China had shown a strong interest
in sericulture, so that in their Annals foreign production of silk also, was
mentioned as soon as it existed.' Wada mentioned too, that the most
distant land known to the late Han dynasty (25-220) was Ta-Chin (Ta-
Ts'in). This land, Wada explained in a footnote, was identified with Roman
Asia Minor by some historians (Wada 1972:28, note 4). On the subject of
the identification of Ta-Chin Hirth concluded that this name denoted

Syria as a Roman province before the time of the Arab conquest. Subsequently, in the period coinciding with the Tang dynasty (618-906), the Chinese called the same place under Arab rule 'Fulin'. The latter name applied too, during the period of the Sung dynasty (960-1279) in China, when 'Fulin' was a Seldjuk province (Hirth 1855:214ff.).

The relevance of Ta-Chin, later Fulin, to this study, is that the Chinese documents identify it as a sericultural region of note. Hirth mentioned the San-kuo-chih compiled before 429 and based on records of the third century. This document has a passage which referred to Ta-tsin in which the domestic animals of the country were listed as, 'the donkey, the mule, the camel, and the mulberry silkworm' (Hirth 1855:13-14). If this place was indeed, Syria under Roman rule in the period prior to the seventh century Arab conquest, surely it would have been the ideal place from which to transport silkworm seed to Constantinople. Naturally, the validity of this argument depends on the positive identification of Ta-Chin (later Fulin) and of course, this identification is fraught with difficulties. One obvious problem is some of the Chinese sources providing details about the place, describe events several centuries after the date that they happened. On the other hand, it could be argued that Chinese Annalists stuck closely to their original sources. One Chinese document of particular interest here is the Chiu-t'ang-shu, which described Fulin between 605-719: the period prior to Arab rule from c. 605-37, as well as the next years under Moslem occupation (Hirth 1855:69, 111, 256ff.). It was written by Wu Tei (d. 945).

There are four significant events in the Chiu-t'ang-shu, that should be considered:

1. The account of the Chinese embassy of 605-17 to Fulin from Emperor Yang-ti (Hirth 1855:293-307, K33).
2. The account of the embassy in 643, sent by the King of Fulin named Po-to-li, to China (Hirth 1855:K34).
3. Undated news report that the capital of Fulin had been besieged and over-run by the Arabs (Hirth 1855:K35)
4. Embassies in 667, 701 and 719 from Fulin to China (Hirth 1855:K36, K37, K38).

Although the date of the fall of Fu-lin to the Arabs is not given in the Chinese document, Hirth reasoned that it could have been prior to 643, and that the King of Fulin sent word to China after the event. If on the other hand the four accounts are considered to have been written in chronological order then the dating of the fall to the Arabs would lie between 643 and 667. The latter explanation does not tie in with dates of Arab conquests in the seventh century. Syria and Iraq were conquered by the Arabs between 633 to 639 and Egypt fell to them between 639 and 642.

The question is did sericulture exist in Syria before the sixth century? Certainly, it is not possible to believe that sericulture, an immensely complex industry, was imported into Byzantium from distant regions and established overnight. The skills and resources for this to happen simply would not have been available at a moment's notice. Looking outside the narrow confines of the available Byzantine sources, the Chinese documentation argues in favour of the existence of sericulture in Syria from the fifth to the seventh century. This being so, it is reasonable to suggest that the introduction of sericulture into the Byzantine Empire occurred earlier than suggested by either Procopius or Theophanes. Their accounts can be taken only to express the general truth that sericulture spread deeper into the Byzantine Empire in the sixth century.

6. SYRIA AND THE QUESTION OF THE SEALS OF THE KOMMERCIARIOI

THE most detailed study of surviving seals of kommerciarioi is by Oikonomides, following the work of Zacos and Veglery on lead seals in general. Oikonomides, as mentioned above, accepted that all the seals of the kommerciarioi belonged to government raw silk agents (Oikonomides 1986:35, note 12; 45, note 77; appendix 2, 51-52). Hendy proposed that kommerciarioi also bore other responsibilities. In particular, certain kommerciarioi supplied arms and equipment to the Slavs, who were enlisted into the Byzantine army in the late seventh century. Hendy was particularly interested in the question of why an upsurge in seals of this type should have occurred from the 670s onwards. He saw the initial role of the government employed kommerciarioi as part of a drastic increase in state control of trade exchange. He termed this a "desperate governmental search for economies or unexploited sources of revenue" (Hendy 1985:627). Initially, the kommerciarioi served only to sell off surplus state luxury goods such as silks stored in provincial state apothekai, and they collected tax on these sales. Later they also sold arms and other equipment in a similar manner, according to Hendy's thesis.

Oikonomides considered Byzantine silk production as "one of the major elements of the economic force of the Empire" (Oikonomides 1986:34). Like Von Lingenthal and Stein and Lopez he discussed the

possible date of the Novella 'Peri Metaxes'. This undated Novella as described above, set the ceiling price for the purchase of raw silk by the kommercarioi at 15 nomismata a pound. As mentioned earlier also, Oikonomides felt the Novella dated after Justinian's law setting a ceiling price of 8 nomismata (according to Oikonomides for garments, according to Lopez for one pound weight of raw silk) (Oikonomides 1986:34, notes 4, 6; Lopez 1945: 12-13). Lopez was convinced that the Novella belonged to a post Justinianic era (Lopez 1945:13 note 1).

From a practical point of view it is necessary to agree with Oikonomides that without supplementary documentary evidence this problem cannot be solved. However, there are two ways in which the figures of 8 and 15 nomismata might be reconciled. The first would involve 8 nomismata as a ceiling price for garments and 15 nomismata as a ceiling price for a pound weight of raw silk. Nevertheless, this would necessitate very light weight silk garments and seems an unsatisfactory solution. The second alternative would need to allow for a change of heart on the part of Justinian, who having set a very low price for import of raw silk subsequently raised it to an acceptable level. The reason for such a marked change of policy, might have been a drastic shortage of raw material. Without documentary confirmation even in Procopius, this thesis too must remain merely speculation. Of the available options, on present evidence it appears most sound to accept that the Novella 'Peri Metaxes' postdates the 8 nomismata legislation.

Oikonomides noted that the earliest documentary reference to a kommerciarios belonged to the reign of the Emperor Anastasios (491-518). This kommerciarios living in Antioch, subsequently was appointed Comes Orientis. Another documentary reference to a kommerciarios occurred in an early seventh century source and again this official lived in Syria, in Tyre (Oikonomides 1986:34, note 10). Oikonomides considered that these officials had exclusive right to purchase raw silk from foreigners, which they re-sold on behalf of the state. Essentially, Oikonomides thought that to begin with they operated in exactly the same manner as the earlier comes commerciorum. By the sixth century, however, the kommerciarioi were empowered to act as private business men, taking their own profits (Oikonomides 1986:35, 39-40). This assumption was based on the fact that in the sixth century they were entitled personally to confiscate illegally imported silk. Earlier they had been required to hand all confiscated goods over to the state. The question is what did the kommeciarioi do with the silk? Can one assume that they were private raw silk merchants on the one hand, and civil servants on the other? This in turn begs the question, 'When did private raw silk merchants first appear? It must have been some time before the tenth century when they were registered as an established guild in the Book of

the Prefect. As mentioned below, Koder believes the latter was compiled as early as the period of the second Patriarchate of Photius (877-86), even if it was promulgated later. As will be discussed further below also, Oikonomides suggested that raw silk purchase passed from the hands of the state to private individuals around 800 A.D. with the introduction of the tax called the kommercion. For the later period there is documentary evidence to indicate that some wealthy Byzantines invested in shops that they rented out to silk merchants (Svoronos 1976:65; Oikonomides 1972:345-356). Details about the hiring of similar rooms is found in the Cairo Geniza documents of the tenth to eleventh century providing a parallel in the Islamic silk industry (Goitein 1983:69).[14]

Returning to the question of Syria, it is noticeable that the earliest documentary sources as well as the earliest extant seals of kommerciarioi are Syrian. The earliest seal has been identified as belonging to Magnos the Syrian, an influential minister of the time of Justin II (565-78) (Oikonomides 1986:37). This minister, whose seat was at Antioch, was administrator of the Imperial estates. Oikonomides assumed that the significance of this location lay in its proximity to the Eastern frontier with Persia. Antioch he said was the "main outlet of the silk route from Central Asia." Seals of the kommerciarios Magnus, Oikonomides implied, would have been used to seal bales of imported raw silk. However, one may ask what was grown on the Imperial estates subject to the authority of Magnos. Why was such an important minister set over these estates anyway? Of course there is no way of answering this question without further documentary proof but it has occurred to me that the estates need not have been food producing. As they were in the care of a kommerciarios, albeit one who could farm out the exploitation of the estate, is it possible that some land at least was given over to mulberry cultivation? One might ask did mulberry plantations exist in Syria under Imperial protection in the sixth century? Oikonomides, accepting Procopius' report that sericulture entered the Byzantine Empire in the sixth century, thought that Syria would have been a good place to site early mulberry plantations, as the locals had experience with imported raw silk (Oikonomides 1986:42). Bearing in mind the earlier discussed Chinese report of sericulture in Ta-Chin, which both Hirth and Needham identified with Syria, before the end of the fifth century, Imperial mulberry plantations in Syria in the sixth century would not have been impossible.

With the fall of Syria first to the Persians (613-27) and then to the Arabs (638/9) the situation would have changed. Nevertheless, if sericulture already existed in Syria at the time of the Arab conquest, it is reasonable to think it was subsequently encouraged under Moslem rule. Silk was definitely imported from Syria into Constantinople in the tenth century and its importance was stressed in the regulations of the Book of

the Prefect. The question is did the Byzantines or the Arabs introduce sericulture into Syria? The Chinese evidence discussed above comes down in favour of the Byzantines.

Oikonomides divided the extant seals into three groups as follows: **Differing**
1. Seals of kommerciarioi, down to 672 without the indiction **interpretations**
 number. **on the**
2. Seals of kommerciarioi, with the indiction number dating **significance of**
 between 673/74-728/29. **the seals**
3. Seals of 'imperial kommercia' dating from 730-31 onwards.

The earliest of the three stages, he argued, reflected the activity of state kommerciarioi selling guaranteed imported quality raw silk to the workers at stable prices (Oikonomides 37-38, 42ff.). The addition of the indiction number he saw as heralding tighter Imperial controls. This coincided with an increase in the farming out of duties associated with the office of kommerciarios, he argued (Oikonomides 1986:39-40, 44). The third radical change was foreshadowed by the appearance of the Imperial portrait on the seals of the kommerciarioi from the 730s onwards (Oikonomides 1986:41). He considered too, that the seals may not have been a guarantee of quality. Earlier seals showed signs of having been attached to sacks, but the later seals did not have traces of burlap on them. The later seals did not name a province or city on them either. Only some of these seals bore the title 'general kommerciarios' and this often in conjunction with the title of 'archontes tou blattiou' (Oikonomides 1986:40). Finally, after the early ninth century the Imperial portrait and the term 'general kommerciarios' disappeared from the seals.

There is no proof that kommerciarioi throughout the period from the sixth to the ninth century dealt with silks. Oikonomides based his assumption that they did so on the evidence of the surviving seals. He thought that the locations mentioned on some three hundred extant seals and plotted on a map, corresponded to the areas "where silk traditionally originated" (Oikonomides 1986:43). No documentary references accompanied the term 'traditionally' but the map indicated that the two key areas Oikonomides had in mind, were Asia Minor and the Balkans. The question that Oikonomides did not pose was: how feasible was sericulture in all the regions plotted? In Asia Minor certainly, there were problems outside the coastal areas, and much land definitely would have been unsuitable for moriculture. This is an aspect that should not be over-looked in considering the nature of the role of the kommerciarioi in general. Hendy has looked at the geography of Asia Minor (Hendy 1985:26ff., 31, map 8).[15] It does not appear feasible that the whole of Asia

Minor could have had as extensive sericulture as Oikonomides implied (Oikonomides 1986: 44).

As a general thesis Oikonomides considered that sericulture retreated from Asia Minor to the Balkans in the face of the Arab threats between 674-8 and the 740s (Oikonomides 1985:44-45). However, it could be suggested that the kommerciarioi need not necessarily have had identical functions in Asia Minor and in the Balkans. The discussion between Oikonomides and Hendy over the exact duties of the kommerciarioi cannot be solved easily. Oikonomides considered that the kommerciarioi could not have provisioned the army as Hendy suggested, because they were not located in war zones (Oikonomides 1985:45). Oikonomides thought that the function of the kommerciarioi was primarily economic. With the appearance around 800 of the tax called the kommerkion more fully discussed by Bibicou, Oikonomides tentatively suggested that the kommerciaioi then became directly involved with collecting general sales taxes and ceased to control domestic silk production for the state (Oikonomides 1986:49; Antoniades-Bibicou 1963:104-55, 157-91). At that point purchase of raw silk was in the hands of the guild of the silk merchants detailed in the Book of the Prefect.

Customs and sales tax in the Byzantine Empire Antoniades-Bibicou made an extensive study of customs and sales taxes in Byzantium including the 'commercia' and the 'pratikia', which were levied from the eighth century onwards. She concluded that the customs tariffs of the Late Roman Empire of 2-2.5% rose sharply to 12.5% during the fourth and fifth centuries. This rate then fell probably to something above 8% in the fifth to sixth century and stabilised at 10% under Justinian I (Antoniades-Bibicou 1963:218).

Taxation occurred at border frontiers but taxes were levied too, at commercial frontiers within the Empire (Antoniades-Bibicou 1963:60, 128). The kommerciarioi, who to some extent replaced the officials under the Count of Commerces in the Late Roman Empire, at first held high public office but later were less distinguished. They fell into two categories: those who collected local taxes for a specific city or port and those who were Imperial servants in charge of large customs districts (Antoniades-Bibicou 1963:183-184, 219). An increase in the number of kommerciarioi and their extensive dispersal across the Empire in the seventh to eighth century Antoniades-Bibicou thought might be associated with the organisation of the Empire into themes (Antoniades-Bibicou 1963: 209). She saw the seventh and the tenth centuries as the most significant times for economic expansion in Byzantium. Lopez devoted a special separate study to trade in seventh century Byzantium and also saw this as a time of expansion (Lopez 1959:70-85). During the tenth century Antoniade-

Bibicou thought that an expansion in the Arab world parallel to that of Byzantium was marked by the rise of the Islamic merchant classes (Antoniades-Bibicou 1963:220).

Throughout the period from the sixth to the twelfth century, Antoniades-Bibicou saw a close relationship between commercial prosperity and the extent of the political boundaries of the Empire. The three groups of customs posts at frontiers, ports and at interior locations varied with political circumstances. Trade with foreigners from 297 was channelled through Nisibis. In 408-409 the frontier trading posts were set at Callinicum, Nisibis and Artaxa. A trade agreement of 562 between Byzantium and Persia named Nisibis and Daras as commercial frontier posts and Dvin served in the same capacity in the sixth century. In the tenth century the merchandise from Armenia and Syria passed through Adranoutzi, and Trebizond was an important market centre. The commercial traffic of the Red Sea and of the Mediterranean was controlled from Iotabe, Philai and Clysma. Cherson was the base from which trade with the North across the Black Sea was controlled (Antoniades-Bibicou 1963:194-195). The places named on the seals of the kommerciarioi gave a good idea of customs ports and centres of the Byzantine Empire, particularly between the seventh and the eleventh century (Antoniades-Bibicou 1963:208 map). The disposition of these centres was plotted also by Oikonomides, as discussed above.

Antoniades-Bibicou had no doubt that customs revenue was an important aspect of Imperial finance, especially in the seventh century (Antoniades-Bibicou 1963:196). In the eleventh and twelfth centuries she saw the Italian states taking an increasingly leading role in Byzantine export commerce and politics in the face of the considerable Norman and Seljuk threats to the Empire. Venice in particular carried Byzantine goods to Central and to Western Europe. The role of the Italians was discussed at length by Hendy and his views are presented later in this article.

7. THE ORGANISATION OF THE BYZANTINE SILK INDUSTRY: THE ROLE OF THE GUILDS

THE significance not only of the raw silk merchants' guild but of all the silk guilds described in the Book of the Prefect requires examination. First however, it is necessary to define the exact role of these guilds. The Book of the Prefect as mentioned previously is a unique document, a sole Byzantine source that exists to illuminate the economic organisation of manufacture in Constantinople in the tenth century.[16] Nicole using internal evidence dated the Book of the Prefect to the period of the Emperor Leo VI (886-912). Christophilopoulos narrowed down the dating further to the very end of Leo VI's reign, between September 1, 911 and May 11, 912. Most recently Koder affirmed 911-12 as the date of the Book of the Prefect, although he suggested that the guild regulations it contained probably were formulated during the period of the second Partriarchate of Photius (877-86). In any event, he considered that the regulations must have dated before the time of the Byzantine 'trade war' with Bulgaria between (894-96) (Christophilopoulos 1935; Koder 1988:89, 96-97). Koder suggested that the four appearances of the tetarteron coin within the text of the Book of the Prefect, dated probably to the time of Constantine VIII (Koder 1988:89-90; Koder 1991:109, 113, 117, 121). The text of the Book of the Prefect of the Geneva manuscript discovered by Nicole, can be dated to the fourteenth century on palaeographical grounds. The Prologue to the Book of the Prefect survives also in another manuscript, Cod. Athen. olim Pan. Taphu 25,[6] datable to the fourteenth century. It is the latter manuscript that has the inscription stating the Book of the Prefect was promulgated under the Eparch Philotheos in the year 6420 (Koder 1988:87, note 6, 88; Papadopulos-Kerameus 1899).

The original publication of the document was followed by translations into English by Boak and Freshfield and more recently Simon published a detailed article on the silk guilds (Boak 1929:597-610; Freshfield 1938:236-45; Simon 1975:23-46). From Stöckle in 1911 and Meyer in 1912 to Boak in 1929, Freshfield in 1938, Frances in 1962, Simon in 1975 and Koder in 1991 (to mention only some authors), there has been no consensus of opinion about what exactly each silk guild did.[17] Perhaps the reason for this lack of agreement is that the document was interpreted without reference to practical considerations. How did a non-mechanised silk industry actually operate? What were the various specialisations within the industry that could give rise to a guild organisation? A practical

approach to the regulations in the Book of the Prefect yields some new thoughts about the organisation of the Byzantine silk industry in general.

The Book of the Prefect listed twenty two guilds, which cannot be regarded as covering every guild of the Capital. The different lengths of the regulations for individual guilds in any event illustrates a very uneven approach and Koder considers that the Book of the Prefect was probably written at the time when Leo VI was seriously ill. A dual Imperial and guild authorship precluded the regulations favouring only the state. The document clearly was intended to maintain an Imperial monopoly over certain types of purple silks and others of special cut, but it was meant at least as much, to maintain order and standards in the guilds themselves. It offered protection to poorer workers in so far as the richer could sell to the poorer only at the set profit margin of 16 per cent gross, 8 per cent net (Nicole 1970:6.9, Koder 1991:98-99). This suggests that the guild membership was not compulsory; even the poorer craftsmen had access to raw materials. Within the guilds and amongst the poorer non-guild members there was a division between the artisan and the merchant. Three of the five silk guilds were concerned with the marketing side. These were the raw silk merchants; the domestic silk garment merchants and the merchants of imported silks. The other two guilds represented craftsmen responsible for working the silk in some way. The nature of their work will be discussed fully later. In general it should be remembered that no comparable guild system existed in the West or in the Islamic world, so that the Book of the Prefect was quite a revolutionary document at the time it was written.

At first glance, the five chapters in the Book of the Prefect seem to cover most aspects of silk manufacture, that is:

Analysis of the document

- purchase of raw material
- production of yarn
- weaving and tailoring
- retail of domestic silk garments
- marketing of imported silk clothes

However, the document does contain difficult technical terms that today cannot be translated literally or explained etymologically. In particular it is necessary to consider in detail the complex descriptions of silks in the workshops of the Serikairioi. Even where technical terms are less intricate, as for example in the chapters about the Metaxopratai and the Katartarioi, many meanings remain obscure. Before even considering these chapters, it is necessary to ask practical questions. For example, how far could raw silk be transported in the form of cocoons? If perforce the silk rearers were not also the unravellers of the silk from the cocoon,

how long might cocoons be stored before they suffered damaged by emerging moths? Were cocoons transported from just outside Constantinople, but was unravelled and reeled raw silk imported from further afield? Was there in Byzantium, as in modern day China, a great difference in the purchase price of silk cocoons and reeled hanks of raw silk?

The duties of the individual guilds The essential processes for yarn production are:
1. Unravelling and reeling
2. Degumming
3. Doubling and adding twist where necessary
4. Spinning of waste and floss silks

In modern day India the state holds cocoon markets and the silkworm rearers are not the unravellers and reelers. In China on the other hand the non-mechanised silk industry traditionally had some silkworm rearers, who also unravelled and reeled the silk from the cocoon. Silkworm rearing was the accessory occupation of farmers in China up to the twelfth century.

The Metaxopratai and the Katartarioi From the Book of the Prefect it is clear that the Metaxopratai had in their service paid workers. What did these men do? If the silk merchants bought cocoons these had to be locally grown ones. Unstifled cocoons could be stored only for a matter of days before the moths emerged. To process the cocoons the Metaxopratai needed workers for at least the first two stages outlined above. It is possible that the Melathrarioi were workers of spoilt silk (Nicole 1970:6.15, Koder 1991:100-101). The Metaxopratai themselves could not work the silk. The Metaxarioi were less wealthy silk merchants than the Metaxopratai, and probably not members of the guild, not part of the purchasing cartel and not registered on a list kept by the Prefect. The Katartarioi on the other hand, certainly were registered on the Prefect's list (Nicole 1970:7.2, 7.3, Koder 1991:100-101).

The Katartarioi could purchase silk from 'outside'; here perhaps indicating local rather than distant regions. They were limited to buying the silk that they could work. Perhaps this was to prevent a shortage of raw material. If the regulation had meant that they could buy only as many cocoons as they could unravel then the same rule should have applied to the poorer Katartarioi. These men and women, not registered members of the guild, could buy silk via the Metaxopratai.

What was the role of the Katartarioi? It seems to have been distinct from that of the workers hired by the Metaxopratai. The two different tasks that would fit these distinct sets of workers are firstly, the unravelling and

reeling of the silk, and secondly the job of degumming the reeled silk. These two tasks are not performed by one person in the present day in India and it is easy to see that very different skills are involved in these jobs. The unravelling and reeling entails boiling the cocoons over a heated basin and winding the silk filaments on to a reel. It requires a delicate touch and today is often the work of women in India. On the other hand, the degumming necessitates boiling the hanks of unreeled silk in a caustic solution over a charcoal burner. It is a dirty and laborious job taken on by men. The setting of the two occupations is entirely different. The reelers work in clean, light conditions; the degummers work in dark and dirty ones.

The most likely solution to the problem of what tasks were carried out by the workers hired by the Metaxopratai, and the Katartarioi respectively, to me seems to be as follows. The hired workers unravel and reel cocoons brought in locally. The Metaxopratai on the other hand, sell the reeled silk they purchase from further afield to the Katartarioi. The latter degum the silk, and although the Book of the Prefect does not record what they do with the dressed silk, there are two possibilities to consider. Either like the Melathrararioi, who worked waste silk, they sold it back to the Metaxopratai, or they perhaps sold it to the Serikarioi. The Katartarioi had to take care in their work not to damage the silk, literally not to 'tear it apart'. The Melathrarioi most likely had the task of spinning the waste silk.

The workmen hired by the Metaxopratai were on a monthly contract. If they were processing cocoons, these could not be stored for that length of time without the moths emerging, unless they had a special technique for preventing hatching. In mediæval China cocoons could be stored in salted jars for about two weeks but the salt made the silk brittle. If the hired workers were treating cocoons then there must have been a constant supply of fresh material for them to work. This would also entail local production of multiple crops of silkworms. Otherwise, the Metaxopratai would be out of business for a large part of the year. The fact that the Metaxopratai could hire their workers for only one month and that they could not poach workers from other Metaxopratai, suggests that there was a shortage of skilled labour in this field (Nicole 1970:6.2 cf. 6.3, Koder 1991:96-97).

It might even be possible to work out the cost of raw silk if two difficult terms can be identified. The Metaxopratai for each κεντηνάριον of silk paid to the exarch one καγκελάριον. Could this refer to tax paid on 32kg of raw silk, that is on one centenarium?[18] Does the word καγκελάριον signify a coin or a tax percentage? Unfortunately, it seems impossible to tell. If it meant a coin, it would be possible to hazard a guess at the likely rate of tax and to suggest a price per kg for the silk. In the Cairo Geniza documents, standard quality silk cost 2.5 dinars per pound (Goitein

1967:222-224). Although neither term can be identified for certain, the mention of official weights stamped by the Prefect does suggest that the raw silk was sold by weight. Professor Koder has found that the term καγκελάριον did have meaning in a legal context and its use in the Book of the Prefect possibly lent an air of authority to the document.[19]

Conclusions about the Metaxopratai and the Katartarioi Several conclusions can be reached about the Metaxopratai from the information in the Book of the Prefect. The regulations as they appear allow for the possibility that silk cocoons as well as unravelled and reeled silk was handled by them. They could handle first grade silk yarn and secondary grade spun silk. They could sell direct to the Serikarioi too, under whom as described below, weaving was carried out. The silk yarn sold to the Serikarioi might also have had some initial degree of twist added to it. The Metaxopratai could not travel outside the Capital to purchase the silk. Any cocoons they dealt in must have been locally produced so that unravelling and reeling should not be delayed for too long. Foreign silk merchants would hardly have been able to deal in cocoons. In any event, 90% of the weight of cocoons was waste and it would have been foolish to carry a great deal of weight for nothing. In general, there must have been a shortage of raw silk because there was no sales tax on its sale by the producers. This suggests that in the tenth century at least, domestic production was not sufficient. The Metaxopratai did pay tax on their purchases of raw silk from the producers, however. It was relatively cheap at 2 nomismata to join the guild of Metaxopratai but some could not join. This was probably because they had insufficient funds later to pool resources for purchase of raw silk in a cartel. The Metaxopratia could set his slave in his place but took full responsibility for the latter's actions. This provision suggests that the wealthy could trade in disguise. Some Metaxopratai were evidently dishonest in their dealings too, and there were severe penalties for illegal sale of raw silk to the rich. This sort of sale probably took place in the confines of private dwellings, which was why the Metaxoprtatai were forbidden to sell outside a specially allotted open place. No raw silk was to be sold to Jews or traders outside Constantinople indicating a monopoly over raw silk in Constantinople. Did this action reflect a fear of competition, a lack of raw silk, or an attempt to keep the raw silk as exclusive a commodity as possible to maintain prices? How far was it an attempt to centralise the market so that it could be more easily policed? (Nicole 1970:6.13, 6.16, Koder 1991:100-101).

There are conclusions to be drawn about the Katartarioi also. They were entitled to purchase raw silk in a cartel with the Metaxopratai, but only what they could work. A regulation forbade them from passing on raw silk to the wealthy on the black market. The Katartarioi in fact, could not

sell the silk they worked. What did they do with it then? Most likely it was re-sold to the Metaxopratai for retail. The Katartarioi anyway were more humble than the Metaxopratai. They could buy themselves into the guild of the Metaxopratai.

Although as stated above, the Metaxopratai may have dealt with silk given **The Serikarioi** an initial degree of twist to strengthen its use as warp, it is likely that the weavers added their own twist to most of the silk yarn. The reason for this is because each of them would be used to working with a specific degree of twist on their yarn. Differences in yarn tension had major conse- quences on the preparation of the loom and on the techniques of weaving. Some surviving silks reveal that the weavers were used to an incredibly high degree of twist on their warp threads. There must have been a special type of apparatus for adding this to the yarn. In India today this process is carried out by assistants to the weavers working with the silk hung from two horizontal wooden poles set on a small frame.[20]

The guild of the Serikarioi would seem to me not to represent any single guild but rather an amalgamation of several guilds. The tasks outlined in the regulations governing the Serikarioi could not possibly all have been carried out by a single set of workers. The skills entailed required different training. Silk dressers, weavers, tailors and dyers each needed quite separate training for their jobs. All these tasks to some extent were carried out under the auspices of the Serikarioi. I suggest that the Serikarioi were none other than factory owners with a series of work- shops, where the different processes were carried out. Under the protec- tion of the factory owner's guild the different craftsmen worked according to set guide lines. The Serikarioi had both slaves and paid workers. Slaves vetted by them could open workshops and there were supervisors of the workshops ἐκλέκτην (Nicole 1970:8.13, 8.7, Koder 1991:106-107, 104- 105). The fact that the slave might be vetted suggests that the wealthy could disguise their business interests.

The Serikarioi were producing cloths valued up to and over ten nomismata for domestic use, and under ten nomismata for outsiders to the Capital. Some silks they had to forfeit to the Imperial store. The silks were rolled in the workshops and had to be declared and stamped by a representative of the Eparch. They could be dyed but not with specific types of Imperial purples. The technical terms for different types of silks that could and could not be produced will be discussed separately below. The workshops were subject to compulsory inspection by Imperial officers. Severe penalties were imposed on those caught selling slaves, paid workers or supervisors of workshops to those outside Constantino- ple. The purchase of raw silk from anyone but the Metaxopratai was

forbidden. Purchase of silk garments outside the Capital for presentation to the Imperial store house of the Eidikon was also expressly forbidden. This suggests that the Constantinopolitan wares must have been of much higher quality than the provincial silks. It also points to provincial production of silk garments alongside raw silk. Hired workers could not be poached and they could be engaged only for a period of a month. Entry to the guild cost three nomismata.

The Serikarioi appear to be an important guild. Entry to this guild cost 30% more than entry to the guild of the Metaxopratai. There were also several different categories of workers under the Serikarioi ranging from slaves to foremen. The owners could not disperse the workers outside the Capital probably for fear of dispersing trade secrets. It is not unlikely that some prominent civil servants could have registered their slaves into the guild and carried out business in this way. The Serikarioi could have produced silks for their personal use and they were able to sell costly clothes to the merchants of domestic silk garments (Nicole 1970:4.2, Koder 1991:92-93).

The Vestiopratai The βεστιοπρᾶται were retailers of domestic silk garments, whose sales to foreigners were controlled by the Eparch. The Eparch also regulated all purchases made by the Vestiopratai of garments valued at over ten nomismata. These garments were to be declared to the Eparch so that he should register their place of sale. It seems that these extra valuable garments were sold to the Vestiopratai by wealthy Byzantines, known to be producing at home silks intended primarily for their personal use. However, if some of these wealthy individuals placed slaves in their stead to act either as Vestiopratai or as Serikarioi, of course it would be possible for them indirectly to carry out a lucrative business in luxury garments that were not produced at home. As slaves were empowered to buy these luxury items from the wealthy Byzantines and other unspecified persons, some financiers have to be envisaged. Several regulations restricting the activities of the wealthy within the silk industry might be taken to suggest that their participation in the industry was greater than the Book of the Prefect directly suggested (Nicole 1970:6.10, 7.1, 8.2, Koder 1991:98-99, 100-101, 104-105). In fact, if wealthy individuals, perhaps even those with high office in the civil service, wished to invest in the silk industry, they were perfectly able to do so under the disguise of their servants (Nicole 1970:8.13, 4.2, Koder 1991:106-107, 92-93). One might ask, if the Serikopratai from whom the Vestiopratai purchased some of the silk garments valued at above ten nomismata, were not identical with the ἀρχοντικά πρόσωπα named in the Book of the Eparch, who were they? Was there a 'class' of wealthy artisan in Byzantium in the tenth century or were there merely wealthy bureaucrats acting in disguise?

The payment for guild membership was relatively high at six nomis-
mata. The fee was twice that of entry to the guild of Serikarioi and three
times the cost of membership in the guild of the Metaxopratai. On the
recommendation of the Eparch and at the price of ten nomismata some
type of 'factory' could be opened by the Vestiopratai (Nicole 1970:4.6,
Koder 1991:92-93). For those who rented workshops, the guild regula-
tions warned that there should be no upstaging of fellow guild members.
No member either openly or secretly, was to offer bribes to secure rented
accommodation that rightly belonged to another. This regulation suggests
a scarcity of workshop space and one document indeed shows that
workshops were rented out to artisans by wealthy owners, who charged
substantial rents, as mentioned earlier (Oikonomides 1972:345-356).

The Vestiopratai dealt in unsewn silk cloth as well as in made up
garments (Nicole 1970:4.8, Koder 1991:92-93). Foreigners purchasing
unsewn silks were obliged to have them tailored in the Capital. Perhaps
some tailoring was carried out in the premises that the Vestiopratai could
open on payment of ten nomismata, described above.

In the same way as the Serikarioi, the Vestiopratai had to observe
regulations against passing on to foreigners, forbidden goods called
'kekolymena'. In particular they were forbidden to pass on to foreigners
ὀξέων εἴτε καὶ πορφυραερίων μεγαλοζήλων. These terms will be discussed
more fully below (Nicole 1970:4.8, Koder 1991:92-93).

The Prandiopratai

The Prandiopratai operated as a cartel under a single head of guild. The
foreign silks, which the guild retailed, came mainly from Syria and
Seleucia. These silks were all deposited in a special place in the mitata,
where the foreign merchants were housed (Nicole 1970:5.2, Koder 1991:94-
95). In the τόπῳ τοῦ Ἐμβόλου silks were publicly sold to the Prandiopratai
and to Syrian merchants resident in the Capital for more than ten years.
The special status of the Syrian merchants reflected the importance of the
Syrian silk trade to Byzantium. Indeed, after three months, any unsold
imported silks were bought up by the Prefect, himself. The Syrian silk
merchants and other foreign silk merchants were allowed to reside in
Constantinople for no longer than three months. The Bulgar traders were
moved from Constantinople to Thessaloniki at one stage, because they
were considered too barbaric to reside in the Byzantine Capital as Lopez
described (Lopez 1945:31-2, note 3). The wealthy Byzantines were
empowered to purchase imported silk garments, but only for their own
use. There must have been considerable influence from Syria on Byzan-
tine dress at this period, although the exact nature of the imported silks
remains uncertain. It has been suggested that watered silks were de-
scribed but this technique is unknown amongst the surviving silks.[21] The

price of entry into the guild of the Prandiopratai was not recorded in the regulations of the Book of the Prefect.

8. CONCLUSIONS ABOUT THE ROLE OF THE SILK GUILDS IN THE BOOK OF THE PREFECT

Organisation There was a complex inter-relationship between the organisation of the
and marketing private and the Imperial silk industry in Byzantium by the tenth century. There was also a delicate balance between organisation and marketing in both sectors of the industry. These relationships have been expressed in a flow chart (PL. 56).

As I interpret the regulations in the Book of the Prefect the Metaxopratai dealt in both cocoons and in unravelled and reeled silk. The cocoons were brought in locally and the reeled silk was imported from afar. Cocoons were not imported from abroad simply because they needed to be reeled within a matter of days to prevent the moths hatching and spoiling the silk. The Metaxopratai acted in a cartel and they could be joined by the Katartarioi in this activity. The main occupation of the Katartarioi though, seems to have been to work the silk in some way. The hired workers of the Metaxopratai may be seen as unravellers and reelers of cocoon silk. Non-guild members called Melathrarioi were workers of waste silk; that is spinners. The specialised task left to the Katartarioi then, most probably was the degumming of the filament silk.

The Metaxopratai could distribute raw silk to wealthy individuals for limited private use; to the Katartarioi for dressing and to the Melathrarioi for spinning, as well as to the Serikarioi. The Serikarioi could hire workers so that possibly some silk dressing was carried out under them but it seems more likely that they purchased their silk yarn already unravelled, reeled and degummed. They could have used hired workers to add extra twist to warp threads that they might have required. It is unclear from the Book of the Prefect to whom the Katartarioi passed on silk worked by themselves. It is possible that they returned the degummed silk to the Metaxopratai for further distribution to the Serikarioi.

The Serikarioi in my estimation were not multi-skilled craftsmen working at all tasks from dressing to tailoring the silks. More likely they represented some type of 'factory' owners under whom several different

craft guilds were permitted to work. In their workshops it was possible for yarn to be plied or twisted, and for weavers, dyers and tailors to carry out their separate specialised occupations. Naturally all these tasks could not be accommodated in the same type of conditions. The weavers needed very clean conditions for example, in contrast to the dyers. Therefore, it is reasonable to suppose that there was a series of distinct workshops in operation under the Serikarioi.

The Imperial silk industry was producing all those silks termed **The Imperial** 'kekolymena' in the Book of the Prefect. The special names given to these **silk industry** silks will be discussed more fully below. The range of garments produced in the Imperial silk workshops is not fully described in the Book of the Prefect but the Baggage train account appended to the Book of Ceremonies does give details of them, and again this is discussed later.

For the Imperial silk industry as for the private silk industry, it can be assumed that some silk came from local agriculturalists with silk plantations. Other silk from abroad could have entered Imperial silk stores as purchases of Imperial officials. Such stores are not documented but they must have existed given the vast numbers of Imperial silks sent abroad as gifts, and the large quantities of silk garments that were carried in the Imperial baggage trains.

Prior to the establishment of domestic sericulture in Byzantium the Imperial industry of necessity relied on imported silk, probably from China. At some unknown date, but by the fifth century in Syria at least, sericulture was established in Byzantium. To what extent domestic production satisfied Imperial demand, and for that matter private demand is not recorded. The fact that silks were imported in to the Empire perhaps argues against self sufficiency in raw materials in Byzantium. The extent of raw silk cultivateion in Imperial and in private plantations is another aspect about which nothing is known. The Reggio Brebion only indicates that some raw silk was cultivated on monastic land in southern Italy, perhaps but not definitely in the eleventh century (Guillou 1974).

What the sources do make clear is that the Imperial silks were destined for court use. Also they were intended for distribution to foreign courts as diplomatic gifts. At home the splendid silks clothed the Imperial house as well as important civil servants, military officers and ecclesiastics. Only for a short while in the sixth century were even the finest Imperial silks offered for sale to the wealthy Byzantine public. This action seems to reflect two things: a desperate attempt to raise income and a ready market with a wealthy clientele. What types of silks were these and how did they compare with non-Imperial pieces?

A series of inscribed Lion silks and the inscribed Imperial Elephant silk at Aachen have been described in detail elsewhere (Pᴌs. 39ᴀ, 46).

These were diplomatic silks of Imperial manufacture with large scale irregular designs. They were woven to a very high standard by master craftsmen, on hand drawlooms with complex pattern-producing devices that allowed for motifs with very smooth outlines. The series of surviving and documented Lion silks spanned a period of two centuries, from the ninth to the eleventh, and they reveal the remarkable adherence to traditional types in the Imperial workshop. In the case of the Elephant silk in particular, which may be dated around 1000 AD or even later into the eleventh century on technical and stylistic grounds, the degree of expertise required to produce the piece can no longer be matched by hand today. To weave one roundel of the Aachen Elephant silk some three feet wide required 1,440 manipulations of the pattern making device. This device, the figure-harness, had to be set up entirely by hand. An earlier Imperial silk is the Charioteer fabric at Aachen, which like the Elephant silk was taken from the shrine of Charlemagne (d. 814) at Aachen (PL. 60). This silk belongs eighth to ninth century. Contemporary non-Imperial silks that were woven in various centres of the Eastern Mediterranean, both Byzantine and Islamic, display a variety of hunter motifs. Of the Byzantine pieces, the Amazon silk from Maastricht is one example. Two others under Sassanian decorative influence are the Hunter silks of St. Ursula, Cologne, and of the Germanisches Nationalmuseum, Nürnberg, and these relate to the Hunter silk at St. Ambrogio, Milan (PLS. 5, 79). Hunter and charioteer themes were popular in Byzantium during Iconoclasm.

From the ninth to tenth centuries onwards, large scale bird and animal motifs came into fashion and the Imperial silks mentioned above are examples. Large scale eagle motifs and griffins too on silks at Auxerre, Brixen and Sitten, were probably the work of Imperial workshops. Less splendid examples such as the Peacock silk at Beromünster were woven in non-Imperial centres (PLS. 80, 76, 81 AND 82).

A distinct change in taste heralded the arrival of a fashion for monochrome silks with foliate motifs in the tenth to eleventh centuries. These were woven not in the usual twill but in a weave called lampas, which represented a technical breakthrough around 1000 AD (PL. 83). By this stage it is difficult to distinguish Byzantine from Islamic examples except where Islamic inscriptions have been preserved and it is likely that these silks were woven in a variety of high quality non-Imperial workshops into the eleventh to twelfth centuries. Bearing in mind these different kinds of extant Byzantine silks, it is interesting to look at textile terms in documentary sources.

9. DIFFICULT TEXTILE TERMS THAT OCCUR IN THE BOOK OF THE PREFECT AND ELSEWHERE

IT is necessary to admit that there are textile terms in the Book of the Prefect which cannot be explained. These must be seen as specialised silk trade names. It is unwise to take the terms outside the context of the industry to obtain an explanation for them. Identical words might bear totally different meanings in different contexts. The problem can be illustrated in more modern times. The Norwich silk industry of the nineteenth century is adequately documented by the survival of numerous shawls and there are manufacturers' manuals with some silk cuttings and the names of different types of silk. Still it is not possible to say exactly what each 'trade name' silk looked like. Some of the silks were given special names because of their technique, others because of their design or colour. The terms used in the Book of the Prefect may have been similarly descriptive.

It is possible to consider some of the suggested interpretations for textile terms in relation to the surviving Byzantine silks. This is not wholly satisfactory in so far as the most complex terms relate to the class of 'kekolymena' or forbidden silks, and these perhaps do not predominate amongst the extant group. The terms of relevance in the Book of the Prefect can be divided into two groups: those that represented silks forbidden to private manufacture and those that could be woven outside the Imperial workshop under the supervision of the Eparch.[22] References in brackets refer to regulation numbers in the Book of the Prefect.

Silks totally forbidden for private manufacture
 ὀξέων/πορφυραερίων μεγαλοζήλων (4.1)
 βλαττία κεκωλυμένα (8.1)
 σκαραμάγγια ὁλόκληρα καὶ μεσόφορα (8.1)
 ἡμιμηλίνοδιβλαττα καὶ πρασινοδίβλαττα μεγαλόζηλα (8.1)
 ἱμάτιον, ἑξάπωλον εἴτε ὀκτάπωλον πορφυράερον (8.1)
 μονοδέσποτα ὑπόγυρα (8.2)
 αἵματος for τριβλάττια or διβλάττια or διμοιρόξεα (8.4)

Silks to be declared to the Eparch
 τὰ βλαττία καὶ τὰ κατὰ περσικίων διμοίρων ὀξέων θετῶν εἴτε μεσοφόρων (4.3)
 Multicoloured καταπερσίκια (8.1)
 τὰ δὲ βλαττία καταπερσίκια ἢ δισπίθαμα (8.1)

χλανίδια ἐμφανιζέσθωσαν (8.1)

τῷ ἐπάρχῳ ὡσαύτως (8.1)

Monochrome or polychrome δέκα τιμώμενα νομίσματα ἱμάτια (8.1)

ἱμάτιον ... δεκάπωλον or δωδεκάπωλον, και τοῦτο ἀληθινάερον καὶ λεπτόζηλον (8.2)

ὑπόγυρα, ... τῶν μεσοζήλων δύο τοῦ χωνίου, καὶ αὐτῶν πολυχρόων καὶ δεκαπώλων τυγχανόντων silks (8.2)

Not surprisingly, several 'forbidden' or restricted category silks were purple-dyed pieces. In order to understand the terms of the Book of the Prefect most fully it is necessary to recognise the range of shades that could be obtained from dyeing with Imperial murex. The juice of the murex snail was light sensitive. The colour and the shade obtained from the dye depended on at what point the light source was cut off and on how many times the silk was dipped in to the dye. The forbidden purples appeared in the Book of the Prefect as ἡμιμηλινοδίβλαττα (8.1), πρασινοδίβλαττα (8.1), ὀξέων (4.1) and as πορφυραερίων (8.2) or τριβλάττια or διβλάττια ἤ διμοιρόξεα treated with αἵματοη. It can be safely assumed that these were murex purples, numerous earlier decrees having singled out the murex as an Imperial purple dye.[23] As described, murex purples might range in colour from yellow and green to deep blue or red purple. The terms in the Book of the Prefect seem to be describing some of the shades it was possible to obtain from the murex. The peach and the green purple shades use self explanatory terms. The διβλάττια and τριβλάττια as described above, I would see as reflecting silk twice or thrice dipped into the dye vat to obtain the desired strength of purple colour.

The declarable purples termed διμοίρων ὀξέων have been called red purple garments, which seems plausible. The ἑξάπωλον εἴτε ὀκτάπωλον πορφυράερον are obviously purples of some type but the term πωλον up to now has not been satisfactorily explained. The fact that the terms ἑξάπωλον εἴτε ὀκτάπωλον, δεκάπωλον and δωδεκάπωλον occur also in connection with silks suggests some sort of ascending scale in this type of silk. Looking at the silk regulations of the mediæval Italian silk industry a possible explanation presents itself. The types of silks woven in fourteenth century Lucca were strictly regulated in 1376 and this was achieved primarily by defining the type and number of warps threads used. This effectively controlled the quality and weight of the silk produced (D. and M. King 1988:57-76). The number of warp threads to be inserted between dents in the reed on the loom was meticulously set down, so that there were a definite number of warp threads per unit of measure across the width of the fabric. For instance, baudekins woven in the 118 cm prescribed width were to use a reed with at least 1750 dents, with a minimum of three *main warp* threads, single or double, and one binding

warp thread in each dent. This means a maximum of seven warp threads to each dent. In all there were to be some 45 *main warp* threads and about 15 binding warp threads per cm of woven cloth for this type of baudekin. It was sold at a specific price and there were set fines for those weaving this category of baudekin without using the official and approved specifications (D. and M. King 1988:67). The term πωλον is likely to have pointed to some technical qualification as specific as this; perhaps the number of warps per dent in the reed. It is no use looking for a generalised meaning outside the context of silk weaving to explain the very precise terminology characteristic of mediæval and indeed of later silk industries.

Other textile terms too, have been studied from an etymological rather than from a practical point of view. The list of prohibited silks includes the πορφυραερίων μεγαλοζήλων (4.1) and the ἡμιμηλινοδίβλαττα κὰι πρασινοδίβλαττα μεγαλόζηλα (8.1). The related δεκάπωλον ἤ δωδεκάπωλον, κὰι τοῦτο ἀληθινάερον και λεπτοζήλων (8.1) silks are on the list of restricted items. Various explanations have been offered for the term ζήλων covering size, value and degree of public demand for the textile. Whilst all these are possibly implicit in the actual silk trade definition of the term, to me it appears highly unlikely that some technical explanation did not underlie these terms. The fact that fine λεπτόζηλα (8.2) are distinguished from μεσοζήλων (8.2) and μεγαλοζήλων (4.1) immediately points to a difference in weight in the two types of silk. Such a distinction implies that a different denier silk yarn might have been used in the weaving of the two types. The terms might even have expressed the difference between dress weight and furnishing fabric. Whilst the size of motif might play a considerable part in the cost of any given silk, it would be difficult to place silks into categories according to design. Larger scale symmetrical designs for example, were easier to produce than smaller scale asymmetrical ones. Also, the same designs woven in different weaves provided the weavers with varying degrees of technical difficulty and the silks presumably would have been priced accordingly. Haldon has drawn together a summary of suggestions so far offered for a number of textile terms, and these are set out below for reference.

The Greek term is given, followed by the interpretation(s) of its meaning(s). The Haldon reference appears in brackets.[24]

Textile terms in the Baggage Train account appended to the Book of Ceremonies

ἀληθινός	cf. πορφύρα, ὀλοβῆρα, ἀλουργίς, ἰαστά, true purples.
ὀξέατυρέα	red purple.
ψευδοξέα	false purple (Haldon B108-109, C124).
βλάττα	at first described purple silks then silks in general, or alternatively meant sewn silk

	borders (Haldon C173).
σενδές	silk cloths or sheets (Haldon C222).
ἀρραφίων	without decorated panels.
τῶν ἐρραμένων	with decorated panels (Haldon C224).
σκαραμάγγια	military tunics (Haldon C225).
δίασπρα	warp and weft of different colours or alternatively twice dipped into the dye vat (Haldon C225).

μεγαλόζηλα cf. μεσόζηλα, λεπτόζηλα

the size, the value or the degree of demand for the silk (Haldon C226, C227, C289-290, C253-254).

| ἀσπρομύναια | off-white (Haldon C229). |

διυγαντάρια from διβλανταρίου/διβλαττάριον

two coloured (Haldon C229).

τρίμιτα	striped or alternatively a three thread warp (Haldon C229).
λιτά	with one decoration added (Haldon C237).
τουβία	leggings (Haldon C239).

ἀπό διβλαττίων ἀετῶν κἀι βασιλικίων ἀμφιεσμένα

Imperial silks with eagles and other motifs (Haldon C240-241).

θάλασσαι	watered silk (Haldon C241).
μασουρωτά	with thin reed-like stripes.
ἀβδία πλατύλωρα	wide robe with black, broad stripes (Haldon C242).
πρόκριτα καθαρά	pure silk rather than a mixed yarn (Haldon C250, cf. C300-301).
μετά περσικίων	with pockets, or alternatively a type of standard (Haldon C252).

ἱμάτια ... δεκάλια ... ἐξάλια

The number of ounces of gold ornament in the cloth, or the number of threads and the fineness of the cloth, or the silk's value in nomismata. Haldon observed that the ἐξάλια, δεκάλια etc. silks increased in value as the number incorporated in the term grew.

δεκάπωλα, δωδεκάπωλα etc.

by contrast decreased in value as the numerical factor in the term rose (Haldon C289-290).

| χιώμασιν | richly decorated caparison for horses' hindquarters (Haldon C757). |

Some of these terms were briefly discussed above. On the term μεγαλοζήλων Haldon favoured the theory that it indicated the degree of demand for the cloth, but this explanation cannot be put into practical terms. How were the weavers to produce a standard type of silk without specific technical parameters being imposed? Also, what might be in fashion one day could well be out of fashion the next. The Book of the Prefect was a code pertaining to its day but it must have been designed with an eye to the future. Koukoules decided that the term under discussion represented the value of the cloth. Reiske favoured an explanation in terms of the size of the silk (Haldon 1990:C226). Here again there are arguments that can be forwarded against these theories. As other silks were designated by their cost in nomismata, why shouldn't the same apply in the case of the type of silk being discussed? Why not just say it was a silk of x nomismata value? On the other hand, the size of a given silk most definitely would have had little to do with its value. An enormous, unpatterned, plainly woven silk would be less expensive to produce than a tiny, murex dyed, patterned, complexly woven and gold embroidered silk, for example.

The use of the terms δεκάπωλον and ἑξάπωλον in the Book of the Prefect, perhaps can be related to the expressions ἱμάτια δεκάλια and ἑξάλια in the Baggage train account, which also have numerical connotations (Haldon 1990:C289-290). Reiske took the former terms to mean the degree of gold ornament on the fabric. Koukoules preferred to explain the term as signifying the number or the fineness of threads used in the weave. Haldon adopted a different point of view and he suggested that this type of term was a comment on the value of the silks. Perhaps the most plausible of these explanations is that suggested by Koukoules. The number of warp threads per reed dent and the character of these warps in terms of yarn thickness and so forth determined not only the weight of the fabric to a large extent, but also had a bearing on how smoothly design contours might be rounded on silk patterns. I find it difficult to think that numeric terms referred to the number of loom widths used to sew a garment. The vast size of looms by the tenth to eleventh centuries, perhaps over nine feet across, make this consideration irrelevant. On the other hand there is just the possibility that there were set widths in which the silks were woven, as in fourteenth century Italy and that the width of the cloth was indeed intended (D. and M. King 1988:67, 74-75). For instance, the Italian term 'braccia' designated a cloth 58 cm wide. Silks were woven in widths of specific numbers of 'braccia', for example, 2, 5 1/ 4, 7 1/2. The width argument would best apply in those cases where the increase in number within the term represented an increase in value, that is for the terms ἑξάλια, δεκάλια and so on. The surviving silks indicate that some wide looms were in operation but this does not mean that there were

not also narrower looms. Whilst garments could be cut whole from wide fabrics, from narrower loom widths it might have been necessary to use panels. However, it would be difficult to envisage a caftan or a loose tunic made out of as many as twelve pieces, or even eight or ten panels, so that this line of argument remains unconvincing on the whole. In the final analysis it has to be said that the exact meaning of the terms πωλον and ζήλων cannot be established with the evidence at present available.

Haldon's thesis that ἀρράφων and ἀρραμένα refer to silks respectively without and with decorative sewn panels, again requires further consideration (Haldon 1990:C224). The literal meaning of the two words would tend to suggest far more 'without sewing' and 'sewn'. This does not necessarily entail the meanings without sewn panels and with sewn panels. It could, far more simply, indicate woven to shape, as opposed to tailored. Garments were woven whole or to shape on looms since classical times. Whether the tradition survived in tenth century Byzantium has still to be proved (Granger-Taylor 1981:77). The classification of garments by the number of panels sewn on them, in any event, seems an impractical way of distinguishing and therefore, presumably of pricing merchandise. The panels might greatly vary in size and in value according to the decoration and the materials used. Haldon's theory that δίασπρα (Haldon 1990:C225) indicated either one colour warp and a different colour weft or alternatively twice dyed, would argue against some of his other interpretations of textile terms in the Baggage Train account. If δίασπρα meant twice dyed, then why did διβλάττια (Haldon 1990:C173) not also mean twice dyed? It seems more likely that δίασπρα meant two-tone white. This would fit in with what we know of tenth century weaving types. The lampas weaves described above were often off-white and the contrast between the shiny design areas and the duller background areas of the silk was caused by changes in the weave, the whole having been woven from a single off-white silk. The explanation of one colour warp and one colour weft is unacceptable. The surviving silks indicate that Byzantine silks used weft faced weaves and that the warp was largely covered up. In surviving textiles the warp is almost exclusively undyed. In lampas weave where the warp does show in the background of the weave, there is no colour contrast with the weft, because lampases were woven exclusively as monochrome fabrics judging by the surviving silks.

The term τρίμιτα (Haldon 1990:C229) that Reiske saw as a striped cloth and which Koukoules determined meant with a warp of three threads, should be related to the term as it occured in the Alexandrian textile industry of the Ptolemaic period and was noted in papyri of the third century BC. The polymita were valuable woollen fabrics produced under the direction of the state. This does not indicate what the term means but it does show that these fabrics were valuable. Other ancient Egyptian

weaving terms known from hieroglyphic records indicate the sort of criteria used for describing cloths: one thread weave; four thread weave; six thread weave; eight thread weave; nine thread weave; hundred thread weave and two hundred thread weave (Marzouk 1955:14, 21, 8). It is possible that the term τρίμιτα did refer to the thread count. Similar terms were used of fabrics woven under Roger of Sicily in Palermo in the twelfth century (Muthesius 1982: 256-258 and forthcoming).

The suggestion of striped silks for τρίμιτα is less plausible but the surviving silks as well as Baggage Train account references do indicate that these were plentiful in the Eastern Mediterranean at least from the tenth to the twelfth century (Haldon 1990:C242). Haldon (1990:C242) suggested that μασουρωτά meant with thin, reed-like stripes and that ἀβδια πλατύλωρα indicated a robe with broad black stripes. Both thin and broad stripes are found on extant silks, and these are generally thought to be Islamic pieces. If there were Byzantine striped silks they were most probably woven under Islamic influence.

Θάλασσαι (Haldon 1990:C241) as watered silk is a problematic term. The surviving silks do not include the technique known as 'watered silk' in which different parts of the weave are flattened down to give a rippled effect. There are Islamic references to silks that might have given this effect, but too little is known about the history of the technique to attribute 'watered' silks to tenth century Byzantine weaving workshops. Similarly, Haldon's original manuscript suggested that πρόκριτα καθαρά represented "pure silk and not a mixed weave"; this required qualification. In fact, pure silk refers to the nature of the yarn whilst mixed weave is a reference to technique. There were semi-silks woven in the Eastern Mediterranean but they were rare. The Italians from the thirteenth to fourteenth centuries made extensive use of linen for internal warp threads in their semi-silk fabrics. The term 'mixed weave' does not feature in the C.I.E.T.A. Vocabulary for mediæval weaves, and it should not be used. Haldon's amended version reads "of pure silk rather than a mixed yarn" (Haldon 1990:C250).

10. NOTES ON EARLIER SILK LEGISLATION AND THE
EDICT OF DIOCLETIAN

BEFORE reaching any general conclusions about the Byzantine silk industry, it is useful to briefly review the evidence about Late Roman state weaving factories, to examine early Byzantine silk legislation, and to refer back further, and in greater detail than Lopez, to the descriptions of textiles in the Edict of Diocletian.

Late Roman state weaving factories Jones suggested that Imperial silk factories already existed in the time of Diocletian but none were documented (Jones 1986:II, 836-837; 861-862). Only Imperial wool and linen mills and dye works were documented. These establishments made high-quality clothing for the court, the army and the civil service. The Notitia Dignitatum of the first half of the fifth century contained extensive lists of the mills but only for the western Empire (Seeck 1876). The mills were principally supervised by the Comes Sacrarum Largitionum under the direction of individual procuratores. They were staffed by slaves. The factories were obliged to yield levies in kind at first, which later were commuted to payments in kind. Initially the state supplied the mills with grants in kind but later they gave monetary payments to finance the mills. The yarns may have come from fourth century Imperial mills in Egypt. Sometimes, yarns and unfinished cloths were presented to the mills from guilds of private weavers obliged to furnish such a levy in kind (Waltzing 1895-1900). Jones considered the Imperial factories produced no more than a sixth of the total supply needed. The remaining five-sixths of demand was supplied through the private sector (Jones 1986:II, 837, note 33; Jones 1960:183-92).

A number of state silk factories did appear before the end of the sixth century, for example at Constantinople, Thessaloniki, Antioch, Tyre, Beirut and Alexandria. In the fifth century a state dyeing establishment was recorded in Phoenicia.[25] Up to the time of the late fourth century, raw silk was purchased for these factories by the Comes Commerciorum. State-employed purple fishers supplied murex shells for Imperial purple dyeing operations (Lopez 1945:9). Some fishermen neglected their duties and sold their boats but faced serious punishments as did those buying the craft illegally.[26]

The Theodosian Code, the Justinianic Code and the Basilics represent **Imperial silk** legislation over a period of more than six centuries. In the case of the two **legislation** earlier documents, the regulations were issued principally in Constantinople. The question is where was the legislation received? The Basilics were the amended expression of regulations formulated centuries earlier (Schminck 1986). The main themes behind the silk legislation were threefold:

- maintenance of an Imperial silk weaving and purple dyeing work force
- prevention of fraud within the Imperial workshops
- protection of the Imperial monopoly over murex purple and certain gold borders.

The legislation consists largely of a list of fines and punishments imposed on those breaking rules governing the weaving of special types of silks, and matters relating to the behaviour of Imperial weavers, embroiderers and dyers. The relevant pieces of legislation are set out in chart form for convenience and to indicate how much of the legislation repeated itself across the centuries (see chart on next page).

Attention has been drawn to the poor social conditions endured by the Imperial silk and purple workers of the fourth to fifth century (Charbonnel 1964:61-93). Fugitives were mentioned in the regulations and private workshops were clearly trying to poach Imperial workers as the fines imposed to stop this activity indicated.[27] Constantine in 358 demanded a fine of three pounds of gold for illegal poaching of an Imperial slave of a state weaving factory. The fine was increased to five pounds of gold in 372 but reverted back to the former sum in 380. The fines were re-iterated in the Code of Justinian and in the revision of the Code under Leo VI (886-912). The Basilica added a two pound gold fine for those caught corrupting female workers in Imperial textile factories, to a three pound gold fine enforced on those concealing Imperial textile factory slaves. [28]

Lopez traced some of the early legislation and the changes in the status of Imperial weavers (Lopez 1945:3-13). By the fifth century a number of obligations were relaxed. For instance, it was possible for individuals to escape their hereditary caste of Imperial silk weaver or dyer, although descendents were still tied to the state. An appropriate substitute had to be supplied by the departing guildspeople, themselves. The legislation was embodied in a decree of the Emperors Theodosius and Valentinian of 426 that read:

"If any person from a guild of Imperial weavers either a linen weaver or a linen worker, or from the guilds of Imperial minters or purple dye fish collectors or from any similar guild pertaining by connection of blood to the divine Imperial largesses, should wish hereafter to be freed from his guild, he may not rely on the Permission of Our triumphal right hand to

DATE	REFERENCES	LEGISLATION
333	T.C.1.32; J.C.8.2.7; B.54.16.21	No fraudulent enrolment or misappropriation of materials
365	T.C.10.20.3; J.C.8.3.7	Freeborn women adopt Imperial weaver husband's slave status
369	T.C.10.21.1; J.C.9.1.8	Gold/gold and silk borders forbidden on male/female dress. Such borders to be made only in Imperial weaving establishments.
372	T.C.10.20.7; J.C.8.5.7	5 lb gold fine for harbouring Imperial weaver
380	T.C.10.20.9; J.C.8.6.7; B.54.16.6	3 lb gold fine for harbouring Imperial weaver
382	T.C.10.21.2; J.C.9.2.8; B.6.25.7	No gold borders on tunics or linen garments.
385	T.C.10.20.12; J.C.8.9.7	2 lb gold fine for usurping boat of Imperial purple dye collector
406	T.C.10.20.13; J.C.8.10.7	20 lb gold fine for delivery of unwashed, dyed or raw silk
424	T.C.10.20.14; J.C.8.11.7; B.54.16.11	Purple dyers to relinquish illegally held posts. Property of purple fish dyers illegally held to be returned. Slave status for owners.
424	T.C.10.21.3; J.C.9.4.8	No private manufacture of Imperial murex, silk cloaks. No purple yarn to be used either woven or spun.
425	T.C.10.20.15; J.C.8.12.7	Child takes on mother's professional status as purple fish dyer
426	T.C.10.20.16; J.C.8.13.7	Imperial weavers and dyers to provide replacements when leaving guilds
427	T.C.10.20.17; J.C.8.15.7	Children born from now must adopt mother's purple fish collector status. Children born earlier, to follow father's profession.
436	T.C.10.20.18; J.C.9.5.8	Strict check on illegal private dyeing in Imperial factory of Phoenicia. 20 lb gold fine on culprits.
10th century	B.54.16.8	2 lb gold fine for corrupting Imperial, female textile workers.

TC = Theodosian Code JC = Justiniac Code B = Basilics

CONTINUITY IN SILK LEGISLATION

choose as a substitute for his own place any person whatever chosen indiscriminately, but he shall elect only a person who has been approved in every particular as suitable under the very eyes, as it were, of your most August office. It shall be provided however, that if any person should be freed from such ignoble status by a special grant of Imperial favour in accordance with an Imperial regulation, celestially conferred, he shall not doubt that the entire stock of his family shall remain in the compulsory public service of the aforesaid guild, together with all the property of the person, who was thus released, and that the family shall be obligated to the Imperial largesses." (Theodosian Code X.20.16; Novelles of Justinian XXX, VIII.6 and Basilica LIV.16.16)

The Price Edict of Diocletian indicates the expensive range of silks **The Edict of** available to the public in the Late Roman Empire and by way of contrast **Diocletian** it also reveals the lowly status enjoyed by the craftsmen occupied in their **setting price** manufacture. The Edict makes clear the enormous outlay of capital **ceilings in 301** necessary for the purchase of raw materials. The cost of a pound weight of raw silk was 12,000 denarii. If the silk in addition, was dyed with purple of the most costly kind (murex blatta) it commanded the astonishingly high price of 150,000 denarii a pound at a time when this was the equivalent of approximately three pounds of gold (Frank 1940). Finest wool dyed in the same purple sold for a maximum of 50,000 denarii, or one third the price of the silk. Cheaper purples were priced as follows and used on wools:

lighter blatta	32,000 den per lb
bright Tyrian	16,000 den per lb
Milesian purple	12,000 den per lb

Scarlet kermes dye cost 1,500 denarii a pound weight. Archil dyes were cheapest at 300 to 600 denarii the pound (Frank 1940:383). Dyes of high value continued to be used in the silk industry of the Eastern Mediterranean right up to the twelfth century and beyond. The Cairo Geniza documents of the tenth to eleventh centuries include an interesting price list detailing the dyer's expenses for colouring a fabric. The cost of the dye far exceeded any other expense involved (Goitein 1967:107).

(The Edict spoke of dyeing cocoons but this I did not witness in India, although I believe it is possible to do so. In general dye takes best when degummed yarn is used.) The cost of unravelling the cocoons was set down in the Edict but does not survive today. The relative costs of treating the silk yarn were documented. For spinning first quality purple silk, workers earned up to 116 denarii an ounce. Purple silk of second quality was spun at less expense; 60 denarii an ounce (Frank 1940:383). The rates of pay for a selection of different weavers was also given in the Edict.

Fancy silk weavers were distinguished from plain silk weavers and their wages reflected the relative degree of skill entailed in their respective occupations. Fancy weavers received per day their keep and 40 denarii. Plain silk weavers were paid only 25 denarii and given their daily keep (Frank 1940:378). Skilled linen weavers by comparison earned maintenance and 40 denarii daily. Wool weavers were paid 40 denarii and again received their daily keep. For making and attaching a silk collar to a garment a tailor might receive 50 denarii, that is more pay than a fancy silk weaver received for a whole day"s work (Frank 1940:343).

The lowly status of the silk weavers is apparent from the fact that the plain silk weaver received like wages to the water carrier or the sewer cleaner. This amounted to only 25 denarii a day with maintenance. It was low pay at a period when a hair cut was priced at 2 denarii (Frank 1940:342). The wheat buying power of the wages of the plain silk weaver appear more or less to have been on a par with those of low paid farm labourers documented in contemporary Egyptian papyri. Downey calculated that maintenance had the value of 10 denarii a day and bearing this in mind one can reason that the status of the master silk weaver was precisely on a par with that of stone masons, cabinet makers, carpenters, lime-burners, wall mosaicists, tessellated floor makers, blacksmiths, wagonwrights, shipwrights, bakers and model makers (Frank 1940:338-341).

Indeed, the stigma attached to any kind of craft or business enterprise persisted from Late Roman times into the Byzantine period. Only those handling very precious materials such as gold could rely on high wages for their skills. Thus gold embroiderers were given high wages, but there again these probably included the cost of the working materials (Frank 1940: 378). The embroiderers were receiving up to 500 denarii an ounce of gold worked. Brocade weavers fell into a similar category; they received 1000 denarii for each ounce of woven cloth.

The extravagant prices paid for the best textiles, proves that of necessity the most exclusive fabrics were available only to the super rich. The prices of some silk cloaks and shirts and of a number of semi-silk garments as they occured in the Edict are as follows:

- New pure silk dalmatic with hood, 600 denarii. (Fifteen times the daily wages of a skilled silk weaver.)
- Hooded, semi-silk dalmatic, 300 denarii.
- Pure silk dalmatic without hood, 400 denarii.
- Hoodless, semi-silk dalmatic, from 125 to 200 denarii.
- Pure silk shirts, 250 denarii.

If valuable silks were retailed at such high prices when the craftsmen were receiving such low wages, then profits must have been relatively high even

allowing for the high cost of raw material. Allowance should also be made for tax payable on sales, although the amount due was not recorded.

It cannot be said that the market was geared only to the rich, however. The use of the word 'new' in the description of the dalmatic above suggests that second hand clothing was available too. Also less cost was involved in buying non-silk garments than in purchasing silken ones. Decoration came in graded categories and was priced in three classes to suit different pockets. Embroidery on pure silk commanded not unnaturally a high price, at 300 denarii an ounce. Embroidery on semi-silks was paid at the rate of 200 denarii an ounce. Coarse embroidery on wool was rated at a maximum of only 25 denarii an ounce (Frank 1940:371).

The wealth of detail available in the Edict for the early fourth century acts as a guide to the intricacies of the Late Roman and the early Byzantine textile industries. No doubt the wealth of specialised textile terms discussed above in connection with the regulations of the Book of the Prefect and other sources, indicates an equally complex silk production in the later period. In any consideration of the Byzantine Silk Industry the details of the Edict of Diocletian should not be overlooked. The craftsmen had certainly gained in status between the fourth and the tenth centuries even if categories of textiles that they produced; fancy woven silks; precious purples and gold embroidered pieces, had changed but little.

11. STATE REVENUE AND THE SILK TRADE

LOPEZ did not attempt to gauge the size of the silk industry in the absence of statistics. Neither did Antoniades-Bibicou attempt to do so. Recently Treadgold and Hendy independently suggested that the state gained only a very small percentage of its income from trade revenue (Treadgold 1982:58-61; Hendy 1985:157-158). In the ninth century Treadgold estimated state revenue at 3.3 million nomismata of which the hearth and land tax represented 2.9 million nomismata (Treadgold 1982:51-61). The revenue from trade he considered amounted to no more than 100,000-200,000 nomismata (Treadgold 1982:60). Hendy admitted that very few figures on taxation were available but he referred to the estimate made by Jones that only 5% of state revenue came from trade (Hendy 1985:157, note 1). Jones took the example of Edessa on the trade route from Persia via Nisibis at the end of the fifth century.

There the collatio lustralis or trade tax was only 2,520 solidi a year. This, Jones felt, contrasted with the annual land taxes of 57,500 and of 59,500 solidi paid in the sixth century cities of Heracleopolis and Oxyrhynchus respectively (Jones 1986:I 465). He also contrasted the wealth of rich merchants with that of territorial magnates, the former enjoying annual incomes less than a fifth of those of the richest documented landowners (Jones 1986:870-871). Hendy similarly pointed out that the 860,000 hyperpyra he roughly estimated to be the Italian trading investment in Constantinople between 1170-1190, amounted to no more than the fortunes of six provincial Byzantine magnates of the time (Hendy 1985:590-602).

There are two points that perhaps have been overlooked here. The first is that we have no way of telling what part of the land tax was paid on mulberry plantations. The taxation of the Calabrian mulberry trees recorded in the Reggio Brebion illustrates the practice did exist (Guillou 1974). The second point that can be made in relation to the theories discussed is that we do not know the ratio of rich merchants to that of very rich provincial magnates. If there were numerous wealthy traders but only a handful of immensely rich magnates then the available figures might give an unbalanced picture of the true situation. It is possible that by the ninth century there were mercantile magnates of the order of the provincial magnates if the case of the widow Danielis is taken as an example. This textile manufacturer was able to present numerous rich gifts to the Emperor Basil I (Hendy 1985:207). We have no way of telling how many mercantile magnates there might have been. The situation is further complicated by the fact that servants could be set in the place of wealthy individuals to engage in manufacture and trade according to regulations in the Book of the Prefect as remarked earlier. How far were 'noble faces' embroiled in 'under cover' mercantile transactions?

Hendy felt that the Byzantine mercantile class and artisanate were suppressed deliberately by the state and by its administrators, whose ideology was predominantly anti-mercantile (Hendy 1985:569). He pointed to the evidence of legislation, which prevented the mercantile classes from taking up posts in the state administration and which likewise discouraged the administrative classes from entering into trade (Hendy 1985:569 note 64). Nevertheless, the mercantile classes gradually gained greater status and political power in the eleventh century; a process initiated by Romanus III, and perpetuated during the reigns of Michael IV and Michael V, in the period from 1028-1042.

Hendy thought that between 1034-42 in particular, the Empire was administered by "members of a family which originated at no great remove" from the mercantile classes (Hendy 1985:572-573). He went on to detail the distribution of offices and honours to members of the

metropolitan guilds and their probable enrolment in the senate under Constantine IX (1042-55) (Hendy 1985:574). Isaac I (1057-59) withdrew some of the privileges but his successor Constantine X (1059-67) proceeded to shower personal honours on members of the guilds. The guilds had clearly become leaders of the popular faction that distinguished itself both from the regional military aristocracy and from the metropolitan administration. This third political force, correctly identified by Hendy, played a significant role in the deposition of the Emperors, Michael V, Michael VI and Michael VII. Not until the reign of Alexius I (1081-1118) was the policy of conferring social status through the grant of special Imperial privileges brought firmly into check. Alexius cut off annual payments that accompanied special dignities granted by his predecessors to guild members amongst others and re-instated the idea of a clear social distinction between the senatorial and the mercantile classes (Hendy 1985:584-585). Hendy assumed that the same attitude prevailed under John and Manuel Comnenus up to 1180 but that Andronicus I (1182/3-5) again granted privileges to guild members. He concluded that the period 1081-1181 represented a time of severe constraint on the mercantile classes when their development was held in check by economic, political and social measures effected by the state (Hendy 1985: 586-587, 590). Whilst others had seen the competition from Italian merchants as the cause of the lack of growth, Hendy saw it as nothing less than deliberate state policy. Unlike Frances, Hendy did not believe that Byzantine merchants were thwarted by Italian competitors (Frances 1964:93-101; cf. Lilie 1984). Lopez very much saw the Italians, the Venetians in particular, as intermediaries for silk trade with the West (Lopez 1945:35-41). The present author agrees with Lopez and cannot trace an appreciable break in the export of Byzantine silks to the West at any given point, from the evidence of the surviving pieces. Political constraint is evident from the documents but how far this affected economic production is not certain.

12. SUMMARY OF CONCLUSIONS

THE conditions necessary for the development of the silk industry in Byzantium were essentially Imperial. It was a luxury industry that required large injections of cash as well as an extensive body of

craftsmen, skilled in handling precious materials. The Imperial silk guilds as Lopez suggested probably grew out of the Late Roman Corporations. Boak remarked,

> "the early fourth century saw the culmination of the process whereby the professional guilds of the Roman Empire were transformed from volun-tary associations formed with government approval and encouragement, into compulsory public service corporations entirely controlled by the state."

True enough early Imperial silk guilds were subject to strict and harsh rules. They were obliged to pursue their craft in the city of their birth and guild membership was hereditary. Once enrolled into a silk guild it was difficult to leave and inter-marriage between members of different guilds was discouraged. Although legally free the craftsmen were in all but name "slaves to their occupation and to the state."

Initially the Imperial policy of overall control of the industry fostered a caste system of hereditary workers. These craftsmen worked in the Imperial factories and produced silks for the court. They enabled the Imperial house to establish and maintain a monopoly over specific luxury silk goods destined for Imperial use. When supply exceeded demand it was necessary to free some of the Imperial craftsmen from their hereditary duties in the Imperial factories. These craftsmen probably sought work in the private sector of the industry as Lopez remarked.

Little is documented about private silk weaving in the Byzantine Empire before the tenth century. There were non-Imperial workshops in the provinces but nothing is known about the types of silks they produced. Perhaps from the sixth century onwards a controlled growth in the private sector of the silk industry did occur. Then as silks increasingly were freed into the public market the separation between craftsmen and merchants became more marked. With the developed non-Imperial guild system of the tenth century, private silk manufacture represented an industrial enterprise and demanded commercial capital. The industry moved from a low profit situation to a potentially high profit enterprise in a widening market.

Strict separation of tasks in the silk industry was normal. Dyers, weavers, gold embroiderers and tailors were mentioned in the Edict of Diocletian and in the Theodosian Code in the fourth to fifth centuries. The Book of the Prefect of the tenth century even more clearly demonstrated the principle of strict division of labour within the silk industry. The regulations in the Book of the Prefect were instigated to maintain a proper code of conduct between private silk workers and to insure standards in the silk industry centred in Constantinople in the tenth century.

There were five principle aims behind the legislation:

 1. prevention of shoddy workmanship

2. maintenance of a standard uniformity of finished product
3. discouragement of unethical conduct amongst guild members
4. provision of centralised control to act as a link between trade and industry
5. correct payment of taxes

By policing every stage of the silk producing process, it was possible for the government to broaden its tax base and to increase revenue considerably. Careful regulation of import and export taxes meant that foreign markets could be manipulated as the situation demanded. Special trade concessions were also granted for purely political ends; most particularly in return for military and naval support.

Whilst problems of cash flow cannot have been identical in the Imperial and in the private silk sector there were problems they shared in common. Both sides required large amounts of seasonal capital to secure imported raw silk. In the private silk industry resources were pooled and guild members acted in a cartel. This not only increased the cash base but it insured fair distribution of raw material. Poorer workers unable to join the guilds could buy their materials from the richer guild members, who sold at a reasonable, pre-set profit margin.

The date of the introduction of sericulture into the Byzantine Empire has been misinterpreted by many authors including Lopez. It seems unlikely that sericulture was transposed from the Near East overnight in the sixth century. Hitherto unused Chinese sources indicate it existed in Syria already in the fifth century. Unfortunately, nothing is known about how Imperial or private mulberry plantations were administered, but mulberry trees were taxed in Byzantine southern Italy. In the absence of necessary statistics it is impossible to tell how far the Byzantine silk industry was self-sufficient in raw material and how far it needed to import raw silk. However, the importation of Syrian silk, documented in the Book of the Prefect, would suggest that there was a general shortage of raw silk in the Byzantine Empire.

Another important consideration is the permanently high risk factors involved in the industry, whether through lack of the essential raw silk, or the result of costly mistakes in manufacture. In the Imperial industry costs mainly were immaterial because profit generally was not the aim of the industry. Nevertheless, even here, as Lopez remarked, one may wonder at the expense involved in providing the court with all its silken splendour as reflected in the Book of Ceremonies and elsewhere. Indeed, there was even a time in the sixth century when Imperial silks were sold to the public.

The private silk industry with a long term eye on ensuring profits, depended on adequate cash flow to seal the success of its enterprise. The relative cost of securing raw materials, of maintaining labour and of

covering overheads had to be balanced against the demands of the home and the foreign markets. Outlay had to be measured against the ceiling prices that at any one time could be demanded for the finished silk articles. The types of silks that could be produced both by the Imperial and by the private silk industry, were regulated by the state.

Murex purple dyed Byzantine silks were a personal status symbol of the Emperors and they symbolised the power and the glory of the Empire. In Imperial hands silk was an active and powerful political tool capable of securing diplomatic alliances and foreign support. The distribution abroad of fine Byzantine silks encouraged credibility and respect for the Empire as Lopez rightly remarked.

Equally significantly, Byzantine silks acted as a form of currency. For instance after shipwreck, survivors were required to forfeit salvaged valuables including silks as a contribution towards the general loss. Eastern Mediterranean merchants could settle trade transactions in payments of silk rather than currency. Large reserves of silk were stored in the Imperial Palace and wealthy Byzantines hoarded silks in monaster-ies for safety (Muthesius forthcoming).

Mismanagement of the silk industry could seriously affect the bal-ance of trade in the Empire and indirectly give rise to political unrest. Lopez was correct to say that balanced silk production and trade provided stability for the citizens of the Byzantine Empire even if they could not afford to buy the silk themselves. In addition, the sale of Byzantine silks abroad was one means of ensuring the influx of foreign gold into the Empire. Conversely, to prevent the flow of gold from the Empire, regula-tion and strict control of imported silks was required. Lopez was again right to point out the necessity of control over export. However, his insistence on the all important role of the Imperial silk monopoly should be viewed with care. The use of silk was widespread by the tenth century not only in the Byzantine Empire but in the whole of the Islamic Mediterranean and Near East. Clearly, the surviving silks demonstrate a near identical silk production in Islamic and in Byzantine silk weaving centres by the tenth century. Byzantine silk production was part of a much larger silk weaving operation that covered the entire Mediterranean basin. The survival of so many Byzantine silks in the West between the sixth and the twelfth centuries indicates well the influence of the Mediter-ranean on the West. The traditional picture of restricted silk production and export relies too heavily on the evidence of the surviving historical documentation without sufficient recourse to the extant silks.

Maintenance of a hierarchy of dress cannot be denied from the documentation, but in general the close supervision of the silk industry by the Byzantine State I believe should be seen as no more and no less than the essential protection of an important part of the economic and

political welfare of the Empire. It is difficult to believe that economic growth was entirely stifled to contain the political activities of a rising mercantile force. From the fourth to the twelfth century, silk held far too unique a place in Byzantium's economic, political and social development. Lopez drew attention to the Byzantine silk industry nearly half a century ago but its full significance has still to be truly appreciated. It is possible to argue that the silk industry represented one of the Byzantine Empire's most crucial assets up to the time of the fall of Constantinople in 1204, and as a witness to this, it is relevant to note it survived even that catastrophe.

ACKNOWLEDGEMENTS

The author would like to thank Rex Gooch of IBM UK for preparation of the text and figures.

The author is pleased to acknowledge the support of Wingate Scholarships in her research.

NOTES

1. The text of the Book of the Prefect was discovered and first published by J. Nicole in Geneva in 1893. Subsequent translations and editions were made by a number of authors. The work of Nicole and Freshfield was incorporated in a Variorum Reprint (Nicole 1970). Most recently see Koder 1991. Nicole 1970 and Koder 1991 are used in the present article. Most of the vast relevant literature on the Book of the Prefect was listed by (Vryonis 1971:293-4 note 13). See further note 17 below.
2. The law 'Peri Metaxes' was first published by (Zachariae von Lingenthal 1865).
3. (Nicole 1970:16 and note 3). Book of the Prefect 6.15, 7.2, (Koder 1991:101).
4. On forbidden purples see (Nicole 1970:35-36), Book of the Prefect 8.1, 8.2, amongst the regulations pertaining to the Serikarioi. (Koder 1991:102-105).
5. Novel 80 of Leo the Wise is in (Noailles and Dain 1944: 272-274). Freshfield translated the Novel to read as follows:

"I do not understand why the Emperors, my predecessors, who dressed
in purple, were induced to legislate to forbid any piece of purple material
from figuring as an article of commerce, or prohibit the purchase and
sale thereof. To prevent the trade in a whole piece of fabric would not be
a vain matter for legislation; but since scraps and clippings cannot be
of practical use or advantage to buyers and sellers, what honest
purpose, and exempt from jealousy of their subjects can have prompted
the idea of the legislators: and how can it be prejudicial or derogatory
to the imperial rank? Since we do not approve of such an idea, we ordain
that scraps and clippings, to which our subjects attach distinction and
importance, and which they can use for any purpose not forbidden by
law, may be bought and sold. Besides other benefits which the Emperor
confers upon his subjects he must not be envious of their luxuries".

6. (Nicole 1970:32, 38), Book of the Prefect 6.8, (Koder 1991:99). The Metaxopratai
 purchased raw silk as a cartel and the Katartarioi in agreement with them could
 also purchase raw silk, see Book of the Prefect chapter 7.4.

7. (Nicole 1970:19). Slaves could enter the guilds of either the Metaxopratai, Book
 of the Prefect 6.7, or of the Serikarioi, Book of the Prefect 8.13, (Koder
 1991:99,107).

8. Both Imperially manufactured clothing, and garments purchased on the open
 market, were documented in the Baggage train account appended to the Book
 of Ceremonies: (Haldon 1990:C289-290) for bought silks and C226 for garments
 produced in Imperial workshops or under state commission.

9. (Treadgold 1982:111-114, table VI) suggested rates of pay for military and civil
 offices, for instance. (Ostrogorsky 1932:293-333) cited mules at fifteen nomismata
 each. Horses costing 12 nomismata were documented in the Baggage train
 account appended to the Book of Ceremonies, (Hendy 1985:311 and note 265).

10. Michael Choniates Epistolai in Mikhael Akominatou tou Khoniatouta Sozomena,
 L.11.83.

 "For what do you (in Constantinople) lack? Not the wheat bearing plains
 of Macedonia, Thrace and Thessaly, which are formed by us (provincials)
 nor the wines of Euboia, Ptelion, Chios and Rhodes, which are pressed
 by us, nor the fine garments, which are woven by our Theban and
 Corinthian fingers nor all of the moneys, which just as many rivers flow
 into one sea, flow into the Queen City." (Constantinople)

11. The oath was discussed by (Starr 1939: 163, 219, 221-222) and it read as
 follows:

 "In the name of the blessed Lord, the God of our fathers, who made the
 heaven and the earth and led us on dry land across the Red Sea, I do
 not testify falsely. If I be found a perjurer, may the Lord God afflict me
 with the leprosy of Gehazi and Naaman and with the punishment of Eli;
 may the earth swallow me alive even as Dathan and Abiram".

12. A skilled labourer earned just over 3 dinars for working four weeks and the cost
 of the average quality raw silk per pound weight c. 1050-1150, was from 25%-
 50% over a standard price of 2 dinars.

13. The significance of the Edict has been discussed quite widely but it is not
 possible to cover the material in this article. For a recent contribution see

(Williams 1985:126-139).

14. Parts of houses were rented out and used for commercial purposes. The rents and the selling prices of houses are recorded. Some houses were bought and sold by merchants and dyers, for example, document 272 Bodl. b. 11. Document 278, TS 8J9. f 17c item 1 dated 1160, mentioned the sale of two out of twenty four shares in a house containing two inter-connected apartments and a silk worker's qa'a, for 3 dinars. The house cost 36 dinars. Document 278 TS 8J 32 f 4 and TS 10J 21 f 17 dated 1229, one dyer sold to another, half a house for 430 dirhems. The house cost 20 dinars.

15. Hendy indicated land use in modern Anatolia. The central plateau and peripheral mountains form over 70% of the total surface area of the peninsula. This territory is most suitable for the grazing of flocks and herds. It is relevant to note that the Crusaders found the plateau arid (Hendy 1985:40-44).

16. Professor Koder of the Byzantine Institute, University of Vienna, has prepared a new edition of the Book of the Prefect, and has published a number of useful articles on silk regulations in particular (Koder 1991, 1988, 1989).

17. It is beyond the scope of the present article to consider Byzantine guilds in general. In this respect literature of note includes (Ostrogorsky 1933:389-95; Mickwitz 1936:63-76; Brehier 1938:354-59; Bratianu 1939:497-511; Mendl 1959:302-19)

18. Book of the Prefect, 6.4. Clearly the tax was regulated by weight, and the scales of the silk merchant had to bear an official stamp. (Schilbach 1970:174) gives reasons for identifying the ταλαντου with the κεντηναριου which represented a weight of 32kg. If the tax was paid in coin then one καγκελαριονwould have been the appropriate tax payment on 32kg. of silk, which seems a plausible explanation. The difficulty is that the term καγκελαριον is unknown from surviving Byzantine coins. Could it have been a special tax token used only by the trading community? (See Koder 1990, Problemwörter: 189-190).

19. Personal communication from Professor Koder.

20. The process is carried out in this traditional manner in centres such as Kancheepuram in the south-east of India.

21. Watered silk refers to an effect obtained by pressing the silk in a special way after weaving so that the surface reflects ripples of light. There were many different types of names for Eastern Mediterranean silks and they are difficult to identify. See for example, the wealth of terms for silks in (Ahsan 1979:19-75).

22. Totally forbidden for manufacture, Book of the Prefect, 4.1, 8.1, 8.2, 8.4. Silks to be declared to the Prefect were detailed in Book of the Prefect, 4.2, 4.3, 4.4, 4.8, 5.3, 8.1, 8.2, 8.9.

23. No private manufacture of Imperial murex, Theodosian Code 10.21.3, Justinianic Code 9.4.8.

24. Dr. Haldon's manuscript on the Baggage Train account was made available to the author for editing purposes regarding textile terms prior to publication. References here accord with those of the published work, see Haldon 1990:153-293.

25. Theodosian Code 10.20.18 and Justinianic Code 9.5.8 for purple in Phoenicia.

26. Theodosian Code 10.20.14, Justinianic Code 8.11.7, Basilics 54.16,11.

27. Theodosian Code 10.20.7 and 10.20.9, Justinianic Code 8.5.7 and 8.6.7 and Basilics 54.16.6.
28. Basilics 54.16.8.

LITERATURE

Ahsan, M. M. 1979. Social Life under the Abbasids 289-902. London.

Antoniades-Bibicou, A. 1963. Récherches sur les Douanes à Byzance. Paris.

Boak, A. E. R. 1929. Notes and Documents. The Book of the Prefect. Journal of Economic and Business History 1:597-610.

Bratianu, G. J. 1939. Les études Byzantines d'histoire économique et sociale. Byzantion 14:497-511.

Brehier, L. 1938. Histoire byzantine, Revue Historique 184:354-59.

Charbonnel, N. 1964. La condition des ouvriers dans les ateliers impériaux au IV et V siècles. Travaux et Récherches de la faculté de Droit et des sciences économiques de Paris. Séries Historiques 1:61-93.

Christophilopulos, A. 1935. Το Επαρχικον Βιβλιον. Athens.

Cross, S. H. Sherbowitz O. P. 1953. The Russian Primary Chronicle. Cambridge Mass.

Farag, W. 1979. Byzantium and its Muslim neighbours during the reign of Basil II. PhD thesis. Centre of Byzantine and Ottoman Studies, University of Birmingham.

Farag, W. 1990. The Aleppo question. BMGS 14:44-60.

Frances, E. 1962. L'État et les metiers à Byzance, Byzantinoslavica 23:231-49.

Frank, T. 1940. The Edict of Diocletian. An economic survey of ancient Rome V. London.

Freshfield, H. 1938. Ordinances of Leo VI c. 895 from the Book of the Prefect in: Roman Law in the Later Roman Empire. Cambridge.

Goitein, S. D. 1963, 1971, 1983. A Mediterranean Society I, II, IV. New York.

Granger-Taylor, H. 1981. Weaving cloths to shape in the ancient world. C.I.E.T.A. Bulletin 53:77.

Guillou, A. 1974. Le brébion de la metropole byzantine de Reggio in: Corpus des actes Grec d'Italie 4. Vatican City.

Haldon, J. F. 1990. Constantine Porphyrogenitus. Three treatise on Imperial military Expeditions, CFHB, 28. Vienna.

Haury, 1905. Procopius, De Bello Gothico IV 17. Leipzig.

Heimbach, K. 1833-46. Basilica. Lipsiae.

Hendy, M. 1985. The Byzantine Monetary economy. Cambridge.

Hennig, R. 1933. Die Einfeuhrung der Raupenzucht im Byzantinerreich. BZ 33: 295-312.

Hirth, F. 1855, 1966. China and the Roman Orient. Shanghai, Hongkong. New York.

Jerussalimskaja, A. 1972. The formation of the Sogdian school of weaving. Srednia ia Aziia i Iran Gosudarstvennogo Ermitazha, 5-46. Leningrad.

Jones, A. H. M. 1986. The Later Roman Empire 284-602 I-II. Oxford.

King, D. and M. 1988. Silk weaves of Lucca in 1376. Opera Textila Variorum Temporum. To honour Agnes Geijer on her ninetieth birthday 26th October, 1988. The Museum of National Antiquities, Stockholm, Studies 8:67-76. Stockholm.

Kislinger, E. 1988. Gewerbe im späten Byzanz, in: Handwerk und Sachkultur im Spatmittelalter. Wien.

Kislinger, E. 1990. Jüdische Gewerbetreibende in Byzanz, in: Die Juden in ihrer mittelalterlichen Umwelt. Wien.

Koder, J. 1987. Probleme des Eparchenbuches. Vortrag. East Berlin.

Koder, J. 1988. Ueberlegungen zu Aufbau und Entstehung des Eparchikon Biblion in: Kathegetria. Essays presented to Joan Hussey for her 80th Birthday. Camberley.

Koder, J. 1989. Επαγγελματα σχετικα με τον επισιτισμο στο Επαρχικο Βιβλιο in: Akten Symposion über Alltagsleben. Athen.

Koder, J. 1990. 'Problemwörter' im Eparchikon Biblion, in: Kolloquium zur byzantinischen Lexikographie. Wien.

Koder, J. 1990, 2. Delikt und Strafe im Eparchenbuch: Aspekte des mittelalterlichen Korporationswesens in Konstantinopel. Wien.

Koder, J. 1991, Das Eparchenbuch Leons des Weise. CFHB 33, Wien 1991.

Krueger, P. Mommsen, T. Schoell, T. Kroll, G. 1954. Codex Justinianus, Berlin.

Lauffer, S. 1971. Diokletians Preisedikt. Berlin.

Lopez, R. S. 1945. Silk Industry in the Byzantine Empire. Speculum 20 no.1:1-42.

Marzouk, A. 1955. History of the Textile Industry. Alexandria.

Mendl, B. 1961. Les corporations byzantines. Byzantino Slavica 22:302-19.

Meyer, E. 1912. Review in BZ 21:531-35 of A. Stockle, Beitrage zur alten Geschichte. Spätrömische und byzantinische Zünfte. Klio 9 Beiheft:24-148. Cf. next entry.

Mickwitz, G. 1936. Die Kartellfunktionen der Zünfte. Helsingfors.

Mommsen, T. Meyer, P. M. Krueger, P. 1962. Codex Theodosianus I-II. Berlin.

Muller J, Theophanes of Byzantium. Fragmenta Historicorum Graecorum, IV, 270.

Muthesius, A. M. 1982. Eastern silks in Western shrines and treasuries before 1200 AD. PhD Thesis. Courtauld Institute of Art, University of London.

Muthesius, A. M. 1984. A practical approach to Byzantine silk weaving, JÖB 34:235-254.

Muthesius, A. M. 1989. From Seed to Samite, aspects of Byzantine Silk Weaving. Ancient and medieval textile studies in honour of Donald King. Textile History 20, 2:135-149.

Muthesius, A. M. forthcoming. A history of the Byzantine Silk Industry. 2 vols. ed. Byzantine Institute, Vienna.

Nicole, J. 1893, 1970. Le Livre du Préfet. Geneva, London Variorum Reprint

Noailles, P. N. Dain, A. 1944. Leo VI Sapiens. Les Novelles. Paris.

Oikonomides, N. 1972. Quelques boutiques de Constantinople au Xe siecle: Prix, loyers, imposition (Cod. Patmiacus 171). DOP 26:345-56.

Oikonomides, N. 1986. Silk trade and production in Byzantium. DOP 40:33-53.

Ostrogorsky, G. 1932. Lohne und Preise in Byzanz. BZ 32:293-333.

Ostrogorsky, G. 1933. Review of G. ZORAS, Le corporazioni bizantine. Rome 1931. BZ 33:389-95.

Papadopulos-Kerameus, A. 1899. Hiersolymitike Bibliotheke 4. St. Petersburg.

Persson, A. W. 1923. Staat und Manufaktur im römischen Reiche. Skriften vetenskaps-societeten Lund 3:68-81.

Pharr, C. 1952. Theodosius II Emperor of the East. The Theodosian Code and Novels and the Sirmondian Constitutions. The Corpus of Roman Law I. Princeton. New Jersey.

Reiske, I. I. 1829-31. Constantini Porphyrogentii imperatoris, De Caerimoniis aulae Byzantinae. Bonn.

Scheltema, H. J. Wal, N. Holwerda, P. 1955. Basilika. Gröningen.

Schilbach, E. 1970. Byzantinische Metrologie. Munich.

Schlumberger, G. 1884. Sigillographie de l'empire byzantin. Paris.

Schminck, A. 1986. Studien zu mittelbyzantinischen Rechtsbüchern. Forschung zur byzantinische Rechtsgeschichte. 13. Frankfurt.

Seeck, O. 1876. Notitia Dignitatum. London.

Shepherd, D. G. 1980. Zandaniji Revisited in: Festschrift für S. Müller-Christensen 105-122. Munich.

Shepherd, D. G. Henning W.B. 1959. Zandaniji identified? in: Festschrift für Ernst Kühnel 15-40. Berlin.

Simon, D. 1975. Die byzantinische Seidenzünfte. BZ 68:23-46.

Starr, J. 1939. Jews in the Byzantine Empire. Athens.

Stöckle, A. 1911. Spätrömische und byzantinische Zünfte, Klio 9:24ff.

Svornos, N. 1976. Remarques sur les structures économiques de l'Empire Byzantin du XI^e siècle. TM 6:65.

Treadgold, W. T. 1982. The Byzantine State Finances in the Eighth and Ninth Centuries. New York.

Vogt A. 1935. Constantini VII Porpyrogenete Le Livre des Cérémonies I, commentary 1-2. Paris.

Vryonis, S. 1971. Byzantium its internal history and relations with the Muslim World. Variorum Reprint. london.

Wada, K. 1972. Prokops Rätselwort Serinda und die Verpflänzung des Seidenbaus von China nach dem oströmischen reich. PhD thesis, Cologne University.

Waltzing, J. P. 1895-1900. Étude historique sur les corporations professionelles chez les Romains. Louvain.

Weigand, E. 1935: Die helladisch-byzantinische Seidenweberei. Mneme S. Lampros. Athen.

West, L.C. 1951. The Coinage of Diocletian and the Edict of Prices. Studies in Roman economic History in Honor of Allan Chester Johnson 290-302. Princeton, New Jersey.

Williams, S. 1985. Diocletian and the Roman Recovery. London.

Yule, H. 1866. Cathay and the way thither I. Preliminary essay. London.

Zachariae von Lingenthal, K. E. 1865. Eine Verordnung Justinian's über den Seidenhandel aus den Jahren 540-547. Mémoires de l'Académie Impériale des Sciences de St. Petersbourg, ser. 8, vol. 9.6.

Zacos, G. Veglery A. 1972. Byzantine Lead Seals I. Basel.

XVII
Constantinople and its Hinterland: Issues of Raw Silk Supply

IN 1204 after the fall of Constantinople to the Latins, Niketas Choniates painted a vivid portrait of the distraught citizens of Constantinopole. He wrote that they were searched as they fled, 'in case they had wrapped a splendid garment inside a torn tunic'. Over the fall of Constantinople he lamented, 'O prolific city, once garbed in royal silk and purple and now filthy and squalid and heir to many evils...'[1] These references to silks and splendid garments in Byzantium were more than figures of speech. Between the fourth and the twelfth centuries, Byzantine silks (particularly certain murex dyed purple examples) acted as powerful symbols of national identity.[2] Byzantine silks served as an effective political weapon and they were frequently deployed to manipulate foreign powers.[3] Wealthy citizens increasingly aspired to sumptuous wardrobes as silk began to function as a catalyst for courtly, civil, military and ecclesiastic hierarchies.[4] In effect, a continuous and buoyant Byzantine silk manufacture became part of the profile of an ordered, secure and potent Empire. The purpose of this paper is to explore the role of Constantinople and its hinterland in the supply of raw material to the Byzantine silk industry before 1204 AD. How did Byzantium maintain her raw silk supplies in the face of shrinking territorial boundaries? How were raw silks priced, regulated and taxed?

Geographical distribution

Byzantium from the fourth to the fifth centuries relied on Persian imports of raw silk, and her supplies were threatened whenever hostilities with

Byzantine raw silk supplies

Persia broke out.[5] In the fifth century there is evidence that sericulture did exist in Byzantine Syria, as will be more fully discussed below.[6] The legendary accounts of Procopius of Cæsarea (500-565) and of Theophanes (end of sixth century) indicate that sericulture penetrated further into the Byzantine Empire in the sixth century.[7] When silk producing provinces were lost to the Arabs in the seventh century (notably Syria in 638-39) and after the fall of the Sassanian Empire to Emperor Heraclius, the need for fresh raw silk supplies became acute. Oikonomides has postulated that a series of seals of kommerkiarioi can be used to plot the growth of domestic Byzantine sericulture. He saw the traces of burlap on some seals as particularly indicative of the fact that they were used to seal bales of valuable raw silk.[8] He suggested that from the first quarter of the seventh century up to the second quarter of the eighth century, sericultural activity was spread right across Asia Minor (FIGS. 24 AND 25).[9] He further suggested that by the 730s to the 750s, because of Arab hostilities, sericultural activity was restricted to Western Asia Minor (FIG. 26). The decisive Byzantine victory of 740 only temporarily halted the Arab threat to Asia Minor. Of necessity, sericulture was expanded into the Balkans

Provinces

1 Hellespontus	2 Helenopontus	3 Armenia I
4 Galatia Salutaris	5 Galatia I	6 Cappadocia II
7 Cappadocia I	8 Cilicia I	9 Cyprus

FIGURE 24 PROVINCES ON SEALS OF KOMMERKIARIOI (629-72) (AFTER OIKONOMIDES)

(FIG. 27).[10] Hendy on the other hand, considered that this move from Asia Minor was indicative of increased military activity in the Balkans, and that the provisioning of the army came under the remit of the kommerkiarioi. Haldon, and also Dunn saw the apotheke-kommerkiarioi organisation as one in which taxes were paid in kind, in conjunction with other specialised operations.[11]

In the tenth century, the Book of the Prefect indicated an established private raw silk guild in Constantinople. The Imperial monopoly over raw silk purchase of earlier centuries was replaced by a system of free silk trade and enterprise.[12] Nevertheless, the Book of the Prefect included

5-9 times	3-4 times	1-2 times
1 Hellespontus	11 Achaea	
2 Bithynia	12 Insulae	22 Paphlagonia
3 Helenopontus	13 Creta	23 Armenia II
4 Armenia I	14 Lydia	24 Armenia III
5 Cappadocia I	15 Phrygia Pacatiana	25 Armenia IV
6 Cappadocia II	16 Pisidia	26 Galatia Salutaris
7 Isauria	17 Pamphylia	27 Lycaonia
8 Cilicia I	18 Lycia	28 Phrygia Salutaris
9 Caria	19 Armenia I	
10 Asia	20 Paphlagonia	
	21 Cilicia II	

FIGURE 25 PROVINCES NAMED ON SEALS OF KOMMERKIARIOI (673-74 TO 728-9)
(AFTER OIKONOMIDES)

detailed regulations preventing export of domestic raw silk. indicating a shortage of raw material in both the private and the Imperial Byzantine silk industries.[13] The Book of the Prefect documented the importation into Constantinople, of considerable amounts of Syrian raw silk and Syrian and other imported silk garments.[14]

By the tenth to eleventh centuries there were at least twelve types of raw silk available on the Islamic Mediterranean market centred at Fustat. But Constantinopolitan and Byzantine hinterland silk was not listed amongst them.[15] The general picture that emerges is one of a constant vigilance against export of most Byzantine raw silk. It is evident that only approved domestic and imported raw silk supplies were used by both the private and the Imperial Byzantine silk industries. This could have been designed to protect quality and to maintain standards.

Syria and the introduction of sericulture into Byzantium
To interpret documentation on raw silk supply to the Byzantine silk industry (whether Imperial or private and whether based in Constantinople or in the provinces), it is necessary to apply practical considerations

Provinces

1 Bithynia	2 Phrygia Salutaris	3 Phrygia Pacatania
4 Lydia	5 Asia	6 Insulae

FIGURE 26 PROVINCES NAMED ON SEALS OF IMPERIAL KOMMERKIARIOI (730-31 TO 755-56) (AFTER OIKONOMIDES)

to the evidence of the sources.[16] Silk production was an extremely labour intensive and costly business. There were three initial time-consuming and capital-demanding phases of operation:

1. Mulberry Cultivation
2. Silk worm rearing and
3. Yarn Processing

The extreme intricacy of moricultural and sericultural processes, not to mention the skills needed for yarn production itself (including unravelling, degumming, twisting and reeling), entailed a great deal of organised and specialist division of labour. These practical considerations preclude the possibility that raw silk cultivation was introduced into the Byzantine Empire 'overnight', as Procopius and Theophanes misleadingly implied. These authors differ in their accounts of exactly how sericulture was introduced into Byzantium. The silk moth seed described by Procopius was said to have been carried by Indians from legendary and unidentifiable Serindia. Theophanes reported that the seed was carried by Persians from the 'Land of the Seres': literally 'the land from where the silk came'.[17] Elsewhere I have shown in detail that a Chinese source, the San-kuo-chih written before 429 (based on records of the third century), listed domestic

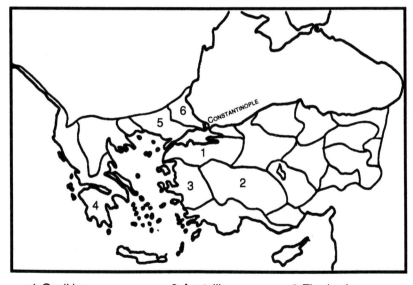

| 1 Opsikion | 2 Anatolikon | 3 Thrakesion |
| 4 Hellas | 5 Macedonia | 6 Thrake |

FIGURE 27 THEMES NAMED ON SEALS OF IMPERIAL KOMMERKIARIOI 730-31 TO 755-56 (1-4) AND UP TO THE EARLY NINTH CENTURY (5-6) (AFTER OIKONOMIDES)

animals of Ta-tsin (identifiable with Byzantine Syria), as ' the donkey, the mule, the camel and the mulberry silkworm.'[18] Far from originating in the legendary lands of either Serinda or of the Seres, as Procopius and Theophanes would have one believe, the roots of Byzantine sericulture lay in Byzantine Syria. When, and from where, sericulture was introduced into Syria is not documented. Chinese silk seed could have been carried to Syria either via India and the Arabian Gulf, in the same way as Chinese raw silk traditionally arrived there, or via the Tarim Basin. Raschke argued that Chinese sericulture was transplanted into central Asia by the third century.[19]

In the fifth century, Syria as a domestic raw silk producer, would have enjoyed important status. It was at this time that the 'Imperial image' was being underpinned by symbolic restrictions on the use of special Imperial purple silk raiment. Under Theodosius II in 424, purple silk garments of Tyre and Sidon were high in importance amongst the cloths reserved exclusively for imperial use (Codex Theod. 10.21.3 ; Codex Iust. 11.9.4.).[20] Furthermore, one knows that in sixth century Tyre, there was an Imperial weaving factory (Code Theod. 16. 10. 21; Code Iust. 11. 8. 2 and 11. 9. 1).[21] The Imperial purple dye factories were also located along the Syrian coast.[22]

By the sixth century, one important administrative ministerial official under Justin II (565-78) was Magnos the Syrian.[23] He is known from two seals (Zacos and Veglery no 130 and no 130bis).[24] He was designated, 'ex consul and count of sacred largesses' on one seal, and 'curator of the divine house and kommerkiarios of Antioch' on the other. Six further seals of similar type are known. Significantly, five of these bear reference to the office of a kommerkiarios of Tyre.[25]

Oikonomides argued that the kommerkiarioi were officials primarily involved in the administration of raw silk supplies, of silk circulation and internal trade. Unlike Antoniades-Bibicou Hendy and others, he did not see them as tax collectors.[26] Nevertheless, he himself pointed out that the titles of some kommerkiarioi did show that they collected taxes.[27] The evidence indicates that tax collection was part of the job of some if not of all kommerkiarioi. They are further discussed below.

The evidence of the seals of Antioch and Tyre, taken in conjunction with the evidence for fifth century Byzantine sericulture in Syria, is significant. I would suggest that Syria served as a raw silk provider in the fifth to sixth centuries and up to the Arab conquest of 638-639: Syrian raw silk, alongside imported Persian raw silk, supplied the Byzantine silk industry. One may ask, did Justinian discourage import of Persian raw silk to encourage local Syrian production? Syria, close to the eastern frontier with Persia, was naturally well placed to act as the main outlet of the silk route from Central Asia. The Emperor Justinian, however, may

have considered that Imperially regulated domestic Syrian supplies would be preferable to imported Persian supplies. What exactly was grown on the Imperial estates under the care of Magnos: could they have been no more and no less than Imperial sericultural concerns? This is speculation and further evidence is required to substantiate such a suggestion. However, this thought is relevant to the interpretation of two conflicting early sources, which set ceiling prices for raw silk and for woven and tailored silk garments.

A report by Procopius

Procopius wrote of the early Byzantine silk industry in Syria:

> 'Garments made of silk had been wont from ancient times to be produced in the cities of Beirut and Tyre in Phoenicia. And the merchants and craftsmen and artisans of these stuffs had lived there from ancient times, and this merchandise was carried thence to the whole world. And when, in the reign of Justinian (527-565), those engaged in this trade both in Byzantium and in the other cities were selling this fabric at an excessive price, excusing themselves with the statement that at the time in question they were paying the Persians a higher price than formerly, and that the customs houses were now more numerous in the land of the Romans, the Emperor gave everyone the impression that he was vexed with this, and he made a general provision by law that one pound of this stuff should not cost more than eight gold pieces'.[28]

The 'Peri Metaxes'

A second relevant source is an undated piece of legislation, 'Peri Metaxes'.[29] Stein and Antoniades-Bibicou have suggested that it was probably enacted under Justinian in the period before 540.[30] The legislation stipulated:

1. That the kommerkiarios should buy raw silk from the Barbarians at a ceiling price of 15 nomismata per lb and only sell it unworked and at the same price to the metaxarii or to others
2. That if someone other than a kommerkiarios should purchase raw silk from the Barbarians, then the merchandise should be appropriated by the kommerkiarios and the offender exiled for life and his worldly goods confiscated
3. That if a metaxarios or a kommerkiarios should purchase at below the set ceiling price they should suffer the same penalties
4. That the Count of the Sacred Largesses in person should calculate the demosion tax dues on all silk articles

Sixth century prices of raw silk and of woven and tailored silks

Procopius and the 'Peri Metaxes': conflicting evidence
Procopius spoke of a ceiling price of 8 nomismata per lb for silk garments.
The 'Peri Metaxes' regulations on the other hand, referred to raw silk with
a ceiling price of 15 nomismata. The question is how does one reconcile
the ceiling prices of 8 nomismata per lb for finished and tailored silk cloth
to the much higher 15 nomismata per lb ceiling price for simple raw silk?

Procopius complained, 'It was not possible for the importing mer-
chants, having bought these cargoes at a higher price to sell them to the
dealers for less. Therefore they no longer cared to engage in the importa-
tion of this stuff...' Procopius suggested that manipulation of the provin-
cial Syrian silk industry under Justinian was intended to boost the sale
of Imperial (Constantinopolitan?) silks at vastly inflated prices. In this
respect one should recall that even Imperial semi-purple silks were sold
to private wealthy Constantinopolitan females, from the House of Lamps,
prior to the Nika riots of 532.[31]

For the sake of argument, if both regulations belonged to the time of
Justinian, one could suggest that the motive behind the Imperial policy
would have been to starve the private Syrian silk industries of imported
raw silk and of finished silk garments. Either merchants would have been
forced out of business because they could not afford to retail imported silk
garments at a loss (the 8 nomismata ceiling), or raw silk would have been
rendered so prohibitively expensive that merchants were unable to
purchase it in the first place (the 15 nomismata regulation). In the event
that the 15 nomismata ceiling preceded the 8 nomismata ceiling price, one
has to envisage that the raw silk producers could first have been led to
believe they would be able to sell silk yarn for a high price. Subsequently
they would have found themselves asked to part with finished silk
garments for almost only half the price of the raw material involved. If the
15 nomismata regulation postdated the 8 nomismata regulation, then
either it would have had to have been very much later, or one would need
to envisage a crisis in Byzantine raw silk supply in the sixth century. In
the final analysis, if raw silk had become too expensive to purchase, then
a cessation of Byzantine silk production must be envisaged. However, as
discussed further below, the surviving Byzantine silks indicate that there
was no such appreciable break in production.[32] The problem of which
regulation came first has still to be satisfactorily solved. In this respect,
Oikonomides made another suggestion.[33] He thought that the 15 nomis-
mata regulation might indicate no more than a nominal price and that the
silk could have been purchased at a lesser price. As the metaxarios could
not make a profit on resale of the silk he would have to ensure that the
lower price plus any taxes due did not exceed 15 nomismata. Further
evidence is required to validate this interesting theory.

At this point, several hypothetical questions spring to mind: how far could Syrian raw silk supply alone support a substantial Imperial silk industry? To what extent could total domination of imported raw silk supply by the State really have allowed Imperial silk production to be exploited for maximum profit and at the expense of private silk manufacture? Finally, just how profitable would such an operation have needed to be in order to justify its implementation? If one relies on Procopius, one could suggest that the sale of Imperial silks potentially could have been very profitable indeed.

Bearing in mind the disruptive nature of the Persian Wars and the fact that both the land route and the sea route from China via India were dominated by Persian merchants, one begins to suspect that Byzantium, even prior to the fall of Syria to the Arabs in 638-639, might have been anxious to explore the possibility of expansion of domestic sericulture across its hinterland. The loss of Syria must have provided a serious incentive towards the concentration of sericulture in Asia Minor. As briefly outlined earlier, such a development certainly appears to be clearly reflected in a great increase in seals of kommerkiarioi across Asia Minor between the 640s and the 720s (Figs. 24 and 25). On eleven seals variously dated between 687-688 and 785-786 there is an association of the office of kommerkiarios with that of archon of the Blattion (the purple dye factory dealing with precious fabrics).[34] This strengthens the argument for a predominant role in silk administration for at least some of the kommerkiarioi; even if as Hendy and others argued, others may also have been involved in supplying the military.[35] Accepting that the kommerkiarioi in some part were involved with sericulture, it is unclear whether or not they all collected taxes prior to the introduction of the kommerkion around 800. In addition, it should be noted that many kommerkiarioi held several offices simultaneously and that these tended to differ in combination from kommerkiarios to kommerkiarios. The overall duties of different kommerkiarioi perforce must be seen as varied, and also as variable amongst documented kommerkiarioi. These points have to be considered as well as the fact that any core role of the kommerkiarioi may have changed over time.[36]

Hinterland sericulture and the seals of the kommerkiarioi

One should note too, that seals of kommerkiarioi do appear in the Balkans earlier than stressed by Oikonomides, so that sericultural activity there did not necessarily entirely post-date the development of sericulture in Asia Minor.[37] Also, it is doubtful that the entire terrain of Asia Minor was suitable for mulberry cultivation, although most provinces were represented on the seals. The seals most plausibly do have a relationship to sericulture, but their geographical distribution does not

necessarily indicate precise location of mulberry plantations in every instance. The raw silk required processing and some areas may have been active in yarn production rather than in mulberry cultivation and in silk worm rearing. Centralisation of such processes by private guilds in Constantinople is not attested until the tenth century in the Book of the Prefect.

According to the evidence of the surviving seals, there does appear to have been a great shift of activity from Asia Minor to the Balkans in the eighth to the ninth centuries (FIGS. 26 AND 27). From a practical point of view this would have signified quite a change in raw silk supply to the weavers of Byzantine silks. Such a variation in the supply of raw silk was capable of causing havoc within Byzantine silk weaving workshops. The handle of the silk was so intimately connected to the setting up and the operation of the loom, that significant variation in thickness and quality of raw yarn might at worst have the effect of rendering impossible traditional techniques and patterns. A constant and steady supply of raw material from known sources would have been an absolute essential to the efficient running of the Byzantine silk industry. This would have been one of the main reasons why Byzantium was loathe to export her own home grown raw silk. This fact is amply illustrated by the Book of the Prefect, as mentioned above, and it is a point to which I will return below.

Raw silk supplies and the evidence of the surviving silks Uninterrupted Byzantine silk production can be discerned in the surviving material, so one must conclude that there was a continuous supply of raw silk to the industry. The question is, are there visible differences in the types of silk yarn used amongst the surviving silks? For the sixth to the seventh centuries there are two categories of silks with Greek inscriptions. The first of these includes a silk with scenes from the life of Joseph (Sens cathedral treasury), (PLS. 84 AND 85).[38] The second category includes Hunter silks of the so-called Zachariou and Joseph class (London, Victoria and Albert Museum, and other collections), (PL. 86).[39] For the eighth to ninth centuries, one can point to a series of silks such as the Aachen Charioteer fabric and various Hunter silks in Mozac, Cologne, Milan and elsewhere, (PLS. 60, 64, 87, 79).[40] Although no tests have been carried out upon the silk yarn of these fabrics, it is possible to discern by eye a difference in the type of silk used. The sixth to seventh century fabrics employ a lighter yarn in comparison to the later silks. The difference in weight between sixth to seventh century and eighth to ninth century silks is further emphasised through the technical introduction of a paired rather than a single main warp in Byzantine silk twill weaves.[41] Further scientific investigation could well provide an accurate guide to changes of raw silk supply in Byzantine workshops. Present evidence

does suggest a change in raw silk supply between the seventh and the eighth centuries.

The tenth century Book of the Prefect implies that Byzantine silk weaving **Forms of raw** was centralised in Constantinople. In what form did the Imperial and the **silk supply:** private silk industries of the Capital receive their raw silk? It should be **cocoon versus** noted that raw silk could be exported either in the form of cocoons, salted **unravelled silk** for transportation but rendered brittle by prolonged exposure, or as silk unravelled from the cocoons and wound into silk hanks. For practical reasons long distance transportation of raw silk in cocoon form was undesirable; it was preferable to transport silk unravelled from the cocoons and wound into hanks. Unravelling the silk overcame the danger that unstifled moths within the cocoons would break out, tearing the continuous silk filaments surrounding them. Continuous filament silk yarns as against broken and spun silk yarns, were prized and more highly priced.[42]

The Book of the Prefect spoke both of raw silk brought into the Capital by strangers and of raw silk imported from Syria. The term 'strangers' probably referred to anyone not resident in Constantinople, and may have indicated production from Constantinople's hinterland.[43] Hinterland raw silk could have been imported in the form of cocoons, to be swiftly treated once sold in the capital. On the other hand, Syrian raw silk would have been brittle if imported in cocoon form. From a practical point of view it would make sense to see a supply of cocoon-based hinterland silk arriving in the Capital from regions of Asia Minor and the Balkans (earlier represented on seals as centres of activity of the kommerkiarioi and including both Bithynia and Thrace). I would see these postulated hinterland cocoons as being unravelled by hired workers employed by the Metaxopratai and detailed in the Book of the Prefect.[44] The degumming of the Syrian hank raw silk I would see as being undertaken by the Katartarioi also described in the Book of the Prefect.[45] This leaves the waste silk spinning to the Melathrarioi described in the same source.[46] The raw silk merchants, the Metaxopratai, under whom these other raw silk handlers worked, in my estimation would thus have been responsible for the purchase of quantities of both domestic cocoons and of unravelled, imported, Syrian hanks of raw silk. So valuable was the latter source of raw silk that Syrian merchants in Constantinople were granted residence for periods of up to ten years as against the three month limit imposed on other visiting merchants.[47] It is significant that Syria once more featured as a centre of fine raw silk production. Indeed, Byzantium collected tax revenue from silks passing through Aleppo in the tenth century, as discussed below.

The evidence of The existence of an imported Syrian (Islamic) raw silk supply to the
later sericulture Byzantine capital in the tenth century is certain. The tentative argument
in Brusa for concurrent hinterland supply of raw silk to Constantinople gains
(Bithynia) strength when one considers the later sericultural history of centres such
as Brusa in Bithynia. Here, from the fourteenth to the seventeenth
centuries, and again in the nineteenth century and up to 1922 (when the
Greeks were ejected from Asia Minor), major sericultural activity and silk
weaving was documented.[48] The last wholesaler of Brusan raw silk in
Constantinople was Taki Terliktsoglou, who spoke of three qualities of
silk. He reported, 'We bought the silk in the quality we wanted from the
market in Brusa. We had permanent workers there. They used to twist the
silk in their cellars. Then we gave the dyers the list of colours we wanted
to be dyed and they sent them to Constantinople. The cocoons yielded
1,500 metres of fine silk yarn like that of a spider's web. From the union
of 12-20 cocoons was made the finest silk yarn and from 48-50 cocoons
came the thickest. The centre of the retail business at Brusa was in the
street called Peran at the arcade of Hadzopoulos and at the arcade of
mirrors. Most shop keepers were Greek. When the silk was being wound
into balls in the street pedestrians could not pass'.

As early as the fourteenth century, Italian merchants from Galata in
Constantinople came to Brusa to buy silk. Also, Francesco Meringi, agent
of the Medici in Florence, was stationed in Brusa. By the sixteenth
century, Brusa became the key silk producing centre of the Ottoman
Empire, and its raw silk was continuously in demand in Italy. A report of
1630 described how Brusans were habitually clothed in locally produced
velvets and silks. By the nineteenth century, 90% of the silk production
of Brusa was exported to Europe. In 1883 Kandis estimated its value to
be 500,000 lbs of gold.

How far this later sumptuous Bithynian silk production (PL. 88)
reflected earlier silk activities remains an open question, but it does
illustrate a strong aptitude of the region for silk worm rearing and silk
manufacture. It also reflects the potential profitability of sericultural
exports from the region.

Non-Byzantine In considering the supply of raw silk to Byzantium in the eleventh to
supplies of twelfth centuries, it is useful to bear in mind the fact that there was no
raw silk: the such thing as a single standard type of Eastern Mediterranean raw silk
evidence of the at this date. Raw silk would have varied enormously according to the
Cairo Geniza species of moth involved, and with regard to the type of leaf upon which
documents it fed, and because of regional differences in the detailed nature of the care
of the silk worms.[49]

As stated above, the Cairo Geniza detailed twelve types of raw silk sold on the open Islamic Mediterranean market in the eleventh to twelfth centuries. Average quality continuous filament silk cost 2 dinars a lb, a sum sufficient to maintain an average sized family for a month.[50] The main suppliers of raw silk to the Islamic silk industry were first Spain and then Sicily. Egypt produced a lesser silk, whilst Indian silk was scarce, and Syrian and Palestinian raw silk were expensive. Hardly any Syrian silk was traded to the rest of the Islamic world, probably because Byzantium had monopolised the supply. Here it is important to recall the Byzantine trade treaty of 969 with the Hamdanid emir of Aleppo, briefly referred to above.[51] This treaty allowed Basil II considerable silk tax revenue whilst ensuring that Aleppo acted as a buffer between Byzantium and the Fatimids in Palestine and central Syria.

The presence in the treaty of what appears to be Byzantine brocade as well as Byzantine raw silk is puzzling, and this leads one to suggest that some provincial Byzantine raw silk was indeed available for export by this date. In the Book of the Prefect all Byzantine raw silk, although free of import taxation, was forbidden for export. This included the (hinterland?) silk brought in by 'strangers'.[52] However, one knows from at least two Cairo Geniza documents (one eleventh century, the other twelfth century in date) that a certain type of Byzantine raw silk was sold in the Muslim world.[53] Goitein interpreted the sources as references to raw silk grown in Byzantine Sicily, which was destined for export to Egypt.[54] This is an interesting point taken in connection with the Byzantine raw silk production for Calabria in the eleventh century, documented by Guillou, which I have discussed elsewhere.[55] Was the Calabrian raw silk too, intended for export to Islamic lands? Certainly, Islamic raw silk was produced in Sicily for export to Egypt.

The evidence would suggest that there was a degree of decentralisation of raw silk production and export at the same time as provincial Byzantine silk industries were growing in strength. Thebes and Corinth had a silk industry in the mid twelfth century as the Byzantine weavers plucked off to work in Palermo by Roger of Sicily in 1147 indicate, and as Jacoby most recently stressed.[56] Thebes in the twelfth century was exporting silk cloths both to the Venetians and to the Genoese merchants frequenting the region.[57] Italian merchants at that time had their own quays in Constantinople, from where they were active in carrying Byzantine silks to the Latin West.[58]

Benjamin of Tudela in 1161-1162, spoke of extensive silk weaving in Jewish hands in the Peloponnese. Of Thessaloniki he reported: 'It is a very large city with about 500 Jews. There are restrictions on the Jews and they are engaged in the manufacture of silk garments.' But the tenth century Book of the Prefect had regulated that raw silk should not be sold

to Jews. From where could Jewish artisans have gained their supply of raw material unless there had been a deregulation and decentralisation of raw silk supply by the eleventh to twelfth centuries? Provincial Italo-Byzantine raw silk did exist. Also, the Cairo-Geniza documentation indicates that Islamic raw silk was sold to Byzantine merchants in the 1060s to the 1070s. Jacoby has no documentation to support the existence of Theban sericulture in the eleventh to twelfth centuries. On present evidence it would seem that provincial hinterland silk, and imported Italo-Byzantine and Islamic silks, were available.[59]

CONCLUSION

To summarise, one can distinguish at least five distinct stages of raw silk supply to the Imperial and the provincial Byzantine silk industries between the fifth and the twelfth centuries:

1. An initial phase from the fifth to the early seventh centuries, centred around domestic Syrian production alongside impor-tation of Persian raw silk.
2. The next phase, from the seventh to the eighth centuries, saw the demise of Syrian raw silk supply accompanied by wide-spread sericultural activity in Asia Minor (in part also in the Balkans)
3. The following phase from the eighth to ninth centuries saw a concentration of sericultural activity in western Asia Minor and the growth of Balkan raw silk production
4. A further phase was heralded in the tenth century with the reintroduction of imported raw silk (Syrian) to bolster supply of hinterland raw silk to the industries centralised in Constantinople
5. By the eleventh to twelfth centuries (before the fall of 1204), there was decentralisation of raw silk supply. Provincial Byzantine silk (Sicilian and Calabrian?) was sold in Egypt. Plausibly, (provincial Italo-Byzantine silk), (hinterland) silk and (imported Islamic silk) were available to Byzantine Jewish craftsmen working in the Peloponnese. Evidence for local sericulture is lacking.

The state monopoly over raw silk production, distribution, and taxation, evident in the sixth to ninth centuries, and policed in part at least by the kommerkiarioi, was broken in the ninth to the tenth centuries. From that time onwards, the introduction of the kommerkion tax, the rise of the private silk guilds and the growth of private provincial silk weaving enforced a deregulation. State control gave way to public enterprise. Given the delicate nature of silk workshop adaptation required in the face of changing sources of raw silk supply, it is a measure not only of the skill of Byzantine craftsmen but also of the political significance of the industry, that splendid silks were woven right through to 1204 and beyond.

NOTES

1. Niketas Choniates, *Historia* (Van Dieten ed.) Berlin 1975. H. J. Magoulias, O City of Byzantium, Annals of Niketas Choniates, Detroit 1984. Present references (Van Dieten 577) and (Magoulias 317).

2. A. Muthesius, A History of Byzantine Silk Weaving (editors J. Koder, E. Kislinger) forthcoming. Chapter 3 is on Dyes including purples, and it contains an extensive special bibliography.

3. See three earlier articles by the present author. A. Muthesius, 'Silken diplomacy' in: Byzantine Diplomacy ed. J. Shepard and S. Franklin. Twenty fourth Spring Symposium of Byzantine Studies, Cambridge 1990. London 1992, 237-248. A. Muthesius, 'The role of Byzantine silks in the Ottonian Empire' in: *Byzanz und das Abendland im 10. und 11. Jahrhundert*, International Symposium for Greek/German Co-operation, Cologne and Bad Gandersheim 1991, under publication. A. Muthesius, Silk, power and diplomacy in Byzantium in: *Textiles in Daily Life*. Proceedings of the Third Biennial Symposium of the Textile Society of America. Seattle 1991, 99-110.

4. For example, see P. Gautier, Le typikon du Sébaste Grégoire Pakourianos. *Revue des études Byzantines* 42 (1984) 5-145. Also, P. Lemerle, 'Le Testament d' Eustathios Boilas (April 1059) in: *Cinq études sur le XI siècle byzantin*, Paris 1977, I, 15ff. Silken yarn and splendid silk garments were confiscated from the Byzantine protostrator Manual Camytzes in 1200 by Alexius III (Van Dieten 533), (Magoulias 293). Silk was plentifully used in the Byzantine Church, in the civil service and the military. The present author has collected several hundred documentary references to these uses. It is beyond the scope of this paper to deal with the issues involved, but a paper on 'Patronage and the uses of silks in Byzantium' is under preparation for publication.

5. For the relationships between Byzantium and Persia and the early importation of foreign raw silk into Byzantium see N. Pigulewskaja, Byzanz auf den Wegen nach Indien. *Berliner Byzantinische Arbeiten* 36 Amsterdam 1969, 78-87 and 150-171. For the activities of the Sogdians, the Persians and the Turks in relation to silk and Byzantium, see especially 158ff. Extensive study of the Byzantine silk industry as a whole was made by R. S. Lopez, 'Silk industry in the Byzantine Empire' *Speculum* 20 (1) (1945) 1-42. This seminal article was fully reviewed and its core themes were expanded in A. Muthesius, 'The Byzantine silk industry: Lopez and beyond' *Journal of Medieval History* 19 (1993) 1-67.

6. This subject I initially broached in two earlier articles. See A. Muthesius, 'From Seed to Samite: aspects of Byzantine silk production'. *Textile History* 20 (2) 1989 135-149, especially 136-137 and A. Muthesius, 'The Byzantine silk industry; Lopez and beyond', 23-28.

7. For full discussion of the evidence see A. Muthesius, 'The Byzantine silk industry: Lopez and beyond' 19-23.

8. N. Oikonomides, 'Silk trade and production in Byzantium,' *Dumbarton Oaks Papers* 40 (1986) 33-53. Cf. N. Oikonomides, 'Commerce et production de la soie à Byzance' in: Réalités Byzantines. Hommes et richesses dans l'Empire byzantin. IV-VII siècle, foreword G. Dagron, Paris 1989, 187-192. In volume two of the same work VII-XV siècle, Paris 1991, note also, N. Oikonomides, 'Le kommerkion d'Abydos, Thessalonique et le commerce bulgare au IX siècle' on 241-248.

9. Oikonomides, 'Silk trade' 43-45.

10. Ibid. 46.

11. This short paper could not enter into a full discussion of the nature and the role of the apotheke and the kommerkia. For these aspects of study see A. Dunn, 'The kommerkiarios, apotheke, dromos, vardarios and the West', *Byzantine and Modern Greek Studies* 17 (1993) 3-24; esp. 9 note 22, 11-15 and 20, 23. Dunn saw two periods of development: mid-seventh to ninth, and ninth to eleventh centuries, with a functional evolution as taxation was remonetarised. Dunn follows Haldon in several respects. See J. F. Haldon, Byzantium in the seventh century. Cambridge 1990, esp. 235-238.

 The theories of N. Oikonomides, 'Silk trade' must be contrasted to those of M. Hendy, The Byzantine Monetary Economy, Cambridge 1985. See in particular in Hendy, 'The apotheke and the basilika kommerkia' on pp. 626-642, and 'The apotheke and the lommerkia again' on pp. 654-662. Oikonomides does not accept Hendy's theories that the kommerkiarioi were tax collectors or that they were engaged in the provisioning of the military. See 'Silk Trade' 35 note 12, 45 note 77.

 Oikonomides makes only passing reference to H. Antoniades-Bibicou, Recherches sur les Douanes à Byzance, Paris 1963, 'Les commerciaires et leurs sceaux' on 157-191 with list of seals on 225-238. He does note that some of Antoniades-Bibicou's views differ from his own. See Oikonomides, 'Silk trade' 34 note 10 and 35 note 12.

 Oikonomides, 'Silk trade', 35 note 13, states that the work of G. Zacos and A. Veglery, Byzantine Lead Seals, I/I Basel 1972, 129-363, and I/3, 1592-1596,

supplants earlier work on seals including that of Antoniades-Bibicou. A fuller review of the evidence of the work of Antoniades-Bibicou is desirable, as remarked by Dunn, cited above, 5 note 6. It is possible that kommerkiarioi were of differing types and that they were assigned varied rather than standard duties. Certainly, kommerkiarioi held a wide variety of additional titles, particularly in the later period, see Antoniades-Bibicou list on 225-238; Dunn as cited above 9-12. Dunn argued that the role of the kommerkiarioi as fiscal agents (as opposed to commercial agents) of the state, in part declined in the ninth century. This was because of increased monetarisation of taxation in provinces such as the Peloponnese.

D. Jacoby, 'Silk in western Byzantium before the Fourth Crusade'. *Byzantinische Zeitschrift* 84/85 (1991/92) 452-500, esp. 453-454 adds nothing new to this debate.

12. J. Koder, Das Eparchenbuch Leons des Weisen. CFHB XXXIII, Wien 1991, 96-101, regulations 6.1 - 6.16. See A. Muthesius, 'The Byzantine silk industry: Lopez and beyond', 29-40 for an in depth analysis of the role of the individual private silk guilds in the Book of the Prefect.

13. Koder, Das Eparchenbuch, 101, regulation 6.16.

14. Ibid., 95-97, regulations 5.1 - 5.5.

15. S. D. Goitein, A Mediterranean Society, I, London 1967, 222 and 454 note 53.

16. Oikonomides, 'Silk trade' 42 note 72, says that details about sericultural processes 'can be found in any encyclopaedia'. The present author considers such details inadequate. Figures in these sources tend to be based on the evidence of the capabilities of interbred moths fed off artificially irrigated and chemically treated mulberry plantations. To witness non-mechanised sericultural practices closer to those that would have pertained in Byzantium, it was necessary to visit rural parts of southern India. The fruits of this Indian research I found helpful to interpret Byzantine sericultural documentation. The many and varied skills involved in sericulture and in yarn production were discussed in detail in A. Muthesius, 'From seed to samite', 135-146. They were later summarised in A. Muthesius, 'The Byzantine Silk industry: Lopez and beyond', 16-19.

17. J. Haury, Procopius, De Bello Gothico. Leipzig 1905, IV, 17. J. Müller, Theophanes of Byzantium, Fragmenta Historicorum Graecorum, IV, 270. Both accounts and the source material were extensively discussed in H. Wada, Prokops Rätselwort Serinda und die Verpflanzung des Seidenbaus von China nach dem östromischen reich, PhD thesis, Cologne University 1972, 63-70. For the English translations, see H. Yule, Cathay and the way thither, I, preliminary essay, London 1866, clix, clx.

18. A. Muthesius, 'The Byzantine Silk industry: Lopez and beyond', 19-23.

19. M. G. Raschke, 'New studies in Roman commerce with the East' in: Aufsteig und Niedergang der römischen Welt (H. Temporini, W. Haase ed.) II, 9.2, Berlin-New York 1978, 604-1361, especially 622.

20. For the Theodosian Code, see C. Pharr, Theodosius II Emperor of the East. The Theodosian Code and Novels and the Sirmondian Constitutions. *The Corpus of Roman Law* I, Princeton NJ, 1952 and T. Mommsen, P. M. Meyer and P. Krueger,

Codex Theodosianus I-II, Berlin 1962. For the Justinianic Code see P. Krueger, T. Mommsen, T. Schoell and G. Kroll, Codex Justinianus, Berlin 1954.

21. For Theodosian and Justinianic Code sources see note 20. For a discussion of the early silk legislation see A. Muthesius, 'The Byzantine Silk industry: Lopez and beyond', 56-67.

22. There were strict checks on illegal purple dyeing operations. In this respect consider Cod. Theod. 10.20.18 and Cod. Iust. 9.5.8. concerning purples in Phoenicia. Other early regulations regarding purple fishers and purple dyers are summarised in A. Muthesius, 'The Byzantine Silk industry: Lopez and beyond', 59, Table 1.

23. D. Feissel, 'Magnus, Mégas et les curateurs des maisons divines de Justin II à Maurice. *Travaux et Mémoires* 9 (1985) 465-76.

24. For Zacos and Veglery reference see note 11 above.

25. See Zacos and Veglery, cited in note 11 above, 214. Tyre was conquered by the Arabs in 638.

26. Oikonomides, 'Silk trade', 35 note 12 and 45; Haldon and Dunn as cited in note 11 above.

27. Ibid., 45-46. Five seals indicate that the kommerkiarioi functioned as tax collectors in the 720s.

28. Procopius VI *Anecdota* (H. B. Dewing ed.) Harvard 1969, xxv 14-17.

29. Imp. Iustiniani Novellae (C. E. Zachariae von Lingenthal ed.) II, Leipzig 1881, 293, CLIV; here given the date c. 545.

30. Antoniades-Bibicou, as cited in note 11 above, 159-160. See further, Oikonomides, 'Silk trade' 34 and note 6 for the dating suggested by these and other authors. E. Stein, Histoire du Bas-Empire I, Paris-Brussels-Amsterdam 1949, 770ff., 843-845. Note also, Stein I, 210-225.

31. Theophanes *Chronographia*, (C. de Boor ed.) I-II, Leipzig 1883, 1885; I, 184.

32. The surviving Byzantine silks are the subject of the publication by the present author cited in note 2. This publication incorporates material from, A. Muthesius, Eastern Silks in Western shrines and treasuries before 1200 AD, PhD thesis, Courtauld Institute of Art, University of London, 1982. Byzantine silks that have been published earlier are found in widely scattered literature, see A. Muthesius, 'Crossing traditional boundaries: grub to glamour in Byzantine silk weaving', *Byzantine and Modern Greek Studies* 15 (1991) 326-365, with bibliography. Most Byzantine silks are housed in West European church treasuries and access to them is extremely restricted.

33. Oikonomides, 'Silk trade', 35 note 11.

34. ibid., 50-51. Cf. Zacos and Veglery, cited in note 11 above, 143, also 203.

35. Hendy as cited in note 11 above, 632-636.

36. On the kommerkion, see Dunn, Haldon, Antoniades-Bibicou and Hendy, cited in note 11, above; in particular Dunn 4ff., Antoniades-Bibicou 97-156 and Hendy 592. Oikonomides in 'Silk Trade' does not deal with this tax in detail but he does so in another article cited in note 8 above. The ideas of Antoniades-Bibicou were summarised in A. Muthesius, Byzantine Silk trade: Lopez and beyond', 28-29.

37. Antoniades-Bibicou, cited in note 11 above, 226ff., nos. 16, 17, 35, 44 for example; all dated to the seventh century.

38. A. Muthesius, History cited in note 2, chapter 8.1, cat. no. M16.

39. Ibid., chapter 8.2, and notes 16, 17 with reference to the fragment found at Avdat. Cf. Oikonomides, 'Silk trade', 108 note 51. These silks technically and stylistically belong to the sixth to seventh centuries and not later.

40. A. Muthesius, History cited in note 2, Chapter 7.4, cat. nos. M29, M333; chapter 7.3, cat. nos. M34, M348, M31, M32, M33.

41. For technical terms see C.I.E.T.A. Vocabulary of Technical Terms (D. King ed.) Lyons 1964. The techniques of Byzantine silk weaving are discussed in A. Muthesius, History cited in note 2 above, Introduction, chapter 2 and in the appendix on weaving types. Cf. summary of weaving types in A. Muthesius, 'The impact of the Mediterranean silk trade on Western Europe before 1200 AD.', in Textiles in Trade Proceedings of the Textile Society of America Biennial Symposium, Washington 1990, 126-135, especially 127. See also, A. Muthesius, 'Byzantine and Islamic silks in the Rhine-Maaslands before 1200', in: Medieval textiles particularly in the Meuse-Rhine Area, Proceedings of the first Euregio Congress, Alden Biesen 1989, 143-161, especially 144-145.

42. See Goitein, Mediterranean Society, cited in note 15 above, 454 note 53 for instance, with reference to 'Spanish pickups'.

43. Koder, Eparchenbuch, cited in note 12 above, 99, regulation 6.5. see also 16, under Koder for further useful bibliography.

44. A. Muthesius, 'The Byzantine silk industry: Lopez and beyond', 32-33, Koder, Eparchenbuch, cited in note 12 above, 96-101, regulations 6.1 to 6.16. Brittle yarn would have been a problem in spite of Jacoby's remarks (Jacoby, as in note 11 above, pp. 484-485).

45. Muthesius, as note 44, 33-35, Koder, Eparchenbuch, 100-102, regulations 7.1 to 7.5.

46. Muthesius as note 44, Koder, Eparchenbuch, 101, regulation 6.15.

47. See Koder, Eparchenbuch, 94-97, regulations 5.1 to 5.5 for the foreign silk retailers dealing with Syrian and other imported silks.

48. For the sericulture of Brusa and for all literature cited in this section of my paper see Soula Bozi, The silks of Brusa (in Greek), Athens 1991, with bibliography on 106.

49. A. Muthesius, History cited in note 2 above, chapter 1 with special bibliography.

50. Goitein, Mediterranean Society, cited in note 15 above, 222-223.

51. See W. A. Farag, 'The Aleppo question'. Byzantine and Modern Greek Studies 14 (1990) 44-60.

52. Koder, Eparchenbuch cited in note 12 above, 98-99, regulation 6.10, and regulation 6.5.

53. Goitein, Mediterranean Society, cited in note 15 above, 103 and 417 note 21.

54. Ibid., 417 note 21, 'Rumi silk' and 'coloured Constantinopolitan silk' are mentioned.

55. A. Guillou, Le brébion de la métropole byzantine de Règion (Corpus des actes Grecs d'Italie, IV) Vatican City 1974. I am most grateful to professor Guillou for a copy of his manuscript, sent to me many years ago. After sericultural research travels in India in 1987-1988, it became clear to me that the size of the silk yield calculated by Guillou requires some qualification. See A. Muthesius, Seed to samite, cited in note 6 above, 143-144.

56. The events are reported by Otto of Freising, *Gesta Friderici*, MGH Scriptores XX, 370 and by Niketas Choniates, *Chronike diegesis* (Van Dieten ed.) 98, 7-9, and others. Otto states that weavers were forcibly captured from Athens as well as from Thebes and Corinth. For the other references, see Jacoby, 'Silk in western Byzantium' as cited in note 11 above, pp. 462-3, note 54. For Sicilian silk weaving see A. Muthesius, History as cited in note 2, chapter 13.2 with further references.

 Jacoby, 'Silk in western Byzantium', p. 471, speculated that sericulture was established in Thebes, but he has no documentary proof for this. He himself correctly notes that there is no evidence of sericulture in the Theban Land Registers (471-472). The (undiscussed) reference on p. 472 note 106 does not constitute proof to the contrary. Jacoby (478) goes on to say that any local sericulture would have been inadequate to meet demand. He plausibly postulates that silk from Thessaly and southern Italy was used. Perhaps his most positive contribution is to stress that documented Theban silks were requisitioned for the Imperial Byzantine court, and that Italian merchants were documented in the region. Other suggestions about the nature of Theban silk weaving and the role of the Italian merchants tend to move well beyond documented fact.

57. See for instance, D. M. Nicol, Byzantium and Venice, Cambridge 1988, 109 and note 1. On Genoa, see G. W. Day, Genoa's response to Byzantium 1155-1204, Illinois 1988, 3-14, 108-134.

58. On Italian Byzantine economic and political relations see R. J. Lilie, Handel und Politik zwischen den byzantinischen reich und den italienischen Kommonen Venedig, Pisa und Genua in der Epoche der Komnenen und der Angeloi (1081-1204) Amsterdam 1984. Further references in E. Kislinger, *Handwerk*, as cited in note 59 below, 106 in note 20; 112 in notes 49, 50.

59. For Benjamin of Tudela and the Jewish involvement with the silk industry, see the very useful work of E. Kislinger, 'Jüdische Gewerbetreibende in Byzanz,' *in: Die Juden in Ihrer Mittelalterlichen Umwelt*, Vienna 1991, 105-111; id. 'Gewerbe im späten Byzanz' in: *Handwerk und Sachkultur im Spätmittelalter* (Österr. Akad. Wiss., phil. hist. Kl., Sitzungsberichte, 513) Vienna 1988, 104-105; id. 'Demenna und die byzantinische Seidenproduktion' *Byzantium and its neighbours from the mid ninth until the twelfth centuries*, BSl 54/1 (1993) 43-52. I am grateful to Dr. Kislinger for copies of these articles.

 See also Jacoby, 'Silk in western Byzantium' as cited in note 11 above, pp. 466ff. Jacoby (p. 487 note 199) disagrees with A. Muthesius, 'The hidden Jewish element in Byzantium's silk industry', *Bulletin of Judaeo-Greek Studies* 10, (1992) 19-25. The latter was a cursory article in the context of the *Bulletin* format. Nevertheless, the following points are relevant:

 1. Jacoby himself supports the idea of a twelfth century Corinthian silk industry (p. 455 and note 14). Lack of references to Jewish workers in silk in Corinth by Benjamin of Tudela (Jacoby p. 455 and p. 468 note 87) is negative evidence. He does discuss a positive reference to Jewish silk workers taken from Thebes and Corinth to Sicily in 1147 (Jacoby *Annales Cavenses* p. 463 and end of note 54, p. 466 note 74).

2. The raw silk I referred to on page 23 of my article was that documented in the Book of the Prefect, and therefore of the tenth century. I was not discussing eleventh to twelfth century raw silk supplies in that instance. I do refer to such later silk in the present article (see relevant text and notes 53 and 54 above)

3. The fact that I wrote the first **Latin** silk workshop was established only in 1147 in Sicily (Jacoby p. 472 and note 58) does not mean I claimed there was no silk weaving in Sicily earlier. The Sicilian silk weaving of a century earlier was clearly Islamic. Possibly Jacoby was misled after reading Goitein; see Goitein, 'Mediterranean Society' cited in note 15 above, p. 102 and p. 417 note 16.

Jacoby did not note that some Byzantine merchants bought raw silk in Egypt in the 1060s to 1070s; Goitein, 'Mediterranean Society' as cited in note 15 above, IV, 168 and note 128. Jacoby did note shipment of silk cloths from Constantinople to Egypt (Jacoby p. 496 and note 250). Byzantine bedcovers at Fustat were discussed by me in 'The hidden Jewish element', p. 24. Such traffic between the Islamic and the Byzantine silk industry needs closer scrutiny. This is true also of the matter of possible raw silk supplies from Cyprus (Jacoby p. 496 and note 256).

XVIII
A Silk Reliquary Pouch from Coppergate

THE anærobic conditions of the Coppergate site have been respons-
ible for the preservation of a number of textiles, amongst which is
one item of high quality and exceptional interest. This is a small lined
silk pouch which once held an ecclesiastical relic (FIG. 28). The relic was
dated by its archaeological context to the latter half of the tenth century.
It is probably the smallest surviving reliquary pouch of its period, the size
possibly being related to the fact that some of the yarn was dyed with a
valuable purple (FIG. 28).

The small pouch meas-
ures only 35 x 25 mm. It is
made up of two components:
an outer pouch cut from a
compound twill silk, and a
small inner packet con-
structed from two different
fawn-coloured *plain tabby
weave* silks. The colours of all
three silks have faded. The
outer twill cover was made by
taking a piece of silk cut into
an elongated hexagon, folding
this in half, turning in the raw
edges, then stitching the
folded edges together using
silk thread.

The twill weave of the outer
silk (FIG. 29) consists of two

FIGURE 28
THE COPPERGATE SILK
RELIQUARY POUCH

sets of horizontal threads or *wefts*, and two sets of vertical threads or *warps*. Paired *main warps* are sandwiched between the upper and the lower weft. A single *binding warp* appears on the obverse and the reverse of the fabric after every three pairs of main warps, where it serves to tie down the wefts. Each pass of the weft begins one pair of main warps further to the right. The warps are undyed and twisted to the right. The weft is untwisted and this allows maximum reflection of light, giving the silk its sheen. In places the surface wefts have unfortunately worn away. The wefts were dyed purple before weaving.

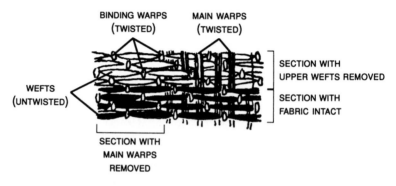

FIGURE 29

WEFT-FACED PAIRED MAIN WARP TWILL

'True purple' dyes, obtained from the juice of certain sea snails, were highly valued in the early mediæval period, and purple silks were costly items. Indeed, in the Byzantine Empire, certain categories of purple silks were reserved for the use of the Imperial household. If a scientific analysis of the dye used for the reliquary pouch were to show that it is a 'true purple', this would partially explain the minimal size of the object. Its meagre dimensions also make it possible that it was worn on the person of its owner.

Inside the outer pouch, visible through a worn fold, is the crumpled packet of pale fawn silk. This has been made of two different unpatterned, plain tabby weave silks, one finer than the other. The two tabbies have been sewn together, in the same fashion as the outer pouch. Inside the tabby packet, there may have been yet another protective layer around the relic or relics. This fabric seems to have been made of linen, as traces of fibres resembling flax were discovered during cleaning.

A small cross is embroidered in an uneven chain stitch, with a thick, undyed, silk floss, on one side of the outer pouch. This cross suggests that

the pouch contained either one or more tiny relics, but, despite X-ray examination, nothing has been found. It is unlikely that the relic was metal, as there is a total absence of corrosion products. There may have been something made of wood or vegetable fibre that has rotted away. A cutting of hair, or a splinter of wood (perhaps from the 'true cross') are the types of relics which could have been in the pouch.

There were no Latin weaving centres in the tenth century, so the silks used for the pouch and its lining must have been imported either from an Islamic or a Byzantine centre. As the silk lacks any pattern, it is difficult to suggest an exact provenance for it. Judging from the inexpert stitching, it is unlikely that the pouch and lining were sewn in the centre where the silk was woven: it is more probable that the object was constructed and embroidered in the West, using an imported Eastern silk.

SPECIAL NOTE

For further information, see

P. WALTON, Textile Production at Coppergate, York: Anglo-Saxon or Viking? in *Textiles in Northern Archaeology*, 1990, 61-72, NESAT III. Textile Symposium in York, 6-9 May 1987, London.

P. WALTON, Textiles Cordage and Raw Fibre from 16-22 Coppergate in *The Archaeology of York, The Small Finds*, 360-382, esp. 369-371, 377.

XIX
The Silk Fragment from 5 Coppergate, York

ONLY a handful of early mediæval silks survive in England, and all are imports from Eastern Mediterranean or Near Eastern weaving centres. The Coppergate silk (651) can be closely compared with a similar fragment found at Saltergate, Lincoln.[1] So similar are the weaving characteristics of these two silks that they may indeed have been woven on the same loom, and have been cut from a single roll of cloth. Both seem to date to the late ninth or early tenth centuries.

For the purposes of comparison, the technical characteristics of the York and Lincoln pieces are given side-by-side. Neither silk is patterned.

	York, Coppergate	Lincoln, Saltergate
Size	See Figure 30A	See Figure 30B
Weave	Plain tabby	Plain tabby
Warps	c. 22-24 per cm Golden-yellow, Z-spun	c. 22 per cm Darkened golden-yellow, Z-spun
Wefts	c. 18-20 per cm Golden-yellow, untwisted	c. 20-24 per cm Darkened golden-yellow, untwisted
Selvedge	Width 14 mm Warps paired, Z-spun c. 26-28 per cm	Width 15 mm Warps paired, Z-spun c. 24-28 per cm

The York silk survives in a more stable condition than that from Lincoln; both were similarly conserved.[2] The fragile condition of the Lincoln silk is partly due to the fact that it was discovered screwed up into a tight ball. The Lincoln silk is a single, narrow, rectangular piece, c. 0.51 m long (now in five fragments, Fɪɢ. 30ʙ, 1-5), which was folded in the middle and stitched with a dart; the fold and the dart are on fragment 1.

During conservation it is evident that the fibres of 651 absorbed a considerable amount of moisture and that they expanded. Prior to conservation the width of the fragment was 0.165 m. At present the width varies between 0.174 and 0.180 m. The width of the Lincoln piece after conservation is 0.168 - 0.175 m. The golden-yellow silk used for the two pieces is undyed, and in both cases the weft measures c. 0.5 mm across. No. 651 has a more shiny appearance than the Lincoln silk. This seems to be due only to the fact that the wefts are more consistently spaced on the former, so that light is evenly reflected.[3] The two silks use a plain tabby weave in which there is a single system of warps and a single system of wefts. The weft passes alternately over and under single warps, except in the area of the selvedges, where it passes over and under paired warps. The wefts are untwisted and the warps are Z-twisted on the two silks. The selvedges are practically equal in width (15 and 14 mm). Parts of the warp system have been lost in certain areas of the silks so that, on occasion, two or three warps have been pushed side by side.

10 ᴄᴍ

Fɪɢᴜʀᴇ 30ᴀ
Sɪʟᴋ ꜰʀᴀɢᴍᴇɴᴛ ꜰʀᴏᴍ 5 Cᴏᴘᴘᴇʀɢᴀᴛᴇ
(651)

A survey of the structural characteristics of surviving plain tabby weave silks without pattern, which are of the twelfth century or earlier, shows that their warp and weft counts vary enormously, and that the threads are variously twisted. The silk thread used may be either dyed or undyed. No two known silks of this type exhibit the same technical characteristics, which makes the similarities between the York and Lincoln fragments all the more significant.

Unpatterned plain tabby weave silks dating from before the end of the fourth century AD were discovered at Palmyra, Syria; at Edsen Gol,

Mongolia; and at Lop Nor, Eastern Turkestan (Pfister, 1934, S7, S12-13; 1937, S24-5, for example; Sylwan, 1949, 32, 99, 101 and pl. 10A; also 25ff., 33-77). Unlike the York and Lincoln silks, these tabbies use mainly untwisted warp threads. The warp and weft counts are very uneven. The most extreme case is the combination of thirteen warps to c. 90 wefts per cm. Even the Lop Nor tabbies, which come from the Small River graves (and which are thought to date c. AD 600-750), have much higher counts than the York and Lincoln pieces, viz. 35-40 wefts and 40-50 warps per cm.

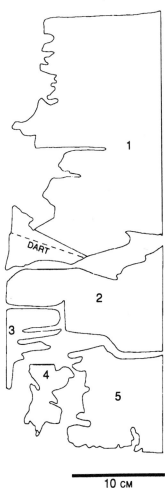

Plain tabby weaves without pattern survive in the form of wrappings for relics, reliquary pouches, burial shrouds and miniature protectors in several Western treasuries, six of which are in Switzerland (Schmedding, 1978, nos. 24, 35-7, 79-82, 163, 165, 167-77, 184, 285, 295). Like the York and Lincoln tabbies, the Swiss examples use an untwisted weft with a twisted warp: about one third of them have roughly even warp and weft counts. The closest count to that of the York and Lincoln silks occurs on a Swiss piece with 29 warps and 29 wefts per cm. All the Swiss tabbies seem to be earlier than the thirteenth century.

Other silks of this weave were discovered in the Bible of Bishop Theodulf of Le Puy (d. 820); (Pfister, 1950, 501-29). Three quarters of the silks have both warp and weft S-twisted. Only two of the fragments have an untwisted weft and a twisted warp like the York and Lincoln tabbies. Nevertheless, as on the York and Lincoln pieces, the warp and weft counts are either identical to, or nearly identical to, those on 75% of the Le Puy silks. One of the French tabbies (Th. 14) has 20-24 warps, and the same number of wefts per cm; it uses an undyed golden-yellow silk, and the warps are paired in the selvedge. The only feature that distinguishes it from the York and Lincoln silks is the twisting of both warp and weft to the right.

10 CM

FIGURE 30B
SILK FRAGMENT FROM SALTERGATE,
LINCOLN

An unpatterned plain tabby weave silk in the Bamberg Diocesan Museum can be dated to before 1047. It came from the grave of Pope Clement II (d. 1047) and it was woven with a Kufic inscription in an Islamic centre (Müller-Christensen, 1960, 54, Abb. 60, 61). The silk was used undyed, and both warps and wefts are Z-twisted. The warp and weft counts are quite close at 26-29 warps and 31 wefts per cm. In the selvedge the warps are grouped in fours and fives. Silk tabby weaves were found in the graves of Gisela (d. 1043) and of Henry III (d. 1056) at Speyer Cathedral, and here again both warps and wefts are twisted to the right. The warp and weft counts are not comparable with those of the York and Lincoln silks (Müller-Christensen et al., 1972, 940c, 942c). A small fragment of the same weave from the grave of Henry V (d. 1125) at Speyer Cathedral has only eighteen warps and wefts per cm, but neither warp nor weft seem to be twisted (ibid.). A number of early mediæval tabby silks found recently in Winchester also differ technically from the York and Lincoln pieces.[4]

The tenth century graves at Birka housed a number of silks, including a plain tabby weave fragment which has several features in common with the York and Lincoln fragments. The Scandinavian piece uses a golden-yellow, undyed silk with a weft c. 0.5 mm across: there are nineteen warps and 26-28 wefts per cm (Geijer, 1938, S2. Taf. 13,2). The distinguishing feature of this silk is its use of untwisted warp and weft, the thread being in the gummed or grège state.

The archaeological evidence surrounding the York silk suggests a general date around the tenth century for the piece: this dating is reinforced by the archaeological context of the Lincoln silk. The Lincoln fragment was found in a wicker-lined pit at Saltergate, in association with pottery dated to the early tenth century. Allowing a delay for the arrival of the silk in the West, it can be suggested that a late ninth to early tenth century date is the most appropriate. It is likely that both Byzantine and Islamic centres were weaving plain tabbies at this date, so it is not possible to specify from which Eastern centre the Lincoln and York silks may have come.[5]

Moving on to the question of the function of the two silks, it should be noted that both have a neat hem about 4 mm wide on one or more sides. All three edges of the Lincoln silk are hemmed in this way. In addition, approximately 0.22 m down from the top left hand side of the piece, there is a diagonal line of stitching forming a dart about 70 mm along the fabric. Assuming that the Lincoln silk was not sewn on to any larger piece of textile, it can be suggested that it may have served as some form of female head scarf. The silk could have been worn with the dart over the back of the head, with ties attached beneath the chin, as indicated in FIGURE 31. Most of the head at the back would have remained uncovered, in a manner

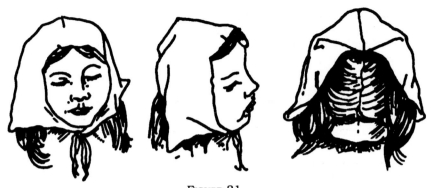

FIGURE 31
LINCOLN SILK FRAGMENT WORN AS A HEADSCARF

not unlike that of the silk head-dress found at Lop Nor (Sylwan, 1949, 84, fig. 49a). Too little of the York silk survives to indicate whether or not it may have been a head scarf, but its comparatively narrow width must have restricted the functions which it could have performed. While the silk was wet during the course of conservation, diagonal lines from the upper and lower right hand sides of the fabric were clearly visible. These met in a point two-thirds of the way across the silk. The lines seem to indicate the continuation of embroidery stitches, visible near the selvedge on the upper and lower right hand side. Evidently the York silk was a decorative piece, even if its exact function is unclear.

A complete silk cap in a remarkable state of preservation has been found in more recent excavations in Coppergate: this lends strength to the case for the Lincoln and earlier York fragments being some sort of head covering. The new discovery has been described by Penelope Walton (1980, 3-5).

NOTES

1. I am indebted to Nicholas Reynolds of the Scottish Development Department for allowing me to study this silk, and for providing me with details of the archaeological context before the site has been published. The silk will be included in a report on Saltergate to be printed under the guidance of Nicholas Reynolds. The pottery of the site will be discussed by Glyn Coppack.

2. The Lincoln silk was conserved by G. Edwards of the Department of the Environment, London. The York silk was conserved by J. Glover of the North Western Museum and Art Gallery Service. I express my gratitude to both for their assistance.

3. An analysis of the fibres will be made by J. Hofent de Graff in Amsterdam. It will be included in the publication on Saltergate.

4. Thanks are due to E. Crowfoot of the Department of the Environment, London, for drawing my attention to these unpublished silks, as well as to S. Keene of the Winchester Research Unit for providing a copy of E. Crowfoot's report on the textiles.

5. Silk weaving was not practised in Scandinavia until the seventeenth century. I wish to express my gratitude to A. Geijer of Stockholm for making this point clear to me. She also informed me that the unpublished Oseborg silks do not include examples of tabby weave.

ADDITIONAL NOTE

See also the later work of E. Heckett, 'Some silk and wool head-coverings from Viking Dublin: uses and origins — an enquiry' in: *Textiles in Northern Archaeology*, NESAT III Textile Symposium in York, May 1987, ed. P. Walton, J. P. Wild, London 1990, 85-95, with further bibliography.

BIBLIOGRAPHY

Geijer, A., 1938. *Birka 3: Die Textilfunde aus den Gräben* (Uppsala), Müller-Christensen, S., 1960. *Das Grab des Papstes Clemens II im Dom zu Bamberg* (Munich).

Müller-Christensen, S., Kubach, H. E. and Stein, G., 1972. 'Die Gräben im Königschor' in H. E. Kubach and W. Haas (eds.), *Der Dom zu Speyer I* (Munich).

Pfister, R., 1934, 1937. *Textiles de Palmyre* 1 and 2 (Paris).

Pfister, R., 1950. 'Les tissus orientaux de la Bible de Theodulf', *Bulletin of the Byzantine Institute*, 48, 1950, 501-30. Studies in Honour of Walter Ewing Crum (Boston).

Schmedding, B., 1978. *Mittelalterliche Textilien in Kirchen und Klöstern der Schweiz*, Schriften der Abegg Stiftung Bern, 3, (Bern).

Walton, P., 1980. 'A Silk Cap from Coppergate', *Interim* 7 (2), 3-5.

SPECIAL NOTE

Since excavation of the York and Lincoln silk fragments described above, further silk head coverings have been excavated in Dublin. Publications relevant to these finds are as follows:

Heckett, E., 1986, '*A group of Hiberno-Norse silk and wool head coverings from Fishamble Street, St. John's Lane, Dublin*', vol. 1 (text), vol. 2 (catalogue), MA thesis, University College, Cork.

Heckett, E., 1990, 'Some silk and wool head coverings from Viking Dublin: uses and origins - an enquiry' in *Textiles in Northern Archaeology*, NESAT III Textile Symposium inYork, 6-9 May 1987, 85-96, (London).

XX
Review:
Silks at Lyon

MarielleMARTINIANI-REBER, Lyon, musée historique des tissus. Soieries sassanides, coptes et byzantines Vᵉ-XIᵉ siècles (*Inventaire des collections publiques françaises* 30). Paris, Ministère de la Culture et de la Communication, Éditions de la Réunion des musées nationaux 1986. 131 S. m. 8 Farb. u. 107 Schwarzweißabb., farb. Einbd. ISBN 2-7118-2009-2. 120F.

MARIELLE MARTINIANI-REBER's book provides a definitive catalogue of 109 early mediæval silk fragments in the Musée Historique at Lyons, and it forms a welcome addition to the literature in a specialised field of study.

The publication has a black and white photograph of each silk fragment and there are also eight colour plates. Preceding the catalogue proper are a series of short discussions ranging in topic from the history of the museum, to questions of date, provenance, technique, distribution, and uses of the silks themselves. A dictionary of technical terms is included, based on C. I. E. T. A. definitions.[1]

Martiniani-Reber combines traditional art historical methods of analysis with a scientific approach involving the careful technical analysis of different silks. Whilst retaining some of the geographical classifications suggested by Otto von Falke, who worked entirely without reference to technique, she illustrates that the grouping of the silks relies not only on stylistic, iconographic and historical analysis but on a thorough knowledge of how the silks were woven.[2] Indeed, it is the relationship of technique to style and iconography that forms the crux of this study in its attempt to provide chronology for the Lyons collection of silks.

Some general, and a few more specialised points, may be added to those made by Martiniani-Reber on the topics of 'dating', 'assigning provenance' and 'analysing technique'. When discussing dating, more emphasis should be placed on the fact that the only precisely datable Byzantine silk to survive is the lion silk from Siegburg, now in Berlin, which has an inscription that yields the date 921-23.[3] As she frequently acknowledges, in general mediæval silks are datable only by century.[4] On the question of provenance, she follows Falke in distinguishing Byzantine, Coptic and Sassanian groups of silks, but is not unaware of the fact that these headings may serve as no more than a convenient means of grouping the material. For instance, were the 'Antinoe' silks imported Sassanian silks or could they have been woven locally? The problems of the textile historian in this context are highlighted by the entry for no. 42 of the catalogue (p. 70) which reads, 'Sassanian, Egyptian or Byzantine'. Similarly, no. 49 (p. 74) is assigned to either 'Byzantium or Egypt', and no. 36 (p. 66) was woven either in 'Egypt or Constantinople'. Moving on to general points about technique, it is particularly commendable that Martiniani-Reber takes great pains to explain weaving types with dia-grams. It would perhaps have been a suitable opportunity to include a diagram of a hand drawloom. On occasion she uses a highly specialised weaving term such as 'cord' (no. 62, p. 89 was woven on 90 cords), without providing a definition in the vocabulary of technical terms. She states that she uses the technical data of C. I. E. T. A. in the museum records, and it is perhaps because these notes are incomplete that her use of the most highly specialised information is selective. It would be most useful to have further details for comparative purposes and some sort of explanation of the significance of the technical information would prove beneficial for all but the most seasoned textile historian.[5]

It is interesting to note that Martiniani-Reber refers to the use of 'a thicker weft than planned' in conjunction with no. 56 (p. 76). Could this perhaps reflect an inconsistency in the supply of yarn? The whole setting up of the hand drawloom depended on the correct use of the appropriate weight of silk yarns. When the thickness of yarn was known the weaver could decide on the number of warps and wefts per unit of measure to be employed, and thread the loom accordingly. Sometimes silk was com-bined with another thread, linen for instance, as with no. 35 (pp. 65-66). This would have added weight to the fabric.

With regard to using technical data as an aid to establishing chronol-ogy it is useful to bear in mind that the surviving twills datable before 1200 are divisible into two groups. The twills dating up to the 9th century use single main warps, whilst those of later date pair these threads.[7] This was probably because wider looms were being developed to produce heavier fabrics.

In her description of weaving types, Martiniani-Reber distinguishes only between twill and tabby weave, before the appearance of lampas weave around the year 1000 (p. 15). However, there were at this date other weaving types, in particular tabby weaves with extra wefts for the pattern, and damask weave silks. Examples of the former are in Swiss treasuries and of the latter in St. Ambrogio, Milan, amongst other places.[8] It should also be explained that tabby and twill weaves could be compound or non-compound weaves, that is either with or without a second set of warps (main warps). For the weaving of complex patterns there were main warps that could be lifted or lowered so as to allow the passage of the weft in a manner appropriate for the formation of the design.[9]

Only rarely can one establish a relationship between technique and provenance for the silks. Martiniani-Reber suggests that fine twill weave is characteristic of Egyptian production (no. 67) but it is likely that several centres in the Eastern Mediterranean were producing this type of silk simultaneously. A written merchant's mark on the back of one silk at Huy has been analysed and assigned to Central Asia, allowing Shepherd to assemble a group of so-called 'Zandaniji' silks.[10] To this group of silks Martiniani-Reber correctly refers an eagle fabric (nos. 28, 29, pp. 59-60) at Lyons.

Another point of interest tackled by Martiniani-Reber is whether or not there is a relationship between the iconography of the silks and their provenance. For instance, she refers to no. 33, which shows an odd mixture of Byzantine and Near Eastern motifs, but which she assigns to Egypt. By way of comparison she refers to the Vatican Annunciation and Nativity silk and to the Dioscurides silk at Maastricht and she calls both 'Near Eastern'. Perhaps a more detailed analysis of the iconography of these silks could suggest that a Byzantine provenance is appropriate for them".[11] Byzantine workshops had opportunity to acquire knowledge of 'Sassanian' design elements in particular, before the eighth century. The Byzantine princess Maria, daughter of the Emperor Maurice (582-602), married the Sassanian ruler Khusrau II Parwez (591-628), establishing an intimate connection with the Sassanian Empire. Not only this, but upon the Byzantine defeat of the Sassanian Empire in 628, it is documented that a large number of silks were seized as booty.[12] The Dioscurides silk with its odd combination of a Mithraic sacrifice and a classical column setting could well prove to be a deceptive Byzantine piece. In general it is unwise to assign provenance to any silk merely on the basis of its design though. For example, Martiniani-Reber tends towards this method in the case of no. 45 (p. 72), but small scale ornament of this type was prevalent all over the Eastern Mediterranean, perhaps deriving from Roman mosaic design.[13] On the other hand, no. 78 (p. 94) is sufficiently different in design to be clearly distinguishable, in this aspect anyway, from the rest of the

silks assembled into an 'Achmim' group by her. There are motifs within the group that give the silks some sort of unity of design. For example, the undulating border motifs, the palmette foliate ornament and the tear shaped leaves are characteristic of Achmim silks. The Antinoe silks have peculiar small round bird and animal motifs, and mask designs. Some of the motifs can be paralleled on Sassanian sculpture, but it should be remembered that in 616 the Sassanians occupied Egypt, and that their motifs could have been copied. A number of the Achmim silks bear Greek inscriptions and Martiniani-Reber follows Shepherd in thinking these refer to patrons. On the other hand, could they possibly be the names of the weavers?[14]

Martiniani-Reber chooses to group together the 'Amazon' silks because of their design (p. 115), and it is true the surviving silks suggest that not only hunters, but also charioteers, were popular subject matter in the eighth to ninth centuries, in both Islamic and Byzantine weaving centres. Large scale, monochrome, foliate and geometric designs on silks became fashionable in the Greek and the Islamic worlds from the period around 1000, and surviving examples at Lyons are again grouped separately by Martiniani-Reber (nos. 101-109). A point that should be made about one of the so-called 'incised, monochrome twills' at St. Rémi, Reims, is that the embroidered inscription on it takes the form of an attached band. The embroidered inscription yields a date pre-852 for the silk, which would make it two centuries older than the rest of the silks of this type that survive. However, it seems likely that the band may have been transferred from an earlier silk, especially as the relics around which the silk was placed were thrice translated after 852.[15]

A final point about motifs on silks is that very ancient designs are quite often found. For instance a griffin is shown attacking a quadruped on silk no. 75, and the motif can be traced back thousands of years.[16]

Techniques were sometimes changed alongside motifs. The arrival of the large scale foliate and geometric designs around the year 1000 was accompanied by the development of the lampas techniques, which broke the monopoly held by twill weave. From the sixth to the eleventh centuries twill predominated in both Islamic and in Byzantine weaving workshops.

Martiniani-Reber's book, indeed, does give rise to questions about many interesting aspects of mediæval silk weaving. It is much to be hoped that she will continue her researches in the field and that she may be able to draw more comparisons with mediæval silks in other collections including those at Sens Cathedral, at the Vatican in Rome, at St. Servatius, Maastricht and at Schloß Charlottenburg in Berlin.

NOTES

1. C. I. E. T. A., the International centre for the study of ancient textiles, has published technical vocabularies in a number of languages. The English, French, Italian and Spanish edition was printed in 1964, under the title "Vocabulary of Technical Terms".

2. O. VON FALKE, Kunstgeschichte der Seidenweberei. Berlin 1913. Falke's so-called "Alexandrian group" of silks probably came from several different centres of the Eastern Mediterranean and the term is no longer used. See D. KING in *C. I. E. T. A. Bulletin* 23 (1966) 47-52.

3. See title on p. 48 in n. 1 and refer in particular to p. 247 of the article cited.

4. Refer to no. 47 on p. 73 (5th or 6th centuries) or to no. 31 on p. 62 (c. 7th-10th centuries).

5. Useful reference could be made to D. K. BURNHAM, A Textile Terminology. Toronto 1980, 48-49.

6. Coptic tapestries combine silk and linen. Linen was also used in the 13th century by Latin weavers. A number of semi-silks were originally assigned to Regensburg by FALKE, but D. KING has suggested Venetian provenance; see D. KING in *Victoria and Albert Museum Yearbook for 1969*, 53ff.

7. See A. MUTHESIUS, Eastern silks in Western shrines and treasuries before 1200. PhD thesis, Courtauld Institute of Art, University of London 1982. Also note 9 below.

8. See nos. 63 and 64 in the publication by B. SCHMEDDING as cited by Martiniani-Reber on p. 23 of her bibliography. See also A. DE CAPITANI D'ARZAGO, Antichi tessuti della Basilica Ambrosiana. Milan 1941, 41-61, pls. IX-XV, and 61-62. no. 58.

9. The C. I. E. T. A. Vocabulary definition of compound weave is as follows: 'weave in which the weft or warp is divided into two or more series...' A broader definition of compound weave, although not recommended by C. I. E. T. A., is in use. This definition allows textiles with a second set of warps called main warps, automatically to be termed compound weaves.

10. Two articles by D. SHEPHERD are quoted by Martiniani-Reber on p. 23 of her bibliography.

11. See reference in note 7, above, pp. 126ff. and pp. 150ff.

12. See also A. GRABAR, L'art du moyen âge en Occident: influences byzantines et orientales. London, Variorum Reprints 1980, on the subject of 'Le rayonnement de l'art sassanide dans le monde chrétien'.

13. Martiniani-Reber uses a vocabulary for describing motifs taken from mosaic studies; see her reference at the base of p. 33.

14. See N. OIKONOMIDES, Silk trade and production in Byzantium from the sixth to the ninth century. The seals of kommerkiarioi. *DOP* 40 (1986) 51, n. 108, and further references there.

15. Such a wide time gap is unlikely to be the result of the accident of survival. See MUTHESIUS (as in note 7, above), Cat. no. C. iiia 77 and p. 189 and notes 2 and 3 on pp. 204-6.

16. The subject is found for instance on items from Thrace; see "Thracian treasures from Bulgaria", Brit. Mus. Cat. 1976, no. 278.

Index

Index

A

Aachen 64, 105, 220, 222, 227
 coronations 227
 cult of the Virgin 223
 list of relics made in 1238/39 222
 Palace Gospels 220
 pattern of textile acquisition 219
Abbot Gontran (1034-1055) 149
Abbot Rodulphe in 1112 149
Abd al-Malik, son of al-Mansur (d. 775) 86
Abd al-Rahman III (912-61) 94
 son of, Prince al Mughira 86, 87
Abegg Stiftung, Bern 84
Abu Mansur of Khurasan (d. 961) 140
Adalbero II (d. 1026) 26
administration, Byzantine
 Comes Sacrarum Largitionum 298
 Count of the Sacred Largesses 258
 Eidikon 169
 Imperial finance 279
 list kept by the Prefect 282
 Prefect of the City 258
Adranoutzi 279
Aghia Sophia, see Constantinople
Aleppo 141, 262, 327
Alexandria 298
Alexandria and Constantinople 138
Alexandrian textile industry, early 296
Alfonso VII, king of Castile (1126-57) 89
Almanzor, under Caliph Hisham II
 (987-988) 92
Anargyroi church in Kastoria 234
Anastasius reliquary 225
Anglo-Saxon Royal cults 225
Anglo-Saxon soldiers 237
Antioch, administrator of
 Imperial estates 122
Anvers 148

ἀπὸ τῶν ἔξωθε 260
Arab conquests 138
Arborfield 47
archaeological catalogues and finds 183
Archbishops
 Anno of Cologne (d. 1075) 78, 210
 Heribert of Cologne (d. 1021) 58, 210
 Hubert Walter (1193-1205) 45, 50
 Peter of Corbeuil (d. 1222) 49
 Wenilon in 853 78
 Willicaire of Sens in 769 78
 Willigis of Mainz (975-1011) 29, 210
archon of Zeuxippos 65
archontes tou blattiou 277
ἀρχοντικά πρόσωπα 260
argaman 248
Armenia 279
Arnoldo Ramon de Biure in 11th
 century 112
art historical approaches 178
Artaxa 279
Aschaffenburg 29
Asia Minor 128
Astana 88
Augsburg, St. Ulrich and Affra 208
Auxerre Cathedral 204
Auxerre, St. Eusèbe 61

B

Baggage Train account 234
Bamberg Cathedral 29, 210
Bamberg Cathedral treasury 29
Basle antependium 30
Bayerisches Nationalmuseum, Munich 29
Benjamin of Tudela 249, 327-328
bindings on manuscripts 21
 see also Mondsee, Gospel Lectionary

bindings on manuscripts (*continued*)
 life of St. Stephen from
 Weihenstephan 23
 Patriarch Photius 21
 rare bindings 21
 silk-sheathed spine 21
Birka, tenth century graves 344
Bishops
 Adalbero I of St. Trond
 (11th century) 148
 Adalbero II of Trier (d. 1026) 26
 Amalarius in 838 21
 Bernard Calvo of Vich (1233-43) 49
 Bernward of Hildesheim (993-1022) 211
 Gaudry of Auxerre (918-33) 61, 204
 Godehard of Niederaltaich
 (d. 1038) 30,210
 Henry II of Thun (d. 1238) 26
 Hubert Walter at Salisbury (1189-93) 50
 Kolborn, "provicar" of Mainz 29
 Meinwerk of Paderborn
 (d. 1036) 28, 210
 Theodulf of Le Puy (d. 820) 343
Black Sea 279
Bohemond I, Prince of Antioch
 (d. 1111) 141
Brauweiler, St. Nicholas 105
British Library charter Add. 19611 51
Brusa (Bithynia) 326
burial shrouds 142
Bursa *see* Brusa
Byzantine army 234
Byzantine dress 288
Byzantine Emperors *see* Emperors
Byzantine envoys 28
Byzantine Imperial authority 202
Byzantine provenance 139
Byzantine silk and Imperial
 authority 240
Byzantine silk industry *see* industry
Byzantine silks in mediæval European
 treasuries 28
 see also silks, surviving
Byzantine silks in the Ottonian
 period 201
Byzantine vestments 181
 see also ecclesiastical vestments
Byzantine-Syrian relationships 240
Byzantium and the West 168

C

caftan or a loose tunic 296
Cairo Geniza
 documents 124
 documents, standard quality silk
 cost 284
 fragment Or 1081 J 9 247
Caleb epitaph 249
Caliph Al-Radi Billah 160
Callinicum 279
Canon Bock 28
Canterbury 45, 47
Carolingian inventory of relics at
 Aachen 222
Carolingian period, imported silks 240
Cathedral of Paderborn 30
Cave of the Thousand Buddhas at Tun-
 huang 88
Central Asian silks 6, 110
Centula 222
Ceylon 121
charka 126
Charlemagne
 burial place 220
 canonisation 225
 chapel reliquary 221
 cult 223, 225
 talisman 220
Charles the Bald at Soissons 225
Cherson 138, 279
China 121
Chinese Annalists 273
Chinese drawlooms 129
Chinese silk 140
Chiswick 47
Christian Kingship 224
Chur Cathedral 77
Church of the Virgin at Székesfehérvár
 30, 211
Cluny 29
Clysma 279
cocoons, prehistoric 121
 see also sericulture
Codex Aureus of Echternach at
 Nürnberg 23
Cologne
 Diocesan Museum 58
 St. Gereon, Western tapestry 153, 207
 St. Pantaleon 208
 St. Ursula 112
Cologne Deutz, St. Heribert 58

Columbia Textile museum 84
computer aided analysis 183
computer pictorial retrieval 173
confraternity of St. Euchère 149
Constantinople
 Church of the Virgin Blachernae 222
 Church of the Virgin Chalcoprateia 221
 Church of the Virgin Hodegetria 222
 Haghia Sophia 222
 Pera district 249
 Zeuxippos bath 65
conversion of Russia to Byzantine
 Orthodoxy 239
Coptic Egypt 88
Cordoba 87
Corinth 92, 139, 251, 327
Coronation ivory (Cluny Museum,
 Paris) 210
coronation vestment in Vienna 46
Cos island 121
cotton 151
cotton selvedges 151
Crimean coast 137
Crusader kingdoms in Syria and
 Palestine 141
cults
 Anglo Saxon Royal 225
 of Charlemagne at St. Denis 223, 225
 of relics 142
 of the Virgin at Aachen 223
Cunigunde (d. 1024), consort of
 Henry II 29

D

Danielis, the widow 304
Daras 279
dearth of raw material 259
diplomacy
 alliance, tenth century Anglo-
 Byzantine 237
 Basil II and 200 Imperial silk
 costumes 236
 categories of silken diplomacy 235
 channel for diplomatic relationships 238
 Constantine IX and one thousand silk
 costumes 236
 dialogue between Byzantium and the
 West 202
 diplomatic gifts 28, 167

diplomacy (continued)
 diplomatic silks of Imperial manufac-
 ture 290
 Greek legates in the West 165
 marriage alliances between Byzan-
 tium and the 'Franks' 203
 marriage alliances, East-West 203
 marriage of Vladimir of Russia to
 Anna, sister of Basil II, in 989 239
 marriage, proposed, of Otto III and
 Zoe in 1000-1002 206
 marriages, sixteen diplomatic 140
 nuptial alliance: daughter of Pepin
 and Leo, son of Constantine V, in
 765ff. 167
 nuptial alliances, Carolingian courtly
 203
 nuptial diplomacy 168
 political gifts of silks 141
 trade, diplomatic with silk 135
 tribute of silk textiles 240
drawlooms 24, 55, 56, 183
 Chinese 129
 multi-tier 129
 narrower looms 296
 pattern producing device 57, 130
 Persian 129
 reed of 292, 295
 vast size of 295
dress weight 293
Dvin 279
dyes 55
 aniline dye, nineteenth century 85
 Archil dyes 301
 blatta, lighter 301
 bright Tyrian 301
 colour scheme 59
 διβλάττια and τριβλάττια 292
 dyeing 124, 127
 dyeing cocoons 301
 dyers 124
 dyer's expenses 301
 purple dyes 63, 160, 298
 indigo and a lichen 160
 indigo and madder 160
 murex 160, 315
 murex blatta 301
 murex-dyed silks 128
 murex dyeing, illicit 169
 murex purple dye, Imperial 202
 murex shades 292
 purple, false 293

dyes (*continued*)
 purple, finest wool dyed 301
 purple fishers 298
 purple, Milesian 301
 purple silk at St. Peters (Imperial) 209
 purples, imitation 169
 purples, price of cheaper 301
 purples, Imperial, seven categories 232
 purpurarii 257
 red purple garments 292
 resist-dye techniques 88
 scarlet kermes 301

E

East Caspian sea coast 121
East-West cross-currents 201
Eastern frontier with Persia 276
ecclesiastical vestments 45
 amice 45
 baudekin 293
 bell chasuble of St. Bernard 218
 buskins 30
 chasuble from St. Peter's, Salzburg
 26, 30
 chasuble of St. Edmund, Archbishop
 of Canterbury 48
 chasubles 47
 at St. Victor, Xanten & Mainz 112
 dalmatic 45
 Fermo chasuble 94
 mitre 45
 orphrey 46
 pluvial 30, 45
 stole 46
 tunicle fragment 45
economic expansion in Byzantium 278
Edessa 303
Edsen Gol, Mongolia 342
Edward the Confessor,
 canonisation in 1163 225
Egypt 137
Elephant silk from St. Josse 140
Ely 47
embroidery
 chain stitch 338
 coarse embroidery on wool 303
 embroiderers 124
 gold embroiderers 302
 on pure silk 303
 on semi-silks 303

embroidery (*continued*)
 plait stitch 50
 Spanish embroidery in Fermo 85
 Spanish embroidery, less refined 86
 stem stitch 50
 underside couching 50
Emperors, Greek
 Alexios I (1081-1118) 207, 239, 305
 Alexios V Murtzuphlus (1204) 233
 Anastasios (491-518) 275
 Andronicus / Andronikos I (1182/3-
 1185) 233, 305
 Basil I and Constantine VII (867-
 869) 60, 205
 Basil II (d.1025) 160
 Basil II and his brother Constantine
 VIII (976-1025) 60, 157
 Constantine V (741-75) 168
 Constantine VIII (1025-1028) 280
 Constantine IX (1042-55) 305
 Constantine X (1059-67) 166, 305
 Constantine Porphyrogenitus (905-
 59) 203
 Isaac I (1057-59) 305
 John II (1118-43) 305
 Leo III (717-41) 62, 204
 Leo IV (775-80) 62, 204
 Leo V (813-20) 62, 141
 Leo VI (886-912) 62, 109, 232, 280
 Manuel I (1143-1180) 233, 305
 Maurice (582-602) 351
 Michael III (842-67) 209
 Michael V (1041-42) 238
 Michael VI (1056-1057) 238
 Michael VII (1071-1078) 238
 Nicephoros III (1078-1081) 232
 Romanos I (920-944) 160
 Romanos II and Eudocia in 945 210
Emperors, Western
 Charlemagne (d. 814) 78
 Charlemagne's canonisation 220
 Charles IV 221, 223, 227
 Charles V in 1520 227
 Ferdinand I in 1531 227
 Frederick II (1220-50) 65
 Frederick Barbarossa
 (1155-90) 65, 225
 Henry I (919-36) 109, 168
 Henry II (1002-1024) 23
 Henry III (1028-1056) 109, 225, 344
 Henry IV (1084-1105) 207
 Otto I (962-73) 109

Emperors, Western (*continued*)
Otto II (976-83) 30
Otto II (976-83) and Theophanou 210
Otto III (996-1002) 65, 109
Empress Theophanou 30
experimental archaeology 183

F

factory owners 125
falconer mosaic 82
Fatimid conquest in 969 AD 138
Fatimid crystals 155
feast of the deposition of the girdle of
 the Virgin 222
fineness of cloth 294
fines and punishments 299
Frankish saints 221
Fulin 273
Fustat 138

G

Gabras, envoy of the Turkish sultan 233
Genoa 141
Gisela (d. 1043) 211, 344
Glastonbury 47
gold *see* uses of gold
gold ornament on the fabric 295
Gospel Book of Echternach 207
graves
 grave of Viventia, daughter of Pepin
 the Short (d. 768) 207
 of many archbishops 45
Greek and Roman traders 137
Greek caravans 263
grouping and dating of silks 181
grouping of silks
 'Achmim' 352
 'Antinoe' 352
 Aresta, Cloth of 219
 damask 107
 double and triple cloths 84
 holoveron pieces 259
 'irregular twill' weave 159
 lampas pseudo/true 107
 monochrome compound twill 22
 monochrome lampas weave 136, 219
 monochrome or 'incised' paired main
 warp twills 112

grouping of silks (*continued*)
 paired main warp twill 111
 plain tabby weaves without pattern 343
 polymita 296
 samite 110, 119
 semi-silks 219
 single main warp twill 51
 Spanish tabby, tabby lampas 48
 tabby: one or two systems
 of warp/weft 46, 107
 tabby, tabby lampas 47, 112
 tabby, twill lampas 107, 112
 tabby with extra pattern wefts 107
 tablet woven fabric 46
 tapestry slit 107
 tapestry fragment with arch and
 tendril 112
 technical structure 58
 threads, number or fineness 295
 triple weave 84
 twill, 3/4 main warps 107, 110
 twill, chevron 107
 twill, paired main warp, grège 107
 twill, paired main warp, twisted,
 degummed 107
 twill, single main warp, twisted,
 degummed 107
 two-toned tabby weave silk, woven
 down loom 137
 watered silks 288
 weave: one-, two-, four-, six-, eight-,
 nine-, hundred- thread 297
 weaving categories, five main 55
 Zachariou and Joseph silks 324
 'Zandaniji', Central Asian 103-107,
 110
guilds 266
 five non-imperial silk guilds in tenth
 century Constantinople 127
 guilds and workshops 120
 non-Imperial, in Constantinople 120
 order and standards in 281
 political power of Constantinopolitan
 178, 238
 private 120
 provincial, in the Late Roman
 period 258
 regulations: silks forbidden for private
 manufacture 291
 role 266
 Serikarioi as an umbrella guild 126,
 127, 266

guilds (*continued*)
 textile guilds of Western Europe 260
Gurgan theory 272

H

Halberstadt Cathedral 88
Han dynasty, late, (25-220 AD) 272
Han tomb 88
Harun al Raschid (786-806), Caliph 222
hearth and land tax 303
Heracleopolis 304
Huy 105, 148

I

icon of the Virgin 222
Iconoclasm 160
iconography *see also* silks, surviving
 addorsed, rearing griffin type 156
 Amazons wearing scarves with Kufic
 inscriptions 140
 ancient designs 352
 animal and bird designs, small 137
 Archangels Michael and Gabriel 50
 bird and animal motifs, large 290
 bird and gazelle motifs 91
 birds, griffins, lions and foliate
 motifs 25
 border motifs, undulating 352
 bust in a medallion 25
 Byzantine and Near Eastern motifs 351
 charioteer design 79
 Christ, seated, with sun, moon, and
 letters 50
 complex, large-scale 129
 cruciform, swastika and labyrinth
 designs 50
 Dioscurides 78
 eagle, double-headed 48
 eagle, figure being carried aloft by 88
 Eagle and a Griffin silk 48
 Eagle silks at Auxerre and Brixen 208
 eagle motifs woven on silk leggings 234
 eagles on tunics 234
 elephant motifs 79
 falcon, held by a crowned Byzantine
 emperor 85
 Falconer silk in the Detroit Institute
 of Fine Art 84

iconography (*continued*)
 falconer with hunting dog 85
 figurative subject matter 179
 foliate motifs on monochrome silks
 290
 griffin attacking a quadruped 352
 Griffin silk 153
 at the Diocesan Museum, Liège 150
 dyed with murex purple, in Sion
 Cathedral 166
 from St. Trond, now in Liège 147
 of St. Chaffre, Le Monastier 157
 of the Stiftskirche, Berchtesgaden
 157
 Hunter motif on Imperial silk from
 Mozac 166
 irregular designs, large 290
 Lion silks 28, 58
 foot of an Imperial lion 109
 from the grave of Maria Almenar 49
 from the shrine of St. Anno
 (d. 1075) 56
 Imperial 109
 Imperial, from various Rhenish
 treasuries 166
 inscribed 238
 Ravenna 109
 with cut Kufic inscription at
 Maastricht 112
 Lion and bird silk at St. Servatius,
 Siegburg 112
 'Lion-strangler' silk from Vich 48
 lions, addorsed 48
 mask designs 352
 medallions with paired griffins and
 panthers 30
 Mithraic sacrifice 351
 'Nature Goddess' silk at Durham
 Cathedral 95, 165
 Old and New Testament scenes 29
 ornament, small scale 351
 paired quadrupeds and foliate
 ornament 91
 palmette foliate ornament 157, 352
 Peacock silk, Thuir parish church
 89, 90
 peacocks, single-headed 93
 peacocks, double-headed 89
 rider with stirrups 83
 Samson, in combat with a lion 79
 Samson silk at Maastricht 111

iconography (*continued*)
 scrolls, foliate, with large 'tear'
 shaped motifs 50
 'sea design' 234
 seated rulers in Eastern costume 29
 stripes, thin reed-like 294
 stripes, broad and narrow, on tunics
 and mantles 234
 symmetrical designs, large 293
 victorious and glorious Emperor 167
Imperial Baggage train 209
Imperial Byzantine silks in the West 236
Imperial inscription 57
Imperial saint 221
Imperial silk ceremonial 234
Imperial silks, stored, renovated 64, 169
Imperial wool and linen mills and dye
 works 298
Indian Nistari moth 121
industry, Byzantine silk 128
 artisans, status of 266
 assistants 266
 bapheis 257
 barbaricarii 257
 behaviour of Imperial weavers,
 embroiderers and dyers 299
 brocade weavers 302
 capital, seasonal, to secure imported
 raw silk 307
 carpenters for looms 124
 cartel 261
 craftsmen 125
 craftsmen for design prototypes 124
 craftsmen preparing the warp 124
 director of the weaving establish-
 ments 258
 division of labour 307
 domestic raw silk 128
 domestic silk production for the state
 278
 drawboys 124, 266
 drawlooms *see* drawlooms
 duty, transformation from obligatory
 and hereditary 257
 economic organisation of manufac-
 ture in Constantinople 280
 Eparch, silks to be declared to the
 285, 291
 fancy silk weavers 302
 fabric brokers 128
 financiers 286
 foremen 286

industry, Byzantine silk (*continued*)
 fraud, prevention of 299
 garments made of costly silk 266
 guild regulations 176
 guilds, silk. *see* guilds
 gynaeciarii 257
 illicit manufacture of forbidden cloths
 259
 katartarioi, role of the 283
 manufacture of controlled silks 178,
 267
 marketing of the finished products 120
 melathrarioi 127
 monopoly, Imperial 232
 monopoly over raw silk
 in Constantinople 284
 monthly contract 283
 'noble faces' embroiled in
 the manufacture of silk 178
 origins of the Imperial and the private
 silk industries 257, 265
 pattern makers 124
 pay for a selection of different
 weavers 301
 policed standards and prices 261
 prandiopratai 128
 private business men 275
 private manufacture of silks 56, 128,
 266
 procurator 258
 production, steady silk 265
 prohibited silks 293
 provincial
 production of silk garments 286
 silk manufacture 262
 silks 286
 surplus state luxury goods in state
 apothekai 274
 textile factories 258
 workshops 139
 public workshops 55
 purchasing cartel 282
 regulations, strict 202
 reserves of silk were stored in the
 Imperial Palace 285, 308
 selvedge 151
 semi-silk garments 302
 semi-silks 297
 service, privileged and non-hereditary
 257
 shops that they rented out to silk
 merchants 276

industry, Byzantine silk (*continued*)
 size of the Byzantine silk industry 257
 skilled labour, shortage of 283
 skills, sequence of, in the workshops
 269
 smaller workshops 266
 social conditions 299
 spinners 288
 sumptuous nature of the Byzantine
 silk industry 179
 supervisors of the workshops 285
 tailors 124, 296
 twist on warp threads 124, 127, 285
 Tyre and Beirut, silk industry in 122
 unfinished cloths 298
 unravellers 288
 unsewn silk cloth 287
 vat tenders and reelers 124
 vestiopratai 128
 weavers of silk 124, 322
 plain silk weavers 302
 status of master 266, 302
 status of Imperial 299
 weaving faults 182
 weighers of silk 124
 weight of the fabric 295
 widths in which the silks were
 woven 295
 workers, poorer silk 260
 workers, power to hire in 261
 working practices 119
 workshops
 Imperial Byzantine 55, 107
 series of distinct 289
 woven to shape 296
 yarn 119, 319
 mixed 294
 production of 123
 yields of mature mulberry trees 126
industry, non-Byzantine silk
 late Roman Corporations 306
 late Roman Count of the Sacred
 Largesses 258
 late Roman provost of workers 258
 later provincial manufacture 265
influence, Byzantine
 cultural influence on the West 188
 court ceremonial 159
inscriptions
 Coptic, Byzantine, and Kufic 140
 pseudo Kufic 49

interaction between yarn, technique
 and design 186
'International style' of silk weaving 140
Iotabe 279
Islamic
 centres 45
 inscriptions, pseudo Kufic 49
 rise of the merchant classes 279
 silk industry 276
 silks 6-7, 12-15, 29, 45-51, 62-64,
 77-96, 109-111, 140, 159-161,
 351
 tiraz factory 92
 twill and lampas weave silks 219

J

Jerusalem 221
Jewish element in Byzantium's silk
 Industry 245, 247
Jewish silk association 262
Jewish silk trading activity in the Latin
 West 250
Jewish silk workers and merchants 138,
 245, 250

K

καγκελάριον 284
καταρταριοι 127
κεκωλυμένα 260
κεντηνάριον 283
Kherson 262
Khorasan 121
Kings
 Edmund (939-946) 166
 Henry IV, King of the Romans
 (1054-1084) 166
 Stephen of Hungary (1000-1038) 30,
 221
 Ordono IV of Spain in 962 94
 Roger II (1130-54), King of Sicily 92,
 141
 Pepin (751-768) 168
 Stephen of Blois (1135-1154) 140
Klinte Oland 82
kommerciarioi *see* trade

L

Land of the Seres 120
Late Antique fairs 137
Latin occupation 128
Latin silk weaving
 establishment of centres 165
 royal workshop 140
 Sicilian Hare silk 220
 Sicilian silk weaving 92
 Sicilian twill, thirteenth century 219
 workshop in Palermo in the mid
 twelfth century 262
legislation, Byzantine silk 120, 300
 see also trade, fines and sources
 aims behind the legislation 307
 annual land taxes 304
 Basilics 169, 300
 ceiling prices on silks 178
 collatio lustralis 304
 decree of the Emperors Theodosius
 and Valentinian 299
 decrees, Imperial 232
 Justiniac Code 300, 320
 Notitia Dignitatum 298
 "Peri Metaxes" 177, 321-323
 regulation against selling raw silk to
 Jews 262
 regulations restricting the activities of
 the wealthy 286
 Theodosian Code 248, 300, 320
Le Puy, chapel of St. Michael 77
Liber Pontificalis 105, 142, 160
Liège 105
linen weavers 302
Liudprand of Cremona 169
looms see industry
Lop Nor, Eastern Turkestan 343
Lucca 292
Lutold I of Arburg (d. 1213) 26

M

Maaseik 105
Macedonia 128
Macedonian dynasty 107
Magnos the Syrian, minister of Justin II
 (565-78) 122, 320
Mainz, St. Stephen 29
manuscript bindings, see bindings
Marseilles 138

Marwanid dynasty 28
Maximilian in 1486 227
mediæval silk weaving 119
mediæval textiles rewoven 183
Medina az Zahira, marble basin 92
Mere, silk chasuble 47
Merovingian Gaul 137
μεταξάριοι 260
methodology for the study of Byzantine
 silks
 inter-disciplinary research method
 173, 185
 pictorial retrieval system for
 Byzantine silks 173
 practical approach to historical
 documentation 256
 scientific analysis of fibres and dyes
 179, 182
 stylistic and iconographic data 181
 technical data, aid to establishing
 chronology 182, 183, 297, 350
 technical problems 183
 vocabulary of technical terms 136
military aristocracy, regional 305
Mondsee
 Benedictine abbey of Ss. Peter and
 Michael 22
 Gospel Lectionary 21, 42
Monte Cassino Abbey 29, 210
moriculture 120
 bush or tree mulberry 123
 cropping and gathering of leaves 122,
 123
 cutting 123
 grafting 123
 layering 123
 manuring 123
 propagation 122
 pruning 122
 tilling 123
 trimming of shoots 123
 weeding 123
mosaics at Hosios Lukas near Delphi 167
Moslem East and West 139
Mount Athos 21
Münsterbilsen 105, 111

N

Namur 148
Nasr ad Daulah, in 1010-1025 140

Nijmwegen 208
Nisibis 279
Nivelles 148, 208
non-industrialised silk industry 176
Norman Sicily 140, 141
North Africa 138
Northern Caucasus 139

O

Oxyrhynchus 304

P

Pala d'Oro, St. Mark's, Venice 87
Palermo 92
Pamplona Cathedral treasury 86
patronage
 Imperial 112
 patrons 105
 (Western) at Aachen 220
Persian silk 315
Persian wars 323
Persian weavers 84
Peterborough, silk chasuble 47
Philai 279
Philip of Swabia (d. 1204) 49
Phoenicia 298
Photius, second Patriarchate of (877-86) 276
piety and the silken cult of relics 217
pilgrimage to Aachen 222, 226
Pisa 141
Popes
 Benedict III (855-8) 209
 Clement II (d. 1047) 30
 Gregory IV (827-44) 61
 Leo III (795-816) 78, 221
 Paschal I (817-24) 61, 205
 Paschal II (1099-1118) 61
praepositi 258
Praetorian Prefect 258
prehistoric cocoons 121
prices of silk
 Diocletian, Price Edict 264, 301, 321
 garments priced at 50 bezants 261
 high price of 150,000 denarii a pound in 301 AD 301
 Imperially controlled purchasing 258
 inferior silks 169

prices of silk (continued)
 on a par with gold 245
 one pound of standard quality raw silk at 2.5 dinars 264, 295
 prices of the best textiles 302
 pricing merchandise 296
 qualities of silk 126-127
 raw silk 126
 at 8 nomismata per pound 258
 sold by weight 284
 secondary grade spun silk 284
 set profit margin of 16 per cent gross 281
 silk garments 264
 silks of lesser quality 246
 silk's value in nomismata 258, 261, 294, 295, 322
 twelve varieties of silk thread 176
Prince al-Mughira, son of the caliph Abd al Rahman (III (912-61) 86
production of silk see sericulture
Prüm 222
πωλον 292

Q

Quedlinburg 208
Queen Gisela in 1031 30

R

Regensburg, St. Emmeram 22
Reggio 126
Reims, St. Rémi 352
relics 77
 display in the fourteenth century 226
 early Christian and of later mediæval saints 221
 Holy Innocents 78
 inventory of Centula of 804 222
 inventory of Prüm of 1003 222
 of lesser importance 79
 St. Athanasius 147
 St. Austremoine at Mozac 167
 St. Columbe and St. Loup 78
 St. Cuthbert 80
 St. Julian at Rimini 206
 St. Potentien 78
 St. Siviard 78
 St. Victor 78

relics (*continued*)
 silks for the relics of saints on the
 continent 80
 sponge of Christ 222
 swaddling clothes of Christ 222
 sword of Charlemagne 220
 True Cross 222
 Virgin, garment of, and girdle 222
Reliquaries
 Aachen plate reliquary 221, 227
 Charlemagne, bust 221
 precious reliquaries and shrines 77
 S. Apollinaire, Early Christian
 reliquary grave 220
 St. Cuthbert, coffin-reliquary 80
 St. Eustace, head reliquary from
 Basle Cathedral 79
 St. Librada, early Christian martyr 91
 shrine of Charlemagne (d. 814) 64
 shrine of St. Anno (d. 1075) 91
 shrine of the Virgin 220
 shrouds 147
 Simeon reliquary 221, 227
Rhadanite Jewish merchants 110
rich provincial magnates 304
Robert Guiscard, Duke of Apulia
 (1057-85) 141
Roman liturgy at Aachen 221
Roman pavements 168, 351
Roman Syria 121, 272

S

St. Ambrogio, Milan, golden altar 220
St. Amour 149
St. Denis, national saint 225
St. Florent de Saumur 210
St. Goar 209
St. Lazare, Autun 86
St. Paulinus, Trier 77
St. Riquier 209
St. Servatius, Maastricht, enamel
 cross 79
St. Trond as a religious centre 148
St. Trond at the heart of International
 trade 149
St. Trond, Notre Dame Friary 149
St. Vitalis 157
saints, Roman 221
Saltergate, Lincoln 341
Sancta Sanctorum 78

Sassanian influence on Byzantine silk
 weaving 88, 179
Sassanian ruler Khusrau II Parwez
 (591-628) 351
Sassanian sculpture 352
seaports of Italy and Dalmatia 138
seed *see* sericulture
Seleucia 287
Sens, Abbey of St. Pierre 78
Sens cathedral treasury 77, 109, 159
Sens, St. Columbe 78
sericulture, Byzantine 120
 access to raw materials 281
 apotheke 317, 330
 Byzantine Syria 177
 Calabria as a supplier of raw silk 176
 cocoons, gathering and grading 124
 cocoon processing 120, 125, 288
 cost of raw silk 283
 costs of treating the silk yarn 301
 degummed silks, hanks of 269
 degumming 127
 denier 293
 disease (fungal and bacterial) 123
 dismantling of spinning boards 124
 dressing 127, 288
 economic documents on Byzantine
 sericulture 176
 εὐτελέστεροι Καταρτάριοι 260
 feeding of the silkworms 123
 government raw silk agents 274
 graders 124
 grège silk 110
 humidity control 124
 illegal sale of raw silk to the rich 284
 import of raw silk 128, 275, 276
 mulberry
 cultivation 122
 plantations 126, 276
 trees 122, 123
 trees in Calabria 176
 noise levels 124
 planting 122
 processes 267
 essential to yarn production 282
 processing of cocoons 123
 processing of the yarn 120
 production, insufficient domestic raw
 silk 246
 production of the raw material 120
 pupation 125
 purchase of raw silk 276

sericulture, Byzantine (*continued*)
 quality raw silk 277
 raw materials 55
 reelers of cocoon silk 288
 seed 119
 seed, fast-hatching 126
 seed, laying by female moths 123
 seeding 123
 size of the silk 295
 spinning of waste silk 125
 spinning boards, setting up 123
 supply of raw silk 315-335
 Three Stages from Seed to Samite 119
 waste or floss silk 124, 288
 worms 105
 introduction into Byzantium 259, 265
 moulting 125
 mounting 123
 rearing 119
 yarn, first grade 284
Serindia 120
shroud of St. Siviard at Sens Cathedral
 155
Sicily 138
silks, surviving
 Aachen, Charioteer silk 111
 Aachen, Elephant silk 64
 Aachen, Hunter silk 111
 Amazon silk at Maastricht 111
 'Amazon' silks 352
 Auxerre and Brixen, Eagle silks 93
 Bird silk at Utrecht from
 Dokkum 112
 Bird silk in Salamanca 48
 Bullock silk at St. Servatius,
 Maastricht 208
 Cologne Lion silk 58
 Durham Cathedral silks 77, 81, 95
 Durham Cathedral, 'Nature Goddess'
 silk 95, 165
 Durham, Rider and Peacock silks 77
 England, surviving early mediæval
 silks 341
 Gunther tapestry at Bamberg
 Cathedral 157
 Hunter silk of the eighth century 83
 Huy, Ram silk 110
 Kunstgewerbemuseum, Berlin (1881-
 474a 91
 Liège Al 30 with eagles and antelopes
 112
 Liège, 'Heraclius' silk 111

silks, surviving (*continued*)
 Samson silks at Liège and Maastricht
 111
 London, Victoria and Albert Museum
 fragment 157
 Munich, National Museum fragment 157
 Paris, Cluny Museum (21.872), Prince
 with Eagle 88
 Quedlinburg Cathedral, formerly
 Berlin (1882-1170) 91
 Riggisberg, Vitalis chasuble 47
 Sens cathedral treasury fragment 153
 Siegburg Lion silk 58, 105
 Sitten griffin silk 155
 'skaramangia', short court tunics 233
 Speyer, Historisches Museum
 fragment 157
 Thuir, Peacock silk in parish church
 89, 90
 tomb of Peter Lombard (d. 1160 or
 1164) 91
silk as currency 308
silk bindings *see* bindings
silk groups *see* groups
silk patrons 105
Silk Route from Central Asia 276
silk yarns of the Mediterranean 176
silk-clad nobility 142
slaves and timber 141, 261
Slavs 274
soldiers, Anglo-Saxon 237
sources *see also* Cairo Geniza, legisla-
 tion, prices of silk, relics
 Aristotle's 'Natural History' 121
 Bible and Talmudic literature,
 purple 248
 Book of Ceremonies 169, 178
 Book of the Prefect 120, 178, 186,
 202, 280
 Book of the Routes and the
 Kingdoms 147
 Caleb, epitaph of Jewish dyer 249
 Constantine Manasses 232
 De Administrando Imperio 168
 Diocletian, Price Edict 264, 301, 321
 Ekkehard of Mainz in 1083 165
 Florus of Lyon in 838 21
 Geng Zhi Tu c. 1145 125
 Ibn Dhaldun (1332-1406) 94
 Jewish oath 249
 Maimonides (d. 1204) 248
 merchant's mark, written 351

sources (*continued*)
Nicetas Choniates (1155-1215) 233, 315
Nicetas Paphlago 21
Otto of Freising 262
Periplus of the Erythraen Sea 137
Procopius of Cæsarea (500-65) 120, 316, 321
Pseudo-Codinus 233
San-kuo-chih 120, 319
textile terms in documentary sources 291-297
Theophanes Continuatus 169
Theophanes of Byzantium 120, 316
Wei Shu written before 572 AD 121
Southern Italy 127
Spanish ivory caskets 86
Speyer 105
Stephan burse reliquary 220
Sung dynasty (960-1279) 273
Sustern 105
Syria 137, 160
fall to the Persians (613-27) 276
Syrian silk garments 128
Syrian silk merchants 125
Syrian silks decorated with Christian themes 160
Syrians, Greeks and Jews living in Gaul 138

T

tabby *see* grouping of silks
Ta-Chin (Ta-Ts'in) [Roman Syria] 272
Tang dynasty (618-906) 273
taxes *see* trade, tax(es)
technical terms 136, 281
techniques, silk
see also grouping of silks
brocaded twill 92
brocades, Byzantine 138
chevron twill 154
chevron twill and tapestry 112
chevron twill with griffins 112
weaving types, chronology of 55, 136, 174
tekhelet 248
temple vestments 248
terms to describe Byzantine silks 291-297
with or without decorated panels 294, 296

terms to describe Byzantine silks (*cont.*)
without sewing 296
tetarteron coin 280
textiles as decorative objects 179
Thebes 92, 139, 251, 327
Theophanou's dowry 170
Thessalonika 138, 249
tola at hassani 248
Tongeren 105
trade, Byzantine silk 110
agreement with Venice, ninth century 239, 263
alliances, three special with Russia, 907-971 AD 238
apothekai 262
blockade of Arab goods by Byzantium 138
Bulgaria, 'trade war' of 894-9 280
Byzantium, seventh century 278
Central Asia, trade connections with 250
Comes Commerciorum per Orientem 258
commercia 278
concessions 135, 263
for political gain 238
granted to Syrian silk merchants 240
granted to Venice by Byzantium 141
customs and sales taxes in Byzantium 278
customs centres and dues 262, 278-279
demand for cloth 295
exchange, state control of 274
export controls 238, 249, 250
fines
of gold for corrupting Imperial female weavers 299
of three or five pounds of gold 299
frontier trading posts 279
impact of trade on the West 142, 239
import of raw silk 128, 275, 276
imports, illegal 275
Italy, trade with 105, 178
kommerciarioi 258, 277-278, 316, 320, 323, 331
kommercion 276, 329, 332
markets, domestic and foreign 120
merchants 304
(Byzantine) at Fustat 250
Italian, French and Spanish merchants 137, 138
mitata 260

trade, Byzantine silk (*continued*)
 monopoly, Imperial 232
 names 291
 pratikia 278
 revenue from trade 178
 Rhine Maas trade arteries 208
 routes 120
 early mediæval 139
 Russian traders 261
 sale of Byzantine silks abroad 308
 sales tax of 10% 262
 seals of kommerciarioi 122, 274, 277
 secrets 286
 silk, trade and politics 135
 slaves lost on Byzantine territory 239
 spices and culinary herbs 138
 state-controlled fairs 262
 surveillance over export of silk goods
 202
 taxes
 at Aleppo in the tenth century
 141, 160, 240
 at border and commercial frontiers
 278
 import, export, sales and purchase
 239
 taxation systems in Byzantium 176
 on raw silk sales 127, 260
 stamped by the Eparch 169
 trading quarters in
 Constantinople 239
 transactions settled in silk 308
 treaties with the Russ and the
 Bulgars 141
treasures of the Hungarian chapel 221
treasuries with silks in the Rhine-
 Maaslands 105
treaty with the Fatimid Caliph of Egypt,
 1001 160
trees, mulberry *see* sericulture
Trebizond 138, 262, 279
Turco-Sogdian embassy in Constantin-
 ople in 568 272
twills *see* grouping of silks
Tyre and Beirut, silk industry in 122

U

Umayyad house of southern Spain,
 caliphs of 87

uses of gold
 borders 299
 printed silks 88
 threads with silk cores 124
 weight of gold ornament in the cloth
 294
uses of silks
 appropriate for the Imperial
 cradle 233
 bed covers, Byzantine brocade 249
 cloaks and shirts 302
 clothing for the court 142, 298
 cloths 294
 cloths covered trolleys 233
 costume, elaborate 232
 curtains over gilded miniatures 46
 curtains, palatial silk 233
 cushions 142
 dress of provincial Byzantines 249
 ecclesiastical silks 45, 181, 208
 theca, bursa and marsupium 79
 females of the court of Charlemagne
 209
 for Arab armies 234
 for caparison of horses' hindquarters
 294
 for caps 345
 for currency 308
 furnishing fabric 45, 293
 garments, made up 287
 head scarf, female 344
 in Byzantine and the Latin Church
 135
 in churches, over doors, on altars,
 around ciboria etc. 142
 in Western society 135
 leggings 294
 leggings, hornet designs on second
 quality 234
 leggings with eagle motifs 234
 military tunics 209, 294
 pallia Graeca 166
 processions, Imperial silken 209
 pulpits covers 142
 purses 79
 raised throne platform covers 233
 range of silks available to the public
 301
 relic wrappings 45
 reliquary pouch, smallest surviving
 337
 reliquary pouches 79

uses of silks (*continued*)
 ribbons 30
 robe with black, broad stripes 294
 sails 239
 seal pouches 46
 sheets, Imperial 209
 shoes 46
Utrecht 208

V

Venetians
 mercenaries in the Byzantine army 239
 merchant marine in Byzantine
 waters 239
 merchants carrying prohibited silks 240
 selling precious cloths at special
 fairs 240
vestments at St. Servatius, Maastricht 5
victory of the Emperor Manuel I over
 the Serbs 235
Vladimir of Kiev in 989 239

W

weaving types *see* grouping of silks
Western military and naval aid 135
wool weavers 302
worms *see* sericulture, worms
Wu Tei (d. 945) 273

X

Xanten 105

Y

yarn *see also* sericulture
 degummed 124
 plied or twisted 289
 processing 124, 285, 289, 295, 319
 tension 285
 thickness 295
York
 Coppergate silk (651) 341
 Coppergate site 337
 Coppergate, Viking dig 79

Z

Zeuxippos bath *see* Constantinople

Acknowledgements

The papers printed in this book first appeared in the following works and are used here with permission.

I *Overdruk vit Publications de la Société Historique et Archéologique dans le Limbourg*, 6, Maastricht, 1974
II *Journal of the Walters Art Gallery* 26, Baltimore. Maryland, USA, 1978
III *"Medieval Art and Architecture at Canterbury before 1220", ed. N. Coldstream and P. Draper, British Archaeological Association Conference Proceedings*, London, 1982
IV *Jahrbuch der Österreichischen Byzantinistik*, 34, Wien, 1984
V *St. Cuthbert, his cult and his commmunity to AD 1200*, Woodbridge, 1989
VI *"Medieval Textiles, particularly in the Meuse-Rhine Area", Proceedings of the First Euregio Congress*, Alden Biesen, 1989
VII *Ancient and Medieval Textiles, Studies in honour of Donald King, Textile History*, (special edition ed. L. Monnas and H. Grainger-Taylor), 20, Pasold Foundation, 1989
VIII *"Textiles in Trade", Proceedings of the Second Biennial Symposium of the Textile Society of America*, Washington, 1990
IX *"Medieval Textiles, particularly in the Meuse-Rhine Area", Proceedings of the Second Euregio Congress*, Alden Biesen, 1991, pp. 100-120
X *"Byzantine Diplomacy", papers from the Twenty-fourth Spring Symposium of Byzantine Studies*, Cambridge, UK, March 1990, London, 1992
XI *Journal of Byzantine and Modern Greek Studies*, 15, Birmingham UK, 1991
XII *"Byzanz und das Abendland im 10. und 11. Jahrhundert", International Symposium for Greek/German Co-operation*, Cologne and Bad Gandesheim, 1991 (under publication)

XIII *"Medieval Textiles, particularly in the Meuse-Rhine Area", Proceedings of the Third Euregio Congress*, Aachen, 1991 (under publication)

XIV *"Textiles in Daily Life", Proceedings of the Third Biennial Symposium of the Textile Society of America*, Seattle, 1992

XV *Bulletin of Judæo-Greek Studies*, 10, Cambridge UK, Summer 1992

XVI *Journal of Medieval History*, 19, nos. 1-2, Cambridge UK, March/June 1993

XVII *"Constantinople and its Hinterland", Proceedings of the 27th Spring Symposium of Byzantine Studies*, Oxford, March 1993 (under publication)

XVIII *Interim Bulletin of the York Archæological Trust*, 6, no. 1, York, 1979

XIX *Anglo-Scandinavian finds from Lloyds Bank, Pavement, and other sites. The Archæology of York: the Small Finds*, ed. A. MacGregor, York, 1982

XX *Jahrbuch der Österreichischen Byzantinistik*, 37, Wien, 1987

List of Plates

(Photographs by Michael Brandon-Jones, University of East Anglia)

1 Byzantine and Islamic Weaving Types before 1200 AD

2 Maastricht, St. Servatius inv. 7-2. 'Antinoe' foliate silk

3 Maastricht, St. Servatius inv. 24. 'Dioscurides' silk

4 Maastricht, St. Servatius. Copy of 'Dioscurides' silk by Eugen Vogelsang

5 Maastricht, St. Servatius inv. 1. 'Amazon' silk

6 Säkkingen, St. Fridolins. Amazon silk

7 Maastricht, St. Servatius inv. 4-2. Small birds in star motifs

8 Maastricht, St. Servatius inv. 7-1. Paired lions in 'toothed' medallions

9 Sens, Cathedral Treasury. Paired lions in 'toothed' medallions

10 Maastricht, St. Servatius inv. 2. Lion silk.

11 Cologne, Diocesan Museum. Imperial Byzantine Lion silk from shrine of St. Heribert, Cologne

12 Maastricht, St. Servatius inv. 25. Diamond lattice with foliate motifs

13 Maastricht, St. Servatius inv. 4-8. Lions in medallions

14 Maastricht, St. Servatius inv. 4-4. Lion and bird, with tree form from which a snake's head emerges

15 Maastricht, St. Servatius inv. 6-1. Bullocks in lobed medallions on diapered ground

16 Maastricht, St. Servatius inv. 9-5. 'Incised' geometric and foliate design

17 Maastricht, St. Servatius inv. 17-1. Geometric forms in horizontal bands

18 Maastricht, St. Servatius inv. 5-2. Head of figure, horns of cattle, medallion border

19 Maastricht, St. Servatius inv. 8-1. Reliquary pouch

20 Maastricht, St. Servatius inv. 23-1, 23-2, 23-3. Fragments with lions, birds, tree motif and kufic border

21 Maastricht, St. Servatius inv. 13. Lion seated, with kufic inscription across shoulder

22 Maastricht, St. Servatius inv. 19-1. Birds and lions. Quadrupeds and foliate motifs in horizontal borders

23 Baltimore, Walters Art Gallery. Mondsee Gospel Lectionary, Ms W8

24 Baltimore, Walters Art Gallery. Upper cover of the Mondsee Gospel Lectionary, Ms W8

25 Baltimore, Walters Art Gallery. Lower cover of the Mondsee Gospel Lectionary, Ms W8

26 Munich, Bayerisches Staatsbibliothek Clm 21585, Cim I 56. Life of St. Stephan from Weihenstephan: binding from front

27 Munich, Bayerisches Staatsbibliothek Clm 21585, Cim I 56. Life of St. Stephan from Weihenstephan: spine of binding from front

28 Nürnberg, Germanisches Nationalmuseum, Ms K. G. 1138. Codex Aureus of Echternach: metalwork cover

29 Nürnberg, Germanisches Nationalmuseum, Ms K. G. 1138. Codex Aureus of Echternach: worn silk spine

30 Baltimore, Walters Art Gallery: Mondsee Gospel Lectionary. Woven silk spine with 'incised' geometric and foliate motifs

31 Bamberg, Cathedral Treasury. 'Cunigunde' mantel

32 Bamberg, Cathedral Treasury. Chasuble of Pope Clement II (d. 1047). 'Incised' geometric and foliate design

33a Canterbury, Cathedral Treasury. Chasuble of Archbishop Hubert Walter. Birds in medallions and bands of 'kufic' script

33b Canterbury, Cathedral Treasury. Chasuble of Archbishop Hubert Walter. Detail

34a Canterbury, Cathedral Treasury. Chasuble of Archbishop Hubert Walter. 'Tunicle' fragment

34b Canterbury, Cathedral Treasury. Vestments of Archbishop Hubert Walter. Largest hemmed panel

34c Canterbury, Cathedral Treasury. Vestments of Archbishop Hubert Walter. Two smaller hemmed panels

35a Canterbury, Cathedral Treasury. Vestments of Archbishop Hubert Walter. Dalmatic silk. paired birds in medallions.

35b Canterbury, Cathedral Treasury. Vestments of Archbishop Hubert Walter. Dalmatic silk, detail

36a Canterbury, Cathedral Treasury. Vestments of Archbishop Hubert Walter. 'Kufic' ornament on largest hemmed panel

36b Canterbury, Cathedral Treasury. Vestments of Archbishop Hubert Walter. Buskin: birds and forms in diamond lattice

36c Canterbury, Cathedral Treasury. Vestments of Archbishop Hubert Walter. Buskin: detail of embroidery

37a Canterbury, Cathedral Treasury. Shoe of Archbishop Hubert Walter

37b Canterbury, Cathedral Treasury. Shoe of Archbishop Hubert Walter (detail)

38a Canterbury, Cathedral Treasury. Vestments of Archbishop Hubert Walter. Amice apparel: birds and figures in medallions

38b Canterbury, Cathedral Treasury. Vestments of Archbishop Hubert Walter. Stole: detail of embroidery

38c Canterbury, Cathedral Treasury. Mitre of Archbishop Hubert Walter

38d Siegburg, St. Servatius. Fragments of lion silk. Photographed by A. Muthesius at Schloß Charlottenburg, Berlin in 1979

39a Siegburg, St. Servatius. Photograph published by Migneon in 1908

39b Berlin, Kunstgewerbemuseum, Schloß Charlottenburg. Unpublished watercolour drawing of Siegburg lion silk, 1881

40 Berlin, Kunstgewerbemuseum, Schloß Charlottenburg. Imperial lion silk fragments with inscription

41 Düsseldorf, Kunstmuseum. Imperial lion silk fragments with inscription

42 Cologne, Diocesan Museum. Imperial lion silk with detail of the woven inscription

43 Krefeld, Kunstgewerbemuseum (now lost). Watercolour by P. Schulze, 1893. lion silk with imperial inscription

44 Maastricht, St. Servatius. Inv 2. Lion silk (detail)

45 Aachen, Munster Treasury. Imperial Byzantine elephant silk

46 Aachen, Munster Treasury. Imperial Byzantine elephant silk: detail

47a Aachen, Munster Treasury. Imperial Byzantine elephant silk. Obverse view of more complete of two inscriptions

47b Aachen, Munster Treasury. Imperial Byzantine elephant silk. Reverse view of second (less complete) of the two inscriptions

48 Durham Cathedral, Monks' Dormitory. Rider silk

49 Durham Cathedral, Monks' Dormitory. Rider silk (detail)

50 Durham Cathedral, Monks' Dormitory. Peacock silk

51 Durham Cathedral, Monks' Dormitory. Peacock silk (detail)

52 London, British Museum. Central Asian Hunter silk

53 The Three Stages from Seed to Samite

54 Stage One further defined: Production of the raw material

55 Stage Two further defined: Manufacture of the silks

56 Further definition of Stages II and III: Organisation and Marketing

57 Distribution of Eastern silks in the West before 1200 AD: The Main Centres (map)

58 Dating of different weaving types in the West from 300 to 1200 AD

59 Paris, Louvre 7502. Elephant silk from St. Josse

60 Aachen Munster treasury. Charioteer silk

61 Liege, Diocesan Museum. Griffin silk from St. Trond

62 Le Monastier, St. Chaffre. Griffin silk

63 Computer Screen from pictorial database of Byzantine silks

64 Lyons, Textile Museum. Imperial Byzantine Hunter silk from Mozac

65 Aachen Munster Treasury inv. 010603. Hunter silk

66 Aachen Munster Treasury inv. 010602. Silk with palmettes

67 Aachen Munster Treasury inv. 010608. Silk with bird motif

68 Aachen Munster Treasury inv. 010610. Silk with three small birds

69 Aachen Munster Treasury inv. 010609. Silk with duck motifs

70 Aachen Munster Treasury inv. 010620. Silk with hares

71 Aachen Munster Treasury inv. 010616. Silk with bicephal lion motifs

72 Aachen Munster Treasury inv. 010613. Bird silk

73 Aachen Munster Treasury (unnumbered). Dragon silk

74 Aachen Munster Treasury Inv. 010622. Foliate design and Kufic inscription

75 Vienna National Library, Cod. Hist. gr. 53. Portrait of Emperor Alexius V, c. 1204 AD

76 Brixen Cathedral. Imperial Byzantine eagle silk

77 Durham Cathedral, Monks' Dormitory. So-called 'nature goddess' silk

78 Bamberg Cathedral Treasury. Gunther tapestry

79 Milan, St. Ambrogio. Hunter silk

80 Auxerre Cathedral. Imperial Byzantine eagle silk

81 Sitten Cathedral Treasury. Griffin silk

82 Beromünster Parish Church Treasury. Peacock silk

83 Mainz, Cathedral Treasury. Detail of one of two chasubles of Archbishop Willigis. Foliate motif in ogee (cf. Pl. 32)

84 Sens, Cathedral Treasury. Silk with scenes from the life of Joseph

85 Sens, Cathedral Treasury. Silk with scenes from the life of Joseph (detail)

86 London, Victoria and Albert Museum. Hunter silk of the "Zachariou and Joseph" group

87 Cologne, St. Cunibert. Hunter Silk

88 Silk from Brusa (Brusa)

Plates

1A WEFT FACED COMPOUND TABBY

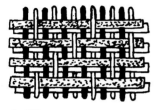

1B WEFT FACED COMPOUND TWILL
(SINGLE MAIN WARP)

1C WEFT FACED COMPOUND TWILL
(PAIRED MAIN WARP)

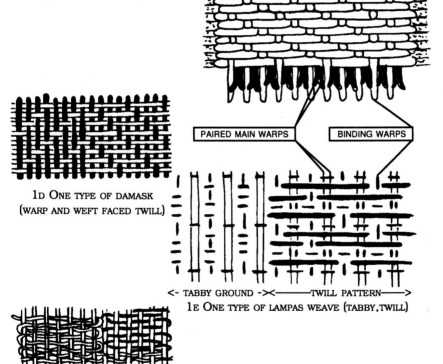

PAIRED MAIN WARPS BINDING WARPS

1D ONE TYPE OF DAMASK
(WARP AND WEFT FACED TWILL)

<- TABBY GROUND -><———TWILL PATTERN———>
1E ONE TYPE OF LAMPAS WEAVE (TABBY,TWILL)

1F TAPESTRY (SLIT)

BYZANTINE AND ISLAMIC WEAVING TYPES BEFORE 1200 AD

PLATE 1

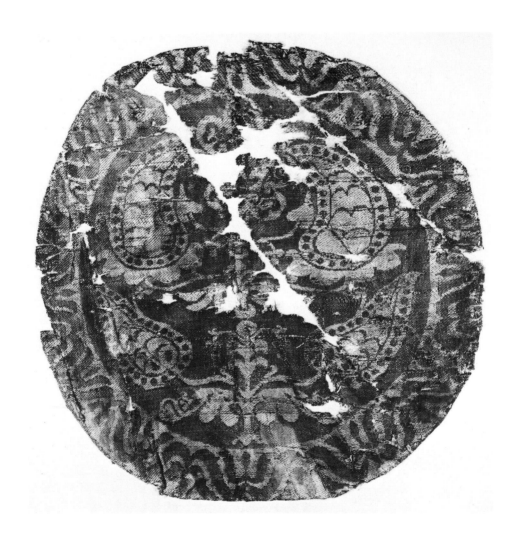

MAASTRICHT, ST. SERVATIUS INV. 7-2. 'ANTINOE' FOLIATE SILK

PLATE 2

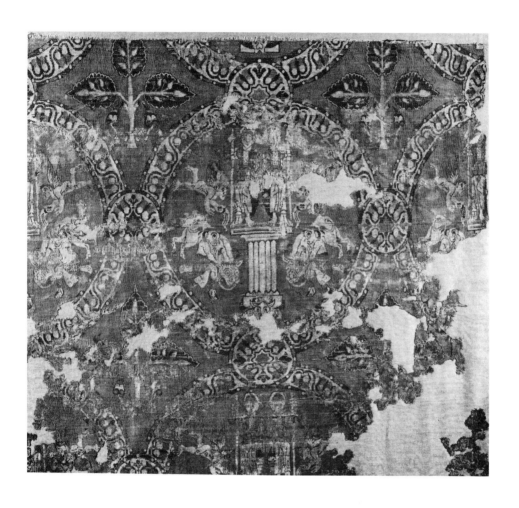

MAASTRICHT, ST. SERVATIUS INV. 24. 'DIOSCURIDES' SILK

PLATE 3

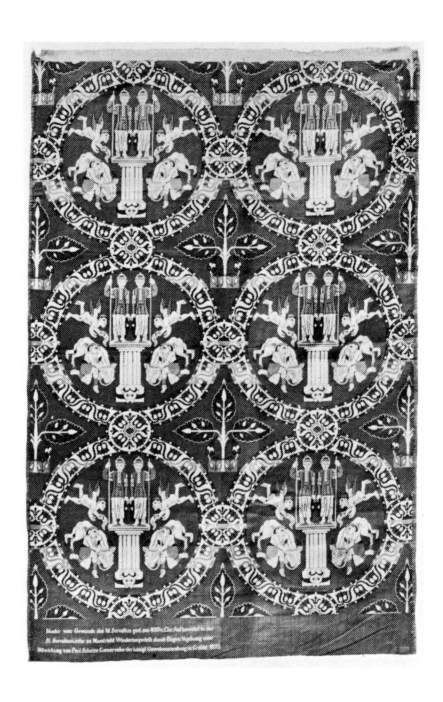

Made in Krefeld in 1895. Now in Metropolitan Museum, New York

MAASTRICHT, ST. SERVATIUS. COPY OF 'DIOSCURIDES' SILK BY EUGEN VOGELSANG

PLATE 4

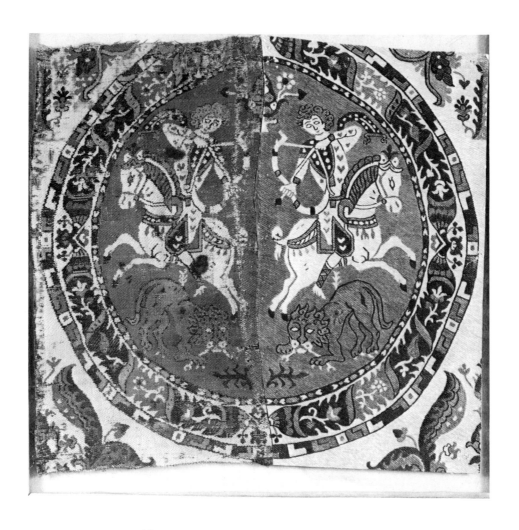

MAASTRICHT, ST. SERVATIUS INV. 1. 'AMAZON' SILK

PLATE 5

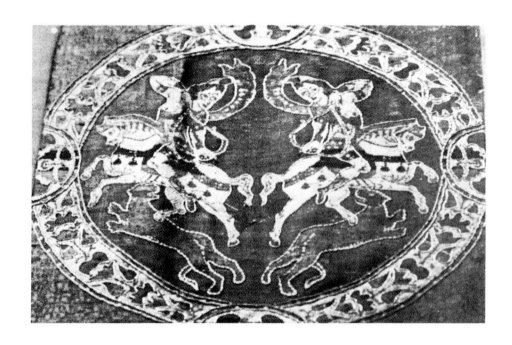

Säkkingen, St. Fridolins. Amazon silk

Plate 6

MAASTRICHT, ST. SERVATIUS INV. 4-2. SMALL BIRDS IN STAR MOTIFS

PLATE 7

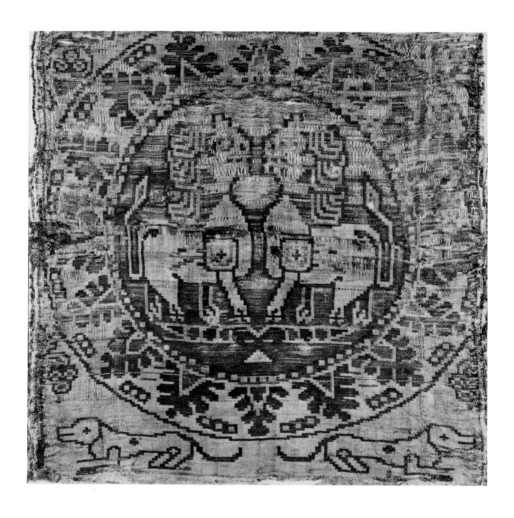

Maastricht, St. Servatius inv. 7-1. Paired lions in 'toothed' medallions

Plate 8

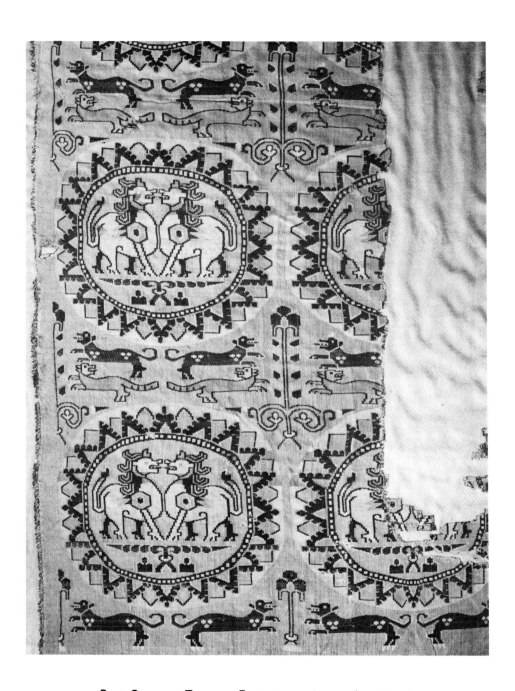

SENS, CATHEDRAL TREASURY. PAIRED LIONS IN 'TOOTHED' MEDALLIONS

PLATE 9

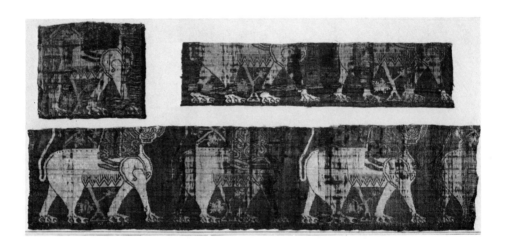

MAASTRICHT, ST. SERVATIUS INV. 2. LION SILK

PLATE 10

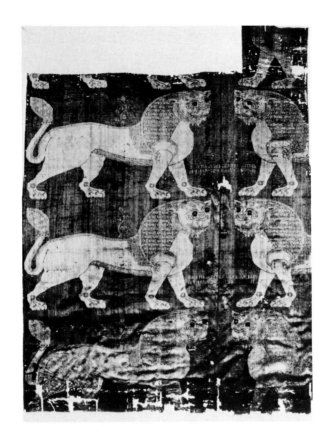

COLOGNE, DIOCESAN MUSEUM

IMPERIAL BYZANTINE LION SILK FROM SHRINE OF ST. HERIBERT, COLOGNE

PLATE 11

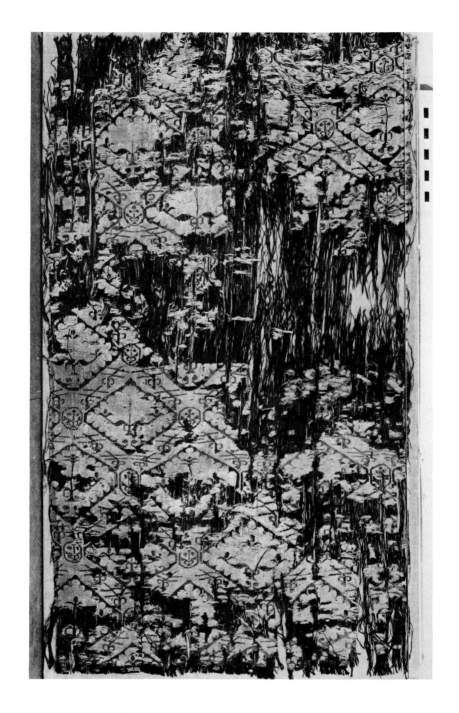

Maastricht, St. Servatius inv. 25. Diamond lattice with foliate motifs

Plate 12

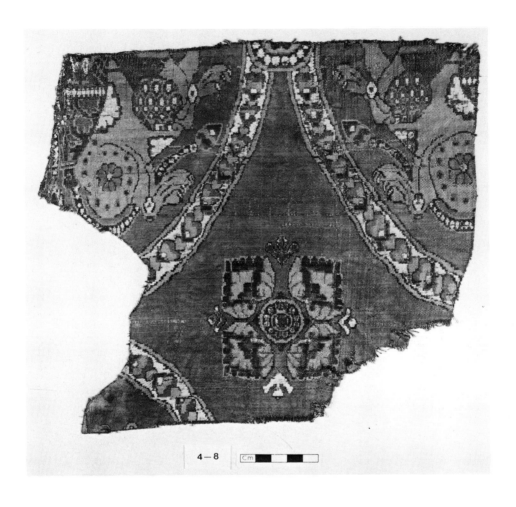

4 — 8

MAASTRICHT, ST. SERVATIUS INV. 4-8. LIONS IN MEDALLIONS

PLATE 13

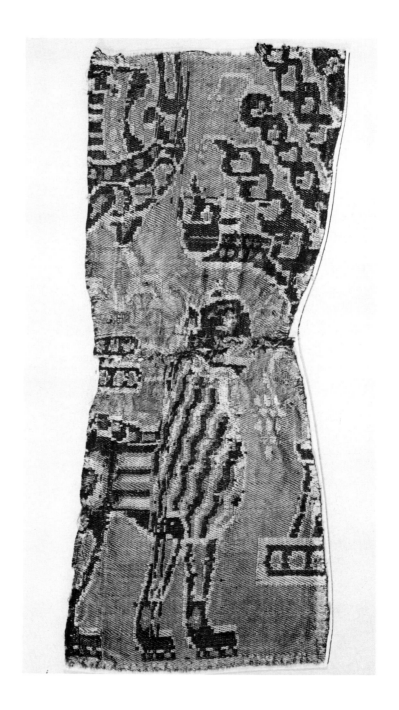

MAASTRICHT, ST. SERVATIUS INV. 4-4.
LION AND BIRD, TREE FORM FROM WHICH SNAKE'S HEAD EMERGES

PLATE 14

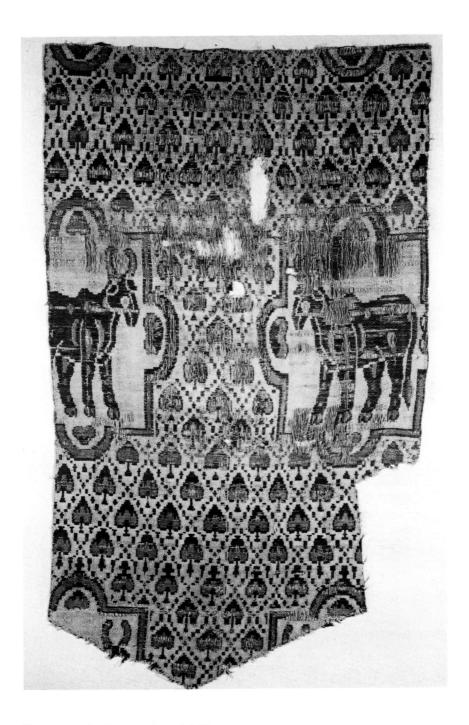

MAASTRICHT, ST. SERVATIUS INV. 6-1. BULLOCKS IN LOBED MEDALLIONS ON DIAPERED GROUND

PLATE 15

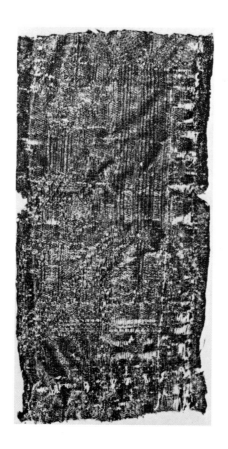

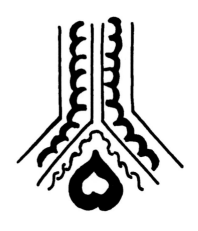

MAASTRICHT, ST. SERVATIUS INV. 9-5. 'INCISED' GEOMETRIC AND FOLIATE DESIGN

PLATE 16

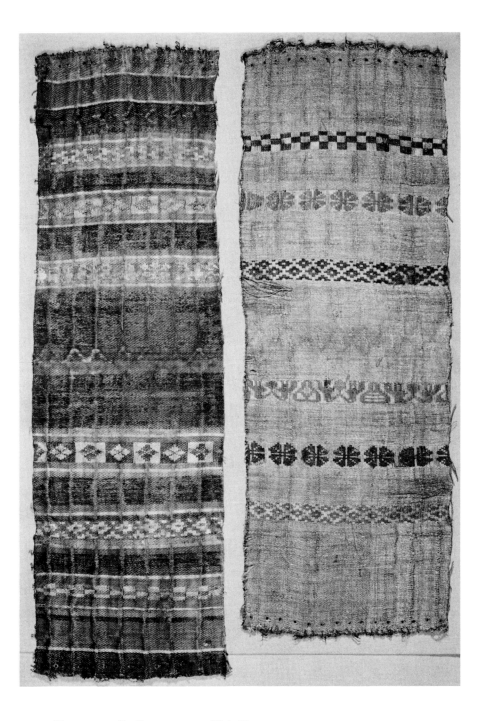

MAASTRICHT, ST. SERVATIUS INV. 17-1. GEOMETRIC FORMS IN HORIZONTAL BANDS

PLATE 17

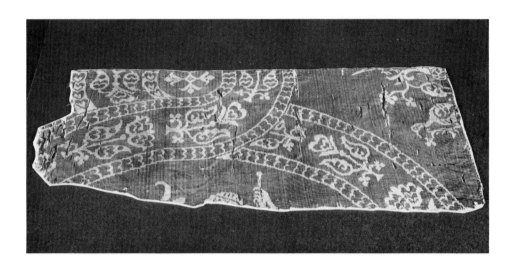

Maastricht, St. Servatius inv. 5-2. Head of figure, horns of cattle, medallion border

Plate 18

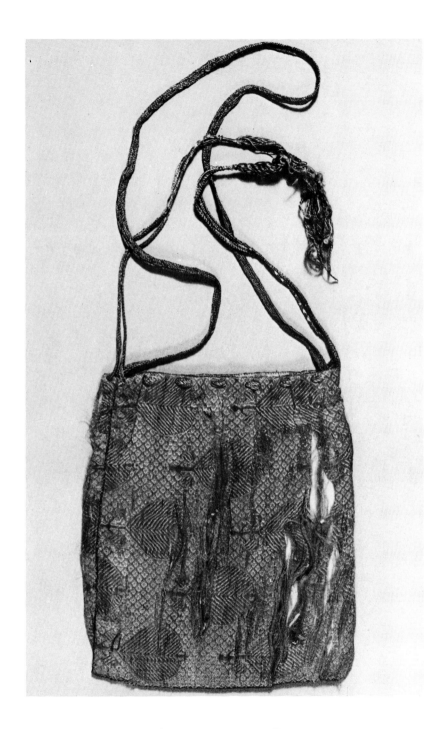

MAASTRICHT, ST. SERVATIUS INV. 8-1. RELIQUARY POUCH

PLATE 19

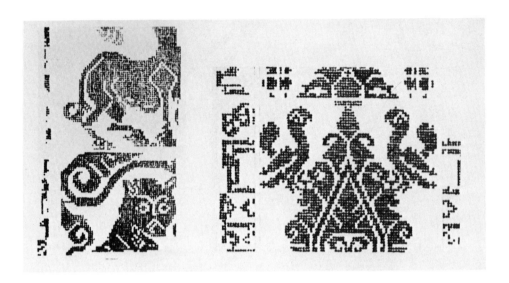

MAASTRICHT, ST. SERVATIUS INV. 23-1, 23-2, 23-3
FRAGMENTS WITH LIONS, BIRDS, TREE MOTIF AND KUFIC BORDER

PLATE 20

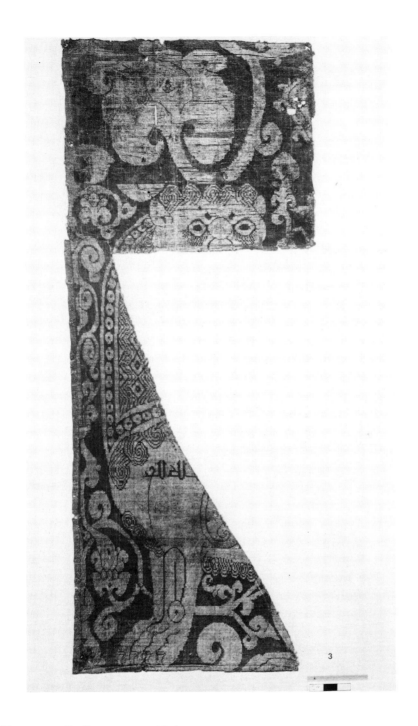

MAASTRICHT, ST. SERVATIUS INV. 13. LION SEATED, WITH KUFIC INSCRIPTION ACROSS SHOULDER

PLATE 21

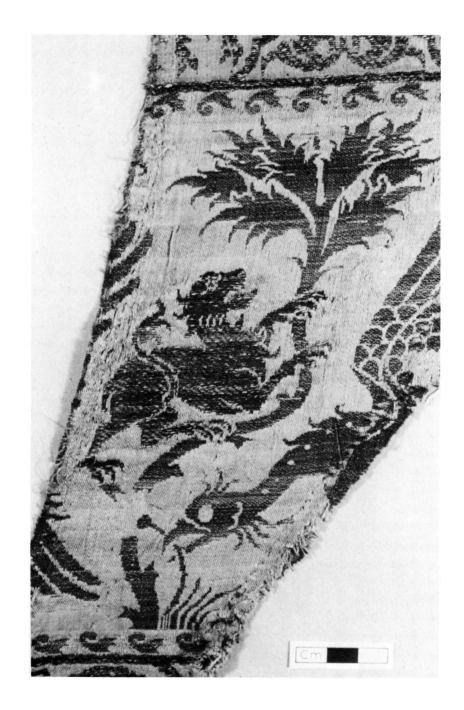

MAASTRICHT, ST. SERVATIUS INV. 19-1
BIRDS AND LIONS. QUADRUPEDS AND FOLIATE MOTIFS IN HORIZONTAL BORDERS

PLATE 22

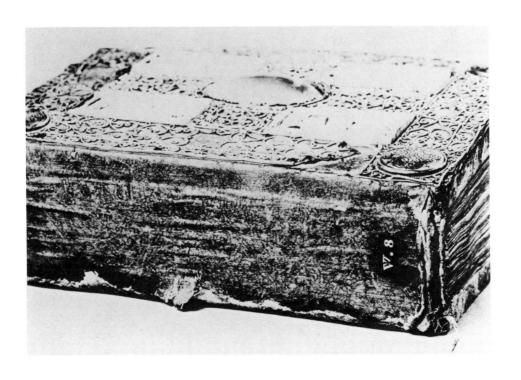

BALTIMORE, WALTERS ART GALLERY. MONDSEE GOSPEL LECTIONARY, MS W8

PLATE 23

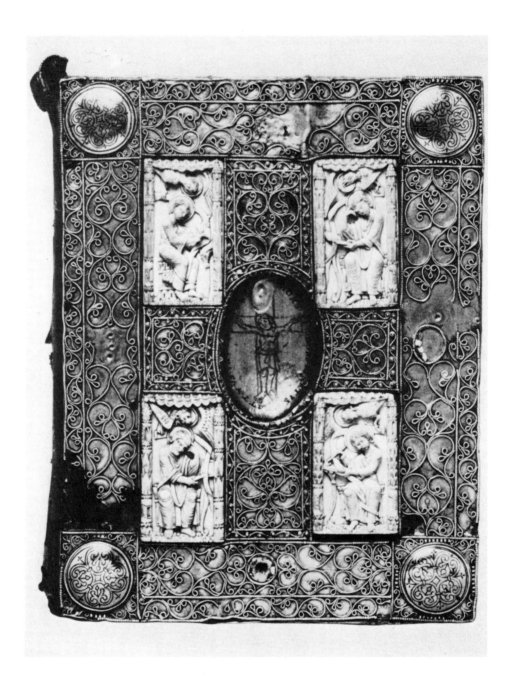

BALTIMORE, WALTERS ART GALLERY. UPPER COVER, MONDSEE GOSPEL LECTIONARY, MS W8

PLATE 24

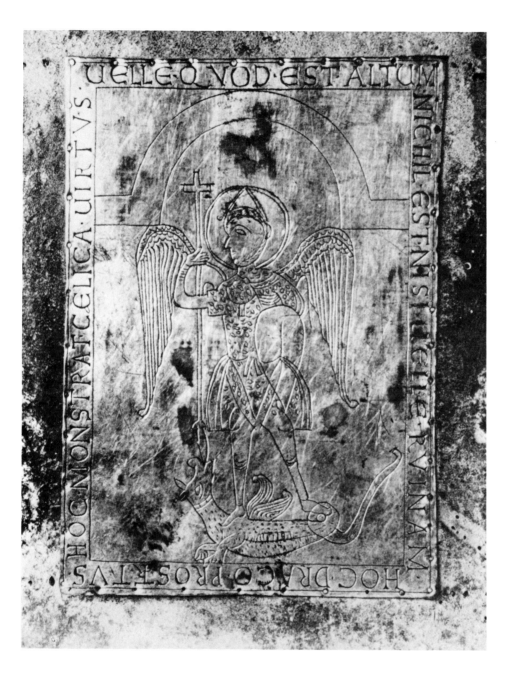

BALTIMORE, WALTERS ART GALLERY. LOWER COVER, MONDSEE GOSPEL LECTIONARY, MS W8

PLATE 25

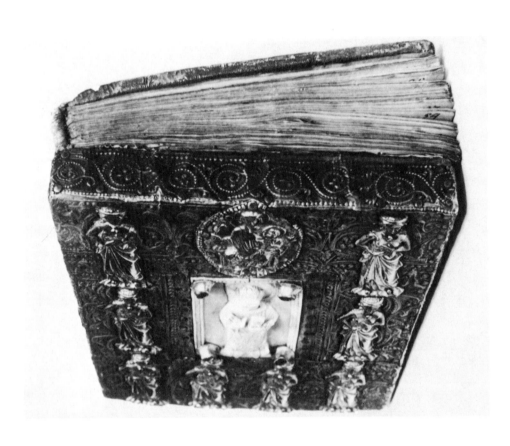

MUNICH, BAYERISCHES STAATSBIBLIOTHEK CLM 21585, CIM I 56
LIFE OF ST. STEPHAN FROM WEIHENSTEPHAN: BINDING FROM FRONT

PLATE 26

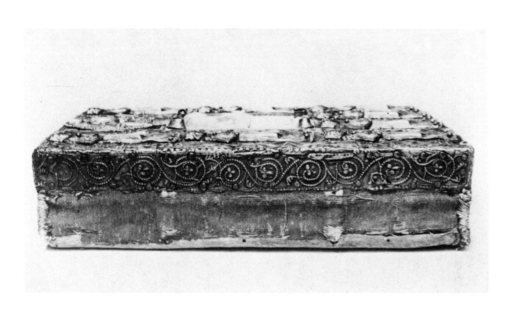

MUNICH, BAYERISCHES STAATSBIBLIOTHEK CLM 21585, CIM I 56
LIFE OF ST. STEPHAN FROM WEIHENSTEPHAN: SPINE OF BINDING FROM FRONT

PLATE 27

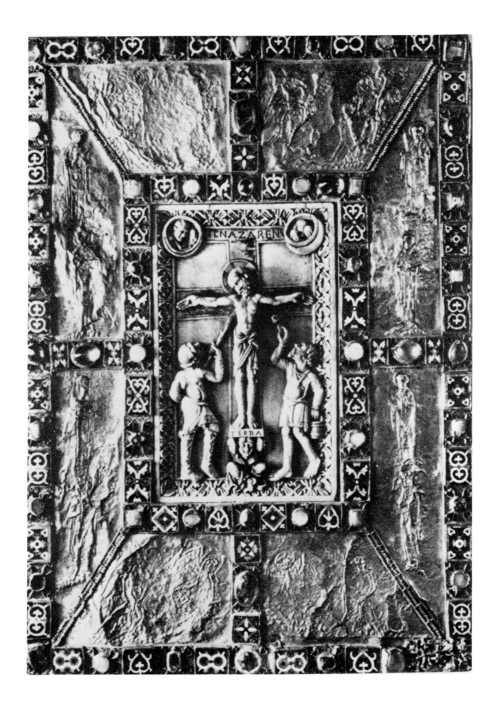

NÜRNBERG, GERMANISCHES NATIONALMUSEUM, MS K. G. 1138
CODEX AUREUS OF ECHTERNACH: METALWORK COVER

PLATE 28

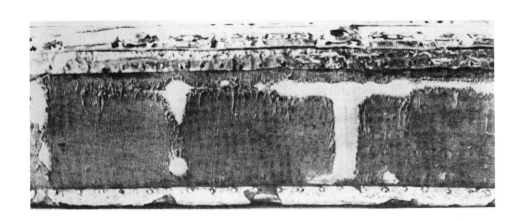

Nürnberg, Germanisches Nationalmuseum, Ms K. G. 1138
Codex Aureus of Echternach: worn silk spine

Plate 29

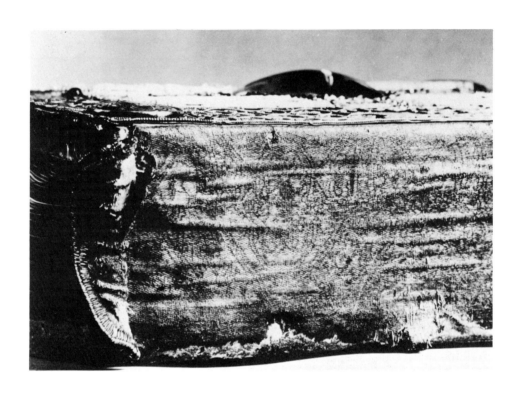

BALTIMORE, WALTERS ART GALLERY: MONDSEE GOSPEL LECTIONARY
WOVEN SILK SPINE WITH 'INCISED' GEOMETRIC AND FOLIATE MOTIFS

PLATE 30

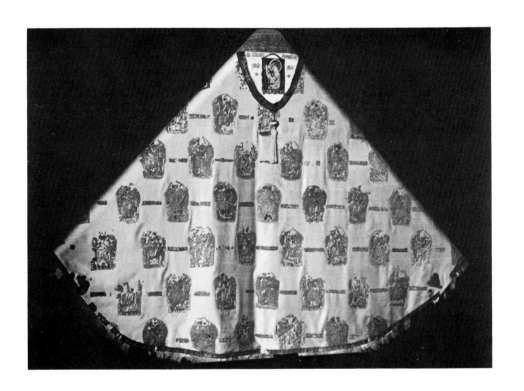

BAMBERG, CATHEDRAL TREASURY. 'CUNIGUNDE' MANTEL

PLATE 31

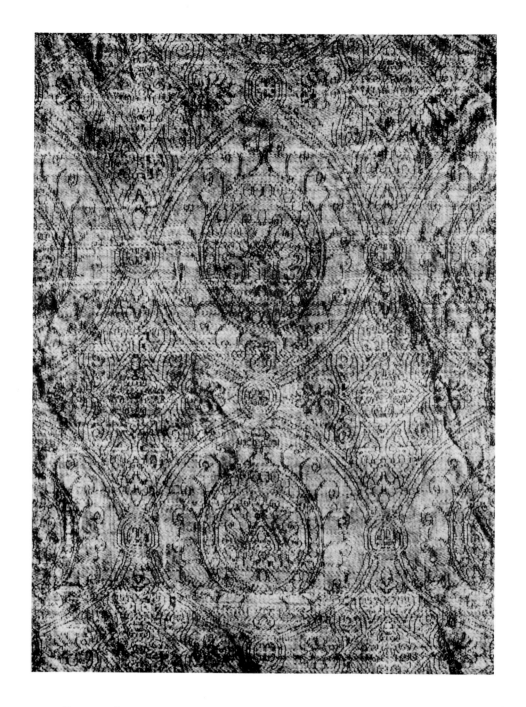

BAMBERG, CATHEDRAL TREASURY. CHASUBLE OF POPE CLEMENT II (D. 1047). 'INCISED'
GEOMETRIC AND FOLIATE DESIGN

PLATE 32

Canterbury, Cathedral Treasury. Chasuble of Archbishop Hubert Walter.
Birds in medallions and bands of 'kufic' script

Plate 33a

CANTERBURY, CATHEDRAL TREASURY. CHASUBLE OF ARCHBISHOP HUBERT WALTER. DETAIL

PLATE 33B

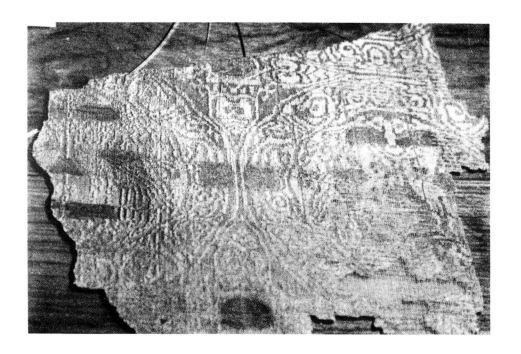

CANTERBURY, CATHEDRAL TREASURY
CHASUBLE OF ARCHBISHOP HUBERT WALTER. 'TUNICLE' FRAGMENT

PLATE 34A

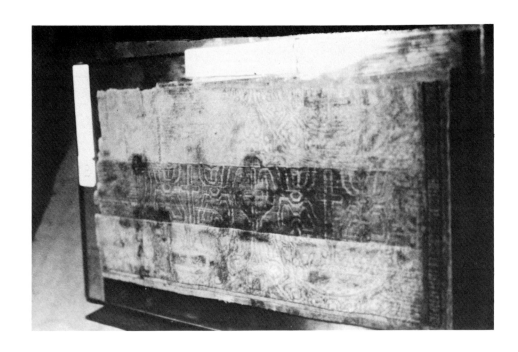

CANTERBURY, CATHEDRAL TREASURY
VESTMENTS OF ARCHBISHOP HUBERT WALTER. LARGEST HEMMED PANEL

PLATE 34B

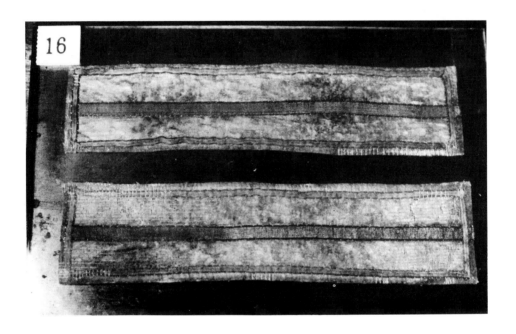

CANTERBURY, CATHEDRAL TREASURY
VESTMENTS OF ARCHBISHOP HUBERT WALTER. TWO SMALLER HEMMED PANELS

PLATE 34c

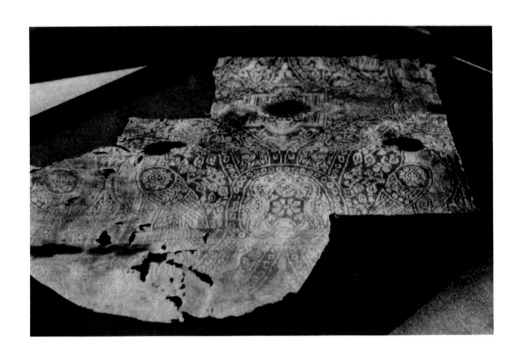

Canterbury, Cathedral Treasury
Vestments of Archbishop Hubert Walter. dalmatic silk. paired birds in medallions.

Plate 35a

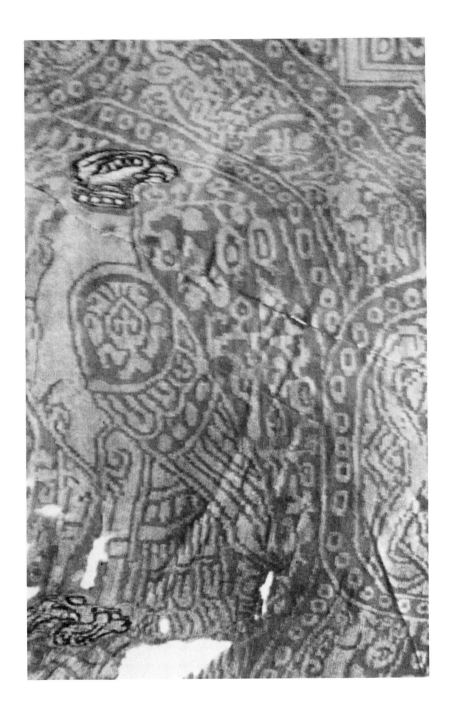

CANTERBURY, CATHEDRAL TREASURY
VESTMENTS OF ARCHBISHOP HUBERT WALTER. DALMATIC SILK, DETAIL

PLATE 35B

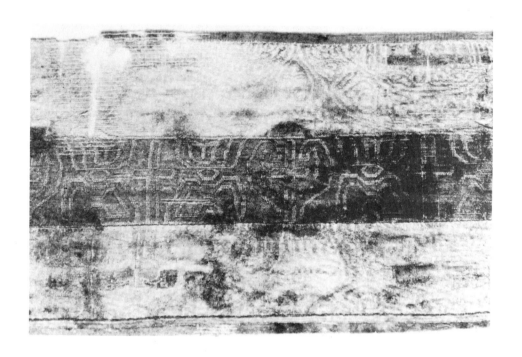

CANTERBURY, CATHEDRAL TREASURY
VESTMENTS OF ARCHBISHOP HUBERT WALTER. 'KUFIC' ORNAMENT ON LARGEST HEMMED PANEL

PLATE 36A

CANTERBURY, CATHEDRAL TREASURY
VESTMENTS OF ARCHBISHOP HUBERT WALTER. BUSKIN: BIRDS AND FORMS IN DIAMOND LATTICE

PLATE 36B

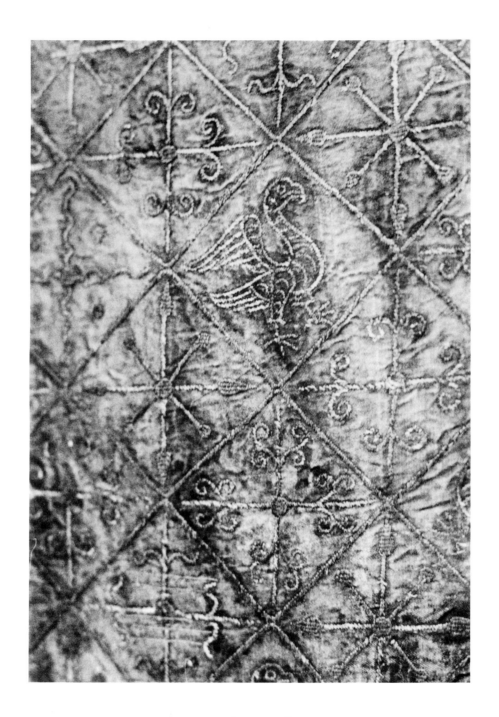

CANTERBURY, CATHEDRAL TREASURY
VESTMENTS OF ARCHBISHOP HUBERT WALTER. BUSKIN: DETAIL OF EMBROIDERY

PLATE 36c

CANTERBURY, CATHEDRAL TREASURY. SHOE OF ARCHBISHOP HUBERT WALTER

PLATE 37A

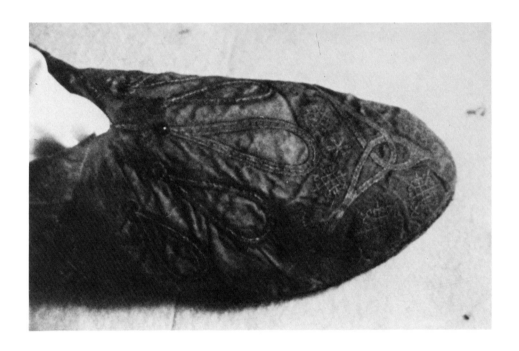

CANTERBURY, CATHEDRAL TREASURY. SHOE OF ARCHBISHOP HUBERT WALTER (DETAIL)

PLATE 37B

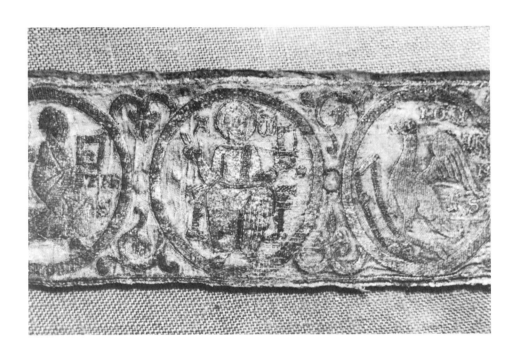

CANTERBURY, CATHEDRAL TREASURY
VESTMENTS OF ARCHBISHOP HUBERT WALTER. AMICE APPAREL: BIRDS AND FIGURES IN MEDALLIONS

PLATE 38A

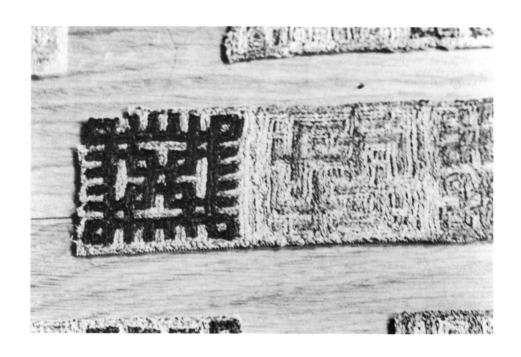

CANTERBURY, CATHEDRAL TREASURY
VESTMENTS OF ARCHBISHOP HUBERT WALTER. STOLE: DETAIL OF EMBROIDERY

PLATE 38B

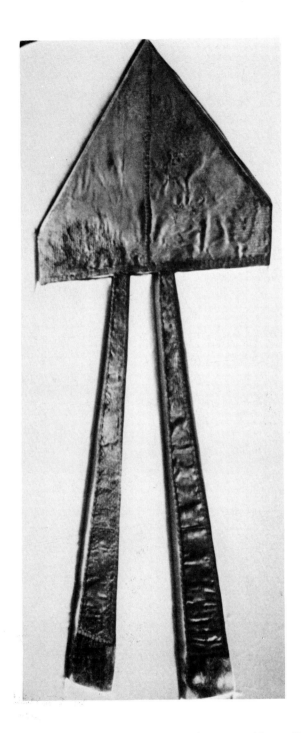

CANTERBURY, CATHEDRAL TREASURY. MITRE OF ARCHBISHOP HUBERT WALTER

PLATE 38C

Photographed as seen by A. Muthesius at Schloß Charlottenburg, Berlin, 1979

SIEGBURG, ST. SERVATIUS. FRAGMENTS OF LION SILK

PLATE 38D

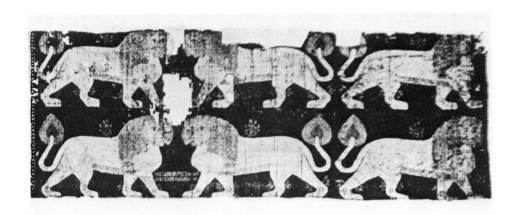

SIEGBURG, ST. SERVATIUS. PHOTOGRAPH PUBLISHED BY MIGNEON IN 1908

PLATE 39A

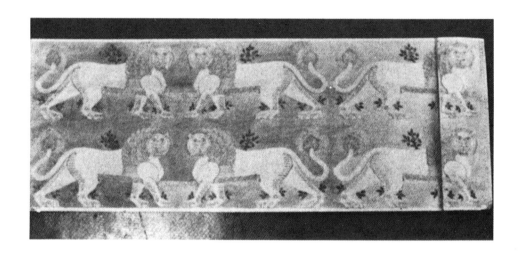

BERLIN, KUNSTGEWERBEMUSEUM, SCHLOß CHARLOTTENBURG
UNPUBLISHED WATERCOLOUR DRAWING OF SIEGBURG LION SILK, 1881

PLATE 39B

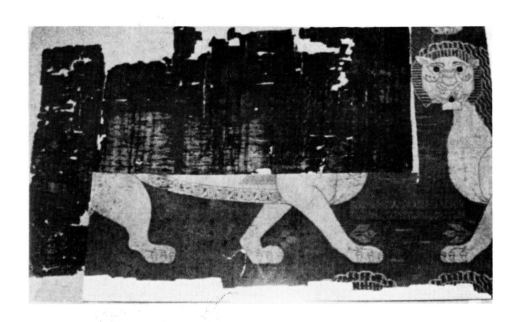

BERLIN, KUNSTGEWERBEMUSEUM, SCHLOß CHARLOTTENBURG
IMPERIAL LION SILK FRAGMENTS WITH INSCRIPTION

PLATE 40

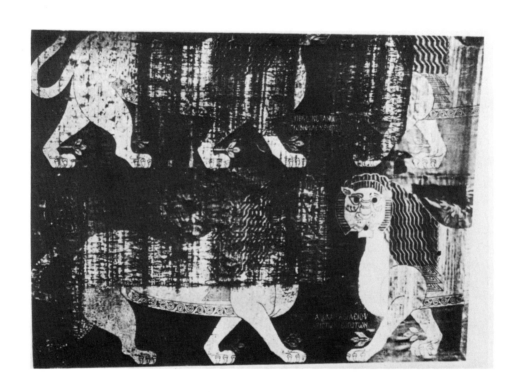

DÜSSELDORF, KUNSTMUSEUM. IMPERIAL LION SILK FRAGMENTS WITH INSCRIPTION

PLATE 41

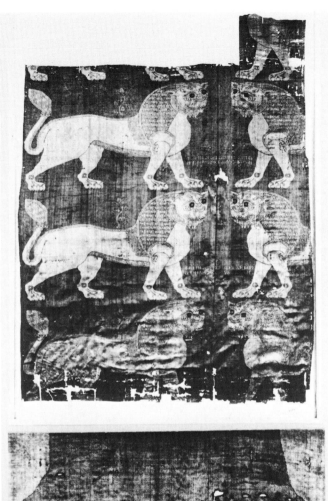

COLOGNE, DIOCESAN MUSEUM. IMPERIAL LION SILK WITH DETAIL OF THE WOVEN INSCRIPTION

PLATE 42

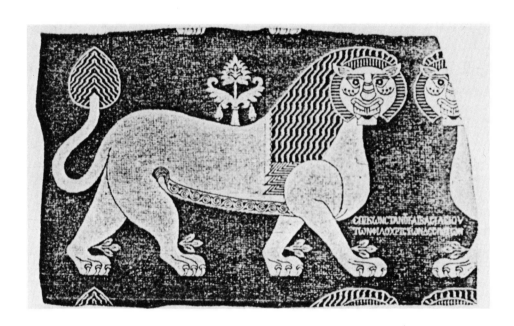

KREFELD, KUNSTGEWERBEMUSEUM
WATERCOLOUR BY P. SCHULZE, 1893. LION SILK WITH IMPERIAL INSCRIPTION (NOW LOST)

PLATE 43

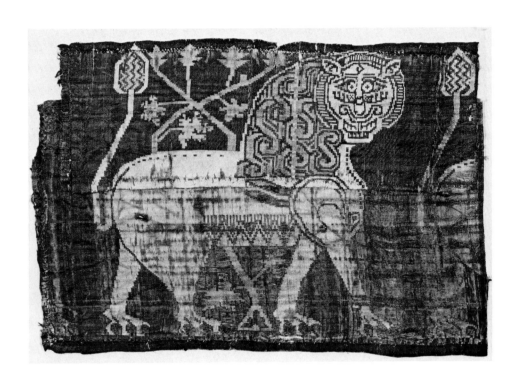

MAASTRICHT, ST. SERVATIUS. INV 2. LION SILK (DETAIL)

PLATE 44

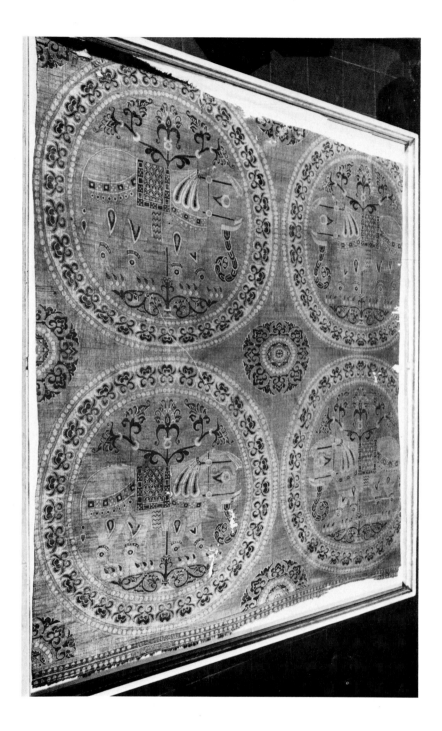

AACHEN, MUNSTER TREASURY. IMPERIAL BYZANTINE ELEPHANT SILK

PLATE 45

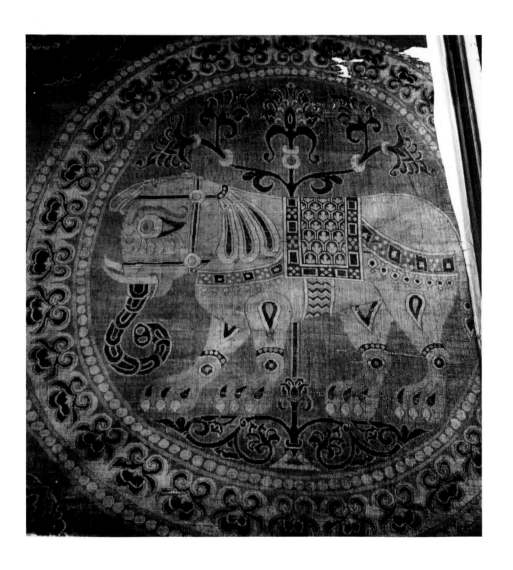

AACHEN, MUNSTER TREASURY. IMPERIAL BYZANTINE ELEPHANT SILK, DETAIL

PLATE 46

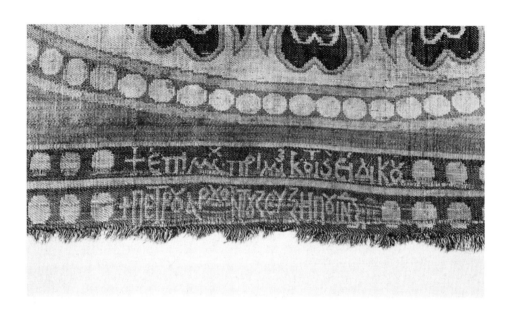

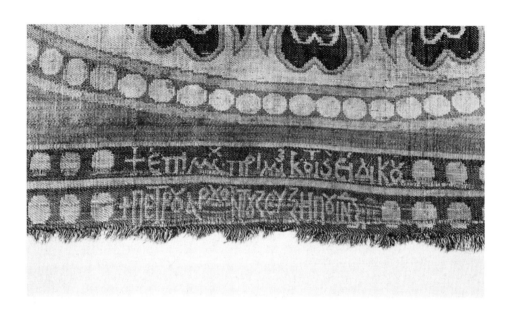

AACHEN, MUNSTER TREASURY
IMPERIAL BYZANTINE ELEPHANT SILK. OBVERSE VIEW OF MORE COMPLETE OF TWO INSCRIPTIONS

PLATE 47A

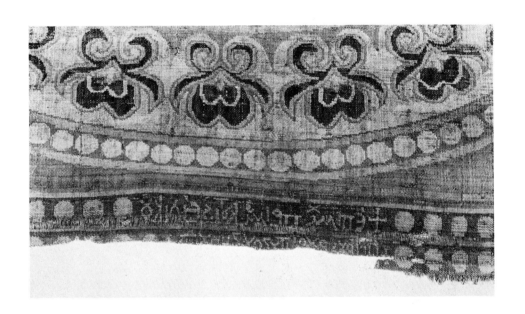

AACHEN, MUNSTER TREASURY. IMPERIAL BYZANTINE ELEPHANT SILK
REVERSE VIEW OF SECOND (LESS COMPLETE) OF THE TWO INSCRIPTIONS

PLATE 47B

Durham Cathedral, Monks' Dormitory. Rider silk

Plate 48

Durham Cathedral, Monks' Dormitory. Rider silk (detail)

Plate 49

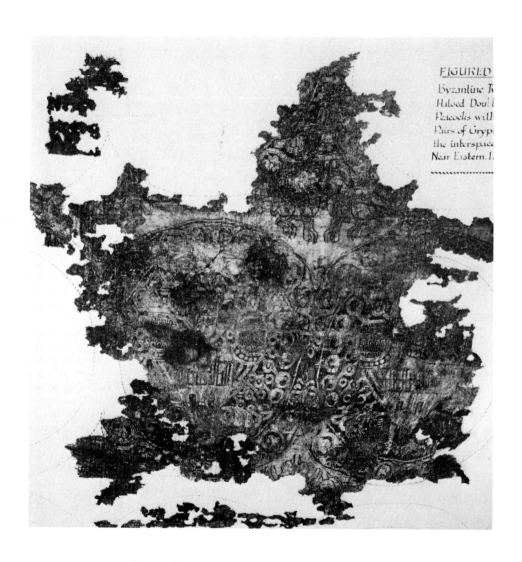

FIGURED
byzantine T...
Haloed Doul...
Peacocks with...
Pairs of Gryp...
the interspace...
Near Eastern. I...

DURHAM CATHEDRAL, MONKS' DORMITORY. PEACOCK SILK

PLATE 50

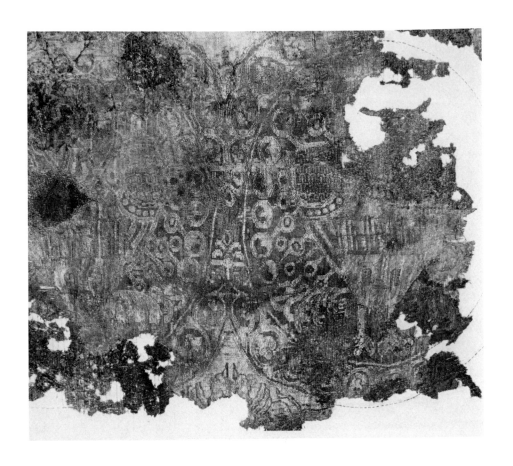

DURHAM CATHEDRAL, MONKS' DORMITORY. PEACOCK SILK (DETAIL)

PLATE 51

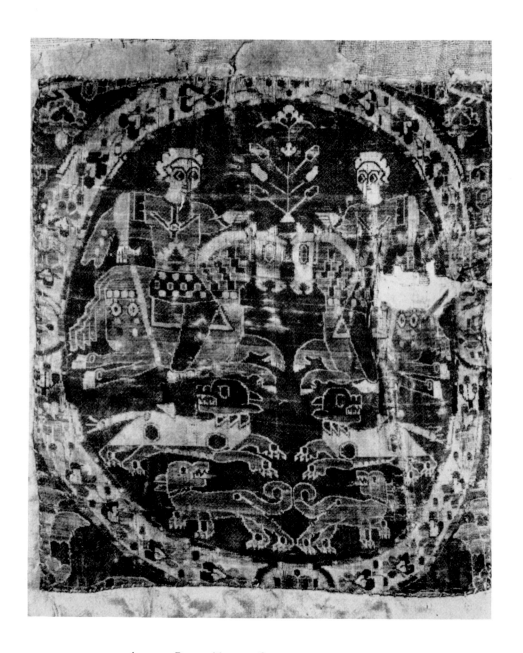

LONDON, BRITISH MUSEUM. CENTRAL ASIAN HUNTER SILK

PLATE 52

```
┌─────────────────────────────────────────────────────────────┐
│                          STAGE I                              │
│      PROCESSES ESSENTIAL TO THE SUPPLY OF THE RAW             │
│                        MATERIAL                               │
│                                                               │
│   Mulberry Cultivation                                        │
│   Silkworm Rearing                                            │
│   Processing of the cocoons into silk yarn                    │
│                                                               │
└─────────────────────────────────────────────────────────────┘
                              │
┌─────────────────────────────────────────────────────────────┐
│                         STAGE II                              │
│     ORGANISATION AND RUNNING OF THE SILK INDUSTRY:            │
│          GUILDS, WORKSHOPS AND LEGISLATION                    │
│                                                               │
│                      ORGANISATION                             │
│                                                               │
│   Organisation into guilds, imperial and non-imperial         │
│   Private Manufacture in the homes of wealthy individuals     │
│   Possibly silk weaving in some monasteries by nuns and monks │
│                                                               │
│                       LEGISLATION                             │
│                                                               │
│   Imperial legislation governed the running of both the       │
│   Imperial and the private silk industry                      │
│                                                               │
└─────────────────────────────────────────────────────────────┘
                              │
┌─────────────────────────────────────────────────────────────┐
│                         STAGE III                             │
│             MARKETING OF THE FINISHED SILKS                   │
│                                                               │
│   DOMESTIC MARKET supplying:                                  │
│        Imperial patrons                                       │
│        Secular patrons                                        │
│        Ecclesiastical patrons                                 │
│                                                               │
│   FOREIGN MARKET supplying the same three categories of       │
│   patrons                                                     │
│                                                               │
└─────────────────────────────────────────────────────────────┘
```

THE THREE STAGES FROM SEED TO SAMITE

PLATE 53

MULBERRY CULTIVATION

1 Propagation (after purchase of original stock)
2 Planting
3 Cultivation, tilling, weeding, manuring
4 Cropping, gathering leaves and cutting shoots
5 Pruning

DOMESTICATED SILKWORM REARING

Building of rearing house and acquisition for feeding etc.

Feeding of silkworms:
 Hatching to maturity, correct sizing of chopped leaf
 Adaptation of trays to suit growing silkworms
 Clearing of litter (waste products) after feeding

Cocoon production:

1 Setting up of spinning boards and mounting of the silkworms
2 Special humidity and temperature control. Protection of silkworms from excessive noise
3 Gathering of cocoons and dismantling of spinning boards
4 Grading and storing cocoons
5 Production and storing of seed by allowing some cocoons to be pierced by emerging moths which subsequently mate, allowing the female to lay seed

Yarn production:

6 Treatment of cocoons to produce yarn. Baking and reeling or spinning, requiring vat tenders, reelers and floss (waste silk) collectors
7 Degummers of hanks of raw silk
8 Dyers of raw silk
9 Silk throwsters, add twist to the warp yarns
10 Silk spinners, for non-filament yarn
11 Silk weighers and graders?
12 Preparers of silk core gold yarns

STAGE ONE FURTHER DEFINED: PRODUCTION OF THE RAW MATERIAL

PLATE 54

SEQUENCE OF SKILLS IN THE WORKSHOPS

1 Carpenters to build the looms

2 Pattern makers to design the silks

3 Workers to make a design prototype to be transferred to the loom, in India known as 'Naksha' makers

4 Workers who prepare the warp for the loom

5 Weavers. Probably responsible for tying up the loom in preparation for weaving. Different categories of weaving

6 Drawboys, who in conjunction with weavers, produce the patterned silks

7 Dyers of woven silks?

8 Embroiderers of woven silks. Use of silk, gold and pearls.

9 Printers of woven silks?

10 Tailors of silk garments

STAGE TWO FURTHER DEFINED: MANUFACTURE OF THE SILKS

PLATE 55

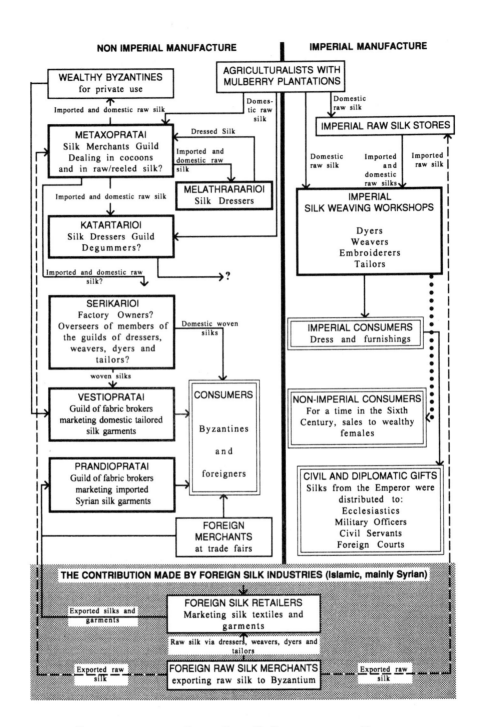

NON IMPERIAL MANUFACTURE IMPERIAL MANUFACTURE

FURTHER DEFINITION OF STAGES II AND III: ORGANISATION AND MARKETING

PLATE 56

NUMBERED LOCATIONS

1 Münster
2 Herford
3 Münsterbilsen
4 S. Trond
5 Maastricht
6 Namur
7 Nivelles
8 S. Amand
9 Houthem
10 Echternach
11 Zürich
12 Säkkingen
13 Weingarten
14 Diessen
15 Wessobrun
16 St. Gall
17 Augsburg
18 Freising
19 Mauern
20 Andechs

Verdun refers to:
 Abbey of S. Vanne

Cologne refers to these:
 Cathedral
 St. Cunibert
 St. Ursula
 St. George

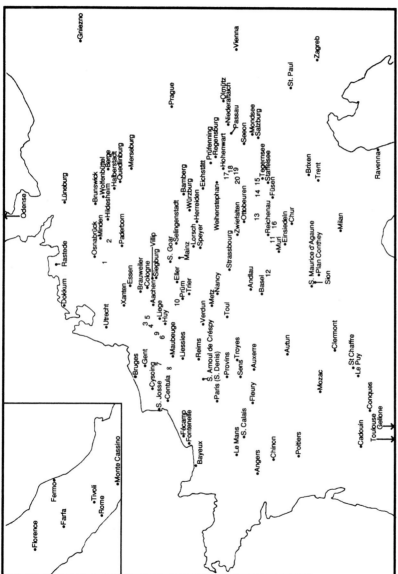

DISTRIBUTION OF EASTERN SILKS IN THE WEST BEFORE 1200 AD: THE MAIN CENTRES

PLATE 57

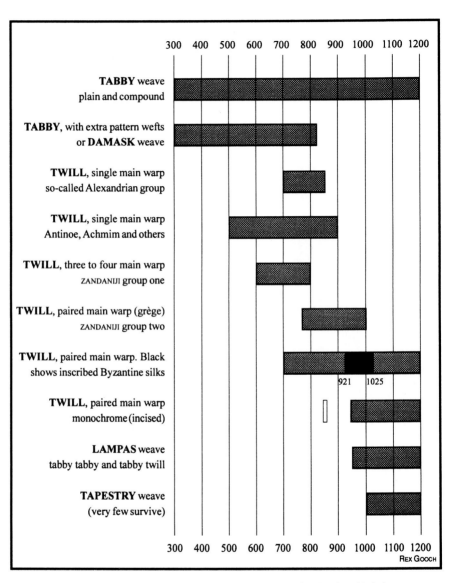

The white box represents the St. Rémi silk at Reims, which cannot be dated to the mid ninth century, as shown in this diagram, and as generally accepted.

DATING OF DIFFERENT WEAVING TYPES IN THE WEST FROM 300 TO 1200 AD

PLATE 58

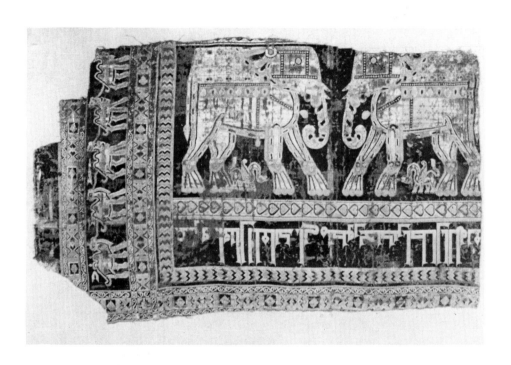

Paris, Louvre 7502. Elephant silk from St. Josse

Plate 59

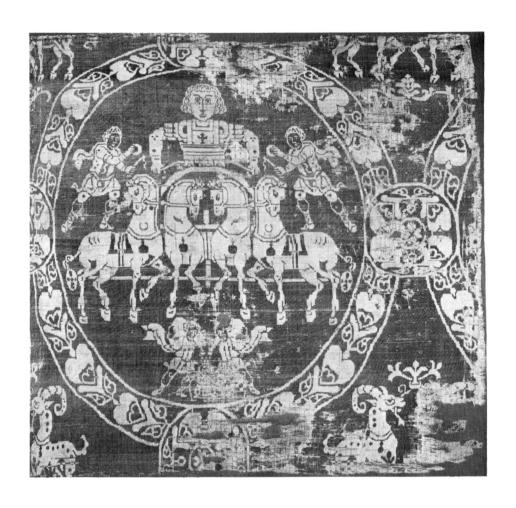

AACHEN MUNSTER TREASURY. CHARIOTEER SILK

PLATE 60

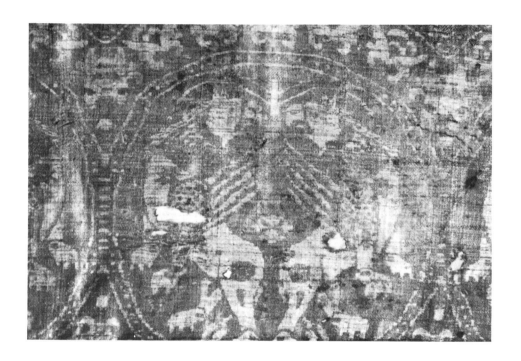

LIEGE, DIOCESAN MUSEUM. GRIFFIN SILK FROM ST. TROND

PLATE 61

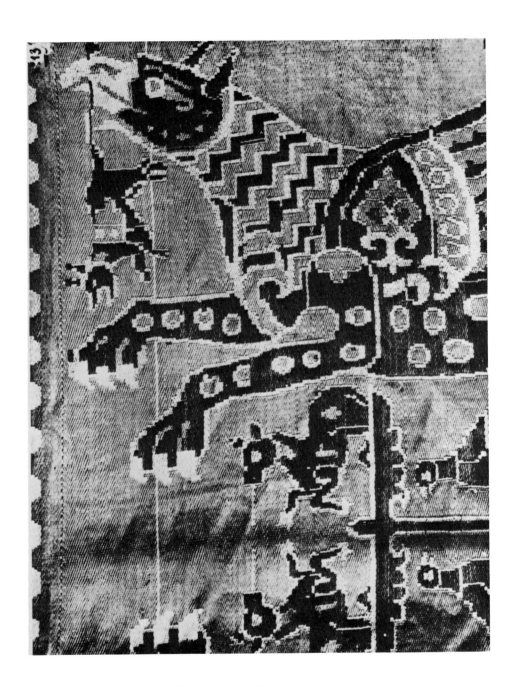

LE MONASTIER, ST. CHAFFRE. GRIFFIN SILK

PLATE 62

```
Cardbox-Plus  file = L:SILK.FIL                    READY
LEVEL 0 - RECORD 2 OF 11
     M34 C.i.34              LOCN: Lyons, Musée Historique des Tissus.
                             CAT:  904.III.3 (was 27.386)
                             ORGN: Silk from relics of St. Austremoine, at St.
                             Calmin, Mozac (Puy-de-Dome).
                             DIM:  73.5cm ht, 71cm max width. Medallion diam 88cm
                             Weave: 1\2, weft faced, twill
                             Warps: 1 binding, 1 main. Twisted Z.
                             Wefts: Deep-blue, red-brown, straw, light-blue.
                             Untwisted.
                             COND: Area of loss top right. Some surface weft worn.

                             PHOT: CIETA Bulletin 17 (1963) pl. 2 (colour)
                             DYES:
                             INSC:

DATE: 8th century. Byzantine.
DESC: Almost the whole of one medallion survives and it houses paired, facing
horses carrying two figures in Imperial, Byzantine costume, who plunge a spear
Enter command: -
  MAsk; SElect, INclude, EXclude, KEep; BAck, CLear; HIstory; FIlter; TAg; QUit
  ADd, DUplic, EDit, DELete, UNdelete; REad; SOrt; FOrmat, TEmplate; PRint, WRite
ENTRY:  ESC=erase  LIST: ↑=1st ↓=last ←=back →=fwd  TAB=tag  SCROLL: ←F1→ ↑F4↓
```

COMPUTER SCREEN FROM PICTORIAL DATABASE OF BYZANTINE SILKS

PLATE 63

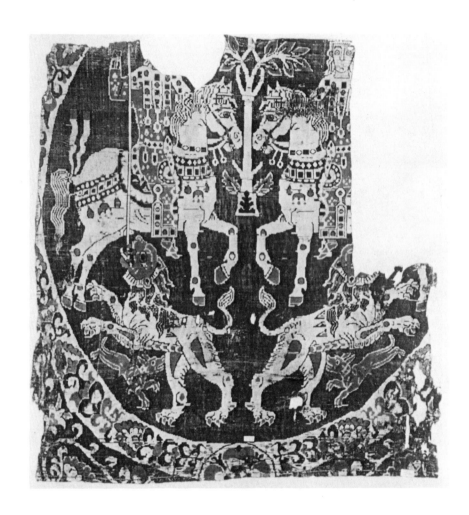

Lyons, Textile Museum. Imperial byzantine hunter silk from Mozac

Plate 64

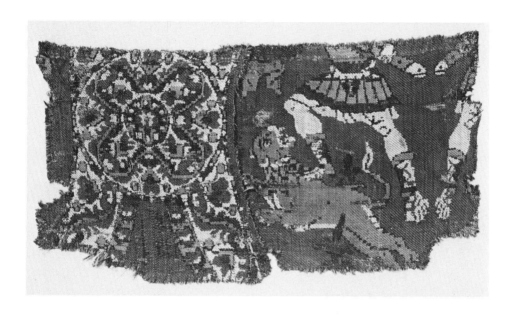

AACHEN MUNSTER TREASURY INV. 010603. HUNTER SILK

PLATE 65

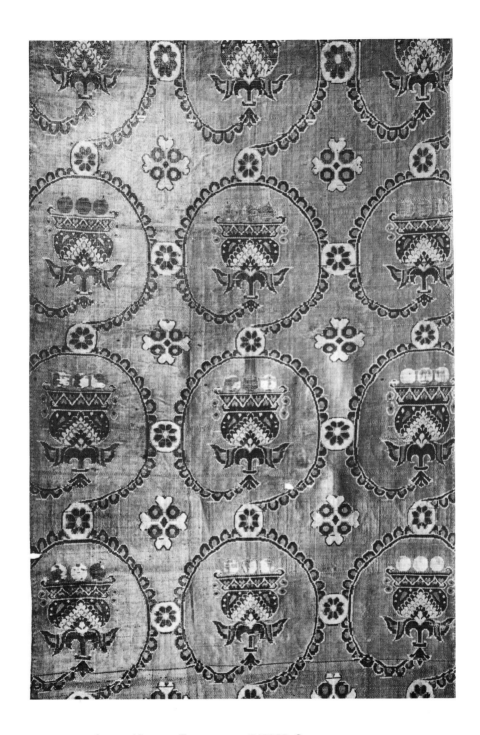

AACHEN MUNSTER TREASURY INV. 010602. SILK WITH PALMETTES

PLATE 66

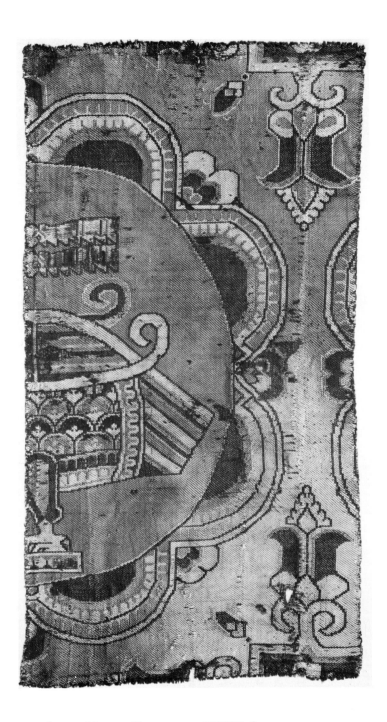

AACHEN MUNSTER TREASURY INV. 010608. SILK WITH BIRD MOTIF

PLATE 67

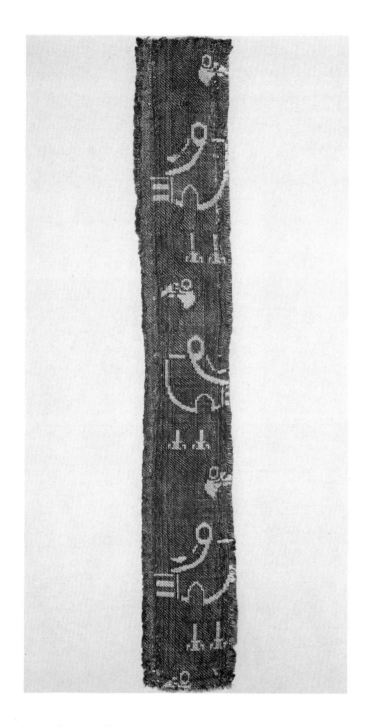

AACHEN MUNSTER TREASURY INV. 010610. SILK WITH THREE SMALL BIRDS

PLATE 68

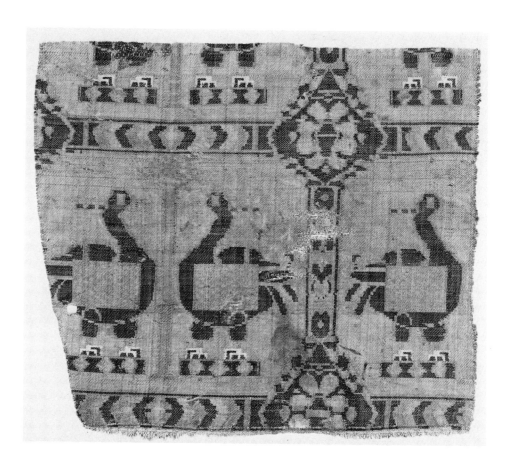

AACHEN MUNSTER TREASURY INV. 010609. SILK WITH DUCK MOTIFS

PLATE 69

AACHEN MUNSTER TREASURY INV. 010620. SILK WITH HARES

PLATE 70

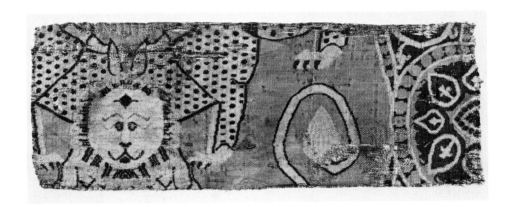

AACHEN MUNSTER TREASURY INV. 010616. SILK WITH BICEPHAL LION MOTIFS

PLATE 71

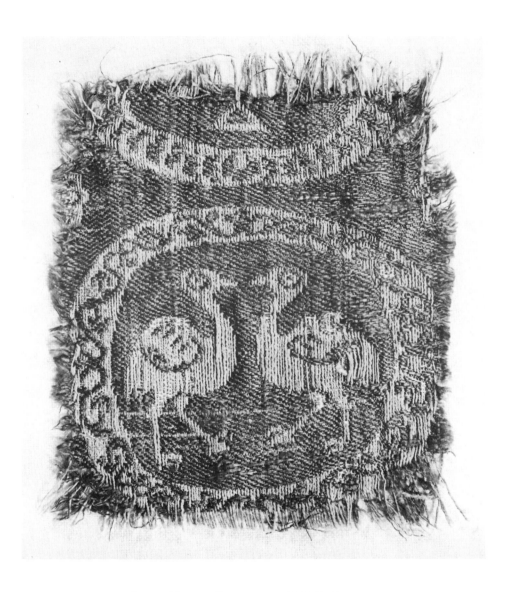

AACHEN MUNSTER TREASURY INV. 010613. BIRD SILK

PLATE 72

AACHEN MUNSTER TREASURY (UNNUMBERED). DRAGON SILK

PLATE 73

AACHEN MUNSTER TREASURY INV. 010622. FOLIATE DESIGN AND KUFIC INSCRIPTION

PLATE 74

VIENNA NATIONAL LIBRARY, COD. HIST. GR. 53. PORTRAIT OF EMPEROR ALEXIUS V, C. 1204 AD

PLATE 75

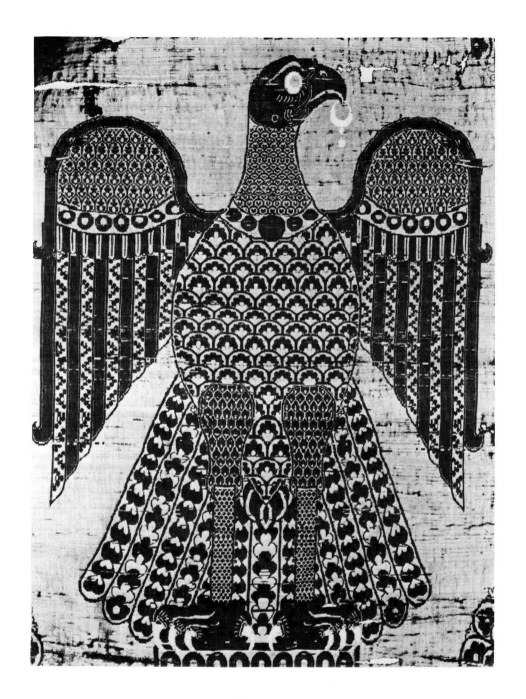

BRIXEN CATHEDRAL. IMPERIAL BYZANTINE EAGLE SILK

PLATE 76

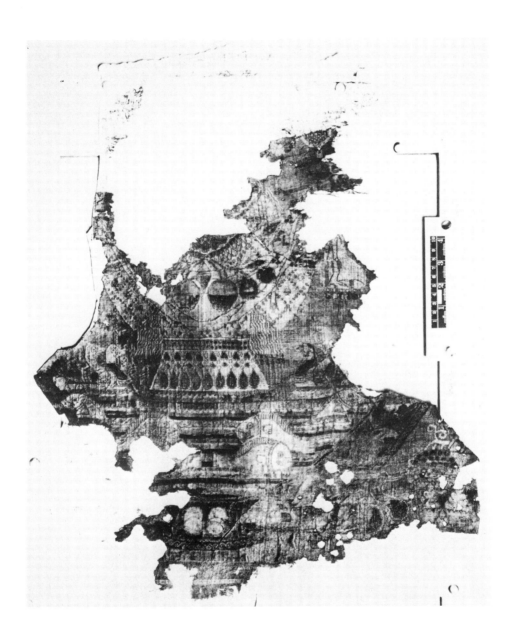

DURHAM CATHEDRAL, MONKS' DORMITORY. SO-CALLED 'NATURE GODDESS' SILK

PLATE 77

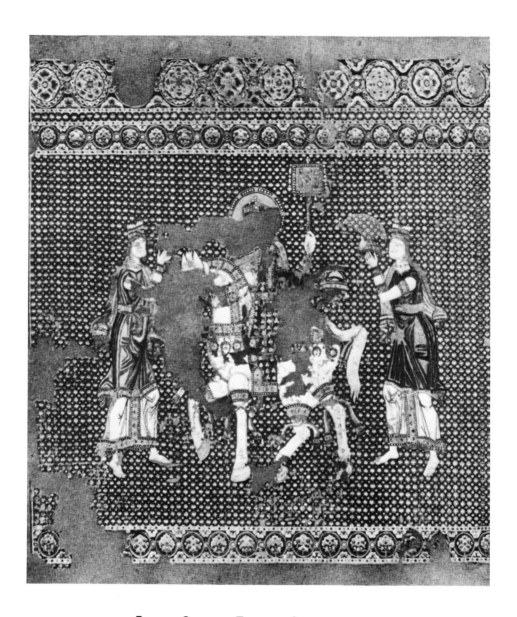

BAMBERG CATHEDRAL TREASURY. GUNTHER TAPESTRY

PLATE 78

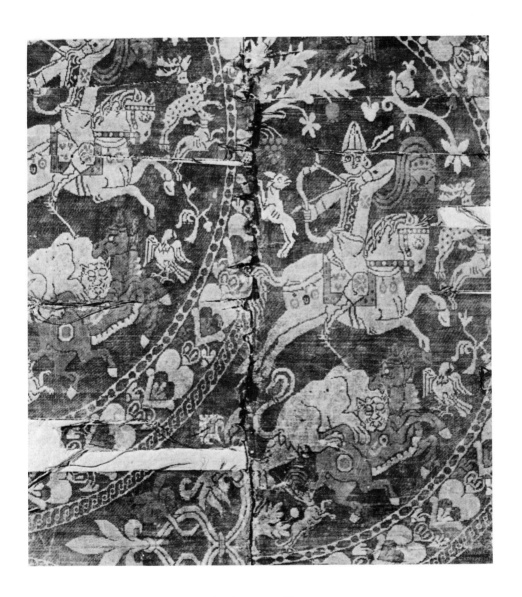

MILAN, ST. AMBROGIO. HUNTER SILK

PLATE 79

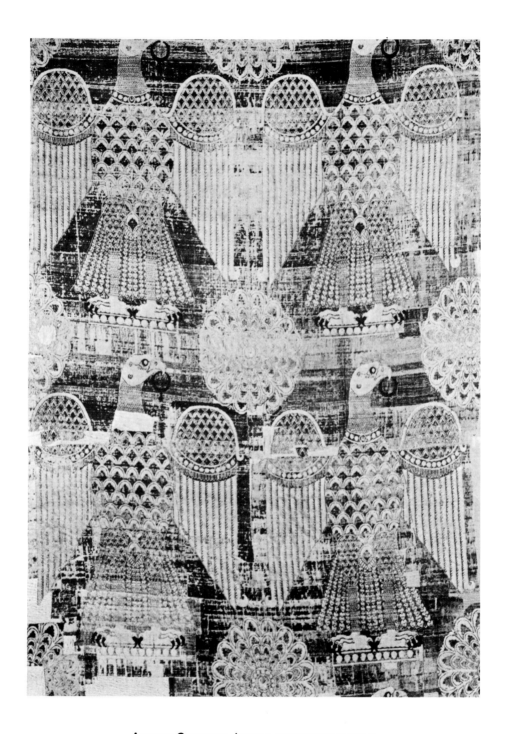

AUXERRE CATHEDRAL. IMPERIAL BYZANTINE EAGLE SILK

PLATE 80

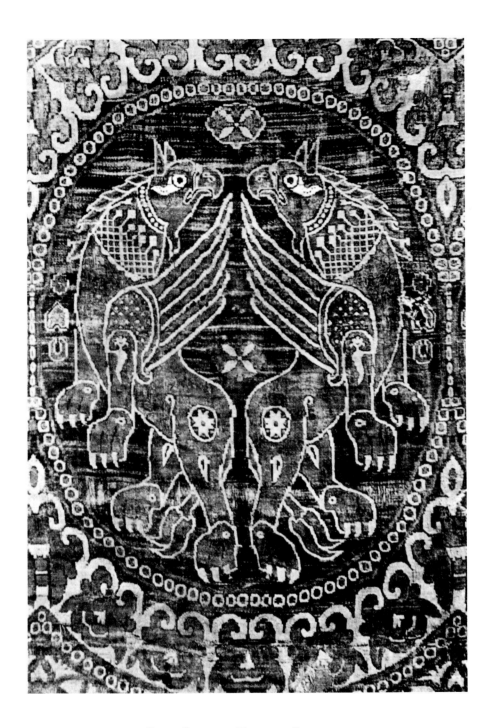

SITTEN CATHEDRAL TREASURY. GRIFFIN SILK

PLATE 81

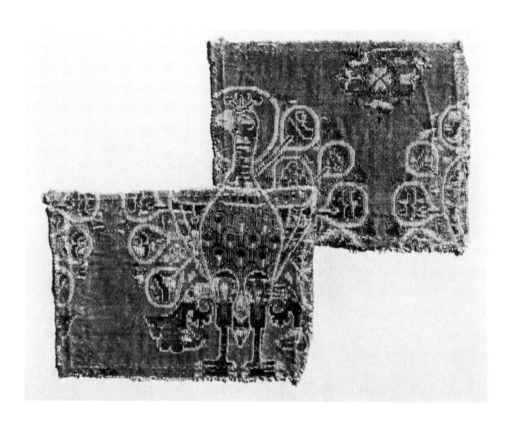

BEROMÜNSTER PARISH CHURCH TREASURY. PEACOCK SILK

PLATE 82

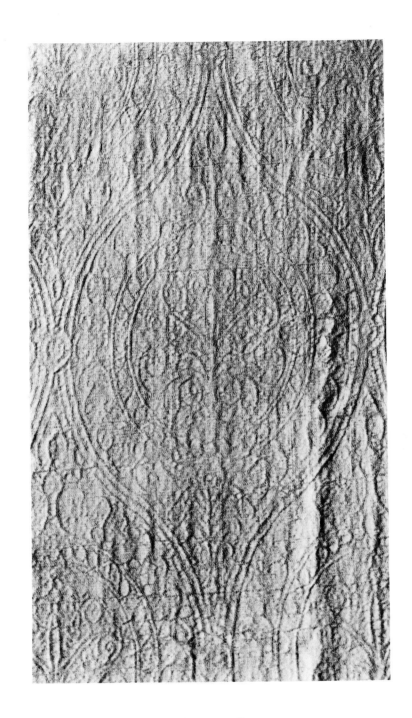

MAINZ, CATHEDRAL TREASURY
DETAIL OF ONE OF TWO CHASUBLES OF ARCHBISHOP WILLIGIS. FOLIATE MOTIF IN OGEE (CF. PL. 32)

PLATE 83

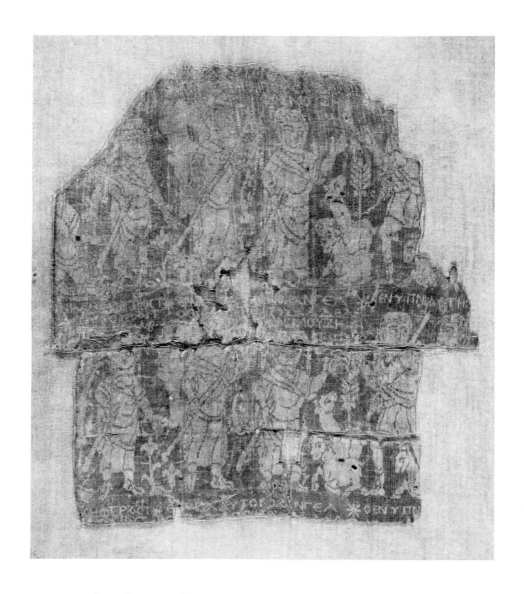

SENS, CATHEDRAL TREASURY. SILK WITH SCENES FROM THE LIFE OF JOSEPH

PLATE 84

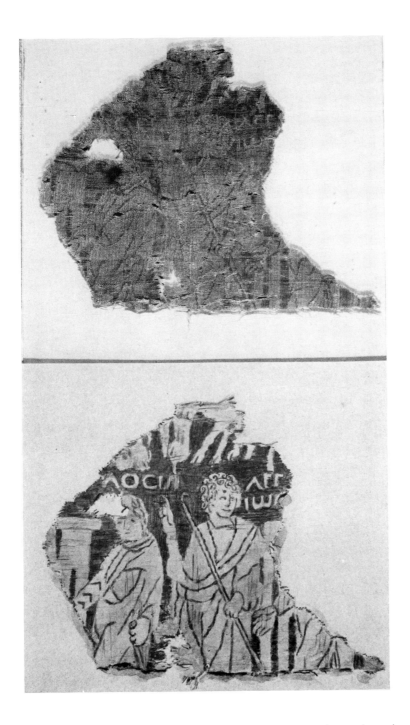

SENS, CATHEDRAL TREASURY. SILK WITH SCENES FROM THE LIFE OF JOSEPH (DETAIL)

PLATE 85

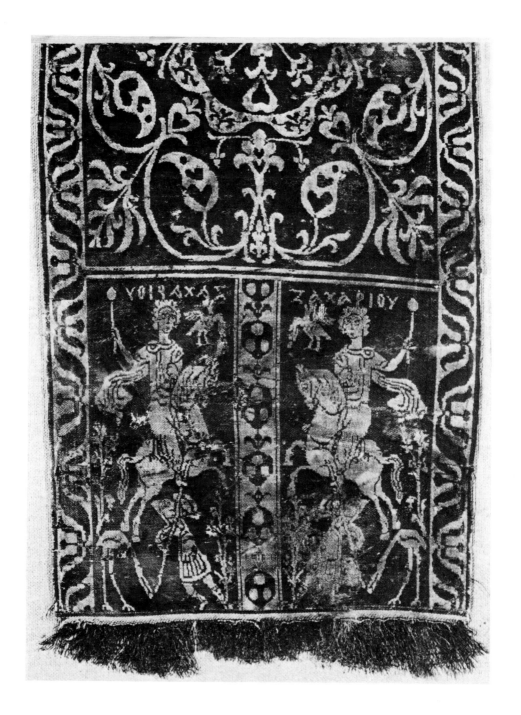

LONDON, VICTORIA AND ALBERT MUSEUM. HUNTER SILK OF THE "ZACHARIOU AND JOSEPH" GROUP

PLATE 86

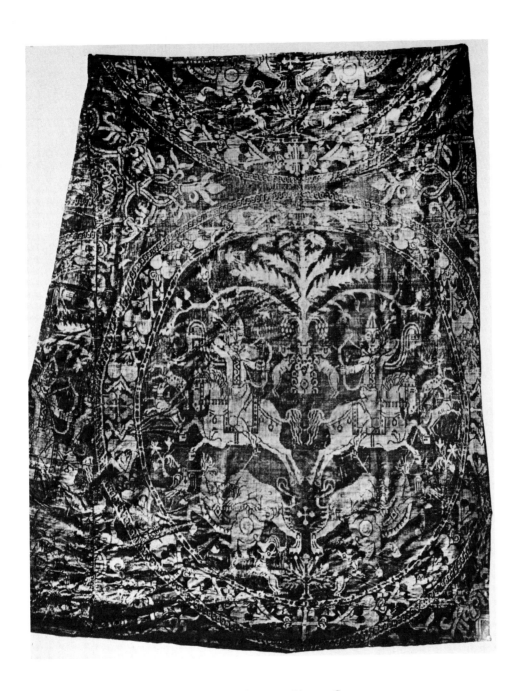

COLOGNE, ST. CUNIBERT. HUNTER SILK

PLATE 87

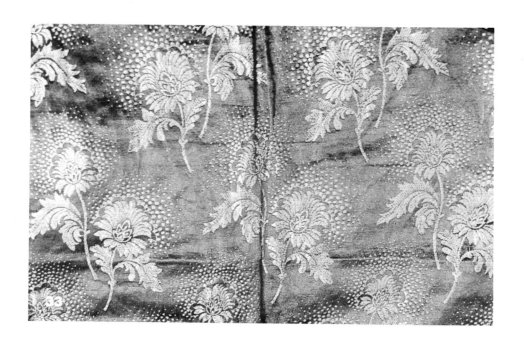

SILK FROM BRUSA (BURSA)

PLATE 88